D1162023

Yaxchilan

*The Design of a
Maya Ceremonial City*

YAXCHILAN
The Design of a Maya Ceremonial City

CAROLYN E. TATE

University of Texas Press, Austin

To the Instituto Nacional de Antropología e Historia de México, in recognition of its multifaceted efforts to preserve, study, and make accesible thousands of ancient American cities.

Published with the assistance of the Getty Grant Program

Copyright © 1992 by the University of Texas Press
All rights reserved
Printed in the United States of America
Second printing, 1993

Requests for permission to reproduce material from this work should be sent to Permissions, University of Texas Press, Box 7819, Austin, TX 78713-7819.

Photographs copyright © 1991 by Lee Clockman except when otherwise indicated. All rights reserved.

Photographs of Lintels 15, 16, 24, and 25, © 1985 by Justin Kerr, used courtesy of the Trustees of the British Museum.

Drawings and photographs included in Figures 2, 9–12, 14–20, 25, 28, 29–33, 36, 37, 39–41, 44, 45, 47–50, 57, 59, 62, 64, 68, 90, 91, 93, 94, 99, 101, 111, 112, 114, 125, 147, 148, 149, 153, 154, 156, 157, and 159, are copyright by the President and Fellows of Harvard University and published in *Corpus of Maya Hieroglyphic Inscriptions*, Peabody Museum of Archaeology and Ethnology, Harvard University, Cambridge, Mass. Lintels 1–28 (except 19 and 23) were drawn by Ian Graham and Eric von Euw, published in Vol. 3, Part 1, 1977. Lintels 28–58 were drawn by Ian Graham, published in Vol. 3, Part 2, 1979. Lintels 19 and 23 and all hieroglyphic steps were drawn by Ian Graham and published in Vol. 3, Part 3, 1982. Used by permission, Harvard University Press.

Drawings and photographs included in Figures 8, 44, 54, 57, 72, 78, 92, 98, 103, 117, 126, 129, 135, 144, 146, and 148, from Teobert Maler, *Researches in the Central Portion of the Usumatsintla Valley*, Peabody Museum Memoirs, vol. 2, no. 2, 1903, are reprinted with permission of the Peabody Museum, Harvard University.

Drawings and photographs included in Figures 64, 66, 67, 119, 120, 121, 126, 129, 131, 135, 144, 147, 149, 150, and 151, from Sylvanus G. Morley, *The Inscriptions of Peten*, copyright 1937–1938 by the Carnegie Institution of Washington, are reprinted with the permission of the Peabody Museum, Harvard University.

♾ The paper used in this publication meets the minimum requirements of American National Standard for Information Sciences—Permanence of Paper for Printed Library Materials, ANSI Z39.48-1984.

Library of Congress Cataloging-in-Publication Data

Tate, Carolyn Elaine.
 Yaxchilan : the design of a Maya ceremonial city / by Carolyn E. Tate. — 1st ed.
 p. cm.
 Includes bibliographical references and index.
 ISBN 0-292-77041-3 (alk. paper)
 1. Yaxchilán Site (Mexico) 2. Mayas—Art. 3. Mayas—Architecture. I. Title.
 F1435.1.Y3T38 1992
 972'.75—dc20

91-3248
CIP

OVERSIZE
F
1435
.1
.Y3
T38
1992

9497567

pco

Contents

UWEC McIntyre Library
DISCARDED
APR 07 1995
Eau Claire, WI

Illustrations

Abbreviations Used

Names

AA: Ah Ahaual, captive of Shield Jaguar
AC: Ah Chuen, captive of Shield Jaguar
AK: Ah Kan Cross, captive of Shield Jaguar
BJ: Bird Jaguar (I), third ruler of Yaxchilan
BJII: Bird Jaguar II, eighth ruler of Yaxchilan
BJIII: Bird Jaguar III, thirteenth(?) ruler of Yaxchilan
BJIV: Bird Jaguar IV, sixteenth(?) ruler of Yaxchilan
CoM: Captor of Muluc, associate of Bird Jaguar IV
FB: Flint Bat, captive of Knot Eye Jaguar
GI: God I of the Palenque Triad, Hunahpu
GII: God II of the Palenque Triad, God K
GIII: God III of the Palenque Triad, Xbalanque
GS. *See* Lady GS; Lord GS
JS: Jeweled Skull, captive of Bird Jaguar IV
KEJ: Knot Eye Jaguar (I), ninth ruler of Yaxchilan
KEJII: Knot Eye Jaguar II, eleventh ruler of Yaxchilan
Lady GS: Lady Great Skull, wife of Bird Jaguar IV and mother of Shield Jaguar II
LAI: Lady Ahpo Ik, companion of Bird Jaguar IV
LIS: Lady Ik Skull, mother of Bird Jaguar IV, wife of Shield Jaguar
LP: Lady Pacal, mother of Shield Jaguar
Lord GS: Lord Great Skull, brother of Lady Great Skull
MKS: Mah K'ina Skull (I), sixth ruler of Yaxchilan
MKSII: Mah K'ina Skull II, tenth ruler of Yaxchilan
MKSIII: Mah K'ina Skull III, eighteenth(?) ruler of Yaxchilan
NC: Nak Chi, captive of Shield Jaguar
Q: man captured by Bird Jaguar IV on 9.16.4.1.1

SJ: Shield Jaguar (I), fourteenth(?) ruler of Yaxchilan
SJII: Shield Jaguar II, seventeenth(?) ruler of Yaxchilan
Xoc: Lady Xoc, companion of Shield Jaguar

Dimensions

Dia: diameter
H: height
H Block: height of block
HSc: height of sculptured area
L: length
MTh: mean thickness
MW: mean width
Rel: depth of relief
Th: thickness
W: width
WSc: width of sculptured area

Miscellaneous

A: altar
DN: Distance Number
HS: hieroglyphic stairway
INAH: Instituto Nacional de Antropología e Historia, Mexico
L: lintel
MNAH: Museo Nacional de Antropología e Historia, Mexico City
Ref: reference to published work
Sp: step
St: stela
Str: structure
819: 819-day-count verb

This study began as an effort to interpret the iconography of Maya art within a closed system—a single ceremonial city. Yaxchilan, Chiapas, was chosen because its many sculpted monuments are well documented and have suffered little looting. Dating between A.D. 454 and 808, they show a great variety of format and subject matter. Adding to the suitability of Yaxchilan for an iconographical study was the fact that the original locations of the sculptures relative to architecture could be reconstructed. Also, a firm chronological and historical footing was provided by Tatiana Proskouriakoff's studies of the dates and hieroglyphic inscriptions. However, the distributional and relational analyses of iconography that I thought would answer questions about the meanings of imagery provided unexpected benefits, allowing me to see provocative patterns of ritual behavior. The Maya, it seemed, conceived the imagery of each monument in relation to nets of meanings woven by the symbols on previously existing monuments placed throughout the city. Also, it was clear that cultural ideals and community identity were being forged through art. The city itself was the work of art, not one which was passively admired, but one whose creation attracted ideal order into the lives of its inhabitants.

After this realization, Yaxchilan and other Maya cities seemed fundamentally different in character and focus from cities of the modern industrialized world. How valid was this perception, and what was the nature of the difference? To interpret public art in the city of Yaxchilan, I had to consider what roles art and the city played in the cultural map of the ancient Maya.

Understanding the conceptual systems of ancient civilizations and making them comprehensible across cultural barriers can be done—carefully—by identifying the categories of order regarded as appropriate by the people under study. This goal is more commonly undertaken in the interpretation of ancient texts, but it can also be approached through ethnography and through art. That has become the aim of this volume—to interpret the cultural and aesthetic bases for the design of public art within what I believe was a relevant ideological matrix for the Maya—a community. The study focuses on the best-documented period of Yaxchilan's history—the reigns of Shield Jaguar (reigned A.D. 681–742) and his son Bird Jaguar IV (reigned A.D. 752–772).

Two basic assumptions are inherent in this approach. The first is that art objects, as primary documents, speak as clearly as the written word about the ideals and cultural systems of a society. This concept is fundamental to the history of art, but not widely accepted as valid in other fields, in which the written word is usually the only admissible primary source relating to ideology. Yet some anthropologists have taken this view and developed the relationship between art and culture more profoundly, perhaps, than art historians have. The visual arts materialize a way of experiencing, even if they are, as Clifford Geertz puts it, "notoriously hard to talk about."[1]

This realization, that to study an art form is to explore a sensibility, that such a sensibility is essentially a collective formation, and that the foundations of such a formation are as wide as social existence and as deep, leads away not only

from the view that aesthetic power is a grandiloquence for the pleasures of craft. It leads away also from the so-called functionalist view that has most often been opposed to it: that is, that works of art are elaborate mechanisms for defining social relationships, sustaining social rules, and strengthening social values. . . . The central connection between art and life does not lie on an instrumental plane, it lies on a semiotic one. . . . The signs or sign elements . . . that make up a semiotic system we want, for theoretical purposes, to call aesthetic are ideationally connected to the society in which they are found, not mechanically.[2]

Geertz suggests that the work of art expresses the "feeling a people has for life." The greatest challenge in interpreting the aesthetic phenomenon is "how to incorporate it into the texture of a particular pattern of life. And such placing, the giving to art objects a cultural significance, is always a local matter . . ."[3]

The second assumption made here relates to Geertz's observation that meaning in the arts always depends on a local usage and a local way of being. This study begins to prove that Maya pictorial symbols do not necessarily have the same meaning in every city's art and ritual, and in this it differs from most previous studies of Maya iconography. Until now, the method used in deciphering iconography (and hieroglyphs) has been to find as many examples as possible of the item, determine the various contexts for its use, seek phonetic values for the item, find supporting clues from ethnographic and ethnohistorical works, then make a definition that encompasses the greatest number of associated factors of evidence. Great progress in our understanding of Maya civilization has been made in this manner. However, I think that the time has come to make sharper definitions of symbols used in Maya culture, based on a more profound knowledge of the specific local calendric, ritual, and political contexts in which the symbols were used. Focusing on a single site allows a richer texture of Maya culture to be brought into play.

Before asserting that symbols had local shades of meaning at individual cities, I made or supervised studies of all costume and cosmic elements in the art of Tikal, Palenque, Caracol, Bonampak, Site Q, and Piedras Negras. It became clear that symbols of the supernatural tend to be pan-Maya and also that some costume elements, such as the "drum-major headdress" used for accession ceremonies, are widely distributed among Maya sites, but that in most cases each site uses a distinct version of the element. Other costume items are specific to a single site or to a few sites within a region. Some items were copied from the repertoire of regalia at one city by another, but the exact use of the item tends to differ. These observations are noted in the interpretations of symbolic elements in this study, but deserve a much fuller treatment in the future. Such an analysis, tracing the adoption of ceremonial items from one city to another, will provide dated evidence of interaction among sites.

Studies of the art as systems of information about beliefs, ritual practices, social structure, and the like led to some tentative hypotheses about art in Maya society for which I wanted confirmation. For example, analyses of the contextual and relational organization of pictorial symbols and themes, coupled with a basic familiarity with the hieroglyphic texts, led to the discovery of some principles in the design of art and the city. Also, based on the number of unique elements of costume and pictorial theme at Yaxchilan, it seemed to me that the design of public art was directed toward producing a sense of local identity for the inhabitants of each ceremonial city. To see if others had observed similar tendencies among the Maya people, I turned to the ethnographic literature. There are no accounts written by members of European-derived society about life in the Maya lowlands during the period under investigation. However, because it is well documented that, in a general sense, fundamental aspects of Maya culture lived on in Yucatan and Guatemala, I have used Colonial and modern studies of Maya societies to establish a general frame of reference with which to consider the ancient Maya. Only when similar observations about Maya behavior were described—often obliquely—in several of these accounts did I trust the veracity and cultural implications of my perceptions of the Yaxchilan pictorial tradition.

To give the art of Yaxchilan a fuller cultural context than I think currently exists in the archaeological or art historical literature, I have attempted to synthesize a very preliminary picture of Maya traditional culture based on a concordance of traits found in Classic Period art and hieroglyphs, Colonial Period reports, and modern ethnographic studies. This view of the Maya, presented in Chapter 1, focuses on the concept of self and on art, oral tradition, and dreams as important modes of social integration among the Maya. Chapters 2 and 5, on aesthetics and city planning respectively, are tentative first steps toward identifying the cul-

tural ideals shared by rulers and community in the Classic Period, and are based on my analyses and supported by ethnographic data. Chapters 3, 4, and 6 present the categories of iconography and the version of history decided upon by the patrons and artists of Yaxchilan, and of course do not necessarily reflect what actually happened, but like any history, are an idealized account from a particular viewpoint and with a particular purpose.

Some of the implicit cultural attitudes observed in Classic, Colonial, and modern Maya societies also exist in other non-Maya societies. Several scholars in various disciplines have examined this phenomenon of broad similarities in cultural outlook. Their comments, which I have found to be extremely helpful in bracketing my own cultural bias in order to see the Maya on their own terms, are used to place the data on the roles of self and art in Maya civilization (in Chapter 1) in a larger, cross-cultural perspective.

I gratefully acknowledge the scholarly, financial, and spiritual support of several generous institutions and individuals over the last six years. On-site research at Yaxchilan in 1984–1985 was supported by a grant from the International Institute of Education under the Fulbright-Hays Act, and by a University Fellowship from the University of Texas at Austin in 1985. A fellowship at Dumbarton Oaks in 1988 allowed me to place the analysis of costume at Yaxchilan in the context of six other major sites and to study many of the Colonial and modern sources on the Maya. Dr. Steven Nash of the Dallas Museum of Art granted me a leave of absence shortly after I was hired. Since then, Richard Brettell and Emily Sano have been supportive of this undertaking.

My work in Mexico was facilitated by many kind individuals. Dr. Miguel León-Portilla helped arrange my placement as Visiting Investigator with the Institute of Esthetic Investigations at the National Autonomous University of Mexico. There, Dras. Beatriz de la Fuente and Maricela Ayala Falcón of the Centro de Estudios Mayas provided research facilities and the opportunity to interact with other scholars. Special thanks go to Dras. Doris Heyden and Constanza Vega Sosa for their most warm and gracious hospitality.

Alfonso Morales C., then in Austin, had provided me with magical envelopes to deliver around Palenque, where I lived for nine months. Those envelopes opened doors to the homes of many people and introduced me to my first close-knit community. Moisés Morales translated Chiapaneco into Spanish and made sure that I participated in all the local adventures. Merle Greene Robertson gave me charge of the Pre-Columbian Art Research Center, where I learned how to get frogs to sing the refrains of popular songs, to spot coatimundis, to keep howler monkeys from stealing the flan, to fight termites with diesel fuel, to plant bananas, and to *amarrar guano* (tie palm leaves onto roof structures). Marco Antonio Morales F. was a constant friend and supporter in all situations, performing no fewer than four death-defying rescues. The community of eclectic personalities at La Cañada was one of the most wonderful experiences I have ever struggled through.

Jungle survival training was provided by Martin Diedrich, without whose patient lessons I would never have been able to lead others into Yaxchilan. At the beginning of my research, Martin shared his own ideas on his favorite spot with me.

Several groups of people have accompanied me into Yaxchilan and helped measure and photograph and also helped with the entertainment while I worked; in June 1984, Francisco Amezcua, Tabor Stone, Jim Wright, Jim Strickland, and my father, Will Tate; in December 1984, Connie Cortez, George Nelson, Dorie Reents-Budet, Andrea Stone, and Blake Williams; in June 1985, John C. Odom, J. Clayton Odom, Julia Underwood, and Aristoteles; in February 1986, Ryan Amey, Mike Copher, and Jim Wright; in June 1987, Ken Grant; in June 1988, Lee Clockman, Ken Grant, and John Caldeira. Of this group two have passed away, Tabor Stone and Pancho Amezcua. I am especially grateful to Francisco Amezcua, a man of great experience in the jungle and a profound spirituality, for spending his last days with me at Yaxchilan.

Many scholars have exchanged ideas and information and provided direction. Nicholas Hopkins and Kathryn Josserand wisely insisted on accurate documentation of the physical appearance of the site. Since January 1986, David Carrasco has occasionally helped me place this work into larger, more interesting, and ultimately more challenging contexts. An indication of how great the publication of the archaeology of Yaxchilan will be was provided by discussions with Ramón Carrasco V., Sylviane Bouchet, and Don Patterson. Many people have provided helpful comments on sections of the manuscript: Rex Koontz, Chip Morris, Donald Preziosi, Norman Hammond, Alana Cordy-Collins, John Verano, Meredith Paxton, Lorraine Williams-Beck, Connie Cortez, Chester

Williams, Martin Diedrich, Mimi Crossley, Andrea Stone, and Ken Grant. Betty Ann Brown, Rosemary Joyce, and Chris Jones gave the most thorough and appreciated criticisms of earlier versions of the manuscript. I also wish to acknowledge the work of Jay Kotliar, Bridget Hodder, Cynthia Kristan-Graham, Kaye Durland, and George Kershaw, graduate students at UCLA in 1986, who analyzed costume at Tikal, Caracol, and the Chichen Itza Temple of the Warriors.

The comments and examples of several professors at the University of Texas have been continuous inspiration. Terence Grieder's insistence that the right question is better than the right answer has helped in many muddled situations. For his instruction in scholarly method, I am very grateful to Tom Reese. Linda Schele's energy and dedication, her brilliance, her intuition, her eye, her flair for performance are a constant challenge in a very positive sense.

Documentation of the magnificent architecture of Yaxchilan was realized by Lee Clockman and financially supported by George Steffens and Landon Clay. Copies of the photographs in this book are deposited in the Peabody Museum for Archaeology and Ethnology.

To my family—Will, Eve, and Mattie Tate, and Marilyn Koenitzer—I express my undying appreciation for never telling me I am crazy for doing what I love.

A final comment about dating[4]—all the Maya Long Count dates in this study were converted into Julian dates using the 584285 correlation number, which was proposed by J. Eric S. Thompson in 1935 and re-evaluated favorably by Floyd Lounsbury in 1982.[5] Using the Thompson correlation, I found the Jupiter-Saturn stationary conjunctions, the summer solstice phenomena, and the Venus events at Yaxchilan. David Kelley's latest correlation number was tested with negative results. I am convinced that somewhere between 584283, the correlation supported by contemporary Maya calendrical practice, and 584285—a difference of two days—lies the correct correlation.

Maya by Design

Maya Society in the Ceremonial City

Today's visitor to Yaxchilan, Chiapas, Mexico, arrives by small aircraft, raft, or cargo canoe. Once on land, welcomed by the guards at a small hut overlooking the river, one heads southeast into the site. The walk provides some time to prepare the imagination for a confrontation with the creations of an ancient kingdom. Winding along a humid trail framed by enormously tall trees and walls of vines and paved by slippery rocks which one suspects fell from a temple, one first glimpses a high stone wall that parallels the trail and recedes in steps as it rises. Set into the wall are large, corbel-vaulted niches, each fitted with a bench and each with an opening back into utter darkness. Across from the niches on the other side of the trail is a pyramidal platform about thirty feet high, completely covered by heart-shaped leaves. The trail leads to a pointed entrance into a solid stone wall (Figure 1). Almost completely surrounded by the platform, the wall of benches, and the temple whose door looms ahead, one can pass through this opening or turn back. Taking a last, deep breath of fresh but sodden air, one enters a pitch-black passageway. As bats whiz overhead, one wants to cling to the walls for guidance, but a guide warns not to touch the walls, because they are coated with delicate ancient stucco and also because the enormous insects that colonize the black depths might be poisonous. Right turn, left turn, climb high steps; then a little light begins to enter the labyrinth. Stepping into the immense chamber at the top of the stairs, one sees framed by the narrow front entrance an emerald-green world. On the right, a trail winds up a hill to a small but elegant façade. Ahead and to the left stretches an immense flat area, a plaza whose full extent cannot even be seen, framed by buildings on both sides. Having passed through this frightening passage, one is confronted by the emotional and intellectual challenges of the Maya. What variety of social and scientific skills enabled them to construct this incredible place? One senses that the images on the sculptures and the buildings wove a net of information and ideological power that somehow bound the people in a meaningful way. How did the art and the city create a matrix for human experience at Yaxchilan in the eighth century? These are the questions that will be explored in this book.

Yaxchilan, with Tikal, Copan, Piedras Negras, and Palenque, is one of the most important Classic Period Maya cities in terms of its size and the number and quality of its monuments. It is best known for its sixty carved lintels, which, aside from being aesthetically interesting, depict Maya ritual bloodletting and warfare with an explicitness presented nowhere else. Other unique aspects of the art and inscriptions of Yaxchilan are the inclusion of many women in ceremonial roles, the complex cosmological format of imagery on the stelae, the degree of documentation of the reigns of two Late Classic kings, Shield Jaguar and his son Bird Jaguar IV, and the unusual design of the city to mimic the passage of the sun over the earth.

As with most ancient Maya cities, the natural surroundings are extraordinary. Situated in the tree-fringed hilly lowlands of Chiapas, Yaxchilan is surrounded on three sides by the Usumacinta River. That formidable river runs fast and muddy in the rainy season, from May through November, when it drains most of the

1.

A contemporary entrance to the city is through the corbel-vaulted entrance to the Labyrinth (Structure 19). The walls in the right foreground are the base of the West Acropolis. Photo © 1991 by Lee Clockman.

rain forest associated with the Petén of Guatemala and Chiapas. From December through April the river subsides, and the water is pleasantly clear. From the landlocked side of the peninsula, a small range of deeply cleft hills reach like fingers toward a flat embankment, averaging about 40 meters wide, that parallels the curve of the river. Only a small portion of the embankment was used for construction of temples; instead, the Mayas built atop the highest hills overlooking the river.

What can be seen of this magnificent ancient city was constructed between about A.D. 450 and 808, under the reigns of about ten generations of kings of the Skull and Jaguar lineages. The existence of seven earlier kings is recorded in hieroglyphic writing on dynastic lists on architectural lintels (see Figure 3).

The first king, who was of the Jaguar lineage, lived around A.D. 300. He and his contemporaries established an important aspect of what might be considered as the spiritual identity of the city through the selection of its location. They decided upon this area not only because it is surrounded on three sides by the river. The placement of the temples high on natural pin-

nacles at the site demonstrates that their interest was not only in the river, but also in the view of the eastern horizon afforded by those hills. This early king lived during the leap in social and scientific development that brought about the establishment of rule by dynastic kings who claimed sacred origins and authenticated their claims through written genealogies backed up by a complex calendar based on precise astronomical observations and mathematical calculations. His claims for power, like those of kings at other cities, were supported by individuals who had developed esoteric knowledge of astronomy. They must have used the hills of Yaxchilan for years as observatories which allowed them to measure the length of the year and see the passage of the planets. From the hill on which Structure 41 was eventually built, they saw that on the longest day of the year, the sun rose in a cleft between the two highest mountains in the Usumacinta region. This day marked the annual waning of the strength of the sun. With this information, the kings and astronomers were able to calculate the cycle of the year based on their own geographical surroundings. This important geo-

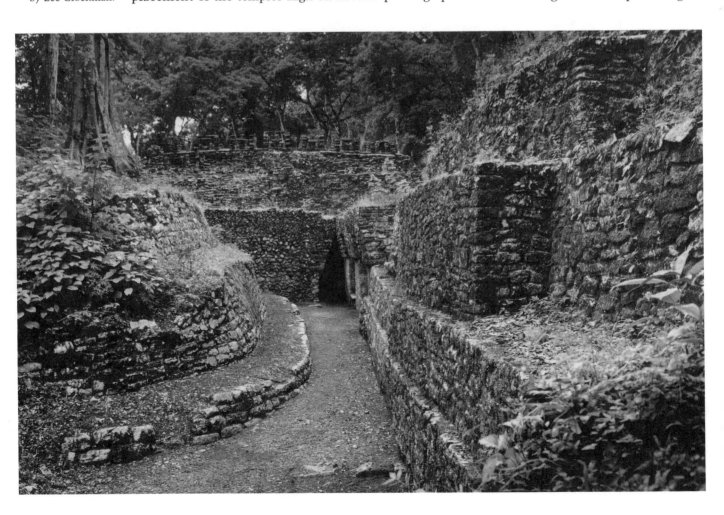

graphical-astronomical feature became the name of the city: Split Sky. It was recorded as one of the two Emblem Glyphs used to refer to the relationship between the place and the royal lineage in the inscriptions.

By the time Classic Period civilization collapsed at Yaxchilan, just after A.D. 800, the city's stone structures and monuments were distributed over an area extending 1,100 meters from northwest to southeast and 500 meters from northeast to southwest. This ceremonial center must have been, like all other Maya cities which have been thoroughly mapped, surrounded by a substantial area in which its inhabitants lived and farmed. Its periphery is not well known today, but thanks to fourteen seasons of clearing and consolidation of structures done by the Instituto Nacional de Antropología e Historia de México (INAH), over 100 stone buildings and about half of its known sculpted monuments are visible at the site.[1]

Rediscovery

The work undertaken by the INAH was preceded by several important studies, all of which contributed to the scholarly understanding of Maya culture as well as to the rediscovery of a history of Yaxchilan. A brief résumé of the discoveries concerning Yaxchilan made in the last 150 years provides a basis of information upon which the present study builds.

To John Lloyd Stephens, the intrepid explorer of antiquity during the first half of the nineteenth century, the history of the Maya was irrevocably lost. He never visited Yaxchilan, but mused after having lingered weeks at Palenque:

> Here were the remains of a cultivated, polished, and peculiar people, who had passed through all stages incident to the rise and fall of nations; reached their golden age, and perished, entirely unknown. The links which connected them with the human family were severed and lost, and these were the only memorials of their footsteps upon earth. We lived in the ruined palace of their kings; we went up to their desolate temples and fallen altars; and wherever we moved we saw the evidences of their taste, their skill in arts, their wealth and power.[2]

As the science of archaeology developed in Europe and the United States, Stephens' accounts of the once-splendid Maya civilization attracted several explorer-archaeologists to the Maya area. Although Yaxchilan had likely been vis-

ited in the seventeenth century by Spaniards attempting to reach a stronghold of Maya political authority at Lake Petén Itzá, the conquest of which would extend the dominion of God and of the King of Spain, little attention was paid by these persons to the uninhabited ruins of the heathen past. Several scholars, especially Roberto García Moll, Teobert Maler, Sylvanus Morley, Ian Graham, and I have searched for enlightening descriptions of Yaxchilan in the seventeenth-century literature, but found only vague references to sightings of the ancient city. Perhaps it was briefly visited by a campaign led by Maestro de Campo Jacobo de Alçayaga in 1696, as reported in the *Historia de la conquista de la provincia de el Itza* by Juan de Villagutierre Soto-Mayor in 1701. It may have been visited by Juan Galindo, who encountered impressive ruins during his explorations of the Usumacinta River, an undertaking published in 1833. Indications of the existence of a great city eventually reached Edwin Rockstroh of the Colegio Nacional in Guatemala City, who visited the city in 1881. He apparently wrote an account which found its way into the hands of Alfred Percival Maudslay, an Englishman working on a report on the archaeological wonders of Central America. Within two days of Maudslay's arrival in 1882, a Frenchman, Désiré Charnay, who had heard of the lost city from a local official in Tenosique, Tabasco, and had traveled over land from Tenosique to an outpost upriver of Yaxchilan on what is now the Guatemalan side, arriving in time to see Maudslay's outfit float past on the river, was picked up by Maudslay's boat and transported to Yaxchilan. A member of the Comission Scientifique du Mexique, Charnay received support to explore the ancient cities of America from Pierre Lorillard, an American of French heritage. He published *Cités et ruines américaines*, 1863, and *Les anciennes villes du Nouveau monde*, 1885, which briefly describes the city, but dwells more on several groups of Lacandon Maya who lived nearby.

Although Maudslay seems to have been extremely deferential to Charnay, the former's work is the first which actually records some of the buildings and sculptures of Yaxchilan, and which provided the first map. It was published as part of a five-volume work, the archaeological sections of *Biologia Centrali-Americani*, in London between 1889 and 1902. Maudslay made many paper casts of the sculptures he found and took them to London. The casts were photographed and/or drawn, and he also made some photographs of the original sculp-

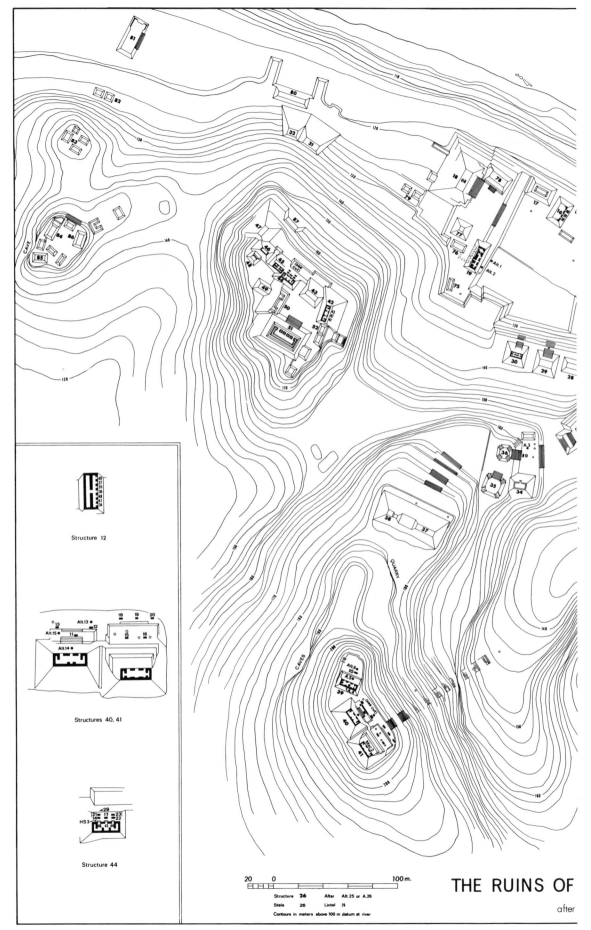

Structure 12

Structures 40, 41

Structure 44

20 0 100 m.

Structure **26** Altar Alt.**25** or A.**26**
Stela **26** Lintel **26**
Contours in meters above 100 m datum at river

THE RUINS OF

after

2.

Map of Yaxchilan by
Ian Graham
(1977:7–8) after
John Bolles' map of
1931.

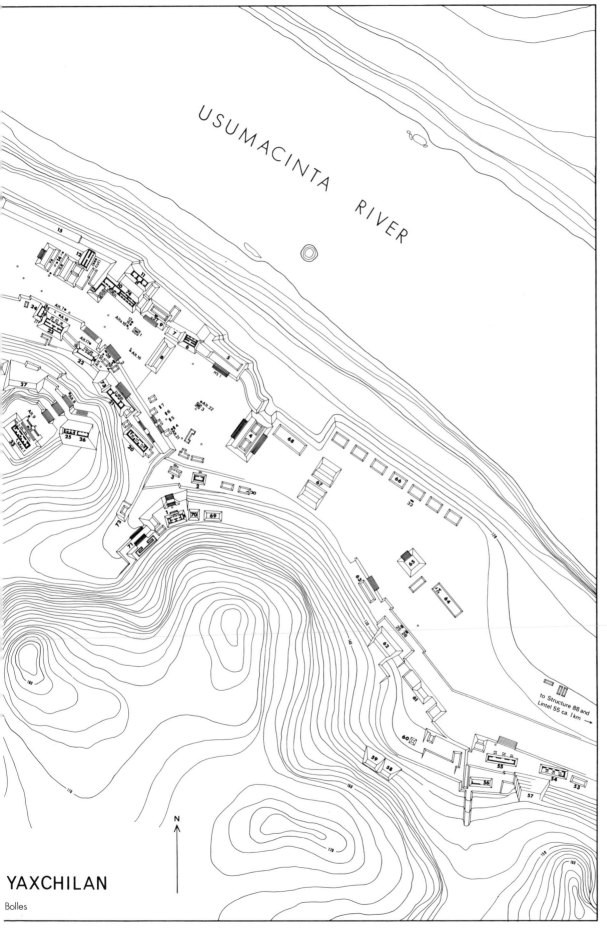

YAXCHILAN

Bolles

tures, particularly those which he took or had shipped to the British Museum. Images of nineteen lintels and one stela appeared in the publication, along with plans and photographs of some of the thirteen buildings which were visible. His description of the site is fairly brief, his report focusing instead on the journey and the natural and social surroundings. Several of his projects were destructive—he thinned eight of the lintels for their transport to London, in at least one case losing precious hieroglyphic inscriptions without recording them first, and according to a later researcher, Teobert Maler, the fires he built in the doorways of temples in order to dry the paper molds of the lintels caused cracking of some of those lintels.[3] Nevertheless, the only lintel that was destroyed completely was from House C, now called Lintel 56 from Structure 11, which was shipped erroneously to the Museum für Völkerkunde in Berlin and was destroyed by bombing in World War II. Fortunately, a cast made of this lintel survives and is in the Museum of Mankind, London.

The report which has formed the basis of modern research on Yaxchilan was that of Teobert Maler, finally published in 1903 by the Peabody Museum as a part of his two-volume work *Researches in the Central Portion of the Usumatsintla Valley*. A good command of Spanish allowed Maler to gather from the local inhabitants provocative accounts of the surroundings which led him to many more sites in the area than had previously been reported. Trained as an architect in Austria, he was fiercely protective of the ancient buildings and sculptures and had developed an eye and a vocabulary for describing the constructions in painstaking detail. His goals were to find more sculptures and temples, to prepare (by clearing and moving) and photograph the sculptures, to draw plans of the buildings, and, although he did not state it, to give detailed descriptions of what he observed. He also was able to excavate for new sculptures through "having familiarized myself with the method of construction employed in building the principal edifices, when drawing their several plans . . ."[4] He targeted excavations so accurately that he found the sought-for lintel in every case, although some were plain. Maler compiled the finding of his three visits (in 1895, 1897, and 1900, during which he located twenty stelae and fourteen lintels and discovered the South Acropolis) into a logical plan and system for discussing buildings and their associated sculptures. The numbering systems he devised are still used today. Thanks to Maler, there also exists a record of the remains of stucco sculpture and paint used on the monuments. He was able to record the existence of much paint and stucco sculpture on interiors and exteriors that has since deteriorated.

Maudslay, Charnay, and Maler each gave this city a different name, and still others had been applied to it in the Colonial Period. The origin of Maudslay's appellation, Menché Tinamit, has been attributed by Thomas Joyce to Rockstroh, who was said to have called the city after the ancestors of the Lacandon living nearby in the 1880's.[5] Charnay published it as La Ville Lorillard and Villa Lorillard after his patron, but this name was never widely adopted. Maler objected to "Menché Tinamit" because it would not be understood by local people, who referred to the site as the ruins downriver from the confluence of the tributary Yaxchilan into the Usumacinta, or the ruins upstream from the creek of Anaite. He named it Yaxchilan, giving a gloss of *yax* as "green" and *tsilan* as "that which is scattered about," referring to the stones, apparently in justification of the name.[6] He also mentioned a monumental city with spacious buildings in the Usumacinta region that Cortés called Izancanac. This is provocative, since part of the word is likely *ka'an*, "sky," which refers to the Emblem Glyph; perhaps it could be something like *Itz'an kanak* or *Tsah kanak*. In Yucatec, *tsah* is "split." For the present, Yaxchilan is the name commonly used, and Place of the Split Sky might be accepted until the Maya equivalent of the Emblem Glyph is deciphered.

In 1931, Sylvanus Morley led an expedition to Yaxchilan under the auspices of the Carnegie Institution of Washington. Working with him were Karl Ruppert as archaeologist and John Bolles as surveyor, while Morley devoted himself to drawings, photographs, and descriptions of the inscriptions. Despite the heat of the dry season, between April 5 and May 5 the crew, with three assistants, were able to survey for the map still used today and discover twelve new stelae, thirteen altars, eight carved lintels, five steps at Structure 44, and the Southeast Group.[7] The results of the epigraphic study, the map, and the majority of the photographs and drawings were published by the Carnegie in 1937–1938 as part of Morley's *The Inscriptions of Peten*. In this work, Morley followed Maler's nomenclature for buildings and sculptures. He made some iconographic identifications of the imagery, referring, for example, to the "celestial cartouche" at the top of some of the stelae, but mostly confined himself to determining Long Count equivalents for the many Calendar Round dates based on his knowledge of the mechanics of the calendar and on sculptural style. Unfortunately, he made the assumption that all

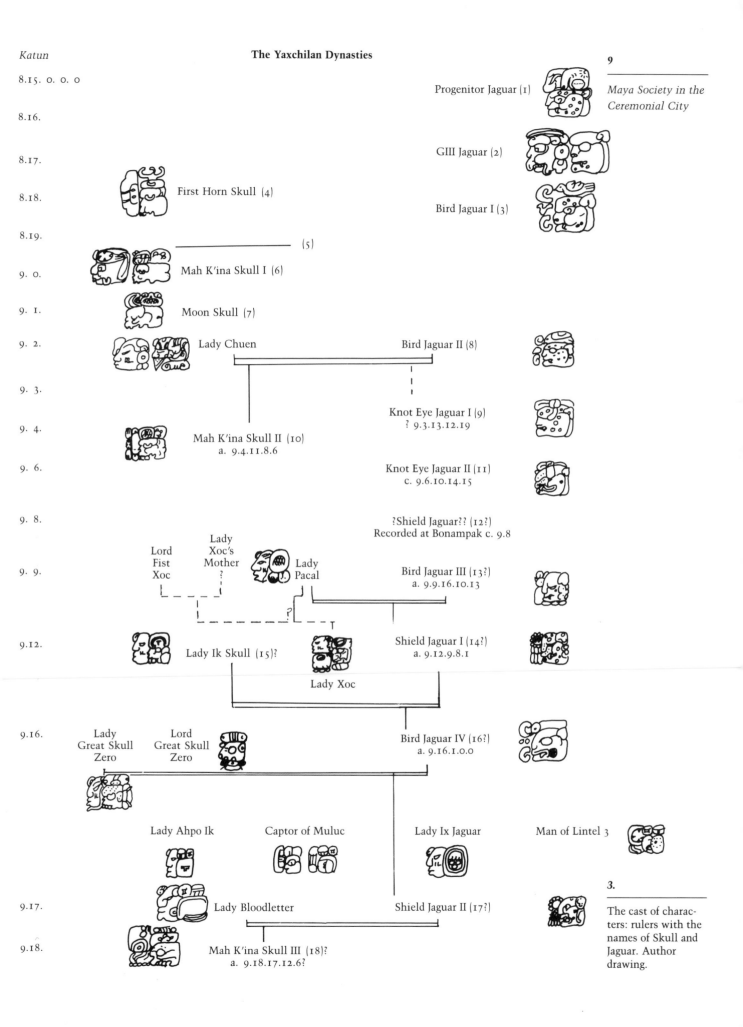

8.15. 0. 0. 0

Progenitor Jaguar (1)

8.16.

GIII Jaguar (2)

8.17.

8.18. First Horn Skull (4)

Bird Jaguar I (3)

8.19. (5)

9. 0. Mah K'ina Skull I (6)

9. 1. Moon Skull (7)

9. 2. Lady Chuen Bird Jaguar II (8)

9. 3.

Knot Eye Jaguar I (9)
? 9.3.13.12.19

9. 4. Mah K'ina Skull II (10)
 a. 9.4.11.8.6

9. 6. Knot Eye Jaguar II (11)
 c. 9.6.10.14.15

9. 8. ?Shield Jaguar?? (12?)
 Recorded at Bonampak c. 9.8

 Lady
Lord Xoc's
Fist Mother Lady
9. 9. Xoc ? Pacal Bird Jaguar III (13?)
 a. 9.9.16.10.13

9.12. Lady Ik Skull (15)? Shield Jaguar I (14?)
 a. 9.12.9.8.1

 Lady Xoc

 Lady Lord
 Great Great
 Skull Skull
9.16. Zero Zero Bird Jaguar IV (16?)
 a. 9.16.1.0.0

 Lady Ahpo Ik Captor of Muluc Lady Ix Jaguar Man of Lintel 3

9.17. Lady Bloodletter Shield Jaguar II (17?)

3.

9.18. Mah K'ina Skull III (18)?
 a. 9.18.17.12.6?

The cast of characters: rulers with the names of Skull and Jaguar. Author drawing.

the "beautiful" sculpture belonged to a single period, and this means of classification led him to many errors in the chronology of the monuments. Morley rarely discussed the subject matter of the sculptures.

Twenty-five years later, Tatiana Proskouriakoff, then of the Carnegie Institution of Washington, tackled the content of the inscriptions using the assumption, which she had explored in an article of 1960, that the "texts are largely historical and that the human figures depicted were real persons . . ." With this hypothesis, and based on relationships between certain groups of hieroglyphs, sculptured motifs associated with them, and the arrangement of monuments and buildings on which they appear, Proskouriakoff established the existence of three kings of the Late Classic Period.[8] She reported on Shield Jaguar I, born about A.D. 647, who reigned from 681 to 742; on Bird Jaguar, born 709, who reigned from 752 to about 772, and on Shield Jaguar's descendant, now known to have been born in 752, who reigned from about 772 to 800. (She gave these dates in the Maya system; I have transcribed them here to the Julian calendar.) She was able to advance well beyond Morley because she paid attention to the noncalendrical portions of the glyphs and recognized within them patterns of relationships which associated a series of glyphs with another glyph, each group falling within a possible human life span. In other words, she discovered glyphs for names and events. She then observed the relationship between names of kings and Long Count dates, and was able to fit dates with only Calendar Rounds into logical positions within the Long Count. (The Maya calendar systems are explained later in this chapter.)

In addition to establishing a chronology for Yaxchilan that has needed little revision, Proskouriakoff also discovered the meanings of several important event glyphs, such as those for birth, death, capture, bloodletting, and accession to the throne. She also demonstrated that images of historical women were included in monumental sculpture.[9] Her conjectures concerning motivations and history were conservative, and usually correct. For the most part, only when new texts have filled in a crucial bit of information in the history have her conclusions been shown to be mistaken.

The social implications of artistic style have been explored by Beatriz de la Fuente (1967 and 1974) and Marvin Cohodas (1976a), with the result that themes and styles of art were attributed to schools of artists. Recently, I reevaluated this work from a different angle, that of identifying hands of scribes, then tracking specific traits to the figural portions of monuments. This study, which identifies individual hands and their collaboration in workshops, is presented in Chapter 2 of this volume.

Proskouriakoff's work enlightened a generation of epigraphers and iconographers who have made crucial discoveries based at least partially on the glyphs and imagery of Yaxchilan. Linda Schele, Peter Mathews, and Floyd Lounsbury worked out the dynasty of Palenque and then identified parentage statements in a paper presented in 1977. They noted that Shield Jaguar had documented his genealogy in several monuments at the city, and was not a usurper as Proskouriakoff had suggested. Peter Mathews worked out the succession of early Rulers 5 through 10 and their relationships to kings from other cities, as well as the father of Shield Jaguar I on the lintels of Structure 12. When a new lintel was discovered by INAH in Structure 12, David Stuart identified the names of Rulers 1 through 4. He also has identified images of bloodletting on the Period Ending stelae at Yaxchilan; has found a glyph on pottery which names artists and also appears on some lintels of Yaxchilan; and has identified certain verbal glyphs referring to temple dedication ceremonies and nominal glyphs for some temples at Yaxchilan. The glyphs of Yaxchilan have been treated in the *Notebooks for the Maya Hieroglyphic Writing Workshops at Texas* by Linda Schele, and Peter Mathews has also made handbooks to the glyphs at Yaxchilan for workshops around the United States.

The lintels taken by Maudslay to the British Museum were prominently featured in the exhibition and accompanying catalogue *The Blood of Kings* by Linda Schele and Mary Ellen Miller. Themes of bloodletting, the "Vision Quest," and warfare in Maya art were illustrated with monuments from Yaxchilan. Some of the interpretations and conclusions drawn by these scholars in this much-needed synthesis of Maya iconography are reexamined in this work, in light of the material on Maya society and the city presented in this chapter.

Greatly facilitating the study of the iconography and hieroglyphs of Yaxchilan are the efforts of Ian Graham, which began in 1970 and so far have resulted in three volumes, covering the lintels and hieroglyphic steps, in the series *Corpus of Maya Hieroglyphic Inscriptions*, published by the Peabody Museum of Archaeology and Ethnology in 1977, 1979, and 1982. The availability of Graham's and Eric von Euw's ex-

cellent drawings was a primary consideration in the undertaking of the present project. The artists generously have made unpublished materials available as well.

Serious archaeology began at Yaxchilan in 1972, and in 1973 its goals were established as conservation and presentation of the site and performing a systematic investigation into the socioeconomic rise and fall of Yaxchilan as an important site within the Maya Lowlands.[10] Thus far over twenty-six buildings have been freed from encroaching vegetation, many new monuments have been found, eight tombs discovered, and a ceramic sequence developed and tied to the chronology of buildings. These studies are forthcoming. A first major publication produced by Roberto García Moll, the project director, and Daniel Juárez Cossío is called *Yaxchilán: Antología de su descubrimiento y estudios* (1986). It gives a much fuller treatment of the discovery of the city than that given here and translates into Spanish the work of Maudslay, Charnay, Maler, Proskouriakoff, and Gerónimo López de Llergo, placing each in a biographical context. Under the direction of Roberto García Moll, the project has carefully preserved the natural environment of the site and admirably consolidated many structures, with no resort to speculative reconstruction.

My own published work on Yaxchilan has established the importance of the summer and winter solstice sunrise points on the horizon in the design of monuments, in rituals, and in the planning of the city; has identified the roles for women in royal ritual at the city; has reported a very important and rare stationary conjunction of Jupiter and Saturn in A.D. 709 that was used as an appropriate time to celebrate the anniversaries of the reigns of Shield Jaguar and his father, Bird Jaguar III; has discussed the reconstruction of the eroded dates and events on the eleven Period Ending stelae; and has established the presence of many solar-year anniversaries implicit in the ceremonies at the city. These published studies have been based on the knowledge of the entire city and its art that is presented here.

After almost one hundred years of study of the art and inscriptions of Yaxchilan, it can be securely stated that these works of art and architecture are primary records of Maya cultural ideals. They document the deeds of royalty within the complex matrix of Maya intellectual culture. In the hieroglyphic writing, names and events are plugged into complicated calendrical data that can be considered as the empirical scientific observations which support the body

of myth shared by all Maya peoples. The pictorial imagery and the design of the city instructed the simple people who did not read and materialized the esoteric, fundamental knowledge concerning the cosmos in the eyes of the beholders, providing them with a common vision of the sacred.

It is that common vision or common knowledge, the implicit culture, that needs to be considered before the city and its art can be approached on its own terms. In his book *Painting and Experience in Fifteenth Century Italy*, Michael Baxandall refers to "the period eye." Each beholder brings to a work of art interpretive skills developed in other activities valued in the society; for example, the fifteenth-century viewer might have highly developed skills and vocabulary used to evaluate the proportions of a good horse which might be useful in evaluating proportions of figures in a painting. Each beholder also possesses common cultural knowledge to some degree, such as a knowledge of the story of the Annunciation, and makes some assumptions about conventional representations in art, for example, that building units, such as walls or floor tiles, tend to be regular and rectangular. This kind of knowledge assists in enriching the experience of viewing a fifteenth-century Italian painting, such as Domenico Veneziano's *The Annunciation*.[11] It is crucial for any individual attempting to see Maya art for what it meant to the society that made it to have some notion of the cultural attitudes of the ancient Maya. The next section is a very preliminary attempt to identify what might have been common knowledge to the Maya in the Central Lowlands during the Classic Period.

A Maya Cultural Map

THE WORLD OF THE SUN: TIME AND SPACE

Explorations of Maya attitudes about the sun have been made by several scholars. All report that the sun conceptually relates and orders both space and time. Gary H. Gossen says, "In the concept of the sun, most units of lineal, cyclical, and generational time are implied at once, as are the spatial limits and subdivisions of the universe, vertical and horizontal. Most of the other deities (with the important exception of the earthlords) and all men are related lineally or spiritually to the sun-creator, who is the son of the moon."[12] Cardinal directions are

determined relative to the changing path of the sun among modern Chamula Maya of Mexico. In Tzotzil, the literal translation of the term for east is "emergent heat (day)"; the term for west is "waning heat (day)"; north is "the side of the sky on the right hand" and south is "the side of the sky on the left hand." Since the sun moves along the horizon, the directions are not absolute. The sun, of course, also determines the measuring of time. The basic unit of time, *k'in*, is the word for both "day" and "sun" in most Maya languages. The calendar, as will be discussed, is built with many interweaving, simultaneous cycles of groups of days.

Similar concepts are held by the modern Quiché of highland Guatemala. Barbara Tedlock observes,

> The word for "day" is the closest the Mayan languages come to having a term for "time" itself, but it is more than that. A day, each day, has its "face," its identity, its character, that influences its events; a person's luck of the moment, or even his fate in general, is called "the face of his day" . . . Further, the Mayan word for "day" serves as a stem in words meaning "worship," as in Quiché *k'ijilabal*, which might be literally translated as the "means of daying". . . . This same word can also mean the "place of daying"—that is, the "place of worship"; as . . . places of worship change according to what day it is. . . . Here is temporalization of space, expressed at the cosmic level by the Quiché words for east and west that (unlike the English terms) make overt reference to the motion of the sun.[13]

According to John M. Watanabe, in the thinking of Mam speakers, the east is "where, as well as when, the sun 'comes in'; west is where and when the sun 'goes out.'"[14] Among the Quiché, the Mam, and other Maya groups, the directions north and south are also given by referring to the sun's (or day's) right and left sides from the point of view of the sun's emergence on the eastern horizon.[15] There is considerable disagreement among Mayanists about whether the concepts of north and south as cardinal directions existed in Maya thinking. A review of the issues appears in Appendix B of the second edition of Miguel León-Portilla's *Time and Reality in the Thought of the Maya*. León-Portilla finds the words of the modern Maya and the words of the *Popol Vuh*, which refers to the "fourfold siding, fourfold cornering, measuring, the fourfold staking" of the sky-earth during its creation, to be the more emic of the interpretations of Maya cosmology.[16] Ethnographic evidence clearly suggests that the Maya ordered

their world from the point of view of the sun in its travels over the earth, which shift seasonally. This system of ordering is seen in the manner in which ritual processions take place. Among the Chamula, ritual circuits proceed counterclockwise in order to reproduce on the plane of the earth the cycles of the sun as it moves from east to west and from south to north on the horizon. According to Gossen, any ritual location becomes conceptual east. The greatest status and ritual potency resides in the east. In a gathering of ritual officials, the most senior, or most important and potent, will be seated in the east and will be the last in line in processions, thereby remaining closest to the east.[17]

The world upon which humans live is the center of many layers of the universe. Above this world is a heavenly realm through which travel the stars and planets and of course the sun. This is apparently more than a single level—in the *Ritual of the Bacabs*, seventeenth-century ethnohistoric documents, there are references to thirteen deities of the upper realm. Ancestors, who live in mountains, are sometimes conceived as in the celestial realm, and sometimes below, in the place of burial. It could be that they progress through the lower realm into the upper one, according to a belief reported by J. Eric S. Thompson that the ancestors' souls climb the roots of the sacred ceiba tree to the highest branches.[18] Below the world of humans is the Underworld, a place of decay, where the soul of the deceased; the royal ball-player, who follows the tradition set by the Hero Twins in the *Popol Vuh*; and the sun and Venus all undergo rigorous trials which lead to death but eventual resurrection. In the Underworld are nine lords, perhaps aspects of the Nine Lords of the Night. These lords are mentioned in the *Popol Vuh*, and sometimes a few of them appear as characters in scenes on Classic Period polychrome vases.

The tree, whose roots are in the Underworld and whose branches reach into the sky, acts as one of many axes of communication between the three realms. Other objects that have a similar shape—basically long and thin—also reach between the levels. From its iconography it is clear that the stela, the sculptural form used most frequently in Maya monumental art, was also viewed as linking the realms, as were snakes, ropes, pyramids, caves, and mountains. Human figures represented in monumental art were traditionally erect, their verticality emphasized by towering headdresses. As such the body itself was like the tree, a vascular system

through which energies ran between the Underworld and the sky.

The sun, "our father," is the source of life as well as the concept of worship and of space. As a paradigm of organization, it suggests dynamic categories. In the ordering of time and the articulation of this aspect of the sun with daily life, the Maya system allowed for great complexity. Mathematics, astronomical observations, agriculture, and medicine were among the most highly developed empirical sciences, and all were linked through solar or ritual cycles to the calendar.

THE MAYA CALENDAR

In the Pre-Columbian era, many civilizations of Mesoamerica kept a calendar that consisted of two interlocking cycles—a 365-day or approximate solar cycle and a 260-day or ritual cycle. Evidence for the antiquity and origin of this cycle is not conclusive. It can be attributed to the period around 600 B.C., when the spread of influence from Olmec civilization had reached much of Mesoamerica, and it is found in those places which had some contact with the Olmec.

The 260-day calendar is called variously the "Almanac of 260 days," the *tzolkin*, and the "divinatory calendar." It is apparently based on the average period of human gestation. The use of lunations in calculating due dates of pregnancy has been documented from several Maya groups,[19] and 260 days equals 9 lunations of just under 29 days each. It is also a multiple of 13 and 20, both very important numbers in Maya thought, and is approximately the period of time between 14 August and 5 May, the dates of zenith passage at 17 degrees north (where Yaxchilan is). It was not divided into months, but is a combination of two cycles running simultaneously, one which assigns each day one of thirteen numbers (1, 2, 3, 4, 5, 6, 7, 8, 9, 10, 11, 12, 13) and one which assigns each day one of twenty names (in Yucatec: Imix, Ik, Akbal, Kan, Chicchan, Cimi, Manik, Lamat, Muluc, Oc, Chuen, Eb, Ben, Ix, Men, Cib, Caban, Etz'nab, Cauac, Ahau). Each day in the divinatory calendar has a number and a day name, for example 13 Cib, 1 Caban, 2 Etz'nab, 3 Cauac, 4 Ahau, 5 Imix, etc. The combination of thirteen numbers and twenty day names yields 260 unique number-plus-day-name combinations.

The solar calendar consists of eighteen months, each of 20 days, and one month, Uayeb, of only 5 days which are considered dangerous, for a total of 365 days. In the literature on the Maya, this year is called the "vague year" (be-cause it is vaguely close to 365.2422 days, the average length of time of the solar year), or the *haab*, the Yucatec Maya term. The months each have a name (in Yucatec: Pop, Uo, Zip, Zotz, Tzec, Xul, Yaxkin, Mol, Chen, Yax, Zac, Ceh, Mac, Kankin, Muan, Pax, Kayab, Cumku, and Uayeb). Within each month, the days are numbered, beginning with 0 and going through 19 (in the case of Uayeb, the days begin with 0 and run through 4). Thus, each day in the solar calendar has a number and a month name, for example, 0 Mac, 1 Mac, 2 Mac, 4 Mac, etc., resulting in 365 unique combinations of number-plus-month-name.

The 260-day and the 365-day cycles mesh to produce what is called the Calendar Round.[20] On the first day of the first month, or 0 Pop, the corresponding day in the divinatory calendar is called the Year-bearer. Only four of the day names ever occur with the beginning of the vague year. This is because within the vague year run eighteen complete cycles of twenty days, leaving five days. Therefore the name of the day in the *tzolkin* corresponding to 0 Pop advances five positions from the previous year. The number corresponding to the day name advances only one position each year, since 13 numbers divided into 365 equals 28 with a remainder of 1. Therefore, the number and Year-bearer combination only repeats once every thirteen years, and the whole system of Year-bearers repeats thirteen times four or every fifty-two years. Each of the four Year-bearer day names (Ik, Manik, Eb, Caban in the Central Lowlands during the Classic Period) has a character which is considered to dominate its year.

A single day in the Calendar Round is called by a number and a day name from the divinatory calendar and a number and a month name from the solar calendar, for example, 5 Imix 4 Mac. Because there are 260 uniquely named days in the divinatory calendar and 365 uniquely named days in the solar calendar, and both numbers are evenly divisible by 5, there are 73 times 52 times 5 or 18,980 unique combinations of number-plus-day-name and number-plus-month-name. The divinatory calendar revolves seventy-three complete times every fifty-two vague years. The day 5 Imix 4 Mac, or any other day in the Calendar Round, occurs only once every fifty-two years. The Calendar Round was useful for referring to specific days within a fifty-two-year period, or within the average life span. The thirteen numbers and twenty names of the 260-day calendar also certainly were used for performing lineage, divining, and political rituals, and in a system of

throwing beans or seeds, for divining and advising, in a manner antecedent to the one explained by Barbara Tedlock.[21]

If on March 14, 692 (or 8 Ahau 8 Uo) a person of Yaxchilan said, "On 5 Imix 4 Mac he sat upon the mat as the First Ancestor, Shield Jaguar," the listener would know that the speaker referred to the accession of Shield Jaguar as king on a day about ten years or fourteen *tzolkins* ago. If however, one said, "On 12 Akbal 6 Yax he was seated upon the mat as First Ancestor, Bird Jaguar," the listener might be confused. The last occurrence of 12 Akbal 6 Yax fell only 307 days before 5 Imix 4 Mac. Surely Bird Jaguar had not been seated upon the mat on that particular 12 Akbal 6 Yax. Was it the one fifty-two years earlier? Or fifty-two years before that?

Very long ago, the Maya created another method of counting time which allowed them to refer to specific days long in the past. This system, called the Long Count, or Initial Series, appears on monuments and royal regalia and is clearly a device associated to genealogical documentation for the purpose of legitimizing royal descent. Its earliest appearance on a Maya monument is on Stela 29 at Tikal, dated A.D. 292 or 8.12.14.8.15. No explicit statement of genealogical documentation survives in the hieroglyphic inscription, but an image known to refer to a royal ancestor appears above the head of the figure.[22] This stela marks the beginning of the Classic Period of the lowland Maya civilization, when the so-called "stela cult"—actually a series of practices linking sacred time and space with royal lineage—flourished.

The Long Count is a method of counting days since a first day—set as 13 August 3113 B.C. By the time of Shield Jaguar's accession to the throne of Yaxchilan in A.D. 681, the count was on the 1,385,801st day. The Maya were accustomed to measuring time in groups of twenty as in months of the solar year. Perhaps for that among other reasons, they used twenty as the base of their system of place notation. They recorded the number of days since the beginning of time in five places. In the hieroglyphic inscriptions, the largest units come first, at the top of a pair of columns which are read downward. They had two numerals and a zero. A dot or circle stands for one and a bar stands for five. The largest figure in any place would be four dots and three bars, or nineteen. When twenty is reached in any one place, a zero (a shell sign) is put in that place and a one is carried over to the next place. For the purpose of explanation, we will start with the smallest unit first.

The Long Count is used only for counting time, or days. The smallest unit is the *k'in*, or day. From 0 to 19 *k'ins* are recorded in this place. When 20 *k'ins* are counted, a 0 goes in the *k'in* place and a 1 is put in the next place, called *uinal* (from *uinac*, the word for man, who has 20 digits). So 20 is written 1.0. Only 17 *uinals*, or 340 days, can accumulate in this place. When 18 *uinals* (or 18 times 20 or 360 days) are reached, a 0 goes in the *uinal* place and a 1 in the *tun*. *Tuns* are units of 360 days, or approximately one year. The next position is *katuns*, or 20 times 360 days, or 7,200 days, approximately equal to 20 years. The biggest unit used in a normal Long Count date is the *baktun*, a period of 144,000 days (20 times 7,200 days or approximately 400 years).

Shield Jaguar's accession date, 5 Imix 4 Mac (19 October A.D. 681) was the 1,385,801st day since 13 August 3113 B.C. Since the beginning of time,

	9	12	9	8	1
Name	*baktun*	*katun*	*tun*	*uinal*	*k'in*
Units	400 *tuns*	20 *tuns*	1 *tun*	20 days	1 day
Days	144,000	7,200	360	20	1

had been counted.

Long Count dates generally occur at the beginning of an important inscription. They are usually the most important historical lineage event or the focus of the inscription, and are usually linked by a Distance Number (using the same units of time) to a later Period Ending. Monuments often were dedicated or erected on Period Endings, actually *katun* endings, and the inscriptions on the monuments record important events of the previous *katun*. The basic Long Count records the number of *baktuns*, *katuns*, *tuns*, *uinals*, and *k'ins* the date has reached, and also the more practical Calendar Round names for the day. Often, if an event is important enough to warrant commemoration as a Long Count date, placed within those huge cycles of time, its nomenclature and character are supplemented by a wealth of additional information.

Many Long Count dates also include much information on the moon. The glyphs tell the patron of the present lunation; the phase of the moon; the position of the current lunation in the lunar half-year; the name of the lunation; a phrase meaning "its holy name"; and how many days are in the current lunation. Preceding the lunar data is a single glyph indicating which of the Nine Lords of the Night rules over that *k'in*. The lunar data and the Lord of the Night are usually recorded between the day in

the divinatory calendar (the number and day name of the 260-day cycle) and the number and month in the 365-day cycle. For example, the text on the lower register of the east side of Stela 11 (see Figure 136) says something like this:

> And then it came to pass, under the patron of the month Tzec,
> 9 *baktuns* and 16 *katuns*,
> 1 *tun* and 0 *uinals*
> and 0 *k'ins* on 11 Ahau
> The Ninth Lord of the Night reigned
> and ??? was patron of the lunation ???
> It was the twelfth lunation of the half-year,
> and ??? Mirror-Skull
> Was its holy name.
> Twenty-nine days were in the lunation.
> On 8 Tzec he took the royal bundle
> as *ahau* of the lineage, Bird Jaguar,
> Captor of Ah Witz, he of twenty captives,
> who is in his third *katun* of life, who is a *batab*,
> who is of the royal blood of the kings of Yaxchilan,
> the sacred blood of the mat of the Place of the Split Sky.
> He is child of the mother Lady Ik Skull,
> Sky, Lady of Royal Descent,
> Lady Bacab.
> And he is of the blood of the 5 Katun Ahau (king)
> Shield Jaguar,
> Captor of Ah Ahaual,
> Royal blood of the kings of Yaxchilan,
> Sacred blood of the mat of the Place of the Split Sky, Bacab.

In this way, the Long Count served to integrate into a single relationship the sacred lineage events in the life of the king; his links with his ancestors; the activities of the moon, which governed the lives of women and the planting and harvesting of crops; and the characters of the *katun*, the *tun*, the *uinal*, and the *k'in*.

THE ANCESTORS

It is generally accepted that the Maya believed that their forebears continued to interact with them after death.[23] The ancestors in modern Momostenango are on a cosmological level with all the Christian gods and saints, who are lumped together collectively as Tioz (Dios), and with the Mundo, which consists of all the sacred, supernaturally charged areas of the local landscape. Before the introduction of the Christian gods, it is likely that the ancestors and the Mundo were considered the most powerful influences on human beings.

Among the Maya, the homes of ancestors are generally in mountains around the commu-

nity, where they convene and deliberate. They are reached via shrines set up near caves and springs, through wooden crosses set up near those shrines, and with the aid of percussive noises. Communication with them is essential for a good life.[24]

The ancestors are considered the repositories for the definitions of the world and the rules for acting within it. The ancestors know best how to cultivate maize, how to build houses (so that the cosmos is properly replicated in the home of the lineage member), how to keep animals, how to most properly and effectively perform social interactions with kin and others, and how all ceremonies should be performed.[25] "Ancestor worship" is ritual practice whose details vary from society to society but which focuses on preserving the minutiae of life as it was given to the ancestors by the creator beings.[26]

The ancestors are linked to the living directly through shared "souls." The belief in multiple aspects of vitality or "souls" is present in many Maya communities. Among the Mam speakers of Chimaltenango, Guatemala, it is believed that three nonphysical or spiritual qualities govern existence and behavior. These qualities affect life, not the fate of the "soul" after death. The first quality is the *aanme*, the personal animating essence inside the breath. After the death of the body, this soul survives to interact with the living. It either goes to live inside the mountain, working for the *Witz*, or Earth Owner (also called, in other communities, Yahwal Balamil, or Mundo), or wanders earth as a ghost. The *aanme* is the essence of human personality retained by an ancestor.

The *kleel* is the nagual or spirit double of the human. At the moment of human birth, a plant or animal is born who shares this aspect of the soul with the human. Their fates are thus intertwined, and humans can learn to manipulate their animal doubles through the control of this "soul."

Every individual also has a third quality, a social soul, *t naab'l*, which is the internalization of social conventions. *Na* is the Mam root for "to feel, perceive, pray, remember, behave, be careful, assume," and *bil* is the suffix indicating the instrument used to perform the action specified by the verb. *Naab'l* is always possessed (*t-*); thus it is part of the possessor.[27] Each person possesses, then, the memory and perception of kinds of behavior that are considered successful for the welfare of the community. *Naab'l* is not a constant cultural framework. It is acquired gradually in childhood through socialization and observation of how

things are done rather than through explicit instruction. Illness and sleep can diminish the *naab'l*, but it can become more complete. Not every person possesses a complete *naab'l*. Those with a complete *naab'l* are intelligent, resourceful, strong. One with a complete *naab'l* has healthy, hot blood. One with an incomplete *naab'l* lacks emotional control and is unable to focus attention. Failure to act in mutual conformity with community values results in the loss or impairment of the *nabb'l*.

The shared communicative aspects of the *naab'l* transcend the individual personality. The possession and exercise of the *naab'l* allow an individual to perceive the *naab'l* of another. This contributes to the perception of a bond of implicit social conventions, and ultimately to a powerful sense of identification with the persons, social structure, and environment of one's community, in other words, an identity linked to a place, the social community, the ancestors, and the features of the environment that are utilized in ritual.

Ancestors have the experience of successful living, and therefore know best. Their responsibility is to take charge of the life and death transitions that people undergo. In Zinacantan, it is believed that when a child is conceived, the ancestors install a *c'ulel* or innate, personal "soul" in it and, simultaneously, in an animal embryo. In the instant that a child is born, its animal companion is also born. The animal companions are guarded in corrals in the Senior Large Mountain by the ancestors. If the ancestors neglect the human's animal companion, it can wander off and get lost or killed, causing illness or death for the human. If humans break with traditional or moral behavior, the ancestors will punish them with disregard for their animal companions.[28]

In Momostenango, new babies are introduced to the ancestors at the lineage shrine on a day named Akbal.[29] This practice finds an intriguing ancient parallel with the presentation of the young heir to the throne of Palenque by the King Pacal on 9 Akbal 6 Xul (which fell that time on 14 June 641, very near the summer solstice), an event documented in the Group of the Cross.[30] In Momostenango, the willingness of the woman's parents and grandparents (whether living or dead) is crucial to the positive outcome of a marriage.[31] Days selected for house-building rituals are the Ahau days. The house, as home of the living members of the lineage, must properly echo the cosmic schema and must please the ancestors. A positive response

from a Momostenango diviner concerning plans for a house will be that "the ancestors know." After death, Ahau days are also chosen to introduce the departed soul of an ancestor to its new house in the Mundo.[32]

The ancestors make many decisions about the activities and welfare of the living. As guardians of the traditional way of life, they decide who can become a shaman or a daykeeper, they allow the municipal cargoholders to respond to questions addressed to them in prayer by diviners, and they teach the people how to do many things. Many of their messages, when not directly sought through divination or prayer, are sent to the living through dreams. In modern Chamula, the ancestors summon and speak to persons with strong souls as they dream. Through dreams, when the person's inner soul convenes with other souls, the original path is explained and made clear to the individual. Ignoring such instruction will cause weakness, and even death.[33]

In order to ensure the devotion of the ancestors to their animal souls and to their business, travel, marriages, children, and crops as well, the living must devote considerable time and attention to the ancestors. Many of the rituals that are performed in modern Maya communities involve making offerings to and invoking the ancestors. In Zinacantan, they particularly are invoked and honored on a regular basis in rituals concerning the lands, the water holes, and the lineages. The ancestors received the lands and rights to the water holes from the creators, and must be thanked. This involves setting up shrines (cleaning them, placing crosses, pine boughs, and geraniums) and offering substances that provide ritual heat to the ancestors in their cold abode—candlelight, liquor, incense from the copal tree, and black chickens. Ancestors also like pure spring water and the odor of certain flowers. Without these substances, they would not survive in the afterlife, and the animal souls of the living would have no caretakers.

Living in a society that practices "ancestor worship" is more than a matter of performing the rituals that will ensure health and survival of the soul. It involves intensive reciprocal responsibility that demands communication through the rituals and also, on a nightly basis, through dreams with the other souls of the community, both those of the dead and those of the living. Even the perception of the self is radically different in such a society. A recent study of the self in cross-cultural perspective

(one of the first such comparative studies undertaken by a psychiatrist) finds that individuals in societies in which ancestors are involved in the activities of daily life have, in addition to a sense of self-identity, a strong sense of familial and community identity. This is a "basic inner psychological organization that enables women and men to function well within the hierarchical intimacy relationships of extended family, community, and other groups. . . . Self-esteem derives from strong identification with the honor of the family and other groups, from nonverbal mirroring throughout life, and from culturally encouraged idealization of elders . . ."[34] The study, which involved a comparison among psychiatric clients in the United States, India, and Japan, found that the Asian clients actually perceived less definition of the boundaries between themselves and their relatives than the American ones. The principle of individualism, so prominent in industrialized societies, is replaced by a "'we-self' that is felt to be highly relational in different social contexts."[35]

Similar statements about the esteem given to social goals over personal goals are explicitly made in the literature on several modern Maya groups. Evon Z. Vogt notes that among the Zinacantecos, "The maximum amount of heat acquired by a Zinacanteco during the course of a lifetime comes from serving his society in an exemplary fashion: the man who is very old, a high-ranking shaman and a veteran of all levels of the cargo system, possesses the greatest heat [or greatest likeness to the sun] possible for a human being."[36]

About the sixteenth-century Maya of Yucatan, Nancy M. Farriss has said: "The relevant question becomes whether the Mayas perceived themselves as self-sufficient. Their social system indicates that they did not. The only explanation of that system consonant with all the admittedly piecemeal evidence of their behavior is that they viewed individual survival as part of a collective endeavor dependent upon mutual assistance and the coordinated activities of the group."[37]

The great value placed on group-supportive or "we-self" behavior is explicitly expressed in a Tojolabal community of highland Guatemala. Community elders "overtly guard and protect both a community ideal and community cohesion. The community requires attendance at ritual community activities. . . . Villages are endogamous. Members of a community must participate in community service, and political decisions are consensus ones reached through town meetings. Individuals affirm these ideals through nearly ritualized chauvinistic verbal expressions of community cohesion."[38]

Since the ancestors possess the same social soul as the living of a particular community, their involvement in community affairs is more valuable because of their years of service. In some of the inscriptions at Yaxchilan, the king Shield Jaguar parallels his captures (surely in service of the community) with those of his father and those of his grandfather. This must have given Shield Jaguar's captures much greater potency.

In some "ancestor-worshipping" societies, for example in ancient China, the achievement of an ancestor could elevate the status of the whole family for many generations, bringing high government positions; and, conversely, the misdeed grievous enough could cause the slaughter of several generations of that person's lineage.[39] A similar belief exists in modern Momostenango; however, instead of punishment being inflicted by the living government, it is sent in the form of "soul loss" by the collective ancestors. If a person does not fulfill the expectations of the community or dies without settling a serious dispute, such as one over water rights, the punishment for that misdeed may be sent by the ancestors unexpectedly to an individual many generations later. Only with the aid of a diviner can the sufferer discover the cause of the illness—sometimes an ancestor who lived so long ago that his or her name has been forgotten.[40] This explanation of the causes of disease is found in Maya communities as widely separated as highland Guatemala and northern Yucatan. Although he did not have a good understanding of the attitudes inherent in ancestor-worshipping societies, Ralph L. Roys, translator of the *Ritual of the Bacabs*, recognized from the attitudes taken by the Maya curers toward the illnesses in the texts that "A disease is considered to be a semi-personified being."[41] He explains that when determining the cause of an illness in order to exorcise it, the shaman would demand of the spirits he had assembled in the ritual enclosure to point to the forebears of the illness. For example, in the case of the tarantula-eruption illness he asked, "Who was his mother? He would be the offspring of Ix Bolon-che, . . . the offspring of Ix Yal-hopoch, . . . the offspring of Ix Yal-sik-che, when he was born in the heart of the sky. . . . Who was his creator? He created him, did Colop-u-uich-kin in the heart of the sky."[42] The latter being is interpreted by Roys as "Snatcher

of the Eye of the Sun" and appears in almost every instance. The females mentioned vary considerably, and could well be references to beings considered to be long-deceased ancestors. The illnesses were also related to plants and trees according to the faces of their days of birth. Thus, knowing the lineage and calendric and natural world associations of the illness, one could successfully deal with it.

THE PEOPLE OF CORN HONOR THE GODS

The common people are not very evident in Maya monumental art nor in the archaeology. Nevertheless, their customs—the ways of the ancestors—are the ones from which the monumental imagery springs. Those who planted corn and made tamales built the ceremonial centers and shared the dreams of the community elite. The ancient Maya population was involved to a large degree in agriculture. Every activity associated with subsistence—gathering materials for building a house, clearing land for planting, gathering natural objects to use as tools or adornment, planting and harvesting—was viewed in a broader sense as part of a reciprocal covenant between the humans and the Earth Lord, via the mediation of the ancestors.

The passage from the *Popol Vuh* that describes the origin of humans says:

> And here is the beginning of the conception of humans, and of the search for the ingredients of the human body. So they spoke, the Bearer, the Begetter, the Makers, Modelers named Sovereign Plumed Serpent. . . .
> ". . . Morning has come for humankind, for the people of the face of the earth," they said. It all came together as they searched and they sifted, they thought and they wondered. . . . And this was when they found the staple foods.
> And then the yellow corn and white corn were ground, and Xmucane did the grinding nine times. Corn was used, along with the water she rinsed her hands with, for the creation of grease; it became human fat when it was worked by the Bearer, the Begetter, Sovereign Plumed Serpent, as they are called.[43]

In the *Popol Vuh*, it was the Grandmother of Light, Xmucane, the grandmother of the Hero Twins, who first began to honor the seeds of corn and the Hero Twins who first began to honor their ancestors. Before they vanished into the Underworld to do battle with the lords therein and clear the way for human life, they placed some ears of corn in the rafters of their grandmother's house and said that if they died,

the seeds of the corn would not sprout. Seeing that the seeds had not sprouted, the grandmother made a memorial to the death of her grandsons. She lighted copal incense in front of the seeds and wept. After that, the seeds sprouted and the grandmother rejoiced, deifying them and giving them names. Shortly thereafter, the Twins, still in the Underworld, found the bones of their fathers and promised to honor them every day named Ahau, or Lord. The belief that human life is bound to the life of corn permeates Maya thought.

Having been created by the gods to honor and nourish them, all persons have an obligation to ask permission for their needs, and to offer thanks when they are met. In traditional communities, the modern Maya still live with this belief.

> We are having this ceremony for the YAHWAL BALAMIL [the axis of the earth], that he should order the clouds to come out of the earth, clouds to rain on our corn, so our corn should not die . . . Because if it does not rain and our corn dries up and perishes, we would perish too. So we are praying to the Lord of the Earth, and we are offering him good peso candles, for we only gave him 50-centavo candles at planting but now we are giving him peso candles, so he will let our corn grow . . . We do not see the Lord of the Earth, but he is there under the earth.[44]

In discussing the attitude of reciprocity, Vogt states that the obligation to repay the owner of materials from the wild forest that are collected or hunted is just as strong as or stronger than the obligation to repay a gift. "When a man becomes the new possessor of anything, in any way, someone—man or god—expects and is entitled to recompense."[45]

The rituals of house building, those involved with clearing, sowing, and planting the fields, and those involved with curing, with the lineage, and with divination are well documented in Vogt's *Tortillas for the Gods*, Walter F. Morris, Jr.'s *Living Maya*, Barbara Tedlock's *Time and the Highland Maya*, and elsewhere. Similar types of rituals are documented for communities across the Maya region where fieldwork has been directed toward ritual practice. Although there is certainly a distinction between ceremonies involving the entire community and those that are more private, involving a family or lineage or water hole group, I suspect that in ancient times the public spaces in the ceremonial center were used by the common people as they participated in community rites and for more private purposes. Today, in Cha-

mula, Chichicastenango, and many other places, private curing ceremonies are performed in the public church. In Momostenango, the ceremonies involved with the 260-day calendar take the daykeeper or trainee to shrines at the perimeter of the community and also to a hill at the center. It seems to me that the ancient Maya of Yaxchilan probably participated in periodic ceremonies with the nobility, and also probably used the stelae much as crosses are used today in Zinacantan and Chamula, and as the *acantuns* (stood-up stones) were by the Yucatec of the sixteenth century—as axes of communication with the ancestors. In addition to revering and asking favors of their own ancestors, they probably obtained great benefit by honoring the ancestors of the king, who of course, was a descendant of the sun.

By incorporating into their community and local rituals the movements of the heavenly bodies as they touch the local environment, the Maya deliberately replicate the cosmos in their activities. The society, as we have seen, was directed toward integration of the population, in its proper place in the hierarchy, into the social order. The ceremonial center was the product of the labor of many individuals, most of them not nobility, and the open plazas and stelae, and possibly the stone temples, were used by them in honoring the ancestors and the Earth Lord.

WARFARE AND COMMUNITY

Warfare against outsiders was a common theme of ancient Maya public art.[46] This hostility toward strangers or nonmembers of the community is also documented among the Colonial and modern Maya. Then as now, hostility was a response to a perceived wrong—especially an insult to one's family, usurpation of land sanctified by the ancestors, or ethnic discrimination—and was not generalized. However, the successful defender of the community was glorified. In *The Annals of the Caqchiquels*, one confrontation with a stranger proceeded: "'Who are you? You are not my brother or my kinsman. Who are you? This moment I will kill you.' And the older and younger brothers killed the stranger, cut his head off, and consecrated a place of rule, where they were honored by thirteen groups of warriors by being given a canopy, throne, seat of honor, and sovereignty."[47]

As in Central Mexico, antagonism on the part of one indigenous Maya community toward those who spoke different languages or even dialects contributed to the ease with which the sixteenth-century Spaniards subjugated the indigenous populations. When Bernal Díaz del Castillo led his soldiers into what is now highland Chiapas, he enlisted the willing aid of the pueblo of Zinacantan in devising strategies for the downfall of neighboring Chamula. These two groups both spoke Tzotzil, but rather than considering each other as allies, they had traditionally been split by ethnic rivalries based on the fact that they formed separate communities.[48]

A cause for antagonism between neighboring communities was the insulting behavior of members of one community toward those of another. An example of specific aggressions between neighboring groups is documented for the Yucatan. Some aggression which was not accepted within a community was apparently channeled toward persons in other communities when people were out in the bush or when the aggressor approached communal lands of another. The Spanish observed personal aggression in the form of insults, blows, and homicide between members of neighboring communities. When such aggression occurred, the aggrieved person informed his lord, whose duty it was to avenge the aggression by punishing the offender's group.[49] This suggests that a ruler not only was served by the community, but also had explicit tasks to perform for the benefit of the other members of the society. Entire communities were responsible for and might be attacked because of the aggressive behavior of their members.

Among the ancient Maya, a necessary condition of any major royal ceremony at most cities was the portrayal of the king's most important recent capture and sacrifice. Warfare against outsiders was clearly one of the duties of Yaxchilan kings. More than at any other site, the kings of Yaxchilan were named as "He of Twenty Captives,"[50] or given "Captor of . . ." titles that stayed with them for the rest of their lives. Furthermore, the desire to protect the community from aggression was so strong that the sides of the stelae which faced the river were carved with images of the kings as warriors, probably designed to serve as a deterrent and as a proclamation of local superiority.

A HIERARCHICAL SOCIETY

In the sixteenth century, the Yucatecans relied on rank as an explicit indicator of social order.

> The Indians in making visits always take with
> them a present to give, according to their rank;

and the person visited gives another gift in return. During these visits third parties speak and listen with attention, according to the rank of the persons with whom they are in conversation, the more humble is wont to repeat with great care the title of office or of dignity of him of highest rank. . . . The women are brief in their conversations, and were not accustomed to do any business for themselves, especially if they were poor; and on account of this the nobles laughed at the friars because they gave ear to the poor and the rich without distinction.[51]

To the sixteenth-century Spanish friars, who were outside the native hierarchy, all the Maya were equally heathen. The Maya, however, saw their rank, whether defined by merit or purely by genealogy, as an inextricable part of social order. In modern Chimaltenango, Guatemala, people say that everyone in the community has a place. They say they fear the sense of meaninglessness they think would result from the acculturation of their community into the Ladino way of life. Any responsible participation in the local system of religious and ritual responsibilities ensures a place in the community structure and ensures that in old age one will not be relegated to sweeping plazas after rituals.[52]

Little, if any, information about the hierarchies of commoners exists for the Classic Period. Hieroglyphic inscriptions and art provide some evidence for the ranking of the nobility. Rulers of major Maya cities were called *ahau*, which is generally translated as "lord." Each and every Maya king claimed descent from a divine First Ancestor, "God K," and had supernatural power and authority that extended to cosmic dimensions. At Yaxchilan, there were at least sixteen kings, who apparently descended from two lineages, the Skulls and the Jaguars. In the hieroglyphic inscriptions at Yaxchilan, a ruler was distinguished from the other elites more by the quantity than the type of his titles. The only titles unique to rulership were the so-called Emblem Glyph, complete with prefixes referring to the ruler's sacred bloodline, and a little-understood title perhaps referring to shamanic powers, the Antler-Vase-Sky title. Most other titles a king had could also be carried by other members of the community. Other men and women besides the king were called *batab* (which referred perhaps to war or to being able to communicate with ancestors) or *bacab* and were given *katun* titles referring to age.

Some men and women were called *cahal*, (from *kah*, village or locality in Yucatec) but this seems to refer to a distinct office, for kings at Yaxchilan were never called *cahal*. These were secondary *ahaus*, who could either be second-strata elite at a major city or holders of the highest office at a minor city.[53]

In the last few years, a few other titles have been deciphered from the hieroglyphs, giving a fuller picture of the nobility. Of particular interest to this study has been the identification of the titles for scribes and painters, called *ah ts'ib*. The scribes whose names survive usually were born of the nobility, and some carry an *ahau* title, suggesting that they were closely related to the kings.

There has long been debate about the mechanisms of elite control over the population. The presence of large-scale construction projects, both architectural and agricultural, from the Late Preclassic to A.D. 1000 in the Central Lowlands has seemed to most scholars evidence of conscription or corvée labor. It is usually assumed that persons do not voluntarily relinquish their freedom to pursue individual needs and satisfaction to any collective cause. However, it has been suggested here that the very identity of the Maya individual extended beyond the individual person to the members of lineage and community, living and deceased. The question becomes one of defining "individual needs." "The enigma of lowland Maya social organization may lie in our alien definition of need and benefit."[54]

After the collapse of Classic Period society, the Maya continued to live in the Petén, in scattered settlements and probably in reduced numbers. They surely realized that their ancestors had coordinated a grand civilization based on elaborate social order and affiliation to divine kings, for the material evidence of cities would not let them forget. Hundreds of years after the collapse, it seems that they felt the longing for an explicit social hierarchy with a spiritual leader. During the "pacification" of the Petén by the Dominican friars, the Chol speakers in the vicinity of the Cancuen River attached themselves willingly to the friars once they determined that what the friars said they offered was spiritual guidance and a return to a community. These Maya, although very poor, "assisted the priests and gave them whatever they could, whatever the land provided, and some voluntarily left their homes and plots to build churches and live near the priests. They carried their burdens from one place to another; they gathered when the *alguacil* called them, and did not leave without permission of the priests." When the Dominicans later aban-

doned the Christianized Chols, the Maya were very upset and "begged for someone to come to give them their spiritual food."[55] What was the spiritual food given by the *ahau* to the people? Among the Colonial Maya and the modern Maya, actual food was provided by the religious leaders to the community as an important aspect of rituals. "Shared meals establish the boundaries of a group, express its collective identity, and sustain its internal cohesion. Ceremonial meals can also define divisions within the group; seating arrangements, the manner and order of serving, and other details of etiquette are capable of denoting the nicest gradations of rank."[56] The staging of actual meals provided psychological reassurance of the explicitness and reliability of order. The "spiritual food" probably referred to other psychological reinforcement as well. The spiritual leader, whether *ahau* or other priest, communicated directly with the ancestors and spirits through his blood sacrifices, and thus bound the ancestors to give him guidance. The definition of the ways of the ancestors, the coordination of a vision of what activities should be undertaken, and the provision for programs of art and ritual were probably desired by the Maya, whose "we-self" took precedence over individual independence. The sixteenth-century Chols acted as a people accustomed to the stability of a hierarchical order and the community self, networks in which their obligation was to exchange their services and what food they had for an explicit community structure whose head was an *ahau*.

ROOTS

Alonzo de Zorita, writing in 1555 of Pre-Hispanic customs, said: "There was never any question of moving people from one town to another. Indeed, they observed as strictly as if it were law (though not through the use of force) the rule that where a man's father and ancestors had lived, there must he live and end his days."[57] Also in the sixteenth century, Spanish attempts to round up the Chiapas Maya groups so that they could better be introduced to Christianity were frequently frustrated because the Maya regularly abandoned the newly established cities on the plains and returned to their steep hillsides or "unhealthful" swamps. Fray Ximénez reported on what he considered to be an unusually strong attachment to a birthplace:

> . . . es tanto el amor que le tienen al barranco y
> al cerro o monte donde nacieron, que mas bien

> dejaran la vida que el lugar, y si los mudan,
> como ha sucedido algunas veces, mas breve se
> acaban . . .[58]
>
> (. . . the love that they have for the valley, hill,
> or mountain where they are born is so strong,
> that they would rather leave their lives than the
> place, and if they are moved, as has happened
> several times, they are soon finished . . .)

Belonging to a lineage, a water hole group, and a community is what gives the modern highland Maya individual a sense of identity.[59] One is tied to one's family through conditioning that duty to one's elders and children is the primary occupation of life. One is tied to the place of birth by the living family and the bones of the ancestors buried under the house or in the milpa.[60] One is inextricably linked to the landscape[61] in and around the community because there, all past events and their recurrences, both the work of being Maya—planting maize—and the rituals that telescope the past into the present and future, have taken place. Identity with the community is not automatic, but must be acquired through socialization. For example, becoming Chimalteco, or acquiring membership in the modern community of Chimaltenango, is called "acquiring *t naab'l*," or developing the social soul of local conventions. The set of local skills, such as corn farming for men and household tasks for women, beliefs, perceptions, dreams, memories, behavior, and of course, language, actually defines what it is to be Chimalteco.[62] Because the community is such a powerful and pervasive structure to a Maya, outward manifestations of community affiliation abound.

Modern Maya people define affiliation in a community by sharing a local dialect, by dedication to a patron saint, by use of local colors and patterns of weaving in clothing, and occasionally through such fine distinctions as the cut of their shoes or the stitching on their hats.[63] These differences are readily observed, remarked upon, and sometimes ridiculed[64] by members of other communities.

This was probably true in the Classic Period as well. My structural analyses of costume from ten Classic Period Central Lowland sites show a significant amount of diversity in royal costume. Specific elements of costume are often unique to a single site, as is the double-faced "jester god"[65] pendant that adorns the upper levels of the royal headdresses on the stucco sculpture of House A at Palenque. Also, entire costumes worn on specific ceremonial occasions sometimes appear at only one site.

One example at Yaxchilan is the summer solstice costume.

In addition to unique ritual costumes and rituals, I suggest that the style and subject matter of monuments and local interpretations of astrology contributed enormously to a sense of local identity. This will be explored at length in the upcoming chapters.

POLITICAL ORGANIZATION

The political organization of the Classic Period Maya is still not well understood. Perhaps each city was organized as a feudal estate with noble lineages controlling land and resident vassals. It is also possible that the ruler of a great city such as Yaxchilan attained his position by being the most charismatic and accomplished person in a lineage that could claim sacred origins. It appears that at several Maya centers, including Yaxchilan, rulers came from more than one lineage. Most epigraphers agree that the Maya cities were a series of city-states with distinctly structured reciprocal obligations with neighboring sites depending on the rank of the neighboring rulers, the history of interdependence, and the goals of the present kings.

In the Late Classic, Yaxchilan had some reciprocal agreements with Bonampak and La Pasadita, where its kings were portrayed on carved lintels, and also some relationship with Piedras Negras, El Cayo, and Palenque in which the rulers visited those sites. However, there is no convincing evidence for a division of the Maya area into regional capitals. Women from other cities did marry into the royal dynasties of Yaxchilan. During the Early Classic, on Structure 12 lintels, carved 9.5.2.10.6 (A.D. 537), kings of foreign cities were recorded in the inscriptions at Yaxchilan, but in the Late Classic inscriptions, no mention of kings from important foreign cities was made. Yaxchilan was apparently important enough and had sufficient identity and prestige as a community not to need substantiation of its glory by foreign lords.

The principles involved in selecting a successor to the throne are important in this volume because of a problematic ten-year interregnum between Shield Jaguar and Bird Jaguar IV, the two Late Classic rulers on whom the study centers. Several studies of the rules of succession in Maya society have been published, and the one which best takes into account the actual patterns of succession documented at Classic Period sites is that of Nicholas A. Hopkins. He finds the evidence for patrilineal organiza-

tion overwhelming and sees seven patterns of succession possible within the patrilineal system in which women also have a position.[66] In the documented cases at Yaxchilan, the rule passes from ruler to son, but the questions are, which son, and by which wife? Not enough data exist in the inscriptions to determine whether Maya elite men were monogamous, and sixteenth-century accounts are conflicting, suggesting that the number of wives kings had could vary depending on local custom, or that the Spaniards were not evaluating properly what they observed. I see at Yaxchilan a distinction made between women who are documented as the mothers of the heirs and those who seem to have other functions, with the former appearing in accession-related contexts and the latter in astronomical-related ritual contexts. It is difficult to prove the existence of sons who did not inherit the throne, since no mention of them exists at the city. If they did exist, then perhaps the dual principles of heredity and election observed in the succession of kings in Pre-Columbian Yucatan applies: ". . . political power was relatively fluid, diffused through a hierarchy of lesser lordships, who had some say in the choice of the territorial ruler and on whose support, in the absence of well-developed state bureaucracies and standing armies, his actual power depended."[67]

What was the basis of authority of the Maya king? In many thoroughly ranked hierarchical societies in which ritual concerns assigning everything to its proper place in the culture, the power inherent in social hierarchy is unconsciously accepted. The notion that political power is not challenged is difficult for those living in an industrialized twentieth-century society to understand.[68] We criticize and question authority because the persons who wield it are no closer to divinity than we are. The evidence, while not conclusive, points to the Maya ruler, as descendant of God K, or the First Ancestor, as being supernatural. His authority was the result of direct communication with the ancestors. We should be cautious in ascribing self-aggrandizing motives that coincide with modern industrialized self-concepts and notions of political authority to the ancient Maya—not because the Maya individual was free of greed or ambition but because such motives would not be condoned by tradition.

KEEPING TRADITION

Before moving on to the study of the design of the ritual center of Yaxchilan, I will intro-

duce two expressive domains in Maya society that have been largely ignored by art historians and archaeologists. Traditional language and dreaming the ancestors' dreams illuminate explicitly and implicitly the way the Maya think about themselves. As shared experiences, they fortify the community soul or "we-self" and are sources of organization, motivation, and direction for overt behavior. Some of the most fundamental views and priorities of Maya society are expounded through oratory and dream analysis. They are two aspects of implicit social control, and in both media are expressed attitudes that can also be seen in Maya art and architecture.

The body of oral tradition, its formalized genres, and the way these sound are community-related.

> Chamulas recognize that the correct use of language (that is, the Chamula dialect of Tzotzil) distinguishes them not only from nonhumans but also from their distant ancestors, from their present Tzotzil- and Tzeltal-speaking neighbors, and from Ladinos and tourists. . . . Language, then, in the present as in the past, is an important criterion by which Chamulas distinguish both separate social groups and specific kinds of attitude and behavior within those groups. In other words, the labels for kinds of verbal behavior are, like kin terms, tags for different kinds of interaction.[69]

As Gary Gossen has demonstrated, the Chamulas have a complex oral tradition with several popularly recognized genres of speech—ordinary language; emotional language; Recent Words, consisting of True Recent Narrative, Frivolous Language, and Games; Ancient Words, consisting of True Ancient Narrative, Ritual Language, Prayer, and Song; and finally, Witches' Words. Within these genres, the style of discourse, the characters involved, and the settings of the narratives all parallel the condition of the universe on a continuum from chaotic to established, but ever-threatened, order. The Ancient Words are explicitly used in what Gossen calls "Serious Explanation, Formal Maintenance and Perpetuation of the Social Order."[70] The elders may shift into the genre of "Ancient Words" in normal conversational interaction among the youth of the community, because it is their responsibility to ensure that this wisdom lives.

"A scattering of jades" was the metaphor for the genre "words of the ancients and elders," the *huehuetlatolli*, of the Aztecs. "Every important event in the life of an Aztec—a reli-gious celebration, the accession of a new ruler, an embassy to another province, the start of a battle, the choosing of a wife for a young man or a midwife for a pregnant woman, among others—was punctuated by long, eloquent orations appropriate to the occasion."[71]

In the Classic Period, the formulaic statements recorded in hieroglyphic writing on the monuments have many of the characteristics of Chamula True Ancient Narrative: high redundancy, formal couplets and triplets, and dense metaphoric stacking. Statements often invoke the whole earth and sky, also like True Ancient Narrative. But unlike True Ancient Narrative, the hieroglyphs do not always involve (although they can) supernatural beings from the first, second, and third creations of the world, nor wild animals. Classic Maya hieroglyphic statements at Yaxchilan record the exemplary events in the lives of the current rulers and the parallel historical events of rulers up to sixteen generations in the past. They are intended to specify just what the ruler is doing in the sky, earth, and Underworld for the service of his community and how precisely he follows ancestral precedent.

Ancient and contemporary Maya genres of formal speech are distinguished from just talking by the insertion of set phrases at the beginning and end of a story, prayer, or command.[72] Allan Burns' study of storytelling in modern Yucatan includes some stories of an old person which end with phrases that stress the relationship between the speaker and his listeners, such as: *yn hach llamail,* "my very beloved villagers"; *llalan unooch ukab in yum,* "beneath my father's right hand" (beneath the sun's right hand); *ti tu lacal in sih sah vini Cilob yokol cab,* "to all my engendered people in the world," and *in sih Sah hex llokol cab,* "ye my descendants in the world."

Similar phrases begin and end the stories told by the Classic Maya inscriptions. Beginning phrases might be translated, "And here begins the count of days, the count of years," and ending phrases always relate the ruler, or subject of the text, to the community or city. The genres of texts on monuments are quite standard and have local variations, as do genres of imagery.

In addition to its functions in creating and maintaining cultural history, in tradition, and in instructing members of the community, oratory also is the medium of political decision-making. Most official discussions consist largely of polite, formulaic passages, into which the matter under consideration is inserted. The

etiquette of talking is intended to provide a basis for trust. Addressing the group in order of rank, supplementing the polite addresses with toasts of alcoholic beverages, and using the patterns of traditional oratory provide a predictable structure to the discussion and allow the speaker to be persuasive while "saving face."[73] Political decisions are made when community leaders reach consensus, in a parallel fashion to the consensus reached by the Bearers and Begetters and Sovereign Plumed Serpent when the world was created. In the Quiché ethnohistorical document *Popol Vuh*, the creators placed equal value on two characteristics they desired in humans—speaking properly to and nourishing the creator gods. "'So now let's try to make a giver of praise, giver of respect, provider, nurturer,' they said."[74]

Once decisions need to be executed within the modern Maya community, leaders stage their commands as group discussions. Participation by the audience is expected, and even required, in most forms of speech from commands to curing rituals to storytelling. Those listening to the decisions of the leaders must respond (sometimes by just repeating the last words of the phrases or by making exclamations), must show initial reluctance to the persuasion, must prolong the oratory with response and resistance, giving the speaker the feeling that the flowery speech is effective, and must drink the prescribed toasts, before finally reaching an accord. This kind of interactive consensus-reaching ideally is practiced at all levels of activities, even planning a day's work in the milpa. This is not seen as control, but as the only natural way to behave.[75] Proper speech lubricates every mechanism of the community.

The consensus-reaching discussions that Burns observed in the Yucatan were also seen by Walter F. Morris, Jr., during his years in highland Chiapas. "The strength of Maya tradition comes from living in tight-knit communities, where all decisions must be agreed upon and accepted by all its members. There are moments when the society opens up to new ideas, like the varieties of brightly colored shawls, only to retreat to a common agreement on what is proper [blue is now used in Chamula]. The most important source of inspiration is dreams . . ."[76]

Dreams are a very important but little-studied cultural focus among the Maya. Three authors who discuss the importance of dreams have done their studies in far-flung parts of the Maya world—the Lacandon jungle, highland Chiapas, and highland Guatemala, and in each case, the community members dream together about the ways of the ancestors. A person's dreams are a matter of family or community interest and import. Robert Bruce reported that during his stay in Najá, he participated with all the other (Lacandon) men in the community in an incense-burner renewal ceremony in which they were secluded from the women. Upon rising each day early enough to watch Venus's appearance as Morning Star, they would rekindle the fire in the wall-less temple and converse. Common topics were cosmology, traditions, and the dreams of that night. Sometimes dreams were interpreted as having interrelated symbols pointing to a single prophecy. Dream prophecies were not absolute, but warnings that preventative measures should be taken to avoid trouble.[77]

In *Living Maya*, Walter F. Morris, Jr., relates that in a Tzotzil community, different individuals are sent the same dream by the ancestors when it is time for something important to happen within the community. Prospective shamans dream of meeting the ancestors, and the other shamans will have the same dream, thereby knowing who is about to receive the teachings of curing the souls of a person. People are taught the proper designs for weavings in dreams. "When the saint in Tenejapa asked for a huipil, three women in the community had the same dream, and each set off to learn brocade. The whole community dreams together."[78]

In a highland Guatemala community, Momostenango, "all dreams, whether 'good' or 'bad,' even including small dream fragments, are shared immediately in public and private discourse frames with relatives and friends; important dreams involving the gods are referred to as private and discussed at length with initiated daykeepers, who are the official dream interpreters."[79] Not only sleeping dreams but phases of waking reverie and active imagination can also be used for contacting one's ancestors for knowledge and instruction. Any of these activities is appropriate for discussion and provides a way of fine-tuning the cognitive map of reality shared by the community.

Morris, Dennis Tedlock, and Gossen have stressed that despite the importance placed on maintaining a shared way of life, the Maya with whom they have come in contact have strong individual characters. Because of their close identification with kin groups and ancestors, however, it might be said that, like the East Indians and Japanese, the Maya tend to have a permeable outer ego boundary—a "we-

self" rather than an "I-self." In modern industrialized European society, individuality is often expressed through choice of friends, family, clothing, or interests. In a Maya society, the discreteness of an individual is more a matter of ego-group and ego-nature relationships and artful expression within cultural forms.

Interconnected dreaming, strict hierarchical relationships, dressing alike, speaking within culturally recognized genres in a local dialect, and acting like one's elders and ancestors are all more powerful methods of maintaining tradition and consistency in a society than the domination of unwilling subjects by a ruler. Various authors have marveled at how similar Maya imagery and hieroglyphic writing were over such a vast extent of time and space. They usually point to interregional trade as the mechanism for achieving standardization of ritual, costume, and ceremony.[80] George Kubler pointed out that traders alone had the necessary geographical experience to travel long distances, and that travel for purposes of politics and pilgrimage was limited to those of the upper classes, who could afford the expense of guards to protect them and goods to trade for food.[81] Some degree of travel by artists or other elites is indicated by the similarities in the content of hieroglyphic inscriptions, including a shared astronomical basis for certain rituals,[82] and the use of identical ceremonial costume elements at various sites. But the evidence for nonrational modes of information sharing should not be ignored. Probably the process of consensus in government and community affairs and notions like the *t naab'l* and group dream interpretation created more of a Maya empire than did political oligarchy. Through these integrative practices, the complex web of implicit culture was constantly strengthened.

The Ceremonial City

Although useful works by urban geographers, anthropologists, and historians of religion pertaining to the preindustrial city have been available since the 1950's, most Mesoamericanists, perhaps in their reluctance to use cross-cultural data to support interpretations of ancient Mesoamerican cultures, have ignored these valuable insights and seem intent on reinventing a definition of "city" to fit the Mesoamerican case. Despite the general consensus that Mesoamerican cities contained socially diversified populations, and therefore could certainly be called urban, those who have recently reviewed this problem have consistently refused to offer definitions of the terms "city" and "ceremonial center" so that they can usefully be applied to the Maya situation. Marshall Becker published a historiography of the debate about the degree of urbanism and social organization in Maya settlements, but offered no new definitions.[83] Richard E. Blanton said that the term "city" had been used arbitrarily by Mesoamericanists to refer to large and architecturally complex regional centers, and pointed out that "precise definitions of the term 'city' or the term 'urban' have not yet developed in our discipline."[84] He saw limitations in the data used to create definitions as part of the problem and agreed with Kent Flannery's criticism that in the 1960's, dominated by the anti-elite focus of the new archaeology, cultural materialists and the cultural-ecologists suggested that civilized people did nothing but eat, excrete, and reproduce, while humanists suggested that civilizations were above all three and devoted their energies to the arts.[85] Blanton called for the consideration of ideology and religion as explanatory factors in urban development and concomitant political organization.

Joyce Marcus added a new line of evidence to the old argument. Like Blanton, she suggested that the material aspect of Mesoamerican cities has been overemphasized in the struggle to create working definitions. She pointed out that while all Mesoamerican cities had temples, and so were probably at the head of regional religious hierarchies, and many had series of adjacent rooms called "palaces" which likely had an administrative function, few had permanent structures to house markets, and thus it appears that they considered commercial activity less important to the organization of society than ritual and administration of social order.[86]

Advancing toward a more meaningful definition, Marcus suggested that while Mesoamerican cities were formally distinct, they shared the concept of the sacred center as an organizing principle for society. To this end, she brought out terms for "city" in several indigenous languages. *Altepetl*, "mountain/water," is glossed in Molina's 1571 dictionary of Nahuatl as "pueblo, pueblo de todos juntamente, rey, provincia" (people or town, all the people together, king, province).[87] Here the term for city refers as well to its inhabitants and ruler, establishing that the identity of the people, their city, and their king are inextricable. The Mixtec term *ñuu* means "town, place where something exists."[88] In Mixtec, the town is the medium in which things have meaning. Marcus points out

that the Yucatec word *cah* refers to the town and place and is used as a root word to make the words for "world" and "inhabitants."[89] Sixteenth-century Mesoamericans viewed their ruler's community as the top of a hierarchy of communities. Marcus cites S. J. Tambiah's definition of the seventeenth-century Thai concept of *muang*—a nesting of affiliation around a central community, a "center-oriented" as opposed to "bounded" space, where the name of the capital also stands for those who perceive affiliation to the capital[90]—as a cross-cultural parallel to the Mesoamerican urban form.

I agree with Blanton that an adequate characterization of the Mesoamerican urban form must be congruent with Mesoamerican ideology, and I would add that a new definition must also consider issues of self-identity and emic concepts of social and environmental order. In this respect, the *muang*, which involves social affiliation and mutual identity between the individual and the city, does seem to parallel the Maya concept of cities. But this definition of the *muang* does not include the ordering of space, time, and activity from the point of view of the sun as does the Maya case, nor the concept of the place of the bones of the ancestors.

In the 1970's, archaeologists used the term "center" to avoid calling Maya cities either "city" or (vacant) "ceremonial center." However, "center" as a concept is too significant among Native American civilizations for the term to be used as an avoidance tactic. Mircea Eliade pointed out that these ritual places functioned among many civilizations as the Axis Mundi:

> To take in all the facts in a single broad view, one may say that the symbolism in question expresses itself in three connected and complementary things:
> 1. The "sacred mountain," where heaven and earth meet, stands at the centre of the world;
> 2. Every temple or palace, and by extension, every sacred town and royal residence, is assimilated to a "sacred mountain," and this becomes a "centre";
> 3. The temple or sacred city, in turn, as the place through which the Axis Mundi passes, is held to be a point of junction between heaven, earth, and hell.[91]

Paul Wheatley's powerful and influential work on preindustrial urban forms recognizes the centripetal and centrifugal influences such centers can have when they are the sources of the sacred lineages and the ancient traditions around which population gathers: "It is the

city which has been, and to a large extent still is, the style center in the traditional world, disseminating social, political, technical, religious, and aesthetic values and functioning as an organizing principle, conditioning the manner and quality of life in the countryside."[92]

Following in the tradition of emic views of preindustrial urban forms, Clifford Geertz, too, saw the widespread desire to establish order in a chaotic world. Writing about the *negara*, the theatre-state in nineteenth-century Bali, he referred to the "exemplary center": "This is the theory that the court-and-capital is at once the microcosm of the supernatural order—an image of . . . the universe on a smaller scale— . . . and the material embodiment of political order."[93]

In the Maya realm, the Tzotzil-speakers of Zinacantan conceive a small mound in their ceremonial center to be the center of the universe. They call it *mishik balamil*, or "navel of the world."[94] The concept of the navel as a transition point on the Axis Mundi survived among the twentieth-century Tzotzil as *yoyal balumil*, "immortal person," literally, "axis of the earth,"[95] a term which would have been related cognitively to the king of any ceremonial center and the stelae that portrayed him in a vertical format, as well as the palace he lived in and the pyramid that formed his tomb. The notion of "center" for the Maya was a nexus of sacred places, beings, and activities. It was the place one looked to for paradigms of order on all levels of existence—for traditional ways to order the agricultural year; for messages from the ancestors regarding appropriate behavior and skills; for the justification of the present by the order of the past; for interpretations of the cyclical orders of the planets, stars, sun, and moon; and for the model of one's role within the world of the sun as exemplified by the Hero Twins and the royal kings.

A single term that explicitly states these ideas does not appear in Maya dictionaries. Maya Emblem Glyphs take the nature of the cities for granted, and must refer to semi-mythical founding tales—Place of Bones, Split Sky, Place of the Bat, Bundle of Twigs. "City" is an appropriate term for the hundreds of examples in the Maya region, qualified as follows. They are unicultural and unilingual, and their priorities are political-religious rather than economic. A core of royal and elite administrative and ritual specialists is surrounded by a culturally homogeneous population organized in ranked, patrilineal, exogamous clans. There is evidence for considerable full- or part-time occupational

Myameea

Miameea

SEVERIN, GREGORY H. THE PARIS CODEX: DECODING
AN ASTRONOMICAL EPHEMERIS
V 71 PART 5. 1981
Transactions of the American
Philosophical Society

Q11
.P6
N.S.
71
5

458246

specialization. Highly refined arts and sciences are centered around the explication of the relation of dynastic royalty to a layered universe with a central axis and bound by the seasonal paths of the sun. A magic-cosmic worldview predominates, in which most objects, plants, and animals partake of an animating spirit and each is an index of an aspect of cosmic order. Mythic and ancestral models and relationships are the basis for self-community identity and also give norms for correct reciprocal behavior in the complex social hierarchy. Local trade was geared toward fulfillment of subsistence needs, while long-distance trade was in exotic materials and was probably related to status-enhancing or shamanic activities of the royalty.[96] To avoid confusion perhaps we should refer to Maya cities as "ceremonial cities," as does David Carrasco, to differentiate these culturally homogeneous ones from feudal estates, cities of native commerce, centers of political administration, and global managerial and entrepreneurial cities.[97]

Viewed from a global perspective, Mesoamerican societies share a magic-cosmic worldview with their town and ruler at the center of time and space and hierarchical social relationships based on mutually interdependent obligations governed by contextual norms. These fundamental structural principles of Mesoamerican civilizations are found in many of the world's societies. Of course, Mesoamerican societies also developed distinctly from the rest of the world. Their particular versions of a calendar, of mathematics and astronomy, of creation, of cultural heroes, of kingship, healing, ancestors, souls, language, customs, economy, and ritual make them unique. However, considering some of the most fundamental cultural attitudes that Maya civilization shares with other preindustrial societies has helped me to be aware of some aspects of implicit culture I might not have recognized otherwise. Two studies in particular have helped clarify my thinking and provide useful terminology that I will use throughout this study.

It has been said that the Maya were obsessed with time. Really, I think, they found themselves in an environment where the natural phenomena—birth, growth, death, decay, rain, sun, animal life—were so extreme and hard to overcome that a longing for orderliness inspired them to fashion elaborate systems and explanations of order. The heavenly bodies and annual rains were some of the few predictable phenomena in this challenging but breathtakingly beautiful landscape. The actual structures of the social hierarchy are unfortunately unknown, but the regularity of imagery in art, the regulation of many genres of speech, and the extreme categorization and indexing of time suggest that achieving an ideal order was a conscious goal. To us, these obsessions seem confining or alternatively intoxicating in the manner of mindless, blissful obedience. But probably to the Maya,

> . . . being in their place is what makes [things] sacred for if they were taken out of their place, even in thought, the entire order of the Universe would be destroyed. Sacred objects therefore contribute to the maintenance of order in the Universe by occupying the places allocated to them. Examined superficially and from the outside, the refinements of ritual can appear pointless. They are explicable by a concern for what one might call "micro-adjustment"—the concern to assign every single creature, object, or feature to a place within a class.[98]

In many societies, the making and keeping of place is a unique and precious notion. Such societies have been called "locative."[99] Persons living in cultures with fundamentally locative points of view consciously try to enact in their social, political, and physical surroundings those structures which reproduce the order of the cosmos as they perceive it. Many of those societies share the concept of the layered universe and four-directional cosmology, beliefs in the influence of ancestors on the living, multiple souls, and permeable outer-ego boundaries.[100]

In a locative culture, the city is not primarily a range of possibilities and services for personal achievement, but is an urban ceremonial center, a landscape or theater for the replication by each individual of the cognized structure inherent in all creation. In a locative society, exchange serves to reestablish and reinforce a sense of place in the hierarchy. It is extremely important that exchanges be equivalent in order to retain one's position.[101]

The terms "locative" and "utopian" are used by Jonathan Z. Smith, a historian of religions, to refer to a fundamental distinction in the way individuals, but mostly societies, see the relationship between self and cosmos. Smith emphasizes that in any society, or even in an individual, both points of view are usually present in varying degrees.[102]

Contrasting with the locative society is the "utopian" society, in which individual freedom is highly valued and a right to rebel against unjust authority is explicitly acknowledged. In

a utopian society, abstract standards of behavior for individuals and institutions are set up and enforced only when violation becomes extreme, and then through impersonal authority. The behavior of an adult is not necessarily a reflection of the family because each individual may decide what standards to follow, within the limits of avoiding bodily, financial, or, less commonly, emotional harm to others. Creativity is synonomous with challenging limits and creating new situations and possibilities. A working definition of contemporary art in a utopian society is that which explores the frontiers of representation, of reality, of the expression of personal imagination, or of the limits of the media used. Utopian societies are characterized by the tendency to move away from centers of political and traditional norms and an avid interest in frontiers and the periphery. Individuals long for a perfect place in which they will be free from aggravation, restriction, and responsibility. Money is an end unto itself, has a life of its own, and allows transcendence from a lowly situation of birth or an unappealing place.

Authors in other disciplines have also seen dual patterns of human "social character." In their classic study, *The Lonely Crowd* (1953), sociologists David Riesman, Nathan Glazer, and Reuel Denney proposed that the drives and satisfactions of the individual are conditioned by the society and culture. The authors had observed two fundamental kinds of conditioning patterns in society—what they termed "tradition-directed" and "inner-directed."

The tradition-directed mode demands a large degree of conformity by the individual, dictated by power relations between various age and sex groups, castes, clans, professions, etc. The culture controls behavior minutely and exercises intensive socialization in childhood. Ritual, religion, and routine occupy the people, rather than finding solutions to age-old problems. The individual may be valuable and encouraged to develop capabilities and initiative. The individual belongs to the system and is never surplus; anyone who transcends boundaries of acceptable behavior is channeled into liminal professions such as shaman, or driven out.

The inner-directed society is characterized by increased personal mobility, rapid accumulation of capital, constant expansion in production of goods and people, and exploration and colonization. The individual who can live without strict tradition-direction has greater choices and initiative.

Riesman, Glazer, and Denney's tradition-directed character stresses hierarchical ranking, a sense of belonging to a system of order, and ritual repetition of archetypal models, and thus corresponds closely to J. Z. Smith's locative point of view. Riesman's model of the inner-directed society obviously corresponds in many respects to Smith's utopian point of view. Both authors emphasize that both approaches to the world can coexist in a single society or even an individual. The ethnographic, ethnohistorical, and Colonial data on the Maya presented in this chapter indicate that Maya society was probably tradition-directed or locative to a very great degree.

The Maya opted for community identity and complicated, burdensome, and prescribed social interaction rather than individual liberty, and the sacrifice they had to make for integration in the community was a great one. The elite, in particular, became the vital link between human insecurity and the temperamental forces of nature, and that link was created through their blood. The Maya did not consent to domination; they created a comforting, strict hierarchical regulation based on the way in which natural forces articulated with their daily lives. As Walter Morris put it, "Every act, even one as humble as sweeping, is given dignity and importance in the world described through myths. Today's daily chores—making a tortilla, cutting wood, weaving—are the same chores performed by heroes and gods at the beginning of time, acts that began the world and that keep it alive."[103]

The Maya ceremonial city was designed with generous quantities of representations of the cosmo-magical order. Drawn from the stuff of collective dreams, the imagery of public art transformed a dwelling and gathering place into a living theater where historical, mythical, and familial roles were played. Now that a general framework for the Maya city has been defined, the unique way in which the Skull and Jaguar kings of Yaxchilan designed their city can be explored.

Public Art: Aesthetics and Artists

In the ceremonial city, carved surfaces make tangible a specific cultural reality, provoking strong psychological responses in the beholders. Within the spacious plazas, each grand vista is deliberately framed by solid masonry temples with richly textured façades. Free-standing stone sculptures, mostly stelae carved with standing figures but also large stone animals, circular pedestals, and thrones, punctuate the vistas, drawing the eye along the definite axes of the city. When one stands among these ornamental surfaces, they penetrate into one's physical and psychological space, immersing one in a realm outside rational experience. On the entablature of one façade, Structure 20, swaying tendrils of Underworld vegetation emanating from the heads of monsters surround symmetrically three staunchly frontal, elaborately costumed figures. At the corners of the building, the jutting features of the rain god's head integrate the actual space of the plaza into the Underworld scene. The careful consideration the Maya gave to the design of public space and its enrichment with sculpted forms reveals their concern for the aesthetic impact of their cities on the beholders.

By "aesthetic" I mean more than the perception of beauty. The definition used here combines ideas springing from Oriental and Occidental traditions. It proceeds from one given by Jacques Maquet—the aesthetic object as one "stimulating and sustaining in the beholder an attentive, non-discursive, and disinterested vision."[1] By aesthetic, then, he refers to an experience or perception which is not desirous, which jars the individual's analytical thoughts into stillness, which therefore exists in the present and does not seek cause-and-effect ex-planations, and which creates in the beholder a temporary sense of union between self and object through perception of form. Adding the considerations of Robert Plant Armstrong to Maquet's definition, an aesthetic object stimulates a contemplative mental state in the beholder because it evokes an ideal or an emotional state—either one which tends to be fundamental to a society or even to human consciousness, or one that is more particularly held among fewer persons who share certain circumstances of time, space, and history.[2] The aesthetic experience is perceived by an individual, but can be perceived similarly by another individual whose cultural conditioning is similar, forming a bond of shared, nonverbal experience of an ideal or an emotional truth that might be effectively manipulated, in the case of Maya public art, by the elite. The form of an aesthetic object can induce in the beholder a psychological response that may complement or reinforce a cognitive response to symbols and signs encoded in the object. In the case of Maya public art, aesthetics governs imagery based on public ritual display and therefore invokes experiences shared by community members.

As we consider art within the Maya ceremonial city, it is important for us to understand what the Maya conception of the function and life of art objects must have been. In our own society, we consider Maya sculpture to be "art." It is pictorially stimulating, it has a canon of iconography which can be learned, we appreciate the calligraphy of glyphs and images, and it is desired, viewed, sold, and collected like other forms of art. However, there is no word for "art" in Mayan language. This is so in many locative societies. If one searches for words

translating as "art" in Yucatec Maya, one finds *its'atil*, meaning art or science, skill, ability, knowledge. The root *its'* refers to art not as a category of objects made to be looked at, but as a skill, often a magical one, as shown in the related word *ah its'*, sorcerer.[3] A similar word, *miats*, means wisdom, philosophy, science, art, and culture. Neither are there words that connote "design" as an endeavor or "aesthetic" as a value judgment. Although the Maya produced thousands of carved monuments, painted vases, frescoes, skillfully crafted ritual objects and adornments, "art" was not a separate conceptual category in Maya civilization. Instead, what we would call "art," such as sculpture and vase painting, was, by the Maya's definition, the practice of skillfully encoding or infusing local wisdom and culture into visible form.

This concept is similar to the "work of affecting presence" discussed by Armstrong in his work on the Yoruba of Africa. Unlike many "works of art" in Western societies, which are often considered great because of their uniqueness, their virtuosity of expression or technique, the completeness of the internal system of relationships which they possess, many objects made in African societies are great because the maker effectively instilled extra-human

4.

View from Stela 1 (Bird Jaguar's marker for 9.16.10.0.0) past Stela 2 (from the reign of an earlier king, dated 9.9.0.0.0—two hundred years earlier) up to Structure 33. Photo © 1991 by Lee Clockman.

forces into traditional forms and materials. Such works of art have a spirit or presence that, like a human's, needs to be invoked, cared for, fed, and perhaps clothed, in order to be charged with power. The object made to be invoked as power generally expresses community rather than individual ideals and is intended to attract the powers of the supernatural rather than appeal to the particular psychological state felt by the artist and perhaps empathized with by the viewer.[4]

It is not entirely clear whether the Maya, in creating aesthetic objects, infused spiritual power into them as do the Yoruba. Certainly the idea that the skillful creation and the use of some objects is a spiritual process exists today in connection with the most common of Maya art forms—the design of clothing. The task of creation of garments is a duty of Maya women today, as it was of Nahuatl women before the encounter between Europeans and Mesoamericans in the sixteenth century, and is not merely a chore but the fulfillment of a social role whereby the woman manifests the sacred in a garment that will enshrine the body of her family member. The designs decorating garments are decided by the community to express their particular relationship with the universe; then each weaver includes specific elements that incorporate her family and herself into the cosmic web. Walter Morris describes how the design of the huipil incorporates sanctifying designs of pine branches around the hole where the wearer's neck emerges, just as pine boughs surround a sacred altar. The design then radiates from this sacred individual human center, to incorporate the sun in its daily motion from east to west across the fields, and other supernatural forces, in a formalized relationship.[5] Local wisdom, science, and philosophy are skillfully given form in an object that defines the sacred and is used by a person as a spiritual definition of self.

The description Diego de Landa left of the making of idols in sixteenth-century Yucatan during the month of Mol suggests that spiritual power was infused into public art as well. According to his report, during that twenty-day month, those persons who felt they needed new "images of wood, which they called the gods," consulted the priest, then asked artisans to participate. Acknowledgment that the process demanded the handling of powerful spiritual forces, which easily could be misdirected with dire results, apparently discouraged the artisans from accepting a role in the creation of new images of wood; they gave as their reasons

that they feared that they or their families would suffer heart attacks or strokes. (This demurral, of course, is part of the tradition for accepting responsibility inherent in formalized Maya speech.) Some finally did accept and they, the four elder, revered men who had devoted their lives to community service and thus gained considerable ritual heat (the Chacs), and the priest began to fast in preparation for the artistic process. The person desiring the wooden sculptures arranged for a supply of cedar wood. A hut was constructed for the making of the idols, and the wood and an urn for sanctified storage were placed within. Shut away within the hut, their needs provided for by their families, the participants invoked the holiness of the four directions with incense and drew blood from their bodies at various times, anointing with it the statues they carved. Thus the activity was performed outside the normal space of social interaction in a specially sanctified enclosure, linked to the cosmos but not to the community. In the succeeding twenty-day month, after the wooden images were made, their power was brought into the realm of the community when they were placed in an enclosure of branches prepared for them within the public courtyard.[6] The extralocal power invoked by the artisans and priest was thereby invested in the social life of the community. This process seems to describe the making of objects intended to be infused with supernatural energy, much like the processes described by Armstrong. Landa's report does not explicitly state whether those same idols were the ones which were carried in procession to the four corners of the town in New Year ceremonies. It is possible that these ritual observances were performed only during the making of works of aesthetic power for family use rather than during the crafting of public art. The cosmological themes of public art, however, suggest that its manufacture involved similar spiritual activities, and that public art as well was conceived as work involving the aesthetic principle of invocation, to use Armstrong's term.

We know that the Maya feed, dress, burn incense to, sacrifice blood to, and carry in ritual processions certain objects. These kinds of activities are described by Landa in his commentaries on ceremonies accompanying the dedication of "the image or clay figure of the demon" at the beginning of each year and are portrayed in the New Year tables of the Dresden Codex. So something similar to Armstrong's category of "the work of the aesthetic of invocation" existed among the Maya, and was applied to sculpted ceramic figures and probably stelae.

The remainder of this chapter includes a consideration of several aspects of Maya public art. As a tool of the elite, what was its potential for emotionally affecting even an illiterate viewer, inspiring the kinds of behavior most beneficial to the art patrons? What other forms of creative and expressive behavior complemented public art in Maya society, and what did that mean for the role of monumental art in the society? What can be intuited about the ideals of the society from the aesthetic choices made in the design of public art? Finally, an analysis of authorship in the hieroglyphs and sculptures is presented. This study, which really is independent from issues of aesthetics, is included here because it gives evidence for the ways in which artists worked at Late Classic Yaxchilan and contributes both to our knowledge of the modes of creative thought among the Maya and to the historical reconstruction of the design of the city.

The Aesthetic Power of Public Art

Why would a Maya ruler or a Maya community wish the city to have an affecting, aesthetic configuration? From the political point of view, idealistic public art generated obedience and loyalty to the dynastic ruler. It also stood as a petition to the gods for the success of the reign and for the community's needs. Magnificent public art and architecture was considered tangible proof of the king's greatness, and it gave pride to the rulers and the community that made it. From the point of view of the individual, public art served as an education in history, philosophy, astronomy, and comportment. It illustrated much of what was considered common knowledge and common sense. It also promoted emotional security by providing shared experiences in several modes of consciousness. In a locative society, this psychological cohesion is the preferred state.

Perhaps an aesthetic consideration of Yaxchilan's public art will demonstrate how it allows shared experiences that unify thought at a fundamental level. Figure 5 shows a composition of forms in a vista which includes two stelae, the Grand Stairway, and the roofcomb of Structure 33. This is a view one would have seen if one had entered the city from the river by climbing the monumental stairway that once stood behind Structure 6, then crossed in front of Structure 7 to stand in the Main Plaza. For our purposes, try to ignore the trees, which

add considerably to the impact of the photograph, for it is unlikely that so many trees were there in ancient times.

I have gazed at this scene many times, and usually I have a similar experience, which alters somewhat according to the position and strength of the sun. The vista is established by the two strong verticals which occupy the right and left (Stela 1 at right; Stela 2 plus the stairway to Structure 33 at left). From the stela in the right foreground, where a warrior-king gazes downward at the viewer, one's gaze descends the stela platform and wanders slowly across the plaza floor, stopped briefly by each of the altars and the throne which was set in front of the bottom of the stairway. Ascending the stairway, the eye rests on two small stelae; then the head pivots on the cervical vertebrae as the sight seeks the interlaced forms of the roof-comb silhouetted against the sky. At this point I usually release my breath in exclamation. Still gazing at the uppermost temple, I am aware of the diagonal forms that directed my vision—the elongated bodies of jaguar and caiman flanking the stela platform, and the two temples set diagonally just below Structure 33 to the left. I am also aware of the rhythms set up by the repetitive façades of the buildings which are on the periphery of the field of vision. Dark shapes of doorways in clusters of threes pierce the brightness of the daytime scene. The great depth of space that is encompassed by the vista is curved upward at the edges. The smaller temples between the stela and Structure 33 are set back from each other on terraces that rise up the hill from the Main Plaza. The entire vista suggests a circular movement that descends the stela, sinks along the plaza floor, rises up the stairway, and travels across the sky to the top of the stela. It creates a sensation of repetitive, circular motion through levels of space and past various rhythmic markers. It seems to me that what is moving is time-space. Then the spell is broken as I think about Bird Jaguar and how he set up Stela 1 and incorporated the early Stela 27 and Stelae 2 and 28 as references to rulers who lived three hundred and two hundred years before him.

Confining my view to Stela 1 also gives me a moment of pause. Elevated on its platform, it towers above me. Human figures appear frozen on the stone, but they are well above my head. The face of the king is inclined to look down in my direction, but instead of being drawn close to him, I am distanced by his impersonal gaze. The monster below his feet elevates him out of my realm and makes the warrior seem to hover between the low space of the courtyard, where I am, and the top of the cylinder of heaven that is contained in this defined space. I experience a moment in which the stela shaft becomes a conduit of vertical energies.

The ineffable, awesome experiences that one has at most Maya sites today are one of the attractions of visiting them. Certainly the allure of the decaying buildings amid dramatic, luxuriant foliage touches many visitors today. Provocative enigmas—What would it have looked like 1,200 years ago? Did the Maya know something I can never imagine?—challenge the imagination. But the sites themselves, especially the great sites, Palenque, Copan, Tikal, and Yaxchilan, provide intense experiences for many visitors that are usually referred to as "magical" or "spiritual." Nearly everyone, from card-carrying mystics to skeptical engineers dragged to the ruins by their families, reports this experience at Palenque. These types of experiences—my apprehension of the circular motion of time in the Main Plaza, my perception of the king floating in the plaza in the center of this time-space as if he were an impersonally concerned servant destined to unite heaven and earth through the feathers tickling the space where his ancestors perch and the soles of his feet as they ride the Sun Monster, to the experiences which people spend hours trying to describe in the bar at Hotel La Cañada—occur in an intuitive mode of consciousness that all humans experience. A humorous passage from Jacques Maquet's *The Aesthetic Experience: An Anthropologist Looks at Art* summarizes his explanation of the differing modes of perception and the impact of aesthetic objects.

> Looking at the striking shape of a sports car, I find it beautiful; for a few seconds, visually overwhelmed, I am fully in the contemplative mode. Then I become aware of how that vision affects me: in fact, I am envious of the owner of the car, and envy belongs to the affective mode. A few seconds later, I wonder why this form is so arresting, and I begin to analyze it in the cognitive mode. Finally, the idea that perhaps I could afford such a car flashes into my mind; in the active mode, I begin to make some practical plans to find out first what is the price of the car, and what would be the trade-in value of my present car. This is a sequence of modes of consciousness following one another very rapidly, but at each moment, one mode is dominant.[7]

This passage demonstrates several modes of thought, including the nondiscursive, selfless mode in which the aesthetic experience occurs.

In our society, aesthetic objects, sounds, writing, nature, and certain events can be contemplated, but such a multiplicity of experiences are available that we do not share many specific, acknowledged contemplative experiences. In traditional societies, participation in ritual (public symbolic behavior), the creation, dedication, and use of art, and other widely shared activities provide common experiences in the active, analytical, and contemplative modes. These shared experiences develop among members of a community a common cognitive map of reality. This reality is represented in public art and other aesthetic loci, and the act of representing them creates the power anew for each artist and each beholder.

Perhaps one of the most important aesthetic loci was time. Like the many bodily pulses perceived by a Maya daykeeper or healer, time was the complex heartbeat of Maya life. It enriched the present by telescoping past events into the moment. Ceremonies were not dedicated to time, but the knowledge of the qualities of the days and the motions of the sun and planets was like a connoisseurship of art. Treatment of time in the inscriptions often is done with the utmost elaboration and skill. The faces of the days dominated fate and influenced behavior, and cyclical time partially defined the self by telescoping many other identities on the individual during rituals.[8]

With its aesthetically designed sculptural, ritual, and temporal environments, the ceremonial city formed the matrix for the self in Maya societies. The ideal articulation of the king and the cyclic sun in local space provided a framework for social behavior. On each stela, the paradigm of respect and sacrifice toward the supernatural was reiterated in the tripartite composition showing ancestors above, the sacrificing king in the middle, and the sun and Underworld below. The structure of social relationships between the king and his ancestors, his wife, his subordinates, members of other elite lineages, and his captives was made evident in images and hieroglyphs. The most important community rituals in which the king was chief instrument were displayed, and the basic framework of the Long Count, Calendar Round, Lunar Count, 819-day count, and other calendric cycles was documented. While in the ceremonial center, the beholders were made aware of local history and of systems of knowledge that linked them to the larger world of Mayan speakers.

Aesthetic expectations and performances were concentrated in most aspects of the making of a ceremonial city. Members of the community were directly involved in the experience of making and/or sanctifying the art and architecture. Of course local artists worked on sculpture and architecture. They also surveyed, did astronomical calculations, and quarried stone, all of which activities were likely performed with great refinement of ritual. Recent epigraphic studies have shown that "temple-dedication" ceremonies—perhaps similar to the rituals described by Landa for the investiture of wood sculptures—were so important that they were recorded in the hieroglyphs. Many such ceremonies are recorded at Yaxchilan.[9] The buildings and stelae were probably not considered infused with power until the dedication ceremonies, which involved autosacrificial rites, probably the depositing of caches of objects of invocation such as eccentric flints and carved jades, and subfloor human burials.

An important ritual such as a Period Ending ceremony, when the stelae and some temples were dedicated, demanded the performance of many aesthetic acts beyond the mere erection of the stone monuments. Ritual sweeping, piling up of stones, processions with images of supernaturals, the acquisition and display of ornaments of jade and other imported materi-

5.

View from the Main Plaza to Structure 33, including (from right) Stela 1, Stela 2 (at bottom of stairway), and Structure 33 roofcomb, seen through the trees. Photo © 1991 by Lee Clockman.

als acquired through long-distance trade, sacrificial acts, the creation of sacred enclosures or platforms, gathering and attaching leaves and flowers to the sacred constructions, ritual imbibing of intoxicating beverages, repetition of prayers and invocations, incense burning, and many other activities were charged with aesthetic expectations.

In daily life, each person shared with others in the community a sacred place, known ancestors, and participation in ritual activities; had a place in the local hierarchy; heard similar myths and histories; and was strictly governed by the calendric and astronomic cycles. Community members told and were guided by clairvoyant dreams. Further along on a spectrum of shared experiences stretching from the physical to the spiritual realms, many shared the actual experience of autosacrificial bloodletting.

Public art probably was recognized as a means to provide direct perception of supernatural power and thus to inspire belief in the elite's vision of society. The aesthetically powerful designs the rulers commissioned became the "spiritual food" for which the sixteenth-century Chols begged the Spanish priests—a sense of belonging through shared ideas of time, history, political efficacy, and community solidarity.

The power of the arts to evoke emotion and to be used in the service of a religion or state is commonly acknowledged in many other civilizations. "Both Plato and Confucius thought of music as a means of producing the right kinds of emotion, attitude, and character, hence as a means of strengthening the state."[10] Both philosophers strove to create a middle path of moderation in times troubled by wars and threats to the established order of society. In such times, they praised art which depicted ideal types of characters such as gods, wise rulers, loyal subjects, and military heroes, and which glorified the ideal conception of the state.[11] We know that Maya society suffered wars, coups, and friction within the community and between communities, and it is clear that the extreme conservatism in subject matter and form in Maya art over nine hundred years was partially an attempt to preserve social control and the continuity of a way of life for the elite. By reacting intuitively to Maya art we are not necessarily accepting its message, or contending that these ideals were embraced wholly by each member of the society, but simply trying to determine what ideals were considered essential by the elite in the governing of society.

The Aesthetic Character of Maya Art

Discussions of aesthetic qualities and intentions in art are usually the work of philosophers viewing the artistic creations of their own societies. Unfortunately, such documents do not survive for the Maya. In the literature of the Aztecs, heirs of the Mesoamerican conceptions of art and cosmos, survives a description of a gathering of poets around the year 1490 in the home of a prince, Tecayehuatzin. The topic of conversation and reflection among the poets was initiated by the host, who expressed his "desire to know the real meaning of flower-and-song, poetry, art, and symbolism." The wise poets each responded differently, calling the arts gifts of the gods, the tangible survivals of the individual human life, the means of discovering divinity, an activity that made the heart glad. The prince retained his belief that poetry and arts were "the only way in which to say true words on earth," and a medium of communication among persons of true hearts.[12] To ancient Mesoamericans, as to ancient Greeks, the arts were a means for expressing fundamental truths and for approaching the sacred. In Maya cities, which tended to be unicultural, very conservative, with a magic-cosmic worldview, where oral tradition was highly developed and specific in the uses of its genres, and which had complex kinship and social hierarchies with attendant rules for social behavior, public art bore the burdens of manifesting traditional wisdom and ideals and of being the vessel for the sacred during public ceremonies.

Once one has some knowledge of the nature of the relationship between self, community, and cosmos among the Maya, a few of their aesthetic aims become apparent. The following is a very preliminary consideration of the aesthetic qualities of Maya art based on the functions and conceptions of art in Maya society. It concentrates on a few monuments and at times draws in objects from other places for comparative purposes.

Maya public art was created primarily in low relief, focusing on the use of line to create flat, complicated, interpenetrating forms. While works of art were large in scale, the illusion of three-dimensional space was strictly avoided. Sculptures and buildings usually were brightly painted, in non-naturalistic colors. These and other design choices formed solutions to the aesthetic problems of expressing the sacred in material form and conveying it to the beholder. Working in low relief was a response to both

the materials available and the kinds of messages that needed to be conveyed. It is interesting to note the period in which low relief took prominence over three-dimensional sculpture in Mesoamerica. Between 1200 and 900 B.C. it appears that art objects, especially those made in societies influenced by the Olmec, were predominantly three-dimensional in form. Around 900 to 400 B.C., in the later Olmec era, incising began to appear on otherwise three-dimensional objects, complementing the three-dimensional forms with information about cosmic supernaturals, as on the Las Limas Figure, now in the Museum of Anthropology of Xalapa. Many symbols incised on Olmec objects were adopted by Maya and other hieroglyphic writing systems and on Maya stelae. The Preclassic Maya (300 B.C. to A.D. 250) made pottery and architectural sculpture that were more three-dimensional in concept than art made during the Classic Period (A.D. 250–1000), when ritual scenes and dynastic documentation found more precise expression in linear low relief and linear painting. The soft limestones and tuffs of Maya sculpture were more conducive to such narratives than the basalts of the Olmec. Both the Olmec and the Maya worked jade, but again, Maya jades tend to be low relief on flat forms while Olmec jades are often more three-dimensional objects with incised symbols. The shift toward low relief seems to have coincided with a shift toward dynastic inheritance as being more important than magical abilities as a criterion for rulership, and toward the narrative of cyclical time in hieroglyphic writing.

The figures in Maya art are composed not as they would be seen in space from the eye level of the viewer, but as they are known to be—in an ontological perspective—using a combination of profile and frontal view, with some ornaments shown in top view as well. The tripartite compositions show a cross-section of the cosmos—a king contiguous with both Underworld and celestial realms. Separation of cosmic areas was achieved by bands, groundlines, and cartouches. Placing a figure in a cartouche suggests that it is not native to the cosmic space created for the rest of the composition. For example, the images of the ruler's mother and father are placed in cartouches when they appear in the celestial register of a stela. They are in the sky now, but they were once on earth, unlike the Skyband Monster, who, as a native of a nonterrestrial cosmic realm, needs no cartouche. The primary figures, who were contemporary kings, do not exist in any kind of

real space, but surrounded by the smallest possible amount of background area. The intrusion of glyphs into the composition minimizes free area around the figure. The actual background for the figure is the ceremonial center itself, just above the eye of the beholder, cohabiting the beholder's space. This is no human-centered reality, but one created to revolve around king and cosmos.

The low relief on monuments at Yaxchilan, which can be dated between A.D. 454 and 808, was a cultural choice. It allowed a permanent commemoration of lineage details and of rituals within the living ritual arena. On a stela, the shallowness of the present, portrayed as a precisely articulated figure in low relief, is seen against the actual space of the ceremonial center with its assemblages of historical markers like layers in the great depth of cosmic space-time.

Many monuments at Yaxchilan are carved with very similar scenes. The southeast half of the Main Plaza contained no less than seven monuments depicting various rulers in a similar pose and costume engaged in autosacrificial bloodletting. The monuments concerned four different rulers over a three-hundred-year span. Repetition and redundancy are characteristic

6.

Lintel 15. Photo © 1985 by Justin Kerr. (A drawing of this lintel is included in Figure 93.)

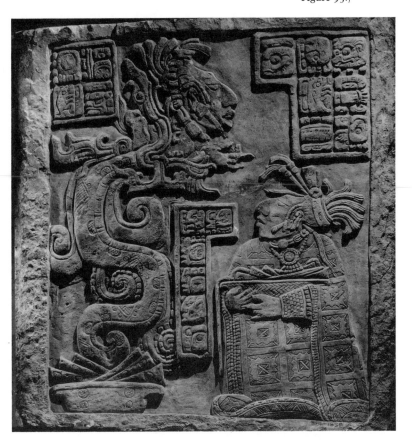

of contemporary Maya ritual activity. Among the modern Chamulas, the ritual setting needs metaphoric heat. Oral or visual symbols used in ritual and the forms of discourse used for ritual language have increased heat, expressed in multivocality and redundancy of the message.[13] Repetition of song, chant, the use of a ritual object, or the performance of an activity increases the amount of "heat." The repetition of images on Yaxchilan stelae demonstrated large patterns of dynastic and ritual immutability and probably created a "heated" arena.

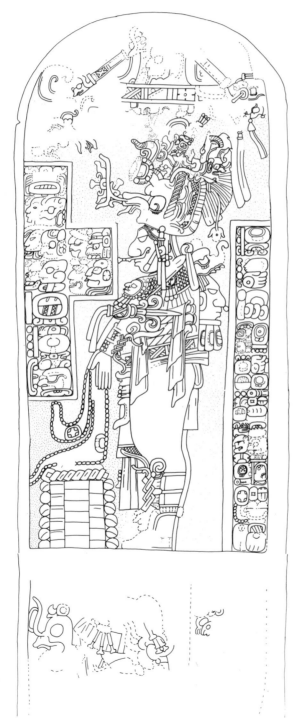

Repetition is used as a compositional device in the sculpture. For example, repetition of shapes is seen in the double outline of hands and legs on Stela 6 (see Figure 7). Subtler rhythms are expressed by the bands on the legs, the groups of feathers, and the curve of the snout of the headdress which finds its echo in the downward-curving flow of blood from the ruler's hands. Rhythm and repetition are strong forces in architecture as well. At Yaxchilan, almost all façades have three front entranceways, generally spaced evenly within the central 50 percent of the front wall. The heights of the buildings are staggered so that from a single viewpoint in the Main Plaza one sees several groups of three dark rectangular entranceways zigzagging up a hill. Decoration on the friezes also sets up interlocking rhythms in relation to the doorways. For example, on the façade of Structure 33, three niches containing seated figures alternate with four sets of two armatures for stucco sculpture. The three niches are further apart than are the three entranceways, creating a counterpoint of two rhythms.

A great variety of shapes are incorporated into the complex rhythms of the designs. The shapes in the reliefs flow, hang, arch, poke, pose, and are knotted. For example, on Stela 6, the use of line creates flat shapes that express the flowing forms of the strips of cloth overlapping the king's hips, the hard regularity of the circular jade beads forming a collar around his neck, the stiff tension of the feathers and the bulbous forms of the forehead of the monster in his headdress, and the woven fiber of the basket. The figure is thick around the middle; it has many projections from the head and an additional appendage in front. Although the array of detailed shapes is confusing to our eye, in fact, they are carefully articulated and usually literally representational. The classification of things by shape is embedded in some Mayan languages, such as Tzeltal, through the obligatory reference to numbers of things using numerical classifiers that often correspond to shape.[14] The variety of textures, shapes, and directions were all intimately observed in the structure of Maya art and apparently in language as well.

The composition and placement of monuments at Yaxchilan suggest that the sun was a crucial organizing principle in the Classic Period, as it is today in Maya societies. Several stelae at Yaxchilan (1, 4, 5, 6, 7, 10, 11, 18, 19, 20) are oriented so that their narrative is "read" by the sun each day. On the eastern-facing side appears the record of a ritual capture prior to

and related to a Period Ending. On the western side is a tripartite composition that describes events that happened after the capture. On both sides, the ruler's figure usually is turned so that his own right hand is toward the eastern, rising sun, the ideal position for maximum ritual heat. The directionality of the sun—in which east and rising aspects possess the greatest potential energy—is perhaps the most important organizing principle in traditional Maya culture today. Among the Chamula, "the sun deity's first ascent into the sky . . . provide[s] the categories of the credible, the good, and the desirable, as well as the negative categories" [of normative thought].[15]

In reconstructing the original positions of the lintels at Yaxchilan, I noticed that the ruler always faces out of the building, and as every structure with figures carved on the lintels faces somewhere in the northeast quadrant of the horizon, the king always faces the northeast, the east being on his proper right side. The primacy of the right hand exists in Maya thought today. In the Tzotzil language, the adjective *batz'i* means "right" and, by extension, "true," "actual," and "the most representative." During ceremonies, ritual cargoholders, who "themselves possess an aspect of deity in that they share with the sun and the saints (the sun's kinsmen) the responsibility and the burden of maintaining the social order . . . metaphorically follow the sun's pattern of motion by moving to their own right through any ritual space in front of them."[16]

The sun's goodness and "heat" increase as it rises. The upward direction is therefore more desirable and better than the downward.[17] Upper and lower are clearly delineated on the Yaxchilan stelae mentioned above. For example, the king occupies the central register. A horizontal band of repeated supernatural heads and symbols separates the king from the smaller images on top. The latter are his ancestors, ideologically the source of goodness and wisdom. The lower half of the ruler is much less decorated than the upper half and particularly the head, which among the Chamula is the source of the heat and power of the images of the saints.[18] Above the ruler's head, the composition is most complex, being densely packed with important astronomical symbols and the finely detailed textiles and regalia of the ancestors. The proportion of the figure relative to the pictorial field offers some insights. When the proportions of the completely outfitted figure are analyzed, the headdress (including the head) often occupies one-third of the total space

of the figure. The head itself is about one-ninth of the figure. Clearly the headdress, the uppermost part of the figure and the most ritually "hot," and the other decorated third, the torso, carry the most information.

The position of the sculpture in public space was usually elevated above the viewer, sometimes so far that it could not easily be seen. The decisions to use the lintels of the buildings, above the heads of the king or commoner, as a proper place for ritual imagery and to elevate the stelae on platforms may have been made deliberately to show the degree of "heat" of the royalty portrayed or of the ceremonies being performed.

Sufficient naturalism exists in Late Classic Maya sculpture so that the physical presence and vitality of the subjects in the ceremonial city is strongly suggested. The figures are of naturalistic proportion, certainly more so than any other Classic or Postclassic Mesoamerican figures. Forms, such as drapery and the figures themselves, respond to a strong gravity that appears to weight them. Compositional balance at Yaxchilan seems to have been achieved by the sheer sturdiness of the massive thighs which support the sprays of feathers, heavy ornaments, and monster heads the kings wear. The kings are as firmly rooted in the sacred space as the massive trees at the four corners of the Maya world. Diagonal gestures and flowing shapes do little to upset the balance of the erect king, but do surround him with a sense of vitality. The absence of perfect symmetry and perfect repetition, in the shapes of the stone monuments as well as in pictorial design, evokes a sense of dynamic process, making the forms seem more vital.

But naturalism does not seem to have been the overarching concern in design. The colors used to paint the monuments could have contributed to their degree of naturalism, but they were not used toward this end. Color was used in saturated hue and covered large portions of the low relief. It did not serve to aid in the differentiation of small forms from one another. It appears to have been used for its symbolic value, although successive layers of paint found on some Maya objects (some that I have observed closely are the painted Wall Panel at the Dallas Museum of Art and the stuccoes of House A at Palenque) clearly indicate that objects were alternately painted different colors. The deep reds, pinks, golden yellows, and blue-greens seen on the lintels of Structure 33 and the murals of Structure 40 suggest the splendor of the macaws and other birds that inhabited the area

until recently. In the *Popol Vuh*, the supernatural 7 Macaw is an important character in the narrative of a previous creation. He exploited his brilliant hues to claim falsely that he was the sun. While bright greens and reds were actually seen in ritual costume, the elements of costume were not always painted the colors we know them to have been. Thus, returning to the sun as the fundamental organizing principle in design and society, it might be suggested that the saturated colors on Maya monuments were intended to evoke the sun's splendor, flight, and brilliance.

From the earliest inscriptions onward, Mesoamerican artists have always contrasted the regular shapes of hieroglyphic texts with the dynamism of figures. Part of this must be due to the demands of preserving a reading order for the glyphs. Having opted for linearity in text areas, the artists then did their best to break up space, to create direction through emphasis on certain words and images, and to tightly enclose the figures. On Stela 6, figure and text touch at four points, creating a tension between the figure and its hieroglyphic frame. Their interaction is one in which each swells to its maximum, a potent figure touching a charged text in mutual interconnectedness and acknowledgment of boundaries. In general, the composition of elaborate figures closely surrounded by chains of hieroglyphs suggests a powerful being connected to a web of specific, ritually charged information.

If we trust our responses to Maya visual form, as they are informed by a concept of the Maya "period eye" or, better, "cultural eye," I think we can identify some of the aesthetic and ethical qualities the ancient Maya valued in art and in their lives. They saw beauty in the clear articulation of form, the creation of elegant curves, the variety of direction and texture of line, the evocation of shape through line, the repetition of rhythmic forms, the penetration of all background by shapes, and brilliant color. Goodness and the proper mode of behavior for rulers and probably commoners were conceived as tied to the motions, mutability, heat, energy, repetitions, and rhythms of the sun. The pivots around which the sun's motions and the ceremonial center revolved were the upright figures of kings, of stelae, metaphorically of cosmic trees.

The creation of monumental sculpture and its inauguration into the life of the ceremonial city must have been realized through the harnessing of considerable ritual heat or spiritual power. The scribes and artists who produced monumental sculpture were persons of renowned skill and the wisdom of the ancients. While the works of ritual power they created were based on the most conservative knowledge, techniques, and tradition, they were also individuals with strong personalities, each contributing special skills to find the best solution to the problem of design.

Scribes, Artists, and Workshops

The identities of any of the artists and scribes who created the thousands of Maya objects which remain have been thought, until recently, to be hopelessly lost. Although qualitative differences have been seen in sculptures, even at a single site, there have been several barriers to determining the authorship of a monument. First, the strict iconographical canons of public sculpture seemed to subjugate the personality revealed by the hands of the designers, drafters, and sculptors to the message that the monument was intended to convey. Second, formal boundaries in the art were sufficiently unfamiliar to make it difficult to distinguish innovative or expressive passages. Third, it was assumed that a single artist made each sculpture. Also, at most sites, monuments were erected only once or twice in a ten-year period, making it difficult to trace the work of a single individual over several monuments. Finally, even if tentative attributions could be made, there were no documents which would verify them.

The sixty carved lintels, five hieroglyphic stairways, and thirty-four stelae of Yaxchilan form one of the few corpuses of monuments ample enough for an investigation into the hands of artists. Furthermore, many dated monuments were erected in the Late Classic Period. In Shield Jaguar's reign of sixty-one years, he patronized at least five stelae, eight carved lintels, and six hieroglyphic steps. His successor, Bird Jaguar IV, commissioned at least four stelae, twenty-two carved lintels, and three steps within a period of only twenty years. Early in my studies on Yaxchilan, I attempted to attribute monuments to the hands of artists based on the figural portion of the sculpture, but was not satisfied with the results.

Several years later, having become more familiar with the aesthetic and iconographic canons of art at Yaxchilan, I tried again to come to terms with this problem. This time, I sought to integrate the results of an exciting contribution which had recently been made by David

Stuart regarding possible name phrases for the artists within the hieroglyphic texts. Stuart had identified a hieroglyphic phrase common on Maya pottery as a form of recording the name of the scribe who painted the vase and wrote the glyphs.[19] This discovery led him to the supposition that a phrase with structural parallels which is found on certain monuments, including some at Yaxchilan, referred to the sculptor or artist of the relief.[20] It can now be assumed that the incised phrases on two sets of lintels at Yaxchilan name individuals involved in the production of the monuments, but whether they name scribe, sculptor, or figure artist, and whether those functions were performed by one or more individuals is not clear from this line of evidence.

As Stuart showed, the *u ts'ib* phrase that frequently occurs on the rim texts of Maya polychrome pots clearly translates "his writing." It refers to the scribe, or the wielder of the brush that drew both figures and glyphs on the pot. A title, *ah ts'ib*, "scribe," appears in the Cordemex dictionary of Yucatec Maya. The glyph incised on monuments is slightly different from the *u ts'ib*, perhaps reading *lu ts'i*, for which a gloss cannot be found in dictionaries of Chol or Yucatec. But it also seems to refer to writing.

On the two sets of three lintels at Yaxchilan, the handwriting appeared very different on each monument, yet the figural areas seemed more homogeneous. I decided to try an analysis of hieroglyphic handwriting and orthography. Oddly enough, the manner in which the scribes dotted their *ti*'s and drew their *u*'s and composed other common words and syllables was clearly diagnostic of individual hands. To demonstrate this observation, I present sample studies of the styles of hieroglyphics and figures on three sets of monuments.

CASE I: IDENTIFYING THE HANDS OF TWO SCRIBES

The upper portion of a well-preserved small stela, inscribed on both sides, will serve to demonstrate that two scribes designed the glyphs on the same monument (see Figure 8). In his description, Teobert Maler commented that one side was "better finished" than the other.[21] Is the difference in carving due to sloppiness or to the hands of two distinct individuals?

8.

Stela 12 (both sides). Photo by Teobert Maler (1903: Pl. 76). (A drawing is included in Figure 137.)

A close examination of the carved texts reveals that the scribes shaped their glyph blocks differently and might even be said to "spell" differently. On the right panel, the outline of the carved area is not rectilinear, causing the shapes of the glyph blocks to be higher at the upper right corner than at the upper left. This makes the glyphs appear to slant slightly. The exterior shape of the forms is very regular. All the glyph blocks fill up the space allotted completely, leaving no space in the corners. In contrast, the glyphs on the left panel fill square rather than rectangular spaces, they are arranged in straight rows and columns, the glyph blocks do not slant in either direction, and the exterior shape of the signs is fluid, leaving small uncarved areas between the corners of glyph blocks. The fluid lines in this text were translated into delicately inscribed and modeled forms in the process of carving. It appears that two individuals laid out the glyphs and drew them on the stone, but as yet it can not be ruled out that the same person drew both sets of glyphs and that the differences lie in the carving.

Both texts include nominal phrases for Shield Jaguar, so there are several glyphs and affixes that are common to both texts and can be compared. Look at the "captor" (T764)[22] glyphs at positions B4 and E4. The scribe of the left panel uses the skull variant of *u* (meaning "his" or "its"). His captor beast has a curl and an egg-shaped affix (T108) above and two overlapping oval affixes (T106) below. The beast's face has no separate nostril and is almost chinless, with four sharp teeth. The "captor" glyph on the right panel is prefixed with the T1 *u*, does not have crosshatching in the egg-shaped superfix, and lacks the subfix. The face has a separate nostril and a substantial chin.

A simpler comparison that shows distinctions between the two texts is the "5" bar. The "5" bar on the right text is fat and plain; the ones on the left are thinner and have diagonal slash decorations. The text on the right repeats the T1 version of *u* exclusively, while the text on the left varies this with one skull substitution for *u* (T232). The T1 *u* on the left text is curvilinear, and the ovals within are small and separated from the bracket. The *u*'s on the right are squared off and the ovals within are separated from the bracket only by a line. In general, the text on the left is characterized by the use of alternating heavy and light lines in the elaboration of the shapes of the glyphs, by fine crosshatching, and by a high degree of modeling, whereas the text on the right has a minimal amount of fine detail.

Differences in slant, "spelling," and line quality indicate that separate individuals drew the glyphs on the two sides of the stela. The carving style, as seen in the control of curves and modeling, is distinct as well, so the two scribes may have each carved their own glyphs, or two separate sculptors in addition to the two scribes may have worked on the two sides of the stela.

CASE 2: THE STRUCTURE 44 LINTELS—SCRIBES WHO WERE ALSO ARTISTS

Lintels 44, 45, and 46 of Structure 44 (see Figures 9–12) were each carved with a scene of a king, named as Shield Jaguar, conquering a different captive. The lintels are not in good condition, and large portions of the glyphs and images are missing, but enough remains to see that the figures are quite similar in size, gesture, composition, costume, and depth of relief. At first glance, these figures appear to have

9.

Lintel 44. Photo by Ian Graham (1979:97). (See also Figure 153.)

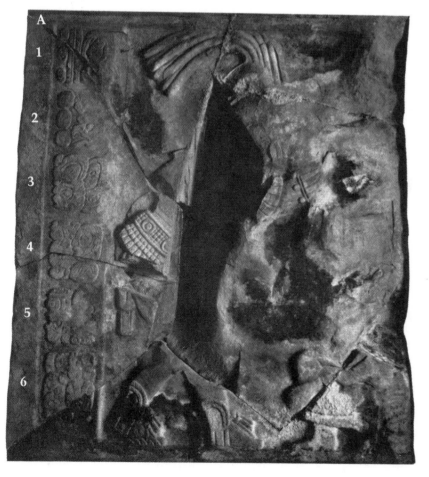

been designed by the same artist and carved by the same sculptor. The glyphic texts on the three lintels, however, appear to have been drawn by three different scribes. Once the handwriting of these scribes becomes familiar, transposition of their treatment of forms to the figural parts of the lintels can be seen.

As in the Stela 12 example, determining the hand responsible for glyphic passages requires scrutiny of both glyphic form and phonetic spelling. Lintel 46 glyph blocks are fairly uniform in size. The exterior shapes are fluid but regular. Little empty space exists within each glyph block. The artist tends to use double outlines and crosshatching, adding elegance to the forms. The text on Lintel 45, in comparison, is characterized by wildly shaped glyphs. The outlines of the glyph blocks are irregular. Unoccupied space is incorporated into the glyph blocks. The scribe does not use double lines with as great frequency as the Lintel 46 scribe.

Despite damage to the Lintel 45 text, some specific syllables and words are common to it and Lintel 46, and can be compared. The T1 *u's* on Lintel 46 (at F4, F6, and F8) are very similar to those on the left text of Stela 12—the bracket forms the center projecting element in a continuous line, and the ovals are delicately small and are modeled to be quite separate from the bracket. In contrast, the T1 of Lintel 45 (at A2 and C6) almost looks like half of a *k'in* sign. Comparing the skull-variant *u's* on both lintels, the Lintel 46 one (at G7) has two holes in the cranium, a ridge at the nostril, teeth, and a single crosshatched subfix. The Lintel 45 skull (at C5) is summarily sketched in comparison. Each lintel has a *k'a* "remembering"[23] statement as well (at F8 on Lintel 46 and C6 on Lintel 45). The two statements are designed with substitutable variables (which perhaps indicates that the composition of words on the trio of lintels was orchestrated by an overseer who made sure that statements were not repetitive), but a difference diagnostic of a separate hand is the treatment of the smoke above the fist. Again, specific differences in glyph form, composition, and "spelling" indicate that the glyphs were drawn by two separate hands. Without belaboring the details, the Lintel 44 text appears to have drawn by a third hand.

Which scribe, if either, was responsible for the drawing of the figures? This is a much more difficult problem. If hands and faces are present in the glyphs and survive on the figures, then the glyphic and figural elements can be compared. We are not that lucky in this case. The only specific element on Lintel 46 that is common to glyphs and figures is the knot at G8 and the many knots in the clothing. The glyphic knot is almost identical to the knots on Shield Jaguar's sandals. The loops of cloth on Shield Jaguar's garments are often elaborated with double lines, as are the borders of his sandals. Double lines are characteristic of the style of the Lintel 46 scribe, as is the practice of adding lines to the end of a lock of hair or feathers, as

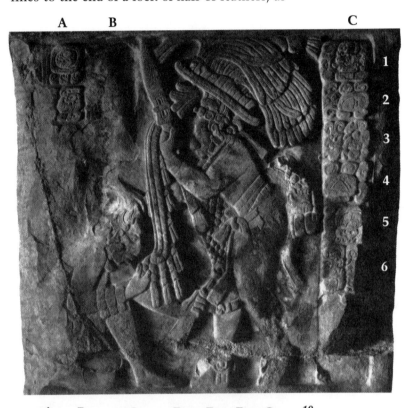

A B C
1
2
3
4
5
6

10.

Lintel 45. Photo by Graham (1979:99). (See also Figure 153.)

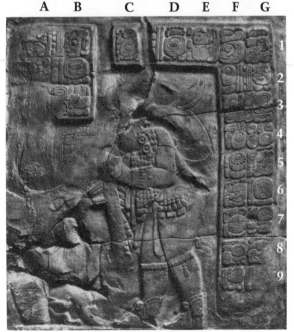

A B C D E F G
1
2
3
4
5
6
7
8
9

11.

Lintel 46. Photo by Graham (1979:102). (See also Figure 153.)

at G4 on the end of the shield, and on the segment of bangs looped through the jade bead on the head of the figure. It seems very likely that the primary artist and the scribe of Lintel 46 are the same individual, whom I will call the Elegant Knot Artist.

The figure of Shield Jaguar on Lintel 45 is more dynamic than that on Lintel 46, just as the writing is. The cloth sashes on Lintel 46 do not indicate movement of the figure; they cling to the body. In contrast, the loincloth on Lintel 45 flies out in back, the sash from the figure's spear moves toward his body as if he is stepping forward, and the knotted loops of cloth at his waist project naturalistically. The treatment of the knots is looser on Lintel 45 than on Lintel 46. The Lintel 45 artist indicates strands of hair throughout the length of each section of hair, whereas the Lintel 46 artist, on at least three occasions, indicates strands only at the end of the hair section. Thus, despite the fact that on Lintels 45 and 46 the figures are similarly proportioned, the gestures are very similar, the subject matter is nearly identical, and the figures on both lintels are well observed, it is clear

that the two lintels were not drawn by a single individual, but were produced through a collaborative process, which is more easily seen on the better-preserved lintels of Structure 23.

CASE 3: STRUCTURE 23 LINTELS—A WORKSHOP PRODUCTION

The lintels of Structure 23 (Figures 13–15) are widely considered to be among the finest of Maya stone sculptures. They appeal to those whose aesthetic ideas spring from the European Classical tradition for several reasons. The figures stand out sharply from a background that has been deeply cut away. This results in a clarity of image unusual in Maya art, which is enhanced through the elimination of extraneous detail. Although the figures are richly dressed, they lack the usual sprays of feathers that obscure the outline of figure and regalia on most monuments. Those items of regalia that are portrayed are depicted with complete accuracy and in fine detail. The items are drawn after careful observation of a real object, unlike other examples of Maya drawing (for ex-

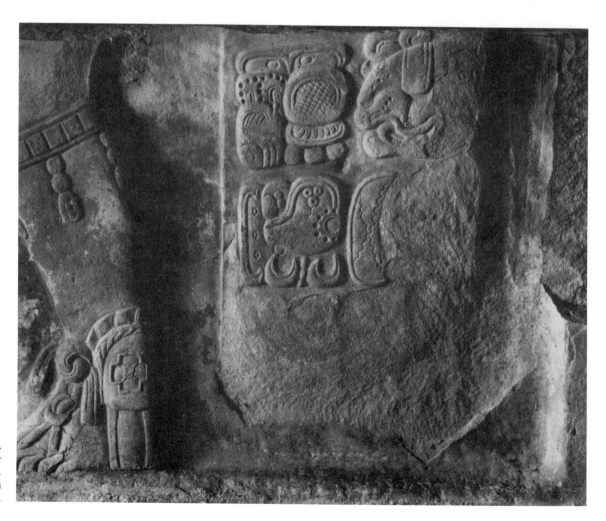

12.

Lintel 46: detail.
Photo by Graham
(1979:102).

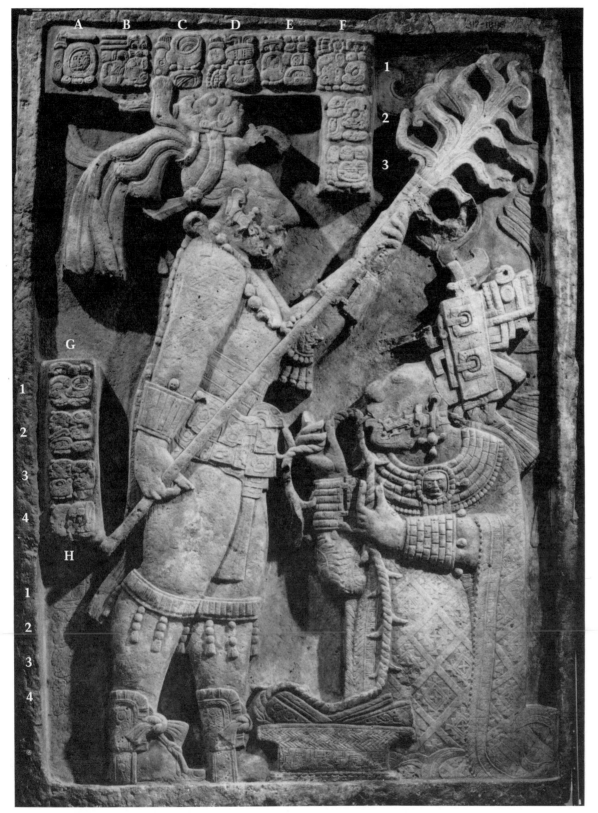
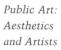

13.

Lintel 24. Photo ©
1985 by Justin Kerr.
(See also Figure 98.)

ample, on Yaxchilan Lintel 5), where the items depicted are poorly observed by the artist and therefore confusing and obscure to the viewer. Elements of the composition are further distinguishable from each other by being placed on slightly different planes of the stone. The poses and composition of the figures are complex and unusual, and the diagonals created through the depiction of forms and the suggestion of gaze and gesture draw the eye of the viewer through the composition. This clarity and the circular aspects of the composition of the scenes are similar to images made in the European aesthetic, such as a Raphael painting, and therefore these lintels are more accessible and better appreciated than many Maya monuments. Also, the depiction of hands and faces is done with great delicacy of line. The use of double outline and fine crosshatching contributes to the beauty of the sculptures and unifies the images on the three lintels.

Such unifying decorative techniques may have been employed to add coherence to the work of a team of two or three artists. Whereas Mary Ellen Miller[24] assumed that a single artist was responsible for the three lintels, there are many discrepancies in the handling of the design and relief that indicate the participation of several. For example, look closely at the folds of Lady Xoc's gowns as they billow out at the groundlines of Lintels 24 and 25. Although they are executed in very low relief, the folds of the Lintel 24 gown seem to incorporate air. They cascade fluidly around her form. The Lintel 25 drapery is formed of stiff, precise shapes that do not really resemble flowing cloth. Could these garments have been designed by the same individual? Compare the borders of the fabric on Lintel 24 and 26 gowns, which are incredibly delicate, as are the textile designs, to the Lintel 25 borders and fabric design, which are coarser. On Lintels 24 and 26, the artist has succeeded in indicating depth of field by showing the inner and outer edges of the garment as it drapes around Lady Xoc's arm. Opportunity for this realistically observed detail exists on Lintel 25, but it was not employed. Another indication of the existence of more than one artist in the design of the lintels is the subtle difference in the treatment of hands. The Lintel 25 hands exist in more of a two-dimensional format than those of Lintel 24, where hands bend around the rope and spear with carefully observed naturalism.

Particular decorative features used by the scribe of at least one lintel, 25, also appear in its figural design. The thick-tipped, long-nailed fingers of Lintel 25's figures also appear prominently in its glyphs, at B1 on the underside and M1 on the front edge. Treatment of hands in the glyphs on Lintels 24 and 26 is quite distinct. In general, handwriting of the Lintel 25 text is easily distinguishable from that of the Lintel 24 and 26 texts, for example, in the size and shape of the glyphs. The Lintel 25 glyphs are larger with respect to the lintel than those of the other two lintels. The Lintel 25 glyphs are bold and regular in shape, expanding to the corners of a now-invisible cartouche. Compare them to the more erratic exterior shapes of the

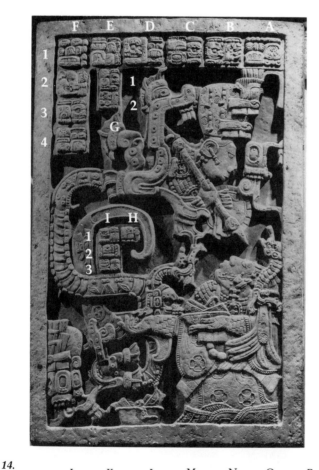

14.

Lintel 25: underside, photo © 1985 by Justin Kerr; front edge, photo by Graham (1977: 56). (See also Figure 98.)

glyphs of Lintels 24 and 26. I have not been able to identify another Yaxchilan monument with the particular style of handwriting found on the underside and front edge of Lintel 25. It may have been the artist/scribe of Lintel 25 who suggested reusing the Early Classic Maya "Vision Serpent"[25] as an accession image at Yaxchilan, an iconographic contribution that became one of the hallmarks of Late Classic Yaxchilan monumental art and of the workshop in which the Lintel 25 artist and the Elegant Knot Artist collaborated. Our present understanding of the "*lu*-bat" glyph suggests that it is related to the authorship of a text.[26] This glyph occurs in the dedication phrase of Lintel 25 (O2–Q1), followed by Lady Xoc's name. This leads us to entertain the possibility that she drew the text and figures of Lintel 25, in collaboration with the workshop artists, who advised the Lintel 25 artist on composition and the execution of faces.

The hand of another scribe can be seen in four carvings: in Structure 44 on Lintel 44 (Figure 9) and Step IV (Figure 16), and in Structure 23 on Lintel 23 (Figure 17) and the front edge of Lintel 26 (Figure 15). This scribe's lines and glyph shapes are exuberant. For example, look at the animated *ahau* glyph on Lintel 23 (F2), and the lively treatment of leaves and smoke (Lintel 26, H2; Lintel 23, C1). This scribe usually uses a superfix on "captor" glyphs consisting of a curl element and an elongated, leaflike oval. The "captor" glyphs on Lintel 23 (M4, O6) and Step IV (A4) are almost identical. The scribe chooses to curve affixes such as numerals and *ah* superfixes, unlike any of the other Yaxchilan scribes (see Lintel 23, N2a, M4b; Lintel 26 front edge, where the entire cartouches are curved; Lintel 44, E1). The ends of the feather "tail" on the shield in Shield Jaguar's name are invariably fanned out by this scribe, who enjoys such details as adding semicircles to elaborate the interior of numerals, and who occasionally uses double outlines.

As a final bit of evidence that the glyphs on the Structure 23 lintels are drawn by different hands, compare the treatment of the turtle shell in the month glyph, Mac, on Lintels 25 (A1) and 24 (B1). The lines in the bottom of the turtle shell on Lintel 25 are very similar in quality to those on Lady Xoc's dress border on the same lintel, just as the hands in the glyphs and figures are quite similar on this lintel.

To recapitulate the scribal characteristics of the three artists, there is evidence for one who uses bold forms and some double outlines, and who tends to present purely frontal and profile forms, whom I call the Lintel 25 Artist. There is evidence for another artist/scribe who commands finer control of the lines, is the premier at textile portrayals, loves to display skill at drawing knots, and adds lines only to the ends of hair or other strands. This Elegant Knot Artist did much of the surface detail of Lintels 24, 26, and 46 figures. I have also identified the more Exuberant Scribe of Lintels 45 and 23, the front edge of Lintel 26, and Step IV.

The Exuberant Scribe's glyphs show some three-dimensional volume. See how the *ahau* glyph is infixed into the forehead of Ah Ahaual on Lintel 45 (C1). The lines describing the

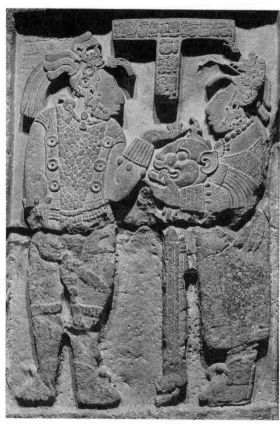

A B C D E F G H I J K L M N

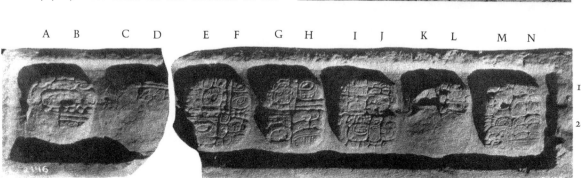

15.

Lintel 26: underside, photo © 1991 by Lee Clockman; front edge, photo by Maler as reproduced by Graham (1977:58). (See also Figure 99.)

hands on Lintel 45 are relatively volumetric, and approach three-quarter view. Perhaps the scribe(s) with this three-dimensional, three-quarter-view aptitude conceived the notion of the high relief on the Structure 23 lintels and was (were) responsible for the three-quarter-view hands on Lintel 24.

I believe that in several cases a lintel was designed by a single scribe-artist. The Exuberant Scribe wrote glyphs and drew figures on Lintel 45. The Elegant Knot Artist wrote and drew Lintel 46. Glyphs and drawing on Lintel 25 were done by the same person. Lintels 24 and 26, however, show indications of several hands. The glyphs on those two lintels were written by scribes other than the three named above. However, the Elegant Knot Artist definitely drew the fine garments and hair of the two lintels. The Exuberant Scribe conceived of the complicated, three-quarter-view hand positions

of Lintel 24 as well as the volumetric representation of the drapery there. These two lintels show clear evidence of the collaboration of at least two artists in producing spatially innovative compositions complemented with the most delicately rendered costume elements and hair.

Thus far I have discussed the drawing of glyphs and figures upon the stone and not the carving. Several bits of evidence suggest that the Maya valued the drawing of the low-relief designs more than their carving. It seems that the processes of carving and drawing were separate. Schele and Miller mention an unfinished hieroglyphic stairway from Dos Pilas on which several blank glyph blocks are roughed out but no glyphs carved on them.[27] This is the process today in the production of limestone replicas of Maya monuments for the tourist trade in Palenque. The master artist of the workshop makes the drawings on paper. They are traced onto the stone by an experienced carver; then the stone goes to the apprentice, who cuts away the background, which is referred to as *la rebajada*. Then the stone goes back to the experienced carver, who does the detail work on the surface.

On the Structure 23 lintels, there is a less-than-uniform approach to shaping the projecting areas. The Lintel 26 background plane is 4.3 centimeters deep, but the depth of modeling within the figures is no greater than 1.1 centimeter. Shield Jaguar's and Lady Xoc's arms overlap their bodies, but this overlapping is enhanced by a change of less than half a centimeter in the plane of relief. Successive levels of relief are much more complex in Lintel 25 than in Lintel 26, yet none of the individual forms are modeled in high relief. Only on Lintel 24 are the hands and arms of the figures portrayed with a degree of three-dimensionality. This suggests to me that the artist/scribes directed a group of sculptors, perhaps including themselves, in the production of these monuments. The artists' familiarity with the qualities of the limestone is evident in the intelligent composition of Lintel 24. The sections which would have been fragile if carved in high relief, such as Lady Xoc's right hand and the shaft of Shield Jaguar's torch, are carefully supported by adjoining or supporting elements. There is also a bit of linguistic evidence that supports my contention that the artist/scribes were more important than the sculptors.

ARTISTS' NOMINAL PHRASES

David Stuart has proven that a phrase in the hieroglyphic texts of many vases reads *ah ts'ib*, which is found in both Yucatec and Ch'ol dic-

16.

Structure 44, Step IV. Photo by Graham (1982 : 170). (See also Figure 154.)

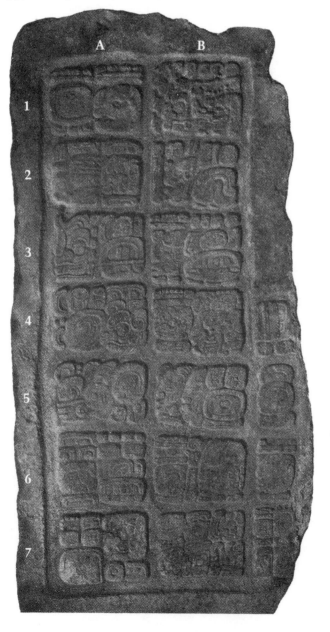

tionaries glossed as "escribano" and "dibujador" (scribe and drawer). In the Cordemex dictionary of Yucatec Maya is also a term, *ah woh*, referring to a scribe. *Woh* is glossed "pintar" (to paint) and *wooh* is "jeroglífico, signo, símbolo" (hieroglyphic, sign, symbol). These words seem to refer to making linear words or drawings. In contrast, although there is an entry for the verb "to sculpt" in the Cordemex (*hot'*), and a phrase glossed as "to sculpt images" which literally means "to carve sacred tree" (*hot' k'ul che'*), there are no words which are titles for sculptors.

Still unresolved is the exact meaning of the "*lu*-bat" glyph in the incised texts on the Structure 44 and 23 lintels and monuments from other places. The bat head likely reads *ts'i*, and thus probably refers again to writing or drawing rather than sculpting. Obviously, however, the fact that they inscribed their names on the monuments means that this group of artists considered themselves important and their status was upheld by the kings.

Of the 125 monuments at Yaxchilan, only these two groups of lintels carry artists' nominal phrases. One of them, the Lintel 46 (Elegant Knot) artist, carried the title *ahau*, suggesting royal status, and all the artists had a GI title, so all must have been of relatively high status. In addition to the six scribes who worked on Structures 44 and 23 lintels, there were several other artists working at Yaxchilan under the reign of Shield Jaguar. Besides the two sets of lintels, Shield Jaguar also commissioned six stelae, six carved steps (one carved by the Exuberant Artist), and another single lintel (56). In my estimation, at least four other hands can be seen on those monuments. This means that there were at least ten artists, scribes, and/or sculptors in the service of Shield Jaguar, some of whom formed a collaborative workshop that produced sculpture between 9.14.5.0.0 (Structure 44 lintels) and 9.16.1.0.0 (the erection of Stela 11).

With the initiation of the reign of Bird Jaguar IV, Shield Jaguar's son, in 9.16.1.0.0, two new workshops were in operation at Yaxchilan, one

identified by Marvin Cohodas[28] as the Master of Structure 13, and another which was responsible for the lintels of Structure 33. The workshop of the Elegant Knot Artist and Exuberant Scribe trained a generation of artists who were probably responsible for the lintels of Structure 21, Lintels 41 and 43 of Structure 42, and perhaps Stela 1. Bird Jaguar IV commissioned about twenty-three lintels, a wall panel, ballcourt markers, sixteen carved steps, four or five stelae, two stone thrones, numerous altars, interior and exterior stucco decoration, large mural programs, and at least thirteen buildings, all in a period of about twenty years. In the service of these three workshops and their offshoots were no fewer than twelve scribes. I have no evidence to support a suggestion as to the number of designers, sculptors, and related workers who would have been employed during Bird Jaguar's reign, but my guess would be about fifty persons associated with the creative aspects in the production of stone monuments during this period.

CHARACTERISTICS OF SOME OF YAXCHILAN'S OTHER SCRIBES

My best estimation of which artists and scribes worked on Late Classic monuments is shown in Table 1. The following is a discussion of the characteristics which led me to make these attributions.

Scribe G

Shield Jaguar commissioned the earliest known extensive hieroglyphic stairway around 9.14.10 .0.0. It consists of six steps, five of them carved on both tread and riser (see Figure 154). The one carved only on the tread differs from the others in that it has no image of a kneeling captive. That one, Step IV, was clearly an early work of the Exuberant Artist (Scribe C). Four of the other five texts are the work of a single scribe, who often composes in blocks of four glyphs, whose glyphs are broader than tall, and who never fouls up on arithmetic. Compare the

17.

Lintel 23 front edge. Photo by Graham (1982:135). (See also Figure 99.)

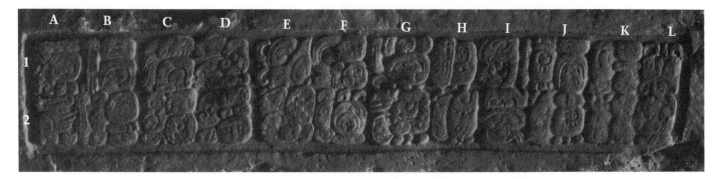

T1 *u* on Steps I and V, as well as the "captor" glyphs.

Scribe I

The glyphs of Stela 18, Stela 11 bottom, the Structure 24 lintels, and Lintel 56 share enough characteristics to be considered as the work of a single scribe (see Figures 145, 136, 101, 59). The erection of these monuments spans twenty-five years. Four of the monuments are lintels carved only on the front edges, and two are stelae. Scribe I makes somewhat squat glyphs with a firm line and does not use double outlines. The "captor" glyphs have no subfixes and no separate nostrils, just a little hole in a short, beak-like nose. The superfixes have one curl and one egg. The "Lady" glyphs have blunt faces and often include an earplug assemblage. The hair on the "Lady" glyphs is not crosshatched but

consists of some wiggly lines over the ear. This scribe never draws in an eyebrow. The "Jaguar" glyphs have a single fang in the corner of the mouth, and the eyes are done expressively with three lines. The ear is shell-like. The *u* (T1) prefixes are strongly rendered, with a bracket, the two round dots, and a separately drawn pointy center element. Scribe I likes to set many glyphs on a subfix of T23 or series of circles and uses more geometric than zoomorphic variants.

Scribe N

Two of the Structure 33 lintels seem to have been written by someone from outside Yaxchilan. The *u*'s are out of this world! Look at the prefixes for the "captor of Jeweled Skull" glyphs on Lintels 1 and 3 (Figure 114). No previous Yaxchilan scribe ever wrote like that. The "Jag-

	Completion Date	Structure	Monument	Scribe	Artist
Table 1	9.13.10. 0.0	41	Stela 20	D	D
Tentative identification of scribes and artists in sculptures commissioned under Shield Jaguar I and Bird Jaguar IV	9.14. 5. 0.0	44	Lintel 44	A	C&D
	9.14. 5. 0.0	44	Lintel 45	C (Exuberant)	C
	9.14. 5. 0.0	44	Lintel 46	D (Elegant Knot)	C&D
	9.14.15. 0.0	44	Step IV	C	
	9.14.15. 0.0	23	Lintel 23	C	
	9.14.15. 0.0	23	Lintel 24	E	C&D
	9.14.15. 0.0	23	Lintel 25	Xoc?	Xoc?, C&D
	9.14.15. 0.0	23	Lintel 26	F	C&D
	9.15. 0. 0.0	41	Stela 15	B?	
	9.15. 0. 0.0	44	Steps I, II, V, VI	G	
	9.15. 0. 0.0	44	Step III	?	
	9.15. 0. 0.0	41	Stela 18	I	
	9.15.10. 0.0	41	Stela 16	B?	
	9.15. 6.13.1	11	Lintel 56	I	
	9.16. 1. 0.0	40	Stela 12, side *a*	D	
	9.16. 1. 0.0	40	Stela 12, side *b*	H	
	9.16. 1. 0.0	40	Stela 11, accession text	I	
	9.16. 1. 0.0	40	Stela 11, flapstaff scene		Stela 11 artist
	9.16. 1. 0.0	40	Stela 11, 1 Imix 19 Xul	D	
	9.16. 1. 0.0	40	Stela 11, GI scene		C&D
	9.16. 1. 0.9	22	Lintel 21	J	
	9.16. 5. 0.0	24	Lintels 27, 59, 28	I	
	9.16. 5. 0.0	21	Lintel 16, Stela 21	L	Trained in C&D workshop
	9.16. 5. 0.0	21	Lintels 17, 15	?	
	9.16. 5. 0.0	1	Lintels 5–8	M	M's workshop
	9.16. 5. 0.0	42	Lintel 41	?	Trained in C&D workshop
	9.16. 5. 0.0	42	Lintel 42	O	M's workshop
	9.16. 5. 0.0	42	Lintel 43	?	Trained in C&D workshop
	9.16. 6. 0.0	33	Lintels 1, 3	N	N's workshop
	9.16. 6. 0.0	33	Lintel 2	P	N's workshop
	9.16. ?. 0.0	13	Lintels 32, 33	M	M's workshop
	9.16.10. 0.0	33	Stela 1	I	Stela 11 artist

uar" glyphs look froggy. The human faces have very slanty eyes. The skulls are unconvincing. A scribe who has such terrible writing, so ill-observed, must have bought into the court at Yaxchilan with goods or foreign power.

Scribe P

The handwriting on Lintel 2 (Figure 114) is more acceptable, but still strange. Lintel 42 writing (Figure 148) has a loose quality, and it uses the strange T1 prefix introduced by Scribe N. Scribes N, P, and maybe some others have formed a workshop, and their influence is seen on Structure 21 glyphs and later on Structure 20. At this point, handwriting is very hard to distinguish, and the numerous scribes are probably trained in the workshops established by M, the Structure 1 master, and N, the Structure 33 artist.

What has been seen as the work of a single master (Structure 23—Mary Miller's view) or the work of two schools (Marvin Cohodas' "Narrative" and "Symbolic" schools) is now argued to be the result of three and fifty artists, respectively. This analysis of the number of artists working at Yaxchilan, if accepted, has several important implications. First, although a large group of individuals were creating monumental sculpture during the periods of intensive production, and although their individual characteristics can be observed today, their work still conformed to formal and iconographic canons unarguably recognizable as emanating from Yaxchilan. This means that strict agreement or control over the local style was maintained, and that some individual—the king or a chief officer of artist training or monument appearance—performed this function. The degree of consistency with which specific objects were selected and represented implies that those costume items did actually exist and were observed by the artists, either during ceremonies or when modeled by some individual, or that they were available occasionally to the artists for study. The portrayal of costume elements was realized through study and was highly naturalistic. Furthermore, closely following the apogee of artistic production at Yaxchilan (that is, between 9.14.5.0.0 and 9.16.10.0.0, a forty-five-year period, when artists became numerous and even began to sign their work, thereby demanding individual recognition at Yaxchilan and elsewhere), the Maya social system in the Central Lowlands began to suffer and eventually broke down. But before examining the dissolution of Maya royal society, I present an analysis of how Maya orthodoxy was manifested in public art during the Late Classic.

SUMMARY

This chapter attempts to establish some fundamental cultural attitudes and ideals that governed the use and the creation of art in Maya society. If Maya public art was created in a spiritually charged ritual time and space through the efforts of a patron, some senior community members who had engaged in years of community ritual activities, a priest, and the artists, as is suggested by the passage in Landa's *Relación de las cosas de Yucatán*, then it must have served to intensify spiritual and cultural rapport among its patrons and its makers. Through public art, the rulers (the likeliest patrons) provided "spiritual food" in the form of a coherent view of the place of the individual in the world of the sun. Through art, the individuals who participated in the creation of their ceremonial city extended their concept of self to interlock with the community as illustrated by imagery of shared history, dreams, and ritual experiences. The following chapters deal with the specificity of local identity and history at Yaxchilan.

3

Manifesting Tradition: Imagery at Yaxchilan, Part I, The Cosmos, Rulers, and Regalia

The forms on a Maya sculpture may appear to be fantastic. However, the major portions of the subject matter—the rulers and their costumes—are naturalistic images of real objects. In real life, costume elements were probably chosen for specific rituals; therefore, the costumes as portrayed in art are referents to those ceremonies. Other forms in Maya iconography are images of things or concepts for which non-Mayas have no mental image. For example, the skyband is a conventionalized form which has monster heads at either end of a band infixed with glyphs standing for heavenly bodies. What Mesoamerican peoples wished to represent with monsters is not clearly understood but probably involved concepts of multi-identity and transformation of an individual in a ritual situation. Since the monsters are constructed from several animals and fantastic forms, and can be affixed and infixed with many kinds of specific signs with conventionalized meanings, they are partially analogous to the concepts of multi-identity and transformation, and may thus be symbols of those concepts. They may also have been representations of images described to children in a familial setting or in ritual theater, which would have been familiar as characters to the average individual. Although it is not easy to understand the mental processes which led to the formulation of these images, we can derive clues to their meaning through contexts of use and ethnographic parallels.

In this chapter, the component parts of monumental imagery are examined in the following order: humans, supernaturals, cosmic symbols, ritual equipment, and costume. Interpretations of these elements are based on three kinds of analyses: one in which an element is considered in the context of the other symbols on the same monument, one in which the semantic niches of the element's appearances are compared, and one in which the use of this element at other sites is considered. An attempt is made to determine whether the image or symbol is one invented at Yaxchilan or one widely used throughout the Maya realm or in the western region, and whether the meaning of a "pan-Maya" symbol remained constant when the symbol was used at Yaxchilan. Of course, published interpretations of these symbols at Yaxchilan and elsewhere have been carefully evaluated and are usually discussed here.

Human Figures

The cast of human characters appearing on sculpture at Yaxchilan includes elite males and females, one child, deceased ancestors, dwarfs, kneeling figures involved in sacrificial rites, and male captives. A typical costume for royalty of either sex consists of an elaborate headdress, composed of perhaps thirty elements attached to one of eleven headdress bases, which was selected as a symbol for the ceremony; a jade beaded collar; jade wristlets and anklets; an incised pectoral; several layers of brief cloth garments; an elaborate belt carrying attached plaques or masks; and sandals. Males and females can be distinguished by their garments more easily than by their ornaments. Males wear short kilts or loincloths, beads encircling the upper calfs, and often a backrack of feathers

with attached symbolic elements. The salient characteristic of female dress is a long garment[1] with elaborate woven or embroidered designs and beaded or stitched borders. Captives are identified by kneeling posture, simple clothing, bound limbs, or being grasped by the hair. Children are small versions of adults with the same bodily proportions. The two dwarfs on Structure 33 Step VII are stocky and have an abnormal, square projection at the base of the skull. All human figures are proportionally and physiognomically naturalistic in proportion, although they were somewhat regularized to correspond to local ideals of appearance.

Supernaturals

THE PALENQUE TRIAD

Few complete supernatural beings are depicted in Yaxchilan monumental art. Nonhuman heads and regalia associated with supernaturals known from other sites do appear frequently, however.

A triad of supernaturals who have been observed in art at most Maya cities was first identified in the hieroglyphic inscriptions of Palenque by Heinrich Berlin (1963). He named the group the "Palenque Triad" and numbered the individual gods GI, GII, and GIII. Their birthdates were identified by David Kelley in the inscriptions of the Cross Group at Palenque. The supernaturals were born over a thirteen-day period about 2359 B.C.—or about 3,049 years before the dates were recorded at Palenque in A.D. 690. Kelley also related the Palenque Triad to Postclassic Central Mexican supernaturals, referring to GI as 9 Wind, the Venus God, and Quetzalcoatl; to GII as (Bolon) Dz'acab, 1 Flower, and the God of Vegetation; and to GIII as 13 Death, the Old Jaguar God, and the God of War.[2] A concise review of the diagnostic formal characteristics of the Palenque Triad is presented by Linda Schele and Mary Ellen Miller in *The Blood of Kings*.[3] Although the Triad members have been studied for several decades, their identities are still not completely clear. A great leap forward was made when Michael D. Coe proposed that Hunahpu and Xbalanque of the sixteenth-century ethnohistoric document *Popol Vuh* were Postclassic parallels to the Classic Period Triad.[4] However, the attempt to correlate the two major sources of information about these characters—the inscriptions on the Cross Group at Palenque, dated A.D. 690, and

the *Popol Vuh*, a Postclassic ethnographic literary account of mythical and historical knowledge of the highland Quiché—confounds scholars with some inconsistencies.

In keeping with the character of the hieroglyphs, Classic Period inscriptions focus on the Triad's genealogy and their relationship to calendric cycles. The Palenque inscriptions state that early in the present era (which runs from 3114 B.C. to A.D. 2011), triplet boys were born to the first female. The first (GI) was born on the day 9 Ik, or 9 Wind. The second (GIII) was born four days later on the day 13 Cimi (13 Death). The third (GII) was born on the day 1 Ahau (1 Lord). The triad gods function in the Palenque inscriptions as the divine origin of the royal lineage,[5] and most Maya royalty claim descent from them.

Who are these supernaturals? First consider GI and GIII. Schele and Miller have shown that their nominal glyphs consist of identical profile faces with differing diagnostic characteristics. The salient attributes of GI are a spondylus shell earplug and a fish fin on his cheek. GIII has a jaguar ear, a *k'in* or sun glyph on his cheek, and often a pretzel-like shape called a cruller between his eyes.[6]

If considered as complementary to the information from the inscriptions, the *Popol Vuh* account fleshes out the lives and adventures of GI and GIII as the prototypes of the Hero Twins, "whose adventures make the sky-earth a safer place for human habitation."[7] Quintessentially Maya, they establish their self-worth by magically making a milpa, a sacred planting of corn. Then they master the ballgame.[8] Summoned to fight the irrational Lords of the Underworld, they survive by their wits. They are like humans in that they grow corn and honor their parents and grandmother. They are more than human because their mother is the daughter of a Lord of the Underworld and their father is the skull of their elder brother. In the Underworld they are able to resurrect beings at their own discretion. The twins generally act in concert, except when one of them is temporarily conquered by the Lords of the Underworld and must be rescued by his brother.

In the Classic Period glyphs, GIII is named Ahau K'in, or Lord Sun. In the *Popol Vuh*, he is named Xbalanque, Jaguar Sun. One of the names of GI in the Palenque glyphs can be read Hunahpu, the same name he has in the *Popol Vuh*. GI is associated with Venus by his birthdate of 9 Wind, which he shares with the Central Mexican Quetzalcoatl, also associated

with Venus.[9] However, various attributes of GI associate him with the sun, and some characteristics of GIII may associate him with the moon.

Dennis Tedlock addresses this dilemma. There are at least three major problems with any attempt to give unambiguous astronomical assignments to Hunahpu and Xbalanque or to their counterparts at Palenque, the gods designated GI and GIII. The first is that a single celestial light need not be assigned to a single god. The second problem is the converse of the first, which is that a single god need not be limited to a single astronomical assignment. The *Popol Vuh* treats a given celestial phenomenon as a "sign" (*retal* in Quiché) or (in the case of the rising sun) a "reflection" (*lemo*) of a past event; given that Hunahpu and Xbalanque undergo various transformations and take on various disguises in the course of their adventures, there is no reason to suppose that if the sun and moon (or aspects thereof) are signs or reflections of their past actions, all other celestial phenomena are thereby eliminated. The third problem cited by Tedlock in assigning fixed celestial identities to GI and GIII is that the modern Quiché use the same word for "Venus as Morning Star" as they do for "sun" and "day."[10]

Tedlock suggests that Xbalanque (GIII) might be considered the night sun and Hunahpu (GI) the day sun. Similarly, Schele and Miller observe that representations of GI can be divided into two or more types, one who wears a quadripartite headdress and one who wears a diadem infixed with crossed bands. The quadripartite-headdress GI is certainly associated with the sun, perhaps the day sun, and the diadem GI, who wields an axe, may signify Venus as Morning Star.[11]

REFERENCES TO GI AT YAXCHILAN

Schele and Miller provide a list of diagnostic characteristics for GI.[12] From their list, the following characteristics are found at Yaxchilan: the shell earplug, the diadem infixed with crossed bands, and the quadripartite headdress. Using these criteria, four forms of GI can be identified in Yaxchilan imagery (see Figure 18).

(1) Two groups of persons impersonate GI by wearing the quadripartite headdress—secondary individuals during ceremonies involving transfers of political power which fell on the summer solstice (see Figure 18*a*), and deceased ancestors depicted in the celestial realm. I suspect this use of the quadripartite-headdress GI signals a metaphor: as the sun's potency and heat wanes after summer solstice or after noon, so the ruler's potency wanes in old age or death, and he passes the responsibility on to his successor.

(2) The crossed-bands diadem, attribute of Chac Xib Chac,[13] is attached to numerous headdresses. The pan-Maya Chac Xib Chac has a looped hank of hair and reptilian body features. He carries an axe or disk marked with God C (blood). On several codex-style pots, he sacrifices the Baby Jaguar in an Underworld ceremony[14] that parallels the sacrifice of Hunahpu by Xbalanque as they trick the Lords of the Underworld in the *Popol Vuh*. On monuments at Yaxchilan, Chac Xib Chac impersonators wear some of the symbols shown in Figure 18*b*. Yaxchilan rulers impersonated Chac Xib Chac during every Period Ending ceremony. The impersonation is depicted on the temple sides of cosmological stelae and in some Underworld ballgame scenes (see Figure 112). During those impersonations the ruler embodies a Hero Twin, the sacrificer who has the power to bring his dead brother or other victims back to life.[15]

(3) An unusual reference to GI appears on the uppermost part of headdresses on Lintels 2 and 5 (see Figure 18*c*). The typical roman-nosed head and shell earplug of GI act as the rear head of a serpent. Infixed into the GI head is a *k'in* sign. On the highest point of the serpent's body is a Venus symbol. This complex symbol seems to suggest the path of the twin bodies, the Sun and Venus, through the ecliptic. A related headdress element (see Figure 18*d*) consists of a skeletal, double-headed creature. One head is a snake and the other appears to be a monkey skull. The monkey is used for the full-figured form of the day glyph, *k'in*, and substitutes for the day glyph on Lintel 48. The snake, *chan*, is homophonous with the word "sky" and often represents it, and can also be Quetzalcoatl, who has Venus associations.

(4) The dwarfs that accompany Bird Jaguar IV in his pre-accession cosmic ballgame wear GI shell earplugs and have Venus signs tucked behind their arms (see Figure 18*e*).

IMAGES OF GIII

Several isolated and subtle references to GIII occur in the glyphs and imagery at Yaxchilan.

(1) A ruler impersonates GIII when he wears the waterlily-jaguar headdress, and he perhaps evokes GIII's adventures when he holds jaguar paws, or wears a jaguar headdress (see Figure 19*b*).

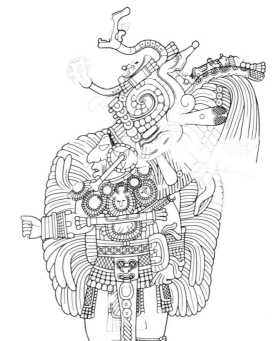

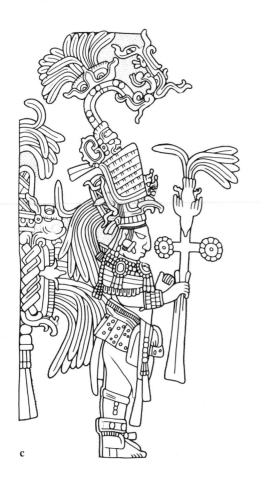

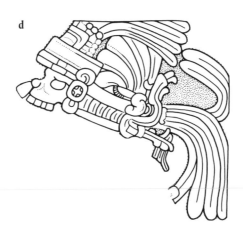

18.

Manifestations at Yaxchilan of God I of the Palenque Triad: *a*, Lintel 14; *b*, Lintel 33; *c*, Lintel 2; *d*, Lintel 17; *e*, Structure 33, Step VII. Details from drawings by Graham (1977:15, 37, 43; 1979:75; 1982:160).

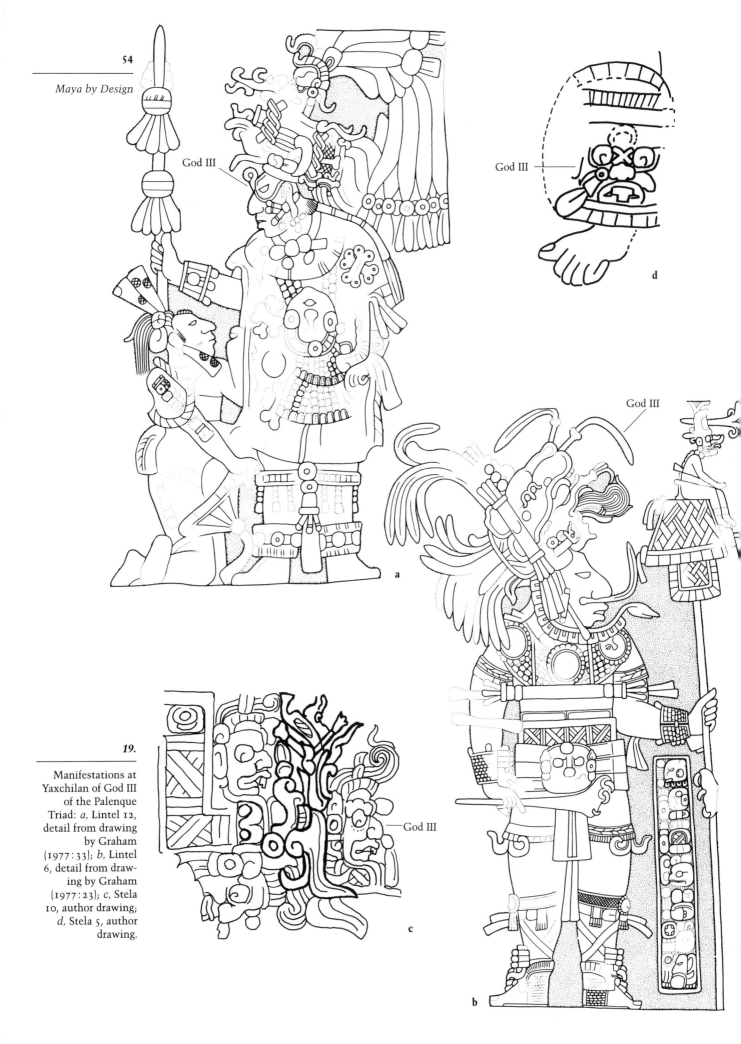

God III

God III

God III

God III

God III

19.

Manifestations at
Yaxchilan of God III
of the Palenque
Triad: *a*, Lintel 12,
detail from drawing
by Graham
(1977:33); *b*, Lintel
6, detail from draw-
ing by Graham
(1977:23); *c*, Stela
10, author drawing;
d, Stela 5, author
drawing.

a

b

c

d

(2) Busts of GIII identified by a jaguar ear are associated in multiples of nine with skybands (see Figure 19c).

(3) GIII was portrayed on one of the site's earliest monuments, Stela 14, dated 9.4.8.8.15, where he emerged from one head of a stiff ceremonial bar (see Figure 150). This typical Maya object never again was held by a live ruler in his monumental portrait at Yaxchilan.

(4) The name of the second ruler of Yaxchilan, recorded in the genealogical history document of Ruler 10 (Structure 12, New Lintel) seems to be GIII Jaguar.

(5) Ruler 8 and Shield Jaguar I both carry a headless jaguar title, one that appears with GIII on polychrome figural pottery from the Central Lowlands in the Late Classic Period.

(6) On Lintel 48, the day name Cib is represented by a cruller-nosed GIII.

(7) A roman-nosed face with a *k'in* infixed in the forehead refers to one of the Hero Twins as the sun on carved pectoral pendants (see Figure 98, Lintel 25, on Shield Jaguar).

(8) Yaxchilan kings often carry a GIII shield, a pan-Maya symbol. They wear it with a crossed-bands pectoral and sometimes the hummingbird-and-flower diadem (see Figure 19d).

(9) GIII is impersonated by Shield Jaguar II on Lintel 12. The king wears the cruller mask and displays four captives (see Figure 19a).

REFERENCES TO GII

Representations of GII, also called by scholars God K,[16] at Yaxchilan occur in the form of typically pan-Maya manikin scepters (see Figure 29b). God K was the third-born of the Palenque Triad. His salient characteristics are a serpent foot, mirror infixes in his forehead and limbs, and a long, thin object, an axe or cigar, projecting from his forehead. Eduard Seler called him Bolon Dz'acab, translated from the Yucatec as "He of Nine (or Many) Generations," *cosa perpetua*. Seler identified him with the rear head of the Earth Monster and as a water god.[17] The Earth Monster is now called the Celestial or Cosmic Monster, and its rear head, which does have a puffy snout and an eye infixed with a spiral, as does God K, has been recognized as being distinct from God K.[18] J. Eric S. Thompson thought God K was a "manifestation of Itzam Na as a deity of vegetation."[19] Kelley pointed out his calendric association with the day 1 Ahau or 1 Lord.[20] Noting that God K does not appear only associated with vegetation, Schele

proposed that he was "god of lineages and ancestry, especially royal ancestry," and later, noting that the torch emerging from his head is a phonetic complement indicating that the mirrored forehead should be read *tah*, or "obsidian," called him "the obsidian mirror."[21] Because he so often appears in the context of Period Ending and accession autosacrifice, the presence of God K, whom I think of as the First Ancestor, is fundamentally associated with ancestor-related sacrificial rituals.

With the recognition by Schele and Peter Mathews that much space in Maya inscriptions is devoted to documentation of ancestry and sacrificial honor of ancestral events, God K's identity has become clearer. The Maya practiced some form of ancestor worship, and God K was considered the origin of all royal lineages. The concept of descent was linked metaphorically with branches and fruits of trees, as seen on the sides of the Palenque sarcophagus, and with corn as the substance of human flesh and sustenance.

As manikin scepter, God K is usually held vertically, and I suspect that this verticality is metaphor for tree, or conduit. Through God K, then, sacred substances flow from the community to the cosmos. Bloodletting phrases in the glyphs at Yaxchilan frequently name God K as the object of the sacrifices (e.g., Lintel 24). If he receives the sacrificial blood, then he must be the means by which it is conveyed to the other gods and to the cosmos.

In addition to blood, other important sacrificial substances were maize and copal incense. The Maya always dedicate part of their maize crop to the earth and the ancestors. When the Hero Twins left their grandmother to contest the Lords of the Underworld, they buried four ears of maize in the floor in the middle of her house. The fate of the corn would mirror the fate of the boys in the Underworld.[22] Maize has an "inner soul" just as humans do,[23] and of course, the present race of humans was made from maize. Maize grows vertically as the ceiba tree grows, as a stela stands, as a king appears beneath his towering headdress, and as the manikin scepter is held. Further iconographic association of maize vegetation with blood, lineage blood, and blood sacrifice is suggested by Karl Taube.[24] God K, then, stands for the complex of sacred substances that are human and royal, particularly maize and blood, and for the behavior of sacrifice of these most sacred of substances for the benefit of the community of the living and the dead.

God C is represented in a similar manner whether the reference is in a hieroglyphic inscription or embedded in the iconography. God C glyphs appear in the names of the relative of Lady Xoc on Lintel 23, of Lady Ahpo Ik (Lintel 38), and of Lady Ik Skull (New Stela, rear, and Stela 11, upper register, temple side). In the iconography, God C is an element of the skyband on Stela 1 (see Figure 20c). God C loincloths are worn on Lintels 7, 32, and 58 (Figure 20a). On all those lintels, bloodletting is indicated by the presence of the bundle or the manikin scepter. God C symbols also appear on the top of headdresses on Lintel 9 (worn by Bird Jaguar IV; see Figure 20b) and Lintel 24 (worn by Lady Xoc). A God C head rides the tail of the Vision Serpent on Lintels 13 and 14 (Figure 20e, f). Blood sacrifice, sky, and royalty are the recurring contexts in which the God C symbol is used.

David Stuart has made significant progress in the understanding of the God C glyph in texts and iconography. His discovery was based on one made by Schele,[25] who recognized that the beads on the cheek of Lady Xoc on Lintel 24 must be blood resulting from her tongue sacrifice (see Figure 98). Stuart made the analogy that the circles that fall from the hands of the Tikal ruler parallel the streams of fluid bordered with dots from the hands of the Yaxchilan rulers on the temple sides of the cosmogram stelae. Additonally, he noted that the symbols within the stream of blood, the Kan Cross, the shell, the Yax sign, and the God C glyph, all appear interchangeably as prefixes with streams of dots in the Emblem Glyphs that refer to specific sites or lineages.[26] Thus the Emblem Glyphs should be read as "Blood Ahau of the site of such-and-such," referring to the blood and bloodline of the ruler.

Additionally, the God C glyph appears in contexts where bloodletting is specified, such as on the Tablet of the Cross at Palenque at O9. The clause refers to a three-day ceremony in which bloodletting was required. It reads "On the third day he let blood, . . . Mah K'ina Chan Bahlum, Bac Balam Ahau, Blood Ahau of the throne of Palenque."[27]

The God C glyph, then, stands for blood, specifically, royal sacrificial blood. The God C image appears on stelae commemorating Period Endings at many sites. An example is the God C loincloth on Dos Pilas Stela 1 (Figure 21d). The text states what happened on the Period Ending: the ruler perforated his penis, letting spill drops of blood. The verb for the action of scattering blood is shown at A4 on the stela. But what is depicted pictorially is not the act of letting blood, but the result. His loincloth is marked with the symbol for blood, God C. Some God C loincloths appear on lintels at Yaxchilan, but on the stelae, no God C loincloth was needed to symbolize the bloodletting, because the blood that was the sacred sustenance offered by the king to the supernaturals was clearly depicted.

The God C loincloth symbolizes the blood that the ruler has let from his loins. But does the God C glyph in the skyband mean the same thing? Some of the other skyband symbols are understood. There are symbols for sun, moon, and Venus or star. The crossed bands are surely a celestial symbol. Why is a blood symbol in the skyband and on top of headdresses? Examining another use of the God C symbol demonstrates its multivocality.

The concept of the Axis Mundi definitely existed among the Maya, and many of their monuments subtly illustrate this pervasive Maya concept. On the Sarcophagus Lid of Pacal's tomb in the Temple of the Inscriptions at Palenque, Pacal is shown falling into the Underworld as he died, via the Axis Mundi (see Figure 21c). It is portrayed as a tree, marked with God C signs. That it is a tree is shown by the glyph for "tree," or "wood," te,[28] on the trunk.

The concept of the king's blood and bloodline as the tree was documented in a collection of papers from Yucatan during and after the Conquest, some of which were published in 1937 by William Gates.[29] These papers included a genealogy of the Xiu family, which claimed rule at the site of Uxmal during the Postclassic Period. The illustration shows the reclining figure of the paterfamilias, Tutul Xiu (Figure 21a). A tree emerges from his loins. The fruits of the tree are his progeny, and the sepal of the flower is a lobed form. This same form appears on the World Tree on the center of the Tablet of the Cross at Palenque (Figure 21b). Like the tree linking Tutul Xiu to the names of his descendants, the tree at Palenque links the dead king Pacal to his successor. The tree serves as a medium of communication between Chan Bahlum, the acceding king of Palenque, and the ancestors who are named in the text.

The modern Maya still contact their ancestors through trees and crosses. Evon Z. Vogt relates that the modern Tzotzil erect crosses at the sacred spots in their environment, and the

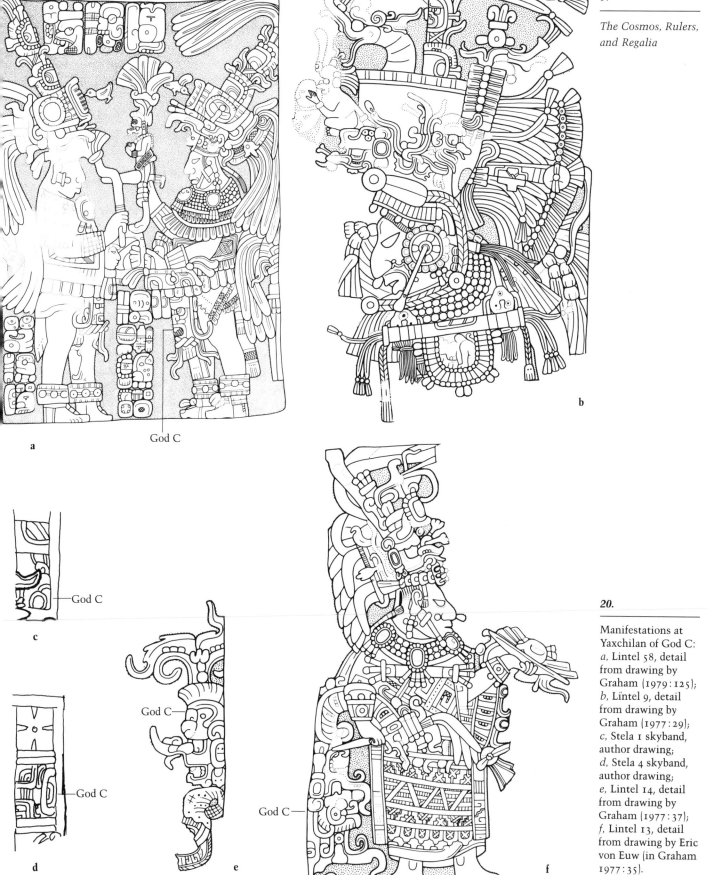

God C

God C

God C

a

b

c

d

God C

e

God C

f

20.

Manifestations at Yaxchilan of God C: *a,* Lintel 58, detail from drawing by Graham (1979:125); *b,* Lintel 9, detail from drawing by Graham (1977:29); *c,* Stela 1 skyband, author drawing; *d,* Stela 4 skyband, author drawing; *e,* Lintel 14, detail from drawing by Graham (1977:37); *f,* Lintel 13, detail from drawing by Eric von Euw (in Graham 1977:35).

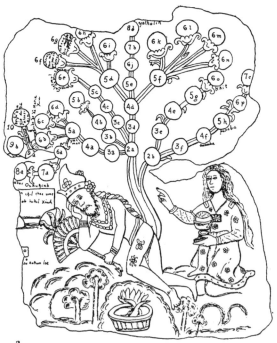

a

21.

The Axis Mundi—
cosmic trees and
bloodlines: *a*, Tutul
Xiu's genealogy
(Gates 1978 : 120);
b, Palenque Tablet
of the Cross, draw-
ing by Linda Schele
(1976a : Fig. 6);
c, Palenque Sar-
cophagus Lid, draw-
ing by Schele (Schele
and M. E. Miller
1986); *d*, Dos Pilas
Stela 1, drawing by
Schele (Schele and
M. E. Miller
1986 : 77); *e*, Yax-
chilan Stela 3, au-
thor drawing.

Bloodletting bowl

Mirror,
brightness

te 'tree'

God C
(blood, sap, sacredness)

God C

b

c

d

e

crosses serve as a "doorway," a "channel of communication to some deity in the cosmological system."[30] The concept of the tree or axis as the medium for the attainment of immortality persists as indicated by the gloss for the Spanish word *inmortal* in the Alfa Hurley Vda. de Delgaty and Agustín Ruiz Sánchez *Diccionario tzotzil*. The word is translated *yoyal balumil, eje de la tierra*, literally, "axis of the earth."[31]

The God C marking the Axis Mundi tree on Pacal's sarcophagus lid must have referred at once to royal blood and bloodline, and to blood as the cosmic channel of communication. When the ruler wears the God C loincloth, he is marked as the Axis Mundi. When he wears a God C on his headdress, he must also be marked as the Axis Mundi, the conduit that connects the community to the supernatural realm. The God C in the skyband may also refer to this world axis.

Some authors have noted God C glyphs in the codices as substitutions for the direction north.[32] Paul Schellhas' argument for the God C glyph as North Star refers to the appearance of a God C glyph in a rayed circle in the Madrid Codex 10c. The application of the European concept of a rayed circle as a star or sun is not a good argument for the interpretation of God C as north, but this same page of the codex presents some interesting images of God C acting in four places. Three of the four glyphic phrases begin with glyphs accepted as directions: east (*lakin*), west (*chikin*), and south (*nohol*). The second passage begins with a God C glyph, suggesting that it represents the other direction. The illustrations of this passage show God C in four places: the "east" passage shows an anthropomorphic God C sitting on the rayed circle infixed with God C. The "north" passage is related to an image of God C sitting on top of a tree. The "west" passage is illustrated by God C hung from a skyband. The "south" image shows him sitting on a temple marked by "earth" (*caban*) signs. The "north" image refers to "up"—on top of a tree—and the "south" image refers to "down"—on the earth. The issue of whether the Maya recognized north and south or whether they conceived of north and south as the zenith and nadir or the right- and left-hand sides of the path of the sun will not be resolved here. However, it is clear that in the Postclassic codices, God C functioned as an indicator of a vertical direction (whether it is called north-south axis, or above-below, or zenith-nadir). This relates to the significance of

God C on the Axis Mundi tree and on the loincloths. The God C in skyband and headdresses at Yaxchilan referred to the axis between it and the cosmos, and to the ruler's blood as the sap or blood of the axis.

Most recently, David Stuart, Nicolai Grube, John Carlson, and Ruth Krochock have suggested a reading of *k'u* for God C and perhaps *k'ul* for the blood-group prefix, meaning, respectively, "god" and "divine."[33] The arguments support a suspicion I have had regarding the meaning of the blood-group prefix since 1986.

Cosmic Locatives

Complex symbols which indicate the cosmic domain of a ritual portrayed are discussed here in the order in which they typically appear on Period Ending (or cosmological) stelae, from top to bottom.

ANCESTOR CARTOUCHES

Large oval cartouches containing human figures were carved on the upper registers of stelae, on ballcourt markers, and in headdresses at Yaxchilan. The most frequent appearance of these cartouches is in the upper register of the temple sides of cosmological stelae. Cut out of the corners of the cartouches, for example, on Stela 1 (see Figure 22b) are semicircular notches containing skeletal serpent snouts. These fanged snouts are the abbreviated versions of the skeletal head on Lintel 39 (see Figure 68), which is clearly a serpent. Within the cartouches are portraits of royal humans, either full length and seated, or bust length only. The figures often hold stiff, double-headed serpent bars. One of the figures wears a female garment and the others, male clothing.

Similarly shaped cartouches containing royal portraits were used at other prominent cities, such as Palenque and Tikal (see Figure 23). They occur at Palenque on the lower façade of the east side of House D of the Palace (Figure 23c). There nine stone and stucco cartouches once contained three heads each. On the stone armature between the cartouches, God K images were once visible.[34] On the interior wall of House A of the Palace, thirteen stucco cartouches each contain a portrait bust (see Figure 23e). A painted cartouche appears on the west interior wall of House E of Palenque. A similar cartouche was used at Tikal as well. It appears as the major element of the Late Classic Tikal

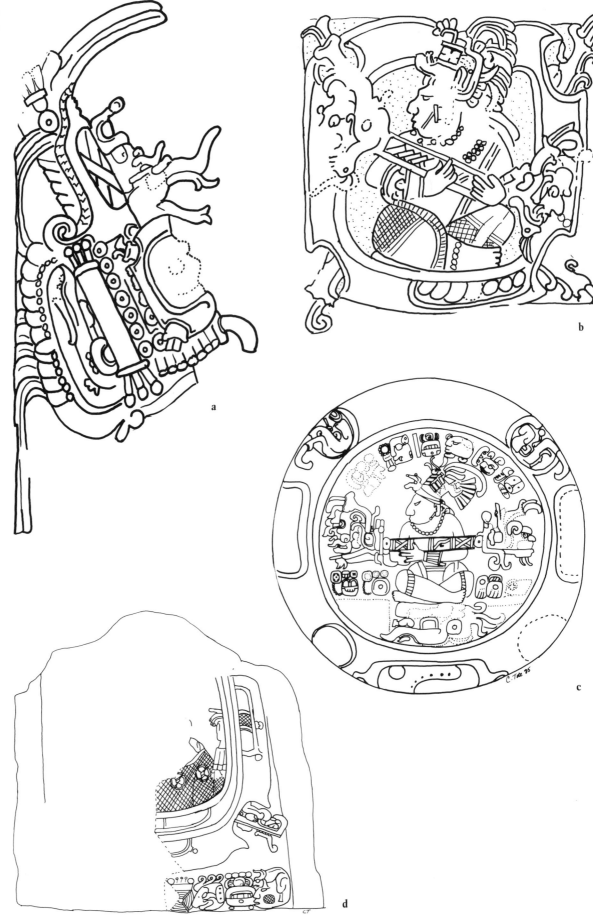

22.

Ancestor cartouches at Yaxchilan: *a*, Stela 11; *b*, Stela 1; *c*, Structure 14, ballcourt marker; *d*, Stela 8. Author drawings.

backrack on Period Ending stelae 5, 19, 21, 22, and earlier Stela 27, as well as on the lower register of Tikal Stela 1 (see Figure 23a and b).

Textual evidence that the figures inside the cartouches are ancestors appears in the glyphs identifying the figures on the temple side of Stela 11 at Yaxchilan. The upper register shows portraits of two seated figures in the same semantic domain as the cartouches. These figures are named by the glyphs flanking them as Shield Jaguar and Lady Ik Skull, the deceased parents of the acceding king, Bird Jaguar IV (see Figure 136). Precedents for the placement of the parents, or father, of the ruler above his head on stelae exist at other sites, for example at Tikal Stela 31, where Curl Snout floats over the head of his son, holding part of a double-headed serpent bar.

At most Maya cities the double-headed serpent bar was a common insignia of divine royal lineage, indicating the capacity of the ruler to mediate between forces of the sky, earth, and Underworld, and the resulting attainment of ritual power and community survival. In contrast, at Yaxchilan, a living king held the serpent bar only on one Early Classic stela, Stela 14. During the Late Classic Period, double-headed serpent bars appear only in ancestor cartouches, signifying that the ancestral parents control the power represented by the double-headed serpent bar in their afterlives. (The portrayal of the serpent bar at Yaxchilan is discussed later in this chapter, in connection with the Cosmic Monster.)

Wherever they are found, ancestor cartouches are marked with celestial signs. An early example on the basal panel of Tikal Stela 1 shows the notched-corner cartouche infixed with a *k'in* sign as the earplug of a monster whose face is the anthropomorphic version of the Tikal Emblem Glyph (see Figure 23a). On one example at Yaxchilan, Stela 4, one of the pair of ancestor cartouches is lunar, providing a lunar-solar contrast. Thus, in their location in the upper registers of Yaxchilan stelae, the ancestors are depicted as associated with the sun and moon. Between the paired cartouches is always a bust of one of the GI-GIII twins wearing a skeletal headdress which has been associated with Venus as Evening Star.[35] The three images—the parents in the celestial cartouches and Venus—appear to "ride" the skyband.

Ancestor cartouches at Yaxchilan appear in other contexts besides the upper registers of cosmological stelae. On Stela 11 river side, Shield Jaguar wears a cartouche as part of his headdress (see Figure 22a). An ancestor cartouche forms the backrack of Bird Jaguar on the same side of the same monument. The scene on the river side of Stela 11 is the image of Shield Jaguar passing the ritual authority to Bird Jaguar IV on the summer solstice. Shield Jaguar, who was deceased when the monument was carved, is indicated as an ancestor by the presence of the cartouche on the front of his headdress. Bird Jaguar IV wore the cartouche on his back, behind him, recalling the previous ruler, as did the rulers of Tikal. The ballcourt

23.

Ancestor cartouches at other sites: a, Tikal Stela 1 base, and b, Tikal Stela 5 detail, author drawings, after drawings by William R. Coe (Jones and Satterthwaite 1982); c, Palenque House D, eastern side, base, d, Palenque House A, central wall, facing east, and e, another stucco cartouche from Palenque House A, eastern interior wall, drawings by Merle Greene Robertson (1985b).

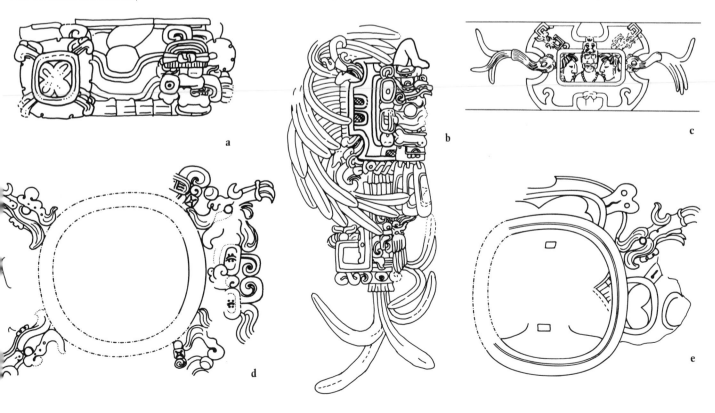

a

b

c

d

e

markers at Yaxchilan are carved with images of royal humans within ancestor cartouches. Figure 22c is Ballcourt Marker b, with an image of Shield Jaguar seated within the cartouche and holding the bicephalic serpent bar. He is named as a 5 Katun Ahau, so the portrait could not be early and is probably a posthumous one commissioned by Bird Jaguar IV. At least one other ballcourt marker has a skyband around its perimeter, reinforcing the notion that the semantic domain of the ancestor cartouches is celestial (see Figure 67e).

Images of deceased parents were part of the cosmic community in which the Period Ending sacrifices were enacted at Yaxchilan. Physically, they appear in death just as they did in life; they are of indeterminant age and have no particular symbols infixed in their heads or limbs. The placement of their portraits above the terrestrial realm, the small scale of the images, and the fact that they are framed by these celestial cartouches indicate that these are not regular living humans. The presence of the ancestors in important ceremonies confirms that they were as integral to the welfare of the present generation in the Classic Period as they are in contemporary Maya communities. A structural opposition to ancestor cartouches is the quatrefoil, a cave-Underworld marker which also functions as a cartouche, but appears at Yaxchilan only on textiles.[36]

THE SKYBAND

Skybands are part of the composition of at least five stelae and at least one ballcourt marker, and sometimes decorate backrack framework at Yaxchilan. They are band-like forms infixed with symbols of celestial bodies and other celestial phenomena.[37] At Yaxchilan, they are often terminated on each end by a monster head, thus forming the body of a Skyband Monster. Symbols infixed in the band are securely associated with the heavens: a moon sign; Akbal, meaning night or darkness; Lamat signs, which indicate Venus; *k'in* signs; and a God C head. From the gaping jaws of the monster heads emerge portraits of GI or GIII. The Skyband Monsters are elaborated with beards, upward-turning snouts infixed with mirrors, noseplugs, earplugs, and an irregular form counterbalancing the upturned snout (see Figure 24). The one on Stela 1 is a full-bodied reptilian monster with legs, paws, and a deer ear infixed with a Venus sign. Its eyes are also infixed with Venus signs. A similar monster with deer

hooves replacing paws appears on the stela fragment near Stela 3. Associated with each Yaxchilan stela skyband are nine pendant GI or GIII heads.

The ballcourt marker illustrated by Sylvanus G. Morley (see Figure 67e), now extremely effaced, was once carved with a skyband forming a circular strip around the perimeter of its upper face. The image in the center of the marker is difficult to see, but, based on the fact that two other visible reliefs on markers have images of seated rulers holding bicephalic serpent bars and are very likely posthumous, it is safe to assume that this image was also of an ancestor in the royal lineage. In each appearance, skybands are associated with a royal ancestor.

The appearance and function of the skyband backracks are discussed later in the chapter.

THE COSMIC MONSTER

The Cosmic Monster has a front head and a tail, and carries an additional head, often referred to as the "rear head," on its back. The most perceptive study of this monster to date is included in Andrea Stone's work on the Cosmic Monsters that appear as gigantic stone zoomorphs at Quirigua and Copan and those that appear as "Vertical Models" at Palenque, Piedras Negras, and Copan.[38] In this work, Stone has enumerated the inventory of iconographic components of Quirigua Cosmic Monsters. Using her classificatory system, I have identified two Cosmic Monsters at Yaxchilan: one on the backrack worn by Bird Jaguar III on Step VIII of Structure 33 and one on the lower register of Step III of Structure 44 (see Figure 25). Each has a reptilian body, a Quadripartite Monster as the "rear head," and the tail of a caiman. The Structure 33 monster has as its front head (appearing on the bottom of the backrack) a deer head. In its center is a cartouche containing a specific jade plaque frequently worn as a pectoral by Bird Jaguar IV. The Structure 44 monster has a caiman as its front head and a large cartouche where its body should be. The cartouche contains a bust of an old supernatural wearing a "snaggletooth" headdress (see below). This monster rests on or sprouts from a split-headed supernatural, a zoomorphic form of the Yaxchilan Emblem Glyph. Additional interesting features are a rodent in a cartouche under the monster's front head and a glyph beside the rodent that has some features of a "seating" glyph.

a

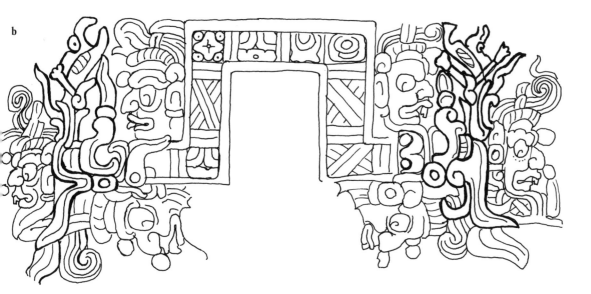

b

24.

Skybands at Yax-
chilan: *a*, Stela 11,
river side; *b*, Stela
10, temple side;
c, Stela 4, temple
side; *d*, Stela 1,
temple side. Author
drawings.

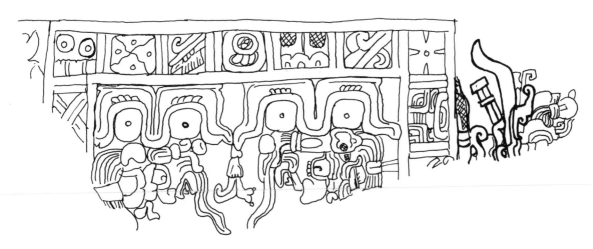

c

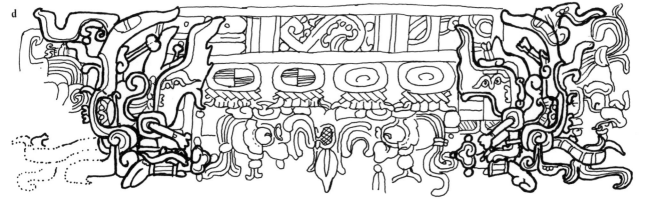

d

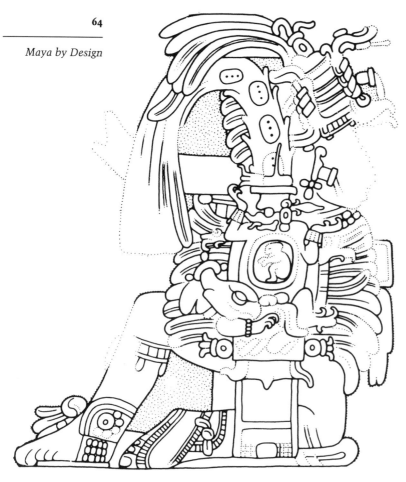

a

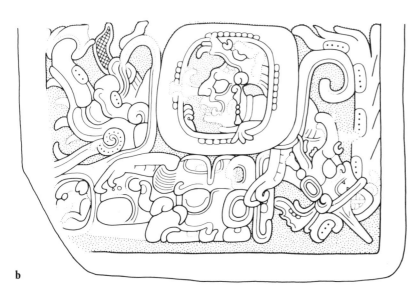

b

25.

Cosmic Monsters at Yaxchilan: *a*, Structure 33, Step VIII; *b*, Structure 44, Step III. Details from drawings by Graham (1982:162, 169).

The Cosmic Monster is a composite of various other symbols. Fixed traits include reptilian limbs and the presence of the quadripartite badge carried on its back or serving as a second head. In using this badge the ruler likened his authority and responsibility to that of the sun (represented by the *k'in* sign infixed in the badge) which cyclically travels through the heavens (crossed bands), the Middle World (stingray-spine bloodletter), and the Underworld (represented by the shell).[39] David A. Freidel and Linda Schele suggest that the reptilian aspect of the Cosmic Monster evolved as a replacement for the serpent form of the skyband when the Late Preclassic cosmological façades were adapted to become bicephalic serpent bars in the Classic Period.[40]

A deer as the head of the Cosmic Monster may be a reference to the sun, since it can replace the *k'in* symbol in Distance Numbers. Marvin Cohodas linked the deer to the setting sun through the connection of the deer, the number 7, and the date 7 Ahau.[41] On the Structure 33 Cosmic Monster, then, the Quadripartite Monster and the deer may represent two aspects of the sun—rising and setting, sun, both of which are transported by the body of a caiman.

Skyband, Serpent Bar, and Cosmic Monster at Yaxchilan

Most Cosmic Monsters depicted at other sites include a reference to Venus or a band of celestial symbols, but those at Yaxchilan do not. It seems that the designers of iconography at Yaxchilan split the portrayal of the travel of celestial bodies into three separate representations: the Skyband Monster, with two identical dragon heads; the bicephalic serpent bar; and the Cosmic Monster. The distinction made at Yaxchilan is similar to one observed at Late Preclassic Cerros.

Freidel and Schele have proposed a developmental sequence among three types of imagery which include references to the celestial bodies as paradigms for the ruler and his importance to his people. The sequence begins in the Late Preclassic with the stucco façade of Cerros 5C 2nd.[42] This is a multilevel pyramid formed of recessed platforms of diminishing size. Two of the platform façades are decorated with stucco imagery. The band-like borders of the stucco panels terminate in serpent heads and include symbols similar to those found on earlier skybands at Izapa. As the Preclassic iconography was adapted to the Classic Period cult of the ruler, as expressed on stelae, the bicephalic,

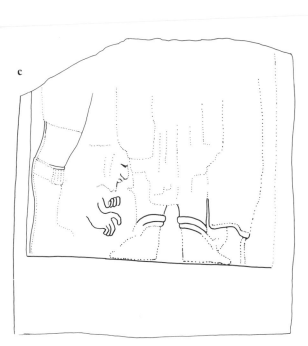

a

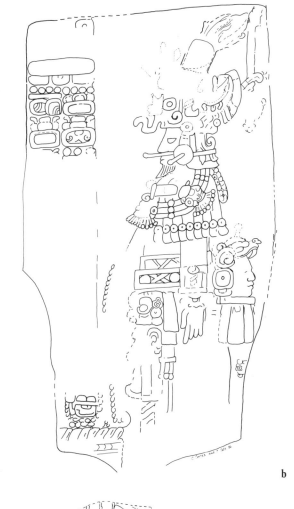

b

d

c

26.

Early prototypes for
the Late Classic cos-
mological–Period
Ending stelae:
a, Stela 2 (9.9.0.0.0),
the warrior image,
photo © 1991 by Lee
Clockman; *b*, Stela
27 (9.4.0.0.0), the
bloodletting image,
author drawing;
c, Stela 3
(9.10.16.10.13), the
warrior side, author
drawing; *d*, Stela 3,
the bloodletting
side, author drawing.

serpent-headed skyband was lifted off the façade of pyramids and became regalia held by the king on those stelae. Schele suggests that the saurian-bodied Cosmic Monster (which she calls the Celestial Monster) was developed to fill the semantic domain of the celestial realm on architecture. A saurian body for the Cosmic Monster was used to avoid confusing the realm of the sky (Cosmic Monster) with the royal emblem (double-headed serpent bar). I further propose that when the bicephalic serpent bar was held by a ruler, it signified his power to mediate among the sky, earth, and Underworld, just as a serpent can travel among these realms.

A similar developmental sequence is seen in the portrayal of the double-headed serpent bar, the Skyband Monster, and the Cosmic Monster at Yaxchilan. This can be observed in the five earliest stelae. The first known stela, 27, shows a ruler scattering blood or maize on the Period Ending 9.4.0.0.0 (A.D. 514; see Figure 26b). He uses one hand to direct the drops into a receptacle, and the other hand hangs unoccupied. Yaxchilan's second stela, 14, is dated 9.4.8.8.15 (A.D. 523). The ruler, again depicted in profile, holds a double-headed serpent bar (the only one held by a living king at Yaxchilan; see Figure 150). The third stela erected at Yaxchilan (Stela 2) shows a ruler holding a war spear (Figure 26a). The fourth, Stela 3, combines the bloodletting imagery of Stela 27 with the warrior imagery of Stela 2 (Figure 26c–d). On Stela 6, dated around 9.11.16.10.13 (A.D. 669), the ruler again spills drops as on Stela 27, this time using both hands to direct the droplets (Figure 88a). Because his hands are occupied, the double-headed serpent bar appears above his head in the form of a skyband, indicating not the power of mediation but the travel of celestial bodies and royal companions across the sky. At Yaxchilan, it became more important to perpetuate an early image of the sacrifice in progress, creating a special local format for Period Ending stelae, than to imitate the use of the double-headed serpent bar seen at other cities. The use of the bicephalic serpent bar as royal emblem is retained in the iconography, but it is confined to use by the images of royal parents who are portrayed in cartouches above the skyband, reiterating their cosmic potency.

At sites where the Cosmic Monster appears, the "front" head with its deer ear or head and the Venus glyph infixes always appears on the west, and the Quadripartite Monster always appears on the east. If Step III of Structure 44 were in place, its Quadripartite Monster would also be on the east side of the monument and the alligator head on the west.

Basal Monsters

On stelae at Yaxchilan, kings are depicted standing over monster heads that occupy the lower register of the stela. No two basal monsters at Yaxchilan are identical, but most of them are puns on the Split Sky toponym for Yaxchilan. The first use of such a monster was on Stela 2, erected 9.9.0.0.0. It is a frontal monster head with large earflares. Its only identifying characteristic is a large bar-and-dot "nine" infixed in its forehead. Presumably it refers to the *katun* ending 9.9.0.0.0. Stela 6, erected around 9.11.16.10.13, had a basal monster, but it is eroded beyond recognition, as are those on Stelae 18, 19, and the back of Stela 1.

On the temple side, or front, of Stela 1, a frontal sun god holds a skeletal bicephalic serpent bar (see Figure 27a). The sun god wears an *ahau* belt like a ruler and is seated like a ruler, but is marked as the sun and holds a skeletal emblem of royal mediating power. This could be a reference to the deceased members of the Yaxchilan dynasty, who traditionally performed transfers of power on summer solstice, now transformed into the sun and existing in the Underworld.

The Stela 7 basal monster (Figure 27b) is a marvelous version of the Cleft Sky toponym. Its profile head is saurian, with an upturned snout. Its eye is lidded and crossed bands are infixed. It is a sky caiman with a split waterlily (terrestrial or aquatic) forehead. From its eye issue vegetal stems, culminating in waterlily-blossom cartouches. Within the cartouches are two little animals, a rabbit and what is probably a monkey. The rabbit in a cartouche is known to be the Maya image of the moon, and monkeys can substitute for the *k'in* glyph in the day position of the Long Count. So from the eye of the cleft sacred earth at Yaxchilan issue the sun and moon.

The Stela 4 monster (Figure 27c) is a frontal bird with *muan* feathers in its mouth and a split-sky toponym in its forehead. The sky and bird can be read "*chan-muan*," and it is noteworthy that this particular image was fabricated in an era when the Yaxchilan ruler had close political ties with Chaan-Muan of Bonampak.

THE VISION SERPENT

Yaxchilan has six Vision Serpents among its monuments. Because the meaning of the Vision Serpent is more easily explained in the context of the associated iconography, its significance is explained in Chapter 4, as a sculptural theme.

Bloodletting Equipment

Spiked implements are held or appear in containers on some monuments. Naturalistically portrayed stingray spines, obsidian lancets, thorny cords, and strips of bark paper can be identified. They often appear in flaring-rimmed, low baskets which are shown in profile (see Figure 28). On several of the stelae, tall cylindrical objects composed of knotted fiber (Stelae 7 and 4) or topped with a matted border (Stela 1),

are shown. Unfortunately all these objects are shown in full profile, and no top view reveals whether these were containers, like the low bowls, or stacks of knotted flexible material.

Objects Held

THE GOD K MANIKIN SCEPTER

See the section "References to GII" above. This pan-Maya symbol appeared at Yaxchilan for the

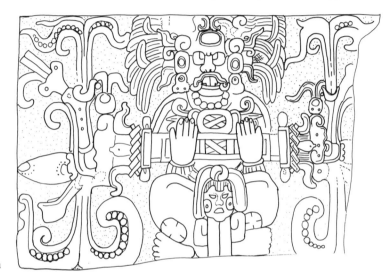

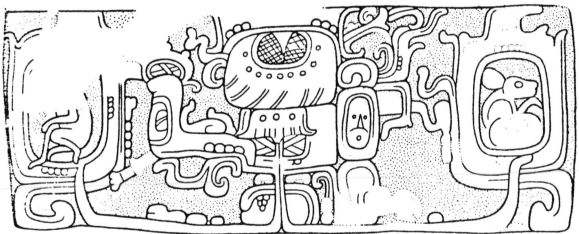

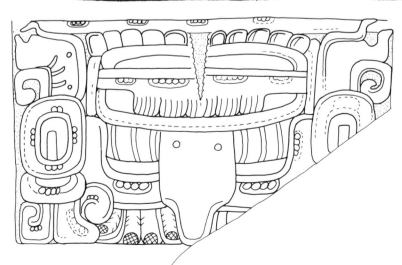

27.

Basal monsters on Yaxchilan stelae: *a*, Stela 1, author drawing; *b*, Stela 7, drawing by Ian Graham; *c*, Stela 4, author drawing.

first time as an illustration of the accession of Bird Jaguar IV on Lintel 1 (Figure 29*b*).

BUNDLES

The image of women holding bundles during royal accessions appears more at Yaxchilan than at other cities (see Figure 29*d*). On six Yaxchilan lintels (1, 5, 7, 32, 53, 54) women hold bundles on the occasions of accession, Period Ending, and accession anniversaries of ancestral rulers. At Yaxchilan and elsewhere, the bundle is used glyphically as a metaphor for accession.[43] Merle Greene Robertson became interested in the possible contents of the mysterious bundles while making rubbings in Yaxchilan. In a subsequent paper, she suggested

that the bundles contained the bloodletting bowls seen on other monuments, the bloodletting equipment, and hallucinogenic mushrooms.[44] Since then, a tomb containing the remains of a bundle has been opened. In the excavations in the Mundo Perdido area of Tikal, fragments of pigment from cloth were attached to two cache vessels, placed lip to lip, the shapes similar to the Yaxchilan bloodletting bowls. The vessels contained, among other things, obsidian blades, snail shells, snake skeletons, and turtle shells.[45] If this Tikal bundle was typical of other bundles, it can be assumed that the bundles were actually cloth-wrapped vessels filled with bloodletting paraphernalia and other ritual objects. The presence of hallucinogens has not yet been confirmed. Glyphically, the bundle is associated with bloodletting and accession ceremonies. The bundle glyph, T684, is used verbally as an accession expression at Yaxchilan and elsewhere, referring to the bloodletting activities associated with accession and kingship.[46] One lintel, 1, bears an affixed "spotted maize" glyph. The affixes read *yi-ca* or *i-ca*, and there is disagreement about the reading of T507, the "spotted maize" glyph.

THE BIRD-CROSS STAFF

On Yaxchilan Lintels 2 and 5 are crosses with flowers and small birds terminating the arms of the crosses (see Figure 29*c*). Lintel 5 is the completion of two *uinals* of Bird Jaguar's reign, and Lintel 2 is the five-*tun* commemoration of his reign.

V. Garth Norman collected examples of the use of cross-like forms to represent trees in his interpretation of the three-branched cross on Izapa Stela 25.[47] He concluded that in all cases, the cross was a stylized tree. Tree symbolism appears in Maya art from the earliest period. In addition to the Izapa stela, tree images appear on Early Classic pots which illustrate royal human participation in the cosmic process.[48] The bird-cross scepter is probably a local reference to the Axis Mundi, as is the Sarcophagus Lid at Palenque.[49]

Birds are often associated with cosmic or world trees. Examples are on Izapa Stela 25, on the Palenque Tablet of the Cross, and on cosmological pots. In Maya art, these birds are usually the "principal bird deity."[50] At Yaxchilan, this deity does not appear, and the birds represented resemble those appearing in Bird Jaguar's name and the bird-and-flower headdresses. They may be a way of specifying this cosmic tree symbol as a local one. The bird-

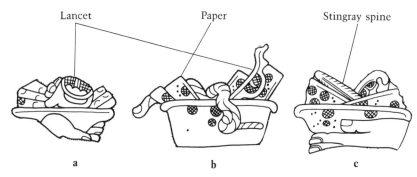

Lancet Paper Stingray spine

a b c

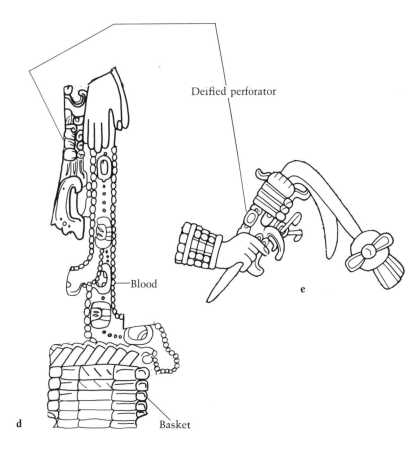

Deified perforator

Blood

Basket

e

d

28.

Bloodletting equipment: *a, e,* Lintel 14, and *b, c,* Lintel 25, details from drawings by Graham (1977:37,55); *d,* Stela 3, author drawing.

cross scepter appears to be another reference to the destiny of the sacrificial blood spilled by a present and a future king on the Period Ending 9.16.6.0.0, and to the completion of the five-year series of accession ceremonies for Bird Jaguar IV on Lintel 5.

THE GOD K BASKET-STAFF AND JAGUAR-PAW CLUBS

A piece of regalia unique to Yaxchilan appears on two lintels (6 and 43), both of which commemorate the same event on the same day (9.16.1.8.6). It consists of an image of God K sitting on a basket at the top of a staff (Figure 29a). Other unique items appear with it—namely, the jaguar-forearm clubs held by Bird Jaguar IV and his companion, Captor of Muluc, on Lintel 6. The date on which the basket-staff event occurs is the seventh anniversary of the ritual ballgame Bird Jaguar performed before his accession, and it appears that in some way the seven years were a necessary cycle for the successful completion of his confrontation with the Underworld Lords. This particular ceremony was the beginning of a three-day rite which concluded with Bird Jaguar displaying the God K manikin scepter and his female assistant clutching a bundle. The God K and bundle suggest that the rites are related to accession, and the ceremonies on these three days seem to finalize Bird Jaguar IV's lengthy quest for the throne.

STREAMS OF OFFERINGS

On six stelae, 1, 3, 4, 6, 7, and 18, drops fall from the outstretched hands of the ruler. The identification of this motif has been the subject of much speculation in the history of Maya studies. Teobert Maler described the falling circlets as little bee's heads. He called the motif a "honey cord" and a "string of joys" that was offered to grateful humans by a beneficent deity.[51] Morley, more pragmatic, called it a "maniple-like appendage, the lower ends resting on an altar(?)."[52] J. Eric S. Thompson did not specifically identify the liquid flowing from the hands of rulers on Yaxchilan stelae, but he did deal with the symbols contained therein: the yax, Kan Cross, and jade symbols, which he noted were interchangeable prefixes to a glyph that introduced ruler's names and Emblem Glyphs. He called this the "Water Group."[53] George Kubler noted the circlets being thrown from the outstretched hand of the ruler on Piedras Negras Stela 40 and called them "grains of

maize."[54] It has also been suggested that these were grains of copal incense.[55] To all these authors, the undulating form suggested an offering of a substance that could be poured.

The interpretation of the nature of this offering has changed recently as the prominence of blood in Maya ritual and visual idiom has been convincingly demonstrated. Linda Schele identified the circlets on Lintel 24 near Lady Xoc's mouth as she pulled a thorny cord through her tongue as blood.[56] David Stuart extended the identification of such dots to the motifs on the Yaxchilan, Tikal, Piedras Negras, and other stelae, suggesting an iconographic relationship between the dotted streams falling from the rulers' hands and the dotted scrolls in the upper registers of stelae from the central Petén. These

29.

Hand-held objects: *a*, God K basket-staff, Lintel 6; *b*, God K manikin scepter, Lintel 1; *c*, bird-cross staff, Lintel 2; *d*, bundle, Lintel 1. Details from drawings by Graham (1977: 13, 15, 23).

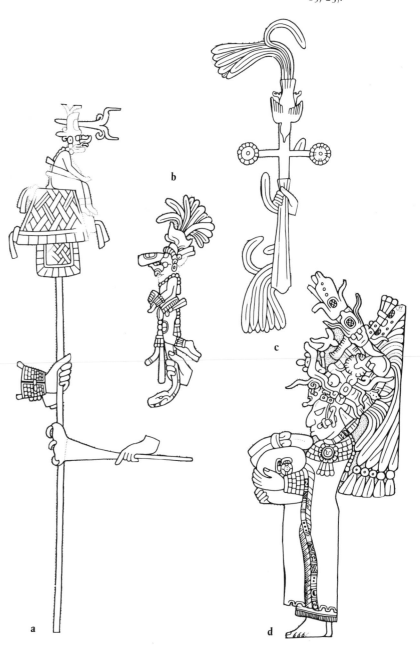

dotted streams and scrolls, he suggested, are royal lineage blood.[57] The argument is quite convincing, since the penis perforator[58] is shown in front of (if not inserted in) the ruler's groin on the Yaxchilan stelae. Several authors, including Karl Taube, have argued that the dotted streams, the infixes of maize-like dots within the streams, and the dots on the "Water Group" prefix refer to both maize and blood. Taube refers to both modern and ancient agricultural practices and linguistic evidence which relate the seeds of beautifully formed maize to blood.[59] I present no new evidence on this subject, but agree with Taube, Cecelia Klein,[60] Mercedes de la Garza,[61] and others that the sign is likely to be multivalent. It is surely a reference to bloodletting, maize planting, and feeding the spirits of the ancestors as simultaneous nurturing duties of the kings on the behalf of the community.

Symbolic Elements of Costume

The royalty of Yaxchilan appear on monuments completely dressed for the ritual in process. Costume is the most elaborated subject of the monuments. Its representation is highly codified because it bears the burden of communicating the nature of the occasion and the role of the ruler as an impersonator of the gods in the cyclical cosmic drama. Headdresses and objects held in the hand were selected as important elements in the ritual and provide the most secure clues to the nature of the occasion portrayed. When the kings and their assistants dressed for ritual occasions, they selected from a large inventory of symbolic objects.

ROYAL HEADDRESSES

Fourteen varieties of headdress were used by royalty at Yaxchilan. Most of these are local versions of traditional pan-Maya headdresses worn by contemporary rulers at various sites in the Central Lowlands. In addition to the fourteen varieties of royal headdresses, other headdresses worn by captives, foreigners, or supernaturals appear on the Yaxchilan monuments.

The Long-Snouted-Beast Headdress
One headdress, standard throughout the Maya area from early times (i.e., 9.0.0.0.0 on El Zapote Stela 5), seems to be composed of the head of a caiman, identified by its upturned snout (perhaps made of wood or plaster) and the mirror infixes which frequently appear in its flesh. This identification is not secure, and so the term "long-snouted beast" will be used until a firmer identification can be made. At Yaxchilan, only one long-snouted head is worn at a time, though at other sites they can occur in stacks. To this basic headdress can be added many elements, according to the ceremonial context or local prerogative. Its earliest appearance at Yaxchilan is on Stela 27 from 9.4.0.0.0, where it is an accessory to the bloodletting scene. It appears on all subsequent Period Ending stelae except an aberrant one (Stela 9). Unfortunately, most of the heads of the rulers on the stelae are missing, though usually enough clues remain to indicate the presence of the long-snouted-beast headdress. Stela 6 provides the best example of a Late Classic Period Ending stela headdress (see Figure 30a). The beast's elongated snout and spiral eye are clearly visible. At the upper back portion of the headdress, a GI head emerging from a serpent mouth can be discerned. Just above the beast head there is a cantilevered *akbal* medallion. Behind that, on the main part of the headdress, a skull form can be seen. This assemblage of elements is similar to those found on the front head of a Cosmic Monster. The headdresses appearing on the later monuments Lintel 13 (on Lady Great Skull), Lintel 3 (on Bird Jaguar IV's companion), and Lintel 14 (on Lord Great Skull) also carry such medallions, and in each case bloodletting is implied by the presence of the bloodletting loincloth, the penis perforator, or bloodletting knots.

On Stelae 11 and 31, the beast head is combined with a GI diadem as the traditional Period Ending and bloodletting headdress. On lintels (the stelae are too eroded to observe properly) a jaguar tail and skeletal serpent upper jaw are sometimes tied on by the headband of the medallion. A beaded headband is always tied on between the beast head and the forehead of the wearer. This headdress is worn on bloodlettings at Period Endings and other sacrificial ceremonies. It is not worn with an *ahau* pectoral, but with a GI or *k'in* pectoral. It always is worn with a jade collar, and often with a human head or half-backrack.

Two women holding bundles wear the long-snouted-beast headdress, on Lintel 5 and Lintel 53. Other appearances are on Lintels 14, 13, 5, 3, and 6; Stelae 11, 1, 27, 3, 6, and 5.

The Drum-Major Headdress
The drum-major headdress is part of a specific costume created by Bird Jaguar IV (see Figure 30d). The headdress appears only on lintels. It was first portrayed on the lintels of the three

30.

Yaxchilan head-
dresses: *a,* long-
snouted beast, Stela
6, author drawing;
b, Mexican year
sign, Lintel 17;
c, bird-and-flower
diadem, Lintel 26,
and *d,* drum major,
Lintel 1, details from
drawings by Graham
(1977:13, 43, 57).

structures Bird Jaguar IV dedicated in 9.16.6.0.0. The tall cylindrical headdress sits on the head of a large bird or other animal with a down-turned, hooked beak. This is the headdress Bird Jaguar IV wore on his accession lintel (1), and it is the headdress most frequently associated with the holding of the God K manikin scepter and the bundle. It is part of the regalia for dynastic succession and accession anniversaries. When Bird Jaguar IV wears this headdress, he always wears a backrack. In some cases it is clear that the backrack has a skyband framework (Lintels 2, 5, 32, 42, 53). Two kinds of ornaments are added to this headdress: the GI-Venus-serpent ornament and mirror medallions (either or both).

This headdress is a local variation of the drum-major headdress worn in accessions at Palenque,[62] where it was handed to Pacal by his mother as depicted on that site's earliest figural monument, the Oval Palace Tablet, dating to after 9.9.2.4.8 (A.D. 615). An earlier use of a similar tall, beaded headdress was at Lacanha on Stela 1, dated 9.8.0.0.0.[63] At Yaxchilan it was adopted during the reign of Bird Jaguar IV in an obvious attempt to participate in a regional (Western Maya) tradition. Similarly, for his accession, Bird Jaguar's predecessor, Shield Jaguar, demonstrated his links with Uaxactun and Piedras Negras by wearing a "balloon" headdress.[64] The drum-major headdress appears on Lintels 53, 32, 1, 42, 5, 54, and variations of it on Lintel 2 and Stela 16.

The Balloon Headdress

The image of his accession on Lintel 25 shows Shield Jaguar wearing a "balloon" headdress (see Figure 98). This is the first known use of the balloon headdress on monumental sculpture at Yaxchilan, although it was used as early as 8.17.0.0.0 at Uaxactun on Stela 5.[65] In the Usumacinta region, its first use was at Piedras Negras on Lintel 4, in a scene of royalty and warriors dedicated around 9.11.7.0.0. Shield Jaguar's accession image on Lintel 25 combines motifs from historical monuments and regalia signifying foreign glory with an innovative, complex double-figure composition. From the past was borrowed the "Vision Serpent." The emergence of the king from the maw of the Vision Serpent was not unprecedented; for example, it appears on the Yaxha vase. Adherence to tradition was also demonstrated through the use of the balloon headdress and the Tlaloc mask and head at either end of the "Vision Serpent." Tlaloc iconography is often used to signify warfare that was undertaken in response

to or at the behest of Venus' first appearance as Evening Star; however, in this instance, no such event can be related to Shield Jaguar's life.

The Bird-and-Flower Diadem

Another headdress consists of four large circular blossoms attached to a headband that is tied onto the head (see Figure 30c). A hummingbird sucks at each of the four blossoms. Flower and bird are shown in profile or top view, depending on their location. The headdress can be worn by itself, as on Lintel 25 and the Structure 21 New Stela (Stela 34?) (rear), or it can be added to a long-snouted-beast headdress. Large mirror medallions are added to two of the diadems on Lintel 54 and a frontal GI ornament to the diadem on Lintel 1.

The bird-and-flower diadem is found in the area between the Central Petén, the Pasión, and the Usumacinta. It seems to have developed after 9.13.0.0.0. Its first appearance in Yaxchilan art is at 9.14.15.0.0. At other sites, it can be worn alone or with other elements by the ruler on Period Ending stelae (e.g., Aguateca Stela 7, Tikal Stelae 16 and 22, Site Q Stelae A and B). At Yaxchilan, it is worn not by the ruler but by another member of the royal family. On three of the six occasions upon which it is depicted, a female bloodletting assistant wears it. An *ahau* pendant always complements the selection of this headdress.

The Tlaloc and Year-Sign Headdresses

The Tlaloc headdress and the year-sign headdress are related through being attached to a rectangular headband at Yaxchilan. One or both appear on Lintels 8, 17, 24, 25, and 41. The image called "Tlaloc" (the central Mexican rain supernatural whose meaning in the Maya area is discussed in the last section of this chapter) is a masklike object characterized by large, circular eyes, a few upper teeth, no lower jaw, and a skeletal or curved nose. The Tlaloc mask has no headdress "base" and must be tied onto the head (Figure 31a). The "year sign" is composed of stiff material bent into a particular format resembling the trapezoidal Mexican year sign. It is also attached to the head with cloth (Figure 30b). This headdress was used at many sites as war attire.[66] At Yaxchilan, its historical contexts are actual (rather than implied) bloodletting by women, actual capturing of sacrificial victims, and the portrayal of Shield Jaguar in his role as warrior on his accession day. In the capture scenes, the typical Yaxchilan war outfit—a long scarf, a cape and skirt of spotted material, and feather plumes—complement the

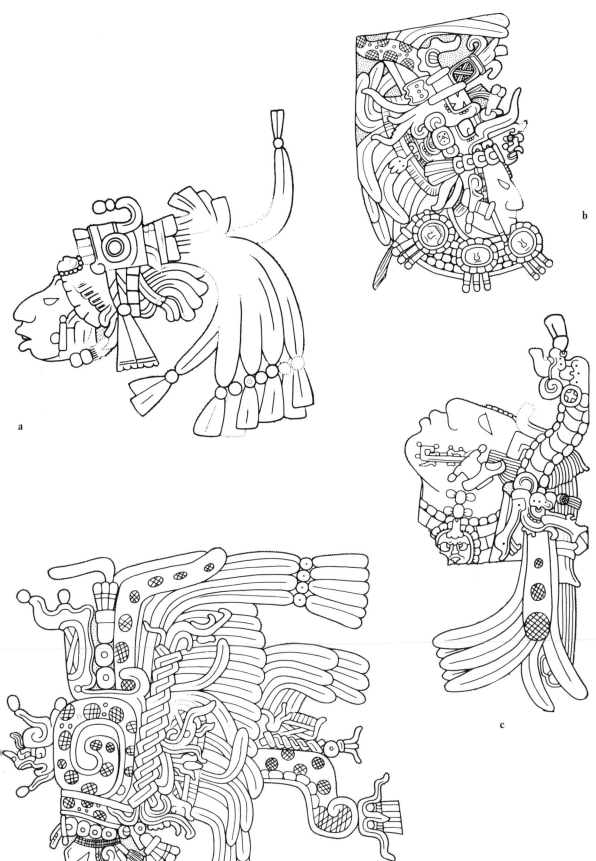

31.

Yaxchilan head-dresses: *a*, Tlaloc, Lintel 8; *b*, quadripartite, Lintel 14; *c*, skeletal serpent and monkey skull, Lintel 25; *d*, coiled serpent–Chac Xib Chac, Lintel 3. Details from drawings by Graham 1977: 17, 27, 37, 55.

Tlaloc and/or year-sign headdress elements. The origins of this outfit are discussed more fully at the end of this chapter.

The Quadripartite Headdress

The quadripartite badge is composed of a skeletal long-snouted head with a *k'in* infixed in its forehead.[67] Above the skeletal head are a shell, a stingray spine, and a crossed-bands symbol. These elements refer to the three levels of the Maya cosmos: shell = Underworld; stingray spine = terrestrial realm; crossed bands = celestial realm.[68] It appears in Maya art at the inception of the Classic Period in statements and imagery relating a ruler to the esoteric knowledge of the supernatural. At Yaxchilan the quadripartite badge appears for the first time late in the reign of Bird Jaguar IV as a headdress worn by posthumously portrayed individuals, namely deceased ancestors, and regents (see Figure 31*b*). On Lintels 32 and 14 and Stela 1 the individuals wearing the headdress were portrayed after their deaths by their heirs.

Schele identified the Quadripartite Monster as the sun that moves through the three cosmic levels on its daily journey,[69] and this identification has formed the basis of the refinements which have been presented. Freidel suggested that it is the skull of Hun Hunahpu, which was planted in a tree by Vucub Hunahpu, and which spit into the hand of Blood Woman, thus engendering the Hero Twins.[70] Based on the quadripartite badge's obvious solar and sacrificial references, and on the fact that it was worn by deceased royal ancestors at Yaxchilan, I agree with Freidel that it represents the skull of the First Father (Hun Hunahpu), but I think its meaning was conflated with the skull of Hunahpu (which was used as a decoy in the Underworld ballgame), who is apotheosized as the sun. At Yaxchilan, it seems to signify that a deceased member of a royal lineage is identified as the sun.

The solar symbolism of the quadripartite badge is reinforced on Lintels 14 and 9, on which it was attached to the headdresses of Lady Great Skull and Lord Great Skull, respectively. The ceremonies commemorated on these lintels occurred near summer solstices many years apart. Lintel 14 relates to a shift of political power at the city, as does Lintel 9, which falls at the end of Bird Jaguar's reign and prior to that of his son, Shield Jaguar II. When Lintel 14 was carved, Lady Great Skull had died; this is posthumous use of the quadripartite headdress. The date of carving of Lintel 9 is less clear, and it cannot be confirmed that Lord Great Skull is portrayed posthumously there.

The Skeletal-Serpent-and-Monkey-Skull Headdress

A two-headed creature is attached to a headdress seen on three monuments. One of its heads is a skeletal serpent and the other is probably a monkey skull (Figure 31*c*). As worn by Lady Xoc on Lintel 25, the headdress appears as a headband with no other adornments. Lady Xoc holds a similar creature on her outstretched wrist (see Figure 98). With a life of its own, it rises from her wrist toward the image of Shield Jaguar above her. The two bicephalic creatures are arranged so that on the headdress the monkey skull is in front of her head and the serpent skull behind and lower, while the converse is true of the creature on her wrist. The monkey skull on her wrist almost seems to drink from the bowl of bloodletting equipment she holds in her other hand.

Lady Ik Skull wears the skeletal-serpent-and-monkey-skull headdress and carries the same creature on her hand on Stela 35, found in Structure 21. The Vision Serpent floating behind her is reminiscent of the one on Lintel 25. On Stela 35, a "year sign" is affixed to the headdress and a band of "death eyes" appears above the skeletal body in her headdress. As on Lintel 25, the occasion seems to be one of the adoption of royal duties, this time by Lady Ik Skull.[71] She is shown with this creature on one side of the stela and on the other side is portrayed engaged in active bloodletting. A skeletal-serpent-and-monkey-skull headdress is worn by Bird Jaguar IV on Lintel 17, the only lintel in which a ruler spreads his legs in the unequivocal position of penis perforation (Figure 93). He wears a striped cloth around his waist, identical to the one that Lady Xoc wears on Lintel 25. Both also wear the bar pectoral. The occasion of Lintel 17 is not certain; no date is given, though the text seems to state that the ceremony was done in connection with the birth of Chel-te, the child who later became Shield Jaguar II. The snake has shed its skin; the monkey (sun) is dead; perhaps this headdress signifies the deathlike state deriving from blood sacrifice which is necessary for initiation into power in shamanic societies.[72] This headdress is not common at other sites.

The Coiled-Serpent Headdress

A headdress composed of a giant coil of spotted material—snakeskin or a roll of stuffed jaguar pelt—was invented during the reign of Bird Jaguar IV (see Figure 31*d*). It is worn with a standard set of accessories: a bead headband, the "bell element," a stuffed jaguar tail, a jester god, the serpent-wing element, *muan* bird feathers,

and the GI–Chac Xib Chac diadem. A relatively naturalistic serpent is attached to the front of two of the headdresses. The coiled-serpent headdress is twice worn with a God C loincloth. The king wears a knot around his neck and a backrack with this headdress.

On three of the occasions, the ruler holds the God K scepter, and once he holds the flapstaff, a staff to which a cut cloth is attached and which is associated with summer solstice ceremonies. Each occasion is an anniversary. The Lintel 33 date is 6 × 365 days after the previous time Bird Jaguar held the flapstaff.[73] The Lintel 7 date is 8 × 365 days since Bird Jaguar played the ballgame in the Underworld on 3 Muluc 15

Mac (Structure 33, Step VII). Lintel 3 commemorates the four-*tun* anniversary of Bird Jaguar IV's accession and a Period Ending, and Lintel 52 is the fourteen-*tun* anniversary of his accession and a Period Ending.

The Waterlily-Jaguar Headdress
On the monuments he commissioned himself, Shield Jaguar used only three kinds of headdresses: a jaguar head with a bit of waterlily foliage on top when he had taken a captive, the balloon war headdress for accession, and a feather bonnet for fighting. At Yaxchilan, the simple waterlily-jaguar headdress was worn only by Shield Jaguar (see Figure 32a).

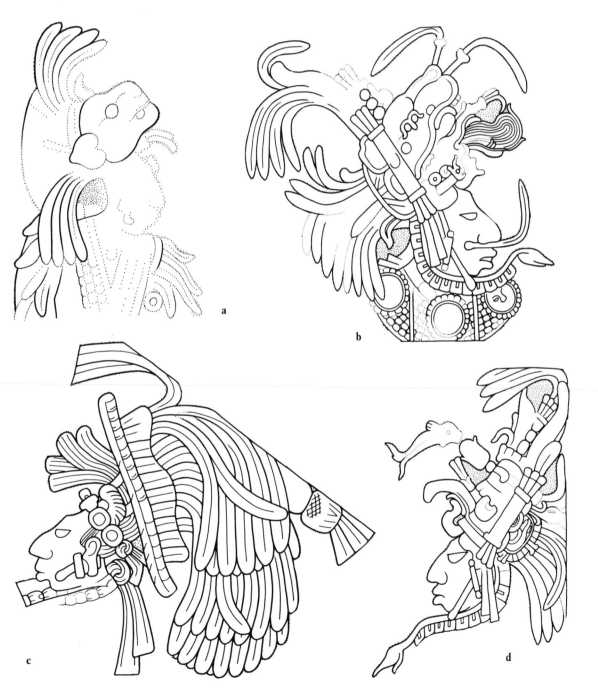

Yaxchilan headdresses: *a*, waterlily jaguar, Lintel 4; *b*, waterlily-GIII jaguar, Lintel 6; *c*, feather bonnet, Lintel 45; *d*, fish eating waterlily, Lintel 6. Details from drawings by Graham (1977: 19, 23; 1979: 99).

The Waterlily-GIII-Jaguar Headdress

A headdress that appears on only two monuments (Lintels 6 and 43; see Figure 32*b*) consists of a large jaguar head with a Venus glyph as eye. The chin strap is a waterlily, as is the growth on top of the jaguar head. A hank of tied hair billows out of its mouth, indicating that it has swallowed one of the Palenque Triad (GI or GIII). The two lintels commemorate the same event shortly after the accession of Bird Jaguar IV. It appears to be a three-day ceremony related to the Lintel 24 event and to the ballgame event on Step VII of Structure 33. The presence of the supernatural jaguar-GIII headdress in the context of a ballgame commemoration sug-

gests that Bird Jaguar IV is impersonating Xbalanque, the archetypal ballgame player associated most closely with GIII.

The Feather Bonnet

In some of Shield Jaguar's battles, he wore a simple headdress of medium-length feathers attached to a stiff base. This can be seen on Lintel 45 (Figure 32*c*), and it was likely shown on Lintels 44 and 46 as well. Bird Jaguar IV wore this headdress on Lintel 16, where it may have been chosen as the simplest alternative by an artist who had little expertise in rendering costume detail.

a

b

c

33.

Yaxchilan headdresses: *a*, cloth through double loop, Lintel 41, detail from drawing by Graham (1979:91); *b*, tall beaded helmet, Structure 44, Step I, detail from drawing by Graham (1982:166); *c*, snaggletooth, Stela 1, author drawing; *d*, monkey skull, Stela 1, author drawing; *e*, deer, Structure 44, Step VI, detail from drawing by Graham (1982:173).

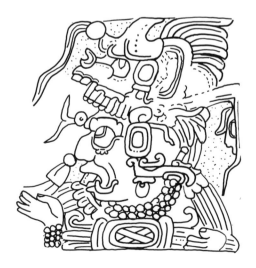

d

e

The Fish-and-Flower Headdress

The fish-and-flower headdress is worn by ballplayers during the ballgame scenes on Structure 33 steps and by Captor of Muluc in his role as ritual assistant on Lintel 6 (Figure 32d), the lintel that commemorates Bird Jaguar IV's ballgame event. The fish nibbling a waterlily flower is a pan-Maya symbol of the watery Underworld. The imagery is derived from observation of the ecological processes in the tropical forest swamps and canals made to support raised-field agriculture.[74]

Elements of Headdresses

Male headdresses often include many common elements, some of which were used in many cities. The "serpent wing," called "wing panel" by Herbert Spinden,[75] functions as a sort of ear ornament or lateral head ornament for a head worn as a headdress. It is often attached to the headdress head by means of a long, tubular jade bead. Other elements include a squared, conventionalized serpent head, such as the one protruding from Bird Jaguar's headdress on Lintel 1 (Figure 30d), which appears at other sites on loincloths and headdresses. Common at many sites are medallions cantilevered from the front of the headdress often associated with the Period Ending costume, as they are at Yaxchilan. Most are quite eroded, but their general form is like the cantilevered *akbal* medallion frequently worn by God D.[76] Mirrors were worn by Bird Jaguar IV in his accession portraits, most likely as a metaphoric statement that he was the mirror of his people.[77] Stuffed jaguar tails were worn by kings at many cities. Recently David Stuart showed that a glyphic compound consisting of a knot and jaguar tail was sometimes used to express a child-father relationship.[78] Possibly the jaguar tail in many royal headdresses also refers to the descent of the son (present king) from his royal father. A universal element in Maya royal regalia is the "jester god" ornament attached to the front of the forehead or headdress. It was identified by Schele as a referent to the ruler as the living manifestation of God K. Many such ornaments actually survive, carved both of jade and obsidian.

HEADDRESSES WORN BY ASSISTANTS AND CAPTIVES

Cloth through Double Loop

A headdress consisting of a spotted cloth or strip of paper passed through two circular objects with a projecting, undulating lower edge is associated with sacrificial victims and assistants (see Figure 33a). It is worn by a prisoner of Shield Jaguar on Step V of Structure 44, by Lady Ahpo Ik on Lintel 41 (she holds bloodletting equipment, and Bird Jaguar IV captured Jeweled Skull that day), and by an unidentified assistant on Stela 10. In each case the wearer also wears a knotted cord around the neck.

Tall Beaded Helmet

A tall beaded helmet fitting snugly over the elongated Maya cranium appears on three prisoners at Yaxchilan, two of whom are the same person, Ah Chuen (see Figure 33b). The records of Ah Chuen's capture appear on Stela 18 and Step IV of Structure 44. The third helmet is from the Structure 44 steps, but the figure is badly eroded and no personal identification is possible. A similar helmet with an additional lobed lower edge is worn by the warrior present at the Period Ending ceremonies commemorated on Stela 10 and by the local La Pasadita ruler on Lintel 2 of that site, and also appears on a noble paying homage to Shield Jaguar II on the "Kimbell Panel" from Laxtunich (see Figure 38a, in Chapter 4). The beaded headdress was worn on some of the earliest Maya monuments.

Snaggletooth Headdress

A skeletal version of the long-snouted-beast headdress has the teeth and fangs of the snake prominently displayed, hence the name "snaggletooth" (see Figure 33c). It is worn by deceased royalty in some ancestor cartouches and by some bloodletting assistants (both on Stela 1). The supernatural in the cartouche in the body of the Cosmic Monster on Step III of Structure 44 also wears it.

Monkey-Skull Headdress

A headdress consisting of an animal skull, perhaps a monkey, is worn by the figure of GI or GIII that appears between the ancestor cartouches on the temple side of the cosmological stelae (see Figure 33d). Floyd Lounsbury proposed that a skeletal image of Venus in the Grolier Codex page 6 corresponds to Venus as Evening Star, and he has found parallels in Central Mexico for the association of the skull with this station of Venus.[79] If this is so, the image symbolizes GI or GIII as Venus, between the ancestral parents of the ruler, riding the skyband.

Deer Headdress

Deer headdresses appear at many sites. At Yaxchilan, they are not worn by the local nobility, but by captives or warriors (see Figure 33e). An

individual wearing the deer headdress was captured in 9.8.0.15.11 (Structure 44, Step VI). A man in a deer headdress appears on Lintel 12 as the king's ally. Two captives of Shield Jaguar II wear the deer headdress on Stela 5.

BACKRACKS

The Maya ritual costume should be considered as a sculpture in the round. A fully adorned ruler wears regalia towering above his head, encircling his chest and waist, flowing down his sides, covering shins and feet, and attached to his back. Usually this elaborate, agglutinative costume is portrayed from front or profile view, and either way, the backrack is obscured, or only the sprays of feathers can be seen. However, as can be seen in the few images of the backs of Maya elite, backracks contained, in addition to abundant green feathers, important symbolic items, usually of cosmographical or ancestral significance.

The backrack was a lightweight structure attached to a thick belt. Some Maya figurines, such as the one in the Kimbell Art Museum, demonstrate how the backrack was attached. The belt is thickly padded or stuffed in the back, and two holes pierce it. Into these holes were placed the sticks that formed the framework of the backrack.

Small Circular Cosmological Backrack

The small cosmological backrack is portrayed three times at Yaxchilan, including once on the early Stela 14. It is clearly shown on Step VIII of Structure 33 (see Figure 34a). There the artist turned the figure of Bird Jaguar III so that the backrack is clearly displayed. The framework of the backrack consists of the Cosmic Monster with a deer-eared dragon as its front head, the tail of a caiman, and a quadripartite badge (skull of the First Father–Sun) riding on the monster. In the center of the "body" of the monster is a pendant worn on many occasions, carved with the image of a profile jaguar. This monument shows Bird Jaguar IV's grandfather engaged in the cosmic pursuit of playing the ritual ballgame. His opponents were likely the Lords of the Underworld.

This backrack appears again on Stela 11, worn by Bird Jaguar IV on the occasion when he portrayed himself as receiving authority for the maintenance of the sun on summer solstice prior to the death of his father. Thus the two times it appears in the Late Classic Period, it is associated with events of cosmic significance

outside of the rhythm of Period Endings. This small backrack could also have been worn on other monuments where the ruler is shown in front view.

Skyband Backrack

As shown from the front, the skyband backrack extends horizontally below the shoulders (see Figure 34c). A rectangular, sometimes single-stepped, rigid framework above the feathers is decorated with celestial symbols. At the upper corners of the frame are stylized bird heads. This backrack is always worn when the long-snouted-beast base is crowned with the drum-major headdress. The skyband backrack appears only on lintels portraying the bundle motif or the bird-cross scepter and on Stela 9. Four of the six monuments on which it is found were planned for dedication in 9.16.6.0.0. At this time, Bird Jaguar IV seems to have initiated the use of this backrack. The events are all anniversaries or commemorations of previous events.

Horizontal Spray of Feathers or Half-Backrack

The feathers of another style of backrack extend laterally from the body between the shoulders and the knees (see Figure 34b). This backrack was also brought into vogue by Bird Jaguar IV. It is worn on Bird Jaguar IV's accession and other occasions when the God K manikin scepter is held and in the ballgame. It is associated with the combined long-snouted-beast plus drum-major headdresses, with coiled-serpent-GI headdresses, and with bird-and-flower headdresses.

Full-Length Backrack

Feathers extend from above the head to the ground in the full-length backrack (see Figure 34d). It is worn on Stela 2, an early monument, and by Shield Jaguar on his accession monument, Stela 19. It also appears on the flapstaff–summer solstice monuments.

Human-Head Backrack

Composed of a life-size human head with a small animal-head headdress and triple jade plaque pendants, the human-head backrack is tucked into the ruler's belt on the rear (see Figure 34e). It is part of the traditional Period Ending costume as seen on stelae and a few lintels. It is worn with the pointed hipcloth and the long-snouted-beast plus GI headdress. This backrack appears on early monuments, such as

a panel from Bonampak in a private collection dated around 9.3.0.0.0, and Stela 27. It was commonly used at other sites.

A skull variant was worn by Shield Jaguar during the capture of Ah Ahaual. Skull backracks also appear in war contexts worn by Chan Muan on Bonampak Lintel 2.

The full backrack worn on summer solstice and the human-head backrack are the Early Classic traditional forms at Yaxchilan. The half-backrack, skyband backrack, and circular backrack were introduced to the site during the reign of Bird Jaguar IV and are all associated with the monuments erected between his accession and 9.16.6.0.0.

MALE SKIRTS

There are only five types of skirts (or lower torso and thigh coverings) worn by males at Yaxchilan. Type I (Figure 35a) consists of narrow pelt or cloth strips tied with a sash. It appears only twice—on Stela 15 in a capture scene and on Lintel 2, which is the five-*tun* anniversary of the reign of Bird Jaguar IV. The context, person, and headdress are different for the two appearances of this skirt.

Type II is a pointed hipcloth (Figure 35b, c). This is Maya underwear and is worn by Maya rulers at many cities during bloodletting. Dedicatory dates span the figural monuments. It is the traditional costume of the cosmological stelae. It also appears on lintels associated with Period Endings and penis perforation. It is worn mostly with GI plus long-snouted-beast headdresses, and with the crossed-bands belt. The hipcloth shows an evolution in design from smooth to notched borders. The notched style appears at Yaxchilan after 9.16.15.0.0.

Type III (Figure 35d) is made of panels with

34.

Backracks: *a*, small circular cosmological backrack, Structure 33, Step VIII; *b*, half-backrack, Lintel 3; *c*, skyband backrack, Lintel 32; *d*, full-length backrack, Lintel 33; *e*, Human-head backrack, La Pasadita Lintel 1. Author drawings.

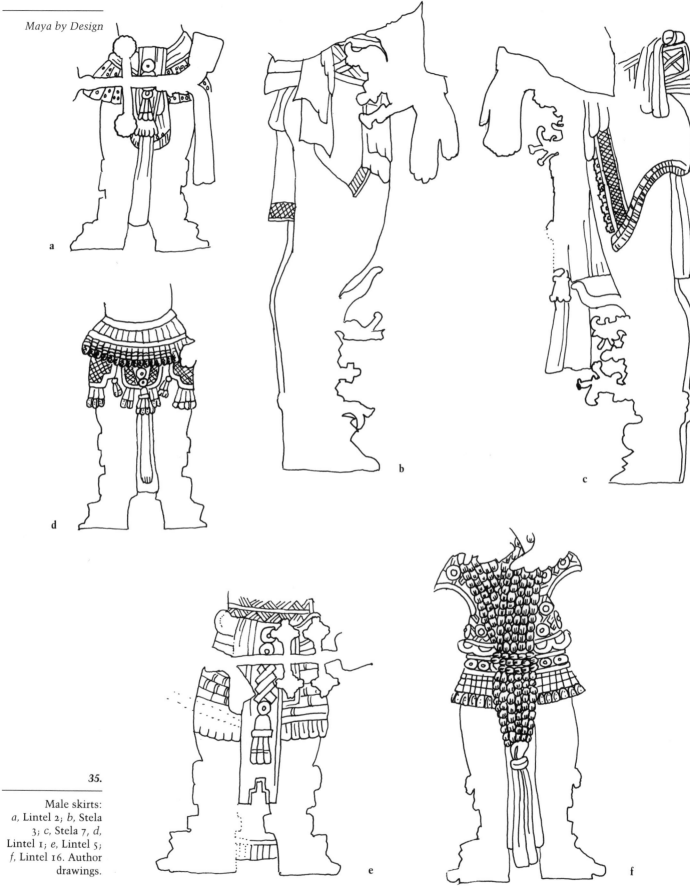

Male skirts:
a, Lintel 2; *b*, Stela
3; *c*, Stela 7, *d*,
Lintel 1; *e*, Lintel 5;
f, Lintel 16. Author
drawings.

crosshatching in the center and notches on the edges. It is worn four times, all after 9.16.5.0.0. Three examples are associated with the drum-major headdress and one with the GI–coiled serpent. On three occasions it is associated with the holding of the bundle. The ruler always carries a shield when he wears this skirt; either God C or GIII appears on the shield.

Of Type IV (Figure 35*e*) there are seven examples. It is a mini-skirt with a plain or fringed hem. It appears early on Stelae 2 and 14, and later on Stelae 9 and 11. When it appears on lintels, it is associated with the crouching jaguar pendant. The mini-skirt appears different each time it is worn, making it difficult to generalize about how it is made.

Sixteen figures wear a Type V skirt (Figure 35*f*). It is very short, barely covering the hips, and made of pendants (most likely spondylus shells) attached at a single point onto a hip belt, so that they swing out, crashing together and making a tinkling sound when the wearer moves. This skirt is part of the war costume, which consists of a spear, a feather bonnet, this skirt, and the long scarf. Half of the appearances of the skirt are during captures. The other occasions on which it is worn include anniversaries and summer solstice. Shield Jaguar wore this skirt with his jaguar headdress and his war bonnet. Bird Jaguar IV wore it with the Tlaloc, coiled-serpent, drum-major, and feather-bonnet headdresses. Only one example of Shield Jaguar II wearing this skirt remains, and he used a bird-and-flower headdress.

The Body, Costume, and the Cosmos

Among the contemporary Quiché there exists a spatio-temporal alignment of the body to the cosmos. The front of the body is associated with things that happen in the present or future—divination of the future, one's descendants, birth, and the day Manik. The back of the body is associated with the past—the ancestors and the day Ahau, on which the ancestors are honored. Right is significant as associated with Ben, maleness, the patrilineage, and lineage ceremonies; left is Cimi, female, and the marriage ceremony. Ritual sequences are scheduled to coincide with the significance of the days associated with front, back, left, and right, and the reading of prognostications through the "blood lightning" depends upon what part of the body feels the lightning.[80] Two observations from the monuments at Yaxchilan sug-

gest that similar correspondences were conceived during the Classic Period.

Specifically, this information may assist in interpreting the human-head and skull backracks. The human-head backrack, which is worn on Ahau days, those associated with the ancestors by the contemporary Quiché and upon which all Period Endings in the Long Count fall, most probably represents the father or perhaps grandfather of the king. The idea that this is an ancestor is reinforced by the Period Ending backracks of Late Classic Tikal, which consist of skulls in ancestor cartouches, such as those on Stelae 5, 19, and 22. The association of left with female, bowls, and bloodletting equipment on Yaxchilan monuments is demonstrated by the fact that in every case that a bloodletting bowl is held, it is held by a female, and every time it is held in one hand, it is the left hand, even when the figure faces the viewer's right, as does Lady Great Skull on Lintel 14.

Costumes Worn for Specific Occasions at Yaxchilan

Several identifiable costumes were traditionally worn for certain occasions at Yaxchilan: a local Period Ending costume, an extra-local war costume, and a local summer-solstice outfit (see Figure 36).

Across the Maya area, the Period Ending involved the display of extra-local ornaments, war prowess, bloodletting, and the ancestors. Despite the common components of the ceremony, each community selected a particular manner of representing it in order to create its own local visual idiom. Yaxchilan was unusual in that it showed the bloodletting ceremony, the means by which the ruler gained the esoteric knowledge of the supernaturals, in progress rather than completed. Yaxchilan's earliest stela depicts a ruler in profile, scattering drops from his hand onto a basket. This image, invented in 9.4.0.0.0, became the template for Yaxchilan's Late Classic stelae. The costume worn on each Period Ending in the Late Classic was identical during the reigns of Bird Jaguar III, Shield Jaguar I, Bird Jaguar IV, and Shield Jaguar II. It consisted of the long-snouted-beast headdress, the GI diadem, the human-head backrack, pointed hipcloth, *k'in* pendant, crossed-bands (Hero Twins) pectoral, a crossed-bands belt, an inserted penis perforator, knee-high sandal straps with mat on the shin, and ankle-

guard sandals. The "action" concept of the scene's design—the king in profile, blood from the inserted penis perforator spilling from his outstretched hands into a basket—is unique to Yaxchilan, although less obvious blood-spilling is shown on some Tikal stelae after 9.13.0.0.0. Below the feet of the ruler in each Yaxchilan stela is a variation on the local Emblem Glyph, a Split Sky metaphor.

The war outfit[81] consists of Teotihuacan-associated elements which seem to have been borrowed from or used because of relations with Piedras Negras. It is well documented that whenever the Teotihuacan-related regalia appear in Maya iconography, it is in a context of aggression by an elite toward people from other locales. Wearing this costume, images of Yaxchilan kings carved on very tall stelae guarded their shore during the Late Classic. Warfare was so important that it was depicted on the very same stelae that documented accessions and Period Endings, as well as on many lintels. Compared to Piedras Negras, where the war stelae appear only after a *katun* of a king's reign, and where the war outfit includes bulky headdresses, the Yaxchilan war outfit appears on the kings' first stelae and is spare and designed for action.

At the very beginning of the Classic Period, the Maya adapted Teotihuacan insignia, specifically the Tlaloc headdress, *atlatl,* and year sign, for use in situations of aggressive behavior (Uaxactun Stela 5 appears to commemorate the capture of a Tikal king by a Uaxactun one). Its use in this context gradually became codified as tradition over the period between about 8.17.0.0.0 and 9.9.0.0.0 (A.D. 375–613). Nevertheless, the Teotihuacan-derived insignia, although used for hundreds of years by the Maya, retained the connotation of making war on an inferior group.

In a recent paper on the use of the "Teotihuacan" costume at Piedras Negras, Andrea Stone suggests that foreign insignia may have been deliberately used as a means to differentiate the privileged status of the most powerful elite in the city from the larger group of high-ranking lineages and to reinforce political authority gained from association with the foreign, exotic, high civilization at Teotihuacan.[82] Upon their accessions, Piedras Negras rulers wore traditional Maya insignia—an animal-head headdress (perhaps a jaguar head) to which is attached a large spray of feathers, serpent-wing elements, a medallion on the top, and various frets and mini-staffs bound into it. Teotihuacan-derived insignia—beaded head-dress, balloon headdress, square shield, snake-headed staff, fur tails attached to the wrist, and the year sign—were portrayed on the warrior stelae (26, 31, 35, 7, 8, 9), which were erected one *katun* after each ruler's accession stela, thus setting up the two types as a deliberately contrived opposing pair. It is not clear, however, whether the "Teotihuacan" style insignia seen on Maya monuments were actually imported from the Central Mexican metropolis, or whether the Maya copied such insignia using local materials. If the items were imported, this would indicate that the Maya rulers wearing imported goods had access to the materials through negotiated trade relationships. If they were simply copied, then the concept of exoticism was invoked, but the necessary infrastructure for foreign exchange was not important. The display of imported sumptuary items signified the acquisition of exotic information and the manipulation of widespread trade networks among chiefs in ancient Panama.[83] As such, wearing imported insignia was an active demonstration of the continuing exercise of supernatural power. These two theories have some parallels—specifically, the adoption of foreign symbols or insignia indicates increased status and power—but evidence for trade of carved jades and Teotihuacan insignia in the Maya area is lacking.

The display of the powers evidenced by the war costume differed at Piedras Negras and Yaxchilan. At Late Classic Piedras Negras, community affiliation and traditional beliefs were the most crucial concepts for a ruler to portray on an accession monument, and foreign relations, including the relationship of dominance, were expected to be forged with other cities by the completion of a *katun* of rule. At Yaxchilan, the Late Classic rulers found it crucial to prove their military prowess prior to accession. Such demonstration was probably a prerequisite for their claim to authority. The only stela that verbally records an accession, Stela 11, portrays pre-accession events rather than accession itself. Stelae 3 and 6, which record the completion of *katuns* of reign by Bird Jaguar III, suggest that the format for accession and Period Ending are identical. Instead, at the *katun* ending following the accession, the king documented a war victory on the east side of the stela (read first by the sun) and his accession information and the accompanying bloodletting ceremony on the west side.

After 9.9.0.0.0, the Teotihuacan-derived Maya war costume was portrayed in art at many, but not all, Maya ceremonial centers. What

does its absence in the imagery at a site mean? At Palenque, for example, only one bit of "Teotihuacan" iconography occurs—a Tlaloc mask as a headdress ornament worn by one of the stucco figures on the House C piers (on the west side rather than in the eastern court where captives are displayed). War was never explicitly depicted at Palenque, either; yet it cannot be denied that Palencanos captured prisoners, for they are shown in the Northeast Court of the Palace. Did its position on the western frontier mean that Palenque's aggressors were non-Maya and therefore the Palencanos chose to create the appearance of alliance with the Maya tradition and the many Maya groups to the east? Perhaps, as Janet Catherine Berlo has suggested, there are several factors in the assimilation of extra-local symbolism—the degree and nature of trade relations (in the Palenque case, clearly directed toward the center and even the southeast of the Maya area), the degree of development of the local style, and the rulers' attitude toward innovation.[84] To that list

should be added the role of imported objects or reproductions of them as evidence of status and esoteric knowledge.

Its position along a major artery of transportation within and beyond the Maya area meant that Yaxchilan could have had relatively frequent contact with nonlocals and perhaps non-Mayas. However, few obviously foreign trade items have been recovered in Yaxchilan. As shown in the art, the costuming reveals little direct input from non-Mayas. Most items were borrowed from the widespread, now "Mayanized" Teotihuacan war costume tradition—the feather bonnet, sleeveless tunic, claw pendant belt, and spear—but Yaxchilan seems to have developed a particularly useful item of war attire, the scarf of "cotton armor,"[85] and the skull backrack as well. The absence of traits imported from Zapotecs, Teotihuacanos, the cultures of Veracruz, and upper Central America suggests that the Classic Period Yaxchilan rulers consistently defined themselves within a Maya cultural sphere, did not need to demon-

36.

Traditional costumes at Yaxchilan: *a*, Period Ending, Stela 6, author drawing; *b*, war outfit, Lintel 8 and *c*, summer-solstice outfit, Lintel 9, details from drawings by Graham (1977: 27, 29).

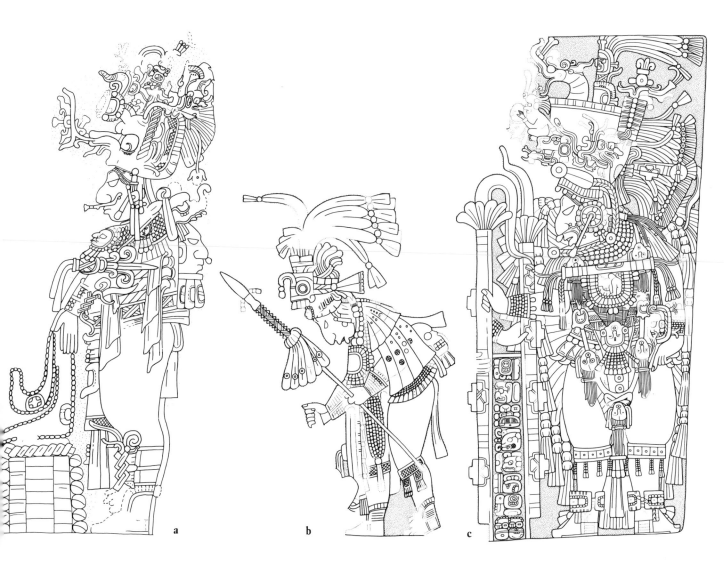

a b c

strate far-flung trade relations, and derived political authority from the use of insignia typical of Maya cities, not foreign ones.

The other consistent costume was the summer-solstice costume. It included a full-length backrack, a tall cylindrical variant of the drum-major headdress, a bar pectoral, a front rack of pendant human heads alternating with sectioned spondylus shells, and the flapstaff. To the best of my knowledge, Yaxchilan was the only city at which summer solstice played such an important role in the political and ritual process that a costume was designed specifically for those ceremonies. The flapstaff was used at other cities prior to being shown on Yaxchilan sculpture, but not necessarily in the context of summer solstice. It appears to have originated at Balancan, far downriver, then to have been used at Site Q (as seen on the Cleveland and Kimbell stelae), and finally to have played an important role in the passage of rulership at Yaxchilan. In portrayals of a ruler holding the flapstaff later than those seen at Yaxchilan, the flapstaff retains the connotation of accession or a passage of power.[86] (For additional discussion, see "The Flapstaff and Summer Solstice" in Chapter 4.) At several Maya sites, after 9.13.0.0.0, a smaller version of the flapstaff was sometimes attached to a head-dress. At Yaxchilan, the practice of including staffs in headdresses was adopted very late, only after 9.16.10.0.0.

The other ceremonies depicted at Yaxchilan are generally non–Period Ending ceremonies. Because they are unique representations of such events, and are unusual in the corpus of Maya monuments, the outfits seem unique as well.

This iconography is intended to establish a vocabulary for the analysis of the scenes on monumental sculpture at Yaxchilan. It is also intended as a point of reference in studies of costumes and symbolic forms at other sites. Preliminary analyses I have undertaken on the costumes of Palenque and those done under my supervision by graduate students at UCLA in 1986 on Caracol, Tikal, and Chichen Itza indicate that there is considerable variation in the use of specific costume elements and in the form of supernatural symbols at other sites. Although many supernatural symbols and royal costume elements are recognizably similar on the sculpture of different sites, I think it is not wise to assume that the meanings are identical without examining them in the contexts of historical background, specific ritual, and placement on the monument. The symbolic elements analyzed in this chapter are considered in these contexts in the next three chapters.

Manifesting Tradition: Imagery at Yaxchilan, Part II, Scenes of Royal Ritual

In designing a scene on a Maya monument, many formal and iconographic decisions were set by aesthetic and political conventions which conformed to the requirements of ritual. Nevertheless, creativity in design and composition was esteemed and to varying degrees, depending on the patron, was encouraged. Creativity was probably seen as having total knowledge of the ritual needs of the art to the extent that new forms of expression could be developed within those requirements. One can trace the role of pictorial innovation by examining the set of lintels in Structure 44.

The Elegant Knot Artist, the Exuberant Scribe, and their workshop were the first designers of sets of figural lintels at Yaxchilan. They were commissioned by Shield Jaguar I (see Figure 3) to create three lintels for Structure 44 (Figures 9–11) commemorating his captures of powerful foes and to link those events to captures realized by Shield Jaguar's royal ancestors. But they had no precedent for the portrayal of such a scene on a monument. Only two kinds of scenes had appeared in Yaxchilan's monumental sculpture before this time. One was the image of the king letting blood on the Period Ending and on the occasion of his accession or the *katun* anniversary of his accession. These images included a king in profile view, standing rigidly upright with his hands outstretched, dressed in a towering headdress, backrack, leg bands, sandals, jade collars, and other ornaments. The other image was of a king, also standing rigidly, holding a spear as if it were a staff, accompanied by a kneeling, already vanquished captive. To this small inventory of sculptural themes present at Yaxchilan before 9.14.5.0.0, the Elegant Knot Artist and

Exuberant Scribe added another type of scene, the active capture. Although they were given license to innovate this kind of scene, they still had to portray the costume that Shield Jaguar had worn during these sacred wars, and had to avoid defining the actual physiognomy of Shield Jaguar, in order to imply that all kings of Yaxchilan had performed similar ritual actions. Despite these restrictions, the artists (and probably their royal collaborators) collectively devised an imaginative new pose and a new kind of hieroglyphic statement as well. The result was a set of lintels showing the same innovative but comprehensible scene in three slight variations of composition, all executed in an elegant style that combined the artistic strengths of the two great artists, as discussed in Chapter 2.

This experiment must have been considered successful, for ten years later, the workshop produced four more lintels designed for another building, Structure 23. Three extremely innovative scenes were produced (Lintels 24, 25, and 26; see Figures 13–15) which drew from traditional Maya imagery produced at other sites and founded three new sculptural themes for monumental sculpture at Yaxchilan. Whereas there had been two themes of figural sculpture in the two hundred years before 9.14.5.0.0, within forty years, by 9.16.5.0.0, there were thirteen.

Because these scenes had to convey a specific subject—sacred ritual—I call the distinct categories of scenes on individual monuments "sculptural themes." Each type of theme portrays a ritual. The glyphs often explicitly state what ritual was being commemorated, such as a capture or an accession to the throne, but sometimes the glyphs refer to holding a kind of

staff or to bloodletting when it is apparent that there is an unstated reason for the bloodletting. In these instances, the dates, which are often anniversaries of previous important events, and the significance of costume elements, as defined by known themes, supply additional information about the significance of the new theme. Interpretations of the sculptural themes form the first major section in this chapter.

As indicated in Chapter 2, several of the principles of order of space and time that were observed by Gary Gossen in twentieth-century Chamula also seem to have governed sculptural composition at Yaxchilan. The placement of symbols in a composition reflected categories of ranking in community life—the hierarchy of society and fundamental categories of discrimination such as the superiority of senior to junior, of high to low, of male to female, and of the changing positions of the sun as a primary ordering principle. Actually it was not the *art* that conformed to such orderings as much as it was the *costume* worn during ritual. So those monuments which show a moment in the ritual in which the ruler displayed the entire spectrum of regalia are the ones which exhibit how the range of semantic niches on the ruler's body functioned during ritual and in monumental art. This will be demonstrated by an analysis of this composition on the local version of the Maya Period Ending or "cosmological" stelae in the second part of this chapter and on a group of ten lintels in the third part.

Sculptural Themes

Compositions in art at Yaxchilan can be divided into thirteen sculptural themes as shown in Table 2. Most are related to themes created at other Maya sites, but all are distinctive compositions created at and for Yaxchilan. This section discusses themes carved on lintels and stelae. The cosmogram theme, which consists of three independent scenes, is better discussed in the section on pictorial syntax at the end of this chapter.

WARRIORS, CAPTURES, AND CAPTIVES

Stelae: 1, 2, 3, 4, 5, 6, 7, 10, 11, 13, 15, 17, 18, 19, 20, 22, always on the river side except Stela 11. Lintels: 4, 8, 12, 16, 26, 41, 44, 45, 46. Steps: Hieroglyphic Stairways of Structures 20 (all glyphic) and 44 (with glyphs and images of captives).

A sculptural scene can be classed as a war scene if the ruler holds a spear, if he wears the war costume consisting of the long scarf, skull backrack, feather bonnet or "Tlaloc" headdress (as shown in Figure 36b), or if a bound captive is present. War scenes on stelae occur on the river side of all Period Ending–cosmological stelae (to be discussed later in this chapter). Their composition is routine—a victorious ruler wears the war costume, holds a spear, and his captive kneels by his side (see Figure 145b).

A scene identical to those on stelae was carved on some lintels, such as Lintel 16, Structure 21. Other lintels, 8, 12, 44, 45, and 46, show the ruler actively taking the captive. In the Structure 44 lintels (Figure 153), Shield Jaguar effects the capture alone, but on Lintels 8 and 12, from later reigns, the ruler has an ally or assistant, and several captives are taken. The Structure 44 lintels were among the first in the Maya area to portray such unprecedented action as leaning down to grasp a captive by the arm, while holding a spear in the other hand. Despite the degree of action in the scenes, other realistic details such as blood and gore are not shown. Nor is the king shown as larger or more muscular than his captive. The victorious outcome of ritual battle seems foreordained by the presence of the war costume and insignia. To the twentieth-century viewer, it seems that the mere approach of the ruler caused his intended victim to fall to the ground, awed by the majesty of the king. After the victim was captured, stripped of ornament, his upper arms tied back with a cord that encircled his neck and sometimes bound his wrists, he continued to gaze raptly at his captor.

Captives always occupy the same register as the ruler in a composition. They are never shown in a separate register, under the ruler's feet, as they are at other sites such as Naranjo. However, in one building, Structure 44, images of the captives were literally underfoot. On five of the stair treads, images of kneeling prisoners are underfoot as one stands immediately in front of the building.

Capture scenes at Yaxchilan are always one component of a larger composition. Even in the case of Structure 44, where only capture scenes decorate the lintels, the stairs include hieroglyphic texts that explain the historical continuity of royal valor in protecting the community's honor among several generations of the Jaguar lineage. When a capture scene appears on one lintel of a building, or on one side of a stela, that scene expresses the war facet of a cosmogram, as will be explained later.

Theme / Ruler	Stelae	Lintels	Other
Warriors, captures, and captives			
Early ruler	33		
SJ	41	44, 23	44 (steps)
BJIV	39, 40	21	
SJII	44?, 20	20	
Bloodletting by penis perforation			
KEJ?	9		
BJIII	6?[a]		
SJ	41		
BJIV	36, 33	21	
SJII	20		
Bloodletting by tongue perforation			
SJ		23	
BJIV	21	21	
Bloodletting implied by bowls of implements			
SJ		23	
BJIV	21	21, 42	
SJII		20	
Vision Serpent			
SJ		23	
BJIV	21	21	
SJII		20	
MKSIII		88?	
Bicephalic serpent with emergent God K			
BJIV	16		33 (steps)
Bloodletting implied by bundles			
BJIV		1, 13, 33	
SJII		54, 55	
God K manikin scepter			
BJIV		1, 13, 33, 42	
SJII		54, 55	
Flapstaff and summer solstice			
SJ	41		
BJIV	40	13, 2	
Ballgame			
BJIV			33 (steps)
Throne scene			
BJIV			39, 33 (roofcombs)
			33 (statue)
			21 (stuccoes)
SJII		54, 55	
		La Pasadita lintel	
		Kimbell Panel	
MKSIII		88	
Cosmogram			
BJIII	6[a]		
SJ	41	23	
BJIV	39, 33, 40	21	
SJII	20, 44?	20	
Holding ritual objects			
SJ		23	
BJIV		1, 33, 42	

[a] Stela 3 was probably originally in front of Structure 6.

Table 2

Sculptural themes (by structure number)

BLOODLETTING BY PENIS AND TONGUE PERFORATION

Stelae: 1, 3, 4, 6, 7, 9, 18, 19, 20, 27, 31, 33, 35, always on the temple side. Lintels: 17, 24.

The sacrifices of royalty are the most frequent explicit and implicit themes of Maya art. Yaxchilan's explicit scenes of bloodletting allowed Proskouriakoff to identify the verb T712, the "hand-fish" glyph, as a bloodletting verb. She noted its appearance with bloodletting equipment, the bowls of obsidian lancets, stingray spines, cord, and bloody paper. The T606 obsidian lancet glyph was associated with the scene of explicit tongue bloodletting on Lintel 24.[1] As mentioned in Chapter 3, there are alternative interpretations of the scenes of flowing liquid on Yaxchilan stelae, but the explicit bloodlettings on Lintels 24 and 17 certainly prove that this theme did exist in Maya art, and suggest strongly that among the substances sacrificed by kings on Period Endings was their own blood.

Common elements of the explicit bloodletting scenes are the presence of the dotted streams that Schele and Stuart showed are blood,[2] instruments of sacrifice such as the penis perforator,[3] the Period Ending costume (see Figure 36*a*), and, on women, a Mexican year-sign headdress adorned with tassels.

Penis perforation scenes on stelae are discussed in the identification of God C in Chapter 3 and in the section on the pictorial syntax on stelae below.

On Lintel 24 (Structure 23) and Lintel 17 (Structure 21) are two well-known examples of females drawing thorny cords through their tongues (see Figures 93, 98). Both women wear Mexican year-sign headdresses and elaborate robes with embroidered or featherwork fringes. The bowl present in both scenes contains spotted strips of paper and the end of the thorny cord, as well as bloodletting equipment. On Lintel 17, Bird Jaguar IV is seated on a pile of rushes. The fact that his legs are spread at the knees is shown by the view of the sole of his right foot slightly elevated from the ground line. The long instrument in his hand could be none other than a bloodletter. The skeletal-serpent-and-monkey-skull headdress that he wears appears three times at Yaxchilan, all in scenes of explicit bloodletting. Another costume item that signifies bloodletting is the striped waistcloth worn by Bird Jaguar IV and Lady Xoc on Lintels 17 and 25 respectively.

The inscriptions on the stelae state that the occasions on which penis perforation was performed were Period Endings and accession anniversaries. The illustrated event on Stela 1 is the Period Ending 9.16.10.0.0, and on Stela 3 it is the completion of a *katun* of rule by Bird Jaguar III. Explicit bloodlettings on lintels occur on a variety of occasions. The date of Lintel 24 is an accession anniversary and a rare Jupiter-Saturn conjunction.[4] The event celebrated on Lintel 17 appears to be the birth of an heir to Bird Jaguar IV. His female companion here is not the mother of the heir, but Lady Ix, a ritual assistant.

Many other symbols and motifs imply that bloodletting has occurred or will occur. They will be discussed in the following sections.

BLOODLETTING IMPLIED BY BOWLS OF IMPLEMENTS

Stela: 35. Lintels: 13, 14, 15, 17, 24, 25, 41, 43.

Proskouriakoff identified the contents of the low bowl or basket on Lintels 24 and 25 as an obsidian lancet, stingray spines, rope, and paper strips upon which the blood was caught.[5] Completed bloodletting is implied by the presence of the bloody strips of paper and the bloodletting bowl on monuments. The bloodletting bowl is held by women and frequently appears in scenes with the Vision Serpent. On Lintels 15, 17, and 25, it is clear that the women have autosacrificed. On Lintels 41 and 43 (Structure 42), the female assistant holds the bowl and Bird Jaguar IV holds another ritual implement. It is not clear who let blood on these occasions. The Structure 42 ceremonies were counterparts to rites portrayed in Structure 1 in which Bird Jaguar IV had a male ally or assistant. The women could have been assisting Bird Jaguar or could have drawn blood from themselves.

THE VISION SERPENT

Stela: 35. Lintels: 13, 14, 15, 25, 55.

On six Yaxchilan monuments, a freestanding serpent appears as a major element in a composition with one or two other figures. It is consistently associated with bowls of bloodletting paraphernalia, although it never appears in scenes where bloodletting is depicted. The serpent usually is positioned above the bloodletting bowls and seems to rise from them. On Lintels 15 and 25, scrolls identified by Stuart as blood intertwine with the body of the serpent (Figure 37*a*, *e*). Some of the serpents have a single head, from which emerges a human head and shoulders. Others (Lintel 25 and Stela 35) are bicephalic, and in at least one of the heads

is a Tlaloc head wearing a year-sign headdress. On Lintels 13 and 14 (Figure 37b, d), the serpent winds in front of the torso of Lady Great Skull but behind her arms. The bloodletting bowls she and her companions hold overlap the serpent in the composition. For some reason, the serpent was placed in a potentially less significant position.

The Vision Serpents occur on a variety of occasions. Lintel 25 is an accession monument of Shield Jaguar. He wears his war outfit, and Lady Xoc holds the bloodletting bowl and wears a skeletal-serpent-and-monkey-skull headdress. Stela 35 records a bloodletting by Lady Ik Skull and names her or someone as *Mah K'ina* on 4 Imix 4 Mol, the day she may have taken an important office at the city. Lintel 14, which was carved much later, records the same date and mentions Lady and Lord Great Skull as protagonists. Lintel 13 is the birth record of Shield Jaguar II. The rationale for the date on Lintel 15 is poorly understood. Lintel 55 has no text. Most of the events upon which the Vision Serpent was portrayed involve entering office or entering life in a royal lineage.

Early interpretations of the scenes with free-standing serpents were guided by the appearance of the human figures emerging from the serpents' upper heads. They were made before the event on Lintel 25 (see Figures 14, 98) was recognized as the accession of Shield Jaguar.[6] Proskouriakoff noted the warrior outfit of the emerging figure and dubbed it the "spirit of a long-deceased warrior . . . whose apotheosis is symbolized by the serpent and the mask."[7] She thought the name of the appearing warrior must be contained in the secondary text, which is now known indubitably to name Lady Xoc (at I2). Although she recognized the name of Shield Jaguar on the lintel, she did not com-

ment on the absence of a portrait of that king. David Stuart[8] and I accept the identity of the emerging warrior as Shield Jaguar, whose name appears in the normal position on a Maya monument, just above his head. Lintel 25 may, as Proskouriakoff suggested, portray the transformation of a royal person to a divine person—a royal prince transforming into a divine king—but it is the apotheosis of a long-dead warrior only in the sense that Shield Jaguar is another in a lineage of kings who assume the responsibilities of ritual warfare.

Recently, Linda Schele and David Freidel have deciphered the text at G1 and G2 as the name of the lineage founder, Yat-Balam (Progenitor Jaguar), and suggested that this is the identity of the figure within the mouth of the Vision Serpent.[9] However, the event is still, after all, Shield Jaguar's accession day, when he performs the role set forth by Yat-Balam. The image of a warrior in the serpent mouth is a metaphor for the psychic transition from mere human to king. The metaphor recalls the spiritually charged transformation made by Yat-Balam and connects the two kings in a continuous tradition. Shield Jaguar becomes, in that moment, the sacred royal person and, through his sacrifices, communicates with his lineage founder.

George Kubler, on the other hand, interpreted the serpent on Lintel 25 as a vision. He said:

At Yaxchilan the direct representations of visionary and penitential rites are unique. . . . In the penitential scenes a devotee draws blood from the tongue in the presence of a priest (Lintels 17 and 24). In the visions, a human being . . . emerges from the open jaws of the reptile (Lintels 18 [*sic*], 25, 13, and 14). The association of

Trait	Lintel 25	Stela 35	Lintel 13	Lintel 14	Lintel 15	Lintel 55
Fan motif	+	+	−	−	−	−
Tlaloc	+	+	−	−	−	−
Beard	+	+	+	0	+	+
God C	−	−	+	+	−	−
Fleshed	+	+	+	−	+	+
Skeletal	+	+	+	−	−	−
Blood/smoke scrolls	+	−	−	−	+	−
Bicephalic	+	+	−	−	−	−
Bloodletting instruments	+	+	+	+	+	+

+ Trait present.
− Trait absent.
0 Eroded area.

Table 3

Presence of variable traits in Vision Serpents

37.

Vision Serpents at
Yaxchilan: *a*, Lintel
25; *b*, Lintel 14;
c, Lintel 55;
d, Lintel 13;
e, Lintel 15. Details
from drawings by
Graham (*a*, *b*, *c*, *e*)
and von Euw (*d*) (all
from Graham
1977:35, 37, 39, 55;
1979:115).

visions and penitence, of blood-letting and apparitions, occurs only at Yaxchilan, and it seems to prefigure innumerable Toltec and Aztec representations of human sacrifices and plumed serpent symbols.[10]

This suggestion of continuous narrative sequence—that on Lintel 24 the woman performed a sacrificial rite which caused a loss of blood leading to hallucination, portrayed on Lintel 25—was elaborated by several authors. Peter T. Furst suggested that Lintels 24 and 25 "may be read in sequence, the one a function of the other." Furst compared the self-mutilation depicted on Lintel 24 to the Plains Indians Sun Dance vision quest for "divine guidance from deified ancestors or guardian spirits in an alternate state of consciousness or ecstatic trance triggered . . . by a massive physical jolt to the system."[11] In this interpretation, the appearance of a deified ancestor on Lintel 25 was a direct result of the deliberately produced ecstatic trance. Furst's suggestion that there is narrative sequence on these lintels needs some examination in light of the sequence of events and discontinuities of iconography of the entire program of Structure 23.[12]

There are some fundamental similarities between the Plains vision quest and the Maya self-inflicted bloodlettings, but also some differences. In Maya societies, the ancestors are believed to exist in the sacred mountains surrounding a ceremonial center, or in water holes and caves.[13] They are reached through ritual sacrifice, on a fairly frequent basis, and communicating with them does not necessarily require such a massive jolt to the body. Moreover,

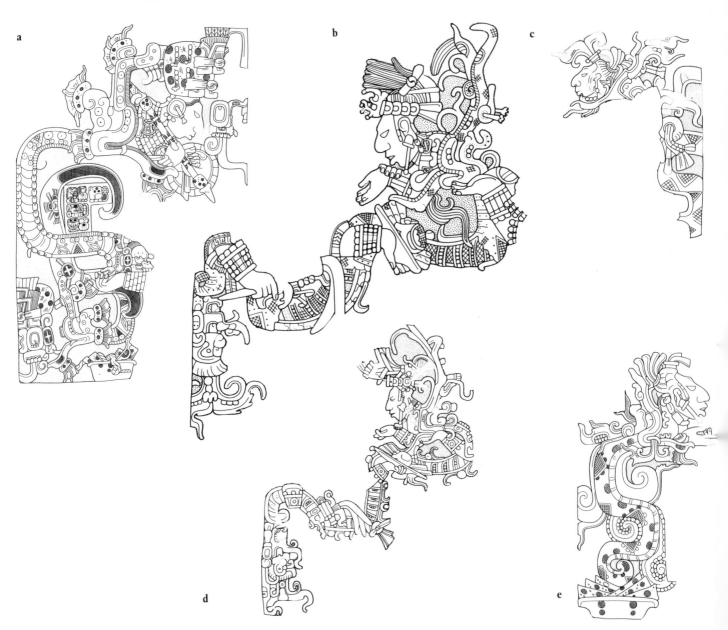

a

b

c

d

e

there is no documentation among Colonial or modern sources of a specific quest for a vision of supernaturals. Another aspect of Furst's proposal, that the pain and blood loss caused by the tongue mutilation of Lintel 24 was endured as a means for attaining contact with the ancestors, is supported by the fact that the date of Lintel 24 is four *katuns* after the accession of Shield Jaguar's father to the throne. Therefore, as Proskouriakoff and Furst suggested, the scene on Lintel 25 depicts contact with ancestral traditions, specifically, the traditions of war and dynastic succession. However, the term "vision quest" refers to a specific set of ritual practices among the Plains Indians that do not have a parallel among the Maya so far as I know.

Although they noted that the serpent appeared above the bloodletting bowl, neither Kubler nor Furst addressed the problem of the substance of the serpent. David Stuart associates the dotted scrolls, *yax, kan,* and shell elements with blood.[14] In her argument for the meaning of the serpent on the Hauberg stela, Schele adopted the concept of the "vision quest" from Furst, noted Stuart's identification of the blood connection of the serpent, and began to call this serpent the "Vision Serpent." Schele pointed out that a God C glyph appears on Vision Serpents at Yaxchilan, Seibal Stela 9, Tikal Temple IV, Lintel 3, etc., and said: "I suspect that the skeletal God C and scroll design form a unit that functions as a variant of the T41 God C blood glyph and, therefore, specifies blood as the source or medium of the vision."[15] It is now shown that God C can be translated *ku,* or "sacred," and is not necessarily only blood.

In their study of the figural bas-relief at the Cave of Loltun, David Freidel and Anthony P. Andrews suggested that dots, volutes, and undulating scrolls identified materials that fell into the category of liquids: blood, fire, smoke, and water. They pointed out that these liquids were often involved in ritual sacrifices. Agreeing with Stuart and Schele that the serpent must be a vision attained through an altered state provoked by autosacrifice, they interpreted the Vision Serpent as a manifestation of the smoky scrolls of burned sacrificed blood, and also of the smoke and clouds associated with fire and rain, gifts of the supernaturals to humans.[16]

Ethnographic observations of Maya ritual practices can help us to place Freidel and Andrews' interpretations in a Maya frame of reference. Gary Gossen states that "deities consume essences and humans consume substances. This is one of the reasons that ritual speech, music, candles, incense, tobacco, rum, fireworks, flowers, and leaves accompany most Chamula rituals. They emit heat, smoke, aroma, or sound, which serve as the gods' food. Men may participate in the religious experience by consuming, producing, or simply being in the presence of the gods' ritual substances."[17] The presence of any of these substances and of a formal ritual genre of language provides a state of increased heat. The life cycle among the modern Chamulas gains heat as the individual matures sexually and socially and assumes cargoes or becomes a shaman. The heat metaphor also exists in Yucatec.[18] If the concept of ritual heat, so pervasive among modern Maya, also existed during the Classic Period, then the scrolls on Lintel 25, and perhaps even the Vision Serpent, may refer to the ritual heat accruing to Shield Jaguar as he acceeds to the throne as king.

The Classic Period scene includes many of the components observed by Gossen in twentieth-century life-cycle rituals. He notes that "Life crisis rituals and cargo initiations include symbols of both life (hot and integrative) and death (cold and disjunctive)."[19] Symbols of death also appear on the lintel commemorating Shield Jaguar's accession in the form of the loss of blood indicated by the bloodletting bowl, and the skulls on Lady Xoc's headdress and arm.

In review, the Yaxchilan Vision Serpents occur on monuments illustrating important moments of transition in the life of a royal Maya: accession to the throne, a transformation from human to divine status, and birth. At these crucial moments Maya individuals gained ritual efficacy expressed in a metaphor of heat. The heat possessed by an individual and by ritual substances and speech rendered human activities and sacrifices more palatable to the supernaturals. In the *Popul Vuh,* this was metaphorically illustrated by the exchange made by Tohil and humans. In return for the gift of fire, the people should nourish the gods with blood. It seems likely that, as Freidel has suggested, this covenant was renewed between the Maya king and the gods, specifically God K, the First Ancestor and Tohil of the *Popol Vuh,* and the god named as the object of the bloodletting verb on Lintels 25, 13, 14, and Stela 35. Whether the Vision Serpent was the embodiment of form that ritually heated substances take, as I suspect, or a hallucination brought about by blood loss is still not proven satisfactorily.

BICEPHALIC SERPENT
WITH EMERGENT GOD K

Lintels: 38, 39, 40. Steps: Structure 33, Steps II and III.

During the reign of Bird Jaguar IV, he and his artists began to depict the sculptural theme of a bicephalic serpentine creature supported by a seated male or female. On the three lintels of Structure 16 (Figure 68), a complementary opposition is set up between portrayals of two seated women holding fleshed bicephalic serpents, flanking Bird Jaguar IV in a ballgame pose holding a skeletal bicephalic serpent. Other than the distinction between fleshed and skeletal, the serpents are identical. The head, shoulders, and arms of God K emerge from both mouths of the bicephalic serpents. Smoke flows from the torch or cigar infixed into God K's forehead. Emanations which are similar in form to the smoke of God K's cigar come from the corners of the serpent mouths.

On the Structure 33 staircase, Steps II and III and maybe I show similar scenes (Figure 111). Seated women hold bicephalic creatures, but the two heads are not identical, and an additional large, gaping serpent mouth frames the outer edge of the two-step composition on Steps II and III. On Step II, the serpentine front head frames a foliated God K type image, and the rear head is a puffy-snouted supernatural. On Step III, a serpentine front head encloses a portrait of God K, and the rear head or tail has no serpent image, but a roman-nosed supernatural head. Identifying characteristics have eroded from these extremely shallow reliefs, making it difficult to identify securely whether these are Vision Serpents or bicephalic serpents. In the absence of the bloodletting bowls and paraphernalia usually associated with Vision Serpents at Yaxchilan, I consider these most similar to the Structure 16 serpents.

In his paper on autosacrifice among the Maya, Stuart argued that representations of serpents in Maya art refer to blood.[20] It is indisputable that they occur in contexts in which royal blood sacrifice occurred, but this is true of a vast majority of Maya scenes. At Yaxchilan they occur with the bloodletting and other verbs, with scrolls of liquids, and with God K. In ethnographic accounts of Maya tales, snakes are usually linked with the "earth god," a fat, very wealthy Ladino who lives in caves and controls thunder, lightning, rain, and the hunting of animals. A Chorti tale points to snakes as being very destructive and dangerous but also full of money, which is something foreign that only the earth god has in quantity. Another tale reveals that when a man outwitted a snake and was able to chop it in half, what spilled out was not the expected money, but molded incense. The man took the incense home, put it in jars, burned some, and censed the jars for eight days, then opened them to see that the incense had turned to money.[21] From another part of the Maya world, similar tales exist in Tzotzil. Gossen reports that snakes are believed to be transformations of the earth god, who is very rich.[22] In none of these stories do snakes signify blood, but they do involve destruction, and they are transformations of a powerful supernatural who controls wealth in terms of foreign substances like money, but also game, rain, etc. It is very interesting that the Chorti tale associated the secret wealth of snakes with incense and smoke. This suggests that the modern and ancient concepts of snakes may have some parallels. The Vision Serpent is associated with burnt offerings on the monuments, and snakes are associated with incense among the modern Chorti.

The glyphic statements and calendrical information provide a historical context for the scenes. The glyphs on the three lintels of Structure 16 state that the individuals let blood to God K. The verb used is the T714 hand-fish glyph, which refers to conjuring visions.[23] In each instance, a God K glyph follows the bloodletting expression. Since the name of the protagonist follows the God K glyph, God K, associated with divine lineage, is the object of the verb. Bird Jaguar and the ladies autosacrificed for their ancestors. The texts on these lintels closely correspond to the imagery. The protagonists are named and portrayed, the object of the action is named and portrayed, and the depiction of the action, the bloodletting, must be related to the serpent. The serpent must be either the blood, as Stuart would suggest, or the manifestation of the ritually hot substances blood, incense, speech, and whatever else accompanied the ceremonies, as the ethnographic information seems to suggest.

Another line of evidence for the interpretation of these scenes is that the dates of the ceremonies are solar-year anniversaries of previous events by deceased women of the previous generation. The Lintel 38 date, 3 Ix 7 Mol (9.16.12.5.14), is $22 \times 365.25 - 3$ days after the bloodletting by Lady Ik Skull on 4 Imix 4 Mol (9.15.10.0.1).

The Lintel 40 date is 13 Ahau 18 Zip 9.16.7.0.0. The verbs are eroded, but were probably the same as those on the other two lintels.

This date is also a solar-year anniversary of an important date in the life of the other important woman of the previous generation, now an ancestor—it is $9 \times 365.25 - 1$ day since Lady Xoc's death.

The Lintel 39 date is 4 Imix 4 Mol. On this monument to that important day, Bird Jaguar IV sacrifices blood to an ancestor. The verbal phrase used on this lintel is followed by an *u cab* phrase, as is that on Stela 35 of Structure 21. The *u cab* phrase means "under the auspices of" or "in the territory of"[24] and generally occurs when a person not the ruler performs a ritual, but here only one individual is named. Lintel 39 was erected at least seventeen years after the date it commemorates. I think that Bird Jaguar IV commemorated the day when his mother went through a life-crisis ritual, assuming some community sacrificial duties, and that he used the *u cab* phrase to clarify that the throne was not his at that time.

In summary, the bicephalic–God K serpents in Structure 16 were used to signify bloodlettings directed to God K, the sacred ancestor, on days that are solar-year anniversaries of important dates in the lives of the female ancestors of the previous generation. The bicephalic serpent may be the zoomorphic form of ritually hot sacrificial offerings through which the Maya reach and summon God K into the worldly realm.

BLOODLETTING IMPLIED BY HOLDING THE BUNDLE

Lintels: 1, 5, 7, 32, 53, 54.

Six lintels at Yaxchilan portray a female holding a bundle in a scene with a male ruler. Although the overall appearance of the group of lintels is similar—each lintel shows two individuals, and the male holds a God K manikin scepter on all lintels but one—the costumes and headdresses worn are not static, and the composition of the lintels changes. The scenes portray similar information, but were not slavishly copied after an original.

The women wear robes over long gowns. The garments either have diamond patterns or are plain cloth with ornate borders. The headdresses worn by the women vary and include combinations of the long-snouted-beast headdress, the bird-and-flower diadem, a possible GI diadem (Lintel 1), and the quadripartite headdress. The males wear the drum-major headdress except on Lintel 7. They always wear a half-backrack. Different skirts are worn by the kings. The God C loincloth is worn once or twice, and the pointed hipcloth appears on Lintel 54, both items indicating that the ritual includes bloodletting.

As an accoutrement of the rites of bloodletting, the bundle first appeared at Yaxchilan at 9.16.6.0.0 in three buildings dedicated by Bird Jaguar IV. Three bundle lintels, 1 (in Structure 33; see Figure 114) and 5 and 7 (in Structure 1; see Figure 44), were dedicated on that date as part of the program of decorated architecture that documented Bird Jaguar's accession. They portray the king with each of three ladies:

ballgame

L 1	9.16.1.0.0	Lady GS	Accession of BJIV
L 5	9.16.1.2.0	LAI	Accession-related
L 7	9.16.1.8.8	Lady Ix?	8th anniversary of ballgame

These three lintels are part of the program of iconography made by Bird Jaguar to document the ceremonies associated with his accession. They suggest that accession ceremonies extended before and after the actual accession day, and that bloodletting was part of the entire series of accession ceremonies.

Lintel 32 of Structure 13 (Figure 64) was probably dedicated in 9.16.10.0.0 as part of the Period Ending ceremonies and of the construction program associated with Stela 1 and the modification of the central area of the Main Plaza by Bird Jaguar IV (see Structure 13 in Appendix 1).

| L 32 | 9.13.17.15.13 | LIS, SJ | Jupiter-Saturn, accession anniversary |

Lintel 32 is an interesting monument because it was commissioned long after the recorded event. Bird Jaguar commissioned it to commemorate the day, two *uinals* after his birth, when his father performed a dynastic event on the stationary conjunction of Jupiter and Saturn. He had his father portrayed in clothing that Shield Jaguar never wore, in clothing that had become the mode in the day of Bird Jaguar IV. He also commissioned a portrait of his mother acting in the Jupiter-Saturn ceremony which Lady Xoc had performed in A.D. 709 and which had been commemorated previously on Lintel 24.

Lintels 53 (Figure 157) and 54 (Figure 156) were also historical commemorations when they were carved. They were probably commissioned by Shield Jaguar II around 9.17.0.0.0 (see Appendix 1, discussions of Structures 54 and 55).

| L 54 | 9.16. 5. 0. 0 | Lady GS, BJIV | Period Ending |
| L 53 | 9.13.17.15.13 | LIS, SJ | Jupiter-Saturn, accession anniversary |

Lintel 54 shows Shield Jaguar II's parents holding the bundle and God K scepter on the next Period Ending after his own birth. This is somewhat analogous to the situation commemorated on Lintel 32. On Lintel 53, Shield Jaguar II portrayed his paternal grandparents holding the scepter and bundle on what is surely intended to be the same day as the Lintel 32 event, two *uinals* after the birth of Bird Jaguar IV. Was this redundancy perceived to create greater ritual potency?

The bundle was used pictorially on accession-related monuments and those commemorating bloodletting shortly after the birth of an heir. It was used three times at Yaxchilan to document historical events of previous reigns.

GOD K MANIKIN SCEPTER

Lintels: 1, 3, 7, 32, 42, 54, 53, 52, 58.

The God K manikin scepter is an object that portrays God K with a leg that is a serpent body and head. Spinden discussed the manikin scepter and its appearances in the Maya area. A review of the literature concerning the identification of God K is given in Schele's article on the iconography of the Group of the Cross at Palenque.[25]

At Yaxchilan, the God K manikin scepter most frequently appears in conjunction with a bundle on accession, bloodletting, and commemorative occasions. Those dates are given above. The other dates associated with the God K manikin scepter are as follows (see Figures 114, 148, 157, 156).

Dedicated 9.16.6.0.0:

| L 3 | 9.16.5.0.0 | Ally, BJIV | Period Ending |
| L 42 | 9.16.1.2.0 | CoM, BJIV | Accession-related |

Dedicated after 9.17.0.0.0:

| L 52 | 9.16.15.0.0 | SJII, BJIV | Period Ending |
| L 58 | no date | SJII, Lord GS | Bloodletting symbolized |

The image of the ruler holding a shield in one hand balanced by a God K manikin scepter in the other while standing on a captive was standard accession and Period Ending iconography in some Central Petén and Petex-Batun sites, but was never used at Yaxchilan. The manikin scepter was a part of the local version of accession and Period Ending, and hence, bloodletting, iconography.

THE FLAPSTAFF
AND SUMMER SOLSTICE

Stelae: 11, 16. Lintels: 9, 33, 50.

Several monuments show Shield Jaguar or Bird Jaguar IV holding an unusual staff with quatrefoil-shaped cutouts (see Figure 45). In each instance the costume is extremely similar, and is unique to the holding of the flapstaff. The most unusual items of the costume are a full-length backrack and a chest ornament composed of a series of shrunken heads, sections of spondylus shells, and a shrunken torso. The flapstaff itself is a unique feature of the theme. It was probably contrived from a frame of wood, to which cloth was attached. Quatrefoil-shaped holes were cut on three sides from the cloth, and the cutout area flapped on the fourth side of the quatrefoil like a hinge, hence the term "flapstaff." As observed by Elizabeth P. Benson, the cutting of fabric was very significant, for Maya cloth was woven to fit its purpose and never cut or tailored with darts.[26] The negative shapes themselves, the quatrefoils, must have had a symbolic significance.

The use of the quatrefoil appears in Mesoamerica well before Maya times. In the Olmec relief carvings at Chalcatzingo, a quatrefoil forms the open mouth of a monster, sprouting plants in its corners.[27] Relief I of that site is the well-known image of a king within a semi-quatrefoil which is again the mouth of a monster. Quatrefoils are related to the mouth of the Earth Monster and hence to caves, the mouths of the earth.

The quatrefoil can be the cleft forehead or the mouth of the Cauac Monster.[28] From the cleft forehead or mouth, supernaturals or ancestors appear (cf. Tikal Altar 4). On the Altun Ha jade plaque,[29] the quatrefoil is at once the forehead of the Earth Monster, the throne for the ruler, and the cartouche for an ancestor portrait. On the edges of the top of the Sarcophagus Lid at Palenque, Pacal's ancestors appear from semi-quatrefoil cartouches.

The quatrefoil functions as a depiction of the opening of the cosmic central axis at the crossroads of the four directions. More specifically, it is the passageway between the celestial and Underworld realms. The shape of the qua-

trefoil is similar to that of the glyph for the sun, *k'in.* It may refer to the shape of the opening where the sun is swallowed nightly and burped out daily.

The ritual function of the flapstaff is partially revealed by its associated costume. The most completely depicted of these costumes, on Lintel 9 (Figure 45), shows the king as an impersonator of GI as the sun. A God C "sacred axis" medallion tops the headdress, which is tall and cylindrical. A fleshed serpent, perhaps alluding to the *chan* sky-serpent homonym, appears in front, as though rising from the headdress. On the front of the headdress, GI as sacrificer sits on a Witz-head throne with a serpent body whose rear head contains the GI with the hank of hair. Perhaps these two aspects of GI are the rising and setting sun, or the sun at its northernmost and southernmost positions on the horizon. Perhaps the sacrificer-sun is related to the severed heads hanging on Bird Jaguar's chest. Lord Great Skull's headdress is the quadripartite badge, the sun (and deceased royal ancestors) in its daily round. His headdress is topped by a skeletal serpent, in opposition to Bird Jaguar's fleshed one. Here the path and activities of GI are stressed, though references to GIII appear in the shields and in the jaguar-claw skirts.

Calendric, architectural, glyphic, and ethnographic evidence shows that the flapstaff monuments at Yaxchilan refer to a ritual that was celebrated within three days of the summer solstice; see Table 4.

At Yaxchilan, several buildings are oriented toward the summer solstice sunrise. The first known building at Yaxchilan that faces summer solstice sunrise, Structure 41, is part of an astronomical hierophany (see Figure 43a). On summer solstice, the sun's first rays make a semi-quatrefoil of light on the floor as they pass through the stepped shape of the doorway. A similar phenomenon occurs at Palenque, in House E, where on summer solstice sunrise, light passes through a small semi-quatrefoil-shaped opening to form a complete quatrefoil

of light. Thus the relationship between summer solstice and the quatrefoil appears architecturally as well as on the flapstaff.

Ethnographic data show that for modern Chorti, the solstices demarcate a period of overlapping ritual responsibilities.[30] As Rafael Girard describes them, the rituals concerning the seasons of the year function on several levels of the society: celestial, political, and agricultural. The rituals of summer solstice involve the positioning of a statue in one of two temples. The Chortis know that summer solstice is the day that the sun reaches its northernmost declination in the sky, and that on winter solstice the sun is farthest south. According to Girard, they duplicate this celestial division of the year through a ceremony in which an idol (obviously signifying the sun) is carried from a southerly temple to a northerly one on winter solstice and back again on summer solstice.

In the Chorti sphere of political/religious leadership, the solstices are the entry and exit points of service for the *sacerdotes* (priests), each of whom serves an eighteen-month term. Entering service on winter solstice, the first year of his service, the *sacerdote* honors the chair of the idol which signifies the sun. When winter solstice returns, he begins a period of relative inactivity, during which he devotes himself not to interceding with the deity, but only to honoring the vacant seat of the idol which is ensconced in the other temple. Summer solstice marks the day that he terminates his duties, having passed responsibility on to the new *sacerdote*, who has had the benefit of a "backup" *sacerdote* for the past six months. The ceremonies of the solstices begin 20 or 21 June and continue for two or three days until the chair and its statue arrive in the second temple.

The rites performed in the temples are performed in a parallel manner by the *paterfamilias* in the milpas. "In this manner, an agricultural labor is transformed into a ritual act."[31] In the Central Maya Lowlands, the duties of the

Monument	Julian Date	Days from Solstice	Calendar Round		
Stela 16	6-23-736[a]	+3	7 Chuen[a]	19 Yaxkin	
Stela 11	6-22-741	+3	12 Cib	19 Yaxkin	
Lintel 33	6-21-747	+2	5 Cimi	19 Yaxkin	
Lintel 9	6-16-768	−2	1 Eb	End of Yaxkin	
Lintel 50	No date recorded				

Table 4

Flapstaff monuments and summer solstice

[a] Possible reconstruction; see Appendix I discussion of Structure 41, Stela 16.

agricultural year correspond to the division of the year by the transit of the sun. The first zenith passage, which in the Chorti area is about 1 May, is the time to plant, because the rainy season begins shortly thereafter. The rains continue until summer solstice, after which begins a *canícula* or temporary dry spell, during which a second planting is accomplished. The *canícula* lasts roughly until the second zenith passage in the beginning of August, when the rains fall heavily again. So usually, sunrise during this period is not obscured by rainclouds.

Similar concepts of the solar half-years are documented by Helen Neuenswander in the Achi communities of highland Guatemala.

> The Achi are aware that the sun is in the south in the beginning months of the dry season and in the north in the beginning months of the rainy season. The concepts which find fullest linguistic expression are concerned with the size of "our father," the sun, his position (he, too, lies on his side), his sudden conversion from one length of day to another, and his relationship to the seasons. . . . In June, the process reverses and the days become "short" (on what is, to a Westerner, the longest day of the year). Another application of the concept of "grabbing onto the pattern to come" seems to be operating here.[32]

The modern Maya concepts of overlapping periods of ritual responsibility are found on two Classic Period monuments. On two of the Yaxchilan monuments, Stela 11 and Lintel 9, two individuals are shown exchanging the staff. On Stela 11, Shield Jaguar performs the last commemorated act of his life at approximately age ninety-five. His last recorded ceremony is passing the flapstaff to Bird Jaguar IV on summer solstice. Five days later, Bird Jaguar's mother performed a bloodletting and she (or an undepicted supernatural) was named with the title *Mah K'ina*. The ritual responsibility at Yaxchilan apparently overlapped between Shield Jaguar, Lady Ik Skull, and Bird Jaguar for ten years until the woman died and the son acceded. On Lintel 9, Bird Jaguar IV is recorded performing his second-to-last official act—dressed as GI, he hands the staff to Lord Great Skull, who wears a solar headdress, on summer solstice. Lord Great Skull never acceded to the throne, but he remained important on the monuments of Shield Jaguar II, where he was portrayed in the same costumes and positions as the ruler.

In addition to ethnographic evidence, tentative linguistic reconstruction of the verbal phrases provides a clue to the meaning of summer solstice rituals. The verbs on the summer solstice monuments are practically identical. Each verbal phrase consists of a T515b:103:683 auxiliary verb and the *ti* locative plus verbal noun construction, T59:563:130:561. This might be pronounced *mul-taj-aj t(i)-aj + ka wa' chan.*[33]

In Ch'ol	*aj*	*kaw*	*wa'*	*chan*
means	he	open stopped	standing	sky

This phrase might refer to the swing of the sun, which lingers at its northernmost declination on the horizon for several days at summer solstice. For a group of people performing horizon observations of the sun, this is one of the most obvious stations of the year, when the movement of the sun slows to a standstill.

Many aspects of the flapstaff scenes indexically refer to summer solstice and the passage of ritual responsibility from an outgoing to an incoming ruler. The dates fall on summer solstice and during times of transition between reigns. Headdress elements refer to GI as the sun and Chac Xib Chac as a sacrificer. Even the quatrefoil-shaped holes in the flapstaff refer to a solar-architectural hierophany. The verb on each of the monuments may refer to a standing still of the sky, perhaps suggesting the imperceptible motion of the sun on the horizon near summer solstice. Two of the summer solstice scenes, those on Stelae 11 and 16, actually face the point on the horizon where the sun rises on summer solstice. Paradoxically, Lintels 33 and 50 face the winter solstice sunrise. The importance of summer solstice as a central focus of community ritual and identity at Yaxchilan is reiterated by the orientation of the two main axes of the site. These data are discussed in Chapter 5.

THE BALLGAME SCENES

Hieroglyphic steps: Structure 33, Steps I, IV–XIII.

Eleven of the thirteen carved stair risers set in front of Structure 33 illustrate ballgame scenes (Figures 111–112). In these scenes, a solitary ballplayer is shown resting on one knee, the arm opposite his knee outstretched for balance. The players wear elaborate headdresses adorned with many plumes, and feather backracks. One

figure, on Step VIII, is shown from back view, so that the entire Cosmic Monster backrack is visible.

References to the Underworld and/or to the agricultural processes of raised-field agriculture are made by the fish-eating-waterlily headdresses. Faint lines around the faces of several of the players suggest long-lipped masks similar to those worn by the supernaturally attired dancers in the lower register of Bonampak Room 1. Thus, headgear on the players indicates the cosmic realm in which the scenes occur.

Large playing balls are present in each scene. They are incised with a number 13, 12, or 9 and an Imix compound, or the image of a nude, bound captive similar to the prostrate figures seen at other sites as the basal panels of stelae. Glyphs beside the bound figures presumably name them, but the glyphs are too eroded to read.

An architectural backdrop for the ballgames is provided by the arrangement of the hieroglyphic text on Steps VI, VII, and VIII, which form a step-shaped area on which the ball bounces. Similar treatment of ballcourts as pyramidal steps occurs on several Late Classic polychrome figural pots, and perhaps in the murals at Bonampak.[34]

The glyphic texts are eroded on most of the risers, but enough can be made of some of the glyphs to identify four or five individuals and two dates. Step VI names Shield Jaguar, and the date is a *hotun* ending. Step VII has a well-preserved, complex text that names three mythological protagonists, First, Second, and Third Ah Knot Skull. The dates associated with the supernaturals are not fixed in the Long Count. A long date that gives 13, or completion, in eight positions prior to the *baktun* glyph begins the historical side of the text. The series of thirteens stresses that the event was locked into tremendously large cycles of time. The date 9.15.13.6.9 3 Muluc 17 Mac recorded for the ballgame event and associated bloodletting[35] is approximately seven years before Bird Jaguar acceded to the throne, during the period of overlapping ritual responsibility with his father and mother. The series of steps serves as an ancestral gallery for the king who commissioned them, Bird Jaguar IV.

An unusual feature of the ballgame scenes is that they are not where we might expect them to be, that is, in the ballcourt. Instead, they are on Bird Jaguar IV's accession-anniversary monument. Although dates and individuals from different reigns appear, it is likely that all or most of the monuments were commissioned simultaneously by Bird Jaguar IV, or at least that they were placed here together when the building was dedicated in 9.16.6.0.0. Taken as a whole, the steps represent a gallery of individuals important to Bird Jaguar IV: grandfather, father, several of his contemporaries, with himself, of course, in the center, playing ball. Conversely, in the ballcourt are ancestor portraits, as proven by the cartouches framing the images.

The ballgames portrayed here must have had supernatural significance. The headgear refers to Underworld or agricultural activity. The backracks depict the Cosmic Monster. Two dwarfs marked with Venus signs accompany Bird Jaguar IV on Step VII. Deceased ancestors are recorded as having participated in this ballgame during their lifetimes. This leads me to suspect that either the ballgame was played for the memory of previous rulers, just as Hunahpu and Xbalanque went to Xibalba to avenge the destruction of their older brothers, or the ballgame was played by the ancestors in the Underworld, and what happened on earth was a mirror of this. Ballgame scenes at Yaxchilan seem to tell of the interaction between the rulers and the *xma'it*, people who are inside the earth.[36] When considered in the context of the sculptural program of Structure 33, the ballplayer stairway is the Underworld segment of a cosmogram, with the lintels forming the earthly realm devoted to bloodletting and inter-level communication, and the stucco sculpture on the entablature and roofcomb representing ancestors who have ascended to the celestial realm.

THRONE SCENE

Lintels: 51, 55, and 57. Stucco wall panel in Structure 21. Three-dimensional statue and roofcomb, Structure 33. Roofcomb sculpture, Structure 39.

A lifesize stucco relief was recently discovered during the excavation of Structure 21 on the inside rear wall. In it, five cross-legged figures are seated on a long throne composed of the body of a split serpent with heads on each side and a central frontal head. Since "snake" and "sky" are homophonous in most Maya languages, this is probably a reference to the Split Sky Emblem Glyph of Yaxchilan and serves as a locality indicator. These five individuals are all depicted seated on the throne of Yaxchilan, suggesting that they enjoy similar status. The five most important persons in the reign of Bird Jaguar IV (who surely commissioned this sculpture as he did the lintels of this structure) are

he, Ladies Ix, Ah Pop Ik, and Great Skull, and Lord Great Skull. The stucco relief shows two men and three women seated on the throne of Yaxchilan. They are likely Bird Jaguar in the center, and the Lord and Ladies seated at his sides. The fact that an image of Lady Ik Skull, the mother of Bird Jaguar and possible relative of Lord and Lady Great Skull, is placed in front of this image, adds some strength to the conjectural identity of these unnamed figures.

In the latest epoch of Yaxchilan, three throne scenes were carved on Lintels 51, 55, and 57. Throne scenes showing a Yaxchilan ruler, specifically Shield Jaguar II (Chel-te), were also created at neighboring cities tied politically to Yaxchilan.

Lintel 57 shows a robed individual with an elaborate hairdo seated on a throne and gesturing to the person standing on the left of the lintel (see Figure 156). An enormous belt and a large water bird eating a fish make up the unusual costume of the standing figure, who is named glyphically as Lady Great Skull. Shield Jaguar II's name appears above the enthroned figure.

Lintel 51 is seriously eroded (see Figure 157). A cross-legged figure sits on a frontal monster-head throne. The personage holds what appears to be the type of bicephalic serpent seen on the lintels of Structure 16 and Steps II and III of Structure 33. No glyphs were carved on this monument.

Lintel 55 was situated considerably out of the main area of Yaxchilan, about a kilometer southeast of Structure 54. Its imagery is certainly within the Yaxchilan tradition (see Figure 159). In a dual-figure composition, the male sits on a low throne and faces a female who holds up a bowl of bloodletting paper. Behind her writhes a serpent from whose mouth emerges a profile human head. On the ground between the two main figures is an incensario similar to the one on the rear of Stela 35. No glyphs were carved on this late monument.

On an elegantly executed panel from Laxtunich, now in the collection of the Kimbell Museum of Fort Worth, is a tri-level throne scene (see Figure 38a). The complex composition parallels those of Piedras Negras Stela 12 and the Bonampak murals, which are roughly contemporary with this monument. Shield Jaguar II, named on the lintel as Chel-te of Yaxchilan, inclines from his position on the throne toward a figure holding a rattle and whisk who partially kneels on a steep stairway. Below the throne are one seated and two kneeling prisoners, all bound and stripped of their finery. One holds bloodletting implements.

A lintel from La Pasadita, now in the Metropolitan Museum of New York, also shows Shield Jaguar II enthroned and receiving a Tlaloc headband from a subsidiary, presumably a chief of La Pasadita (Figure 38b).

Throne scenes are fairly common on roof-comb sculpture in the Late Classic Period at several cities. The towering roofcombs of Tikal Temples 1 and 2 were carved with huge portraits of Ruler 1 and his wife. The Temple of the Sun at Palenque was decorated with an image of a king enthroned and flanked by bicephalic serpents. Similarly, at Yaxchilan, the remnants of stucco sculpture on several buildings suggest that high-relief, enthroned kings were a regular motif on roofcombs. This is clearly the case on Structure 33, where the armature of the seated figure is clearly discernable. Similar armatures appear on Structures 39 and 40, and seated enthroned figures appeared in niches on Structures 20, 33, 40, and 39.

All of the approximately one hundred figural scenes on monuments at Yaxchilan can be classified with the eleven themes discussed above. Some of those themes—the summer solstice, tongue bloodletting, active captures, holding the bundle, holding the bloodletting bowl, and holding the bird-cross and other staffs—rarely occur outside Yaxchilan. Other modes of representing the fundamental Maya subject matter that are commonly found at many sites, such as holding the bicephalic serpent bar and rulers standing on bound captives, are rare at Yaxchilan. The formulation of similar sculptural themes and the use of similar costume elements can be observed within regions of the Maya area. A study of the mechanisms of sharing visual and ritual symbolism, and the extent to which it was shared, would make a valuable complement to studies of regionalism in settlement patterns, ceramic wares, and environmental-subsistence practices. Because Yaxchilan kings and artists deliberately avoided copying sculptural themes from other sites during the Late Classic, I can only conclude that they chose to innovate unique scenes to express their own vision of society and to create a local identity based on their own visual history.

Pictorial Syntax: The Cosmological–Period Ending Stelae

Over thirty stelae have been found at Yaxchilan. Of many, only small fragments survive, but the patterns of iconography are so regular that these are often enough to determine the total original image. Twelve Late Classic stelae

were very similar. These twelve were carved on two, and sometimes four, sides. They were clustered in front of Structures 20, 40, 41, 18, 39, and 33, and are Stelae 1, 3, 4, 6, 7, 8, 10, 11, 18, 19, 20, and 31, the stalactite stela in front of Structure 33. Not only the imagery but sometimes also the dates of the eroded sides can be reconstructed. The descriptions of the stelae in Appendix 1 give evidence for these reconstructions.

Teobert Maler offered an early commentary on the interpretation of this set of stelae. In his careful descriptions, he noted that many of the stelae were carved on both obverse and reverse. Most of these monuments had what he called a "beneficent god" distributing to the people the "ropes of honey" from the "chest of good fortune" on the "deity" side, which faced the temple in front of which it stood.

In connection with the description of Stela 1, it will be well to remark once for all that the stelae of Yaxchilan which may be regarded as mortuary monuments have one side devoted to the memory of a person of rank—generally some great warrior with his prisoner—while the other is reserved for a representation of the divinity

(Ketsalcoatl?)—generally a beneficent god distributing the good things of life to supplicants. I, therefore for brevity, call one side the human side, and the other the deity side.

The deity side of the Yaxchilan stelae *without exception* faced the temple to which it pertained, while the human side was turned toward the city or the people. In other words, whoever leant his back against the temple façade saw the deity side of the stela, but whoever looked at the façade from a distance saw the human side of the stela.[37]

Maler's assumption that the warrior figure was a historical human was proven correct by the decipherment of the accompanying texts as records of captures of specific individuals by the warrior-kings. Tatiana Proskouriakoff showed that the "beneficent deity" was also a human ruler. After having been identified as honey, copal grains, and seed corn, the "ropes of honey" and "chest of good fortune" are now considered to be streams of blood or corn being dropped into a basket. Now it is possible to refer to a bloodletting image on the temple side (Maler's deity side) and a warrior image on the river side (Maler's human side).

38.

Two monuments associated with Yaxchilan: *a*, "Kimbell Panel," from Laxtunich, Usumacinta River Valley, photo courtesy Kimbell Art Museum, Fort Worth, Texas; *b*, La Pasadita Lintel 2, drawing by Ian Graham (Simpson 1976: 103).

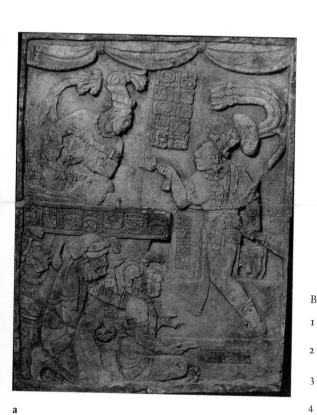

a

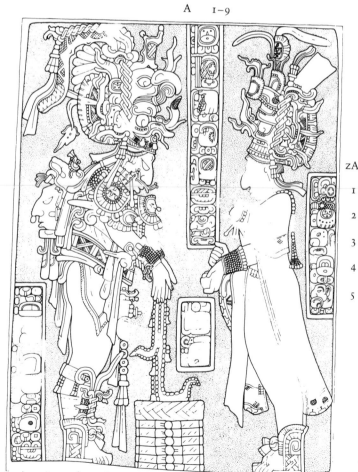

b

The regularity of the imagery and the two-sided format show that this entire composition had a fixed meaning. Each location on the surface of the stone—narrow sides, temple and river sides, and, on the temple side, the upper, middle, and lower registers—was a semantic domain, into which were inserted the particular data pertaining to the individual king, his ancestors, his community, and his deeds.

THE TEMPLE SIDE

Central Register

The temple side is divided into three registers. The central one is the largest, and the upper and lower registers are about equal in size. The central register displays the profile image of the historical ruler who commissioned the monument either in the act of perforating his penis, or having just completed the sacrifice, with the perforator visible in front of his groin. The sacred substances (blood, corn grains, incense) drop from his hands into a basket at his feet. On some stelae, a robed figure with a snaggle-tooth or bird headdress kneels at the feet of the ruler. On others, a female stands behind the ruler and another figure faces him. In every instance the costume is identical—the Period Ending costume. (The earliest two stelae recorded accession anniversaries tied to Period Endings, but the iconography is the same.)

Upper Register

Above the scene of the historical ruler engaged in sacrifice is a Skyband Monster. As discussed in Chapter 3, this symbol has a local meaning which may differ from the meaning of the skyband at other cities. Here it indicates the royal role in maintaining the paths of the sun, moon, and planets through the sky. The myth of the Hero Twins is evoked by the use of nine GI or GIII heads pendant from the skyband. Two ancestor cartouches ride the skyband. Between them is a bust of GI or GIII. The portrayal of the ruler's ancestors in the cartouches is at once genealogical documentation, a depiction of filial devotion, and reference to the cosmic role of the deceased royal lineage as embodiment of the sun and moon.

Lower Register

Below the ruler's feet is his territory, symbolized as a monster composed of toponymic, agricultural, and astronomical symbols (see Chapter 3, "Basal Monsters"). On Stelae 11 and 10, the locality monster is replaced by parentage statements, referring to deceased parents then interred, and forming the ideological equivalent of local affiliation.

THE NARROW SIDES

Stelae 1, 10, and 11, all carved during the reign of Bird Jaguar IV, have glyphs and images running from top to bottom on the narrow sides of the stelae. The glyphs on Stela 10 sides include the Long Count date for the Period Ending, and a human figure in profile. On Stela 11 is a Long Count date for 9.16.1.0.0 and other information describing the accession day of Bird Jaguar IV. Few glyphs survive on Stela 1, but on one side is a beautifully rendered portrait of a female, and on the other, a male figure; I assume these are images of the king's deceased parents (see Figure 124).

THE RIVER SIDE

Facing out toward the river toward all who entered or passed Yaxchilan were images of the kings as victorious warriors. Due to accidents of weather and human judgment, when the stelae on the Main Plaza fell, they all fell toward the hills, with the river sides exposed to rain. Conversely, the winds swirling around the hilltops of the West Acropolis caused the stelae that were erected in front of Structure 41, the highest spot at the site, to fall down the hill toward the river, so that their river sides were well preserved (though some stelae broke badly) and the temple sides were eroded. Therefore, Stelae 18, 19, and 20 of Structure 41 have the best-preserved river side glyphs and images and must be used as the basis for the reconstruction of the information and dates contained on the river sides.

The glyphs of Stela 18 (Figure 145 *b*) record a Calendar Round, a capture verb, the name of the captive, and lengthy titles of Shield Jaguar I. One of the titles is the headless jaguar used to refer to GIII on pots and at the Palenque Group of the Cross. Another association with GIII is the consistent use of the war costume. On one appearance of the war costume at Yaxchilan, the king wears a GIII cruller (see Structure 20, Lintel 12, in Figure 90). Ritual warfare seems to be under the dominion of GIII at most Maya sites, including Palenque, where the crossed spears and GIII shield appear on the panel in which the birth of GIII is recorded. Thus the image of king as captor on the river sides of the stelae is also a depiction of him personifying GIII.

THE COSMOGRAM

The elements of these Yaxchilan stelae refer to the same tripartite synergism of cosmic function as is exhibited in the Cross Group at Palenque. There, the realms in which the ruler was required to mediate were portrayed in three separate temples by the Late Classic ruler Chan Bahlum around 9.13.0.0.0. In the Temple of the Cross, the birth of GI is recorded as having occurred on 9 Wind. As explained in Chapter 3, GI is associated with the path of Venus and the sun through the day sky. At Yaxchilan, the upper registers of the temple sides of the stelae include images of the royal ancestors in solar and lunar cartouches, GI busts, and the Skyband Monster dripping GI heads. In the central register, the rulers all wore GI as Chac Xib Chac diadems, indicating that they sacrificed themselves as Hunahpu did in the *Popol Vuh.*

The third born of the Palenque Triad, GII or God K, is memorialized in the Temple of the Foliated Cross at Palenque. The image on that tablet is one of a corn plant or tree marked with heads of the young Maize God or God K. The plant grows from a skeletal, frontal monster marked as "ancestral temple" by the Kan Cross on his forehead. In the Temple of the Foliated Cross, the creation of the gods and thus the world order is specified glyphically as being enacted through the blood sacrifice of the ruler. The image shows Chan Bahlum receiving a deified bloodletter in front of the corn plant that sprouts from the ancestral temple. Yaxchilan's version of this scene was placed on the central and lower registers of the temple sides of the stelae. Sacrificial blood drips from the ruler's hands onto his territory, where the bones of his ancestors are buried, and which alternately contains images of the Underworld sun or the locality. The ancestors, above, watch the scene and mediate for the ruler using the bicephalic serpent bar.

The river sides of Yaxchilan's stelae are analogous to the Temple of the Sun and the realm of ritual warfare and the Underworld. This was the more public image of the king. The self-sacrificial and ancestral portions of the stelae faced the temples at the site, so that only the individuals privileged to stand on the steps of the temples could view the bloodletting images (with the exception of Stela 1, which was placed in the middle of the Main Plaza with plenty of space on every side). This placement probably paralleled the ritual process. Bloodletting probably occurred within the privacy of the temple

and was announced by assistants on the temple steps, while the people in the plaza gazed upon the image of their ruler as protector. Two groups of people viewing different aspects of the same king simultaneously formed an interesting complementary opposition of imagery and function for the stela and the ruler.

Each group of cosmogram stelae was erected in front of buildings which faced the summer solstice sunrise. On the east side of the stelae, the warrior scene (which was a capture *prior to* the date of the Period Ending on the temple side) was illuminated first by the sun each day. The sun climbed in the tropical sky until it reached its zenith, above the apex of the cosmic axis represented by vertical shaft of the stela. Then it descended, illuminating the sacrificial scene on the west (temple) side, until it sank below the western hills each evening. The deliberately contrived interaction between the cosmogram stelae and the daily transit of the sun metaphorically showed that the sun conveyed the offering of sacrificial blood into the Underworld, daily renewing the periodic blood sacrifices of the king.

Pictorial Syntax on Lintels

The placement of symbolic elements on Yaxchilan lintels is different from that on the stelae, for two main reasons—the settings for the figures differ, and most lintels were designed in groups of three. On the cosmological stelae, figures are portrayed without a depicted space, or, more accurately, their position within the vertical cosmos is shown, but their images are intended to be seen against the background of the actual ceremonial center. On the lintels, no specific reference to cosmic location is made, although the placement of the lintels inside the doorways of the temples was probably a simile for the placement of the ruler (his image) inside the aperture of the Axis Mundi or, in other words, at the opening between cosmic realms. The transference of the setting of the ritual scene to the entranceways into the temples frees the pictorial space of the lintel for its primary purpose—a record of the participation by a member of the royal lineage in a ritual in which the community's sacred objects occupy the space allocated to them, thereby substantiating the cosmic order.

On lintels, the entire significatory load of the iconography is carried by costume elements and their placement. They tell what kind of cere-

mony is portrayed and which mythological supernaturals are being personified, and signify astronomical, political, and sacrificial functions for the ruler.

In this section I will discuss the ten lintels that I believe were carved as an assemblage of complementary information in the five years after the accession of Bird Jaguar IV (between 9.16.1.0.0 and 9.16.6.0.0) in three simultaneously designed structures, 1, 33, and 42. These were selected as the examples of the organization of symbols on lintels because the meaning of the post-accession rituals portrayed on them has never been clearly understood from the glyphs, and a pictorial analysis clarifies the rituals. Also, in this ensemble, the figures are fully dressed, so there is an optimum opportunity for examining the symbolic capacity of the ceremonial regalia. Structures 1 and 42 are "twin" structures, in that the dates of the three lintels of Structure 42 also appear on three of the four lintels of Structure 1. The ruler, Bird Jaguar IV, appears on all ten lintels. On the paired lintels, he is accompanied by the Captor of Muluc in one structure, and on the same date on the other structure, he is portrayed with one of his female ceremonial assistants. Thus two images of the post-accession ceremonies are available to characterize the nature of the events.

This analysis is illustrated in three pairs of charts (Figures 39–41). One chart in each pair is a blow-up of the pictorial elements of the lintels. The other chart of the pair assigns the words which Mayanists use to the pictorial elements. The words are organized in the same order as the symbols actually occur on the lintels. One more chart (Figure 42) organizes the information on all ten lintels according to the significatory levels upon which the symbols function. I did not assume that these symbols were ordered with particular kinds of information; instead, I made the first set of charts, then saw what kinds of categories suggested themselves.

The symbols on these lintels are carried by the human bodies of Bird Jaguar and his companions, and appear on various locations of the bodies. This presupposes a vertical stratification of most of the symbolic elements. Verticality was stressed by the designers through the use of tall headdresses and through the placement of symbolic elements above the headdresses. There seem to be about six vertically stratified areas or semantic niches which carry symbols. The uppermost niche contains those elements that are perched above the headdress and hand-held elements that are the highest

thing in the composition. The headdress and attached elements form the second niche. Backracks protrude into the picture plane above the ruler's shoulders. On these monuments, the protagonists always hold special objects, and they are centrally located in the picture plane. The hand-held objects are important symbols. One feels that any of these objects would not look out of place in a headdress, but that the rulers hold them to impart a sense of activity. Chest ornaments vary less than other elements. Particular pendants are noted here, as are capes and skirts that complete an outfit. Belts were literally the vehicles for another set of ritual symbols. I looked at shoes and leg ornaments, but their portrayal seemed to me to follow fashion more than adding any new information to knowledge about the rites portrayed, so I do not discuss their details here.

It is helpful to consider these rituals in the light of textual information. I will discuss the events in chronological order, noting which events are commemorated and what the symbol system relates about these events.

9.16.1.0.0 (29 Apr 752) Str 33, L 1 Lady GS

Lintel 1 commemorates the earliest event in this series, the accession of Bird Jaguar IV to the throne. The mirrors in the uppermost niche of his outfit may refer to the ruler or heir-designate as the "mirror of his people," a Yucatecan phrase found in the Motul Dictionary.[38] He wears the local version of the traditional Maya accession headdress. Bird Jaguar and the mother of his son, Lady Great Skull, both wear the "jester god" on their headdresses, an indication of their divine lineages. Bird Jaguar's feather backrack is always worn on Period Endings and accessions at Yaxchilan by fully dressed rulers. He holds the God K manikin scepter and the GIII shield, which is typical Maya accession iconography, but unusual for Yaxchilan before that time. Lady Great Skull holds the bundle of bloodletting implements, a local way to imply blood sacrifice. The skyband edging her gown may function as a royal emblem.

9.16.1.2.0 (7 Jun 752) Str 1, L 5 LAI
 Str 42, L 42 CoM

Two *uinals* after his accession day, Bird Jaguar performed ceremonies with two members of his court, Captor of Muluc and Lady Ahpo Ik. With the Captor of Muluc, Bird Jaguar IV displayed the God K scepter and God C shield. Captor of Muluc held an axe and shield and wore a pointed hipcloth, implying bloodletting.

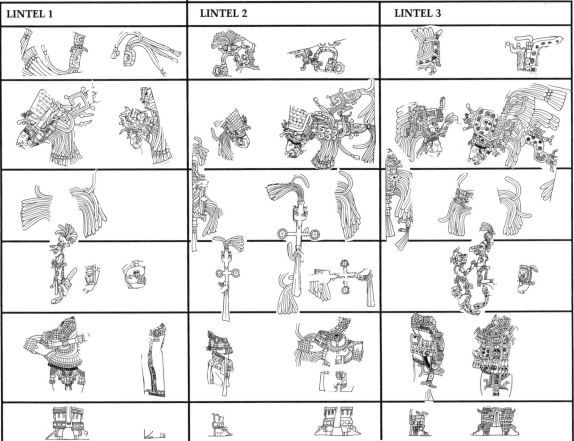

LINTEL 1 · LINTEL 2 · LINTEL 3

LINTEL 1		LINTEL 2		LINTEL 3	
BJIV	2nd	2nd	BJIV	2nd	BJIV
Mirror	Flowers	Sun-Venus serpent	Sun-Venus serpent		GI Diadem
				Jaguar tail	Jaguar tail
			Mirror	Skyband	
Skeletal serpent			Skeletal serpent	Serpent jaw	Venus
Jester	Jester	Jester	Jester		Jester
Drum-major headdress	Bird-and-flower diadem	Drum-major headdress	Drum-major headdress	God K caiman headdress	Coiled-serpent headdress
Backrack		Skyband backrack	Skyband backrack	Backrack	Backrack
God K manikin scepter	Bundle	Bird-cross	Bird-crosses	God K manikin scepter	God K manikin scepter
GIII shield					GIII shield
	Ahau collar			*Ahau* collar	*Ahau* collar
Ahau collar	Skyband	*Ahau* collar	*Ahau* collar	Crossed-bands pectoral	Crossed-bands pectoral
				Ahau belt	*Ahau* belt
		Bloody strips	Bloody strips	Knots on wrists	Knots on wrists
				Pointed hipcloth	Pointed hipcloth
				Knots on ankles	Knots on ankles

39.

Chart (*a*) and verbal description (*b*) of the imagery on Structure 33 lintels. Details from drawings by Graham (1977:13, 15, 17).

LINTEL 5		LINTEL 6		LINTEL 7		LINTEL 8	
BJIV	**2nd**	**BJIV**	**2nd**	**BJIV**	**2nd**	**2nd**	**BJIV**
Sun-Venus serpent	Jester	God K basket		GI diadem		Mexican year sign	Mexican year sign
Skeletal serpent	Jaguar tail	Jaguar tail					
Drum-major headdress		Venus jaguar headdress	Waterlily + fish headdress	Coiled-serpent headdress	God K	Rectangular headdress	Tlaloc
Jester		Snaggletooth					
Skyband backrack				Backrack			Skull backrack
Bird-cross	Bundle		Perforator god	God K	Bundle		Spear
		Jaguar paw	Jaguar paw			Prisoner	Prisoner
							Shield
Ahau collar		*Ahau* collar	*Ahau* collar				War scarf
						Strips	Bloody strips
	Knot belt	Knot belt	Knot belt	*Ahau* belt			
		Jaguar head					
	Quatrefoil		Jaguar tail	God C loincloth			
			Perforator god				

LINTEL 41	LINTEL 42	LINTEL 43

40.

(Opposite page)
Chart (a) and verbal
description (b) of the
imagery on Struc-
ture 1 lintels.
Details from draw-
ings by Graham
(1977 : 21, 23, 25, 27).

LINTEL 41		LINTEL 42		LINTEL 43	
2nd	BJIV	2nd	BJIV	2nd	BJIV
		Mirrors	Skeletal serpent jaw		God K basket
Cloth & double loop	Tlaloc	Drum-major headdress	Drum-major headdress		GIII
	Spotted material				Waterlily jaguar
					Snaggletooth Serpent
			Skyband backrack		
	Spear	Shield, axe	God K manikin scepter	Bloodletting bowl	Flat object
	[Bloodletting bowl]*		God C shield		
	War scarf	Ahau collar	Ahau collar		Ahau collar
	Crouching jaguar pendant		Sun pendant		Crouching jaguar pendant
	Bloody strips	Pointed hipcloth	Dangler belt		Crossed-bands belt
					Shark belt
					Bloodletting knots
					Jade leg ornaments

41.

Chart (a) and verbal
description (b) of the
imagery on Struc-
ture 42 lintels. De-
tails from drawings
by Graham
(1979 : 91, 93, 95).

* There must have been a bloodletting bowl here, but it is now missing.

Two verbal phrases occur on Lintel 42, the first of which refers to the holding of the manikin scepter.[39] Another phrase at E2–F2 includes a "fire" glyph and a GI head, identical to a phrase associated with Shield Jaguar's accession on Lintel 25 at D1. The phrase at E3–F3 is derived from the birth and bloodletting verbs and seems to indicate "the birth of bloodletting." Perhaps this day was the completion of a phase of Bird Jaguar's accession ritual that included bloodletting, and it was glyphically likened to Shield Jaguar's accession. Accession also was recalled on Lintel 5 by the bundle that Lady Ahpo Ik held. The presence of the bundle makes it clear that bloodletting was part of the ritual. On Lintel 1, Bird Jaguar IV had made no reference to the Hero Twins but now that this phase of the accession ritual was completed, he invoked GI through a symbol on top of his headdress that conflates the shell earplug of GI with *k'in* and Venus elements carried by a serpent.

9.16.1.8.6	(12 Oct 752)	Str 1, L 6	CoM
		Str 42, L 43	Lady Ix
9.16.1.8.8	(14 Oct 752)	Str 1, L 7	Lady Ix

On Lintels 6 and 43, which refer to the same date, Bird Jaguar holds a "God K basket staff" and wears the same costume. The costume contains GIII symbols: a waterlily-jaguar headdress, infixed with a Venus sign, and strips of jaguar-skin cloth. On Lintel 6 the costume includes a jaguar-head belt ornament, while on Lintel 43 a shark head appears in the same place. On Lintel 6, Bird Jaguar is accompanied by Captor of Muluc, who wears a fish-eating-waterlily headdress that is also seen on the ballgame steps of Structure 33. He also wears bloodletting knots on his arms and legs and at the waist. On Lintel 43, Lady Ix holds the bloodletting bowl. Whatever this ceremony was, it must have had Underworld significance, and have involved bloodletting. The rationale for an event involving the Underworld 166 days after the accession of the ruler is not obvious. However, this date is five days short of the eighth tropical-year[40] anniversary of an important event in the life of Bird Jaguar which is part of Structure 33—the ballgame event recorded on Step VII. On 3 Muluc 17 Mac, 9.15.13.6.9 (17 October 744), Bird Jaguar had played the ballgame, presumably in the Underworld. He likened himself to the Hero Twins who went to the Underworld to defeat the Lords of Xibalba. Like them, Bird Jaguar was apparently successful. Although these lintels do not show ballgame scenes, the fact that the costume clearly

refers to Underworld activities supports the suggestion that this eight-year anniversary of Bird Jaguar's first descent into the Underworld to play the ballgame was the reason for the inclusion of this ceremony within the cycle of accession ceremonies. The ballgame must have been conceptually linked to Bird Jaguar's accession, because the ballgame monument was placed at the center of the stairs of the temple in which his accession was recorded, Structure 33.

Lintel 7 postdates Lintels 6 and 43 by two days, and is three days short of the eighth ballgame anniversary. On this lintel, Bird Jaguar wears the coiled-serpent headdress associated on all other occasions with anniversaries. He wears the GI diadem, impersonating Chac Xib Chac, and the God C loincloth (a motif borrowed from other sites, where it indicates Period Endings). This Period Ending–anniversary image seems to refer to the completion of eight years since the cosmic ballgame.

| 9.16.4.1.1 | (5 Apr 755) | Str 1, L 8 | CoM |
| | | Str 42, L 41 | LAI |

On this date Bird Jaguar captured Jeweled Skull. This event was commemorated on twin Lintels 8 and 41. Bird Jaguar wore the Maya war outfit. At Yaxchilan, important captures were an integral part of Period Ending statements on the cosmological stelae. Probably in the same manner, this capture sealed the accession of Bird Jaguar.

| 9.16.5.0.0 | (8 Apr 756) | Str 33, L 3 | Man of L 3 |

Bird Jaguar incorporated the *hotun* ending 9.16.5.0.0 into his accession structure. Since that day was also an anniversary of his accession, he wore the coiled-serpent headdress, a backrack, and held the God K manikin scepter and the GIII shield. He impersonated Chac Xib Chac, symbolized by the GI diadem, the Venus symbol on the back of his headdress, and the crossed-bands pectoral (obscured by jade beads). The bloodletting that surely occurred in conjunction with this event is alluded to through the wearing of the pointed hipcloth and bloodletting knots at the wrists and ankles. His links to the dynasty are conveyed through the *ahau* belt, by the T60 knot on the central head of the *ahau* belt (it also ties the accession bundle),[41] and by the holding of the God K manikin scepter. His comrade, called a 3 Katun Cahal, carries the same dynastic accession regalia that Bird Jaguar does. His headdress includes a God

K base, a skyband segment, and an *akbal* medallion. It is possible that this man was made Cahal during this ceremony, but it is not specifically stated in the glyphs.

9.16.6.0.0 (3 Apr 757) Str 33, L 2 SJ II

As the central lintel of Structure 33, Bird Jaguar placed the lintel which closed the saga of his first five *tuns* in office. Here he included an image of his five-year-old son wearing typical dynastic kingly regalia—in fact, wearing a costume identical to Bird Jaguar's. They impersonate GI and GIII simultaneously in their roles as the sun and Venus, as seen by the sun-Venus-serpent element above their headdresses. They wear the drum-major headdress. The Cosmic Monster or Skyband Monster is worn as a backrack. The bloodletting required by the occasion is demonstrated by their skirts made of bloody strips. Wielding the bird-cross scepters, they show that their ritual effectiveness is cosmic in scope. One of the few differences in their costumes is that King Bird Jaguar wears a mirror on his headdress, as the mirror of his people, while the five-year-old Chel-te, later to take office as Shield Jaguar II, does not.

In this triad of structures, Bird Jaguar IV recorded some anterior and posterior events that directly related to his accession day. Each of the costume elements on these ten lintels symbolizes one of the various functions of the ruler in his political, astronomical, sacrificial, and mythological roles. Figure 42 presents an analysis of the distribution of the symbols. It serves as a basis for a discussion of how a pictorial narrative of cyclical time was achieved.

Certain realms of meaning are emphasized in one structure but not in another. Obviously Structure 33 is primarily concerned with the Period Endings and accession. The symbols used in it conform to pan-Maya culture—the drum-major headdress, God K scepter, and GIII shield, the "jester god," the *ahau* belt. The ceremonies are also more typical of other Maya cities than those of the other two structures—accession, *hotun* commemorations, and Period Endings. It is here that the ruler's wife and son are portrayed, and not in the twin structures. Astronomical knowledge aggrandized the political stature of Bird Jaguar in Structure 33. The inclusion of the sun-Venus-serpent symbol on the headdress in the central lintel is interesting in view of the fact that it is through this doorway that the sun illuminates the larger-than-lifesize statue of Bird Jaguar IV on summer solstice. Of the three structures, this is the only one oriented toward the summer solstice sunrise.

Like those of Structure 33, the Structure 1 lintels include references to God K and GIII. However, in Structure 1, Bird Jaguar impersonates Chac Xib Chac twice. Structure 1 seems to emphasize GI iconography, while Structure 42 emphasizes GIII iconography, but the concentration of a particular type of symbol in one structure is very weak. The purpose in ordering the iconography seems to have been to overlap the areas of meaning rather than to segregate them. The ruler often held or wore elements referring to more than one member of the Triad at one time. As in the Group of the Cross at Palenque, the divisions of mythological symbolism are dynamic and interrelated. The identities of the Hero Twins and the Palenque Triad similarly imbricate. The only way to perceive the full intent of the symbolism of these assemblages of monuments is to do so overall, to observe the attempt to create overlapping and redundancy rather than to compartmentalize.

Different parts of the lintels tend to stress references to different cosmic realms. The symbols in the uppermost niche are references to astronomical bodies and the Palenque Triad. Skeletal serpent jaws and jaguar tails also occupy this niche, and may also be references to these mythological characters. The second niche from the top includes the headdress as the most indicative symbol of the event in progress. The backrack indicates a cosmic level, perhaps where the rituals are aimed. Objects in the hands are the magical weapons of ritual sacrifice and warfare. Wrist and ankle bands often indicate whether the ceremony includes bloodletting. The headdress reveals more about the type of ceremony performed than any other single costume element. On these ten lintels, Bird Jaguar IV wears only four different headdresses: the drum-major headdress (accession), the waterlily-jaguar headdress with a Venus infix (Underworld-ballgame), the coiled serpent (anniversary), and a pan-Maya Tlaloc war headdress. The accentuation of the highest point on the figure in pictorial imagery parallels Gossen's observation that "up" is the most important and "hot" ritual direction in the space-time framework of the Chamulas.

Spatial and temporal distribution of the symbols belies a chronological narrative structure. GI is slightly emphasized in the lower building, dynasty and accession in the center, and GIII in the upper one. Temporally, the earliest and latest events are recorded in the middle, and the middle events in the outer temples.

42.

The distribution in
symbolic levels of
the iconography of
lintels in Structures
33, 1, and 42.

Other authors examining Maya sculpture have referred to scenes like this as "monoscenic narrative, wherein one scene from the total event is portrayed and stands for the whole."[42] Inasmuch as the "total event" refers to the entire ceremony which occurred, I agree. However, I think that the kind of narrative employed at Yaxchilan is one which is unique to those societies, like the Maya, which share the concept of nonlinear time in which events from past and present are incorporated into the present. It would have been possible for a group of three lintels to tell a story, but the Yaxchilan designers deliberately avoided using techniques that would indicate a sequence of events. Techniques used at Yaxchilan for indicating that stated events were related can be seen in the all-glyphic lintels of Structure 24, wherein events are recited in chronological order and linked by Distance Numbers. However, the events commemorated on sets of figural lintels were often widely separated in time, sometimes by a few years, other times by more than a *katun*, and were not linked by Distance Numbers, nor set into the building in chronological order. This makes it impossible to "read" the events in a chronological sequence of cause and effect. Another device was used by the designers to reiterate that the events shown were not part of a temporally linear sequence—the actors appear in different outfits in different scenes.

The designers of the Structures 1, 33, and 42

	STRUCTURE 33			STRUCTURE 1	
	Lintel 1	Lintel 2	Lintel 3	Lintel 5	Lintel 6
Astronomical/ cosmic		Sun-Venus serpent Skyband backrack	Venus	Sun-Venus serpent Skyband backrack	Venus jaguar headdress
Mythological/ cosmic	Drum-major headdress God K	GI + GIII Bird-crosses	Chac Xib Chac GIII shields God I as manikin scepter	GI + GIII God K Bird-cross	Waterlily jaguar GIII
Dynastic	God K as manikin scepter	Jester	Jester	Jester	God K basket
Earthly/ political	Accession	Period ending Accession anniversary Presentation of son	Accession anniversary	Drum-major headdress	Recollection of ballgame Jaguar paws
Sacrificial	Bundle	Bloody strips	Skirt and knots	Bundle	Bloody strips
	9.16.1.0.0	9.16.6.0.0	9.16.5.0.0	9.16.1.2.0	9.16.1.8.6

lintels and the ballgame steps conveyed a sense of narrative through reference to the myth of the Palenque Triad. Rather than sequentially reenacting or portraying that story, they presented the notion that there is but one ideal mode of behavior, that of the Palenque Triad, and the ruler reenacts different segments of the myth as the circumstances call for them. The important thing was to make reference to all the Triad (or both the Hero Twins) at some place in the three lintels that function in the building. The story is of cosmic proportions, and its events and heroes exist now, and simultaneously in the past and future. Since scenes on lintels are frozen moments, the symbols on a single lintel do not yield step-by-step information on any given ceremony. Nor were the sets of lintels designed to elucidate a sequence of events within a single ritual. This is a kind of narrative in which the circularity of time is manifested. Perhaps for that reason, there are no Long Counts on the lintels, only Calendar Rounds. The designers' goal in organizing the symbols was to recreate the whole paradigm in each temple.

A series of historical events underpins the texts and images, but the organization of this story deliberately avoids the order of linear time. What is the story? It is hard for those of us to whom time is primarily linear to tell a story that doesn't start at the beginning. Where would we begin? At the left or right? At the top

109

Scenes of Royal Ritual

		STRUCTURE 42		
Lintel 7	Lintel 8	Lintel 41	Lintel 42	Lintel 43
			Skyband backrack	
Chac Xib Chac God K	Tlaloc	Tlaloc	God K	GIII Waterlily jaguar God K Shark belt
God K			God K as manikin scepter	God K basket
Ballgame anniversary Coiled-serpent headdress	Spears Prisoners Shield War scarf	Spear		Ballgame anniversary
Bundle God C loincloth	Bloody strips Skull backrack	Bloody skirt Bloody strips [Bloodletting bowl]	Pointed hipcloth	Bloodletting bowl
9.16.1.8.8	9.16.4.1.1	9.16.4.1.1	9.16.1.2.0	9.16.1.8.6

or bottom? Would we run up and down the temples at Yaxchilan, doing it in chronological order? To tell this story, one would have to know the whole myth of creation and how the Maya dynasties intersected with that saga. Although the historical element of the lintels and steps is confined to thirteen years, the mythological resonances cover an enormous temporal expanse (particularly including the references to the ancient ballgames on Step VII).

> If we had an English word that fully expressed the Mayan sense of narrative time, it would have to embrace the duality of the divine and the human in the same way the Quiché term *cahuleu* or "sky-earth" preserves the duality of what we call "the world." . . . For Mayans, the presence of a divine dimension in narratives of human affairs is not an imperfection, but a necessity, and it is balanced by a necessary human dimension in narratives of divine affairs.[43]

Dennis Tedlock, in the above description of the scope of time in the *Popol Vuh*, was referring to narrative in written texts, both ethnohistoric and hieroglyphic, but I think that his comment applies equally to Maya pictorial representations. In the written account of the Maya creation myth, mythic activities dominate the first three parts and historical activities the last two. In Bird Jaguar's pictorial synopsis of his roles in the drama of the hero gods, the pictorial symbols carry much of the mythic and ritual portions of the narrative while the written words lend validity to the tale through their specificity.

We should consider the actual execution of this massive sculptural campaign. It was accomplished in five years and employed artists from three workshops. To achieve such a complex political-cosmological statement, the artists and scribes must have been supervised by some sort of overseer of symbols and texts. The scribes seem to have had more independence than the artists, for the textual characteristics such as spelling vary more from building to building than do the pictorial symbols. The second generation of artists trained by the Structure 23 workshop executed Lintels 41 and 43. The Structure 33 artists had not worked independently at Yaxchilan previously. At least two scribes worked on the Structure 33 texts and may have also done the images. The Structure 1 lintels, text and images, may have been executed by a single individual, or all drawn by one individual and carved by assistants, for they are all very uniform. The Structure 1 workshop was also responsible for Lintel 42.

In designing public art at Yaxchilan, artists worked within aesthetic guidelines and within the code of meanings inherent in royal costume to create scenes to express a changing political and social reality and to relate it to the cosmological beliefs that united the Maya civilization. An additional consideration in the design of monuments was where they would be positioned at the site—down in the plaza or up on the acropoli—and whether they would face winter or summer solstice sunrise. One wonders if the rulers made the decisions about what kinds of monuments and buildings were appropriate for the era. If it was not the king, then it was some important individual, for the city certainly shows evidence of comprehensive planning.

The City as a
Solar Cosmogram

Yaxchilan occupies a peninsula protected on the south and southwest by tall hills. To the northeast and northwest, the strong current of the Usumacinta creates a natural barrier. The site is in an easily defensible location, but the founders of the ceremonial center selected this particular area on the southwest bank of the Usumacinta for an additional purpose—to use the hills for pyramid bases and to obtain a specific line-of-sight relationship with a mountain on the easterly horizon.

George F. Andrews observed that "within any particular [Maya] site the majority of buildings tend to be oriented consistently with regard to one another and with the cardinal directions." Alignments in the observatory groups of Uaxactun and other sites led Andrews to note that the solstice sunrise and sunset points could also aid in establishing the cardinal points, such knowledge being used in city planning. But while he observed that Yaxchilan was selected to take advantage of the broad shelf along the river, he stated that "there is very little consistency in the orientation of various buildings and no real effort to recognize the cardinal points of the compass."[1]

Clearly the designers of the ceremonial city exploited the hills and shelves of the existing terrain, as Andrews suggests, but if this had been their sole motive, they would have used the even larger flat area to the northwest, where the present airstrip is situated, or the area further southeast of the site for monumental construction. My studies of the site strongly suggest that at least from the era of Bird Jaguar III, planning at Yaxchilan was not purely "organic" as Andrews suggested, but established specific axes of solstitial orientation for architecture,

depending on the function of the building or space or the message of its sculptural program, and was conceived to define ritual areas used by particular rulers.

Horst Hartung noted some regularity in the distribution layout of buildings and monuments at Yaxchilan as it appeared in the Late Classic Period. In general, he looked at the geometrical relationships among the buildings as if the structures were all at the same altitude, as they are represented on a two-dimensional map. In particular, Hartung pointed out conceptual right triangles, isoceles triangles, and cardinal lines created by imaginary lines extending from the walls of the ancient buildings. His most successful analysis was of Piedras Negras, where he observed alignments of stelae that conceptually linked the reigns of successive rulers. I think that some of the alignments Hartung noted at Yaxchilan were intentional, and that they help define boundaries of ritual space. Others, such as the "directly south" relationship between the central marker in the ballcourt (Structure 14) and Altar 9 in front of Structure 23, seem to have no relation to the political and ritual events encoded in art and architecture.[2] If all the altars were placed on north-south axes relative to one another (or ones from the same reign, or ones that linked reigns), then a convincing pattern emerges. What seems to result from this analysis is an interesting set of geometric relationships of objects which were not at the same altitude and which have no clear meaning politically. While Hartung noted north-south and east-west alignments, it seems he failed to seek any cultural reason for the importance of such alignments.

I tested the assumption that the orientation

of the building was done from the perspective of the user by measuring orientations of all standing architecture with a compass, sighting along the interior walls of the three doorways and the exterior walls of the structures. To arrive at a more precise measurement of the original structure, I averaged these eight measurements (to allow for the sagging and settling of walls over the centuries). Thus the number given corresponds to the direction the building itself faces, or the direction one would face who stood in an entrance and looked straight out. The orientations are expressed in degrees east of magnetic north. They fall loosely into five groups: 6–14 degrees, 20–30 degrees, 51–54 degrees, 108–124 degrees (in which several structures face exactly 118 degrees), and a westerly group (see Table 5).

Two of these orientations are very prominent at the site, and are evident in the siting of the earliest known structures, 41 and 12. These axes—53 degrees east of north and 118 degrees east of north respectively—approximate the positions of the sunrise at its maximum elongations on the horizon, in other words, on summer and winter solstice. Begun in the Early

Classic, these axes were enhanced by the Late Classic rulers, particularly Bird Jaguar IV, to create architectural-solar hierophanies in the city.

Looking at the map of Yaxchilan, one sees that the entire Main Plaza is oriented from northwest to southeast. Several small buildings sit perpendicular to this axis, and their apertures face southeast, the same direction as the plaza. Bisecting this major axis is a strong axis in the form of the stairway to Structure 33, the temple itself, and the group of monuments in the center of the Main Plaza. All these face northeast. The other monumental stairway at the site, that to Structure 41, faces the same direction, as do many of the temples along the first terrace of the plaza. This is not accidental, nor is it common at other Maya cities.

At other sites, architectural-solar alignments were used to observe the passage of summer and winter solstice, but not in the same manner as at Yaxchilan. The solstitial sunrise observatory at Uaxactun is well known,[3] and twelve additional examples of similar structures exist at other sites.[4] Many other types of observatories are discussed by Anthony F. Aveni.[5] What is obvious is that the ancient Mayas were aware of the annual transit of the sun along the horizon and used it ritually, even though there was not a method for recording it in the complex Maya calendar. Modern Maya groups are still acutely aware of the solar cycle as defined by the passage of the sun from north to south on the horizon. Gary Gossen states that "The whole cosmological system is bounded and held together by the paths of the Sun and Moon, who are the principal deities in the Chamula pantheon."[6]

Mounting evidence from epigraphers, ethnographers, and astronomers indicates that the Maya conceived of the directions not as east, west, north, and south, but as the four solstitial sunrise and sunset points, plus zenith and nadir.[7] What I have observed in the alignments of structures and spaces in Yaxchilan supports their ethnographic and linguistic data.

In ancient times, as today, the solar year was probably observed on the horizon or with architectural assemblages designed to interact with the horizon. The application of the solar year in city planning and ritual was based on observation rather than calculation. For this reason, the summer-solstice and solar-year anniversary dates at Yaxchilan generally surround by several days the specific solstice recognized by modern calculations. (See Appendix 2 for a list of solar-year anniversaries at Yaxchilan—anniversaries are marked with an "A" in the Recorded Verb column and summer solstice can

Table 5

Orientations of standing buildings at Yaxchilan

(In Degrees East of North)

Structure	Orientation	Ruler
25	9	?
26	9	?
30	14	?
55	6	SJII
39	20–21	BJIV
6	27	KEJII?
7	30	?
23	29	SJ
36	26	?
51	30	?
20	53	SJII
21	54	BJIV
33	54	BJIV
40	53	BJIV?
41	51	BJIII?
12	118	R10
13	118	BJIV?
14	118	?
16	118	BJIV
18	118–120	SJ?
19	118	BJIII?
24	118	BJIV
42	108–110	BJIV
67	124	?
11 + 74	220	?
71	318	?
1	345	BJIV

be seen in the Julian Date column.) If what was remembered about the nature of the day upon which an event occurred was the position of the sun relative to an object on the horizon, and since the sun appears to hold still relative to the horizon for several days around both solstices, then some error is to be expected.

After my initial work on the dates in the inscriptions at Yaxchilan, I discovered that one prominently recurring series of dates fell very near summer solstice. Suspecting that some interesting illumination might occur at the site then, I journeyed there with a crew of assistants in 1984 and again in 1985, 1986, 1987, and 1989. We determined that from the vantage points of Structures 40, 41, and 33 (we couldn't see the horizon from Structure 44 because of a dense growth of tall trees), the summer solstice sun rises from a pronounced cleft between the highest and the second-highest mountain on the eastern horizon at 63 degrees east of north. The sunrise light illuminates the interiors of the group of buildings with 51–54-degree orientation, casting a path of light in the form of the doorway onto the floor of the chamber or onto the rear wall for a few minutes (see Figure 43). In all three of these buildings, interesting interactions of the summer solstice sunrise light with the art and architecture were observed.

Structure 41 is the earliest of these three solar-architectural hierophanies (for date and description, see Part Two). The original doorways had step-shaped tops which were filled in and narrowed in the Late Classic (see Figures 43a and 138). On 21 June 1986, we observed that the sun rose at 63 degrees at 5:43 A.M. Faint light shone in the central door of Structure 41, down the long, narrow entranceway. At 6:00 A.M. the sun appeared next to the projecting flat stone that makes the stepped element in the right side of the doorway as one looks out. The sun illuminated a small portion of the rear wall, and the stepped shape of the doorway was visible. It made a half-quatrefoil-shaped patch of light on the floor and rear wall.[8] This building was probably used as a solstice observatory during the reign of Shield Jaguar, by his father, Bird Jaguar III, and by his grandfather. Shield Jaguar placed his cosmogram stelae here. A very similar architectural-solar phenomenon occurs at House E of Palenque, when, through a step-shaped small entranceway on the east side, the summer sunrise light clearly forms a quatrefoil shape on the floor of the southeast chamber of House E.[9]

Structure 33 houses a more striking solar-architectural hierophany (see Figure 43b). On summer solstice, 1985, we found that as the sun rose (at 5:43 at 63 degrees east of north in a cleft next to the highest hill on the horizon approximately 1,200 meters distant from the temple), it passed through the doorways of Structure 33.[10] Inside the temple, the sun struck the only carved-in-the-round stone statue at the site, a twice-lifesize portrait of Bird Jaguar IV seated crosslegged in a niche created by transverse buttresses in the rear wall of the structure. The sun illuminated the statue of Bird Jaguar for approximately seven minutes. This phenomenon has been observed two days

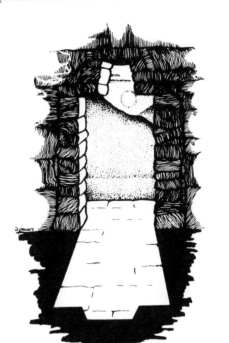

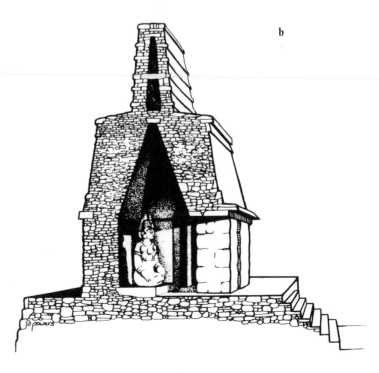

43.

Architectural-solar hierophanies at Yaxchilan: *a,* Structure 41, central doorway, looking out at eastern horizon on summer solstice at sunrise; *b,* cutaway view of sunrise light falling on statue of Structure 33 on summer solstice. Drawings by Daniel Powers.

a

b

before and two days after the actual solstice, and it could extend a few more days, but I cannot attest to it.

By the time Bird Jaguar designed his own accession–Period Ending monument, Structure 33, he could have used the solar-architectural hierophany at Structure 41 as an example. Bird Jaguar deliberately emphasized the summer-winter solstice axes that had been set up by Structures 41, 18, and 12. The central location of the Structure 33 hill and its proximity to the Main Plaza made it the ideal location for a focal point of the city. The orientation of Structure 33 had been developed and used in the construction of Structure 40 and Stela 11, which illustrates a summer solstice event and is illuminated by the summer solstice sunrise. Bird Jaguar knew that if the building faced the notch in the horizon where the sun came up on the day of its longest path, the sun would enter and illuminate whatever was inside for a little while. He had a twice-lifesize seated image of himself carved and placed in a niche in the rear wall of the structure. Through the construction of Structure 40, Stela 11, Structure 33, the Grand Stairway, the three-dimensional statue, and Stela 1, all of which align with the summer solstice sunrise, and later lintels also recording solstice events, he identified himself and his reign with the summer solstice sun, in such a permanent and obvious manner that it can still be observed today.

Another group of alignments includes eight buildings oriented precisely to 118 degrees. Looking at the map, it is clear that this is the orientation of the Main Plaza. These buildings were built at various times. Structure 12 is architecturally enigmatic, but if it was constructed contemporaneously with its lintels, it dates to 9.5.2.10.6 (A.D. 537). Structure 12 lintels record the names and deeds of the nine generations of rulers preceding Ruler 10. Structure 18, the large pyramid at the northwest end of the plaza, faces exactly 118 degrees also. The ballcourt (Structure 14) is situated so that the walls that form the narrow edges of the architectural bodies faced 118 degrees (although the walls sag now). The ballcourt monuments are decorated with ancestor cartouches, images of deceased rulers. Structures 24 and 16 were definitely built under the auspices of Bird Jaguar IV. Structure 24 is the obituary monument for his grandmother, father, mother, and aunt. Structure 16 lintels, as discussed in Chapter 4, record solar-year anniversaries of important events in the lives of the female ancestors of Bird Jaguar IV. Both Structure 16 and 24 lintels

were carved on the front edge only, linking them in terms of design intention. Structure 19 was probably built during the reign of Shield Jaguar II.[11] Every southeasterly hallway and the four front doorways of Structure 19 are exactly 118 degrees in orientation. Another obituary monument, Altar 1, which records the death of Bird Jaguar IV's father, is located in front of Structure 19. This group of buildings was constructed over at least six reigns, from 9.5.0.0.0 to 9.17.0.0.0 (A.D. 771) or later, and each one contains specific, historical references to deceased individuals. Could the 118 degrees direction (southeast) have an astronomical significance?

At Yaxchilan's latitude, the sun rises at 115–116 degrees on winter solstice. Like the summer solstice orientation group,[12] the winter solstice buildings are set slightly outside the path of the sun. Again, this allows for a few minutes of illumination of the interior of the buildings, providing the trees at the southeast end of the plaza were kept cut. Note that all the winter solstice alignments are found on the Main Plaza, where no tall buildings block the path of the sun on winter solstice. So these alignments suggest that at Yaxchilan, winter solstice was the time and direction for the commemoration of the deceased.

The buildings and stelae which face summer solstice, on the other hand, all document Period Endings, accessions, captures, and sacrifices of living kings. Almost every building with associated sculptural or hieroglyphic monuments faces one of these two directions, and the few that do not seem to have been oriented in response to other specific concerns.

Most evidence for the concepts involved in city planning exists from the reign of Bird Jaguar IV, because he was one of the latest known rulers and his buildings cover many earlier ones. In addition to the emphasis on solar axes, Bird Jaguar seems to have deliberately formed spatial boundaries of his ritual territory. Consider the group of temples designed to document his post-accession ceremonies, Structures 1, 33, and 42 (discussed in the last part of Chapter 4). Structure 42 is the northwestern-most of his buildings. It is the only building on the acropolis known to have been built by him. It faces 108–110 degrees east of north, a very odd orientation for Yaxchilan. It is situated so that it faces away from the other buildings on the West Acropolis, toward the rest of the site. The line of orientation of Structure 42 passes precisely over the center of Structure 33 and to the center of Structure 1, its "twin." Structure

42 is the highest of these three structures, at 175 meters. Structure 33 is the middle structure, at 155 meters. Structure 1 is situated at about 135 meters. Structures 1 and 42 are approximately equidistant from Structure 33. Structure 1 is the southeasternmost of Bird Jaguar's structures. At 345 degrees east of north, it exactly faces Stela 1, in the central portion of the Main Plaza, which is also on line with the axis of Structure 33, and which Bird Jaguar erected to commemorate the *lahuntun* 9.16.10.0.0. So the buildings are aligned horizontally, are situated from high to low vertically, and contain iconography that describes Bird Jaguar's post-accession rituals. Structures 1 and 42 define the edges of the area of the site in which Bird Jaguar built. They are also both situated near the most prominent caves at the site. Below Structure 42 on the northeast face of the West Acropolis is a small cave which does not appear on the map. Structure 1 is the closest building at the site to a larger cave which overlooks the valley that leads to the base of the South Acropolis. Oddly enough, the caves which are shown on the map as being west of Structure 30 do not exist; thus the caves near Structure 1 and 42 are the only ones in the main portion of the site and must have played a role in Bird Jaguar's decisions on how to shape the ritual landscape.

Structure 33 is the pivot of two ritual axes. In addition to the Structure 42-33-1 alignment, it is at the center of a summer solstice alignment created by Bird Jaguar's temples 40 and 33 and Stela 1. On the South Acropolis, in front of Structure 40, Bird Jaguar erected Stela 11, a variation of the cosmological stela. It commemorates events that occurred from the time his father passed him the flapstaff on summer solstice ten years before Bird Jaguar's accession, to his accession day on 9.16.1.0.0. The flapstaff scene of the monument faces the summer solstice sunrise. A line drawn from Structure 40 center through that stela intersects the center of Structure 33, where the statue is placed, and Stela 1, the *lahuntun* marker in the Main Plaza. Again, Structure 40 is the highest of the monuments, Structure 33 the middle, and Stela 1 the lowest.

Thus, contrary to the findings of Andrews, axial planning at Yaxchilan is astronomical, specifically solar, in orientation. The summer and winter solstice sunrise axes, so prominent in the Late Classic, were established in the Early Classic as aesthetically and culturally desirable. As mentioned above, the designers of Yaxchilan deliberately did not choose to build their temples on the broad, flat riverbank along the present Main Plaza or along the present airstrip. They opted for the summits of the hills, from which they could observe the course of the sun, planets, and stars along the horizon and along the ecliptic. The fact that they chose the particular group of hills that they did indicates that the view from those hills must have been important. And they saw the sun rising from the cleft in the horizon to demarcate the shift in the path of the sun when the days began to shorten. The view of the sun rising between the two hills, the taller of which, at 2,050 feet,[13] was the highest visible from the peninsula, was such an important facet in the selection of the site for monumental architecture that they perhaps named their city—the Place of the Split Sky—after it.

6

The Design of the Ceremonial City: A History

The images and the hieroglyphic statements on Maya monuments cannot be taken as objective, factual records of Maya cultural history. Obviously, they do not discuss the mundane concerns of the majority of the population, or even of the royalty. In the case of Yaxchilan, the forty-one events in the life of Bird Jaguar IV and his associates which were recorded within a seventeen-year period tempt those who can read the record to recount groups of related events along a temporal continuum, or to find patterns of cause and effect among the documented events.[1] However, it must be acknowledged that Maya records, for the most part, are fables about how best to create and sustain shared beliefs and psychological cohesion within a community.

The messages on Maya monuments may not be historical truths, but they are factual in one sense. If the original locations and dates of the monuments can be securely reconstructed, they are evidence of design decisions. Assuming that the kings and their elite court of advisors and artists decided upon the format of and produced public art, monumental sculpture is tangible evidence of an elite quest to define and influence the prevailing ideology of the community.

In designing public art, the patrons and artists engaged in a dialectic between conservatively sustaining tradition through the use of historical forms and creatively innovating forms and styles that responded to current situations and shifts in thought. To the bare bones of chronology and the recounting of modern nicknames for ancient ceremonies, a study of the creative dialectic in the production of Maya art adds elements of motivation and personality. We will never know, for example, based solely on the hieroglyphic evidence, whether Bird Jaguar wrested control of Yaxchilan from other hypothetical sons of Shield Jaguar. However, by determining which artists continued to work for the new king after the death of Shield Jaguar, by tracing how he interpreted patterns of design established by the early kings of Yaxchilan, and by realizing to which cities Bird Jaguar turned for iconographic inspiration as he prepared to take the throne, we have a fuller picture of his motivations and clues to the degree to which the populace needed to be reassured as he took office.

In this chapter, then, I consider the monuments as evidence of aesthetic decisions framed in specific situations. The challenge is an interesting one—to trace over two lengthy reigns the elite's concerns to provide visual definitions of the hierarchical relationships among themselves; of power relationships with the populace; and of philosophical relationships with time, the environment, and their ancestors.

More evidence survives about the reign of Bird Jaguar IV than about any other ruler at Yaxchilan (and perhaps any other Maya ruler anywhere). Eleven buildings contain lintels or wall panels which date to his reign and were probably commissioned by him: Structures 22, 24, 1, 42, 33, 8, 13, 16, 21, 2, and 10. Stelae or altars which record dates in his reign or name him are associated with Structures 19, 40, 41, 39, 36, and the Main Plaza. Definite dates for most of these monuments have been securely reconstructed. Because so many dated monuments were erected by Bird Jaguar, his monumental *oeuvre* makes an excellent subject for the study of how pictorial symbols necessarily achieved a balance between the expression of cultural ideals and political-ritual demands.

This chapter contrasts the *absolute chro-*

nology of the site (listed in the appendix) to the events and images *in the order in which they were recorded.* Herein I assume that Bird Jaguar selected historical events for specific purposes, designed iconography to best express his political-ritual legitimacy in the face of the political situation at the site at the time, and housed these images and texts in buildings which shaped the ritual aspect of the city.

In order to examine how the city grew in the Late Classic, it is necessary to have a clear idea of the sequence in which the buildings and monuments were erected. Completion dates for these buildings and the freestanding sculpture can be tentatively established by examining the dates of the monuments associated with each structure. The Maya commonly erected monuments dated on *katun* and quarter-*katun* endings, and I assume that the dedication date of a structure fell as soon as possible after the last recorded date it contains, unless there is some evidence that the building was erected later. In some instances, when earlier events were recorded historically by Bird Jaguar IV in conjunction with more contemporary events, it is necessary to consider other factors, such as costume style, the use of specific titles, or the physical superimposition of the structure on contiguous structures, in order to arrive at a more secure completion date. Once the most logical dedication date has been posited for each building, an order of construction of the ceremonial center during the reign of Bird Jaguar IV can be suggested. In Part Two, the specific arguments for the completion date of each structure are given at the end of the section on that building.

The precedents for many of Bird Jaguar's choices of rituals, symbols, themes, and city planning occurred long before he came to power. If more of the Early Classic buildings and monuments were available for study, it would be fascinating to start with the creation of a Yaxchilan style by the early kings. For the most part, however, Bird Jaguar's design can be understood in the light of his father's significatory activities, and because a discussion of the Late Classic reigns covers many of the known monuments, I will begin with a history of Shield Jaguar's design strategy.

9.12.10.0.0. STELA 19

Little is known about the political climate surrounding Shield Jaguar's accession in A.D. 681. Shield Jaguar's reign was first discussed by Tatiana Proskouriakoff in 1963. Because she believed that his accession was not recorded at

the city, she suggested that he may have been a usurper.[2] However, Schele, Mathews, and Lounsbury established his accession date and translated his documented claim that his father was none other than Bird Jaguar III, king of Yaxchilan.[3] Any strife surrounding his claim to the throne is undocumented.

For his accession monument, Shield Jaguar likely commissioned the largest stela that had been carved to date at Yaxchilan (Stela 19).[4] It was carved on two sides, in the tradition established by his father, Bird Jaguar III (called 6 Tun, captor of Yax Ah Te, on Stelae 6 and 3). The side that recorded his accession (facing the temple) was a triple-register design in which Shield Jaguar performed the bloodletting that was a part of his accession ceremony and royal duty; above him were his ancestors and below him, his territory. Unfortunately, this side is very poorly preserved. The better-preserved side was a scene of arraignment of Ah Ahaual, a prisoner obtained during ritual warfare, probably for the purpose of being sacrificed on the Period Ending or the accession. The content of the image was traditionally typical of Yaxchilan—it was modeled directly after Stelae 3 and 6. One of the few new features was a full-length backrack worn by the warrior image of Shield Jaguar. This towering stela was placed at the highest point of the city, in front of a building (Structure 41) that had been a solar observatory for his father and perhaps for his grandfather. The ancient structure and the stela both faced the summer solstice sunrise.

9.13.10.0.0. STELA 20

For the *katun* after he erected his accession stela, Shield Jaguar commissioned another stela (Stela 20) which he also placed in front of Structure 41. In the local tradition, it was carved on two sides. Very little of the temple side remains, but the river side commemorated another capture on 9.13.9.14.14. For this event, Shield Jaguar wore the tunic and belt of shells typical of Maya warfare, the quilted or feather scarf apparently invented by his father, and a jaguar headdress that was probably self-referential. This monument is unlike others at Yaxchilan because its composition includes a disturbing void in the center. The carving of the glyphs and figures is skillful and includes the elegant double outline and very closed, regular forms characteristic of the Elegant Knot Artist. The fine details of his drawing and carving contrast with the awkward, static composition. Shield Jaguar would later employ this artist to work with the Exuberant Scribe, whose spe-

cialty was clever composition, in the creation of other monuments.

9.14.5.0.0. STRUCTURE 44: LINTELS 44, 45, 46

Judging from the content of his relatively scarce monuments, Shield Jaguar must have been preoccupied with war during the thirty-five years following his accession. After the two stelae that (as Period Ending markers) he "owed" to the city and his people, about 9.14.5.0.0 he began work on a more complex public monument, which repeated the most important of his ritual warfare events, this time placing them in a multigenerational historical context. For this monument, he reactivated the local tradition of sets of carved lintels, perhaps established by Ruler 7 and certainly carried on by Ruler 10. Unlike those predecessors, however, he incorporated imagery used previously on lintels at Piedras Negras—scenes of capture.

As a location for his war memorial he chose the acropolis on the western side of the city. Because Structure 44 is perched practically on the brink of the acropolis and therefore does not take advantage of the large, flat area behind it, it was clearly intended to face the river, as had Structure 41. Below Structure 44 are two interesting features: a terrace about 40 meters wide and 10 deep and, farther down, a small cave lined with extremely jagged rocks. The terrace could have served for small public gatherings, and the cave as the site of offerings. (Beginning in summer 1989, a Japanese team was consolidating the buildings and plaza behind Structure 44. Perhaps their work will reveal some of the history of this interesting but poorly understood area.)

As subjects for his sculpture, Shield Jaguar chose scenes in which he was portrayed grabbing the hair of the most important men he had captured, who squatted or knelt before him. The costume that he wore in each scene was the traditional Maya war costume, with the locally innovated flexible shield and long, tufted scarf. On Lintel 45 and possibly on 46, the skull backrack, another soon-to-be-standard part of the Late Classic Yaxchilan war costume, can be observed for the first time. There was little precedent at Yaxchilan for the active poses of these figures, but the piers of House D at Palenque, particularly Piers C and F, also show two figures in similar active poses. The dates of House D stucco sculptures are not certain, but they likely date to the reign of Kan Xul II,[5] who acceded in 9.13.10.6.8 and was captured on

9.13.19.13.3, and if this is the case, these stuccoes would have predated the Structure 44 lintels by no less than four years. Shield Jaguar was known to have links with Palenque; his name appears in a capture statement on the Hieroglyphic Stairway of House C in association with the date 9.11.6.16.11.[6] Shield Jaguar adapted several figures and ceremonies from those displayed in the art of Palenque.

To design and execute the Structure 44 lintels, Shield Jaguar employed at least two artists. One had drawn the glyphs and figure of Stela 20, dedicated at least ten years earlier. That artist, who was acclaimed for the use of elegant double outlines and for careful attention to knots and textile designs, drew the glyphs on Lintel 46, conceived the pose and composition, and did the details of the figure and costume. The other artist had not executed any of Shield Jaguar's stelae, but his contributions at Yaxchilan were responsible for enlivening the figural poses and hieroglyphic styles at the site. He designed the figural portion and drew the glyphs of Lintel 45. The collaboration between these individuals led to the establishment of a workshop which was to produce the lintels of Structure 23 and one side of Stela 11 and would train another generation of artists at Yaxchilan. I have nicknamed these two artists the Elegant Knot Artist and the Exuberant Scribe.[7] It is likely that a third scribe worked with them and was responsible for Lintel 44, but that monument is so fragmentary that it is hard to be certain who created it.

The artists of Structure 44 lintels appear to have signed their compositions. The "*lu*-bat"[8] expressions referring to the act of writing on these lintels are early examples in the Western Maya region. The Exuberant Scribe and Elegant Knot Artist, both named with male titles, also worked on the figures of Structure 23 lintels, but they did not draw the glyphs on the figural lintels. Other "*lu*-bat" phrases appear on those lintels, so if these phrases are indeed signatures, they must refer to the individual who drew the glyphs, and not to the individual who designed the figural portion of the monument. The practice of signing hieroglyphic texts on monuments must have been borrowed from another Maya site, perhaps Piedras Negras or Dos Pilas, but it did not come from the city after which Yaxchilan often modeled its artistic and intellectual practices, Palenque.

Sets of lintels had been created previously at Yaxchilan, but not for 185 years. In commissioning this trio of lintels, Shield Jaguar revived a tradition last observed by Ruler 10, Mah

K'ina Skull II. In addition to recognizing tradition by carving a set of lintels, Shield Jaguar also documented historical continuities by explicitly mentioning his ancestors' captures on at least two of the lintels, 45 and 46. He linked his captures with those of his ancestors, using an identical phrase on Lintels 45 and 46 (on 45 at C5 and C6; and on 46 at G7 and F8; see Figures 10 and 11). This phrase tells of a change in the cycle of kingship and the remembering of the past king and his capture.

9.14.11.10.1. STRUCTURE 44: STEPS III AND IV

Two *katuns*, two *tuns*, two *uinals*, and zero *k'ins* after his accession, Shield Jaguar installed two carved steps, now called Steps III and IV, in and below the central entranceway to Structure 44. The upper and larger step documents a pre-accession capture; then a Distance Number leads an even twelve *uinals* to Shield Jaguar's accession on 9.12.9.8.1. The lower step records a building dedication event[9] and a parentage statement for Shield Jaguar. The date on the lower step (IV) is recorded as a Calendar Round, 7 Imix 14 Zotz. It was originally read by Proskouriakoff as corresponding to a date prior to Shield Jaguar's accession—9.11.18.15.1. That date won support from me in earlier studies because its Julian equivalent is May 6, 671, which was first zenith passage that year. Schele and Berthold Riese also accepted Proskouriakoff's assignment of the Calendar Round to the earlier of the two possibilities within Shield Jaguar's life. No one has suggested a logical reason why an event ten years prior to Shield Jaguar's accession appears here. Therefore, it is reasonable to consider the later possible Calendar Round, 9.14.11.10.1, which still falls well within Shield Jaguar's lifetime. Because of the studies I have made of the hands of scribes, I am now convinced that this step was drawn by the Exuberant Scribe, who also drew the texts of Lintel 23 of Structure 23, which was completed by 9.14.15.0.0, and that therefore the appropriate Long Count is the later possibility rather than the earlier. Supporting this conclusion is the evenness of the intervals among the dates on Steps III and IV. All three dates fall on Imix days. The Distance Number stated between the two events on Step III is 12.0. The Step IV date is 2.2.2.0 after Shield Jaguar's accession. The stated event is the dedication of the house, which could refer either to the entire building, its lintels, and Steps III and IV, or just to the two steps, the lintels having been

completed by 9.14.5.0.0. It is also possible that the building, its lintels, and the two steps were planned for completion on 9.14.10.0.0, in keeping with Shield Jaguar's practice of erecting monuments on *lahuntun* endings, but work was delayed, and then a date which resonated with Shield Jaguar's accession was selected for the dedication of the building.

On the step that commemorated his accession, Shield Jaguar commissioned a cosmogram, complete with a Cosmic Monster, a cleft bird head referring to the Place of the Split Sky, and an ancestor wearing a snaggletooth headdress peering out of a cartouche carried by the Cosmic Monster. Kneeling on the cosmogram is an image of Shield Jaguar's most famous captive, Ah Ahaual. In portraying the captive on the step of Structure 44, associated with an accession statement and Cosmic Monster, Shield Jaguar followed a precedent established in the Early Classic (on such objects as the Leiden Plaque[10] and on many stelae) of portraying the captive under the feet of the ruler upon his accession.

9.14.15.0.0. STRUCTURE 23

Having placed his Period Ending stelae on the highest acropolis and his war memorial on the second highest, Shield Jaguar next commissioned a temple down on the Main Plaza. Structure 23 was innovative in the design of its lintels, in the use of planetary and solar alignments as the bases for ceremonies, and in the prominent portrayal of a noblewoman. Unlike his other monuments, this structure contains no records of his captures. Instead, it centers around his accession and accession anniversaries and, through the selection of astronomically significant dates, implies that the movement of the planets and sun are synchronized with the activities of the Yaxchilan kings and Lady Xoc.[11] Except for his accession, all the dates fall during the lifetime of his son, Bird Jaguar IV. The ceremonies held when Bird Jaguar was in his first, tenth, and seventeenth years of life, the latter two of which occurred on summer solstice, may have been intended as rites of passage for the young heir. Bird Jaguar documented the performance of five summer solstice ceremonies later in his life.

To design his second set of carved lintels, Shield Jaguar called on the artists who had created the masterpieces of sculpture in Structure 44. The Exuberant Scribe and the Elegant Knot Artist worked on the design of Lintels 23, 24, and 26 of Structure 23. Assuming the Structure

44 lintels were finished by 9.14.5.0.0, about three years elapsed until the carving of the Structure 23 lintels was begun. During that period, Steps III and IV of Structure 44 were executed. Step IV was drawn and carved by the Exuberant Scribe, who also worked on Lintels 44 and 45, the figural portions of Lintel 24, and the glyphs of Lintel 23. That artist was the only one at Yaxchilan who realized the possibilities of nearly three-dimensional relief, as seen on the hands of Lady Xoc on Lintel 24. The Elegant Knot Artist designed the composition of Lintel 26—as in his design for Stela 20, a large trough of empty space divides it in the center. He also drew and probably carved the textile, knot, and hair details on Lintels 24 and 26.

The figures and faces of Lintel 25 were outlined with the help of the two highly regarded artists, but the detailing of drawing, the glyphs, and the execution were certainly done by a different hand. A "*lu*-bat" or "its writing" phrase[12] on the front edge of the lintel claims that Lady Xoc herself did the carving. Whether or not that is the case, neither the Exuberant Scribe nor the Elegant Knot Artist did the detailing on Lintel 25, and the glyphs and the figural portion of the lintel were done by the same hand. The Lintel 25 artist was not responsible for any other monuments at Yaxchilan. The Elegant Knot Artist and Exuberant Scribe seem to have interacted intensively on the realization of the figures on their lintels, and it appears that after the completion of Structure 23, members of their workshop continued to work for the next king.

The "*lu*-bat" signatures on Lintels 24 and 26 are not the same as those on Structure 44 lintels, and neither is the handwriting of the glyphs. Therefore, other literate individuals, probably priests or members of the Skull or Jaguar lineages, drew these hieroglyphic statements on the stone after the figural portion had been drawn.

Up until the construction of Structure 23, most of the imagery at Yaxchilan was related to Period Endings or warfare. Neither Period Ending nor war events are portrayed or mentioned in the glyphs or images of this structure; and, as might be expected, the costumes and the ceremonies are unprecedented in the monumental art of Yaxchilan.

Lintel 24 is the record of a multifaceted ceremony involving a rare stationary conjunction of Jupiter and Saturn and the accession anniversaries of Shield Jaguar and his father. To celebrate his twenty-eighth and his father's eightieth accession anniversary, Shield Jaguar performed a ceremony that involved the burning of something, perhaps the bloody paper that resulted from Lady Xoc's tongue bloodletting. The astronomical and anniversary data are not explicitly mentioned in the glyphs, but an implicit reference is made through symbols. The textile designs of Shield Jaguar's cape and Lady Xoc's gown are both "star" patterns. Shield Jaguar's loincloth is decorated with the quatrefoil and mat design that alludes to deceased royalty.[13] Shield Jaguar's pointed cape and the squarish headdress with jeweled Tlaloc affixed are Teotihuacan iconography, but they had been part of Maya costuming since 9.0.0.0.0, making them traditional elements used to signify exotic power, especially associated with the role of king as public defender. It is also possible that this lintel celebrates the birth of Shield Jaguar's heir. Sixty-two days previously, a son had been born to the king and Lady Ik Skull.

Lintel 25, at the center of the three lintels on the front façade, portrays Shield Jaguar's accession as a supernatural event. His outfit is reminiscent of accession garb at Piedras Negras, with the exception that there, the balloon headdress and war outfit are worn on the occasion of the ruler's completion of his first *katun* of reign. (Of course, by the time the lintels of Structure 23 were dedicated, Shield Jaguar had completed two *katuns* of reign.) At Yaxchilan, accessions were celebrated at Period Endings, and so the costume for accession is either identical to that worn on Period Endings or was not explicitly portrayed. The Vision Serpent is not new to Maya monumental art, dating to the earliest known Maya stela,[14] but this is its first appearance at Yaxchilan. As in the case of Lintel 24, Shield Jaguar's artists did not invent the motif; on the contrary, they used extremely traditional motifs in a new combination and style. On the very Early Classic Hauberg stela, the ruler who is being inaugurated holds the Vision Serpent, and on Lintel 25, the king arises from its jaws as a metaphor for the soul of the lineage founder, an avatar of the sun, rising from the Underworld. A parallel to this process is portrayed in the skeletal-serpent-and-monkey-skull headdress and arm device on the same lintel. Under the image of Shield Jaguar emerging from the serpent is a toad being swallowed by a skeletal serpent whose tail or second head is a monkey skull which probably represents the sun. Shield Jaguar's success in having survived a journey to the Underworld is also implied by the skeletal Tlaloc mask (which wears the balloon headdress) emerging from the lower head of the Vision Serpent. Lady Xoc's gown is decorated with an "ancestral royalty" quatrefoil infixed with a

mat design. Her striped sash and the bloodletting bowls tell the viewer that bloodletting was a constituent of this ceremony.

On Lintel 26, Shield Jaguar wears part of his war outfit, but no capture is mentioned. The glyphs seem to refer to a bloodletting bundle and a jaguar-skin-covered throne. Lady Xoc wears a toad design (toads are the guardians of the Underworld) on her huipil and holds Shield Jaguar's headdress and flexible shield. Her headdress is one sometimes worn by kings at other sites. The date 12 Eb 0 Pop is the only one of the three dates on the undersides of the front lintels to have occurred in the period of time when the lintels were being executed. It was the first day in the *haab*—New Year's Day. I suspect that Shield Jaguar intended this scene in which Lady Xoc holds his war garb to announce the end of his career as a warrior (at age seventy-eight); however, he continued to go to war for his community, as documented on the steps of Structure 44.

Several of the dates and glyphic texts on Structure 23 explicitly refer to ceremonies for the dedication of individual sculptures and perhaps for the entire temple.[15] The earliest appears on Lintel 26 (see Figure 15) at G2–J2, where a dedication of a named object is recorded (at I1 the sculpture or temple is named, at J1 the phrase *u k'u kaba*, its holy name, then at I2 *y-otot*, a glyph referring to the temple).[16] The date for this event is 9.14.9.12.9 1 Muluc 12 Yaxkin (20 June 721). Another dedication event was documented on 3 Imix 14 Ch'en (9.14.11.15.1 or 1 August 723) on the front edge of Lintel 25. This event does not include the "fire" verb as does the one on Lintel 26; instead, it has the God N dedication verb (translated as *u huy*, "to make its debut"[17]), the "*lubat*" phrase referring to writing, carving, or signatures, and the *y-otot* "house" glyph, followed by Lady Xoc's name and "under the auspices of Shield Jaguar." Another dedication verb which substitutes for the "God N" phrase appears on the front edge of Lintel 23, but I have not yet satisfactorily worked out or accepted any arguments for the reconstruction of the eroded date. The remainder of that phrase is crucial, for it names, in a rather convoluted statement, Lady Xoc's genealogy and relationship to Shield Jaguar. She is thought to be the sister of Lady Pacal, Shield Jaguar's mother. The latest "dedication" event listed on the underside of Lintel 23 follows the celebration of forty-five *tuns* of rule by Shield Jaguar on 7 Imix 19 Pop. The last dedication event is also a "fire" event and probably restates the name of the temple given on Lintel 26 (I say "probably"

because the glyph at I1 on Lintel 26 is partially eroded). The name of Structure 23 falls at M6 on Lintel 23 (see Figure 17). The "fire" dedication event occurred on 6 Caban 15 Yaxkin, or 22 June 726, almost exactly five years after the Lintel 26 "fire" date. The "fire" events fell on summer solstices five years apart, and are the earliest and latest ceremonies in Katun 9.14.0.0.0 recorded in the structure. These ceremonies may have marked the opening and completion of work on the monuments and perhaps on the building itself. For the first time at Yaxchilan, the Mayas made art about art.

Marking the actual Period Ending at Structure 23 was the circular Altar 7, inscribed with the date 9.14.15.0.0. It was situated directly in front of the building on the terrace.

The themes portrayed in the three lintels relate loosely to the Cross Group at Palenque, as do the use of summer solstice and the Jupiter-Saturn event as an anniversary of father's accession, but neither costumes, compositions, nor the lintel format was inspired by art at Palenque. The active bloodletting poses are the first seen in Maya monumental art and can be attributed to the relationship among Shield Jaguar, Lady Xoc, and the Exuberant Scribe.

9.15.0.0.0. STELA 18

Stela 18, which records the capture of Ah Chuen on 3 Eb 14 Mol (9.14.17.15.12) on its river side, likely celebrated Shield Jaguar's bloodletting on the Period Ending 9.15.0.0.0 on its more eroded temple side. The outlines of traditional Period Ending iconography can be observed on the eroded side. The low relief on the river side, with its image of Shield Jaguar in his traditional war outfit (his flexible shield replaced by a Piedras Negras–style "incense bag"), was executed by an artist not previously used by Shield Jaguar. This is evident in the composition—the Stela 18 artist avoided the disturbing gap in the center of the composition seen in the designs of the Elegant Knot Artist—and in the glyphic handwriting. The glyphs in the lengthy text on the upper portion of the stela are crowded together. Their exterior shape is confined and regular, and they are wider than they are tall. No matter who executed the drawings of the kings at Yaxchilan, their faces have a very similar appearance, as if some arbiter of proportion and beauty demanded that the figure conform to a rigid standard. Or perhaps Elegant Knot Artist or Exuberant Scribe drew the figure.

The stela was placed on the terrace in front of Structure 41, alongside the two gigantic stelae already erected there, 19 and 20. Stelae

16 and 15 could also have been commissioned about this time, but 16 is too eroded to read its date securely, while 15, a commemoration of Shield Jaguar's capture of Ah Ahaual, is in a style anomalous to the others at Yaxchilan.

9.15.5.0.0. STRUCTURE 44: STEPS I, II, V, VI

To commemorate his victory over Ah Chuen, Shield Jaguar commissioned four more stair blocks for Structure 44. The upper two blocks (I and V), like Step III (already in place), were carved on both tread and riser. The lower two blocks (II and VI), like Step IV, were carved on the treads only. Each contained the image of a kneeling captive or captives as well as hieroglyphs reporting the events. The glyphs contain historical accounts of important captures by former kings, linked by Distance Numbers to captures by Shield Jaguar. The four steps appear to have been designed as a set, because the same hand drew all the glyphs, and because each step seems to relate the history of a different former king and of a different *katun* in the long life of Shield Jaguar. For example, Step I tells of a capture by Knot Eye Jaguar II in the *katun* beginning on 9.6.0.0.0 and two captures by Shield Jaguar in the *katun* beginning in 9.14.0.0.0. Step V relates a capture by Bird Jaguar III, (Shield Jaguar's father) in the *katun* beginning 9.10.0.0.0 and three events by Shield Jaguar in the *katun* of 9.15.0.0.0. On the risers of the upper steps were long title phrases of Shield Jaguar including parentage statements. Steps II and VI are much more eroded than the upper steps. Step VI clearly opens with 4 Chuen 9 Xul (the possible Long Counts are 9.8.0.15.11, 9.10.13.10.11, and 9.13.6.5.11) and names someone other than Shield Jaguar as protagonist. A Distance Number with some *katuns* leads to an eroded date with 13 or 18 as the coefficient for the month, then names Shield Jaguar as the protagonist of that event and gives a parentage statement for him.

The upper steps seem to document the most important information—the capture of Ah Chuen on 9.14.17.15.11 and the bloodletting on the Period Ending 9.15.0.0.0, both by Shield Jaguar and both of which occurred within a few years' time, after the dedication of Structure 23. The steps were likely commissioned to be completed on the *hotun* (five-*tun*) ending.

9.15.6.13.1. LINTEL 56

A woman in the court of Shield Jaguar dedicated a small building on the riverbank on 9.15.6.13.1. The "fire" ceremony was recorded on the front edge of a lintel. The design is purely glyphic, and the text begins with a Long Count which incorporates an error in the *uinal* coefficient. The little building is named at G2, and the lady who did the "fire" ceremony is named at I1–2. The handwriting on this lintel is very similar to that of Stela 18, carved a few years earlier. Some of the chambers of the structure faced the river, but have mostly fallen. Other habitable chambers faced a small courtyard separated from the Main Plaza by a larger building, Structure 74. This building is one of the few at the site that has multiple chambers and faces a small, private courtyard. That, and its position near the river, suggest that it may have been a royal habitation at least part of the time.

9.15.9.8.1. THRONE

Fragments of a stone throne discovered by archaeologists working with the INAH are carved with full-figure hieroglyphs that record the date 12 Imix 9 Pax (9.15.9.8.1), the completion of three *katuns* as Ahau by the 5 *Katun* Shield Jaguar. The glyphs run in a band around the perimeter of the altar. I am not aware of its original or present location, but I suspect that it was unearthed during excavations in the southeast end of the Main Plaza, like the other two known carved thrones at Yaxchilan. (Altar 16, which is actually a throne, names Bird Jaguar IV and is now in the Main Plaza between Stela 1 and the Grand Stairway. A new throne, excavated from the northwest platform of Structure 6, names Bird Jaguar III.) This throne was the last known monument commissioned by Shield Jaguar in his reign of over sixty years.

In summary, during the first thirty years of his reign, Shield Jaguar erected only stelae, which closely followed the format established by his father, Bird Jaguar III—they were carved on two sides, with a tri-level explicit bloodletting composition on the temple side and warrior images on the river side. About 9.14.0.0.0, he began to plan an ensemble that revived the very ancient tradition at Yaxchilan of making sets of carved stone lintels. The earlier sets of lintels were greater in number, because earlier buildings were smaller in scale but had more entranceways than typical Late Classic buildings. In the last half of his reign, he paid greater attention to the shaping of the ritual environment. He continued erecting stelae to mark certain Period Endings, but began to commission other types of monuments as well.

Shield Jaguar's attention turned to the repetitive, cyclical quality of life on earth and in

the sky. He brought past kings into the present by reporting their deeds on his monuments and, as he did so, gave new life to the ancient tradition of carved lintels. His partners in this effort were two outstanding artists, Elegant Knot Artist and Exuberant Scribe, who took their task quite seriously. In the Late Classic, the power inherent in public art to inspire and influence public thought and action was realized, and these individuals saw some benefit in having their names attached to the creation of monuments. These artists saw that Yaxchilan stelae had long shown explicit bloodletting and perhaps suggested to Shield Jaguar that his lintels also show explicit capture and his court's explicit sacrifices as a way to add power to the images and to add identifiable character to Yaxchilan public art. It seems that Shield Jaguar agreed, but he was also interested in the way that Chan Bahlum of Palenque had constructed his major ceremonies in harmony with the actions of the sun and planets, and the way that the king of Palenque had named his temples. Helping plan and execute his monuments was a woman of high status and a great ability, Lady Xoc. The distribution of female figures on the lintels of Yaxchilan suggests that she had a special role, associated with ceremonialism and especially with astronomically based rites.[18]

Shield Jaguar followed precedents for city planning developed in the Early Classic. He did not build his temples and monuments in a single area of the site, but deliberately placed them high and low, east, north, and west. He placed his Period Ending stelae in front of an older structure and the temple that housed his war memorials on an acropolis used in ancient times. Wide distribution of temples and monuments to create sacred spaces for various functions was the traditional manner of designing the city. Early Classic Stelae 27 and 14, for example, were found on the Main Plaza and the West Acropolis, respectively, and Structures 41 and 6 were also high and low, paralleling the transit of the sun from dawn to noon to sunset.

Shield Jaguar lived much longer than must have been normal, indicating that he must have been quite a healthy man. It would seem that such a man would father many offspring, but only one was to become king of Yaxchilan, ten long years after the death of his father.

9.15.9.17.16. THE INTERREGNUM

The successor to Shield Jaguar, who was called Bird Jaguar after his grandfather, inherited responsibility for a large city with a burgeoning class of specialists. Like the artists who had been signing the sculptures, many architects, overseers, warriors, and other new specialists apparently had begun to shift allegiance from the community welfare to their personal status. Bird Jaguar was faced with the problem of devising a method of reassimilating these individuals into a changing social system. One approach he took was to illustrate many individuals in public art throughout the city.

Unlike Shield Jaguar, Bird Jaguar IV initiated his reign with the erection of several stelae, altars, groups of lintels, and many buildings. His accession stela documented significant events prior to his accession and prominently displayed his parentage statement. It could be argued that he only accelerated the already swift pace of construction that had occurred in the past two *katuns*. However, some authors have taken this explosion of artistic labor as cause for suspicion of the new king's legitimacy. "The very fact that such trouble was taken to document the circumstances of the succession creates the impression that there was something unusual in it that required explanation," suggested Proskouriakoff.[19] Sandra Bardslay suggests that Bird Jaguar invented the genealogical documentation that he placed on his monuments.[20] Neither of those authors made the parallel suggestion that the seven lintels, six hieroglyphic steps, three stelae, one altar, and at least two buildings erected by Shield Jaguar between 9.14.0.0.0 and 9.15.5.0.0 were also the products of an insecure reign. Rather than look at Bird Jaguar's monuments out of historical context, I propose to look at the facts and to consider the validity of the arguments for and against his legitimacy.

The first fact to ponder is that there was indeed a ten-year gap between Shield Jaguar's death and Bird Jaguar's accession. Bardslay has suggested that this was due to a struggle among contemporary members of a powerful nobility, which Bird Jaguar won by coup or deceptive practices. It is not unlikely that there were several contenders for the throne of Yaxchilan, among them possibly Lord Great Skull and perhaps other offspring of Shield Jaguar, if such indeed existed. In my estimation, however, considerable evidence points to the interpretation that Bird Jaguar knew he would be king for several years prior to his accession. I previously suggested,[21] and still think, that he considered it appropriate to wait until the death of his mother, Lady Ik Skull, before he selected a date for accession to the throne. She died on 9.15.19.15.3, and he took the throne 417 days later. During that period, Bird Jaguar leaped into action. He celebrated the Period Ending

9.16.0.0.0 by erecting Altar 9, he and Lady Great Skull conceived a child on the zenith passage, he captured "Q" on 9.16.0.13.17 so that he would have a sacrificial victim to offer for his child's impending birth (which happened 8 days after the capture), and he planned his accession stela, 11, the hieroglyphic steps of Structure 41, and Structure 40 to be ready for his accession day on 9.16.1.0.0. If he had not been legitimate, it seems impossible that he would have received such support from the community as was shown him through the cooperation of the artists and builders who worked on these projects. The aforementioned events are not definite facts, but inferences from the documented statements. They seem to be straightforward enough to accept at face value.

Neither Bardslay nor Proskouriakoff considered the small monuments that were erected during this interregnum, but they demonstrate that something (exactly what is not certain) was happening during this ten-year period. The sculptures that seem to date to this period are all altars, and all the altars at Yaxchilan are severely eroded, so the evidence obtainable from them is quite fragmentary. In fact, the only references to their dates are from Morley, who found many of them. Morley cleaned Yaxchilan's altars and drew their dates, but, as was his custom, not the nominal portions of the inscriptions. Any names of Bird Jaguar's rivals for the throne are lost to subsequent erosion. In front of Structure 19, Altar 1 records the death of Shield Jaguar on (9.15.10.17.14) 6 Ix 12 Yaxkin, and the Period Ending (9.15.15.0.0) 9 Ahau 18 Xul. Unfortunately the name of the protagonist of the latter event is eroded. Out on the Main Plaza, Altar 10 records a date about a year and a half later, 10 Ahau 13 Pax? (9.15.16.10.0?).

Also, to mark the ending of the *katun*, Altar 9 was carved and placed in front of Structure 33. If there were other contenders, and these are their monuments, and Bird Jaguar rewrote history as Bardslay has suggested, why did he leave these monumental bits of evidence of their claims to the throne extant for future generations to read? If, as I propose, Bird Jaguar was a very conservative man (in the manner advocated by Confucius), he erected these markers in the traditional Maya fashion—on the Period Endings and one other date, recording, as was customary, the major dynastic events within the elapsed time period.

Proskouriakoff suspected (and I agree) there may have been an interim reign.[22] After the discovery of Stela 35 by Roberto García Moll in 1982, I proposed that because Lady Ik Skull was depicted on both sides of the stela letting blood in a ceremony that occurred about a year prior to Shield Jaguar's death, but Shield Jaguar was not named in an *u cab* statement on the stela, as was customary when women did ceremonies while a king was ruler, she may have temporarily had responsibility for ceremonial duties at the site. I cited the existence of a Mah K'ina title, usually reserved for rulers, as evidence that her position was like that of a ruler.[23] Schele and Bardslay argue that the title may refer to an unportrayed supernatural instead of Lady Ik Skull because an *u cab* precedes the Mah K'ina phrase and Lady Ik Skull is named after a second verbal (or verbal noun) phrase. However, on the back of the stela, where her tongue bloodletting is actually portrayed, Lady Ik Skull is again named with a Lady Mah K'ina title, dispelling doubt that the title was hers. Also, Maya monuments do not generally name unportrayed supernatural protagonists (excepting the Palenque Triad and the Paddlers—two old supernaturals, one who has a stingray spine through his nose and one with jaguar ears, who paddle the canoe of deceased royalty to the Underworld, as identified by David Stuart). So I defend my original proposal, and offer it not as a fact but as a likely possibility.

Another fact to consider when weighing Bird Jaguar's legitimacy is that the existence of Lady Ik Skull, mother of Bird Jaguar IV, was not recorded on any known monument during Shield Jaguar's reign. The lack of mention of the king's wife is not unusual at Yaxchilan or at other sites. The only historical women recorded at Palenque are the mothers of kings, in parentage statements. Similarly, no wives of the kings were recorded at Tikal except after their deaths as mothers of the succeeding king. So there is nothing unusual about the lack of mention of Lady Ik Skull except the lavish documentation given to Lady Xoc[24] during Shield Jaguar's reign. Schele and Freidel assume that Lady Xoc was the major consort or wife of Shield Jaguar, and they state that the reason Lady Ik Skull (whom they call Lady Evening Star) is not mentioned as prominently is because she was a minor consort or wife.[25] The marriage customs of the Classic Period kings are not clear, so the relative documentation of these two women is insubstantial grounds to question the legitimacy of Bird Jaguar to inherit the throne of Yaxchilan. Bardslay suggests that Bird Jaguar lied about the identity of his parents.[26] My basic premise in this work is that the Classic Period societies were as community-oriented

as the Colonial and modern Maya societies, and in such a social system (especially one in which the community dreams together), lies about one's parentage would be very difficult to maintain. I contend that the absence of Lady Ik Skull's name on Shield Jaguar's monuments was normal, and that the mention of his mother by the acceding king was also normal practice for Maya rulers, and further, that the retroactive mention of Lady Ik Skull in a ceremony previously documented as having been performed by Lady Xoc (see Lintels 53 and 32) was a political maneuver by Bird Jaguar or even by his son to consolidate the influences of the Skull and Jaguar lineages in an era of social upheaval throughout the Central Lowlands.

Another fact of Bird Jaguar's reign is that his monuments are distinct stylistically and in symbolic content from his father's. This has been interpreted as a deliberate attempt to find new forms of persuasion by a contender who ruthlessly lied and practiced deception in his attempt to seize political power.[27] Bird Jaguar's monuments differ from his father's in several ways. For one thing, Elegant Knot Artist had been working at Yaxchilan for fifty years when Bird Jaguar acceded, and Exuberant Scribe for thirty-five. They seem to have contributed to the figural design of the temple side of Bird Jaguar's accession monument, Stela 11, but then executed no more monuments at Yaxchilan. The artists they trained did work on Bird Jaguar's monuments, but Bird Jaguar or his chief artistic overseer had a different approach to symbolism, using new forms of headdresses and extensive arrays of specific, symbolic costume elements to create epic pictorial assemblages, and this resulted in a different pictorial content. This didactic display of ceremony, I propose, was an aspect of Bird Jaguar's campaign to enhance or restore community solidarity.

It is common knowledge that political and spiritual leaders throughout time have rewritten history to serve their own ends. In such a small community as Yaxchilan, however, and in a society where ritual performance and storytelling preserved some version of history, I doubt that the community could be fooled about Bird Jaguar's suitability for the throne. If he manipulated the facts to gain power, he must have been in league with a larger council of powerful elites, for a lack of verity on monuments intended to honor the ancestors and sun would be perceived as threatening to the social welfare. The most economical explanation of the interregnum is that the Mah K'ina title given to Lady Ik Skull really referred to her as

an interim regent, that upon her death, her son, an offspring of Shield Jaguar, began to plan in a deliberate fashion for his own accession, and that on his accession to the throne, he had the support of the artists and architects of the previous generation who did continue to work for him.

9.15.17.12.10. STRUCTURE 21: STELA 35

The small stela carved on two sides found inside Structure 21 provides additional data but no definite answers about the interregnum. Although it is dated 4 Imix 4 Mol, corresponding to 9.15.10.0.1, it was probably not carved then. On the temple side of the stela is a nominal phrase for Bird Jaguar that includes a 3 Katun title. Bird Jaguar IV entered his third *katun* of life on 9.15.17.12.10, so the stela was probably carved after that.

Stelae at Yaxchilan were erected on three types of occasions: accessions, accession anniversaries, and Period Endings. Since this date is not a Period Ending (mysteriously, it is one day after a Period Ending), and since Lady Ik Skull is named with a Mah K'ina title which refers to reigning rulers, the stela may mark the day that Lady Ik Skull assumed a rulership regency or other function. Arguing against this interpretation is the fact that two other monuments at Yaxchilan record the same date and same verb, but with different protagonists. Both those lintels (39 and 14) were also produced years after the recorded date, however, so the interpretation of the event remains ambiguous.

Arguing for the assumption of an important office by Lady Ik Skull are the glyphs and iconography of Stela 35, which are patterned after Lintel 25, a record of Shield Jaguar's accession that was also carved many years after the recorded date of the event portrayed. Both monuments use the "hand-grasping-fish" verb, once interpreted as bloodletting, but more recently as manifesting the Vision Serpent. The Vision Serpent, which entered the Yaxchilan corpus of iconography with Lintel 25, appears for the second time on Stela 35. Lady Ik Skull wears the skeletal-serpent-and-monkey-skull headdress and holds bloodletting equipment on Stela 35, as Lady Xoc did on Lintel 25. I have considered the 4 Imix 4 Mol monuments as references to Shield Jaguar's accession, since the date is 3.0.10.0 since his accession and falls near summer solstice, but the monuments all mention Bird Jaguar and not his father, who was still alive on that date.

9.15.15.0.0. ALTAR 1

The marker for the Period Ending 9.15.15.0.0 includes in its text the most important event of the previous five *tuns*, the death of Shield Jaguar on 9.15.10.17.14. If the glyphs of Altar 1 were not so badly eroded, it might be possible to state how active Bird Jaguar and Lady Ik Skull were between Shield Jaguar's death and Bird Jaguar's accession. The *hotun* ending 9.15.15.0.0 is tied to the death of Shield Jaguar, but the name of the actor of the *hotun* ending is not clear. Many glyph blocks precede and follow the notation of 9 Ahau 18 Xul (9.15.15.0.0), and it is uncertain whether this altar was actually erected during the "interregnum" or whether it was a historical marker erected after the accession of Bird Jaguar.

9.16.0.0.0. ALTAR 9

The *katun* ending 9.16.0.0.0 is recorded on an altar found in front of Structure 33. The name of the protagonist is eroded.

9.16.1.0.0. STRUCTURE 41: STEPS; STRUCTURE 40: STELAE 12, 11; ALTARS 13, 14; STRUCTURE 39: ALTAR 4

During the interregnum, Bird Jaguar planned several monuments scheduled for erection on 9.16.1.0.0, the day he chose to become king of Yaxchilan at age forty-three. Each records events leading up to his accession and linked to the reign of Shield Jaguar. The latest date among this group of monuments is his accession.

Structure 41: Steps

9.13.0. 0. 0	8 Ahau 8 Uo	I	Period Ending by SJ
9.16.0. 0. 0	2 Ahau 13 Zec	III	No verb or protagonist
(9.16.0.13.17)	6 Caban 5 Pop	III	Capture of "Q" by BJIV
(9.16.1. 0. 0)	11 Ahau 8 Zec	III	Accession of BJIV

On the highest terrace in front of the ancient accession/summer solstice temple, Structure 41, Bird Jaguar placed three small carved steps. The steps served to link his father's accession to his own. Bird Jaguar chose to use the *katun* history format, beginning with 9.13.0.0.0, the *katun* ending following his father's accession. He then named his father's father, his own

namesake, Bird Jaguar III. A second step was carved but is eroded beyond any possibility of decipherment. The third step, in keeping with the *katun* history format, gives a Long Count date for 9.16.0.0.0, then proceeds 13.17 to the capture of "Q," and ends with Bird Jaguar IV's accession statement. The stairway was an effective and unobtrusive way to link the information on Shield Jaguar's stelae, most of which were erected on *hotun* endings, with his own reign.

Shield Jaguar also had linked a prior capture to his accession on Structure 44. Step III there records the capture of Ah Ahaual; then a Distance Number of 12.0 leads to 5 Imix 4 Mac, Shield Jaguar's accession day. So Bird Jaguar emulated the pattern of events followed by his father, and recorded them in a similar format—in a hieroglyphic staircase.

Stela 12

(9.15.10.17.14)	6 Ix 12 Yaxkin	Death of SJ
(9.16. 1. 0. 0)	11 Ahau 8 Zec	Accession of BJIV

Also planned for his accession, Bird Jaguar erected a stela that served as a death record for his father and a monument that linked the two reigns. Stela 12 recorded the death of Shield Jaguar and his becoming a half-spotted Ahau and linked the death to the accession of Bird Jaguar with a Distance Number.

Stela 11

(9.15. 9.17.16)	12 Cib 19 Yaxkin	(22 Jun 741)[a]	SJ
(9.15.15. 0. 0)	9 Ahau 18 Xul	(31 May 746)	SJ *u cab* BJIV
(9.15.19. 1. 1)	1 Imix 19 Xul	(31 May 750)[b]	BJIV
(9.15.19.14.14)	1 Ix 7 Uo	(28 Feb 751)	God K
9.16. 1. 0. 0	11 Ahau 8 Zec	(29 Apr 752)	BJIV
(9.16. 1. 0. 0)	11 Ahau 8 Zec	(29 Apr 752)	BJIV

[a]Summer solstice.
[b]Venus' first appearance as Evening Star.

Bird Jaguar designed Stela 11 to document a series of ceremonies which established his legitimacy as ruler through his knowledge of or identity with the supernatural realm. He intended his timely sanction by the supernaturals, coupled with the capture recorded on the steps of Structure 41, to demonstrate his deliberate path toward the throne. The events recorded glyphically on the stela can be paraphrased as follows.

On the river side: (9.15.9.17.16) on 12 Cib 19 Yaxkin Shield Jaguar exchanged the flapstaff

with Bird Jaguar. On (9.15.15.0.0) 9 Ahau 18 Xul Shield Jaguar performed a Period Ending event (posthumously) *u cab* [under the auspices of] Bird Jaguar. On 9.16.1.0.0 he took the bundle as Ahau of the lineage, Bird Jaguar, child of the woman Lady Ik Skull and child of the parent Shield Jaguar, etc.

On the temple side: On (9.15.19.1.1) 1 Imix 19 Xul he entered (the main sign seems to be *oc* [to enter] but is eroded), Bird Jaguar, Captor of Ah Cauac, Lord of Yaxchilan, etc. (Above this scene is a statement initiated by an auxiliary verb, implying that Lady Ik Skull and Shield Jaguar, who are named, also participated in this event. She was alive on that day; he was not.)

On the narrow sides is a continuous statement which starts and ends with the accession day, the first time as a Long Count, from which are subtracted the days necessary to reach the 819-day-count station prior to the accession (9.15.19.14.14) 1 Ix 7 Uo, white, north; then the accession is restated as a Calendar Round. This is the first time an 819-day-count, apparently a Palenque invention,[28] was recorded at Yaxchilan.

The dates chosen for these events and the intervals between them are linked to celestial phenomena. The 12 Cib 19 Yaxkin date, when ninety-five-year-old Shield Jaguar exchanged flapstaffs with Bird Jaguar, fell on summer solstice. This is the first of several summer solstice documents Bird Jaguar commissioned at Yaxchilan, but the practice was definitely in existence prior to this ceremony. Structure 41 was oriented toward summer solstice sunrise, and the ceremonies associated with the beginning and completion of work on Structure 23 also fell on summer solstice. In this case, Bird Jaguar seems to say that the end of his father's reign and the beginning of his ritual responsibility at the site occurred on summer solstice.[29] Two of the dates fall exactly four solar years apart—the quarter-*katun* ending on 9 Ahau 18 Xul (31 May 746), and the GI event portrayed on the temple side of the stela, dated 1 Imix 19 Xul (31 May 750). But the costumes give more information about the events than do the hieroglyphs on this stela.

The two scenes portraying Bird Jaguar both depict him prior to his accession. On the river side, which faces the sunrise, and therefore has a natural primacy of cosmic reading order, he is shown wearing the long-snouted-beast headdress, typical of Period Endings, and a bloodletting loincloth; he carries a GIII shield and wears a small, circular backrack of which the central element is an ancestor cartouche. His father, then deceased, wears the ancestor cartouche in his headdress, indicating that he *is* the ancestor, and he is not wearing a bloodletting loincloth. For the first time at Yaxchilan, a particular holey staff occurs, one which I call the flapstaff. Both figures hold flapstaffs, although Shield Jaguar holds his casually and Bird Jaguar looks as though he is doing something with his. Because his figure occupies less space, the father is depicted as less important, and his costume indicates that he is no longer the king (no bloodletting loincloth or long-snouted-beast headdress, and the ancestor cartouche in front of his head signifies that he is deceased). Bird Jaguar wields the summer solstice flapstaff and the GIII Underworld Sun shield, and wears the loincloth and headdress of active bloodletting.

The event portrayed on the temple side occurred approximately nine years later. On 1 Imix 19 Xul, Venus made its first appearance as Evening Star and Bird Jaguar made his first appearance as GI. He wears the GI diadem, the hank of hair, a mask, the typical pectoral, and holds a fan associated with scenes of prisoners. Three prisoners kneel before him. GI as the sacrificer is invoked also through the use of bloodletting wristlets and anklets and the bloodletting knots and shells on this loincloth. This is the only image of capture on a Yaxchilan stela that does not face the east. I suspect that this was done because the capture is less important than the fact that Bird Jaguar was entering the lineage as GI. Why does Bird Jaguar masquerade as GI two years prior to his accession as his parents observe from above? A recent interpretation of a similar scene from Palenque illuminates the meaning of this act.

The Dumbarton Oaks tablet shows Kan Xul II of Palenque wearing the Palenque version of the GI outfit, which includes diadem, pectoral, bloodletting loincloth, and a snake-handled axe. The glyphs record three events, the seating [ceremonial beginning or baptism] of 9.11.0.0.0, then a "house" event performed by GI under the auspices of Pacal about four years later, and a "knot-skull" event fourteen years after that, when Kan Xul was twenty-six years of age. In this scene, the living parents of Kan Xul II flank him, as is typical in art at Palenque. A recent paper by Karen Bassie proposes convincingly that these events are the first and second lineage events in the life of Kan Xul II, and further correlates them with similar first and second lineage events in the life of Chan Bahlum II, his elder brother. She also makes the case that Bird Jaguar's masquerade as GI at Yaxchilan is a similar kind of lineage event. It is probably not

coincidental that on Stela 11 the first use of the 819-day count (a Palenque invention) appears with the first GI masquerade (first seen monumentally at Palenque). If masquerading as or personifying GI is important in the legitimization process for heirs, and in Palenque followed an earlier lineage event, can a prior event at Yaxchilan also be identified as parallel to the Palenque first lineage event?

Bassie argues (and I agree) that Bird Jaguar's ballgame event, shown as part of the hieroglyphic staircase of Structure 33, is his first lineage event. It is the second event of which he is named as a protagonist, the date is the thirty-five-year anniversary of the tongue bloodletting depicted on Lintel 24, which occurred sixty-two days after Bird Jaguar's birth, and the verb for the event on 3 Muluc 17 Mac has the same main sign as the verb characterizing the first lineage event on the Dumbarton Oaks Tablet. The verbs for the prototypical events documented on Bird Jaguar's ballgame step are the "knot-skull" event that was used for Kan Xul's second lineage event. Therefore, the lineage information concerning Kan Xul II was recorded in a single panel, and that of Bird Jaguar was distributed between two monuments, but the verbs and costuming reveal the similarities between the sets of events.[30]

The final event on the stela Bird Jaguar commissioned for his accession day was the accession itself. With this stela, Bird Jaguar made a complex statement about his personal history and his political stance as he entered office. Having recorded Period Endings and a capture on the steps of the building where his father had placed similar information, he then selected local and foreign ritual information to appear on the monument to display his role as the personifier of the Hero Twins. He adopted, for the first time at Yaxchilan, several items of ritual attire that had been used previously at other cities but were not exactly pan-Maya. One of the most prominent was the flapstaff, which had been used a hundred years earlier at Balancan, near the northern reaches of the Usumacinta, and sixty years earlier at Site Q, which is probably between Tikal and Yaxchilan.[31] The GI diadem and outfit had been seen earlier at Palenque. However, those items had not been specifically associated with summer solstice or Venus as Evening Star in their previous appearances on monuments. The ritual content of the stela included a summer solstice ceremony in the tradition of those celebrated by Lady Xoc and Shield Jaguar, except that theirs were dedicatory and his claimed a super-

natural power to assist the community: he "held up the sky," as did GI on the Palenque Cross Group Tablets; he masqueraded as GI on the first appearance of Venus as Evening Star, showing his supremacy over those who offended the community and had to be captured. The summer solstice scene faces the sunrise, and Venus as Evening Star faces the west, where Venus appears as Evening Star, indicating that Bird Jaguar's powers encircle the sky. Under his feet, his accession and parentage statements become the foundation for his future activities. He demonstrated his mastery of rituals practiced beyond the local area, but cautiously reiterated important patterns of ritual practice established at Yaxchilan.

Altars 4, 13, and 14 (Structures 39 and 40)

Each documents the accession day, 9.16.1.0.0.

As he designed the ensemble of monuments for his accession day, Bird Jaguar recorded his participation in rituals similar to those his father and other kings had done. He did not show himself in the full royal costume, and this fact leads me to conclude that this group of monuments surely was designed prior to his accession. The taking of the God K manikin scepter and the bloodletting bundle was the climax of Bird Jaguar's accession, but was not depicted until after the fact.

There may have been other contenders for Yaxchilan's throne, but Bird Jaguar obviously had a very grand plan for the elaboration of the ceremonial center that would involve many individuals in its construction. If he had to convince a council of his qualifications, he must have spoken of a fabulous new building at the heart of the city, of augmenting the summer solstice and winter solstice axes already evident at the site, of honor for the auspicious kings and ladies whose accomplishments had made Yaxchilan an eminent city. Bird Jaguar seems to have had a vision of a community integrated through public works, but he also had the ability to inspire and direct the same artists who had worked under his father, and to finish the job.

9.16.2.0.0. STRUCTURE 22: LINTEL 21

| 9. 0.19.2.4 | 2 Kan 2 Yax | 4 *te zotz* by Ruler 7 |
| (9.16. 1.0.9) | 7 Muluc 17 Zec | 4 *te zotz* by BJIV |

From documenting his own life, Bird Jaguar turned to reestablishing the past. In Structure

22, he reset four old lintels from two previous reigns. In deliberately recalling the events of the past, he showed an interest in predicting in what cycle past events would recur. It is not clear whether he erected this building from the ground up or whether an earlier structure was located there. At least the lateral entranceways were built by Bird Jaguar IV, since their platform overlaps that of Structure 23.

He set two lintels naming Ruler 10 (Lintels 20 and 22) over the outer two entrances on the front façade, and two delicately incised, even earlier lintels (18 and 19) over two side entrances. He also commissioned an all-glyphic lintel (21) like the Early Classic ones. It records a ceremony "4 *te zotz*" performed on 9.0.19.2.4 (A.D. 454) by Ruler 7, which is linked to the same type of ceremony performed by Bird Jaguar IV nine days after his own accession. Since the ancient lintels originated in two different reigns, it is unlikely that they originally occupied the same structure. It seems Bird Jaguar IV rescued these lintels from some decaying building, perhaps nearby, and reset them in Structure 22.

This suggests that Bird Jaguar was extremely concerned with creating a strong sense of continuity of lineage and authority in the monumental historical record. For this reason, one of his first actions as ruler was to link his actions and his reign with those of Ruler 7, Moon Skull, 298 years earlier, and indirectly with other early rulers.

9.16.5.0.0. STRUCTURES 24 AND 21

Structure 24

(9.13.13.12. 5)	6 Chicchan 8 Zac*	L 27	Death of LP
1.17. 5. 9	DN		
(9.15.10.17.14)	6 Ix 12 Yaxkin	L 27	Death of SJ
6.17. 0	DN		
(9.15.17.15.14)	3 Ix 17 Zip	L 59	Death of Lady Xoc
1.19. 9	DN		
(9.15.19.15. 3)	10 Akbal 16 Uo	L 28	Death of LIS
4. 9.14	DN		
(9.16. 4. 6.17)	6 Caban 10 Zac*	L 28	Posthumous dedication by Lady Xoc

*The scribes confused "Yax" and "Zac" in this inscription. The correct month names that correspond to the Distance Numbers are given here.

Bird Jaguar recorded the deaths of the three most important elders of the previous generation and Lady Pacal, his paternal grandmother, on the front edge of three lintels that were placed in a small structure which faces winter solstice sunrise. The precedent of carving the front edge of lintels had been established at Yaxchilan in Structure 23. This obituary monument, Structure 24, was placed a few meters from the dynastic and astronomical ceremony memorial, Structure 23, which had been completed by Shield Jaguar and Lady Xoc thirty *tuns* earlier.

The inscription begins with the death of Lady Pacal, and gives the dates of the deaths of Shield Jaguar, Lady Xoc, and Lady Ik Skull. A Distance Number leads from Lady Ik Skull's death date to a posthumous "fire" event, recently paraphrased as a "temple dedication" event,[32] performed by Lady Xoc. Lady Xoc had dedicated Structure 23 (also recorded as a "fire" event) on 6 Caban 15 Yaxkin, and she dedicated Structure 24 as an influential ancestor on 6 Caban 10 Yax, which was exactly forty-one *tzolkins* since the Structure 23 dedication, exactly five *tzolkins* since Bird Jaguar IV's capture of "Q," and exactly forty-six solar years since Bird Jaguar's birth. The dates on the two buildings bracket Bird Jaguar's life from birth (sixty days before the Lintel 24 event) to his forty-sixth birthday. The first astronomical event (5 Eb 15 Mac) was an anniversary of previous accessions, and the last date of the two structures, the dedication of Structure 24, was a periodic commemoration of previous important events in Bird Jaguar's life. With this event, Lady Xoc's commemorative and astronomical rituals spanned two long reigns, even extending beyond her own lifetime. She was so important that Bird Jaguar carefully contrived all of his astronomical and commemorative rites to resonate with those she had done. He also elevated two young women to a position similar to the one Lady Xoc had occupied, and began to record their deeds in another building he dedicated on this *hotun*.

The scribe who drew the glyphs for Structure 24 also had designed Stela 18 for Shield Jaguar, and did the accession text at the base of Stela 11 for Bird Jaguar.

Structure 21

(9.15.10. 0. 1)	4 Imix 4 Mol	St 35	Bloodletting by LIS
(9.16. 0.13.17)	6 Caban 5 Pop	L 16	Capture of "Q" by BJIV

| (9.16. 0.14. 5) | 1 Chicchan 13 Pop)[a] | L 17 | Blood-letting by Lady Ix & BJIV |
| (9.16. 3.16.19?) | 4 Cauac? 12 Zip | L 15 | Blood-letting by LAI |

[a]Implied by reference to birth of SJII.

In his modifications of the Main Plaza, Bird Jaguar had thus far placed the ancient lintels in Structure 22 and constructed the obituary temple, Structure 24, both on the first terrace and on the northwest side of the Grand Stairway. To balance the placement of these buildings and the potent presence of Lady Xoc on the lintels of Structure 23, Bird Jaguar erected Structure 21 on the southeast side of the Grand Stairway. Iconographically and stylistically, it emulated Structure 23, although no artists of genius equal to the Elegant Knot Artist and Exuberant Scribe existed at Yaxchilan in Bird Jaguar's generation. Although it is likely that the Structure 21 artists were trained by the Structure 23 artists, their compositions, glyphs, and details are less complex and less explicit than those of Structure 23, resulting in disappointingly vague imitation.

Structure 21 lintels commemorate events which occurred before or early in the reign of Bird Jaguar and incorporate the two female ritual assistants who accompanied the astronomical and commemorative ceremonies during his reign. On Lintel 15 Lady Ahpo Ik holds bloodletting equipment and gazes at a Vision Serpent (probably the Earth Lord's messenger). Her posture is similar to that of Lady Xoc on Lintel 25, and as on the earlier lintel, the Vision Serpent is accompanied by a hand-grasping-fish manifesting verb. Lintel 16 illustrates the capture of "Q" previous to Bird Jaguar's accession. The appearance of Bird Jaguar in his war outfit corresponds to the appearance of Shield Jaguar in his war suit on Lintel 26. Lintel 17, like Lintel 24, shows a tongue bloodletting, and it also shows a penis perforation. On this occasion, Lady Ix let blood to celebrate the birth of Chel-te to Bird Jaguar IV and Lady Great Skull. On Lintel 24, Lady Xoc had bloodlet after the birth of Bird Jaguar IV to Shield Jaguar and Lady Ik Skull. Although Bird Jaguar requested compositions that would parallel the scenes of Structure 23, and drew additional parallels through including female ritual assistants and echoing some of the occasions and costumes used on Structure 23, evidently direct copying was not desirable.

The dedication date of this structure depends on an eroded date on Lintel 15. If the date is 4 Cauac 12 Zip (9.16.3.16.19), it corresponds to six solar years minus seven days since the death of Lady Xoc. This is an extremely speculative association. However, Lady Xoc was linked to Bird Jaguar in the Lintel 24 posthumous event also dedicated at this time.

Inside this building, Bird Jaguar placed the stela commemorating his mother's bloodletting on 9.15.10.0.1, which was discussed above. As was customary, the explicit bloodletting scene faces the temple rear, and an accession-type image faced the river. A Vision Serpent appears on the front side of the stela, accompanied by Tlaloc imagery, death eyes, and skulls. Thus, Lady Ik Skull balances Lady Xoc on this side of the Grand Stairway.

For the inside rear wall of Structure 21, behind the stela, Bird Jaguar commissioned a stucco sculpture that shows five persons on the throne of Yaxchilan. The throne upon which they are seated is a double-headed serpent, *chan*, split in the center, like the split-sky Emblem Glyph of the city. Like the Lintel 25 serpent, it carries Tlaloc imagery and wears a spotted drum-major accession headdress, as did Shield Jaguar on that lintel. It therefore refers to accession accompanied by the use of "foreign" symbols or power at Yaxchilan.

Proskouriakoff suggested (and I agree) that portraying powerful individuals on public monuments was Bird Jaguar's strategy for consolidating his political control.[33] The three women and two men depicted in the lifesize stucco reliefs probably correspond to Bird Jaguar, Lord Great Skull, Lady Great Skull, Lady Ix, and Lady Ahpo Ik. Lord and Lady Great Skull probably were leaders of an ancient royal family at Yaxchilan, a lineage powerful enough to challenge Bird Jaguar's claim to the throne. Ladies Ix and Ahpo Ik seem to have come from outside Yaxchilan. The proliferation of smaller sites near the Usumacinta in this period (such as La Pasadita, El Cayo, Laxtunich, and Chicozapote) suggests that a shift in social organization was occurring in the Usumacinta area, and that political alliances with nearby communities were particularly necessary.

9.16.6.0.0. STRUCTURES 33, 1, AND 42

Structure 33

| (9.10. 3.11.8) | 9 Lamat 16 Ch'en | VIII | Ballgame by BJIII |
| 9.15.13. 6.9 | 3 Muluc 17 Mac | VII | Ballgame by BJIV |

9.16. 0. 0.0	2 Ahau 13 Zec	A 9	Period Ending
(9.16. 1. 0.0)	11 Ahau 8 Zec	L 1	Accession of BJIV
(9.16. 5. 0.0)	8 Ahau 8 Zotz	L 3	Holding God K
(9.16. 6. 0.0)	4 Ahau 3 Zotz	L 2	Expired his 5th *tun* as *ahau*, BJIV with SJII

Pieces: 1

PLEASE KEEP THIS BOOKMARK IN THIS ITEM.

UWM
UNIVERSITY OF WISCONSIN

Return to:

Library Loan

...ently made long-range plans ...ruction project that would ...cession rituals and define ... He or a designer asso- ...een sense of spatial de- ... likely that he had a ...e buildings and their ...make a single area of ...d Jaguar's precinct,'' ...d reliefs around the ...l his own territory ... the acropoli and ... the previous his- ...is projects delib- ...ing axes along ...en organized— the axis of the Main Plaza, which faces winter solstice sunrise, and the summer solstice sunrise axis established with Structures 41 and 40.

The construction program whose target date for dedication was 9.16.6.0.0 defined Bird Jaguar's ritual space. He distributed these structures and the associated symbols to demonstrate his supernatural role as personifier of mythical beings related to the annual path of the sun. The mode of symbolism used on the lintels and the vertical and horizontal positioning of Structures 33, 1, and 42 have been discussed in Chapter 4. Here I focus on the sculptural and architectural complex of Structure 33 itself.

A comment by Morley comes to mind every time I climb to Structure 33: ". . . considering its conspicuous location on the summit of a high natural hill, at the very center of the city, Structure 33 must have been the most imposing structure of the city."[34] The careful placement and deliberate grandeur of Structure 33 amazed Morley, is still enthralling today, and must have been magnificent in 757.

From the Main Plaza, the roofcomb of Structure 33 can be seen gleaming white above the trees, especially against the deep blue skies on summer mornings. It imparts a sense of mystery to those who wish to view it whole, because from the plaza, and during the entire thirty-five-meter ascent, only the roofcomb can be seen. Each segment of the climb to Structure 33 yields a new experience. On the roofcomb is a statue of Bird Jaguar enthroned, visible from the Main Plaza and during the climb. Only when one reaches the terrace at the top of the immense stairway does the main body of the building become visible, with the hieroglyphic staircase showing ballplayers, the stalactite stela, and the lintels, brightly painted on the undersides, and marked with red hands on white circles on the front edges. Those allowed to enter the building would have found one more surprise—a twice-lifesize sculpture in the round of Bird Jaguar, seated within a niche against the center of the rear wall, enveloped in darkness except on summer mornings.

Structure 33 was an elaborate cosmogram unlike any other at Yaxchilan. The façade is divided into registers. The lowest register is formed by the row of thirteen carved risers of ballgame scenes, directly below the three entranceways. The blocks of the staircase are arranged so that the central three blocks are the largest and the most deeply carved (by the workshop of the Structure 23 artists). The central block, VII, is the largest, and portrays Bird Jaguar IV engaged in his first lineage event, a ballgame that was likened to ballgame events in the distant past. The historical date that he played ball was expressed as a single day within a scale of reference cosmic in dimension, as 13.13.13.13.13.13.13.13.9.15.13.6.9. A verbal couplet states that the ballgame event also involved the letting of blood.[35] Two dwarfs in the scene are marked with Venus signs and one wears a shell earplug. Perhaps, as Venus was called the sweeper of the path of the sun, the Venus sign identifies them as the sweepers of the path for Bird Jaguar as he journeyed to confront the Lords of the Underworld in their ballcourt.

With the design of the ballgame scenes on the temple risers, Bird Jaguar provided an explicit reference to the mythological Hero Twins and their Underworld battle to prepare the world for the arrival of the sun and the present era. Bird Jaguar proclaimed that not only he, but his father and grandfather (Steps VI and VIII), the Captor of Muluc, Lord Great Skull, and other important individuals also participated in the battle against the forces of evil, sickness, and disorder.

The middle register of the Structure 33 cosmogram is the lintels. They portray Bird Jaguar at once as the GI and GIII of the Triad (Lintel 3

refers to Chac Xib Chac through the diadem and to GIII with the shield), as the person responsible for the paths of the sun and Venus (on Lintel 2, the sun-Venus path above the headdress), and as the living God K with the manikin scepter. Bird Jaguar played these roles as he performed the duties of rulership; as he acted on the terrestrial level, he personified the actions of the cosmos.

The celestial register of the cosmogram was expressed by the annual illumination of the enormous three-dimensional statue within the chamber by the summer solstice sunrise. The lintel above the central entrance shows Bird Jaguar and Chel-te as the Axis Mundi, symbolized by the bird-cross scepters and the GI-Venus serpents on their headdresses. Immediately below that entrance is the Step VII cosmic ballgame Underworld event.

As explained in Part Two, three figures enthroned on monster heads were each situated over an entrance, and between the figures were two monster or serpentine masks with semiquatrefoil mouths. Unfortunately, the stucco sculpture is too eroded to state with certainty what symbols appeared there. They seem to have been lifelike figures surrounded by interlacing serpent monsters whose heads terminated in the long, curling snouts seen on Yucatecan façades.

In front of Structure 33 is a stela made out of a stalactite shaft (Stela 31). The irregular natural surface of the stalactite is incised with three figures, two of them standing facing each other, wearing the pointed hipcloth and letting blood with inserted penis perforators. The third figure wears a cape and is crouched at the feet of the others. The stela is now broken in half, but a fragment of the upper section shows that the ruler (presumably Bird Jaguar) is wearing the GI diadem typical of the Yaxchilan bloodletting stelae. No date survives for this monument. The altar associated with Structure 33 is located below the northwest corner of the platform upon which the structure is built, and commemorates the *katun* ending 9.16.0.0.0.

Structures 1 and 42
Bird Jaguar separated references to his family members from references to his ritual assistants and other allies. In the triad of structures erected for 9.16.6.0.0, Structure 33 is the only building in which he portrayed his wife and son, and his father and grandfather. Conversely, ritual assistants Ladies Ix and Ahpo Ik appear in Structures 1, 42, and 21, but not in his accession structure, 33. Bird Jaguar portrayed the Captor of Muluc in Structure 1 and 42 lintels and on the steps of 33. The legitimate dynastic members are concentrated in 33, while political and ritual allies are portrayed in structures nearer the periphery of Bird Jaguar's ritual arena. It seems that dynastic considerations were considered central information, and the incorporation of persons from outlying cities was done in outlying structures.

As was typical of his approach to dates for ceremonies, Bird Jaguar knit the post-accession rituals in webs of cycles to the events of Lady Xoc. The earliest event of the triple temple complex is his ballgame event, which is also physically in the center of the composition. The date selected for this event is thirty-five years (minus seven days) since 5 Eb 15 Mac, the Jupiter-Saturn conjunction that was commemorated sixty-two days after Bird Jaguar's birth. Jupiter was stationary again, lacking eight days until completion of thirty-two cycles since the Lintel 24 event. That this is more than coincidence is indicated by the existence of a monument that is a solar anniversary of the ballgame event. The dates on Lintels 6 and 43 are the eighth *haab* anniversary of the ballgame event. Iconographical similarities support the proposition that an esoteric reference to the ballgame event was made on Lintels 6 and 43. On those lintels in Structures 1 and 42, Bird Jaguar was portrayed in Underworld iconography. On the astronomical level, Venus showed up again, this time in the eye of a GIII jaguar headdress. On the mythological level, Bird Jaguar impersonated Xbalanque, one of the ballplaying Hero Twins. On Lintel 6, the Captor of Muluc wore a fish-eating-waterlily headdress worn also by ballplayers on the steps of Structure 33. Bloodletting knots worn around the waists of the two men on Lintel 6 allude to the bloodletting performed in conjunction with the ballgame. The links between Structures 33, 1, and 42 and the important astronomical-dynastic commemoration on Lintel 24 are reinforced through iconography, calendrics, and astronomy.

A fuller iconography and historical rationale for the design of these twin structures was presented in Chapter 4. There the imaginary line that spatially links Structures 42, 33, and 1 was also mentioned. The fact that the three buildings in three different areas of the city can be connected with a single straight line, however, does not explain the orientation of Structure 1 at 345 degrees. Another conceptual line could be the reason for its placement. A line perpen-

dicular to the back wall of Structure 1 and passing along the doorjambs intersects Stela 1, Bird Jaguar's *lahuntun* marker, in the Main Plaza.

9.16.7.9.2? STRUCTURE 36, STELA 9

(9.16.7.9.2??) 13 Ik? 0? Mac

Stela 9 of Structure 36 is the most unusual stela of the city. It was found in front of Structure 36, a square-based building with a complex system of recessions and projections on the bodies of its stepped platforms. With its low relief carving and frontal pose for the body, the style of Stela 9 is reminiscent of Piedras Negras Stelae 2 and 4. The explicit portrayal of penis perforation suggests that the stela was carved after the completion of the exemplary explicit female bloodletting scene of Structure 23. However, I can find no special significance for the proposed date, 9.16.7.9.2.

9.16.10.0.0. STRUCTURES 8 AND 13 (?); REMODELING WESTERN PORTION OF MAIN PLAZA; STELA I

Having defined the boundaries of his ritual territory, Bird Jaguar next subdivided the Main Plaza into zones with a focal point at its physical center, where the stairway to Structure 33 enters the plaza. He erected two buildings to isolate the heart of the plaza from the surrounding area. Structure 8, placed transversely to the axis of the plaza, creates a partial barrier between the (probable) old location of ancient stelae from the reigns of Ruler 9 and Bird Jaguar III in the southeast and the new focal point of Bird Jaguar IV's Yaxchilan: the stairway to Structure 33. Closing the northwest side of the ceremonial space is Structure 13, which is raised on a platform and faces Structure 8. The resulting area is about 40 by 60 meters. Some buildings along the plaza since 9.5.0.0.0 faced 118 degrees, the winter solstice sunrise axis, and three of the buildings Bird Jaguar had built to date, Structures 24 and now 8 and 13, also face exactly 118 degrees east of north.

Structure 8
Associated with Structure 8, INAH recently found a partial wall panel that names Shield Jaguar and names Lady Ik Skull as a mother. This monument clearly refers to Bird Jaguar, but no information remains to secure the construction date; hence it remains conjectural.

Structure 13

(9.13.17.15.13)	6 Ben 16 Mac	L 32	Holding God K and Bundle, SJ and LIS (Jupiter-Saturn conjunction)
(9.15.16. 1. 6)	5 Cimi 19 Yaxkin	L 33	Summer solstice event by BJIV
No date		L 50	Summer solstice event? MKSIII

Structure 13 was built in several phases. Three lintels were found there, two of which date to the reign of Bird Jaguar IV. L 33 was carved after 9.16.4.1.1, because it names Bird Jaguar as the Captor of Jeweled Skull. So the earliest possible date for the completion of Structure 13 is 9.16.5.0.0. Lintel 33 records a flapstaff event that had occurred previously. Bird Jaguar reported that on summer solstice, 9.15.16.1.6 5 Cimi 19 Yaxkin, six years after the Stela 11 summer solstice event, but before his accession, he had performed another flapstaff–summer solstice event. On this lintel, he displayed the coiled-serpent anniversary headdress, and the Chac Xib Chac diadem. Lintel 33 is the only portrayal of a summer solstice event in the Main Plaza.

The central lintel, 32, names Shield Jaguar and Lady Ik Skull but can be attributed to the reign of Bird Jaguar IV because of sculptural style and iconography. The drum-major headdress and the bundle theme with manikin scepter shown on this lintel were symbols adopted in the reign of Bird Jaguar IV. The Lintel 32 date is 6 Ben 16 Mac, and could only refer to 9.13.17.15.13, in the period of the Jupiter—Saturn conjunction/anniversary of accession/birth of Bird Jaguar ceremony, originally recorded as having been performed by Shield Jaguar and Lady Xoc on Lintel 24. Since no monument from the reign of Shield Jaguar shows him with Lady Ik Skull, this seems to be an attempt by Bird Jaguar IV to celebrate his mother as the actress in a ceremony that Bird Jaguar used as a basis for solar-year commemorations. Shield Jaguar II also commissioned a lintel with this same date, showing his grandmother, Lady Ik Skull, and his grandfather, Shield Jaguar, in the "revised" version of the Lady Xoc performance. This was the event that Bird Jaguar also tied by periodic repetition of cycles to his ballgame event and to the post-accession ceremonies portrayed on Lintels 6, 7, and 43. He

wanted a memorial to this event in the Main Plaza, in the new space he created for his stela gallery.

Remodeling the Main Plaza

Structure 9, a low platform, had existed since Early Classic times. The earliest traditional Yaxchilan Period Ending bloodletting stela was originally placed there, or perhaps Bird Jaguar moved it from another location to the base of his axial composition. This very early stela, 27, dated 9.4.0.0.0, shows a bearded ruler wearing a Tlaloc-like headdress, an *ahau* collar, a cape, a crossed-bands belt and human head backrack, and a jaguar at the waist. The arm closest to the viewer hangs limply, and the further arm was probably extended, releasing the flow of blood that can be seen falling into a waiting receptacle. The bloodletting image faces Structure 33, as was normal for the "temple" side of a stela.

Structure 74 may also have existed at this time, since Structure 10, which had not been built in 9.16.10.0.0, overlaps Structure 74. It formed a backdrop for the *lahuntun* ending marker, Stela 1. Between Structures 74 and 9 is a stairway that ascends toward the river to an artificial terrace overlooking the bluff. From there it is a steep descent to the shore. Close by is the enigmatic masonry pier, which, it has been suggested, might once have supported a bridge across the Usumacinta, or have been a wharf.

The section of the plaza that Bird Jaguar created functioned as a sunken viewing ground for ritual gatherings. Several pedestal stones (altars) carved with glyphic inscriptions are located near the center of this space. The Altar 10 inscription seems to date 9.15.3.1.5, which would place it in Shield Jaguar's reign. Altar 11 records the date 9.16.1.3.5, shortly after Bird Jaguar's accession. Two stones approximately 2 meters long are carved to resemble caimans. These are located at either side of Stela 1 (see Figure 107).

Stela 1

9.16. 8.16.10	1 Oc 18 Pop	819-day-count station
9.16.10. 0. 0	1 Ahau 3 Zip	Period Ending by BJIV

In the center of the 60-meter subplaza Bird Jaguar IV erected a *lahuntun* marker, Stela 1. On the temple side, facing Structure 33, is the three-register composition of his parents above,

the skyband as a royal emblem, and a reference to the cosmological role of the ruler, the image of Bird Jaguar perforating his penis and offering blood, aided by a caped individual wearing a snaggletooth headdress and a shell brooch. In the lower register is a frontal sun monster, in the seated posture of a king, and holding a stiff, double-headed skeletal serpent bar. The sun supernatural faces the summer solstice temple. On the river side of the stela is a warrior image and a basal monster too eroded for definite identification (see Figure 124). Each side of Stela 1 was incised with an image—one male and one female—both in profile and facing Structure 33. I suspect that these are Lady Ik Skull and Shield Jaguar, intended to watch, with the populace, the drama unfolding on the platform and staircase of Structure 33.

Where the First Terrace intersects the monumental staircase, next to Structure 22, Bird Jaguar IV placed two stelae, one on either side of the staircase (see Figure 2). Stela 28 has not been illustrated. The top half of it was found by Karl Ruppert, and Morley described only the remains of a profile image facing left. It is comparable in size to Stela 2. Stela 2 is now placed on a low platform consolidated by Roberto García Moll in the center of the width of the stairway to Structure 33, partially up to the level of the First Bench. A warrior stands on a frontal monster head whose forehead is infixed with the number 9. The warrior image now faces, and probably originally faced, the river.

Remains of an ancient staircase made of gigantic blocks can be seen behind Structure 9, connecting the plaza with the river. Bird Jaguar arranged several of Yaxchilan's stelae to create a processional history gallery along the passageway from the river up to Structure 33. Stela 27, dated 9.4.0.0.0, is the earliest *katun* marker of the city. Stelae 28 and 2 date from the Early or Middle Classic. Nearby, on the First Terrace, Structure 22 houses the lintels from the reigns of Ruler 10 and Bird Jaguar II. At the summit of the Grand Stairway, several generations of kings were portrayed engaged in ritual (ballgame) combat with the Lords of the Underworld. Bird Jaguar wished his own image to be the culmination of the history of many generations of kings.

9.16.13.0.0. STRUCTURE 16: LINTELS 38−40

After 9.16.10.0.0 Bird Jaguar slackened the pace of his architectural and sculptural projects, but kept quite active. In the next ten years, he

erected two more stelae, which commemorated Period Endings, and about three more structures with associated sculptures.

(9.15.10.0. 1)	4 Imix 4 Mol	L 39	Blood-letting God K *u cab* BJIV
(9.16. 7.0. 0)	13 Ahau 18 Zip	L 40	Verbs eroded, Lady Ix
(9.16.12.5.14)	3 Ix 7 Mol	L 38	Blood-letting to God K by LAI

Another building which prominently displayed Bird Jaguar's female ritual assistants was erected at the northern end of the Main Plaza facing the winter solstice sunrise. A long, low platform isolates a limited access area in front of Structure 16 from the public open space of the plaza. For the lintels of the new structure, Bird Jaguar used a design format pioneered by his father in Structure 23, and one which he had used in Structure 24 (which also faces the winter solstice sunrise)—that of placing the carved information on the front edge of the lintel. In this case, figures complement the glyphic information on the front edge. Perhaps it was less effort to carve only the small front edge rather than the larger underside of the lintel. It seems that the format was decided upon first and the design and the posture of the figures were adapted to fit the extremely horizontal format of a lintel front.

The three lintels are carved with similar iconography. As in his other non–Period Ending structures, Bird Jaguar is shown on the central lintel, and his two female ritual assistants are depicted on the two outer lintels. They face Bird Jaguar. The verb in all three cases is the hand-grasping-fish manifesting verb, with God K as the object manifested.

The two women, Lady Ix and Lady Ahpo Ik, lean slightly toward the center of the building as they support a double-headed serpent from whose mouths emerge God K's. If the event is recorded as manifesting God K, and God K appears in the mouths of the serpents, then the serpents must be the vehicle or medium for evoking God K, the symbol of ancestral lineage. The double-headed serpent bar is itself a royal emblem, held by rulers since the Early Classic at various Maya cities.

The images on Structure 16 lintels represent ancestral ceremonies. The dates recorded for these events support this suggestion. The 4 Imix 4 Mol date on Lintel 39 had been commemorated previously—that was the day that Lady Ik Skull let blood and was called Mah K'ina. The only possible interval for this Calendar Round is 9.15.10.0.1, because its next occurrence falls after the disappearance of Bird Jaguar from the historical record. Why did Bird Jaguar state in 9.16.13.0.0 that he let blood on this day, more than ten years before his accession, and what is the significance of the other two dates?

The repetition of the 4 Imix 4 Mol event gives a clue to the meaning of this assemblage by recalling Lady Ik Skull. The Lintel 40 date occurred nine solar years (lacking one day) after the death of Lady Xoc. The Lintel 38 date was twenty-two solar years (lacking two days) since the 4 Imix 4 Mol event. If the Yaxchilan priests were using horizon observations for solar reckoning, as I suspect, then these ceremonies would have occurred on days on which the sun was perceived to have risen in the same position on the horizon as for the events they commemorate.

Other bits of evidence support the efficacy of these calendrical interpretations. On Structure 16 lintels, the two female ritual assistants associated with Bird Jaguar are performing commemorative ceremonies for the women important to the king of the previous reign. The lintels of Structure 16 are carved on the front edge, as are those of Structure 24, where the deaths of these women are recorded. The two buildings share an orientation to winter solstice sunrise. The iconography, the holding of the double-headed serpent plus God K, is surely a reference to an ancestral ceremony. Bird Jaguar IV had taken pains to include numerous posthumous references to his mother, Lady Ik Skull, on his stelae, and to carve monuments depicting her with his father after both parents were dead. Taken together, the evidence strongly suggests that the Maya did practice commemorations of important ancestors on solar intervals, and that this was the impetus for the lintels of Structure 16.

9.16.15.0.0: STRUCTURE 39: STELA 10

(9.16.15.0.0)	(7 Ahau) 18 Pop	Verbs eroded (parentage statement of BJIV extant)

After fourteen *tuns* as *ahau*, Bird Jaguar built a large new temple atop the South Acropolis. Its

axis is skewed in relation to the other temples on the acropolis; it faces just east of north toward Structure 19. A substantial plaza in front of the temple held a large stela carved on all four sides and an altar which commemorated Bird Jaguar's accession day. Two more altars are associated with the buildings, one inside the temple and one on its platform. Their dates have eroded.

Stela 10 is atypical as a Period Ending stela in that the figure of Bird Jaguar is frontal on both sides of the stela. The lower half of the temple side is severely effaced, but the figure is definitely frontal. On the river side, three additional individuals appear with Bird Jaguar, an elite male, an elite female, and a kneeling figure. Bird Jaguar holds a spear and shield, but does not wear the typical war scarf nor an elaborate headdress. He does wear a bloodletting loincloth with notched borders, the first time this item appears at Yaxchilan. Also new to Yaxchilan are the "epaulets" attached to his shoulders. Including a parentage statement on a Period Ending stela was apparently traditional, for another one appears here, but the glyphs are rendered by a new hand. For the first time, Lady Ik Skull is given a foreign Emblem Glyph—that usually called "Site Q"—whose main sign is a *ca* comb and a reptile head.

The 9.16.15.0.0 Period Ending was marked at La Pasadita, a nearby site, with a lintel showing Bird Jaguar as he usually appears on a stela (La Pasadita Lintel 2; see Figure 38*b*). Conversely, Bird Jaguar's 9.16.15.0.0 stela (Structure 39, Stela 10) includes images of a group of individuals on the temple or warrior side, among them a man in a headdress seen also on La Pasadita Lintel 1. The man is standing and holding a flexible war shield, showing that he is an assistant or ally, not a captive, and the bloodletting knots at his wrists suggest that he, like Bird Jaguar, participated in the regularly scheduled sacrifice. This suggests that some ritual or military alliance developed between Bird Jaguar and the ruler of La Pasadita. Thus by 9.16.15.0.0, Bird Jaguar was concerned with his political alliances not only with the local elite, but also with elites from surrounding cities.

9.17.0.0.0. STRUCTURES 10 AND 2

Structure 10

(9.13.16.10.13)	1 Ben 1 Ch'en	L 30	819-day count with "fire" phrase embedded
9.13.17.12.10	8 Oc 13 Yax	L 29–30	Birth of BJIV
(9.16. 1. 0. 0)	11 Ahau 8 Zec	L 30	Accession of BJIV
(9.16.13. 0. 0)	2 Ahau 8 Uo	L 31	House dedication event
(9.17. 0. 0. 0)	13 Ahau 18 Cumhu	L 31	End of his 17th *katun*

One of Bird Jaguar IV's last monuments contained a record of his own birth. No birth records for any previous rulers of Yaxchilan are known to exist, but Bird Jaguar seems to have been particularly historically minded. Additionally, a record of his birth clarified to those unaware of the date the ceremonies that had been performed on his behalf over the years. Therefore, in the area of the plaza where he had created a subplaza in which ancestral and summer solstice data were recorded, in three of the doorways of Structure 10 that were not blocked by Structure 13, he commissioned three lintels that gave a synopsis of his life. The three lintels relate the 819-day count prior to his birth date, his birth date, his accession date, the end of the cycle 9.16.13.0.0, and 9.17.0.0.0. It is interesting that the 819-day-count position selected is also exactly four *katun*s from the date of his grandfather Bird Jaguar III's accession to the throne. In this passage, the verb for the Period Ending 9.16.13.0.0 is a temple dedication, and the phrase names the temple "Mah K'ina Itzam-na." What is not clear, however, is why, if this refers to the temple dedication, the text continues to say that "his seventeenth *katun* expired" which brought the date to 9.17.0.0.0.

Structure 2: Lintel 9

(9.16.17.6.12)	1 Eb end of Yaxkin		Summer solstice staff by BJIV and Lord GS

At the far southeastern end of the Main Plaza, a small structure with one lintel was constructed. Over the single doorway was a lintel which documents a summer solstice ceremony very late in Bird Jaguar's reign. On Lintel 9, he is shown passing the flapstaff to Lord Great Skull. The date 1 Eb end of Yaxkin was probably chosen because the king desired to retain the month Yaxkin as the month the flapstaff ceremony was held, despite the fact that this date fell four days before the solstice that year. Bird Jaguar IV wears the Axis Mundi symbol, God C, and also GI emerging from a serpent mouth (probably a

substitution for the GI diadem) in his head-dress. He wears the rack of shrunken heads and torsos as a chest ornament. Lord Great Skull is dressed as the Quadripartite GI. Bird Jaguar perhaps performs the transfer of ritual responsibility to Lord Great Skull near the end of his reign, as he had portrayed Shield Jaguar doing for him many years earlier, on Stela 11.

Buildings at the southeast end of the site, including Structures 20, 54, 55, and 2, tend to emphasize the roles of Lord and Lady Great Skull and Lady Ik Skull. In Structure 54, Lord Great Skull appears to be Shield Jaguar II's political equal on Lintel 58. Perhaps Lord Great Skull held an important office at the site between this time and the accession of Shield Jaguar II.

9.17.1.0.0. NEW STELA (STELA 33)

A newly found fragment of the top of a cosmogram stela suggests that Bird Jaguar lived to complete a *katun* of rule on 9.17.1.0.0 9 Ahau 13 Cumhu. The fragment was found under the platform of Stela 3 (built by Shield Jaguar II as a part of his plan that remodeled and resurfaced the southeast area of the Main Plaza). The date is eroded, but a high coefficient is visible for the month date. The completion of one *katun* as Ahau of the lineage is clearly visible, and a sky title follows. After the sky title is a "1 *akbal* skull" glyph associated only with Bird Jaguar IV. A Distance Number in this text goes back five *katuns* to a date in Bird Jaguar IV's father's reign. The secondary text names a Shield Jaguar, but not enough of the title phrase remains to determine which one.

No death date has been found for Bird Jaguar IV. Was he captured abroad in a raid as was Kan Xul of Palenque? No city boasts his capture. Did he die in his early sixties? Did he foresee a problem with the continuation of his reign when he passed the flapstaff to Lord Great Skull? The monuments dating from the early part of the reign of his son are extremely fragmentary, so no accession date is known for Shield Jaguar II, although it is clear that he reigned into *katun* 9.18.10.0.0. Bird Jaguar IV, who left more documents about his life than most other Maya kings, ultimately slipped from the grasp of history.

In supervising the design of architecture and sculpture, Bird Jaguar carefully considered its position and orientation within the city. Many of his ceremonies, also, were held on days that paralleled the rituals of his ancestors. These facts suggest his extreme concern with actualizing ideal order. The political climate of the late twentieth century makes us skeptical of claims of order and control by rulers, and during the era around 750, as more polities claimed divine lineage, as a class of artisans and traders arose for the first time in Maya history, and as the forest was cut down and land laid waste, political harmony was also more of an ideal than a real experience. Bird Jaguar referred to none of these problems in his official statements.

The corpus of monumental art he commissioned also demonstrates his concern with cultural and political developments in the region. When he showed members of other polities, they were allies or captives, never competitors. His awareness (or that of his artists) of artistic events outside Yaxchilan is evident in the high degree of borrowing of the costume elements and the intellectual achievements established in the art, hieroglyphic texts, and architecture of other cities. For example, the flapstaff, which became identified with royal rituals on summer solstice in the Usumacinta region, had appeared earlier elsewhere. Also, three-dimensional statues such as the stone one in Structure 33, while little known today, were probably very common in wood at Yaxchilan and elsewhere. Bird Jaguar and his artists borrowed the God C loincloth, the GI diadem, the use of the 819-day count, and the practice of naming temples in their hieroglyphic texts. Little creativity appears among their monuments. What Bird Jaguar lacked in creativity he compensated for in drive. He must have had enormous energy to complete or oversee the completion of so many monuments in less than twenty years, but his monuments lack the aesthetic impact and visual complexity of those done by the Structure 23 workshop.

Bird Jaguar was probably an extremely conservative person who was fascinated by the political and social control that could be derived from modifying the environment. The scope of the Structures 33-1-42 project was as immense as that of the Cross Group at Palenque, but it was not executed with as sweeping a cosmological vision nor as much intellectual depth. With the summer and winter solstice axes and structures, however, Bird Jaguar succeeded in furthering a unique and strong statement of identity and supernatural sanction for his lineage and for his community.

7

Individualism and the Collapse

Bird Jaguar IV's son, born Chel-te and later called Shield Jaguar (II) after his grandfather, certainly ruled at Yaxchilan for about thirty-five years, from about 9.17.0.0.0 to about 9.18.15.0.0. From this lengthy reign, only a few monuments survive—some stelae placed in front of Structures 20 and 44, some lintels at the southeastern end of the city, and a hieroglyphic stairway. The stelae and lintels documented routine events, such as Period Endings, but Hieroglyphic Stairway 5 (Structure 20) told of Shield Jaguar II's accelerating battles and captures. He recorded that in about three years, from 9.18.6.4.19 to 9.18.9.10.10, he captured about twenty opponents. Shield Jaguar deliberately sought an alliance with Bonampak in which he waged war on their behalf, and it is likely that they reciprocated with military support. This strategic alliance is documented by a scene of Shield Jaguar capturing an enemy of Bonampak, on the central lintel of Chan Muan's painted war temple (Lintel 2 of Bonampak Structure 1). (Interestingly, "*lu*-bat" phrases appear on that lintel, a practice which had not been allowed in Yaxchilan for sixty years.) With such upheaval in the central Usumacinta, it is not unlikely that Shield Jaguar II's stelae are in such fragmentary condition because of deliberate damage.

That warfare increased markedly toward the end of the Classic Period has been generally accepted for many years. It is also clear that the "mysterious" collapse of Maya civilization was, like all civilizational failures, not due to a single cause but to many interrelated factors that were rooted in the very successes of Late Classic social and political stability. Increased population engendered environmental stresses

such as diminishing ability to feed everyone, perhaps competition for the most productive land, and deforestation due to clearing. In terms of the social structure, at the inception of the Late Classic, there were likely a small number of elites who could in some way legitimize their claim to descent from the first ancestor or specifically recognized lineages. After several generations of growth and prosperity following the "hiatus," however, the ratio of descendants of the nobility to the non-elite population changed. In their synthesis of the Classic Maya Collapse conference, Gordon R. Willey and Demitri B. Shimkin postulated this demographic shift toward an increasing number and proportion of noble bureaucrats and craft specialists, and perhaps full-time artisans.[1] The study of the hands of artists and scribes outlined here in Chapter 2 enables us to estimate the number of artists with a little more security and to suggest that the degree of individualism evidenced by the extreme degree of innovation and by the autographing of public art signaled a crucial shift in the society from acting for the benefit of the community toward independent, self-conscious behavior.

The Elegant Knot Artist and Exuberant Scribe were individualists who did not succumb to pressure to maintain the status quo. They broke from tradition by substituting complex, diagonal compositions for the old compositions based on a central vertical line with branching horizontals and diagonals. They innovated poses and themes (while still using the same pictorial vocabulary), and they introduced a fundamental change into art—the three-quarter pose. Such a naturalistic pose summoned the figure into real space rather

than being a flattened shape against a void. When a figure occupies real space, it is tied to real time, not mythical, immortal time. Thus the kings, when portrayed as interacting with real space by Late Classic artists at Yaxchilan, and also at Piedras Negras, Copan, and Naranjo, were represented as less divine and more mortal, while artists claimed immortality for themselves by signing their work.

If shifts in such a conservative feature of Maya civilization as public art were affected by the rise of a group of relatively inner-directed individuals (with only marginal claims to nobility) who claimed that their achievements and abilities should earn them higher status, how much more so the daily interactions among community members must have gradually altered. If artists were captured or given as tribute, as suggested by Schele and Miller in reference to Piedras Negras Stela 12,[2] then the rulers were less interested in community identity and structure and, instead, began to be captivated by "foreign" style and by explicit, public statements of imperialism. If a growing elite preferred intersite interaction and opted for individualism over "tradition-direction," then the covenant that wove them in a single fabric with all levels of society was broken. In contrast to the Late Preclassic situation, when social and economic disequilibrium in society was adjusted for with a great sociocultural leap, in the Late Classic no organizational alternative could be found to substitute for dynastic rule. After the collapse of the Jaguar and Skull dynasties, a more egalitarian society struggled to maintain itself at Yaxchilan, still occupying the city. The small temples along the river on the southeast side and the re-use of some of the carved stone there, as at Palenque, Tikal, and elsewhere, are evidence of occupation during the last gasps of conservativism in Classic Maya civilization.

After 9.19.0.0.0 (A.D. 810), considerable population continued to exist in the Petén, but the motivation toward complexity and cultural achievements had died. Small groups did what they could have done at any time during the Classic Period—they subsisted without the cultural benefits of a city. In the beginning of the seventeenth century, Spanish friars Esguerra and Cipriano found six thousand Chol speakers on the Guatemalan side of the Usumacinta, between the Río Cancuen and Yaxha. They gathered them into towns, and we can only imagine how they reacted when the Spaniards tried to convince them that a single abstract being with no relation to their lineages was the arbiter of their fate and would reward them or not in the hereafter. Christianity and government without social structure made no sense to them (in J. Eric S. Thompson's words, town life and the restrictions of Christianity "irked" them), and they fled into the forests repeatedly. During the Classic Period, if the Maya had not seen an advantage to city life, they also would have abandoned it, which is what they finally did, after great upheaval, and probably after many cries for conserving tradition, in the ninth century. The Maya preserved those fundamental concepts of their worldview that were shared by most Mesoamerican peoples—in Western terms, that energy in the form of sacrificial offerings had to be given to natural forces in order to receive nature's bounty; that the ancestors were each family's guide to behavior and link with fate; that the Hero Twins were the ancestors' ancestors and had formed the planets and sun, the models for human life. They continued to be attached to their humbler places; they continued to honor their ancestors, and to auto-sacrifice and burn incense to honor the mountain ancestral homes, the sky, and the earth's bounty and to appease the dangerous crossroads and storms.[3] Small groups of people maintained their own ancestral temples, feeding their idealized forebears with incense near Yaxchilan and elsewhere. In 1897, Maler reported that in any area where the Spanish "element" had not reached, small communities were happy to provide the rare visitor with food.[4]

Their nobility had served to organize them, providing a focal point for rituals in which the implicit tenets of culture were transformed into common sense and the disjunctive aspects of society given a forum for development, examination, and either incorporation or abandonment. Without the royal ancestors and the tools of kingship, the Long Count and the cosmic myths, society had little connection to the past, and, lacking a means of sacralizing the environment through elite sacrifice and structured social interaction, the cities became meaningless shells, muddled messages, and were abandoned. Yaxchilan was neither disturbed nor revitalized by the Postclassic Maya, because no one successfully became the heir of the First Father; no one successfully became the axis of the universe. The Maya called Lacandon were the last to regularly visit Yaxchilan. Their history is not altogether certain, but they seem to have been Chols who were moved about by Spaniards, then fled into ever more distant areas of the jungle. Until the excava-

tions of Yaxchilan began in the 1970s, Lacandon Maya visited the ancient city, laying down their weapons and changing clothes to enter the holy area, but it was one of many holy places of unknown creator gods out in the jungle; it was not, by that time, connected directly with their history or lineages. The Chols, descendants of Pacal and of Shield Jaguar, had lost the force around which the cosmos ordered itself, their "spiritual food"—the king and his ceremonial center.

In the last several years, the governments of Mexico and Guatemala have worked on a proposal to construct a series of hydroelectric dams along the Usumacinta. *National Geographic* devoted a cover story to the problem, specifying what areas of the ancient Maya world and which ceremonial cities would be flooded depending on where the dams were placed.[5] There are already some dams on the tributaries above the Usumacinta, such as the Lacantun, which have doubtless damaged archaeologically rich but little-explored areas. In 1986 both governments claimed that despite the fact that much of the survey work had been done, there was no initiative to actually begin construction. But both nations are interested in using hydroelec-

tric power to develop this remote area and to provide additional power for other parts of their countries. While respecting the difficulties faced by Mexico and Guatemala—nations that wish to embrace the prosperity that has rocketed their utopian neighbor, the United States, and the ancestral homeland of their government officials and business leaders, Europe—I hope that they recognize that the husks of economic success must have a social heart in which all members have a significant and humane role.

This book has only scratched the surface of Yaxchilan's history. At none of the Usumacinta sites—Yaxchilan, Piedras Negras, El Cayo, La Pasadita, Chicozapote, Balancan, and others, known and unknown—has serious archaeology directed at documenting the Early Classic and Late Preclassic periods been done. I hope we, the human race, have a chance to piece together the ancient Maya civilization—not only for its own intrinsic interest, but also as a testimony to the adaptability and variability of human nature. We will need these qualities to make the passage from the problems of the twentieth century to a tolerable future.

Conclusions: The
Art of Tradition

Public art touched many domains of Maya society, and collectively, art, ritual practices, political thought, and the sciences sustained and expressed the feelings the Mayas had for life. To arrive at a definition for art in Maya culture, one must traverse concepts of self, community, the cosmos, and the maintenance of tradition, and of birth, death, and the afterlife.

From the viewpoint of the United States in the 1990's, Maya art seems to allow for very little self-expression. However, creativity, like art, is not a fixed concept. Achieving fulfilment through creative endeavors varies as much as cultures do, and as much, perhaps, as a contemporary artist strives to find a new form of expression or to interpret new experiences. How, then, was creativity expressed in public art at Yaxchilan?

Maya public art expressed conventional beliefs in a relatively systematic format dictated by a concept of cosmic order. Its production served the needs of the elite and, I suspect, the larger populace. A primary function was to provide visible, permanent models of human behavior toward the ancestors and the powers of the cosmos. The erection of stelae, altars, and lintels, which probably accompanied Period Endings, created a tempo that periodically focused community efforts on the construction of art or architecture and the staging of ceremonies invoking tradition, current events, cosmic beliefs, and the ancestors. The information recorded hieroglyphically on monuments, surrounding the figures of the kings served as education in history, philosophy, astronomy, and comportment. It illustrated much of what was considered common knowledge and common sense. Art in spaces used for public and private

ritual also promoted emotional security by providing shared spiritual, ritual, and historical experiences.

Making art was an activity charged with spiritual power, one apparently done in a liminal world separate from the everyday activities of the community. As such, I think making art was a transformation of materials and supernatural energy into a form which, when invoked, had the presence of a supernatural being. Titles for artists were *ah miats* and *ah its'*, "wise ones, sorcerers," those who made wisdom and tradition manifest. When local artists and patrons developed unique monumental imagery, they demonstrated their own contact with ancestral and supernatural forces. Innovation also exhibited local superiority, both in quality of execution, and as a way to demonstrate that one's rulers and artist-sorcerers had superior knowledge of the divine and of the world at large.

Additionally, art may have been a commodity—certainly fine portable art such as painted vases was traded or used for exchange among elites in forging relationships with other cities.

The cosmos—sky, earth, and Underworld, bound by the paths of the sun and heavenly bodies—and the spirits which controlled rain, thunder, fog, earthquakes, disease, animals, plant life, and the formation of precious stones are primary subjects of Maya art. The other obvious subjects of Maya art, the members of divine lineages, were relatively indistinguishable actors in the cosmic setting. Although landscape is not a subject in Maya art (the use of a stylized tree as a symbol is not the portrayal of landscape), I think that the art object was conceived in relation to the actual landscape or

setting in which it would be placed, so that the real landscape was perceived as part of the art work.

At times the cosmos and natural forces are symbolized by fantastic images, and at other times they are not portrayed. However, the placement and composition of cities, sculptures, and paintings reflects the dynamic order in which supernaturals and cosmic forces act. For example, at the broadest level of Maya design, the topographical canvas of the city, a "reading order" governed the placement and orientation of buildings and monuments. Establishing a "reading order" for the imagery in the city is the sun in its daily path from the split horizon in the east to the mountains in the west. On those stelae carved on two sides, the earlier events, the captures, are without exception on the east side, and the later ones, the bloodlettings on Period Endings, on the west. Furthermore, closest to the sun's zenith is the most potent imagery—the towering headdresses that occupy one-third of the figural area of the monuments. Below the feet of the rulers on the west side of stelae are the references to earth and ancestral territory.

Attitudes of Post-Columbian Maya people continue to reflect the influence of the magic-cosmic worldview on the organization of cities. They suggest that physically and topographically, a Maya city was organized around a highly ritually charged central area where the most sacred, vertical works of art and architecture were concentrated. Surrounding the center were the lands of the common people, organized by some arrangement by clan. The boundaries of the city were just inside the last cornfield, often near unusual topographical features that contained evil or potentially dangerous forces or beings, which few people passed. From sacred mountains, springs, and caves within the boundaries of the society's concern, ancestors regulated the souls of newborns, the hunting of game, the growing of corn, and provided models for behavior.

In the centers of ancient cities, the design of public art reflected influences from several sources. Although the mechanism for its consistency is not clearly understood, the "Great Tradition," by which I mean the cultural traditions shared by the many Maya groups, was interpreted at every city in the Maya area. Coloring each reinterpretation of the Great Tradition was a local reality based on the history of each city and royal lineage, the topography, and the heavens as seen from the city. The individuals affiliated with each Maya city evolved a unique manner of expressing these overlapping sets of tradition as a form of their own extended self-consciousness. Occasionally, as at Palenque, the Late Classic artists and patrons stun us with their clear, sweeping expressions of the Great Tradition based on unknown but definitely Early Classic models.

The repertory of subjects and symbols at Yaxchilan suggests that their selection was based upon the Great Tradition of the Hero Twins shared by all the Central and Southern Maya groups, but that the designers deliberately incorporated locally innovated and "foreign" items to strike a balance between the Great Tradition and local history, society, customs, and political circumstances. There seem to be four degrees of intermeshing Maya tradition with local invention:

(1) In all eras, some culture-wide cosmological and royal symbols were borrowed for use in public ritual and art, and used without any shift in meaning established by their initial use. An example is the appearance of the double-headed serpent bar in the hands of the ruler on Stela 14, dated 9.4.8.8.15. It had appeared earlier on Tikal Stelae 29 and 1 and at Calakmul on Stela 43, always with matting on the shaft and supernaturals emerging from either end. It seems to have signaled transformation, sacred bloodline, and kingship wherever it was used. Other items of regalia which identified the king as Maya—such as the beaded collar, the *ahau* belt, the conical helmet or drum-major headdress, and high-backed sandals—were also used by Yaxchilan kings.

(2) Designers used culture-wide cosmological symbols but altered them to achieve variations of meaning. For example, from the tradition that began with the Late Preclassic sun-Venus skyband on the architectural façade at Cerros, and was later a bicephalic staff held by some Early Classic rulers in accession portraits, Bird Jaguar III formulated a bicephalic Skyband Monster with two identical heads and placed it on a stela, to separate the realm of the living king from that of the ancestors who were depicted in solar cartouches. The Cerros Skyband Monster had already been adapted for use as a hand-held royal emblem, but at Yaxchilan it became again a spatial locative, freeing the ruler's hands for other activities.

(3) Innovation of figural postures (the male and female bloodletting postures), elements of royal symbolic costume, and monumental subject matter occurred at Yaxchilan. In the case of the bloodletting postures, the concept symbolized was a traditional one, but the way in which

it was depicted monumentally was conceived at Yaxchilan. In the case of costume elements, newly depicted items of regalia were probably adapted from other contexts, such as the ballgame or traditional curing ceremonies. The innovation of subject matter for monumental art is probably the most radical. The unique scenes are those in which Bird Jaguar IV portrayed a spectrum of regional elites, and I think they indicate a major shift in the political stability of the area and in the direction of society.

(4) The combination of shared, adapted, and innovated public ritual symbols created an unmistakable local tradition in iconography and style. An example is the manner in which accession and Period Ending iconography is treated at various sites. Gauged by the quantity and quality of attention spent on the monumental documentation of accession, the proper observance of rites that established the covenant between the ruler, the populace, and the cosmos was paramount in importance to the community.

At Yaxchilan, Bird Jaguar IV placed the image of his accession day on a lintel, and probably on the stalactite stela. In the Lintel 1 scene, he wore a skyband backrack and the drum-major headdress, held the God K manikin scepter, and was accompanied by the mother of his son holding a bundle. To establish a link with the greater Maya culture, Bird Jaguar used two items—the drum-major headdress and a widely used symbol of divine descent, the God K manikin scepter, in their earliest appearance at Yaxchilan, but to emphasize his ability to shape tradition himself, he invented the image of the mother of his heir with a bundle of sacrificial instruments.

The Yaxchilan Period Ending–cosmological stelae are another example of the overlapping of pan-Maya and local imagery. The culturally necessary statement for a Maya Period Ending is that the ruler let blood. At other sites, this statement frequently appears glyphically, for example, with the T710 scattering hand (e.g., Aguateca Stela 1). Alternatively, the ruler may wear a God C loincloth (e.g., Aguateca Stela 3), indicating that his groin is bloody and that his sacrifice axially unites the cosmic realms. At the Group of the Cross in Palenque, blood is shown flowing from an upraised bloodletter, but blood does not flow from inserted bloodletters. Bloodletting is implied rather than explicitly portrayed. The temple sides of the Yaxchilan cosmological stelae were innovative in that they portray the ceremony in action—a profile image of the king directing a flow of liquid from his groin into a receptacle.

The incorporation of historical, locally innovated imagery into new formats was an active aspect of creativity at Yaxchilan. For example, the profile bloodletting scene first appears on Yaxchilan Stela 27, dated 9.4.0.0.0 and carved only on one side. One hundred thirty-six years later, that image became part of a two-sided composition on Stela 3, combined with a warrior image used earlier on Stela 2. That specific two-sided composition—active bloodletting and victorious warrior—became a local tradition and, I think, a local expression of Maya reality. The composition was created out of the specific history of Yaxchilan, as part of a link of present with past actions.

The mechanisms for communicating the Great Tradition and the rites of kingship are not yet securely understood, because certainly they were ephemeral. It is fairly certain that the people of the Central Lowlands were unilingual or bilingual, speaking Chol with perhaps some Yucatec. Mutual intelligibility plus the lack of extreme differences in the environment made communication possible throughout the area. Within each city, the Great Tradition was perhaps achieved through education—in the form of frequent community enactment of myths, histories, and traditions, along the lines of the rituals described by Victoria Reifler Bricker in *The Indian Christ, The Indian King*. Ritual maintained the strength of tradition through the display and explanation of symbols. Education through public ritual, controlled by a ritual advisor or teacher, who perhaps conferred with others of similar status at other places, was likely based in the community. Artists and members of the royal lineage probably traveled, like the artists of Italy in the sixteenth century, assimilating new ideas, seeing new versions of iconography, and returning home to revitalize aspects of the local tradition. Although it may seem outlandish to us, we should also recognize the powerful influence that communications with the ancestors, through dreams and deliberate invocation, had on the perpetuation of the Great Tradition.

It was essential to any of the functions of Maya public art that it be understood by its audience. The public monuments are very detailed and complex and function on several levels. The largest image, that of the ruler, was certainly understood to be the king by all viewers, and surely they grasped the portrayal and the significance of bloodletting and capture. Did the average person also understand the meanings of the headdresses? And who could read the hieroglyphs? Even if the subtleties of

the iconography and writing were comprehended widely, was the art formulated according to the whims of the ruler, to portray his political prowess and legitimacy in the most favorable light? Or was there a covenant of respect among elite and populace that demanded that the activities portrayed on monumental art be sincere? Did the art serve the king, the gods, or the community? I don't have answers to these questions, but I think the answer will lie only in a consideration of the role of art in the tradition-directed society.

With respect to the symbols incorporated in monumental art, Walter F. Morris, Jr., confided in a conversation that he doubted that the ancient Maya really knew the meanings of the many symbols that surrounded them. He based this opinion on the fact that the weavers in Tzotzil communities in which he lived didn't really know the meanings of the motifs they wove. It does not surprise me that after five hundred years of foreign domination the weavers would not know the details of the Great Tradition and its symbols. They had also forgotten how to weave many of the traditional patterns, simply because the woven designs did not articulate as profoundly with a changing society, one in which living Maya carries with it the disadvantage of being isolated and alienated from the enormous centripetal pull of the technological world society. However, I disagree with his extension of lack of familiarity with the symbols into the Classic Period, during which the symbolism had not been repressed for centuries. The Maya's world was then a locative one, in which the symbols were made under spiritual guidance and were displayed on costumes worn by royalty and community members. The meaning of symbols was taught to youth through discussing dreams, by their participation in ceremonies, and through daily interaction. Symbols in art represented what any properly put together person could not help but think.

Reading and writing are less likely to have been general accomplishments, but we should not underestimate the fundamental familiarity any person had with the animals, images, and concepts employed in writing. The high degree of phoneticism and the regularity of the subject matter and syntax of written compositions make the writing easy to understand today. I doubt that everyone was literate, but I would guess that the twenty or so scribes writing on monuments during Bird Jaguar's time accounted for a small proportion of those who could read.

If we assume that the royalty commissioned architecture and sculpture, then the relationship between them and the majority of society who beheld art is a key to the problem of how thoroughly monumental art was understood. Most authors approach this problem from the point of view that the motivations for personal behavior in Maya society were the same as in ours. Schele and Miller assume that the king maintained an intense degree of self-interest and that, toward the goal of establishing political legitimacy, "art communicated the message of the king to his subjects . . ."[1] Cecelia Klein criticized their assumption that the bloodletting so prominently discussed in *The Blood of Kings* meant the same to the elite as to the people, and implied through the criticism that the Maya depiction of bloodletting might be similar to the Aztec one, which she interprets as exploitive.[2] The lower class of Aztecs, she said elsewhere, were expected by the elite and an elite-conditioned society to offer the ultimate sacrifice, their lives, while the wealthier could make material donations to the gods, sacrifice other people, or only let some blood.[3] The Aztec elite enjoyed a materially comfortable life as a result of the tribute of foreigners and the labor of the lower classes. Klein interpreted Aztec royal autosacrifice as a way of expressing gratitude for their comfort but even more as ". . . a way of justifying, insuring, and augmenting it."[4]

Both approaches, it seems to me, assume that Maya societies were more "inner-directed" than "tradition-directed." In a tradition-directed society, the people feel they need their rulers—the rulers occupy an essential place in the hierarchical order of existence. One of the benefits of having a ruler is to have a person capable of providing spiritual guidance through public ceremony and art as well as through the act of linking cosmic levels through the flow of royal blood. It was the obligation of the ruler to educate and communicate through public display, an important aspect of which was public art.

The Maya governed themselves successfully while building one of the world's major civilizations for over nine hundred years. As in every culture, deceit, exploitation, and poverty had to exist. Relative to other New World societies, however, the Maya were proud, educated people who enjoyed the reading of their history and the benefits of a community-oriented society rich with variety, sciences, art, and literature, oral and written. A major aspect of its stability was that Maya society was guided fundamen-

tally by the deeds and teachings of the ancestors, who had established the right ways to do things a very long time ago.

At Yaxchilan, the process of creating the ceremonial city we know today was achieved by Bird Jaguar IV. As art, the individual monuments he commissioned are not strong sculptural statements. However, his grasp of the power of city design was impressive. The aesthetic and symbolic effect of the whole was greater than that of the individual parts. From an individual lintel or stela one cannot deduce that the sun determined reading order, that the kings faced the sunrise, or that genealogical documentation appears on buildings facing the winter solstice sunrise. In designing art for the city, he responded to many situations. First, he had to consider the historical and formal value of the existing art and architecture. Also, I suspect that after being selected as king from among several contenders from the Skull and Jaguar families, he inherited an increasingly assertive middle class. Pressures on the food-production system by the local nobility and aggressive activities throughout the region influenced his personal vision of the proper form for the ceremonial center. His strategy for maintaining tradition was to knit the structures and art together into an overarching astrological and cosmological scheme. In the face of radical social change, he emphasized tradition. He decided to show that the ancestors and the Palenque Triad were the paradigms of human behavior, that worldly status had a cosmic basis, and that the ceremonial center, as the environment for human ritual behavior, was an approximation of cosmic order. Public art was a means for educating and organizing society to support the community and the monarchy, but its efficacy rested not on the symbols but on the fact that the individual recognized the community's needs and benefits as primary.

The tendency to do things the way that they have always been done by the ancestors is a strong force for conservatism in a Maya community, but it does not mean that individuals do not enjoy creative pleasure. The participation required in cycles of public and private ritual and the duties of the individual within the immediate and extended family provide a variety of roles for an individual within the community. The worth of individuals in a Maya community is defined by how well they have fulfilled the various roles available to them. Like an actor, whether king or commoner, how well one plays the roles gives one esteem as an individual. Ritual roles are transformational, and family and community roles are sacred. This intimacy with the divine gives the individual political and spiritual power. Freedom of expression is not in creating a new form of art or a new solution to a problem, but in enlivening the ancient with one's touch.

Description of the Site and Its Monuments

Definition of Areas

The system of nomenclature for buildings and areas of Yaxchilan which I found most useful is one based on Teobert Maler's enumeration (1903:114). He devised the numbering scheme for stelae, lintels, and structures that is still in use (although new monuments and buildings were discovered by Sylvanus G. Morley and other members of the Fourteenth Central American Expedition [Morley 1931] and discussed by Morley [1937–1938, vol. 2, illustrated in vol. 5], and by INAH archaeologist Roberto García Moll [explorations and consolidation, 1963–1987]). John Bolles' map made during the Carnegie Institution's Yaxchilan expedition in 1931 and published in Morley 1937–1938 has been the foundation for the ones published subsequently by Ian Graham (1977) and Berthold Riese (1977).

In my work at Yaxchilan, I have used the following terms to refer to buildings and areas:

River side structures are those that flank the river or are within the Main Plaza: 4, 5, 6, 7, 8, 9, 10, 11, 12, 13, 14, 15, 16, 17, 66, 67, 68, 74, 80, 81.

First terrace structures are those situated on the partially artificial platform that defines the south and west sides of the Main Plaza: 2, 3, 69, 70, 1, 71, 72, 82, 83, 18, 19, 78, 31, 32, 77, 75, 79, 20, 21, 73, 22, 23, 24.

Second terrace structures sit atop a natural hill whose edges have been faced with stone, overlooking the western portion of the Main Plaza: 25, 26, 27, 28, 29, 30.

Central Acropolis: 33, 34, 35, 36, 37, 38.

South Acropolis: 39, 40, 41.

West Acropolis: 42, 43, 44, 45, 46, 47, 48, 49, 50, 51, 52, 87.

Northwest Group: 84, 85, 86.

Southeast Group: 53, 54, 55, 56, 57, 58, 59, 60, 61, 62, 63, 64, 65, 88.

Descriptions

This section has several functions. First, it serves as a record of how the site appeared in 1986, after much clearing and some consolidation and excavation. It is hoped that a new map will be published soon in conjunction with the INAH project, a map that will indicate much-needed revisions in the plans, dimensions, and locations of structures. Perhaps that map will also be accompanied by a description that includes data from the excavations. If no such description is forthcoming, then this one will be helpful to those studying Yaxchilan.

Second, a number of observations concerning the order of construction of buildings, plazas, and platforms at the site were made when collecting the data for this section. Those discoveries are described here, and interpreted in the historical section pertaining to the construction of each area.

Third, the arguments for specific reconstructions of original location or content of eroded monuments are presented here.

The buildings described here are those which are associated with sculpture, or having standing walls, or have been excavated. Those structures about which nothing could be added to Maler's description are omitted. I have made thorough measurements of the few buildings for which I have drawn plans. This was undertaken when I thought I might be able to learn something about the function or dating of a puzzling building. Other dimensions have been taken from Maler or Morley and are so noted.

In the descriptions that follow, orientation is given in degrees east of magnetic north.

The "construction completion date" is the earliest possible Period Ending by which a given architectural-sculptural ensemble could have been completed.

In Maya dates, parentheses enclose information reconstructed from existing calendric data: Long Counts calculated from stated Calendar Rounds and vice versa. Square brackets enclose dates implied by context: for example, if the date of a 1-*katun* anniversary of accession is known, we can deduce the date of the accession.

Structure 1

(Lintels 5, 6, 7, 8, and Maler's Cave)

Dimensions: unknown.

Orientation: 345 (map); 335 (compass).

Discovery: Maler, 1897 or 1900.

The area around Structure 1 has been cleared of attached vegetation and trees, but it is at present unconsolidated. Traces of lower walls are visible, but the vaults have fallen. The rear of the structure has caved in, and where Maler postulated a central transverse wall in the rear chamber, there is now a large pit about 3 m wide. I could not ascertain the cause of this depression, except that it is artificial.

Structure 1 overlooks the southeast end of the Main Plaza from a terrace approximately 3 m above the plaza level. Its terrace was shaped from a natural esplanade at the foot of a tall hill. I explored this steep hill in 1985 and found no further traces of building activity on its northern slope. Structure 1 is situated at the entrance to the long valley which leads to the South Acropolis. Along the center of the valley are many carved stone objects, some circular altars, some metates, and some stone basins. Branching off the trail, now used for hunting small game and for site vigilance by the guards, about 40 m before the ascent to Structure 41, is a steep

44.

Structure 1, plan by Maler (1903:115) and Lintels 5–8, drawings by Graham (1979:21, 23, 25, 27).

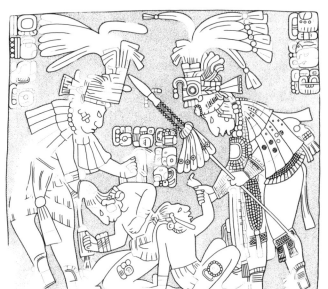

Lintel 8

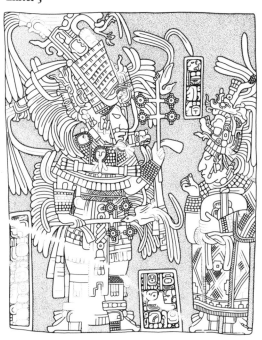

Lintel 5

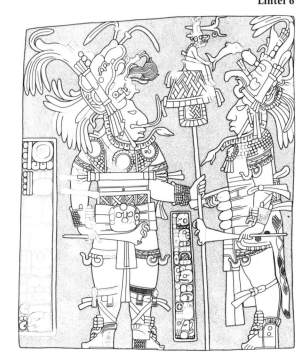

Lintel 6

escarpment on the southeast side of the valley which, when followed south, leads to a single-chambered cave. The cave is approximately 10 by 10 m and composed of jagged, toothlike limestone chunks. A few undecorated potsherds and worked obsidian chips were seen here.

MONUMENTS

Dimensions (from Graham 1977)

	MW	HSc	WSc	MTh	Rel
Lintel 5	0.84 m	0.73 m	0.90 m	0.40 m	0.3 cm
Lintel 6	0.88 m	0.79 m	0.89 m	0.31 m	0.3 cm
Lintel 7	0.89 m	0.75 m	0.90 m	0.37 m	0.8 cm
Lintel 8	0.99 m	0.87 m	0.78 m	0.30 m	0.3 cm

Lintels 5–8 (see Figure 44) were excavated and photographed by Maler (1903:115). All four were pulled out from the structure for recording. Three are grouped in front, and Lintel 8 is on the east side. They have been roofed with lamina, but it slips off its framework, and each lintel is quite covered with plant growth. Maler noted no trace of color on any Structure 1 lintel.

Dates and Protagonists

Lintel 5	(9.16.1.2.0)	12 Ahau 8 Yaxkin	BJIV, LAI
Lintel 6	(9.16.1.8.6)	8 Cimi 14 Mac	BJIV, CoM
Lintel 7	(9.16.1.8.8)	10 Lamat 16 Mac	BJIV, Lady Ix[a]
Lintel 8	(9.16.4.1.1)	7 Imix 14 Zec	BJIV, CoM

[a]I have reconstructed the identity of this woman based on the normal distribution of Bird Jaguar's female companions (Tate 1985).

Morley (1937–1938:414) dated these lintels at 9.10.0.0.0 on stylistic grounds. Tatiana Proskouriakoff (1964:186) correctly recognized the name of the protagonist as the Bird Jaguar who reigned in *katun* 9.16.0.0.0.

Construction Completion Date: 9.16.6.0.0.

Lintel 7

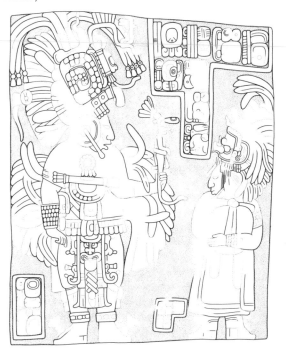

Structure 2

(Lintel 9)

Dimensions, Exterior: 22.7 by 7.5 m.

In 1900 Maler investigated a pile of rubbish which he considered to be the remains of a small temple, and found remains of a frieze once painted bright red and a carved lintel (1903:118). The building has not been consolidated and is surrounded by heavy vegetation.

Structure 2 faces almost directly north, overlooking the southeast end of the Main Plaza from a terrace which I suspect was built late in the history of the site.

45.

Structure 2, Lintel 9.
Drawing by Graham
(1977:29).

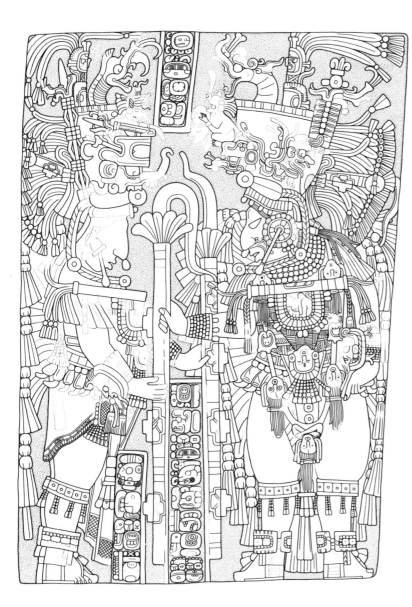

MONUMENT

Dimensions (from Graham 1977)

	MW	HSc	WSc	MTh	Rel
L 9	0.77 m	0.98 m	0.66 m	0.36 m	1.1 cr

Lintel 9 (Figure 45) was discovered in 1900 as Maler and his crew excavated in front of the structure. At that time it spanned the ruined entrance (Maler 1903:118). Maler extricated the lintel from the rubble and left it in front of the structure. At that time he reported that although it had been protected by debris, there was no trace of paint on the lintel. In 1964 the lintel was removed to MNAH, where it is currently on display.

Date and Protagonists

L 9 (9.16.17.6.12) 1 Eb End of Yaxkin BJIV, Lord

Morley dated the lintel on the basis of style at 9.12.12.2.12 (1937–1938:437). Proskouriakoff recognized the name of Bird Jaguar IV and assigned the date to the only possible position in the known reign of that king, 9.16.17.6.12. She noted, "The date 1 Eb 0 Mol (written 'completion of Yaxkin') is probably 9.16.17.6.12 . . ." (1964:190). If the lintel was dedicated on the subsequent Period Ending, the dedication date was 9.17.0.0.0. The scribes must have opted to preserve the tradition of using the month name Yaxkin in association with the flapstaff event. The Julian equivalent of the date is 16 June 768, the closest they could get to summer solstice without moving into the month of Mol.

Construction Completion Date: 9.17.0.0.0.

Stela 30

Stela 30 (Figure 46) is associated with an un-numbered mound just east of Structure 2. This fragment of a stela was found by Ulises de la Cruz, the first guardian of Yaxchilan, in 1934, having been re-used as a metate. Morley published a report of it in 1937–1938 (55; Fig. 80). He gave the measurements as 56 cm long, 30 cm wide, and 12.5 cm thick, and reported that the back and sides were plain. I have never seen this piece and must rely on Morley's account. He thought that the sculptural quality was inferior to that of Stela 8, a fragment showing a similar figure in a cartouche. Neither is dated. Both are the upper portions of cosmological–Period Ending stelae.

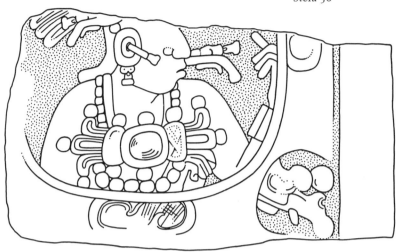

46.

Stela 30, found on a small mound near Structure 2. Drawing by Peter Mathews.

Structure 3

(Lintel 10)

Dimensions, Exterior: approx. 4 by 2.5 m.

Orientation: 24 (map). No standing, cleared walls.

In 1897 Maler noticed a small pile of rocks gripped by trees and thought that the small quantity of stones indicated that the structure must have been roofed with perishable materials. Nevertheless, he succeeded in uncovering two lintels, one completely eroded (1903:120). Today the building is cleared and resembles a small platform because the approximately 2.5 m high walls contain much rubble.

MONUMENT

Dimensions (from Graham 1977)

	MW	HSc	WSc	MTh	Rel
Lintel 10	0.77 m	0.98 m	0.66 m	0.36 m	1.1 cm

Two lintels were found fallen from the doorways of the structure when Maler excavated it in 1897. No traces of paint were found. Lintel 10 (Figure 47) was in good condition, a small fragment broken off the upper right corner of the stone. The other lintel, unnumbered, had fallen with the sculpted side exposed. Lintel 10 is propped up in front of Structure 3 and covered with a lamina roof.

Dates and Protagonist

Lintel 10

A1–A2	(9.18.17.12. 6)	7 Cimi 14 Zip	MKSII
C8–D8	(9.18.17.13.10)?	5 Oc? 18 Zotz	MKSII
E5	(9.18.17.13.14)	9 Ix 2 Zec	MKSII

Lintel 10 is the latest-dated lintel at the site; so its crude execution is due not to an early date, as Morley supposed (1937–1938:393), but to a dissolving political system reflected in a decadent style. Hermann Beyer (1935) correctly identified the dates as *katun* 18. Linda Schele, Peter Mathews, and Floyd G. Lounsbury (1977) noted the presence of a parentage statement of a king whose father was Shield Jaguar II and whose mother was Lady Bloodletter, thereby securing the late date.

Construction Completion Date: 9.19.0.0.0.

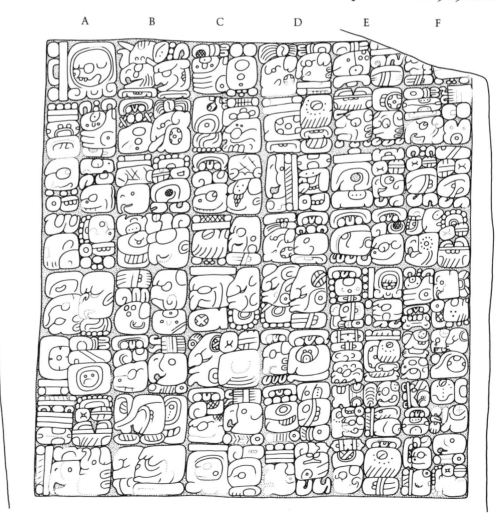

Structure 5

(Hieroglyphic Stairway 1)

Orientation: 210 (map).

Structure 5 is a long, low platform paralleling the axis of the Main Plaza on the southeast end. The southeastern end of the plaza is bordered by three similar platforms: Structures 4, 5, and 8. No trace of a masonry superstructure has been found on top. To the rear of the building is a narrow esplanade and then a steep descent to the river.

MONUMENT

Hieroglyphic Stairway 1 is composed of 188 individual blocks, of which the risers are carved.

Dimensions (from Graham 1982:141)

Length	Step I	13.55 m
	Steps II–VI	13.75–13.90 m
Width	Step I	Platform not measured
	Step II	0.65 m
	Step III	0.65 m
	Step IV	0.80 m
	Step V	1.00 m
	Step VI	0.90 m

Maler first described this stairway, calling it "the most magnificent one I have ever seen" (1903:122), but did not measure it nor enumerate the steps. The members of the Fourteenth Central American Expedition were observing the carved stair risers when Karl Ruppert began to excavate and uncovered steps V and VI (Morley 1937–1938:435). The steps are now cleaned occasionally with brushes to free them from the mold which quickly grows on the blocks, all of which lie fully exposed to the elements. The glyphs are extremely difficult to read, even with a good light.

Dates and Protagonists

Morley attempted to decipher only the first date of the lengthy inscription. He thought that the best possibilities were either 7 Imix 14 Zotz or 7 Kan 12 Zotz (Morley 1937–1938: 435–436). Berthold Riese has made an attempt at decipherment of some of the dates (1977: 80–81). Several of the combinations of day names and month coefficients he suggested are impossible; in particular, at I-15 he reads 4 Cimi 18 Zip, an impossible combination, as is 1 Ahau 7 Xul at VI-4. It is difficult to decipher the eroded dates with assurance, but some names and event glyphs are legible.

Reading order begins at the upper left with Step I (see Figure 48) and proceeds across and down. The first identifiable name glyph ap-

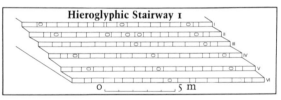

Hieroglyphic Stairway 1

48.

Structure 5, Hieroglyphic Stairway 1, plan and Steps I and II. Drawings by Graham (1982:141, 143, 145).

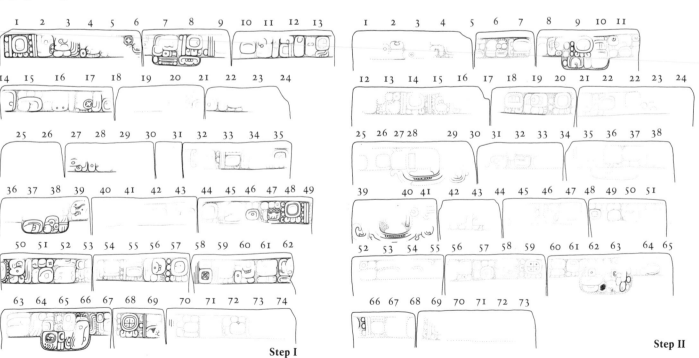

Step I

Step II

pears on Step I at Glyph Block 45 and names someone of the Jaguar family. The verb which precedes it is a *chum wan* "seating" verb. But the date given, 7 ? 14 ? (day and month names eroded), does not correspond to a known accession date at Yaxchilan. At least four other "seating" verbs can be seen on Steps I and II. Several Yaxchilan Emblem Glyphs and illegible dates can be seen among the glyphs. At Glyph 52 appears a clear Bird Jaguar name. No entirely legible names appear until Step VI (Figure 50), where at Block 75 is the name of Bird Jaguar IV with his Ah Kal Bac title. Therefore it appears that the events recorded begin in the life of an early Jaguar and continue into the reign of Bird

Jaguar IV. It seems that this is the only known list of accession of the entire dynasty, compiled by Bird Jaguar IV, but it is unfortunately eroded.

Sixteen cartouches, larger in format than the usual glyph blocks, are distributed irregularly among the glyphs. Some, such as those on Step II, are decorated around the perimeter and seem to have had portrait busts within them. Graham (1982:141) says that they seem to have been carved over the original glyphs. Intriguingly, Bird Jaguar IV was likely the sixteenth king of Yaxchilan.

Because the text is severely eroded, the construction completion date cannot be determined.

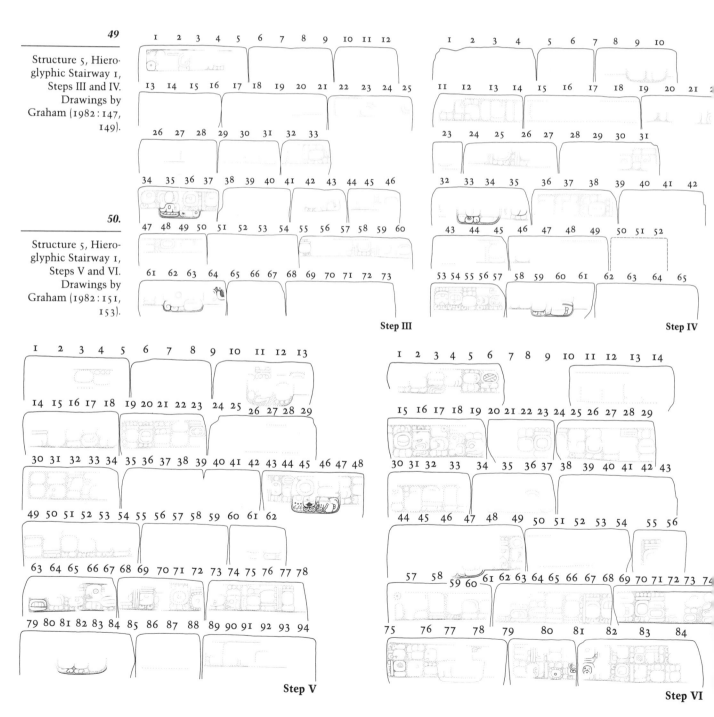

49

Structure 5, Hieroglyphic Stairway 1, Steps III and IV. Drawings by Graham (1982:147, 149).

50.

Structure 5, Hieroglyphic Stairway 1, Steps V and VI. Drawings by Graham (1982:151, 153).

Step III

Step IV

Step V

Step VI

Structure 6

(Full Figure Glyph Throne)

Dimensions, Exterior

Length, 11.46 m; width, 8.29 m; height without superstructure, 5 m; height of remaining superstructure, 4 m; upper story vault, 1.46 m wide at base.

Dimensions, Interior

North chamber, 8.90 by 1.04 m; doorways, 1.25 m, 1.70 m, 1.25 m. South chamber, 9.10 by 1.92 m; walled-up entrances, 1.40 m, 1.70 m, 1.40 m. Entrance from south to central chamber, 1.90 m. Central chamber, 8.64 by 1.17 m.

Orientation: 27 (compass).

Alfred P. Maudslay included Structure 6 on his map (1889–1902:2:Pl.78) but did not name it. The reader is referred to Maler's excellent and interesting description (1903:122–125). Recent excavations, undertaken by INAH in 1976, have encountered the levels of the plaza floor and provide new insight into Structure 6, as does a careful examination of the frieze ornamentation. García Moll of INAH reported finding large quantities of Lacandon ceramics in Structure 6 (García Moll and Juárez Cossío 1986:158).

Structure 6 is situated on what is now the riverbank. Maler suggested that perhaps much of the ancient site of Yaxchilan has been washed away by the river (1903:114). Perhaps a lower terrace of structures, including the area around the Masonry Pier, was once built up. However, a stairway leads from about 5 m below the plaza level up to the area northeast of Structures 6 and 7, and in ancient times someone entering there would have passed between these two structures as a gateway to the city.

Structure 6 was designed to service both the Main Plaza and the river areas. A shallow room with three wide doorways spanned with wooden lintels opens onto the river vista (see Figure 52). Another vaulted chamber once faced the Main Plaza, and an opening in its rear wall led to a central chamber. The three plaza side doors were walled up in ancient times, and 80 cm by approximately 2 m apertures were punched out of the lateral walls of the South Chamber. Maler attributed the closure of the southern entrances to a structural problem—the obvious weight of an immense, nearly solid, double-walled vaulted roofcomb necessitated additional support (ibid.). But an examination of the front doorways shows that the stones do not quite fill the spaces. The walled-up sections

51.

Structure 6, south side. Photo © 1991 by Lee Clockman.

of the doorways are not supporting anything. It is truly amazing that the 80 cm openings knocked out of each side of the front chamber did not cause the collapse of the temple.

Structure 6 was explored and consolidated by INAH in 1976. The explorations revealed a platform 60 cm high and about 1.5 m wide on the plaza side of the building, abutting on the walled-up doorways. The level of the ground is 60 cm lower on the north and northwest side of the structure than in front of the structure. The transition occurs in the form of a steplike drop

52.

Structure 6, north side. Photo © Lee Clockman.

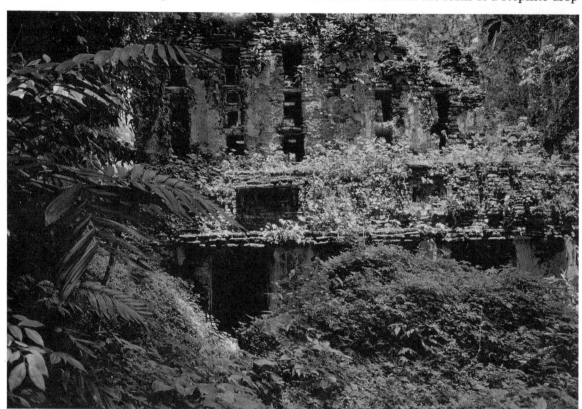

53.

Structure 6, detail of stucco and stone decoration on frieze, with roofcomb above. Photo © 1991 by Lee Clockman.

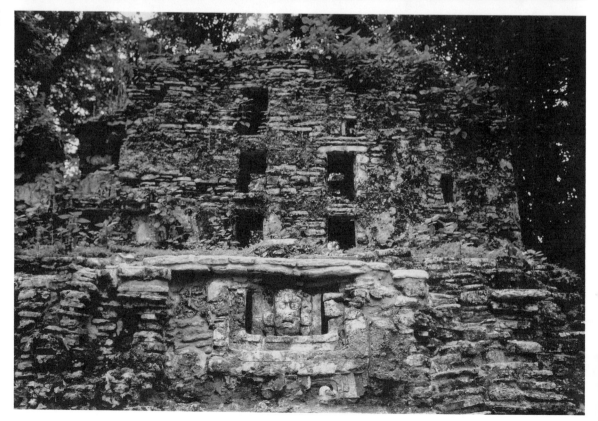

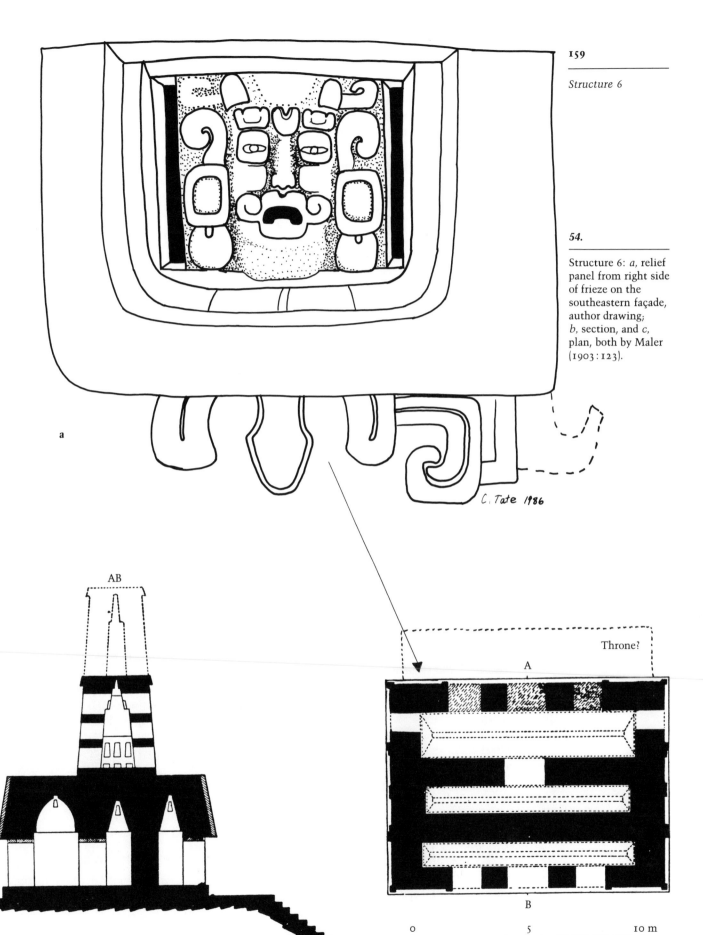

54.

Structure 6: *a*, relief
panel from right side
of frieze on the
southeastern façade,
author drawing;
b, section, and *c*,
plan, both by Maler
(1903 : 123).

a

C. Tate 1986

AB

Throne?

A

B

b

0 5 10 m

c

at the northwest corner of the building. Piles of cut rocks there indicate the presence of a narrow stairway in ancient times.

Sometime after the construction of Structures 6, 7, and 8, the plaza level was raised about 0.60 m. Evidence of this modification was also found by INAH in excavations around the Stela 3 platform. The excavators discovered a new stela fragment (Stela 33; see Structure 20 description) and an earlier plaza level beneath the stela (Ramón Carrasco V., personal communication, 1986). Structure 8 was constructed around 9.16.10.0.0 by Bird Jaguar IV. Certainly Shield Jaguar II raised the level of the southeast part of the Main Plaza to create a separate plaza in front of his most important building, Structure 20. He was also responsible for the placement of Stela 3, probably originally located in front of Structure 6, in the center of the Structure 20 plaza.

Frieze decoration

High-relief stone and stucco mask panels decorated the frieze on all four façades of Structure 6. Three supernatural masks were centered over the doorways on the front and rear façades of the structure, while two masks recessed from the outer plane of the frieze were set on each side. Maler called these "serpent faces" (1903:123). Of the three masks on the plaza side frieze, the two lateral ones are recessed, formed by three-sided stucco cartouches, and the central one projects approximately 30 cm from the plane of the frieze. The central projection is now mostly rubble, but seems to have once consisted of a face with a projecting snout. It is possible that the front frieze was a single large monster face, with the two side masks set into stucco eyes and the three doors serving as the monster's mouth, as seen in sites in the Chenes area. More likely, they were simply three masks, two inset and one projecting.

At present there remains enough of only one of the supernatural face panels to make a judgment about their original form (see Figures 53, 54a). This one mask is the rightmost of the three on the façade facing the southeast Main Plaza. It contains several features characteristic of Late Preclassic Maya and Olmec art: "flame eyebrows"; a cleft form between the eyebrows; a large, cleft, squared oval forming the lips with a downturned opening between them. The eyes are almond-shaped human eyes encased in larger ovals. Standard Maya features are the large earspools with oval pendants and two sets of volutes, one above the earspools and one emanating from the upper part of the head. The stucco frame of the mask is in the form of a Maya supernatural under-eye line, with a series of symmetrically distributed volutes and curvilinear forms below. The face is about 45 cm square, and a deeper, recessed area separates it from the cartouche, adding the illusion of greater depth to the relief.

Construction Completion Date

I suspect that the structure was constructed in the Early Classic era of Yaxchilan, before the apparent hiatus of 9.5.0.0.0—9.9.10.0.0. It could be assigned to the reign of Ruler 10, Mah K'ina Skull II (a. 9.4.11.8.16).

MONUMENT: FULL FIGURE GLYPH THRONE

Dimensions: approx. 0.90 m wide, 1.60 m long, and 0.45 m high.

In the late 1970's a throne was excavated by Don Patterson of INAH, from the platform built to close the entrances to Structure 6 when the plaza was remodeled (Patterson, personal communication, September 1984). Patterson drew the four fragments he found, and Ramón Carrasco V. made a drawing of one additional fragment. Preliminary drawings have also been made by Ian Graham.

The throne broke into two large pieces roughly 0.75 by 0.90 m across the top, with many smaller chunks. It is now buried in its original location.

The throne appears to have been carved along the vertical perimeter on all four sides. Though much of the inscription is damaged, the presence of nine glyph blocks can be reconstructed for the two long edges. Probably four or five glyphs were carved on the shorter faces, though I have not seen drawings of these sections. Remnants of glyph blocks also appear on the legs of the throne, which taper from top to bottom. Of the surviving glyphs, every one is full-figured. Some glyphs are clear: the name of Bird Jaguar, two 4 Katun Ahau titles, and a Sky God title phrase. This suggests that the protagonist is Bird Jaguar III. A G6 of the Supplementary Series suggests the date of the throne may be 9.11.16.10.13, the completion of two *katuns* as Ahau for Bird Jaguar III.

Structure 7

Dimensions, Exterior: 10.50 by 8.08 m.

Dimensions, Interior

Chamber on plaza side, 6.47 by 1.68 m. Walls approx. 0.90 m thick. Wide doorways spanned by wooden lintels.

Orientation: 30 (compass).

First published by Maudslay (1889–1902:2:Pl. 78) as an unnamed mound adjacent to House A (Structure 6), Structure 7 was explored and consolidated by INAH in 1976 (García Moll and Juárez Cossío 1986:155). It is composed of two parallel vaulted chambers, interconnecting by means of an opening on the eastern end of the interior wall (discovered by INAH). On the exterior wall of each chamber are three doorways. One façade faces the river and the other, the plaza. The roof is mostly fallen; it is still standing on the northwest corner of the structure. On that side a hint of the original exterior decoration can be seen: like Structure 6, it had recessed supernatural mask panels in the frieze area. Unlike Structure 6, the exterior was not painted red, but a creamy white.

On the interior, a low bench is nestled in the northwest edge of the southern chamber. A partial wall or bench appears in the southeast portion of the central wall, forming a window between the two chambers. The vaults were designed in three successive overhangs of stone, plastered over to give a slightly stepped effect.

The missing wooden lintels provide the opportunity to observe a construction practice used here. A finished layer of stucco was applied to the tops of the piers and to the walls at the level of the lintels before the lintels were set. It will be interesting to see if excavation reveals any offerings set into the masonry below the lintels.

Structural similarities to Structure 6, such as wide doorways and massively thick walls, suggest that this was built before 9.12.0.0.0.

Structure 7 overlooks the river and has entrances facing the Main Plaza as well. Its importance was later obscured by the construction of Structure 8. Maler (1903:125) provides an excellent description of this elegant building.

Structure 8

(Wall Panel)

Situated transverse to the axis of the Main Plaza, Structure 8 is a long, low mound that divides the central from the southeastern portion of the plaza. A stairway faces northwest, directly overlooking Stela 1. Flanking the stairway are recessed areas on the vertical plane. A fragmentary wall panel was found here several years ago by INAH. It was carved with a hieroglyphic inscription that consists of the end of a nominal phrase of Shield Jaguar, another clause, and a "child of the mother" Lady Ik Skull phrase. The tablet once referred to Bird Jaguar IV as the offspring of this couple. Thus Structure 8 probably was built by Bird Jaguar IV to emphasize and extend the axis created by Structure 33 and the Grand Stairway.

Structure 9

(Stela 27)

Dense growth inhibits investigation of the remains of Structure 9. Maler reported traces of a building with three entrances and perhaps two parallel chambers. He also found a section of a column carved in alternating diamonds of high and low relief (1903:40). Ruppert reported two circular altars associated with this structure (Morley 1937–1938:354). I cannot confirm the presence of the column section.

55.

Structure 9, Stela 27. Author drawing from the monument, inked by Constance Cortez.

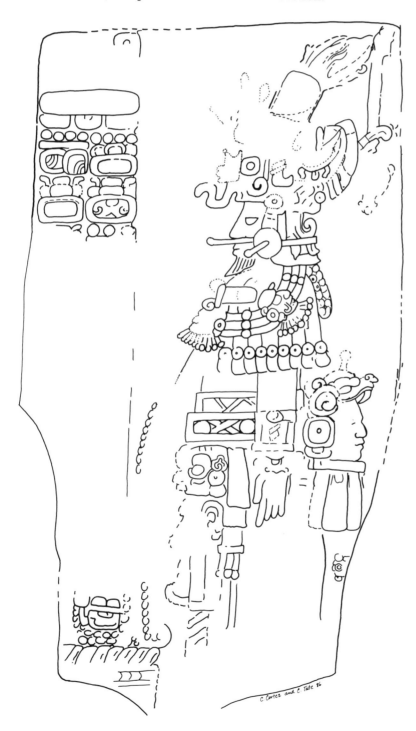

C. Cortez and C. Tate 86

Dimensions (from Morley 1937–1938:364)

	L	W	Th	Sides Carved
Stela 27	1.5 m	0.86 m	19 cm	1?

A small stela (Stela 27; see Figure 55) was discovered by Ruppert in 1931, lying with the carved side down, having fallen across a plain circular altar (Morley 1937–1938:354). It is now lying on its side, propped up with sticks and partially covered by a piece of corrugated plastic, on the ruined stairway in front of Structure 9.

Date and Protagonist

| Stela 27 | 9.4.0.0.0 | (13 Ahau 18 Yax) | KEJ |

Morley called Stela 27 "the earliest contemporaneous monument in the Usumacinta Valley" (1937–1938:364). It no longer has this distinction, as some panels from the Bonampak area have been found, one dating 9.3.3.16.4. There are some early references to a ruler named Knot Eye Jaguar from Yaxchilan and Piedras Negras at about this time. The date 1 Cauac 7 Yaxkin appears on Lintel 37 of Structure 12 associated with this ruler. The syntax of the clause is structured so that the Lintel 37 Calendar Round must precede 9.4.11.8.16, so the position of the date in the Long Count must be 9.3.13.12.19. On Piedras Negras Lintel 12, the date 9.3.19.12.12 is also associated with a Knot Eye Jaguar of Yaxchilan (Morley 1937–1938: Plates 119c and 27a). Thus, even though the name of the protagonist has eroded from Stela 27, it is provisionally associated with Knot Eye Jaguar I.

Structure 10

(Lintels 29, 30, 31)

Dimensions, Exterior: approx. 16.79 by 4.11 m.

Dimensions, Interior Northwest chamber, 7.14 by 2.57 m. Southeast chamber, 4.39 by 2.54 m.

Orientation: 220 (map).

Approximate plans of Structure 10 have been drawn by Maler (1903 : 129) and Morley (1937–1938 : 589).

The building is situated on a terrace elevated approximately 3 m above the level of the Main Plaza. It is composed of two chambers, side by side, of unequal size. Along the back wall of the northwest chamber is a low bench or shelf. Two vertical buttresses form a niche along this wall. The northwest chamber has three entrances; the southeast chamber, two. At this time, three carved lintels are distributed with Lintel 39 in the central doorway into the northwest chamber, and Lintels 30 and 31 over the entrances to the southeast chamber.

Structure 10 was modified by the Maya after its initial construction. The easternmost entrance was partially walled up, making it into a window. Structure 13 was constructed at close to a right angle from the western side of the building. The doorway at the west end of Structure 10 was narrowed during the process of adding a new wing. The vaults of Structure 10 have now fallen. The building was cleared and consolidated by INAH in 1979. During the consolidation, García Moll determined that

56.

Structure 10, with Structures 13 and part of 74, showing location of Lintels 29–33 and 50. Author photo.

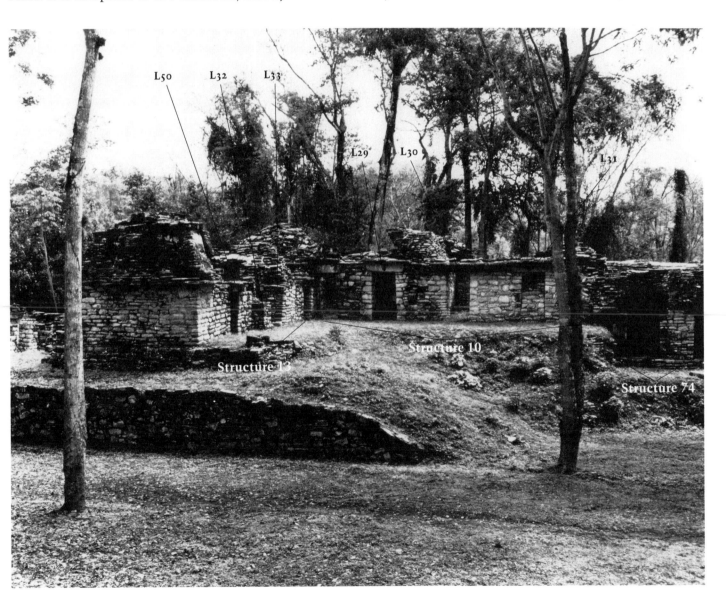

L50 L32 L33 L29 L30 L31

Structure 13 Structure 10 Structure 74

Structure 74 must have been built first, followed by Structure 10, Structure 13, and later modifications (García Moll and Juárez Cossío 1986:83).

Structures 10 and 13 and the L-shaped terrace upon which they were built overlap Structure 74 (Figure 56) and must be later constructions than 11, 12, and 74. The eastern end of Structure 10 clearly abuts Structure 74. The masonry wall of Structure 10 partially rests on the east end of 74. The doorways of Structure 74 are on a floor 1.50 m lower than that of Structure 10.

Lintels 29 and 31 were in situ during the visits of Maudslay and Maler. Maudslay reported that Lintel 30 was in situ, but it had fallen by Maler's visit of 1897. Lintels 29 and 31 also eventually fell from the structure, probably due to the action of a large cedar tree on the western end of the building (Graham 1979:67). In 1977, Graham located Lintel 29 among the debris (ibid.). All three lintels are currently restored to their original locations by INAH, although one temporarily was set over one of the doorways of Structure 12.

MONUMENTS

Dimensions (from Graham 1979)

	MW	HSc	WSc	MTh	Rel
Lintel 29	0.76 m	0.60 m	0.86 m	0.41 m	0.5 cm
Lintel 30	1.04 m	0.89 m	0.82 m	0.28 m	0.5 cm
Lintel 31	1.08 m	0.95 m	0.81 m	0.36 m	0.3 cm

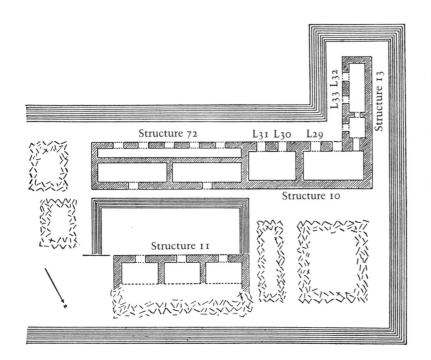

Lintel 29

The inscriptions on these three purely glyphic lintels (see Figure 57) form a continuous statement.

Lintel 29	9.13.17.12.10	8 Oc plus lunar data	
Lintel 30	− 1.17	DN	
	(9.13.16.10.13)	1 Ben 1 Ch'en, the 819-day-count station prior to the Initial Series	
	[9.13.17.12.10]	13 Yax	Birth of BJIV
	+ 2. 3. 5.10	DN	
	(9.16. 1. 0. 0)	11 Ahau 8 Zec	Accession of BJIV
Lintel 31	+ 12. 0. 0	DN	
	(9.16.13. 0. 0)	2 Ahau 8 Uo	BJIV
	+ 7. 0. 0	DN	
	(9.17. 0. 0. 0)	13 Ahau 18 Cumhu	BJIV implied

Construction Completion Date: 9.17.0.0.0.

Lintel 30

Lintel 31

Structure 11

(Lintel 56)

Dimensions: approx. 5 by 15 m.

Orientation: 213 (map).

Designated House C by Maudslay, Structure 11 is placed behind the other structures lining the Main Plaza, off a small, private courtyard (Figure 58). Three entrances face the courtyard at the rear of Structures 10 and 74, and at one time two or three other rooms opened toward the river. The exterior walls facing the river have almost entirely fallen, though the floor of these rooms can be seen, as well as a small stair leading up to their level. At an early date, a doorway connected the two parts of the structure on the eastern end of the common wall, but it was closed during Maya times. All the vaults have fallen. The structure has been cleared and consolidated by INAH. Uncarved lintel stones have been reset over the three entrances.

MONUMENT

Lintel 56 is carved on the front edge only.

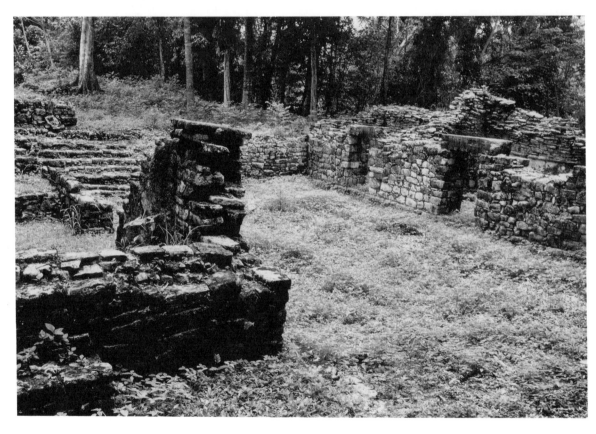

58.

Structure 11 at right, Structure 74 at left, and small plaza in between. Photo © 1991 by Lee Clockman.

59.

Structure 11, Lintel 56. Drawing by Graham (1979:121).

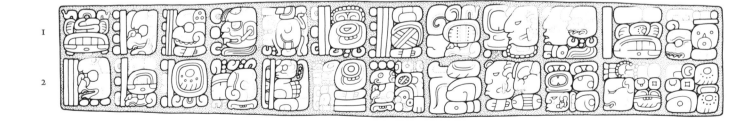

Dimensions (from Graham 1979: 121)

	MW	HSc	WSc	MTh	Rel
Lintel 56	0.80 m	0.27 m	1.57 m	0.38 m	0.9 cm

Lintel 56 is associated with the central doorway of Structure 11. In 1886, Maudslay sent members of a woodcutting firm, the López brothers, to Yaxchilan to obtain some monuments for the British Museum. They apparently did not have, or did not follow, specific directions about which monuments to take. The sculptured front edge was sawed off this lintel by Gorgonio López and sent to Coban to be shipped to England. Due to some error, it was sent instead to the Museum für Volkerkunde in Berlin, and Maudslay allowed it to remain there. Fortunately, a cast was made and sent to the British Museum, for the lintel was destroyed by bombing in World War II. Graham stated that a shaft of a sawed-off lintel which fit the dimensions of Lintel 56 was located off the northeast side of Structure 74 (1979: 121). The shaft Graham noticed is probably the one now over the central doorway of the structure.

Date and Protagonist

Lintel 56	9.15.6.19.1[a]	7 Imix 19 Zip	"Fire" event (house dedication)[b] by a woman *u cab* SJ

[a]Impossible date; see discussion below.
[b]See Schele 1987: 135–136; 1989: 39.

The date of Lintel 56 (Figure 59) is in question due to a scribal error. The Long Count and the Calendar Round do not correspond. If the Calendar Round is correct, which is likely since many of the monument dedications occurred on Imix days, the corresponding Long Count is 9.15.6.13.1. The Lord of the Night is correct for this date. The recorded Long Count, 9.15.6.19.1, is impossible, since the greatest possible coefficient for the *uinals* position is 17.

The female protagonist's identity is not clear. The event is of the type Lady Xoc would perform (a house-dedication event), and the date is within her lifetime, but the name phrase is not her normal one. This is the only time this woman is mentioned in the records of Yaxchilan. The text records the dedication of the building.

Construction Completion Date: 9.15.7.0.0.

Structure 12

(Lintels 34, 35, 36, 37, 47, 48, 49, and 60)

Dimensions, Exterior: 5.40 by 13.50 m.

Dimensions, Interior

Front chamber, 12.30 by 1.17 m. Rear chambers, 8.40 by 2.31 m and 3.30 by 2.34 m.

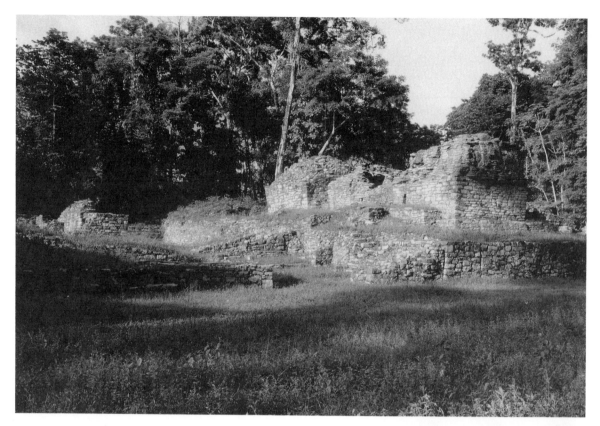

60.

At left, small building is Structure 12. At right, west side of Structure 13, with remains of construction between the two buildings. Photo © 1991 by Lee Clockman.

61.

Structure 12, west side (facing winter solstice sunrise), with Structure 16 in the middle ground and the platform of Structure 18 in the distance. The New Lintel (Lintel 60) of Structure 12 is on the right rear corner of that building. Lintels 37 and 36 are also in situ. Photo © 1991 by Lee Clockman.

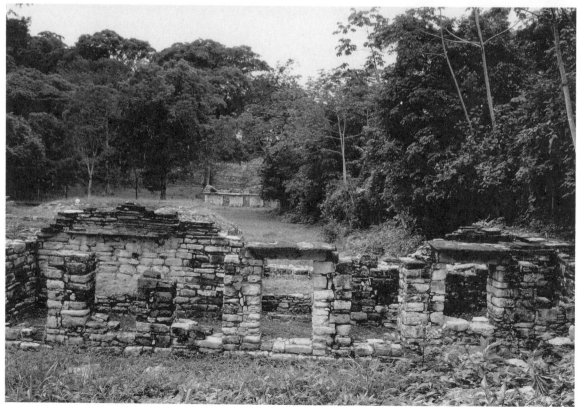

Maudslay named this building House D and found two carved lintels. He described the building as "wholly ruined" (1889–1902:2: 44). Maler reported that he was able to enter the front chamber of the structure through one of the four doorways he found; he discovered two more carved lintels. The Fourteenth Central American Expedition excavated along the line of the façade to the northeast and located three more lintels. Standing walls of this and the surrounding structures were excavated and consolidated by the INAH in January 1984. In addition to the discovery of a new lintel, the excavations revealed the ruins of a great deal of construction in this area.

The approach to Structure 12 is now between the terrace of Structure 13 and the southeast wall of constructions associated with the ballcourt. One steps up a few feet on successive levels and passes the bases of thin masonry walls before reaching the small plaza in front of Structure 12. So the platform upon which Structure 12 rests is slightly higher than the level of the Main Plaza. At the north side of this subplaza, a stairway of eight steps rises to the level of the Structures 10–13 terrace. This stairway overlaps part of Structure 12, and the small constructions at the entrance to this court were built onto the Structure 13 terrace. At least in this small area, the order of construction was Structure 12, then Structure 13 terrace, then the small rooms southeast of Structure 12.

Structure 12 is composed of two parallel vaults. The front vault spanned one long chamber. In the northern end of the room is a long, low bench about 1.20 by 2.40 m. A step of 0.28 m leads to the rear vault, which was divided into three chambers, a long one 6.93 by 2.28 m, a small "closet" in the center which opens onto the large chamber, and a smaller room about 3.30 by 2.10 m with a 1.20 by 2.10 m bench in the corner opposite the door, which led south to the side of the building. Maler suspected that burial chambers would be found beyond the front chamber of this structure, and the publication of the excavations may reveal what the nature of the structure is.

Dimensions (from Graham 1979; Lintel 60 Measured by Author)

Structure 12

	MW	HSc	WSc	MTh	Rel
Lintel 60	0.60 m	0.97 m	0.51 m	0.23 m	0.4 cm
Lintel 49	0.66 m	0.97 m	0.55 m	0.25 m	0.4 cm
Lintel 37	0.70 m	0.93 m	0.57 m	unknown	0.6 cm
Lintel 35	0.63 m[a]	0.97 m	0.57 m	unknown	0.6 cm
Lintel 36	0.65 m	0.99 m	0.56 m	0.24 m	0.3 cm
Lintel 48	0.67 m	0.98 m	0.55 m	0.23 m	0.7 cm
Lintel 47	0.68 m	0.97 m	0.55 m	0.25 m	0.7 cm
Lintel 34	0.65 m	unknown	0.55 m[b]	[c]	0.4 cm

[a] Trimmed.
[b] Approximate.
[c] Not measured.

All lintels are purely glyphic except for Lintel 36, upon which a standing frontal figure holding a stiff ceremonial bar can be discerned.

Discovery and Condition

	Discoverer	Condition	Location
Lintel 60	INAH	Whole, good	In situ
Lintel 49	Ruppert	Chipped	Unknown to me
Lintel 37	Maudslay	Whole, good	In situ
Lintel 35	Maudslay	Sawn, good	British Museum
Lintel 36	Maler	Whole, eroded	In situ
Lintel 48	Ruppert	3 pieces, one missing	MNAH
Lintel 47	T. de la Cruz	2 pieces, good	MNAH
Lintel 34	Maler	Many pieces	Unknown to me

All lintels except 36 showed traces of red paint (Morley 1937–1938:367). Very little remains today.

Dates and Protagonists

Lintel 60	None recorded			Rulers 1–4
Lintel 49	None recorded			Rulers 5(missing)–7
Lintel 37	(9.3.13.12.19)	1 Cauac 7 Yaxkin		Rulers 8 and 9
Lintel 35	(9.5. 2.10. 6)	1 Cimi 14 Muan		Ruler 10 (MKSII)
Lintel 36	Figural; glyphs eroded			Ruler 10?
Lintel 48	9.4. 8.11.16	2 Cib		
Lintel 47	Lunar data		19 Pax	Ruler 10
Lintel 34	None recorded			Ruler 10 and parents

As can be seen by the list of protagonists, the glyphs on these eight lintels compose a continuous inscription by Ruler 10, recording nine generations of ancestral rulers, then his own accession date and parentage statement.

Without archaeological data (such as the dates of associated ceramics, or information about what lies under the floor of Structure 12

62.

Structure 12 lintels.
New Lintel (60)
drawn by author,
Lintels 34–37 and
47–49 by Graham
(1979:77, 79, 81, 83,
103, 105, 107).

and its plaza), the attribution of the construction of Structure 12 remains speculative. The problem remains much as Morley described it (1937–1938:365–366). The lintels are undoubtedly early. Continuing studies of the style of carving on Yaxchilan monuments show that attempts to reproduce styles from an earlier era by Bird Jaguar IV's artists resulted in a "handwriting" recognizably different from the style in which all Structure 12 lintels were executed. However, architecturally, Structure 12 does not seem contemporary to the reign of Ruler 10. Other structures at Yaxchilan known to predate the Late Classic (such as Structures 6 and 41) are constructed with much more massive masonry than Structure 12. Other examples of

Early Classic architecture are surely buried beneath present structures at the site. I could accept that the architect of the building innovated the design of a structure with many entranceways that would accommodate the large amount of information Ruler 10 wished to present on the carved lintels, but find it disturbing that Structure 22, which is closest in design and proportion to Structure 12, was designed or remodeled about 9.16.2.0.0. Either Structures 12 and 22 are contemporary and early (ca. 9.5.0.0.0), or Structure 22 design was inspired by the earlier Structure 12, or Bird Jaguar IV designed both buildings specifically to house the antique lintels that recorded the history of his ancestors.

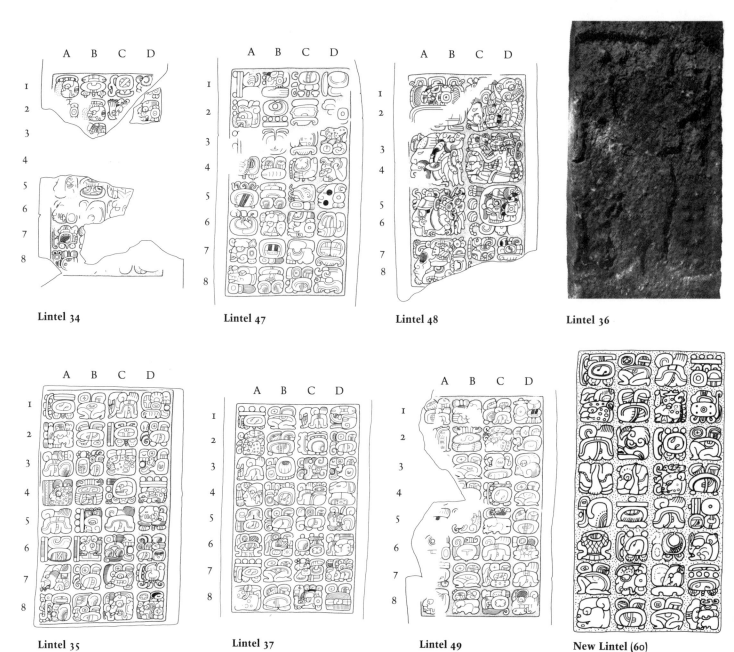

Lintel 34

Lintel 47

Lintel 48

Lintel 36

Lintel 35

Lintel 37

Lintel 49

New Lintel (60)

Structure 13

(Lintels 32, 33, 50)

Dimensions, Maximum Exterior: 11.23 by 4.70 m.

Orientation: 118 (compass).

Structure 13 is situated on an L-shaped terrace 2.5 m above plaza level (see Figures 56, 60, and 63). An additional platform of 0.75 m supports the structure. The transversal position of Structure 13 in the Main Plaza forms a northwestern boundary to the central portion of the plaza, with Structure 8 acting as the southeast edge. The height of the Structure 13 platform blocks Structure 12 from view from the floor of the Main Plaza and from the lower portion of the stairs of Structure 33 as well. Structures 13, 74, 9, and 8 form the walls of the Stela 1 courtyard.

Structure 13 appears to have been built in two phases, the later one partially inside the earlier one. The rear wall is 11.23 m long, and the length of the chamber is 7.70 m. The original structure was a single vaulted chamber entered by three openings facing 118 degrees. One alteration to the building consisted of adding masonry to the interior of the structure, presumably to support walls in danger of falling.

Three thick buttresses were added to the rear wall, in the corners and the center. A support 1.06 m thick was added behind the piers defining the entranceways. Lintel 50, surely a very late monument, may have been placed over the southern doorway when the structure was buttressed. The other major modification was the formation of a passageway between the interiors of Structures 13 and 10. Masonry was added to the south wall of Structure 10 where it faces Structure 13 and to Structure 13's north side as well. This masonry supported a narrow vaulted passage where once the passage had been wider and open to the sky. An opening knocked into the north wall of Structure 13 led through the passageway to the previously existing northwest doorway of Structure 10.

Most of the vault has fallen save that supported by the side walls. Stubs of a roofcomb can be seen in the corner of the building. The roof was finished in a typical Yaxchilan mansard shape, with an upper and lower cornice and projecting stone and stucco sculpture distributed symmetrically at the corners, above doorways, and in the interstices. Fragments of the stucco masks on the southern corners can be seen. Structure 13 was excavated and consolidated by INAH in 1979 (García Moll and Juárez Cossío 1986:158), and Lintel 50 was placed over its doorway.

63.

Structure 13, at left, had three lintels, two of which were summer solstice commemorations. Adjoining it are Structure 10, which contains the latest set of lintels commissioned by Bird Jaguar IV, and Structure 74. Photo © 1991 by Lee Clockman.

Dimensions (from Graham 1979)

	MW	HSc	WSc	MTh	Rel
Lintel 50	0.68 m	0.58 m	0.59 m	0.23 m	0.3 cm
Lintel 32	0.59 m	0.53 m	0.81 m	0.27 m	0.5 cm
Lintel 33	0.71 m	0.61 m	0.81 m	0.32 m	0.9 cm

Lintel 50 was discovered by Ruppert in 1931 in front of Structure 13. It is now in situ. Lintels 32 and 33 were discovered by Maler (1903 : 132) in the debris in front of the building. He noted much bright red paint on Lintel 33, but none on Lintel 32. These two lintels were taken in 1964 to MNAH, where they remain.

Dates and Protagonists

Lintel 50		None recorded	MKSIII
Lintel 32	(9.13.17.15.13)	7[a] Ben 16 Mac	SJ, LIS
Lintel 33	(9.15.16. 1. 6)	5 Cimi 19 Yaxkin	BJIV

[a]Erroneous; should be 6.

I suspect that Lintel 50 dates to the reign of Mah K'ina Skull III for several reasons. It is executed with a careless lack of attention to detail and the canons of form and symbolism typical only of late monuments of Yaxchilan. The lack

64.

Structure 13, plan by Sylvanus G. Morley (1937–1938 : 395) and Lintels 50, 32, and 33, drawings by Graham (1979 : 73, 75, 109).

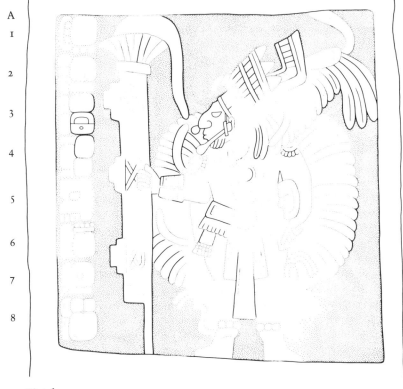

Lintel 50

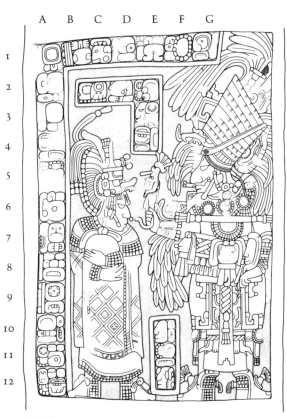

Lintel 32

of a date is typical of other late monuments, such as Lintels 55, 57, and 58. This evidence places its execution later than 9.17.5.0.0. Furthermore, a skull glyph is prominent in the nominal phrase. The only known ruler with a skull glyph in his name at this era was Mah K'ina Skull III.

The interpretation of the erroneous Calendar Round on Lintel 32 was provided by Proskouriakoff (1963:164). This lintel was definitely carved much later than the date commemorated, which may account for the error in the recording of the Calendar Round 7 Ben 16 Mac when 6 Ben 16 Mac must have been intended. My studies of costumes and headgear depicted at Yaxchilan have shown that Shield Jaguar never had himself portrayed with Lady Ik Skull, never was depicted wearing the drum-major

headdress in monuments he commissioned, and likewise never held the God K manikin scepter. His costume and headdress and the God K scepter were conventions of the reign of Bird Jaguar IV. Bird Jaguar IV had this lintel carved to commemorate the real or fictitious presence of his mother at an important ceremony performed during a stationary conjunction of Jupiter and Saturn, a ceremony in which Lady Xoc was the co-protagonist with Shield Jaguar (Tate 1985c).

Bird Jaguar IV is clearly named on Lintel 33, and 9.15.16.1.6 is the only possible position of 5 Cimi 19 Yaxkin during his lifetime. Morley (1937–1938:415) assigned the Calendar Round 5 Cimi 19 Yaxkin to the Long Count 9.10.10.11.16 for stylistic reasons. However, the lintel was carved after 9.16.4.1.1, the date of the capture of Jeweled Skull, as Bird Jaguar IV carries the Captor of Jeweled Skull title here.

Construction Completion Date

The earliest possible date for the original structure, including Lintels 32 and 33, is 9.16.5.0.0. It was probably conceived as part of the modifications to the Main Plaza and dedicated on 9.16.10.0.0. The later modifications and Lintel 50 may date to around 9.19.0.0.0.

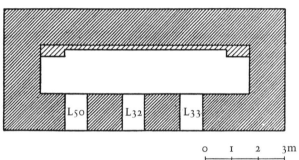

0 1 2 3m

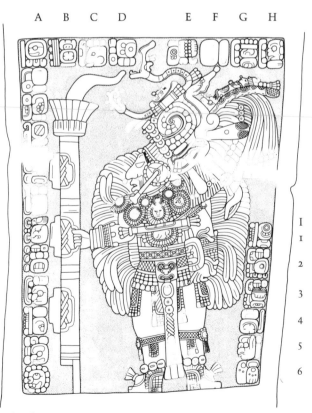

A B C D E F G H

1
1
2
3
4
5
6

Lintel 33

Structure 14

(Ballcourt Markers a–e*)*

Dimensions, Exterior: 42.85 by 18.42 m; playing field (flat area between two platforms), 18.41 by 3.76 m.

Orientation: 118–122 (walls sagging) (compass).

The ballcourt is situated in a large open area on the northern side of the Main Plaza (Figure 65). The entire construction consists of two stepped platforms about 2.40 m tall at their summits. These platforms are about 13.80 by 18.00 m each. The structures are located so that the short sides of the platform (perpendicular to the playing area) are oriented at 118–122 degrees east of north. The long façades are oriented at 25–28 degrees east of north. A stairway 9.90 m wide of nine steps averaging 0.79 m wide and 0.25 m high leads from the northwest side of the ballcourt to the top of the northern platform. On the southern platform, later constructions of small rooms (now roofless) make it unclear whether a symmetrically situated staircase was built on the southeast side.

MONUMENTS

Five sculptured, circular disks were found on the floor and platforms of the ballcourt by Ruppert in 1931 (Figures 66, 67). They are approximately the same size—66 cm in diameter and 46 cm high. All were set into the court so that their upper surfaces were flush with the plaster paving. From the meager remains of relief, it can be seen that each disk shows a cross-legged figure seated on a monster-head throne. Encircling each figure is a type of celestial cartouche—an ancestor cartouche in one case (Figure 67*b;* also shown in Figure 66), a sky-band cartouche in another (Figure 67*e*). Markers *c* and *d* are eroded.

65.

Structure 14, the ballcourt. Photo © 1991 by Lee Clockman.

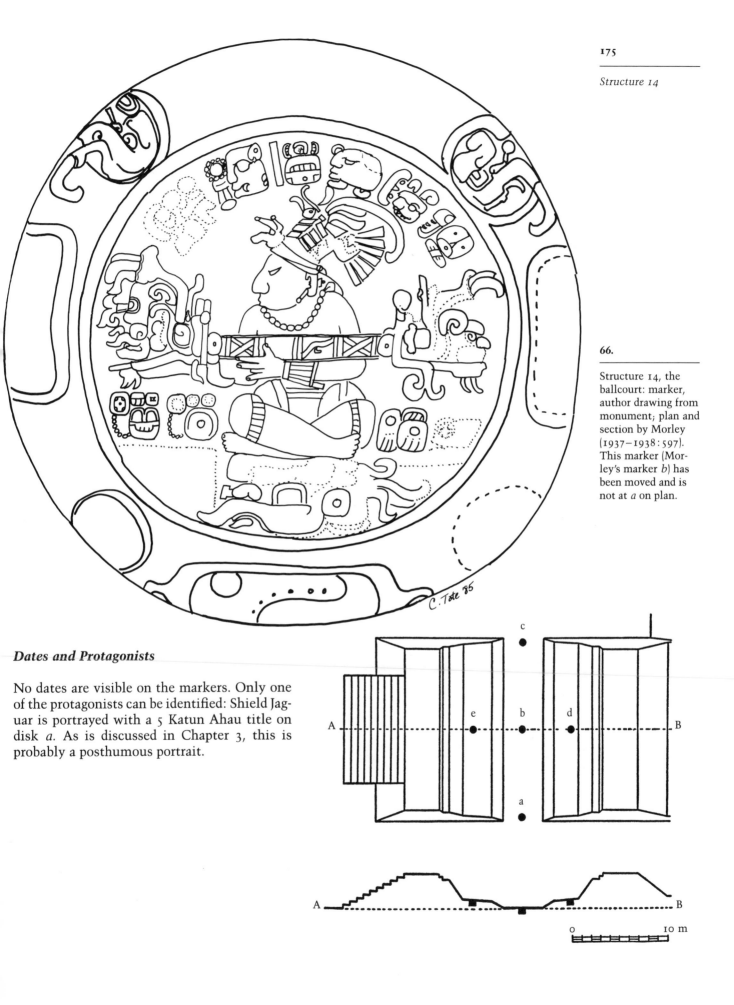

Structure 14, the ballcourt: marker, author drawing from monument; plan and section by Morley (1937–1938:597). This marker (Morley's marker *b*) has been moved and is not at *a* on plan.

Dates and Protagonists

No dates are visible on the markers. Only one of the protagonists can be identified: Shield Jaguar is portrayed with a 5 Katun Ahau title on disk *a*. As is discussed in Chapter 3, this is probably a posthumous portrait.

67.

Structure 14, ball-
court markers *a–e*.
Photos by Morley
(1937–1938: Pl.
116*a–d*), Pl. 178A
d. (Photo shows both
top and bottom of
marker *c*, which
broke into two
pieces.)

Structure 16

(Lintels 38, 39, 40)

Dimensions, Exterior: 18.42 by 8.61 m.

Orientation: 118 (compass).

Structure 16 is situated transverse to the axis of the Main Plaza, near the riverbank, and below the steps to Structure 18 (see Figure 61). A large courtyard lies between it and Structure 14, defined on the north by the long, low, uncleared Structure 15, which Maler supposed might be chambers (1903:124). A low platform about 15 m long separates the area directly in front of Structure 16 from the rest of the plaza.

The INAH excavations of 1981 revealed the true dimensions of this building. Structure 16 was built in at least two phases. The earlier construction is composed of two parallel vaulted chambers, the rear chamber subdivided into three small compartments. Three doorways lead from the plaza into the front chamber of the first phase. Over these three entrances were set lintels carved on their front edges only. The later construction uses the northern wall of the structure. Two more chambers were added on the north side. One opens onto the front façade, and the rear chamber opens onto the north side. A doorway was opened between this later chamber and the northeast rear chamber of the original structure, and was blocked later. In the front chamber of the earlier structure, a narrow bench was built against the central wall of the structure on the south side. A wider, irregularly shaped bench occupies part of the space between the two entrances leading from the front to the rear vault. The central interior door leads to the central rear chamber, which has a large bench, and the right interior door leads to the right rear chamber, which also has a large bench, but the left, or southern, rear chamber has no access door at all. The rear chambers would have been convenient as apartments, and perhaps the chamber with no outlet held burials.

MONUMENTS

Dimensions (from Graham 1979)

	MW	HSc	WSc	MTh	Rel
L 38	0.97 m	0.26 m	1.26 m	0.32 m	0.7 cm
L 39	0.98 m	0.25 m	1.22 m	0.32 m	0.8 cm
L 40	0.95 m	0.25 m	1.26 m	0.32 m	0.5 cm

Lintel 40 was discovered in situ by Maler in 1897. On his next visit to Yaxchilan, he excavated in the mound on the line corresponding to the façade and found Lintels 38 and 39. Lintel 39 was taken to MNAH in 1964 but was brought back to the site in 1984 and placed over the central doorway (García Moll and Juárez Cossío 1986:159). Lintels 38 and 40 have been restored to their original positions. Traces of red paint were reported on the glyphic portions of Lintels 38 and 39 by Maler (1903:135). Paint is still faintly visible.

Dates and Protagonists

L 38	(9.16.12.5.14)	3 Ix 7 Mol	LAI
L 39	(9.15.10.0. 1)	4 Imix 4 Mol	BJIV
L 40	(9.16. 7.0. 0)	13 Ahau 18 Zip	Lady Ix

Lintel 38 was dated 9.15.6.17.8 3 Lamat 6 Mol by Morley (1937–1938:509). Ian Graham's drawing shows the Calendar Round as 3 Ix 7 Mol, and having compared the drawing to the monument, I agree with this rendering. Schele (1982:197) placed the Calendar Round within the reign of Bird Jaguar IV, which is unquestionably correct.

Because Bird Jaguar IV is the protagonist of Lintel 39, the Calendar Round 4 Imix 4 Mol can only refer to the important date 9.15.10.0.1, five days after he performed a summer solstice/flapstaff event with his father, the event that was commemorated on Stela 11.

Of Lintel 40, Morley declared, "The only decipherable glyphs are at A1–B1, which surely record 11, 12, or 13 Ahau 18 Pop, Uo or Zip" (1937–1938:509). Because he associated the Lintel 39 Calendar Round with 9.15.10.0.0, basically for stylistic reasons, he tried to find a Long Count date for one of the nine positions he suggested for Lintel 40 that was closest to 9.15.10.0.0 (ibid:512). Looking at the day coefficient on the actual monument, he decided that it was more likely 12 than 13 because the middle of the three dots is slightly longer than the top and bottom ones. He did not consider that the same is true of the month coefficient, which he stated is 18. His favored reading was (9.15.6.12.0) 12 Ahau 18 Uo.

Proskouriakoff thought that since the images (royalty holding double-headed serpent–God K bars) were like ancestor portraits on stelae, the images could be posthumous. She did not want to attempt to assign Long Count dates until she understood the T712 "handfish" glyph better. Of course, she showed in 1973 that the verb referred to bloodletting and does not have a posthumous significance. Two

178

*The Site and Its
Monuments*

68.

Structure 16, Lintels
38–40. Drawings by
Graham (1979:85,
87, 89).

posthumous events are recorded at Yaxchilan, one on Lintel 28 and one on Stela 11, and they incorporate a different verb. Schele (1982:175) gave the date 9.15.15.6.0, which corresponds to 12 Ahau 18 Ceh. I do not understand the rationale for reading the crossed-bands month glyph as Ceh.

I carefully checked the monument, and assert that the day coefficient is 12 or 13, and the month glyph contains crossed bands with a Zip identifier. We thus have two possibilities for the date during the reign of Bird Jaguar IV: (9.16.19.3.0) 12 Ahau 18 Zip, or (9.16.7.0.0)

13 Ahau 18 Zip. Of these two dates, the latter seems more likely because it is a *tun* anniversary of Bird Jaguar IV's accession, it is nine solar years minus one day since the death of Lady Xoc, and it is close to the date of Lintel 38. The anniversary events of Structure 16 are discussed in the section on the theme of the double-headed serpent in Chapter 4.

Construction Completion Date

The earliest possible date for the early phase of the structure is 9.16.13.0.0.

Structure 17

Dimensions, Exterior: approx. 4 by 8 m.

Orientation: 207 (map).

A small building, recently cleared, Structure 17 has one short doorway that leads into a chamber just big enough for a person or two to stand. Benches flank the hallway, and the arrangement seems to require that any occupants sit upon the benches, facing each other.

Structure 18

(Stela 8; Painted Stucco Panels)

Dimensions, Exterior: approx. 30 by 36 m.

Orientation: 118 (compass).

Beyond Structure 16, to the northwest, rises a low ramp that leads up to a broad plaza surrounded on three sides by structures. Closing the northwest end of the Main Plaza is a stepped platform 5 m tall which apparently never supported a masonry-roofed structure. Distributed in front of the three structures are circular altars, four large ones and three small ones in front of the northeast building and a large one in front of Structure 77 on the southwest side of the Structure 18 plaza. The terrace upon which these three structures are situated overlaps the northwest corner of Structure 19 and, in fact, covers the lower chambers of the Labyrinth and eventually abuts the foot of the hill leading to the West Acropolis. The Structure 18 plaza, the associated terrace, and the three structures 18, 77, and 78 were excavated in late 1984 by INAH.

Structure 18 appears to have had five pyramidal terraces. The lower three form a broad platform. The center third of the platform is occupied by two more terraces. A stairway almost as wide as the upper body leads up the three lower terraces to the top. On each side of the stairway are buttress-like constructions projecting from the main body of the terrace. The surfaces facing the plaza contain broad, flat vertical panels like the *tableros* of Teotihuacan architecture. The projections function as transitional planes between the necessary projection of the stairway and the rectangular body of the pyramidal terraces. Additionally, they provide a flat, emphasized plane for applying decoration or information. One of these *tableros* was reported to show traces of a white stucco surface painted with red hieroglyphs, one of which García Moll judged to be the name of Shield Jaguar. This area has been reburied by the INAH.

MONUMENTS

Dimensions: Stela 8 fragment, 72 cm wide (Maler 1903:136).

At the top of Structure 18, Maler found the upper right corner of a stela, which he numbered 8 (Figure 71). It shows a bust of a female within a lunar ancestor cartouche, plus four glyphs which name a 4 Katun Ahau. Because all the other stelae which have ancestor cartouches

69.

Base of Structure 18, a pyramidal construction at the northwest end of the Main Plaza. Photo © 1991 by Lee Clockman.

70.

Typical condition of
altars—these are on
the platform in front
of Structures 18 and
78. Photo © 1991 by
Lee Clockman.

in the upper registers have a cosmogram format
which included a scene of royal bloodletting, I
will assume in this study that Stela 8 was a
triple-register cosmogram. Maler searched for
the other pieces of this stela without success.
However, recent archaeology may have uncov-
ered the main portion of it. In 1984 another
stela fragment was found by García Moll dur-
ing the process of clearing the structure.

Date and Protagonist

On Stela 8 no date is recorded. The brief glyphic
phrase records a 4 Katun Ahau, possibly as an
ancestor. This gives three possibilities: that the
upper portion of the stela refers to Bird Jaguar
III (the only known ruler who died a 4 Katun
Ahau) as the father of Shield Jaguar in a par-
entage statement; that the stela was commis-
sioned by Bird Jaguar III and those are his titles;
or that Shield Jaguar built this stela before
9.14.15.0.0, when he became a 5 Katun Ahau,
and that is his title phrase. This gives a possible
span of 9.11.0.0.0–9.14.15.0.0 for this frag-
ment, and probably for Structure 18 as well.

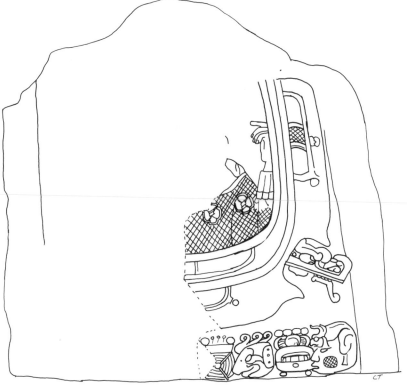

71.

Structure 18, upper
fragment of Stela 8.
Author drawing after
photo by Morley
(1937–1938: Pl.
100*b*).

Structure 19

(Altar 1)

Dimensions, Exterior: modified L shape 19.80 by 8.66 m and 24.19 by 8.41 m.

Orientation: 118 (compass).

Structure 19 was Maudslay's House H. In 1886, Désiré Charnay camped there. Also called the Labyrinth, Structure 19 closes off the northwest corner of the Main Plaza. At the present time, the passage through its dark corridors, up a narrow, pitch-black stairway, and under its step-vaulted lintels is the dramatic transition from the visitor's own world into the ancient ruins of Yaxchilan. Structure 19 is composed of

72.

Structure 19, plan compiled and drawn by author and section by Maler (1903:137).

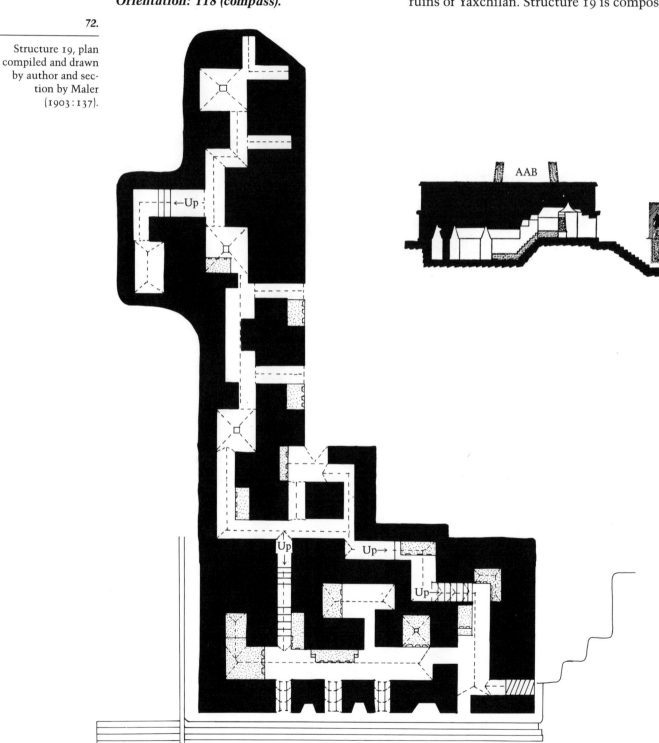

N mag.

0 16 feet

nine vaulted chambers connected by sixteen vaulted passageways situated on three levels. The two lower levels are practically subterranean. Their dark, bat-filled hallways and square, cross-vaulted rooms were filled with stone rubble in ancient times. These were excavated early in the INAH project, and only a portion of them, the southernmost, were discovered by Maler and appear on his plan (1903:137). Maudslay also made a plan of this unique structure (1889–1902:2:Pl. 77).

The upper level faces the Main Plaza (Figure 76). The four front doors all face precisely 118 degrees. The façade is unusual in that it is asymmetrical and may have originally been built that way. Between the doors, door-sized niches, now empty, create the impression of seven openings rather than four. Above the doors, the frieze has an upper and lower cornice. The ancient architect was faced with the problem of trying to create a symmetrical arrangement of frieze sculpture (for all ornament on Yaxchilan friezes seems to have been symmetrically distributed) which would harmonize with the asymmetrically spaced entrances below. Over the three western entrances are three semi-quatrefoil shapes that form thrones for tenoned sculpture. Over the lower niches were frieze niches of similar size. The quatrefoil over the third doorway was skewed to the

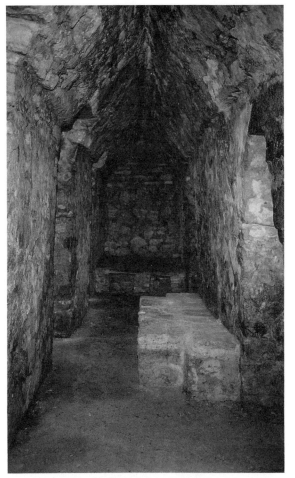

73.

Large chamber on the southeast side of Structure 19. At left are the doorways of the façade facing the Main Plaza. The small doorway at right leads to an interior chamber. The bench in the center and the one at the far end, which has a large niche adjoining it to the right, are where Maler and Désiré Charnay stayed during their visits. Photo © 1991 by Lee Clockman.

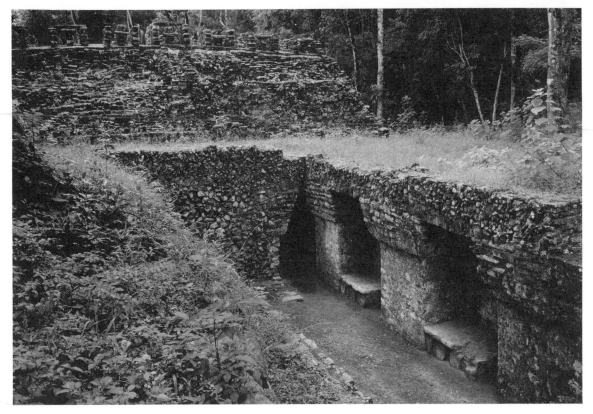

74.

View of the niches containing benches on the north side of the labyrinth. Next to the benches are corridors leading into the interior hallways. Note the roofcomb at left; it is over the main part of Structure 19. Photo © 1991 by Lee Clockman.

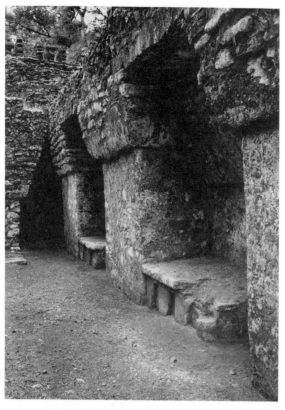

75.

Corbeled niches and benches adjoining the north entrance to Structure 19. Photo © 1991 by Lee Clockman.

76.

Southeast façade of Structure 19. Altars 2, 1, and an unnumbered one are placed in front. Photo © 1991 by Lee Clockman.

right to begin to compensate for the larger distance to the fourth door, and the next frieze niche was situated to the left of its corresponding niche below. An extra semi-quatrefoil throne and sculpture filled the space between the previous frieze niche and the one above the eastern door.

Three of the trapezoidal doors open into a chamber 12.30 by 1.78 m. Immediately behind the center of the three entrances, along the rear wall of the chamber, is a wide T-shaped bench 2.92 by 1.02 m at its largest points. On the southwest end of this chamber is a large, two-level L-shaped bench 4.47 by 2.49 m. On the opposite side of this chamber is the entranceway into the room also reached by the easternmost front door of the building.

Returning to the main front chamber, other peculiar features are encountered. Continuing in the 118-degree line from the westernmost entrance, a narrow stairway 0.83 m wide and 6.27 m long leads down eight steps under a triple-stepped vault constructed in the manner of the vault over the staircase on the interior of the Temple of the Inscriptions at Palenque. Just

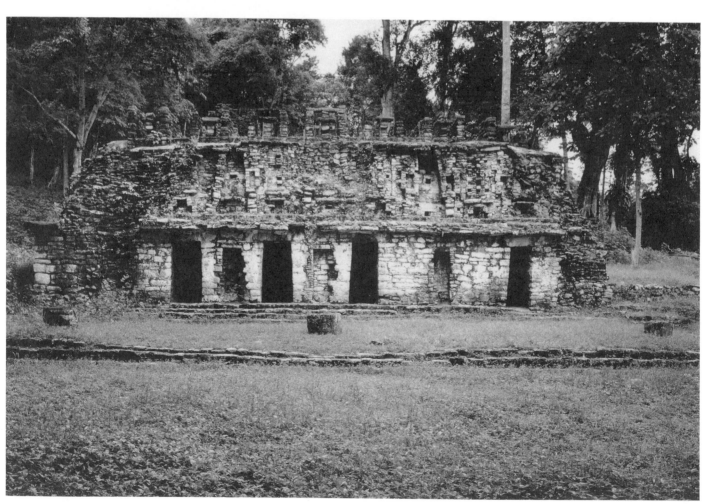

to the right of the stairway, off the main front chamber, is a bench inset into the wall, its rectangular shape parallel to the stairway. Immediately to the right of the central throne in the main chamber a small hallway leads back into a small, vaulted chamber with benches on the east and west sides. Off the east end of the main chamber is a large niche filled entirely with a bench.

The western front entrance leads to a chamber whose longest walls run 118 degrees. At the far end, half of the width of the narrow room is occupied by a bench. Another bench is set into the masonry at the northeast corner of the room. A curtain wall separates the open bench from a stairway situated parallel to the façade of the structure. Seven steps descend under a three-level stepped corbel. Descending the staircase, one makes a right turn at the bottom. In the darkness, 2.40 m ahead, is another stone bench set in the corner of the passageway and nearly blocking it. Turning left and skirting the bench, one steps down another large step for a total of eight, each averaging 25 cm high. This corridor continues 2.90 m, then another right turn reaches the passageway parallel to the façade which is also reached by the western stairway. This 9 m long passageway leads into the lower phase of the structure.

The lower phase is basically a long corridor which jogs along but which retains an orientation of 118 degrees. Three areas were enlarged to make three chambers roughly 2.40 m square, which are cross vaulted. Two passageways lead at 30 degrees from the main hallway to the exterior of the building. At the exterior aperture of each, a bench 1.80 by 1.19 m is set into the masonry of the exterior and covered with a vault. Past the second square chamber, a hall 1.80 m wide leads to the west, away from the exterior openings. Three steps lead up; then the passage makes a left turn. After 1.37 m, it opens into a chamber 3.14 by 1.90 m, without benches. The three square chambers and the western chamber lie underneath the huge stone terraces that cover the base of the West Acropolis. At least these chambers must have been created by tunneling into the hillside.

The interior passages are covered with thick white stucco in good condition. This makes it difficult to discern seams or variations in the masonry which would indicate multiple building phases. As far as I can tell, the entire upper structure was built in one phase, despite the irregularity of the eastern chamber. A doorway once led to the east side of the building from that chamber. It was blocked when the Struc-

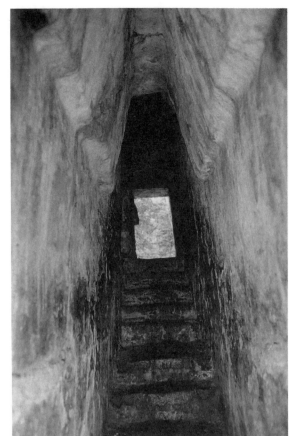

One of the three interior stairways in Structure 19. Photo © 1991 by Lee Clockman.

ture 18 terrace was constructed. It is possible that the fourth front doorway was opened at this time, and that the eastern chamber originally was not accessible from the front of the building.

MONUMENT

Altar 1 was first noted by Maudslay in 1882 in front of his House H. The sculpture of another altar in the vicinity was completely eroded. Morley made a good description of the design of the altar's periphery with its eight profile carved supernaturals framed by a continuous band of glyphs in a meander pattern (Morley 1937–1938:513). The glyphs are badly eroded except for one section which clearly records the Distance Number 6 *kins*, 0 *uinals*, and 4 *tuns*, count to 9 Ahau 18 Xul, the end of a five-*tun* period. Morley correctly gives the dates (9.15.10.17.14) 6 Ix 12 Yaxkin plus 4.0.6 count to (9.15.15.0.0) 9 Ahau 18 Xul. Inscriptions on Stela 12 and Lintel 27 give 6 Ix 12 Yaxkin as the death date of Shield Jaguar, so this monument was created after his death. It recorded events pertaining to the termination of his reign at the site.

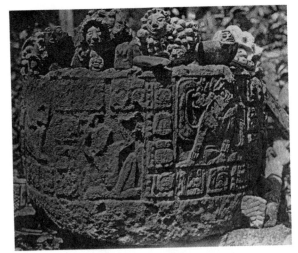

78.

Structure 19, Altar
1: photo by Maler
(1903 : Pl. 80, no. 2);
author drawing.

Construction Completion Date

Architectural features of Structure 19 are simi-
lar to those of Structures 20 and 30: the height
of the vaults, width of the walls, and accuracy
of the construction. This suggests that it is a
relatively late structure. However, the terrace
of Structure 18, which seems to date to Shield
Jaguar, overlaps part of Structure 19. I suspect
that the Structure 18 terrace was built up to
unify the northwest end of the plaza late in the
history of the site, and that Altar 1 was origi-
nally associated with another structure, or with
some platform in the vicinity of the present
Structure 19.

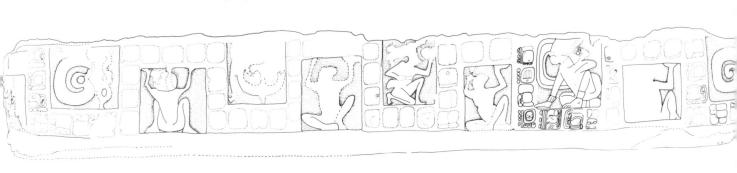

Structure 20

(Stelae 3, 4, 5, 6, 7, and 33; Lintels 12, 13, 14; Stucco Interior Decoration; Hieroglyphic Stairway 5; Associated Altars)

Dimensions, Exterior

Area, 19.96 by 5.61 m. Height excluding roofcomb, 6.30 m. Stubs of roofcomb, 1.07 by 0.36 m. The stubs at the center of the building are generally thicker than those at the edges.

Orientation: from central doorway, 53 degrees; from right doorway, 49 degrees (compass).

From Structure 19 Maler's general enumeration of structures returned to the southeast corner of the Main Plaza. Structure 20 is located on the first bench of structures on the north side of the ravine that leads to the South Acropolis stairway. The area of the first bench in front of Structure 20 was formed into three terraces. On the lowest, the level of the Main Plaza, five stelae were placed by Shield Jaguar II. Associated with each was a circular altar. These monuments serve as a focal point of the

plaza space bordered by Structures 4, 5, 8, and 20. Behind them, the stairway leading to Structure 20 is divided by three small, projecting

79.

Structure 20 in the background, as seen between Structures 6 and 7. Photo © 1991 by Lee Clockman.

80.

Structure 20. Author photo.

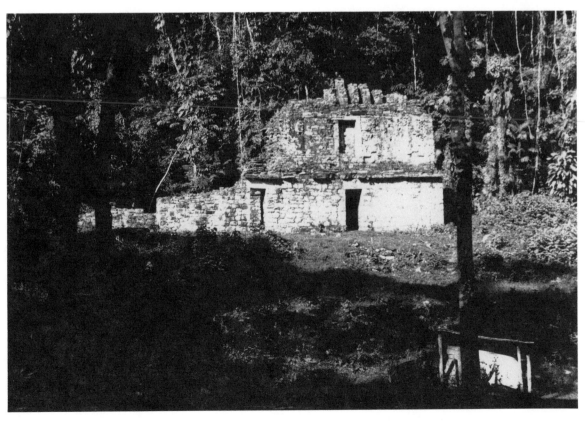

Interior of Structure 20, showing standing vaults and ample interior spaces. The stone armature of a seated figure which once occupied the rightmost of the three niches on the frieze is propped up inside the building for protection. The head of this figure was also found, as well as several other fragments. Photo © 1991 by Lee Clockman.

platforms. The stairs rise about 1.5 m to the second terrace, which is about 5 m wide. Another divided stairway provides access to the third terrace. On this platform, the building is skewed several degrees north of the axis of the stairway.

One more step separates the third terrace from the base of the structure—Hieroglyphic Stairway 5. This row of carved stair risers was uncovered in 1980 during consolidation of the masonry (Graham 1982:177). The carved step runs in front of three structures—Structure 20 and two small structures flanking it at a distance of approximately 2 m on each side. The sculpture on the blocks on the easternmost side is eroded beyond recognition and is not included in Graham's enumeration. INAH has covered the stairway with rocks and dirt for protection.

Three doorways lead into a single vaulted chamber. The room is partially divided at the two ends by transverse walls which are corbeled to lead toward the south (rear) wall, thus forming vaulted apertures 0.90 m wide and 3.0 m tall. On the rear wall two buttresses form a niche behind the central doorway that contains a low bench. On the southeast side of the structure the vault has collapsed, but it still stands on the northwest (right) side.

The placement of the carved lintels is unusual. The front walls of the structure are 1.24

m thick. This excess wall thickness apparently necessitated finding a structural alternative to the normal system of a lintel spanning the entire aperture. Assuming a single slab of that size was inconvenient to handle and likely to break, there were several solutions, among them, using two lintel slabs on the same plane or splitting the height of the piers into two levels and placing a separate lintel slab over each. The latter solution was chosen. The carved lintel occupies two-thirds of the depth of the doorway. The rear third of the doorway is covered by a plaster-covered stone placed on a higher plane than the carved lintel. Thus, the viewer of the carved lintel does not notice a blank stone slab behind the carving, only the void beneath the upper lintel stone, which appears to be unified with the higher interior space of the structure.

The façade is organized so that the three entranceways divide the wall space into four equal sections. Above the doorways, the frieze is bordered by upper and lower projecting cornices. Situated over each doorway is a niche 1.67 m high, 0.96 m wide, and 0.43 m deep. On the back wall of the niche are three roughly square mortises of about 12 cm dimensions. They are arranged in a vertical line and were used for tenoning stone and stucco sculpture. Immediately below each niche is a zoomorphic mask panel which served as a throne for the seated

stucco figure once inside each niche. One niche of similar proportions appears on each end of the structure and three on the rear façade.

In the niche on the northwest end of the structure there remains a cross-legged figure dressed in an elaborate feathered headdress and seated on the zoomorphic throne (at right in Figure 82). It is slightly larger than the size of an average modern Maya. The head is 17 by 14 cm, shoulders 53 cm wide. The figure's knees would have projected out of the niche and over the zoomorphic throne. It is very likely that each niche held a similar figure, because they are very close in size, the mortises are located in identical spots in each niche, and traces of the zoomorphic mask panels remain under each niche.

During his 1980 exploration and consolidation of the structure, Roberto García Moll found no traces of the stucco sculpture that had once been attached to the façade (García Moll and Juárez Cossío 1986:159). However, in July 1985, when Martin Diedrich and I were measuring Structure 20, we noticed a lifesize stone core of a stuccoed torso near the pile of loose stones immediately northwest of the structure. Both of us recognized that it was the lower portion of a seated cross-legged figure, and we began to look for other parts of the figure on the surface of the terrace, without disturbing any soil. In less than a minute we had located the chest area of the figure on the edge of the upper terrace, immediately in front of the northwest niche. It was barely covered by weeds, although the grass around the structure had recently been mowed with machetes. We looked below on the next terrace and easily found the central portion of a head, again without disturbing any soil or digging in any way. We photographed and measured these and other fragments, and brought them to the attention of the guards. These pieces were of the proper size to fit in the niches.

Between the niches on the frieze are large spaces once totally ornamented with stucco relief and three-dimensional sculpture. A considerable amount of stucco remains on the northwest façade. In the very center of the space are two mortises. It seems that the stucco decoration formed a symmetrical pattern around

82.

Structure 20, northeast façade. Much stucco sculpture remains on the frieze on this corner of the building. The niches contain the remains of figures with stone armatures and covered with stucco. Photo © 1991 by Lee Clockman.

83.

Niches in the frieze of Structure 20 have mortises for tenoned stone and stucco sculpture. Note the stucco monster mask below the niche which served as a throne for a seated king. Remains of stucco can also be seen in the right portion of the frieze. Photo © 1991 by Lee Clockman.

84.

The best-preserved part of the stucco sculpture on Structure 20 is this eye of a waterlily monster. Photo © 1991 by Lee Clockman.

the tenoned figure. At both upper corners are monster eyes (see Figure 84), and a "bunch of grapes" signifying Cauac Monster can be seen near the left eye. Many tendril shapes are visible in the lower half of the relief, some with dots infixed, perhaps suggesting the forms of aquatic plants. So the original frieze may have been decorated with scenes of vertical human figures surrounded by Cauac Monsters and aquatic plants alternating with niches containing human figures seated on zoomorphic thrones. This scheme probably wrapped all around the four sides of the structure.

MONUMENTS

Dimensions (from Maler 1903; Graham 1977; 1982)

	MW	H	Th	Sides Carved
Stela 3	1.77 m	2.60 m[a]	0.26 m	2
Stela 4	1.36 m	4.75 m?[b]	0.24 m	2
Stela 5	0.81 m	2.52 m	0.33 m	2
Stela 6	1.18 m	2.96 m[a]	0.42 m	2
Stela 7	1.17 m	3.00 m?[b]	0.25 m	2
Stela 33	0.76 m	1.52 m[a]	0.26 m	2

[a]Measurement of principal fragment.
[b]Estimated total length.

	MW	HSc	WSc	MTh	Rel
Lintel 12	0.98 m	0.79 m	0.87 m	0.33 m	0.8
Lintel 13	0.99 m	0.75 m	0.88 m	0.33 m	1.1
Lintel 14	0.91 m	0.78 m	0.80 m	0.32 m	1.9

	HSc[a]	H Block[a]	Rel[a]	Total Len
Hieroglyphic Stairway	0.18 m	0.30 m	0.9 cm	29.20 m

[a]Average of 45 blocks.

Stelae 3–7 were probably discovered by Maudslay, as on his map he mentions numerous stelae in front of Structure 20. Stela 3 has been reset on a platform in the center of the southeast end of the Main Plaza (Ramón Carrasco V., personal

communication, 1986). The other four stelae were found in a row at the base of the Structure 20 platform. Stelae 5, 6, and 7 fragments are propped up on their sides under pieces of plastic near the spots where they were found. Stela 4 is buried under rocks and dirt near its original location.

All of the stelae are fragmentary. Stela 3 (Figure 85) is very well preserved on the temple side and eroded on the river side of the remaining bottom half of the monument. Approximately six fragments are scattered around the base of the platform on which it stands, but the upper portions of the monument appear to be missing completely. Stela 4 broke into six or more large chunks (see Morley 1937–1938: 570). The river side is almost completely eroded but was decorated with at least one profile figure facing the observer's right. A panel of twenty-four or more glyphs was carved on the top. The temple side (Figure 86), which is better preserved, is a cosmogram, as discussed in Chapter 4.

The second stela from the southeast, Stela 5,

was photographed by Maudslay, who stated that it pertained to Structure 44 as a lintel (1889–1902:2:46, Pl. 97, no. 3). Maler (1903: 144) located the two pieces of the stela in front of Structure 20. As so frequently happens, the parts fell with opposite sides exposed. Maler noted dark red paint in the background of the better-preserved side. It is difficult to ascertain which side faced the temple and which the river, since they twisted as they fell, and since the iconography is similar—a principal and two subsidiary figures—on each side. The carving has been badly eroded on both sides of the lower part and on the exposed side of the upper part. Herein I refer to the remaining uneroded image (Figure 87) as the "river side," since its theme of war corresponds to the river sides of Stelae 4, 6, and 7.

Stela 6 (Figure 88) broke into two pieces. The upper three-quarters of the monument forms one of the fragments and the butt, with a small portion of lower-register carving, the other. It was carved on two sides, although on the river side only the vaguest outline of a figure wear-

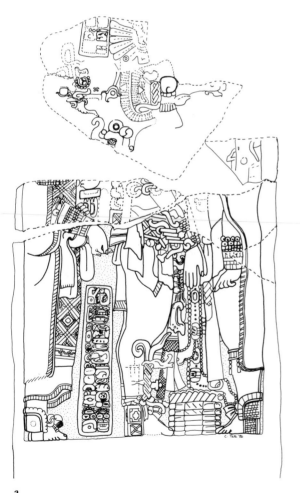

85.

Structure 20, Stela 3: *a*, temple side; *b*, river side. Author drawings from the monument.

a

b

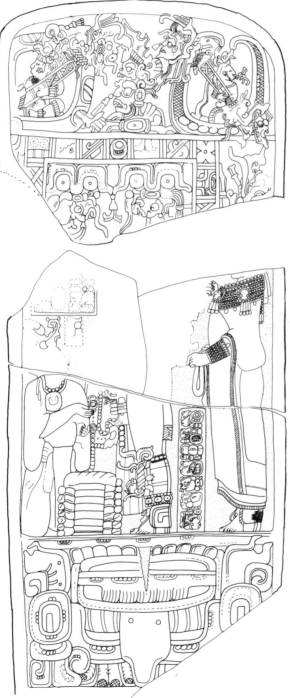

Structure 20, Stela 4,
temple side. Author
drawing after
sketches by Ian
Graham.

87.

Structure 20, Stela 5,
upper half, river
side: an image of
Shield Jaguar II as
warrior. Photo ©
1991 by Lee
Clockman.

ing a war scarf remains. Maler photographed
and described it first.

Stela 7 broke into several pieces. All the
known fragments fit together to form the bot-
tom three-quarters of the stela. The top has
not yet been located. Like the other cosmo-
logical stelae, it has a warrior scene on the river
side and a bloodletting on the temple side (Fig-
ure 89).

The newest stela fragment associated with
Structure 20 (by virtue of its association with
Structure 3) was uncovered during excavations
of the Stela 3 platform, where it had been bur-
ied. It is now called Stela 33. It was carved on
two sides. The longest text appears along the
top of one side. Although the text is fragmen-
tary, it refers to the completion of one or more
katuns as Ahau by some king. Unfortunately
the zone where the king's name falls was bro-
ken. It appears to me to have a skull and a jag-
uar in the name (at provisional B4), which
would suggest to me Bird Jaguar IV, who has a
1 Akbal Skull title. The secondary text does
name a Shield Jaguar, however, which could be
a reference to Shield Jaguar I either as protago-
nist or as the father of Bird Jaguar IV. On the
other carved face are an ancestor cartouche
with a few hard-to-see glyphs tagging the an-

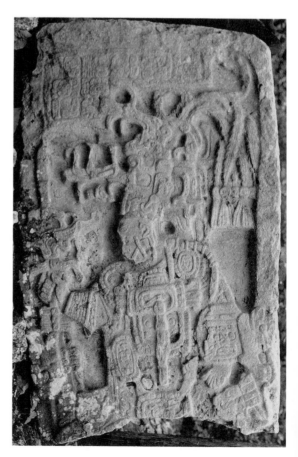

cestor figure and a Skyband Monster. A Lunar Series appears under the Skyband Monster, indicating that the stela originally had a Long Count. That side was undoubtedly the temple side of a cosmogram stela. My measurements suggest that the newly discovered fragment is not the top of any of the other Structure 20 stelae, but must have come from another, hitherto unknown monument.

Lintels 13 and 14 were photographed during Maudslay's visit of 1882. Lintel 14 was in situ, but Lintel 13 had probably fallen, since Maler said it blocked the central doorway. Maler excavated for and found Lintel 12 in 1900. It was taken to MNAH in 1964. It was carved in very low relief, which has eroded to the point where few of the glyphs are positively identifiable. Lintel 13 was replaced in the doorway by INAH, and Lintel 14 remains in situ. Maler noted traces of dark red paint on Lintel 14. Some paint is still visible in the background areas.

Hieroglyphic Stairway 5 was uncovered during clearing and consolidation of the structure by INAH in 1980. It was drawn by Ian Graham,

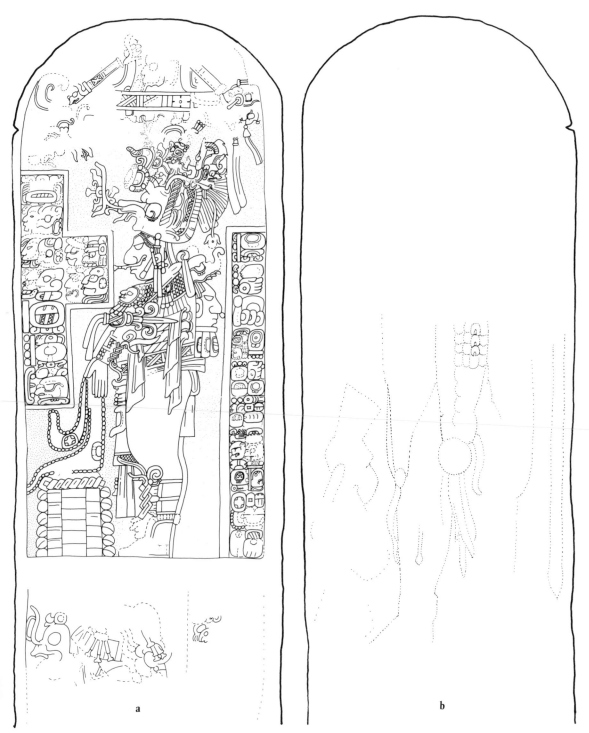

a b

88.

Structure 20, Stela 6: *a*, temple side; *b*, river side. Author drawings.

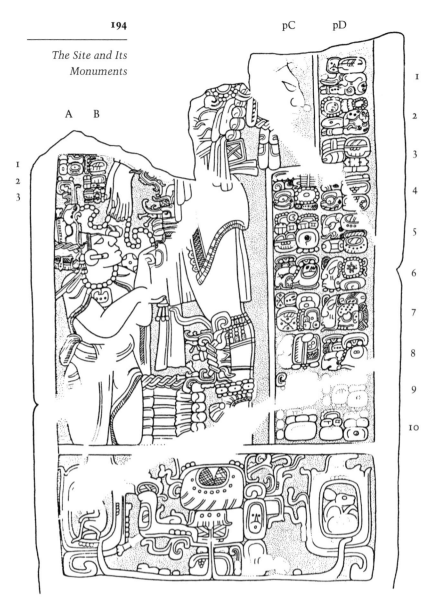

Dates and Protagonists

Stela 3	[9.10.16.10.13	7 Ben 16 Zec]	BJIII
Stela 4	(9.17. 4.15. 3)	1 Akbal 16 Kankin	SJII
	(9.17. 5. 0. 0	6 Ahau 13 Kayab)	SJII, Lad
Stela 5	(9.18. 6. 5.11)	7 Chuen 19 Kayab	SJII
Stela 6	9.11.16.10.13	5 Ben 1 Uayeb	BJIII
Stela 7	No date survives		SJII, Lad
Stela 33	No date survives		SJ? BJIV

The date on Stela 3 can be reconstructed from the brief glyphic phrase remaining. It says, "He completed his first *katun* as Ahau of the lineage, Captor of Moon, Bird Jaguar." This refers to Bird Jaguar III. Stela 6 retains the Long Count date given here for the completion of Bird Jaguar III's second *katun* as Ahau. For the date of Stela 3, simply subtract one *katun* from the date of Stela 6.

Proskouriakoff figured the Long Count of Stela 4 from a remaining Calendar Round which pertained to an 819-day count (1964: 192). She observed with confidence the date 7 Chuen 19 Kayab on Stela 5 and probably correctly assigned it to the Long Count 9.18.6.5.11. She noted that there was no evidence of Shield Jaguar II's reign having lasted so long (ibid.: 193), but that evidence now exists, in the form of Hieroglyphic Stairway 5. On Stela 7 no Calendar Round nor Long Count survives.

Lintel 12	Unknown		Unknown
Lintel 13	(9.16. 0.14.5)	1 Chicchan	Lady GS,
		13 Pop	BJIV, SJII
Lintel 14	(9.15.10. 0.1)	4 Imix	Lord and
		4 Mol	Lady GS

Structure 20, Stela 7, temple side. Drawing by Graham.

then re-covered for protection. The first fifteen or so blocks were effaced entirely and are not numbered by Graham. He numbers forty-five carved blocks arranged in a single row. Several blocks were damaged by stones falling from the structure, but are otherwise in fairly good condition, having been protected by a layer of earth which began to cover the step soon after its abandonment.

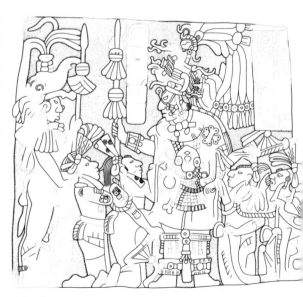

Lintel 12

I examined Lintel 12 in MNAH with a light, trying to read any glyphs, particularly names and a date. The day name appears to be Ahau, the month name Muan or Kankin, and both co-efficients 3. Two possibilities:

3 Ahau 3 Kankin 9.17.6.15.0
3 Ahau 3 Muan 9.16.6.11.0

On the former date, Shield Jaguar II and an ally would have been shown gathering captives. On the latter date, the protagonists would have been Bird Jaguar IV and probably Lord Great Skull.

Hieroglyphic Stairway 5

Block	Long Count		Calendar Round	Ref[a]
50	(9.18. 6. 4.19)	?	8 Cauac 7 (Kayab)?	230
48	8.19	DN[b]		
69	(9.18. 6. 5.11)	?	7 Chuen (19 Kayab)?	231
92	(9.18. 7. 6. 0)		12 Ahau 3 Cumhu	231
101	11.13	DN[b]		
103	(9.18. 7.16. 9)		13 Muluc 7 Yax	231
	(1.13.16)	DN		
113	(9.18. 8. 3. 3)		3 (Akbal) 1 Muan	231
	(7.10)	DN		
123	(9.18. 8.10.13)		(10 Ben 6 Zotz)	
133	13.13	DN		
135	(9.18. 9. 6. 6)		10 Cimi 19 Kayab	231
144	1.12	DN		
146	(9.18. 9. 7.18)		3 Etznab 6 Pop	231
	(1.16)	DN		
157	(9.18. 9. 9.14)		13 Ix 2 Zip	232
165	16	DN		
167	(9.18. 9.10.10)		3 Oc 18 Zip	141

[a]First published references to dates of this stairway are from Schele (1982) on the page number given in this column. She referred to the work of Peter Mathews.
 [b]Speculative.

The protagonist of all these events, which are captures, is Shield Jaguar II.

Construction Completion Dates

Looking at the wide range of dates recorded on the monuments pertaining to Structure 20, it is obvious that the stelae were dedicated at various times, though perhaps placed at one date. Although their dates are early, the lintels could not have been carved until about 9.17.0.0.0. This assertion is based on a small detail of costume, the presence of the notched edge of the pointed hipcloth, which did not appear at Yaxchilan until after 9.16.15.0.0. The hieroglyphic stairway was completed 9.18.10.0.0.

90.

Structure 20, Lintels 12–14. Drawings by Graham (Lintels 12 and 14) and von Euw (Lintel 13) (all from Graham 1977:33, 35, 37).

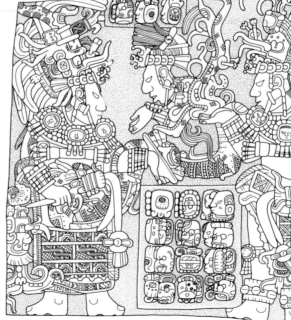

Lintel 13

Lintel 14

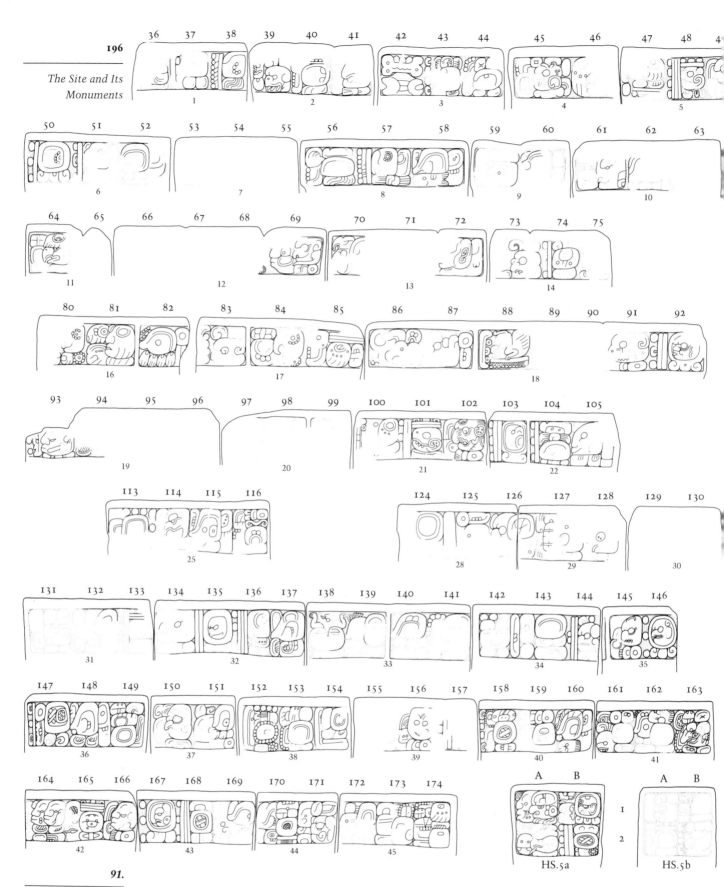

91.

Structure 20, Hiero-
glyphic Stairway 5.
Drawings by
Graham (1982 : 179,
181).

Structure 21

(Lintels 15, 16, 17; Stela 35; Stucco Relief)

Dimensions, Exterior: 18 by 5.5 m.

Dimensions, Interior: central chamber, 7.19 m long.

Orientation: 50 (compass).

Structure 21 is located on the first bench to the south of the Structure 33 stairway. It was first encountered in 1882 by Maudslay, who called it House F. Maler made a plan and section of the building (Figure 92). The plan was adopted by Morley (1937–1938:468), but his scale notation is wrong. The structure was modified at least once. The second phase consists of a wall 53 cm thick which was added directly behind all exterior walls and over the piers in front as well. This wall preserved the inner wall to some degree, but both were unable to support the vault, which has fallen completely. The original building was a single vaulted chamber divided into three separate, non-interconnecting rooms. The central room is twice as wide as each of the side chambers. Three entrances open into the central chamber. These were once topped with carved lintels (Lintels 15, 16, and 17). A single doorway leads into each side chamber. These were apparently covered with plain lintels.

The debris of a long-fallen roof filled the chambers when they were visited in the late 1800's and until 1983, when the structure was excavated and consolidated by INAH. During the course of excavation, two major monuments were discovered by Roberto García Moll and crew. A small stela, carved on two sides, was found on the floor of the chamber. Considerable remains of a stucco relief sculpture of five lifesize figures on the rear wall of the central chamber also came to light. Traces of stucco painted in red and blue can be seen on interior side walls and in the entranceways. The interior was once totally painted with lifesize figures on side walls and the door jambs.

MONUMENTS

Dimensions (Lintels from Graham 1977)

	MW	HSc	WSc	MTh	Rel
Stela 35 (front only)	0.41 m	1.50 m	0.33 m	0.20 m	2.5 cm
Lintel 15	0.83 m	0.80 m	0.67 m	0.08 m[a]	1.0 cm
Lintel 16	0.75 m	0.60 m	0.70 m	0.06 m[a]	0.7 cm
Lintel 17	0.74 m	0.60 m	0.64 m	0.05 m[a]	1.0 cm

[a]Sawn.

Stuccoes: 3.35 by 1.75 m.

Stela 35 was discovered in 1983 by INAH. Its location when encountered has not been published. It now rests on a low bench built into the rear wall of the structure.

The three lintels were removed from the site to the British Museum—Lintel 15 by Maudslay in 1882 and Lintels 16 and 17 under Maudslay's direction by the López brothers in 1883. They were sawn for ease of transport. Traces of red paint remain on Lintel 15 (Graham 1977:39).

92.

Structure 21, plan and section by Maler (1903:147).

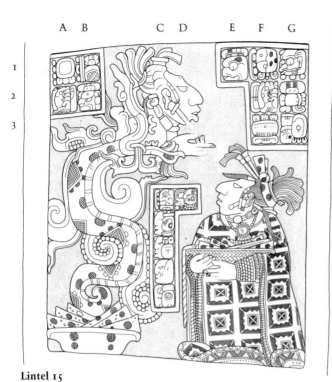

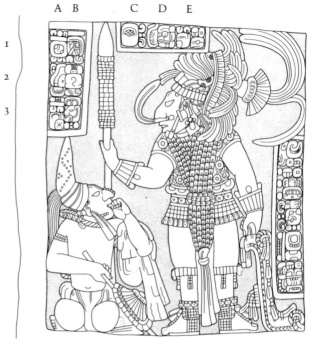

A B C D E F G

1
2
3

A B C D E

1
2
3

F
I
2
3
4
5

Lintel 15

Lintel 16

93.

Structure 21, Lintels
15–17. Drawings by
Graham (1977: 39,
41, 43). (See also Fig-
ure 6.)

Between the two curtain walls is a low U-shaped bench of stone with two carved legs. A stucco bas-relief panel extends from bench level upward. It is composed of two registers. The lower register is a triple-headed serpent (or rather two two-headed serpents sharing a central tail-head). The body of the monster is composed of Kan Crosses, circular markings, and snake markings. It separates the bottom register from the upper one. The two heads face the center of the image. They are bearded, crested serpents with a Muan feather above the eye and Tlaloc masks in their gaping mouths. The central head is Tlaloc-like. A design resembling the Mexican year sign forms its headdress, complete with a Kan Cross headband. Vegetal forms emanate from the lower parts of the three heads. The serpent body here functions as a skyband, or a divider of cosmic realms. The center of the skyband is split, to indicate the Split Sky Place (Yaxchilan).

Five cross-legged figures with profile heads are seated on the split skyband. Three can be identified as women because they are wearing huipils, or long cloaks. The figures are in poor condition, but enough remains to know that they were royalty. The first figure on the left faces the viewer's right. A beaded collar and the figure's right elbow and knee can be discerned. Of the second figure on the left there remain a lower lip and chin and a large pendant surrounded with beads. It once held a central

medallion, now missing. The central figure's crossed legs, two hands, and right shoulder remain. That figure wears a short skirt and a mat loincloth. The fourth from the left is in good condition below the upper arms. An expressive left hand gestures downward. Of the last figure on the right only the right elbow and foot and the traces of an edge of a huipil remain. Traces of blue and red paint can be seen over many parts of the stucco.

Dates and Protagonists

Stela 35	(9.15.10. 0. 1)	4 Imix 4 Mol	LIS
Lintel 15	(9.16. 3.16.19)?	4 Cauac? 12 Zip	LAI
	or		
	(9.16.17. 2. 4)?	4 Kan? 12 Zip	LAI
Lintel 16	(9.16. 0.13.17)	6 Caban 5 Pop	BJIV,
Lintel 17		No date recorded	BJIV,
	[9.16. 0.14. 5	1 Chicchan 13 Pop]ª	Lady

ªImplied by the phrase for the birth of Chel-te.

Morley read the Lintel 15 Calendar Round as 4 Manik 15 Zip 9.13.8.3.7. Proskouriakoff argued, "To read the day sign, Morley alters the month coefficient to agree with the day Manik. I believe . . . that the day sign could be Kan and the date is better read as 4 Kan 12 Zip" (1964: 191). However, the date late in Bird Jaguar's reign does not make sense when combined with the pre-accession event, the capture of "Q," which was never again mentioned after

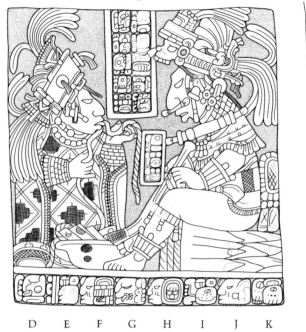

A B

D E F G H I J K

Lintel 17

Bird Jaguar acceded. Therefore, I suggest that another possible day name, Cauac, be considered for the eroded glyph. The resulting Long Count date is closer to the dates of Lintels 16 and 17, and it is also eight years lacking five days since Lady Xoc's death, which provides a possible rationale for the Vision Serpent event.

Construction Completion Date

The dating of Structure 21 depends on the barely legible date on Lintel 15. I suspect that this structure is superimposed on an earlier one. But there are few clues as to the exact date of the structure. It was built between 9.16.5.0.0 and 9.16.17.0.0. Despite the early date (9.15.10.0.1) on the stela, its text includes a 3 Katun Ahau title for Bird Jaguar. Therefore it must have been carved after 9.15.17.12.10.

Structure 22

(Lintels 18, 19, 20, 21, 22)

Dimensions, Exterior of the Inner Structure: 8.40 by 2.80 m.

Orientation: 35 (compass).

Structure 22 is located west of the Grand Stairway on the First Bench. The plan and extent of the building was in dispute by early explorers. Maudslay did not name the structure. Maler reported six sculptured lintels, four from doorways on the front, one from the west side, and one in the rear (1903:149). He photographed only five of these. Ruppert discovered five doorways in the front of the structure, the outer two having plain lintels, and a doorway on each side spanned with carved lintels. He observed Lintel 19 in situ on the northwest side (Morley 1937–1938:387). Linton Satterthwaite excavated around the building in 1935 and reported to Morley that the structure consisted of a three-doorway chamber with extra doorways at each end and two doorways with lintels on either side (ibid.).

Since then, the structure has been consolidated by INAH. As it appears now, a broad stairway with sixteen steps leads from the plaza level to a terrace 4 m deep. Four altar stones occupy this terrace, though none of them retains visible carving. Three additional very tall steps lead to a small ledge in front of the building. The structure sits on a pedestal 1 m high, the edge of which extends to the outside wall of the interior phase of the building. Two more steps lead to the doorway level. On the northwest side, all these steps are covered by the edge of the Structure 23 terrace. The structure appears to have been built and later remodeled. The interior, earlier phase is a small, single-vaulted structure with the dimensions given above. It has three doorways in the front, one on the northwest side, and one on the southeast. A partial opening, like a window, does appear in the rear where Maler indicated a rear doorway on his plan (1903:149). The five carved lintels were located in the three front and the two side doorways.

During the second phase of construction, the doorway on the northwest side was partially blocked. Perhaps the front piers and the back wall of the structure were rebuilt at this time. The rear wall was extended another 6 m

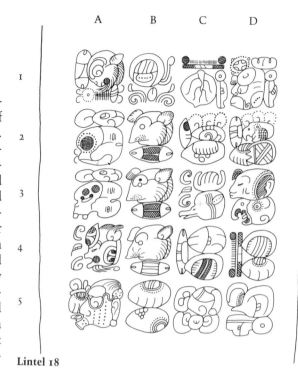

A B C D

Lintel 18

A B C D

Lintel 20

Lintel 19

Lintel 21

Lintel 22

94.

Structure 22, Lintels
18–22. Drawings by
Graham (Lintels
18–20) and von Euw
(Lintels 21–22) (all
from Graham
1977:45, 47, 49, 51;
1982:133).

on the northwest side, and one thick wall was built from the rear to the front, about 2 m from the Lintel 19 wall, creating a niche on the northwest side. An extension was also built on the southeast side. These side chambers were the latest phase, with the 1 m high step and the small court in front of the structure.

MONUMENTS

Dimensions (from Graham 1977)

	MW	HSc	WSc	MTh	Rel
L 18	0.65 m	0.49 m	0.65 m	0.22 m	0.1 cm[a]
L 19	0.65 m	0.52 m[b]	0.67 m[b]	0.21 m	0.1 cm[a]
L 20	0.69 m		0.41 m[c]	0.18 m	0.5 cm
L 21	0.66 m	0.59 m	0.99 m	0.20 m	0.4 cm
L 22	0.68 m	0.58 m	0.98 m	0.19 m	1.8 cm

[a]Incised.
[b]Approximate.
[c]Fragment.

Maler discovered all five lintels and included in his general enumeration an additional number for a lintel he believed would be found on the northwest side of the structure. No such lintel was found, and the unused number (23) was later assigned to the fourth lintel discovered in Structure 23.

	Original Location[a]	Present Location
Lintel 18	Lying on the ground	MNAH
Lintel 19	Fragment in situ	In situ
Lintel 20	Fragment buried in front restored	In situ
Lintel 21	Unknown	In situ
Lintel 22	Fragment in situ	In situ

[a]From Maler 1903:149–150.

Maler reported that traces of red color remained on Lintels 18, 21, and 22. These lintels still exhibit some color.

Dates and Protagonists

Lintel 18	No date recorded		Ruler
Lintel 19	No date recorded		BJII?
Lintel 20	Eroded Long Count with lunar data		?
Lintel 21	9. 0.19. 2.4	2 Kan 2 Yax	Ruler
	15. 1.16.5 DN		
	(9.16. 1. 0.9)	7 Muluc 17 Zec	BJIV
Lintel 22	No date recorded		Ruler

Proskouriakoff first recognized that the particular combination of contemporary and antique lintels in Structure 22 was due to Bird Jaguar IV's desire to document his descent and legitimacy (1964:182). Lintels 18 and 19 are the oldest known at Yaxchilan. They are undated, and no rulers' names can be identified with assurance. The series of glyphs on Lintel 18 at A2, A3, and A4 seem to be names, especially A3, a skull glyph like some of the names of the Early Classic rulers recorded in Structure 12. It perhaps names Ruler 7, Moon Skull. This is supported by the appearance of "7 *le te*" at C1 and a God C "blood group" nominal indicator at D1. The last glyph on this lintel appears to be a Bonampak Emblem Glyph. Lintels 18 and 19 seem to contain undated dynastic information, like the lintels of Structure 12.

Lintels 20 and 22 appear to have been carved in the same style. Note the spacing between glyphs and their exterior form. The dimensions of Lintel 22 are comparable to those of Structure 12. Lintel 22 could possibly have once been part of the information associated with Ruler 10 and the assemblage that is now housed in Structure 12. Lintel 21 was commissioned by Bird Jaguar IV, probably shortly after he took the throne, to create a specific link between himself and two previous kings: the founder of the Yaxchilan dynasty, Progenitor Jaguar (Yat-Balam; named as C2), and Ruler 7 of the Skull clan.

Construction Completion Date: 9.16.2.0.0.

Structure 23

(Lintels 23, 24, 25, 26; Altar 7)

Dimensions, Exterior: 15.72 by 7.10 m.

Orientation: 29 (map).

Structure 23 is the second structure northwest of the Grand Stairway on the First Bench. It has two parallel vaulted chambers, each subdivided into multiple sectors. The vault is almost entirely fallen, except on the southeast side of the central outer doorway. It is a massive construction—the exterior walls are 2.59 m high from base to lower cornice. The cornice projects 0.38 m. The vaults are 4.20 m tall. The rear wall is 1.17 m thick. Lintel 23 is placed 1.88 m above the floor.

In the front chamber are benches running the width of the room on each side. The benches are U-shaped in plan. Above them, sunk into the walls, are niches approximately 30 cm square. The front chamber is divided by two vaulted curtain walls that run transversely from the inner edges of the left and right doorways. The doorways leading to the rear chambers are situated symmetrically within the vestibule of space created by the two transverse walls.

The rear chambers are totally separated by a central transverse wall. In the northwest chamber is a large bench 1.50 by 2.40 m (the width of the chamber). Wedge-shaped legs of stone support the bench. A series of niches are situated behind it. A transverse curtain wall partially divides this chamber in half, but allows access to the exterior under Lintel 23. The southeast chamber has a U-shaped bench along the central transverse wall. The room is divided into two unequal parts by a doorway leading to a small chamber entirely filled by a bench 2.40 by 2.10 m. A door opens on the southeast corner of the building. It is covered by a plain lintel. Traces of stucco decoration of a serpent body (illustrated by Maler [1903:151]) still exist in the central pier of the rear wall in the front chamber, below the vault spring. A bit of red and blue paint can still be discerned under the standing vault. The interiors of the vaults, shaped with five increasingly projecting steps, were heavily stuccoed to create a dynamic surface.

This building has been excavated by INAH, and several interesting burials were found associated with this structure. The material is unpublished.

95.

Structure 23 once had two parallel vaulted chambers divided into several rooms, but little of the roof remains. Photo © 1991 by Lee Clockman.

The Site and Its
Monuments

Dimensions (from Graham 1977; 1982; Morley 1937–1938:494)

96.

The sole standing vault of Structure 23 is stepped and rests against a buttress that juts into the front chamber from the front wall. Next to the buttress is part of a stone and stucco monster mask that once adorned the façade. Photo © 1991 by Lee Clockman.

| | | Underside | | | | Front Edge | |
	MW	HSc	WSc	MTh	Rel	HSc	WSc
Lintel 23	0.85 m	0.86 m	0.67 m	0.25 m	0.9 cm	0.16 m	0.86 m
Lintel 24	Unknown	1.04 m	0.74 m	Unknown	4.5 cm	Unknown	Unknown
Lintel 25	0.85 m	1.18 m	0.74 m	0.29 m[a]	3.2 cm	0.18 m	0.22 m
Lintel 26	0.85 m	1.07 m	0.77 m	0.27 m	4.3 cm	0.19 m	1.06 m

[a]Reconstructed size; actual size 0.07 m.

Altar 7: 94 cm diameter; 46 cm height. Top sculpted with two concentric bands of glyphs, sides dressed but plain.

The provenience of Lintels 24 and 25 is confusing because of poor documentation on the part of Maudslay (1889–1902). During his brief visit in 1882, he photographed one of the lintels associated with the structure he called House G, and he took one with him to England. The lintel prepared for traveling had been severely trimmed, and the front edge was chipped off (probably by Edwin Rockstroh during his visit, which was previous to that of Maudslay [Graham 1977]) before it had ever been photographed. The following year the other lintel found at House G was thinned and shipped to England upon Maudslay's request. Maler cleared up the problem of the provenience of these two lintels by finding the pile of limestone chips resulting from the thinning of the lintel now lacking a carved front edge in front of the eastern doorway of the structure. He found the remainder of the lintel with the serpent scene in front of the central doorway. In Maler's enumeration of monuments, these were called Lintels 24 and 25 respectively. They are now in the British Museum. Lintel 26 was excavated by Maler from the rubble near the northern doorway of the structure. It was removed to the MNAH in 1964. Lintel 23, on the west side, was discovered in 1979 by INAH. It has been replaced in its original position.

Dates and Protagonists

Lintel 23				
A–B1	?		10 ? 17 ?	Lady Xo
M–N2	(9.14.14. 8. 1)		7 Imix 19 Pop	SJ
M–N1	+ (5.16) DN			
M–N5	(9.14.14.13.17)		6 Caban 15 Yaxkin	Lady Xo
Lintel 24				
Front Edge Missing				
Underside	(9.13.17.15.12)		5 Eb 15 Mac	SJ, Lady
Lintel 25				
Underside	(9.12. 9. 8. 1)		5 Imix 4 Mac	SJ
	+ 2. 2. 7. 0 DN			
Front edge	(9.14.11.15. 1)		3 Imix 14 Ch'en	Lady Xo
Lintel 26				
Front edge	9.14.(14.13.16)[a]		(5 Cib 14) Yaxkin[a]	Lady Xo
Underside	(9.14.12. 6.12)		12 Eb 0 Pop	GI?, SJ
Altar 7	9.14.15. 0. 0		11 Ahau 18 Zac	Eroded

[a]The reconstruction of this date is discussed below.

The dates of Lintels 24, 25, and 26 and Altar 7 were published by Morley (1938:482−493) and refined by Proskouriakoff (1963); dates of the underside inscriptions of Lintel 23 are from Schele (1982:112, 280).

Recently, however, as the significance of the ceremonies recorded on Structure 23 has become clearer, there is good reason to accept a different reconstruction for the Initial Series of Lintel 26. Independent work by David Stuart and Ruth Krochock in 1987 led them and Linda Schele to identify the "God N" and "fire" verbs as referring to the dedication, erection, or decoration of pottery, lintels, stelae, and buildings (Schele 1987:135−136; 1989:39). On Structure 23, several such phrases discuss the carving, the dedication, the spiritual debut of the lintels. Securely dated dedication events are the "God N" event on Lintel 25 front edge (9.14.11.15.1) and the "fire" event on Lintel 23 underside (9.14.14.13.17). These dates are 1 August 723 and 22 June 726 respectively. It seems that Lintel 25 must have been completed first and dedicated, then Lintels 24 and 26 completed. The date on Lintel 26 underside, 9.14.12.6.12 (7 February 724; and 0 Pop or New

Year's Day in the *haab*) falls within that span. The front edge of Lintel 24 has been destroyed without a record, but I suspect that it began with an Initial Series date and that the date corresponded to a "fire" event on a summer solstice.

Lintel 26 has an Initial Series date, but it has been badly damaged. As Morley noted, several of its components are clear and the others must be reconstructed. The *baktun* coefficient is clearly 9 and the *katun* clearly 14. The month is clearly Yaxkin, and the coefficient is a number between 10 and 15, that is, either 11, 12, 13, or 14. The stated moon age, as Morley observed, is 31, 32, or 33 days, but likely reads 11, 12, or 13. Morley erroneously read the Lord of the Night (Glyph G of the Supplementary Series) as G2, when it is quite distinctly G6. The reading he proposed, 9.14.8.12.5, was supported by his erroneous reading of the G. The three prevailing reasons to consider another date are to find one with the correct G (6), that also falls close to summer solstice (as the "fire" events during this period did), and that makes sense as the dedication date of the lintel or some other part of the building, in other words, that

97.

The interior rear room on the southwest side of Structure 23, the building whose lintels document the deeds of Lady Xoc and Shield Jaguar, contained a two-tier bench. Photo © 1991 by Lee Clockman.

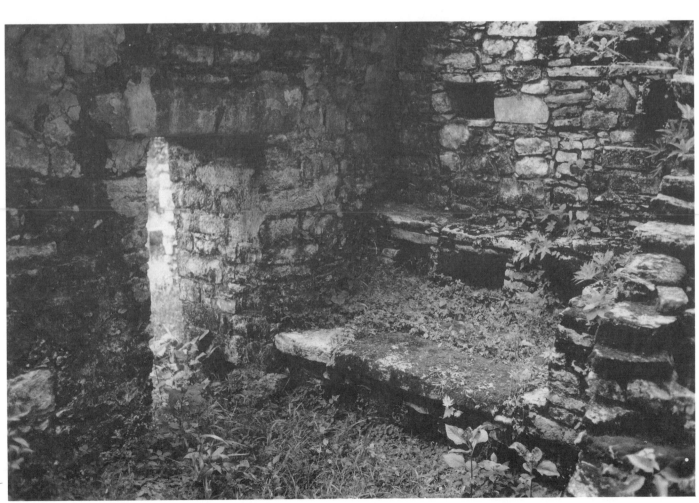

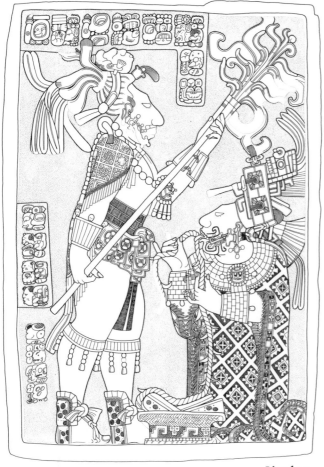

Lintel 24

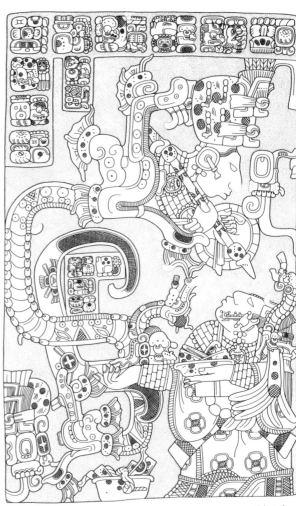

Lintel 25

98.

Structure 23: Lintels
24 and 25, drawings
by Graham
(1977 : 53, 55, 56);
author photo of
structure; section by
Maler (1903 : 151).
(See also Figures 13
and 14.)

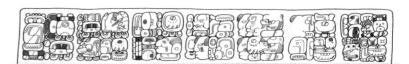

Lintel 25 front edge

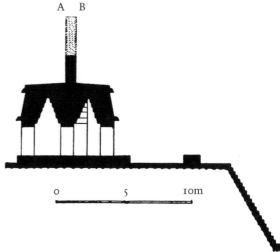

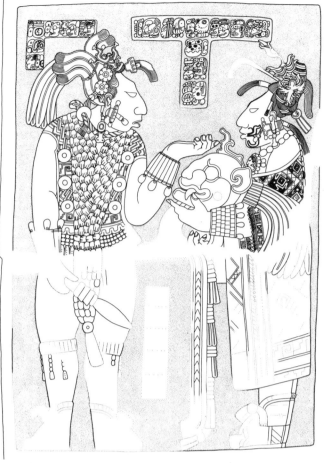

Lintel 26

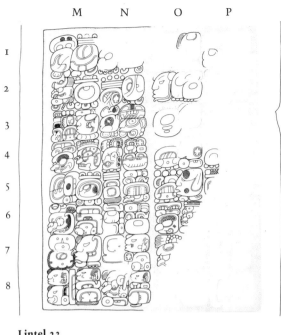

1
2
3
4
5
6
7
8

Lintel 23

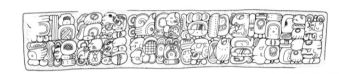

Lintel 23 front edge

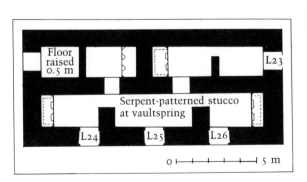

Lintel 26 front edge

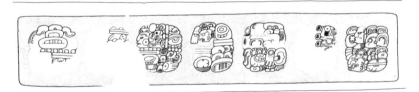

Lintel 23

99.

Structure 23: Lintels 26 and 23, drawings by Graham (1977:57, 58; 1982:135, 136); plan by author; author photo of Lintel 23. (See also Figures 15 and 17.)

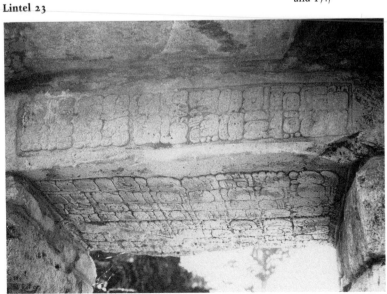

falls between 9.14.11.15.1 and 9.14.14.13.17. It should also be close to 9.14.12.6.12 12 Eb 0 Pop, the date recorded on the underside of Lintel 26, since no distance number is given. The best candidates are:

9.14.9.12.9 11 Muluc 12 Yaxkin G 6 MA 11.5 20 Jun 721

This date fits all the criteria except that it is a bit early.

9.14.11.12.18 12 Etz'nab 11 Yaxkin G6 MA 2.2 19 Jun 723

This is the summer solstice prior to the event on the underside, but the Moon Age is inconsistent.

9.14.12.13.7 4 Manik 15 Yaxkin G6 MA 16.8 22 Jun 724

This is the summer solstice after the event on the underside, but can be ruled out because the coefficient for Yaxkin is too high.

9.14.14.13.16 5 Cib 14 Yaxkin G6 MA 7.6 21 Jun 726

This date falls one day before the dedication of Lintel 23. The only drawback to acceptance without reservation is that the Moon Age is inconsistent. Nevertheless, it makes sense that the lintel-dedication "fire" events might have happened over a period of several days. For this reason, I will use this reading here.

Construction Completion Date

Structure 23 was completed in 9.14.15.0.0, just before Shield Jaguar entered his fifth *katun* of life.

Structure 24

(Lintels 27, 28, 59)

Dimensions, Exterior: approx. 3.5 by 9 m.

Orientation: 118 (compass).

Structures 23 and 24 share the same terrace, one which was built after the Structure 22 terrace. Since Structure 23 was probably the earliest of these three structures, I suspect that when Structure 24 was built transverse to the axis of Structure 23, the terrace and stairway of Structure 23 were modified so that the two structures could be perceived as a symbolic unit.

Structure 24 is a small building that was modified in ancient times. The present structure is a single vaulted chamber containing a smaller chamber with a vaulted "hallway" in the center. Three entrances open on the southeast side, the central one narrower than the flanking entrances. Entrances were built on the southwest and northeast sides as well. The one on the northeast is still open, but the one on the southwest was blocked when two benches were added to the interior of that room.

It is constructed with a very thick rear wall and thinner front piers (rear wall 1.32 m; front piers 0.84 m thick). I suspect that a small, thick-walled building that is now the central niche of Structure 24 was the original structure. It contains a tiered bench about 0.60 m wide, suitable for seating an ancestral statue. Later parts of the wall were dismantled and an enclosure built around the sanctuary to create the three-chambered building. The front wall of the sanctuary was corbeled toward the new front wall of the temple to roof the newly created passageway. The exterior corner of the original sanctuary is evident in the masonry in the rear wall of the building. The joint is filled with cement now. Burials were found in this building by INAH when the building was excavated and consolidated.

MONUMENTS

Dimensions (from Graham 1979; 1982)

	MW	HSc	WSc	MTh	Rel
Lintel 27		0.20 m	1.07 m	0.35 m	0.5 cm
Lintel 59	0.52 m	0.10 m	0.65 m	0.20 m	0.7 cm
Lintel 28		0.21 m	1.08 m	0.37 m	0.5 cm

These lintels are carved on the front edges only.

100.

Structures 23 (at left) and 24 (at right). Author photo.

Lintels 27 and 28 were found by Maler in the debris of Structure 24. Morley, who was a strong believer in uneven numbers of doorways in Maya façades, suggested to Linton Satterthwaite that he look for another lintel in front of this building. Satterthwaite did so in 1935 in conjunction with the Fifth Piedras Negras Expedition of the University of Pennsylvania (Morley 1937–1938:543). All three lintels have been replaced in their original positions over the three southeast entrances to Structure 24. No trace of color was found on any of these lintels.

Dates and Protagonists

Lintel 27	(9.13.13.12. 5)	6 Chicchan 8 Yax[a]	Death of LP
	1.17. 5. 9 DN		
	(9.15.10.17.14)	6 Ix 12 Yaxkin	Death of SJ
	6.17. 0 DN[b]		
Lintel 59	(9.14.17.15.14)	3 Ix 17 Zip	Death of Lady Xoc
	[1.19. 9 DN		
Lintel 28	(9.15.19.15. 3)	10 Akbal 16 Uo	Death of LIS
	4. 9.14		
	(9.16. 4. 6.17)	6 Caban 10 Yax[a]	"Fire" (dedication) by Lady Xoc

[a]The month Yax was recorded in error; the correct month is Zac (Proskouriakoff 1963:162).
[b]Seventeen *uinals* recorded in error; 16 lead between 12 Yaxkin and 17 Zip.

Construction Completion Date: 9.16.5.0.0.

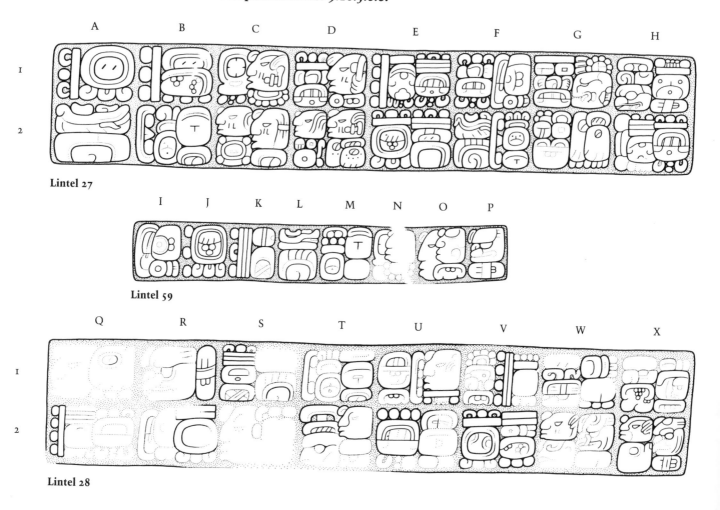

101.

Structure 24, Lintels 27, 59, and 28. Drawings by Graham (1977:59, 61; 1982:131).

Lintel 27

Lintel 59

Lintel 28

Structure 25

Dimensions, Exterior:

Area, 12.37 by 4.93 m; height exclusive of former roofcomb), 5.80 m (Maler 1903–155).

Structure 25 has no inscriptions, stucco, or paint and has not been excavated. It is described, along with Structure 26, by Maler (1903:154–155).

102.

Structures 26 (at left) and 25 (at right) have step-shaped entrances. They are situated on a small plaza just below Structure 33. Photo © 1991 by Lee Clockman.

103.

Structure 25, section and plan by Maler (1903:155).

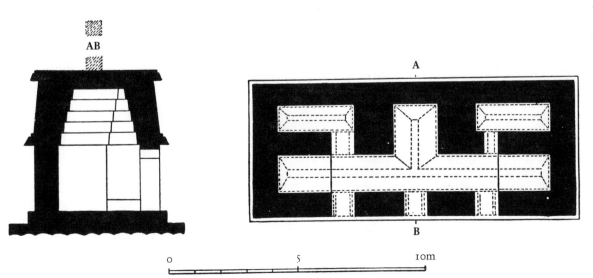

Structure 30

Dimensions, Exterior: 11.45 by 5.41 m.

Orientation: 14 (compass).

High above the viewer, Structure 30 is visible through the trees from the area in front of Structure 19. It is located on the northwest end of the second terrace, and a trail that now leads from behind Structure 30 eventually passes directly over Structure 36 and to the South Acropolis. In front of Structure 30, a monumental stairway once paved the 16 m ascent from the western end of the Main Plaza.

Maler found Structure 30 in good condition. It was explored and consolidated by INAH in 1978 (García Moll and Juárez Cossío 1986: 160). Of its two parallel, vaulted chambers, the entire front vault still stands. The southwest corner of the rear vault has collapsed, but much of the walls remains. Stone armatures for stucco decoration and some traces of frontal supernatural heads are discernible on the frieze. The central doorway was ornamented with a high-relief stucco border on the exterior, still visible on the east side. Maler (1903:156) reported traces of red bands beneath the cornices, and these are still visible.

A directional reading sighted along the lines of both front and rear doorway walls points to 14 degrees east of north for both doorways. The side walls of the structure are aligned identically. The rear walls, the first rear terrace, and the first and second front terraces are aligned to exactly 104 degrees east of north. In other words, the whole construction is composed of 90-degree angles.

The façade's right and left entrances are 0.90 m, much larger than the central doorway, which is only 0.53 m wide. This doorway was emphasized, however, by a 0.23 by 0.025 m projection of stone and stucco on the wall, framing the entrance on the exterior and the interior also. This stucco projection served to lengthen the passageway of the narrow front entrance. It recalls the central doorway of Structure 41. All entrances of this building received unusual treatment. On the façade, the lateral doors are simply rectilinear, but on the interior, these same doors were treated with a three-step, projecting, stuccoed corbel. The apertures in the central wall of the building were given a single step shape at the top.

A spacious terrace surrounds the structure on the northwest, southwest, and north sides. On the southeast side, the retaining wall of the Structure 29 terrace crowds the Structure 30 terrace.

104.

Structure 30 has two parallel vaulted chambers. Photo © 1991 by Lee Clockman.

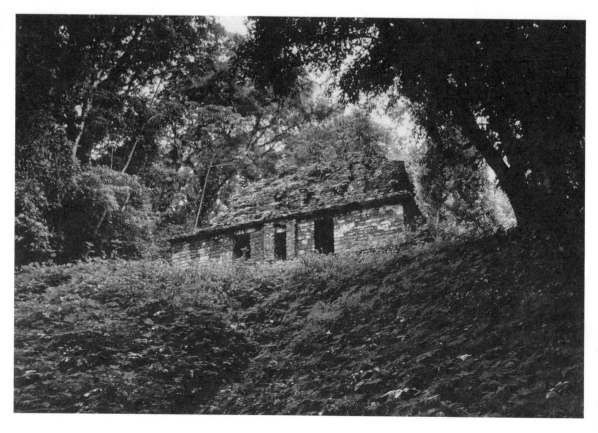

Structure 33

(Stelae 1, 2, 31; Lintels 1, 2, 3; Altars 9, 10, 11, 12, 16; Hieroglyphic Stairway 2)

Dimensions, Exterior: 22.18 by 4.88 m; height, 7 m plus 5.75 m roofcomb.

Dimensions, Interior: 13.33 by 2.60 m by 5.60 m high.

Orientation: varies from 48 to 50 degrees from the three doorways; center door is 50 (compass).

Maler's description of this structure is a patient and concise one, but needs some revision now. Since the building was explored, partially excavated, and consolidated by the INAH in 1975, several new monuments have been found. Structure 33's effective ritual space extended, as Maler suggested, to Structure 9 in the Main Plaza, and included Stelae 27 (discussed in section on Structure 9), 1, 2, and 31, and the altars and loose sculpture (including the caiman statue shown in Figures 107 and 108) around Stela 1 (Maler 1903:158).

Structure 33 has attracted visitors to Yaxchilan since it was built. Maudslay reported large

quantities of copal-burning pots strewn around the temple by the Lacandones. He himself adopted the building as his home during his stay in the ceremonial center (1889–1902:45). Morley called it "the most imposing building at Yaxchilan" (1937–1938:551). In ancient times, the frieze and roofcomb and the Grand Stairway would have been visible to river travelers as they passed the city. I would not be surprised if the bellicose rulers hung bodies of captives on the roofcomb as fair warning to potential warriors.

The structure was cleared and consolidated by INAH, as was part of the Grand Stairway. At the level of the Main Plaza, the 13.54 m wide stairway was consolidated. A large terrace is situated at about 2 m elevation from the plaza. A small Early Classic stela (Stela 2; see Figure 110) was reset on this terrace by INAH. About an additional 4 m of the ascent of the Grand Stairway has been consolidated. Above that, it is mostly rubble. From the plaza and while climbing to Structure 33, only glimpses of the roofcomb offer hints of the spectacular building above. Structure 33 was deliberately set back from view of the plaza below to allow for a 15 m deep plaza for ritual gatherings. Ascending the monumental stairway, one's anticipation is piqued by the presence of two small buildings set to the left of the stairway. One is

105.

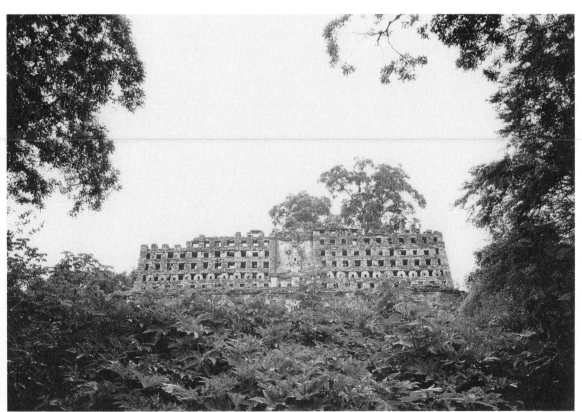

Structure 33 as seen from the top of the Grand Stairway. The roofcomb shows remains of an enormous seated figure in the center. Photo © 1991 by Lee Clockman.

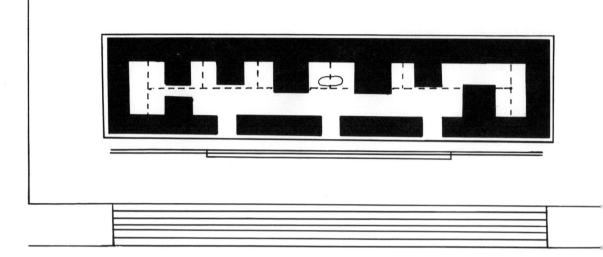

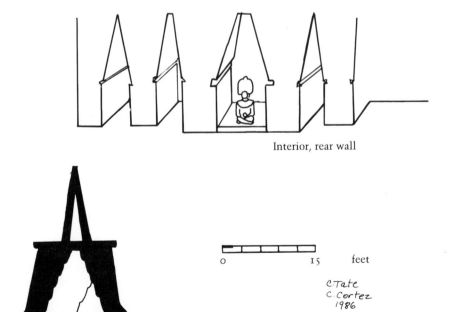

Interior, rear wall

0 15 feet

C. Tate
C. Cortez
1986

106.

Structure 33: plan,
view of interior wall,
and section. Author
drawing, inked by
Constance Cortez.

temporarily distracted by examining these unusual little structures with strange plans and corbeled entrances, but attention is soon focused on the remainder of the ascent to Structure 33. Back on the trail, even when one's head rises above the ground level of the Structure 33 terrace, one still cannot see all the monuments that comprise the message of Structure 33.

At the top of the stairway is a plaza about 30 by 15 m. Aligned with the central doorway of the building, but approximately 5 m from its base, is a pit remaining from the 1975 excavation which revealed that this structure was superimposed over an earlier construction (García Moll and Juárez Cossío 1986: 160). A stalactite stela (Stela 31) was (re?)erected in the pit. Past the stalactite stela are six steep steps which lead to a terrace approximately 2 m wide. Six more steps arrive at the last large step uncovered before 1975 by INAH. This last step is a series of thirteen carved risers (Hieroglyphic Stairway 2; see Figures 111–112). Ten of the steps depict historical individuals of the Yaxchilan royalty engaged in the ballgame. Three show female members of the royal family holding God K scepters. These themes are discussed in Chapter 4. Above the hieroglyphic stairway, a landing 1 m wide provides access to the three entrances. The façade is organized in three registers—the main body, the frieze, and the roofcomb. The walls of the body are relatively plain. Maler reported that a red band ran under the cornice and around the doors. He saw the front edges of the lintels painted red with

107.

Sculptures and buildings at the foot of the Grand Stairway: a sculpture of a caiman and Altar 10 to the west of Stela 1 in the Main Plaza; Structure 22 to the right of the stairway; Stela 2 near the bottom of the stairway; Structure 33 at the top. Photo © 1991 by Lee Clockman.

108.

Caiman sculpture and Altar 10. Photo © 1991 by Lee Clockman.

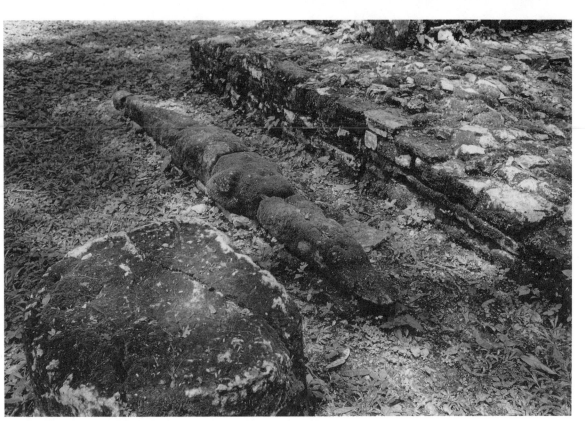

109.

The principal façade of Structure 33. Note the ballgame steps below the entrances (under plastic cover) and the mortises for tenoned sculpture on the frieze and roofcomb. Photo © 1991 by Lee Clockman.

110.

Structure 33, Stela 2, showing an early king as a victorious warrior. Photo © 1991 by Lee Clockman.

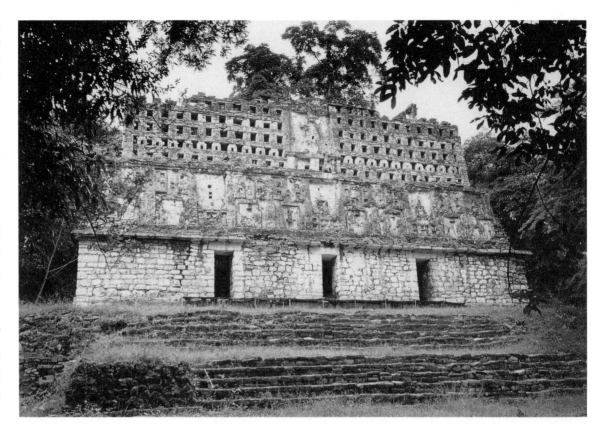

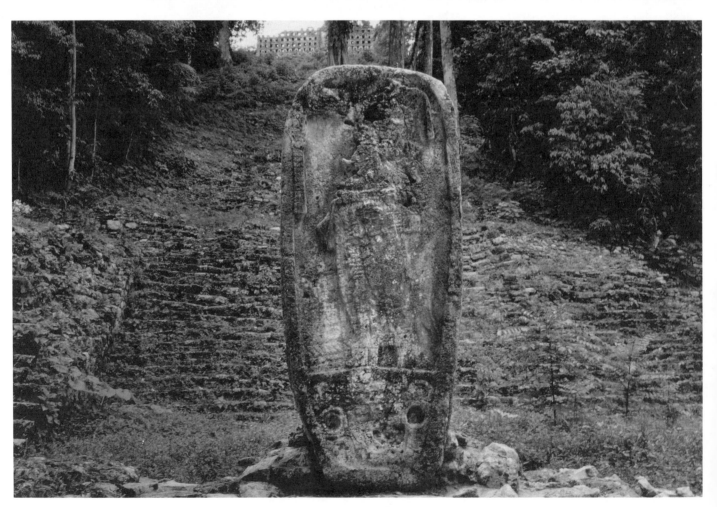

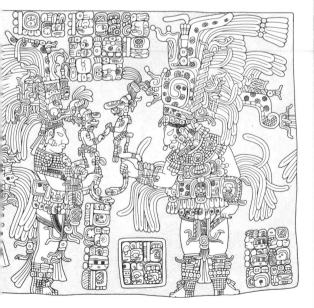

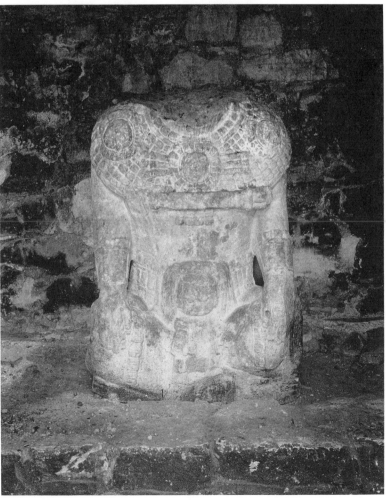

115.

Statue of Bird Jaguar IV in the central niche of Structure 33, illuminated at sunrise on summer solstice. Photo © 1991 by Lee Clockman.

116.

Front view of the statue of Structure 33. Photo © 1991 by Lee Clockman.

	Dia	H	Glyphs (Top)	Glyphs (Sides)
Altar 9	0.81 m	Unknown	24	Unknown
Altar 10	0.81 m	0.56 m	8	Some
Altar 11	0.47 m	0.51 m	8	12
Altar 12	0.84 m	0.47 m	7	None
Altar 16	Unknown		8	

af30

Lintel 3

	H	MW	HSc	WSc	Rel
Hieroglyphic Stairway 2					
Step I	0.40 m	0.77 m	0.27 m	0.60 m	1.0 cm
Step II	0.42 m	0.96 m	0.30 m	0.77 m	0.2 cm
Step III	0.42 m	0.86 m	0.32 m	0.72 m	0.5 cm
Step IV	0.35 m	0.80 m[a]	0.26 m	—	0.2 cm
Step V	0.32 m	0.87 m	0.26 m	0.69 m	0.2 cm
Step VI	Unknown	0.81 m	0.35 m	0.70 m	3.5 cm
Step VII	Unknown	1.65 m	0.38 m	1.53 m	4.0 cm
Step VIII	Unknown	0.97 m	0.33 m	0.84 m	3.0 cm
Step IX	0.56 m	1.10 m	0.30 m	0.81 m	0.2 cm
Step X	0.36 m	0.88 m	0.25 m	0.69 m	0.2 cm
Step XI	0.38 m	0.75 m	0.27 m[b]	—	0.3 cm
Step XII	0.36 m	0.68 m	0.26 m	0.52 m	0.2 cm
Step XIII	0.36 m	0.85 m	0.28 m[b]	0.65 m[b]	Incised

[a]Estimated original width.
[b]Approximate.

117.

Structure 33, statue (restored), drawing by Maler (1903:161), and fragmentary glyphic text on back of headdress, author drawing after photo by Morley (1937–1938: Pl. 178F).

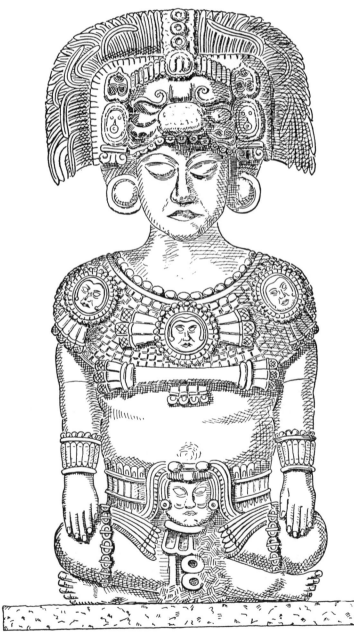

Structure 34

(Lintel 4)

Descending about 8 m from the rear of Structure 33 via the ancient stairway on the west side, one finds an open plaza about 20 by 50 m. To the south is a steep drop into the Structure 1 valley, and to the north another drop to the terrace of Structure 30. The plaza is bounded on the west side by a steep incline of about 6 m. Maler reported that a stairway once led up this slope, but little remains of it today. Once up the slope, one finds another plaza, smaller, and bounded on the north, west, and south by small structures. Circular pedestals or altars are placed in the center and on the north side of this plaza. Structure 34 is on the southern side. Maler said that the structure had three chambers and that the middle one was walled up. He reported narrow chambers that may have been used as tombs. From the debris in front of the middle chamber he extracted a lintel carved in two sections, the inner section cut obliquely to form the vault spring of the chamber. This section retained part of its original sculptured underside. From the other section the sculpture had eroded (Maler 1903:166–167).

MONUMENT

Dimensions (from Graham 1977)

	MW	HSc	WSc	MTh	Rel
Lintel 4	0.97 m	1.11 m	0.87 m[a]	0.32 m	2.0 cm

[a]An estimate derived by doubling the width of the remaining half.

Date and Protagonist

No date survived on the lintel, but the 5 Katun glyph noted by Morley (1937–1938:425) refers to Shield Jaguar.

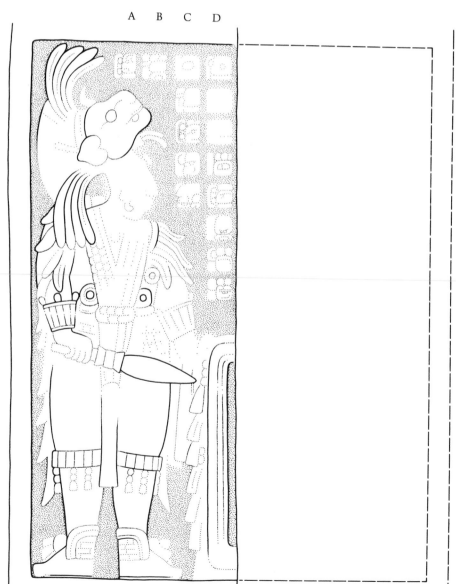

125.

Structure 34, Lintel 4. Drawing by Graham (1977:19).

Structures 35 and 36

(Stela 9; Altar 3)

Structures 35 and 36 share a design not found in any other building at Yaxchilan. They are basically square-based stepped pyramidal platforms, but with a complex system of inward- and outward-projecting stones at the corners, as though a square bite had been taken from the massive stones at the corners of each course of masonry. Maler suspected that these were mortuary temples (1903:168). Archaeological excavation has not been directed toward this type of problem at Yaxchilan, and Maler's idea is still unproved.

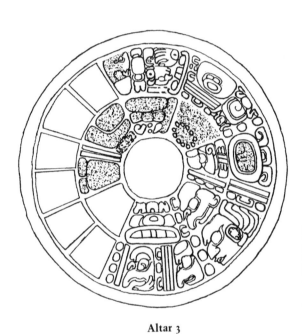

Altar 3

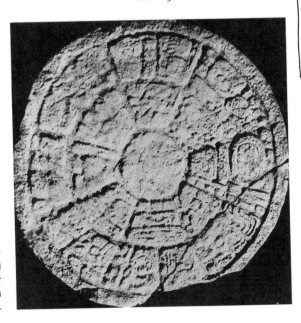

126.

Structure 36, Altar 3 (photo by Maler [1903:Pl. 80, No. 1]; drawing by Morley [1937–1938:Pl. 26a]) and Stela 9 (author drawing from monument).

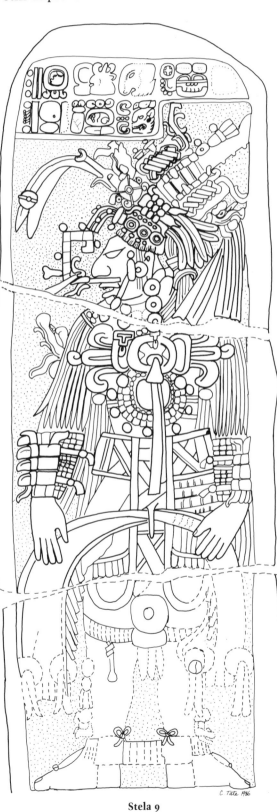

Stela 9

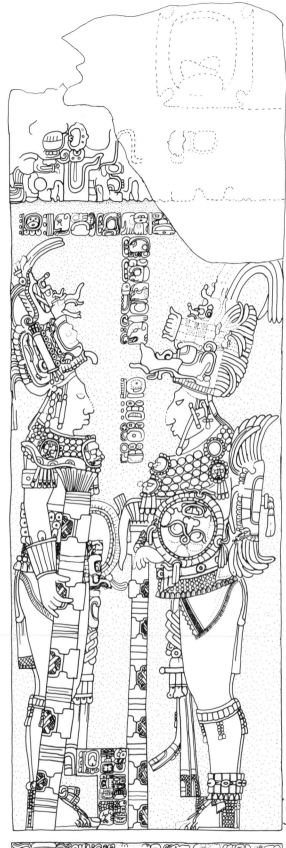

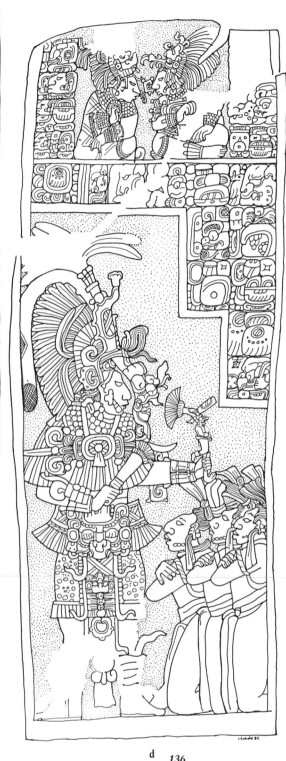

d *136.*

Structure 40, Stela
11: *a, c,* glyphs, au-
thor drawings;
b, river side, author
drawing; *d,* temple
side, drawing by
Linda Schele. Draw-
ings not to same
scale.

A B C D

1
2
3
4
5
6

a

E F G H

1
2
3
4
5

b

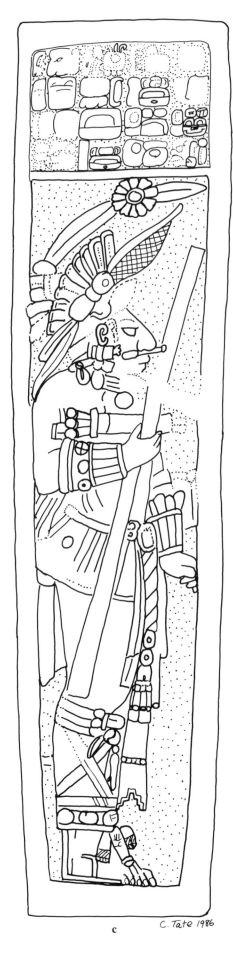

c

Structure 40, Stelae
12 and 13: *a*, Stela
12, river side, and
b, Stela 12, temple
side, drawings by
Linda Schele;
c, Stela 13, river
side, author drawing.

C. Tate 1986

the middle terrace, northwest of Stela 11. The temple side was in low relief but decent condition (Figure 137c), while the sculpture on the river side, which fell face up, is almost completely indistinguishable. The stela was consolidated and re-erected by INAH, in conjunction with the consolidation of the structure.

Dates and Protagonists

Stela 11			
S–T1	(9.15. 9.17.16)	12 Cib 19 Yaxkin	SJ, BJIV
J–K1	(9.15.15. 0. 0)	9 Ahau 18 Xul	SJ *u cab* BJIV
W–X1	(9.15.19. 1. 1)	1 Imix 19 Xul	BJIV
C'3–4	(9.15.19.14.14)	1 Ix 7 Uo	God K
A1–D3	9.16. 1. 0. 0	11 Ahau 8 Zec	BJIV
D'2–15	(9.16. 1. 0. 0)	11 Ahau 8 Zec	BJIV
Stela 12			
A–B1	(9.15.10.17.14)	6 Ix 12 Yaxkin	SJ
	10. 0. 6 DN		
	(9.16. 1. 0. 0)	11 Ahau 8 Zec	BJIV
Stela 13	Unknown		
Altar 13	9.0?. 0. 0. 0	8 Ahau 13 Ceh?[a]	
Altar 14	9.16. 1. 0. 0	11 Ahau 8 Zec?[a]	
Altar 15	Eroded		

[a]The glyphs of Altars 13 and 14 have continued to erode since Morley's visit, and I cannot offer any better readings than his (1937–1938:525–536, 529–530).

Iconographic Theme

The flapstaff side of Stela 11 has a date that fell on summer solstice in the year 741. That side of the stela faces the position of summer solstice sunrise. Stela 11 is a variation of the cosmological-theme stela, but is included in the discussion of the flapstaff theme in Chapter 4.

Construction Completion Date

Stela 11 may have been among the first monuments erected by Bird Jaguar IV in the *tun* of his accession. It celebrates his accession as an event arrived at after a long series of other ceremonies. The death and the posthumous event of his father are prominently featured.

Structure 41

*(Stelae 15, 16, 18, 19, 20; Stalactite
Stelae; Hieroglyphic Stairway 4)*

Dimensions, Exterior

Area, 13.36 by 4.82 m. Front buttresses or walls
of exterior structure project between 1.22 and
1.60 m from original façade.

Dimensions, Interior

Southeast chamber, 1.52 by 2.43 m. Central
chamber, 5.18 by 1.72 m.

Orientation: from central doorways, 49–51 (compass), 54–57 (map); façade, 322 (compass).

Originally the approach to Structure 41 and the
South Acropolis must have been through the
valley that opens between Structures 1 and 20,
past Maler's cave, and up a very long, very steep
stairway. Only traces of this stairway are vis-
ible, but the trail is marked by ancient altars and
stone basins. In A.D. 755, upon arriving at the
top of this breathtaking ascent, one would have
been immediately confronted by three towering
stelae, each bearing the image of a submissive
captive and the victorious Shield Jaguar in his
warrior garb. On a terrace 1.5 m higher were
placed two additional stelae, smaller than the
first three. To the right was a view of Struc-
tures 40 and 39 on the northern end of the
acropolis.

Proceeding up the three terraces that sup-
port Structure 41, one reached the base for the
building. Set into the stucco floor, before each
of the doorways, was a carved stair tread. The
structure is elevated on one additional step.

Across the façade ranged a series of project-
ing masonry elements composed of two paral-
lel walls 1.5 m tall with a shelf between them
that may have held a lifesize stucco seated fig-
ure. Between the center two masonry thrones,
the central doorway to the structure was formed
in a corbeled step. A band of stucco glyphs
formed an inscription under the cornice on all
four sides of the façade. The frieze was richly
decorated with frontal monster masks. A roof-
comb extended the decoration skyward.

Annually, on summer solstice, the sun's first
rays pass through the center corbeled doorway
and shine onto the bench on the rear wall. The
structure has now lost much of its past gran-
deur. In Maler's time, this building was in the
worst condition of those on the South Acropo-
lis (Maler 1903:178). The vaults were mostly
fallen and the interior filled with debris. The
debris covered the projecting masonry thrones
on the front façade. Through a small passage
into the interior, Maler saw that the interior
walls had small projections. He thought that
some remodeling had been done. The two lat-
eral doorways had been narrowed also. At some
time, the entrance to the northwest chamber
had been walled up with stones that form a
true arch.

138.

Structure 41. Author
photo.

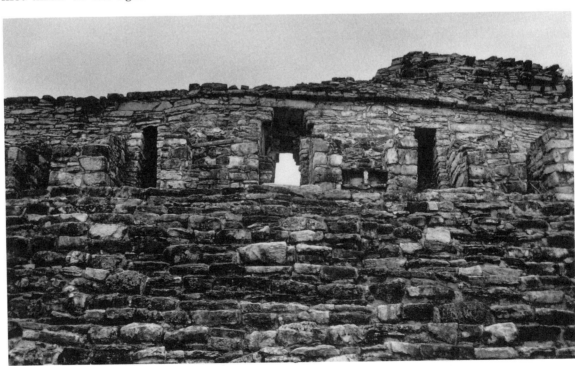

The structure was consolidated in 1979 and 1980 by INAH, and it became clear that it underwent at minimum two phases of construction in ancient times. Not only the building but the several terraces as well have two or more layers of masonry. Of the exterior decoration, no trace now remains on the building of the lifesize enthroned figures that I propose sat on the projecting masonry thrones, but much flaked stucco can be seen littering the terrace. Even over the past two years, the long-snouted monster masks have deteriorated significantly. The first time I saw Structure 41 in 1983, the form of a long-snouted supernatural was visible in the frieze on the northeast corner of the front façade, above the two projecting walls. In March 1985, fragments of that mask had fallen (Figure 139), and I photographed a portion of the snout and eye. In 1931, Morley counted eleven stucco glyphs in the band below the cornice, three on the front, two on the northwest side, and six on the rear. A careful examination in 1985 revealed parts of no glyphs in front, one on the northwest side, and three on the rear (see Figure 140).

The interior of the structure was always small, and the walls extremely massive. A bench runs across the back wall of the central chamber. The entranceways, which have been narrowed, are now only 0.56 and 0.61 m wide, the central one being the widest (see Figures 141, 142).

139.

Fallen monster mask nose from façade of Structure 41. The height of the nose is approximately 2 feet. Photo © 1991 by Lee Clockman.

MONUMENTS

Dimensions (from Morley 1937–1938; Maler 1903; Graham 1979)

	H	HSc	MW	Th	Sides Carved
Stela 15	1.85 m	1.33 m	0.68 m	0.16 m	1
Stela 16	1.95 m	0.98 m	0.76 m	0.31 m	1 or 2
Stela 18	3.77 m	2.70 m	1.42 m	0.24 m	2
Stela 19	4.00+ m	Unknown	1.44 m	0.25 m	2 or 4
Stela 20	3.56 m	2.70 m	1.41 m	0.27 m	2

Of six stalactite columns, one measures 2.80 m in length and the others are not measured.

At least five circular altars, unmeasured and eroded, are associated with the stelae. All are still on the terraces of Structure 41.

	H	MW	HSc	WSc	MTh	Rel
Hieroglyphic Stairway 4						
Step I	1.20 m	0.50 m	1.01 m	0.38+ m	0.08 m	0.4 cm
Step II	0.89 m	0.58 m	Unknown	Unknown	0.16 m	Unknown
Step III	1.40 m	0.72 m	1.05 m	0.44 m	0.18 m	0.9 cm

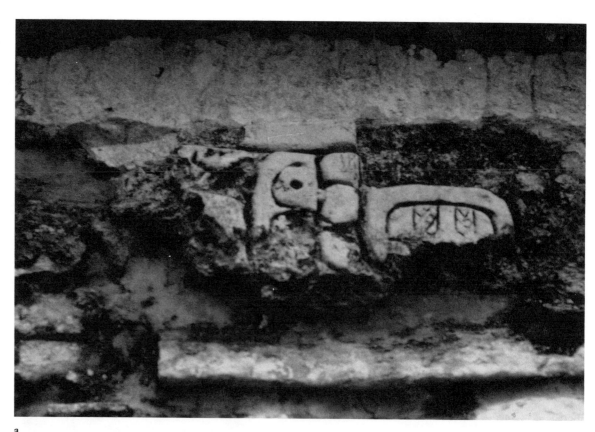

a

140.

Sole remaining
stucco glyph from an
inscription that once
circled Structure 41
underneath the cor-
nice: *a,* in 1985, au-
thor photo; *b,* in
1989, photo © 1991
by Lee Clockman.
Note deterioration
of glyphic element
at upper left.

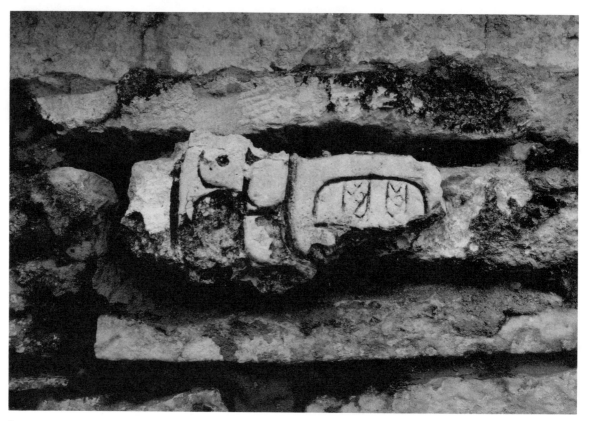

b

Stela 15 (Figure 144) was discovered in 1900 by Maler. When it fell, it broke into two pieces, one large and one much smaller. The smaller piece is still missing. It contained the figure of the captive Ah Ahaual. The stela probably had been erected near where it was found, on the south-southeast side of the middle platform. It was taken to MNAH in 1964.

Stela 16 (Figure 144) was also discovered by Maler, fallen upon the lower terrace from the north side of the middle terrace. The stone broke in the middle when it fell. The form is unusually rectilinear for a stela; most stelae are rounded at the top. Maler thought that a high-relief sculpture of the "deity," or temple, side lay exposed to the elements and was destroyed, and that the downward face corresponded to the "human" or river side (1903:180). Morley's description differs. He states that "The front is sculptured with a human figure and glyphs all in very low relief, the sides and back being plain" (1937–1938:398). He gives a chart of the heights of the sculptured panels of the seven shortest stelae, and Stela 16 is the smallest at 0.96 m. This scale is common among lintels, however. For example, the Lintel 8 sculptured panel is 0.99 by 0.78 m; Lintel 35 is 0.97 by 0.55 m; etc. The iconography of Stela 16 is that of a frontal figure with a profile head holding a particular staff I call a flapstaff. All other single-figure monuments at Yaxchilan utilizing this theme are lintels. The evidence suggests that this monument may have originally been a lintel and that it was re-used as a stela. Examination of the piece could clear up this question, but the present location of the monument is uncertain. It may be buried on the terrace of Structure 41.

Stela 18 (Figure 145) was discovered by Maler in 1900. It had fallen to the lowest level of the South Acropolis from its apparent original position as the northernmost of the three giant stelae on the first platform. The stela had broken into four large pieces, the topmost of which had tumbled down the hillside. Somehow all the pieces must have fallen with their river sides down. The only serious damage to that side is at the breaks in the stone. The temple side is blurred, and only the outline of the figure and glyphic areas can be discerned.

Stela 19 (Figure 146) broke into so many pieces when it fell that Maler said he did not try to count them. This largest of the stelae on the South Acropolis apparently fell from the center of the lower terrace. Maler reported relief sculpture on the front and back and "inferior incised work" on the narrow sides (1903:

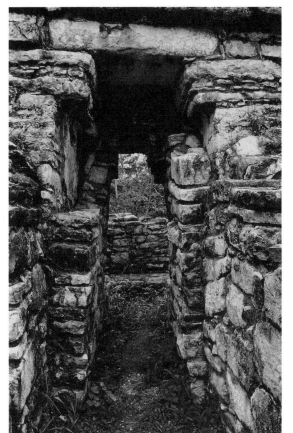

141.

Central doorway of Structure 41, looking inward. Note stepped top and additional construction on exterior of building, as well as inside the corbeled doorway. Photo © 1991 by Lee Clockman.

142.

Southeast doorway of Structure 41. Note that it was narrowed and that additional walls were added to the façade. Photo © 1991 by Lee Clockman.

181). Most of the pieces landed river side down. Maler reassembled the stela for photography, and I suspect that it remains where he left it, on the lower terrace of Structure 41, now covered with dirt and stones for protection.

Maler discovered two large pieces of Stela 20 in 1900. The upper piece is considerably pointed in shape (see Figure 146). It was the southernmost of the three grand stelae on the lower terrace. I suspect that it rests on the lower terrace, covered with earth.

Dates and Protagonists

Stela 15	(9.12. 8.14. 1)	12 Imix 4 Pop	SJ
Stela 16	a		
Stela 18	(9.14.17.15.12)	3 Eb 14 Mol	SJ
	[9.15. 0. 0. 0	4 Ahau 13 Yax]a	
Stela 19	(9.12. 8.14. 0)	11 Ahau 3 Pop	SJ
	[9.12. 9. 8. 1	5 Imix 4 Mac]a	
Stela 20	(9.13. 9.14.14)	6 Ix 16b Kankin	SJ
	[9.13.10. 0. 0	7 Ahau 3 Cumhu]a	

aSee discussion following.
bError; should be 17 Kankin (see discussion below).

The date of Stela 16 is difficult to reconstruct because the day name and its numerical coefficient are eroded. The 5 Katun Ahau title and the name of Shield Jaguar clearly place it within

the reign of Shield Jaguar the Great. The coefficient for the day is 6, 7, or 8, and the day name could be Cimi, Chuen, Cib, or Imix. A month position of 19 Yaxkin is clearly visible. The use of the flapstaff and a particular costume relate the event to the summer solstice. Summer solstice fell in the month of Yaxkin during the reigns of Shield Jaguar and Bird Jaguar. The possibilities are:

9.15. 3.16. 6	6 Cimi 19 Yaxkin	24 Jun 735
9.14.11.13. 6	7 Cimi 19 Yaxkin	27 Jun 723
9.15. 4.16.11	7 Chuen 19 Yaxkin	23 Jun 736
9.15. 5.16.16	8 Cib 19 Yaxkin	23 Jun 737
9.14.10.13. 1	6 Imix 19 Yaxkin	27 Jun 722
9.14.12.13.11	8 Chuen 19 Yaxkin	26 Jun 724

Of these possibilities, 7 Chuen 19 Yaxkin is strong because it is close to the solstice and was during a period late in his life when Shield Jaguar documented bloodlettings and dedications as well as captures. Summer solstice fell about 20–21 June in this era. For a more thorough discussion of summer solstice rituals and phenomena, see Tate 1985.

About the deity, or temple, sides of Stelae 18, 19, and 20, Maler recorded some observations. On Stela 18: "It is with great difficulty that a large upright figure in profile can be recognized. There was no subordinate figure, but all the spaces of the background were filled in with glyphs. The upper finish of the deity side was formed by two ovals, each containing a small human figure" (1903:181). I am surprised that Maler considered this stela to be in such poor condition. He probably had turned it so that the river side received the best light and consequently was unable to discern much about the more eroded temple side. In its present location at MNAH, the temple side of the stela receives raking light from the rear window of the Maya Hall, and the outline of the relief stands out clearly. Shield Jaguar stands in profile, facing the viewer's right. He wears the typical Yaxchilan bloodletting costume. From both outstretched hands, his blood flows into a basket. A form appears in the narrow portion to the right of the basket. Outlines of a skyband with pendant deity heads and two ancestor cartouches above can be seen.

Since the river sides of Yaxchilan stelae recorded either Period Endings or accession anniversaries closely following the event on the temple side, Stela 18 river side probably was a record of the 9.15.0.0.0 Period Ending.

On Stela 19, Maler reported: "On the badly weathered deity side, one can recognize with

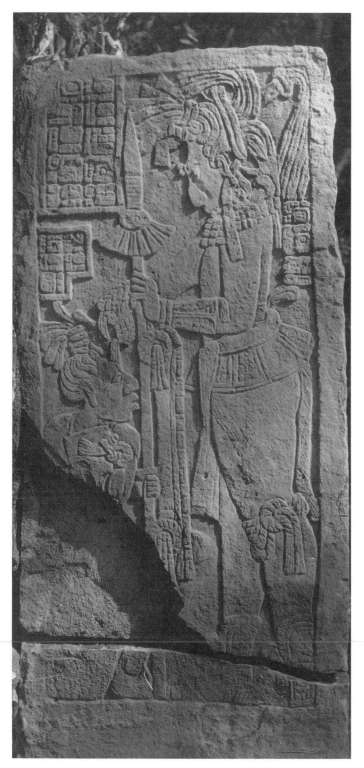

Stela 15

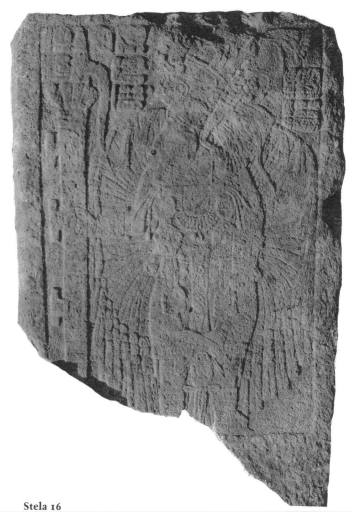

Stela 16

144.

Structure 41, Stelae 15, photo by Maler (1903: Pl. 79, No. 1), and 16, photo by Morley (1937–1938: Pl. 104*c*).

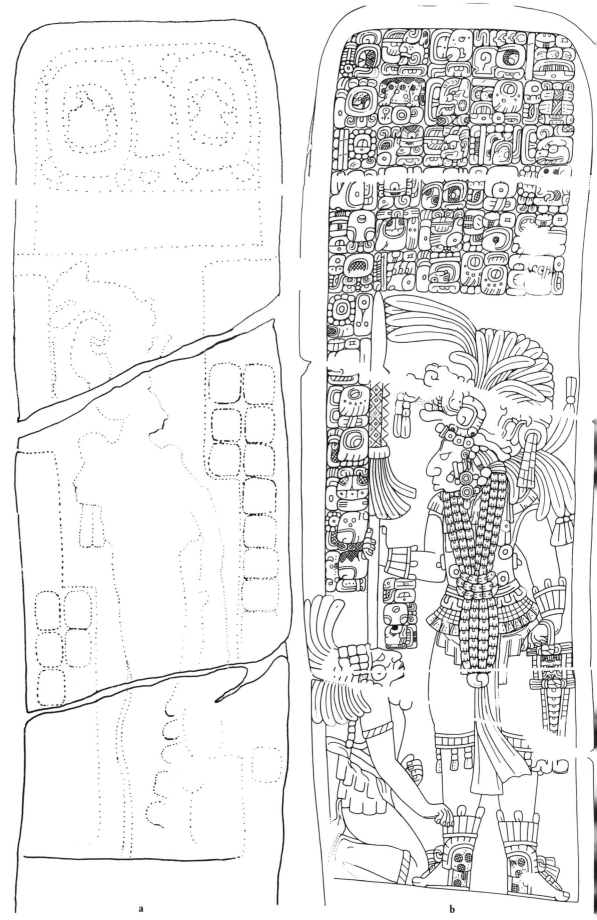

Structure 41, Stela
18: *a*, temple side,
author drawing from
monument and
photo by Martin
Diedrich; *b*, river
side, drawing by
Graham.

a

b

difficulty a figure standing upright. At its feet there are some remains of sculpture, with regard to which it can no longer be determined whether they are part of a crouching personage or of some other object . . . The deity side has, as a finish to the top, two ovals containing little human figures, with a half length picture between them, as it seemed to me" (ibid.: 181–182).

About Stela 20: ". . . it can be determined that the subject of the representation is the beneficent god with the chest of good fortune before him on the ground, and beside it a supplicant for benefits. . . . The upper finish of the deity side is so blurred that it is impossible to make anything out of it" (ibid.: 182).

Maler's "beneficent deity" and "chest of good fortune" are images of a ruler letting blood on a Period Ending, his accession, or an anniversary of his accession at Yaxchilan. So if we assume that the temple sides of the three stelae also follow this pattern, it may be possible to reconstruct the specific dates commemorated in the eroded glyphic texts.

Tatiana Proskouriakoff wrote that Stela 19 was probably the first stela erected in front of Structure 41 (1963:158), and that it was probably the original record of the capture of Death

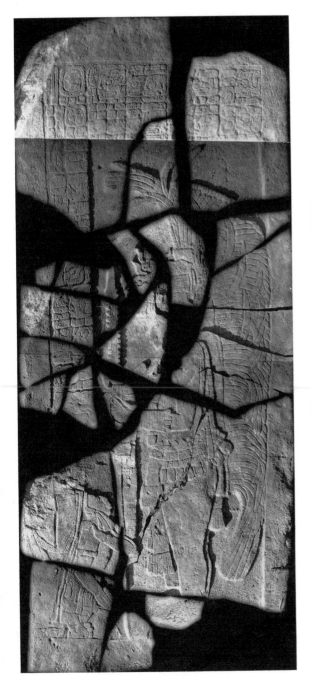

Stela 19

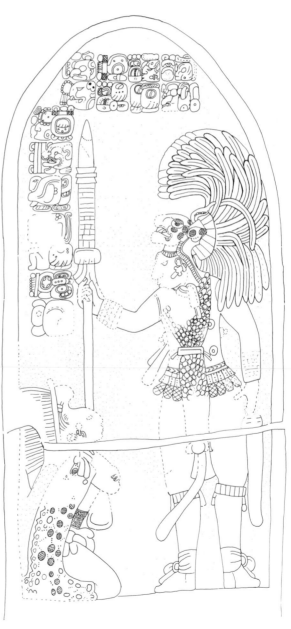

146.

Structure 41, river sides of Stelae 19, photo by Maler (1903:Pl. 77, No. 2), and 20, author drawing after field sketch by Ian Graham. The temple sides of these stelae are carved with bloodlettings and ancestor cartouches.

Stela 20

(ibid: 160), the prisoner whom she realized was the same as Ahau, and whom we now call Ah Ahaual. Her reason was that Stela 19 records the capture of Ah Ahaual one day previous to the record of the same event on Lintel 45, on Step III of Structure 44, and on Stela 15. These three monuments record the date as 12 Imix 4 Pop, which is conveniently exactly 12 *uinals* and 0 *kins* before Shield Jaguar's accession. When he captured Ah Ahaual, Shield Jaguar was in his early thirties. He had not yet attained the 3 Katun Ahau title. Accordingly, among the glyphs that remain on Stela 19, no Katun title is found.

Accepting that Stela 19 was carved contemporaneously to 9.12.8.14.0, the date of the capture of Ah Ahaual on the river side, then the temple side, that is, the image of a bloodletting, should record one of two events: Shield Jaguar's accession on 9.12.9.8.1, or the *hotun* ending 9.12.10.0.0. I think that it is most likely the record of his accession because no known stela records this important occasion, it was the tallest stela in the group, it was definitely carved while he was under sixty years of age, and it was the most prominently placed of all Shield Jaguar's stelae.

Scribal errors confuse the dating of Stela 20. The text records the capture of Ah Kan Cross on 6 Ix 16 Kankin. However, that is not a possible Calendar Round. If 16 Kankin is corrected to one day later, 17 Kankin, the corresponding Calendar Round is 9.13.9.14.14, or 17 November 701. Looking for clues to this problem, Proskouriakoff noted that a date for Shield Jaguar's capture of Ah Kan Cross, 5 Ix 17 Kankin, was inscribed on Lintel 46. Of an unfortunately eroded Initial Series on Lintel 46 survive 14 *katuns*, 5 Ix, G3 of the Lord of the Night series, and 17 Kankin, leading to the Long Count 9.14.1.17.14, or 4 November 713. The correct Lord of the Night seems to substantiate this Long Count as the correct one for the event. Proskouriakoff suggested, "Although there is a seeming discrepancy of 12 years in the dates, their calendar-round position: 3Ix 17 Kankin and 6Ix 16 Kankin are suspiciously similar [*sic*.]. One of these notations may be in error, or the later historians of Yaxchilan, puzzled by the date on Stela 20, may have relied on independent historical evidence to place the event 12 years later" (Proskouriakoff 1963: 160–161).

Concerning the impossible Calendar Round 6 Ix 16 Kankin on Stela 20, it has been sug-

147.

Structure 41, plan by Morley (1937–1938: 397) and Hieroglyphic Stairway 4, Steps I and III, drawings by Graham (1982: 175, 176).

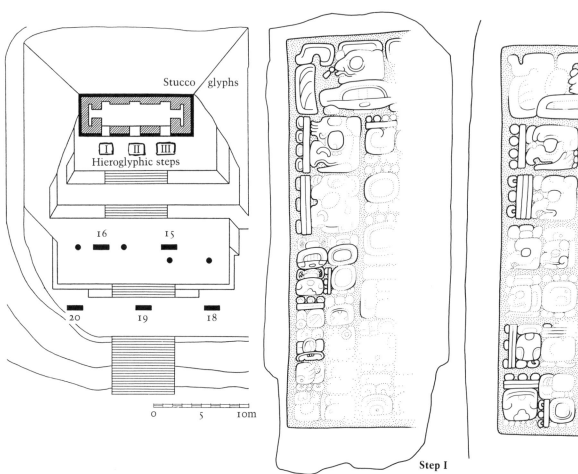

Stucco glyphs

Hieroglyphic steps

0 5 10m

Step I

Step III

gested that the 1 *k'in* head variant glyph preceding the Calendar Round notation might be an indication that the day name and the day of the month changed at different times of day. Thus, when 6 Ix began to be counted (perhaps at noon), 17 Kankin had not yet arrived (perhaps changing at midnight). This unusual inscription of 1 *k'in* may indeed refer to the necessity for adding a day to the *haab,* making 6 Ix 17 Kankin (9.13.9.14.14) the correct date of the capture of Ah Kan Cross. Added bits of evidence supporting 9.13.9.14.14. as the correct date of the capture of Ah Kan Cross are the 3 Katun Ba-te and 3 Katun Ahau titles on Stela 20 for Shield Jaguar, who would indeed have been in his third *katun* of life at the time. But why, then, did the scribe of Lintel 46 record the event as having occurred on 9.14.1.17.14 5 Ix 17 Kankin, supplemented with full lunar data? Shield Jaguar was alive when both monuments were carved—it was not a problem created by "later historians." This becomes more vexing when one realizes that the same scribe, Elegant Knot Artist, wrote both texts!

I suspect that Elegant Knot Artist or his calendar priest had drunk a bit too much *balche* when the Lintel 46 text was composed. Their intent with the Structure 44 lintels was to celebrate historical captures, as is shown by the reference to the deeds of past kings. Perhaps ordinary human inadequacy was responsible for the mix-up. Consider this scenario. In 9.14.5.0.0, when the lintels were being carved, the person responsible for selecting the information to be inscribed sent a message to the Calendar Priest: We need the correct lunar data for 6 Ix 17 Kankin. The Calendar Priest was having trouble calculating the correct lunar information for a date fifteen *tuns* earlier. He then assumed that the artists wanted the lunar data for the day 5 Ix 17 Kankin, which had occurred only four *tuns* ago. Elegant Knot just wasn't thinking when he accepted this information and drew it with his finely pointed brush on the stone.

Hieroglyphic
Stairway 4

Step I	9.13.0. 0. 0	8 Ahau 8 Uo	Period Ending by SJ
Step III	9.16.0. 0. 0	2 Ahau 13 Zec	No verb or protagonist
	(9.16.0.13.17)	6 Caban 5 Pop	Capture of "Q" by BJIV
	(9.16.1. 0. 0)	11 Ahau 8 Zec	Accession of BJIV

Construction Completion Dates

Clearly monuments from two reigns, those of Shield Jaguar and Bird Jaguar IV, are associated with Structure 41. I suspect that this building was used over at least four reigns. The interior structure (with the fallen vaults) may have been constructed during the reign of Knot Eye Jaguar II. Bird Jaguar III may have remodeled it. Shield Jaguar erected his stelae in front of his grandfather's structure, a practice seen again later at Yaxchilan (Structure 44). Finally, at the beginning of his reign, Bird Jaguar IV set the hieroglyphic steps that linked his own accession and pre-accession capture with similar events in his father's reign.

Structure 42

(Lintels 41, 42, 43)

Dimensions, Exterior: 14.45 by 5 m.

Orientation: 110 (compass).

Maudslay called Structure 42 House L on his map (1889–1902:2:Pl. 78). He illustrated parts of Lintels 41 and 43 (ibid.:Pl. 95). Maler visited the West Acropolis in 1897 and made a plan and an elevation. Because the interior of the structure is filled with debris, it is impossible to confirm Maler's plan. The entranceways are also half full of debris. Maler reported an "involved pattern of red bands . . . and red and blue scrollwork" on the interior of the doorjambs (1903:184). I could not see any paint. The West Acropolis has been off limits since I have been working on the history of Yaxchilan, so my explorations of the area have not been as thorough as I would like. Structure 42 is situated southwest of Structure 19. The base of the system of terraces that kept the soil of the West

Acropolis in place overlaps the subterranean labyrinthine chambers west of Structure 19. From there, numerous terraced stone walls were revealed and consolidated by INAH. They rise up to a broad platform about 5 m wide. Remains of three more series of steep terraces and platforms litter the steep hillside southwest of Structure 19.

Rubble with occasional well-placed stair blocks extends from the doors of Structure 42 east to a broad platform overlooking Structure 19. From there it is a swift descent to the plaza, one that terminates with the stairs immediately south of Structure 19, as seen on the map (Figure 2). Two other approaches to the West Acropolis are currently in use, one northwest of Structure 36, through the "saddle" in which Maler noted numerous small mounds, the other leading from the camp trail, turning south, and ascending near Structure 32. This trail leads past Structures 45 and 44 and goes near a cave below an escarpment. The cave is about 4 by 4 m and about 2 m high. I saw no traces of pottery or other objects within on 20 June 1985.

Consolidation of buildings on the West Acropolis was begun by a Japanese archaeology program in 1989, in cooperation with INAH.

148.

Structure 42, Lintels 41–43, drawings by Graham (1979:91, 93, 95), section and plan by Maler (1903:184).

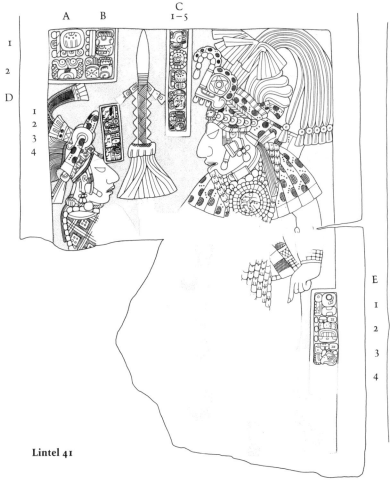

Lintel 41

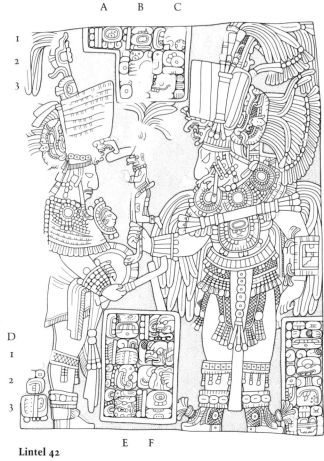

Lintel 42

Dimensions (from Graham 1979)

	MW	HSc	WSc	MTh	Rel
Lintel 41	0.93 m	1.15 m[a]	0.76 m	0.43 m	1.6 cm
Lintel 42	0.98 m	1.08 m	0.84 m	0.33 m	0.7 cm
Lintel 43	0.92 m	1.09 m	0.77 m	0.30 m	1.8 cm[a]

[a]Approximate.

Maudslay saw the upper half of Lintel 41 in 1882. It had fallen out of the doorway. When he requisitioned monuments for the British Museum, this was among them. In 1886 Gorgonio López and brothers thinned the upper half of the lintel and sent it, packed, to London. It is now in the British Museum collection (Graham 1979:92). The Fourteenth Central American Expedition found the lower right quarter in 1931, also on the ground. Morley photographed it then. Until 1989, the fragment was perched precariously, face up, on the mound of debris in front of the south doorway of the structure.

Maudslay (1889–1902:Pl. 96) viewed Lintel 42 in situ in 1882, over the central doorway of the structure. He made a paper cast of the lintel and photographed it. Maler (1903:Pl. 66) pho-tographed the lintel in situ, as did Ian Graham (1979:93), who took four detail photos because of the minimal distance from which it is possible to view the lintel. The lintel is still entire and in situ. Water has filtered through the roof and saturated the lintel. The stone oozes water.

Lintel 43 had broken and the upper piece of the sculpture had fallen into the debris by the time Maudslay photographed it in 1882 (1889–1902:Pl. 95). The lower part remained in situ until Maler removed it and took it outside (1903:Pl. 67). The chips from the left side have not been located. In 1964 the upper and lower parts were taken to MNAH, where they were consolidated and are now on display.

Dates and Protagonists

Lintel 41	(9.16.4.1.1)	7 Imix 14 Zec	BJIV, LAI
Lintel 42	(9.16.1.2.0)	12 Ahau 8 Yaxkin	BJIV, CoM
Lintel 43	(9.16.1.8.6)	8 Cimi 14 Mac	BJIV, Lady Ix

Construction Completion Date

The building was probably erected with its iconographic and ritual twin, Structure 1, by 9.16.6.0.0.

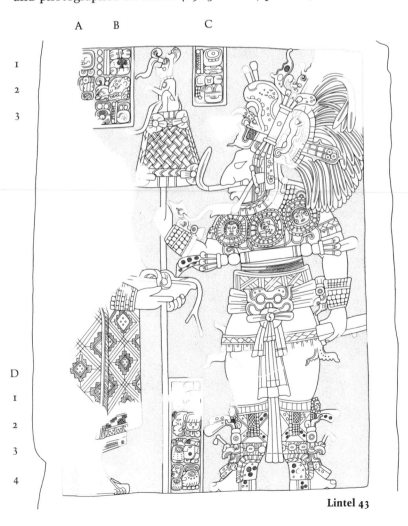

Lintel 43

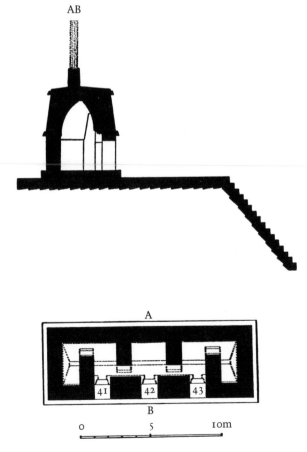

Structure 44

(Stelae 14, 17, 21, 22, 23, 29; Lintels 44, 45, 46; Hieroglyphic Stairway 3; Interior Painting)

Dimensions, Exterior: 12.96 by 4.5 m, approximate (Maler 1903:187).

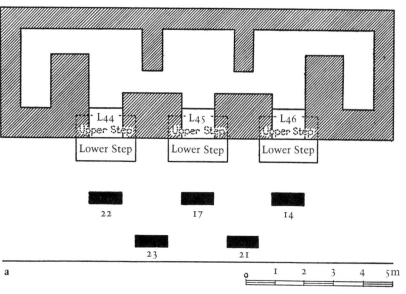

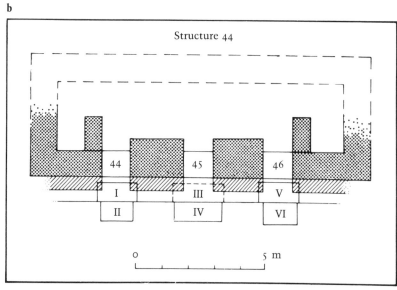

149.

Structure 44, plans: *a,* by Morley (1937–1938:441), showing possible locations of stelae; *b,* by Graham (1982:165).

Orientation: 37 (map).

In 1882 Maudslay named this structure House M. He photographed the three lintels and, in his publication, mistakenly included a picture of Stela 5 in this group (1889–1902:2:Pl. 97). During his investigation of the West Acropolis, Maler thought that Structures 42 and 44 had similar plans. He photographed the lintels and decried what he called their "calcination" due to the improper application of the technique of drying paper molds with a fire set under the lintel. He also chopped through the bush and slid down a terrace in front of the building by means of some stone steps, and encountered below the structure and in line with the central doorway a large monument that he assumed to be a sacrificial altar set in the masonry of that terrace (Maler 1903:189).

On 29 and 30 April and 1 May 1931, Ruppert completely excavated the front doorways of the structure and found that, in addition to the broken lintels above, each entrance had a carved landing and a second carved step below, except the middle doorway, whose upper step was the "sacrificial altar" found by Maler (Morley 1937–1938:443).

The provenience of the stelae is discussed below.

Structure 44 faces north-northeast, and would provide a view of the river if the large trees were cleared. Very little space for public gatherings exists around the structure. There is a large plaza behind it, but the building faces away from this space and has no entrance leading to it. Maler described the terrace in front of the structure as being 4 m wide, but it seems very narrow now, perhaps 2.5 m. Maler may have been correct when he indicated that the terrace near Structure 47 was probably the public space for witnessing ceremonies performed upon the platform of Structure 44.

The building is composed of a single vault. Its one chamber is subdivided by transverse piers, two attached to the rear wall and two to the side walls of the outer entrances (Maler 1903:187 posits the existence of rear transversal buttresses). Now the building has largely fallen, and debris fills the interior. Some of the frieze remains, and the vaults may be salvageable. On the frieze are mortises for tenoned sculpture. The red bands over white stucco can still be seen on the doorjambs. The interior of the temple cannot be seen and I am unable to deny or confirm Maler's suspicion that it was also painted. Traces of red paint remain on the lintels.

Dimensions (from Morley 1937–1938; Graham 1979; 1982)

	H	HSc	MW	Th	Rel	Carved Sides
Stela 14	2.18+ mᵃ	1.70 m	1.43 m	0.11 m	2.5 cm	1
Stela 17	1.73 mᵇ	Unknown	0.86 mᶜ	0.14 mᶜ	Unknown	Unknown
Stela 21	Unknown	Unknown	1.0 mᵃ	0.9 m	Unknown	1
Stela 22	About the same as Stela 23					2
Stela 23	1.15 mᵈ	Unknown	0.69 m	0.16 m	Low	2
Stela 29	One fragment only, unmeasured					1

ᵃApproximate.
ᵇThis is the combined height of two of the three fragments.
ᶜMeasurement of the A (upper) fragment.
ᵈMeasurement of the bottom of two fragments.

	MW	HSc	WSc	MTh	Rel
Lintel 44	0.98 m	0.98 m	0.84 mᵃ	0.30 m	2.0 cm
Lintel 45	1.07 m	0.92 m	0.92 m	0.24 m	2.1 cm
Lintel 46	1.04 m	0.96 mᵃ	Unknown	0.26 m	1.7 cmᵃ

ᵃApproximate.

	H	MW	HSc	WSc	Rel
Hieroglyphic Stairway 3 Treads					
Step I	1.65 m	0.72 m	1.53 m	0.60 m	1.0 cm
Step II	1.46 m	0.75 m	1.29 m	0.61 m	1.5 cm
Step III	1.98 m	0.75 m	Unknown	Unknown	Unknown
Step IV	1.80+ m	0.70 m	1.20 m	0.58 m	0.9 cm
Step V	1.61 m	0.71 m	1.52 m	0.60 m	1.0 cm
Step VI	1.43 m	0.78 m	1.34 m	0.70 m	1.5 cm
Risers					
Step I	0.30 m		0.22 m	1.49 m	
Step III	0.30 m		Unknown	Unknown	
Step IV	0.32 m		0.18 m	1.47 m	

Stela 14 was discovered on 20 April 1931 by John Bolles of the Fourteenth Central American Expedition. He found six pieces of this monument on the slope below Structures 44 and 45. The fragment showing the carved head was found three days later, much higher on the slope. Morley presumed that it had stood on the northeast section of the terrace of Structure 44. Morley and his crew tried piecing the monument together and photographed it (Morley 1937–1938: Pl. 108a, b, and 104d). He drew some of the date (ibid: Pl. 19b). Peter Mathews has made a drawing that makes much more sense of the fragments (see Figure 150). I am unaware of the present location of the fragments.

Stela 17 (also shown in Figure 150) was discovered by Bolles on 20 April 1931 about 30 m below the terrace of Structures 44 and 45. Mor-

ley states that because the relief is of higher quality than the other stelae on this acropolis, it must have been placed near the center of the group, an argument I cannot defend (Morley 1937–1938: 461). Two carved pieces and a blank dressed piece were located. In 1987 the stela was near a big anthill on the terrace 10 m below Structure 44.

Of Stela 21 (Figure 151) two fragments were found on 22 April 1931, one by an indigenous laborer of the Fourteenth Central American Expedition, and one by Miguel de la Cruz, of the family of the guardians of the site. Both were located directly in front of Structure 44, "on the slope of the terrace, just below the top" (Morley 1937–1938: 462, Pl. 104b). I am not aware of its present location.

A few days after the discovery of Stela 21,

Bolles unearthed another stela about the same size on the slope to the northeast of the terrace of Structure 44 (Morley 1937–1938:465, Pl. 178A*e*, Fig. 68). On Stela 22 (see Figure 151) only one figure survives, although it was originally carved on two sides. The figure wears a headdress consisting of a coiled element, kneels, holds a fan-like shield similar to the one on Step III of Structure 44, and faces to the viewer's right. It was probably one of two such figures, and was in a register below a standing figure, according to Morley (ibid.). With luck it will be found and published soon as a result of the cooperation between Japanese university and INAH archaeologists.

Two fragments of Stela 23 (Figure 152) were discovered by Bolles on 27 April 1931 "on the terrace level in front of Structure 44, but so far to the left [southeast] that it must have been the left or southeast monument in front of Structure 44" (Morley 1937–1938:463, Pl. 178 A *a, b*). In the early 1950's, another beautifully carved fragment was found by Ulises de la Cruz, a guardian of the site. It was published in Frans Blom and Gertrude Duby de Blom's *La selva lacandona* (1957) and delivered to the Museo Regional in Tuxtla Gutiérrez by Blom in 1955.

Of Stela 29 (Figure 151) one piece was found on the terrace below Structures 45 and 44 in April 1931 by someone in the Fourteenth Central American Expedition. It was not measured, but Morley photographed it.

Lintel 44 was probably seen by Maudslay, but it was first described by Maler, who saw parts of it in situ. Maler did not publish a photo of fragmentary Lintel 44 and presumed that the missing pieces had been carried away (1903: 187). In 1931, while cleaning the front of the structure, Ruppert noted two deeply buried fragments in the debris of the doorway. They contained carvings of glyphs and formed the left edge of the carved scene (Morley 1937–1938:451). The lintel is broken into five main

150.

Structure 44, Stelae 14, drawing by Peter Mathews, and 17, photo by Morley (1937–1938: Pl. 178H*a*).

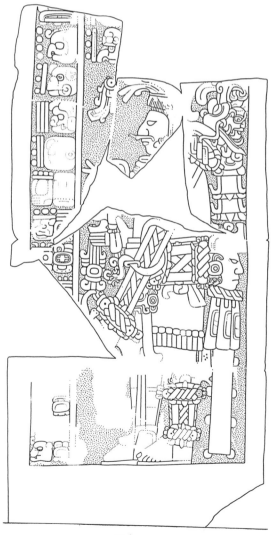

Stela 14

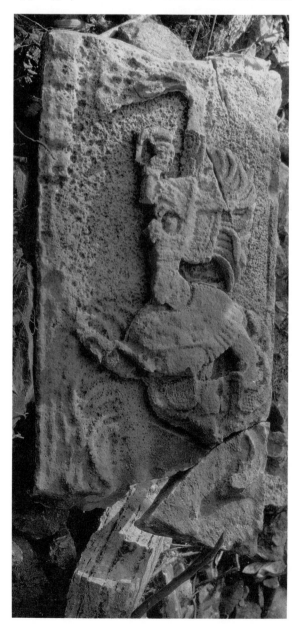

Stela 17

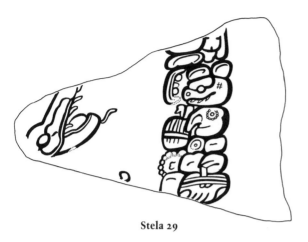

Stela 29

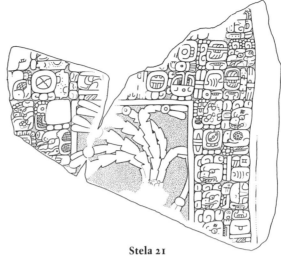

Stela 21

151.

Structure 44, Stelae 21, drawing after photo by Morley (1937–1938: Pl. 104*b*), 22, photo by Morley (1937–1938: Pl. 178A*e*), and 29 (fragment), drawing by Peter Mathews after Morley (1937–1938: Pl. 104*a*).

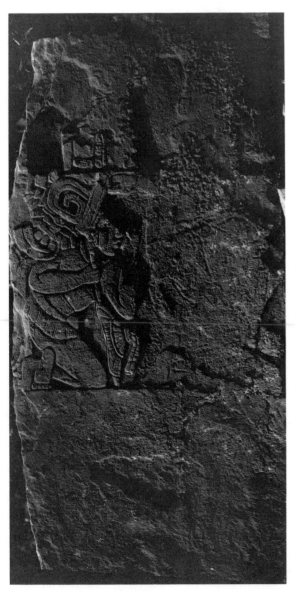

Stela 22

152.

Structure 44, Stela 23, lower front and back, drawings by Peter Mathews.

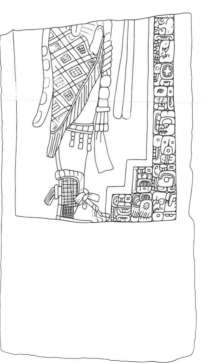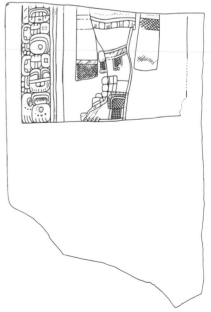

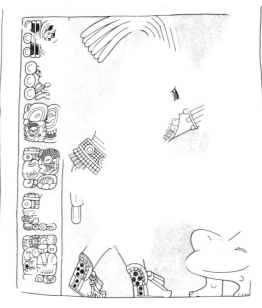

Lintel 44

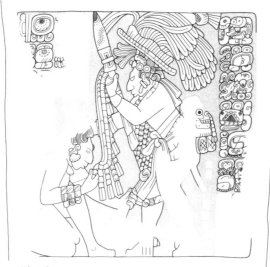

Lintel 45

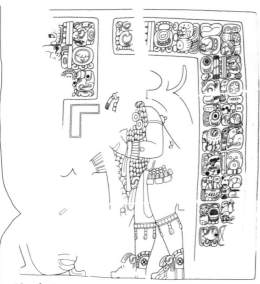

Lintel 46

153.

Structure 44, Lintels
44–46. Drawings by
Graham (1979: 97,
99, 101). (See also
Figures 9–12.)

fragments, three of which until consolidation work in 1989–1990 dangled over the abyss of the doorway. Others lay on the sill of the doorway. Much of the lintel has not been found. Maler thought that damage done to the outer (right) edge of the lintel was caused by a fire lit to dry the paper molds that were made at the request of Maudslay.

The majority of Lintel 45 is still in situ over the middle doorway of Structure 44, where it was discovered by Maudslay. He made a paper mold, now in the British Museum. The lintel is cracked through, and it is amazing that it is still in place. It drips with the moisture that seeps through the cracked and fallen roof above it. As can be seen from Ian Graham's drawing (Figure 153), its condition varies greatly from totally eroded and flaked to excellent. Red paint can be seen, particularly behind the legs of the principal figure, Shield Jaguar.

Some of the five fragments of Lintel 46 were for some years propped up with long sticks in the northwest doorway of Structure 44, where they had been discovered by Maudslay in 1882. The large central fragment fell between 1900 and 1931 (Graham 1979: 101). At this writing, the sticks have fallen and nothing supports the fragments. Maler attributed the destruction of the surface to fire, as in the case of Lintel 45.

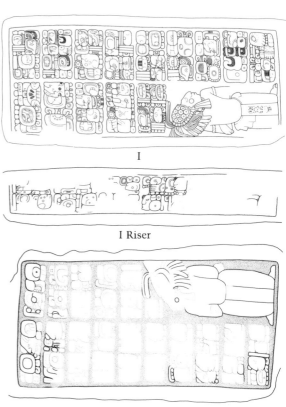

I

I Riser

II

Red paint can be seen in the background area, especially in the corners protected by the higher relief of the figures.

Maler believed that he had discovered a unique type of monument on the edge of the second platform from the top of Structure 44, in line with the central doorway of the temple (1903:189). Because of its location, it seemed to be a planned part of the masonry (as it perhaps was), and Maler dubbed it a sacrificial stone. He turned it on its side and photographed the top. Apparently he felt that it was too much effort for too little information to set the carved front edge into the shaft of light, for he took no picture of that part. He reported that it had eight large oval cartouches each containing four glyphs, some of which were too eroded to distinguish (ibid.).

In April 1931, Karl Ruppert cleared the entrance to Structure 44. In the floor of the doorways and below, he found sculptured steps, and it was realized that Maler's sacrificial stone had once been set into the central doorway. Morley examined Step III (Maler's step), but states specifically that he did not examine the riser, which practically proves that the inscription did not include a date. In any event, he did not photograph the riser, and since that time, the entire step has disappeared (Graham 1982:165).

The other five steps were discovered by Ruppert and photographed by Morley. The treads of the upper steps, protected by the cornice, were in good condition. Carved risers were present only on the upper steps, and they were more eroded, split, and obscured by deposits of lime. Curiously, the central lower step (IV) is in almost perfect condition while the other lower steps are severely effaced.

Dates and Protagonists

Stela 14	9. 4. 8.8.15	13 Men 13 Kayab	KEJ?
Stela 17	a		SJII?[b]
Stela 21	(9.17.18.1.13)?[c]	13? Ben 1 Pax	SJII
Stela 22	a		SJII?
Stela 23	a		SJ[d]
Stela 29	a		

[a]Insufficient data.
[b]Ruler tentatively identified by the headdress.
[c]Another possibility is (9.17.1.15.13)? 10? Ben 1 Pax. The later date seems likelier, as 9.17.1.15.13 is very early for SJII.
[d]This ruler named on one side of the stela.

Lintel 44	(9.12.17.12.0)	13 Ahau 3 Muan	SJ
Lintel 45	(9.12. 8.14.1)	12 Imix 4 Pop	SJ
Lintel 46	(9).14.(1.17.14)	5 Ix 17 Kankin[a]	

[a]Recorded in error. Most likely refers to event on (9.13.9.14.14) 6 Ix 17 Kankin. See discussion of date on Stela 20.

154.

Structure 44, Hieroglyphic Stairway 3, Steps I–VI. Drawings by Graham (1982:166–168).

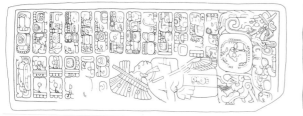

III

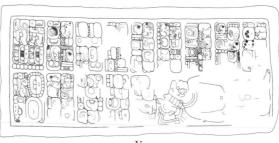

V

V Riser

IV

VI

Hieroglyphic
Stairway 3

Step I	(9. 6.10.14.15)	4 Men 3 Mac	KEJII
	7.11.(2)ª19 DN		
	(9.14. 1.17.14)	5 Ix 17 Kankin	SJ
	15.15.17 DN		
	(9.14.17.15.11)	2 Chuen 14 Mol	SJ
Step II	Eroded		
Step III	9.12. 8.14. 1	12 Imix 4 Pop	SJ
	12. 0 DN		
	(9.12. 9. 8. 1)	5 Imix 4 Mac	SJ
Step IV	(9.14.11.10. 1)	7 Imix 14 Zotz	SJ
Step V	(9.10.14.13. 0)	10 Ahau 13 Mol	BJIII
	4. 5.17. 0 DN		
	(9.15. 0.12. 0)	10 Ahau 8 Zotz	SJ
	3. 3 DN		
	(9.15. 0.15. 3)	8 Akbal 11 Yaxkin	SJ
	−12. 0 DN	(subtract from	
		10 Ahau 8 Zotz)	
	(9.15. 0. 0. 0)	4 Ahau 13 Yax	SJ
Step VI	(9. 8. 0.15.11)	4 Chuen 9 Xul	?
	?.13?.1. 9 DN		
	????	10 ? 13??	SJ

ªIncorrectly recorded on stone as 1.

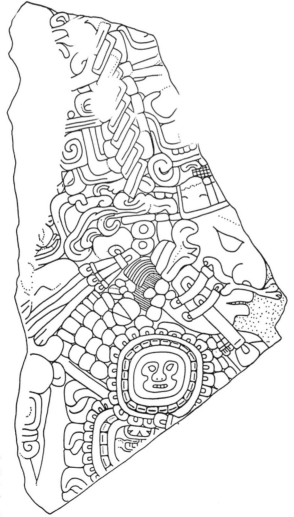

155.

Miscellaneous Stone 1, found near Structure 44. Drawing by Peter Mathews.

With the exceptions of accessions recorded on Stela 14 and Step III, all the events associated with Structure 44 are captures. The deeds of several generations of valiant warrior rulers are recorded here by Shield Jaguar. Stela 14 is one of the earliest monuments at Yaxchilan. It seems to be an accession because it is not a Period Ending nor a capture. It is not clear, until excavations are undertaken, whether a structure contemporary to this stela exists under Structure 44 or not. If the stela was originally located on the West Acropolis, then Shield Jaguar built a later structure (44) and dedicated its lintels to commemorate his war victories on the site of an ancient ancestral building. The lintels could have been dedicated as early as 9.14.5.0.0. Later Shield Jaguar designed the steps, in two phases, the first (Steps III and IV) dedicated on 9.14.11.10.1 and the second (I, II, V, VI) probably completed in 9.15.5.0.0. There he recorded history of some of the rulers not mentioned in the earlier historical summary at the site. Two *katuns* later, Shield Jaguar's grandson, Shield Jaguar II, placed at least four stelae in this hallowed area.

Structure 44 was devoted in part to Shield Jaguar's military exploits, as Proskouriakoff observed (1963:153). On the lintels and steps were also recorded references to the war deeds of his royal ancestors, which were linked to his own. This emphasis on war and the lack of commemoration of typical Period Ending statements gives the content of Structure 44 inscriptions a different character than those of Structure 23, where Lady Xoc's bloodletting and astronomical events were emphasized, and those of Structure 41, which in addition to the well-preserved war scenes had Period Endings recorded on the eroded temple sides of the stelae and prominent summer solstice records.

Structures 45–52

Of the other buildings on the West Acropolis, only one, Structure 45, has a standing vault. It does not have carved lintels, and therefore is not as imposing as its neighbor, but it is possible that some of the stelae associated with Structure 44 could have been placed in front of this structure.

Structure 54

(Lintels 58, 54, 57)

Dimensions: approx. 4 by 20 m.

Orientation: 13 (map).

Relatively little work has been done by INAH in the Southeast Group. It contrasts with the Main Plaza, from which many large trees and most underbrush have been cleared, affording an open view from Structure 4 to Structure 18. South of Structure 4, the boundary of the Main Plaza, a wide trail is kept clear that skirts the edge of the first terrace. Smaller trails wind through this densely shaded section of the site to the monuments.

Structure 54 faced the river from the first bench, about 360 m past the southeastern edge of the Main Plaza. Between Structures 54 and 55 and the Main Plaza are a number of buildings obscured by the growth and decay of one and a half millennia. None appear to have standing walls or to have had carved lintels. Structures 54 and 55, then, are situated so far from the other major decorated buildings as to be a separate enclave. In the course of making the map that is still used today and his description of the site, Bolles encountered Structure 54 on 30 April 1931. He found no standing walls amid the debris. Three depressions in the façade facing the river indicated the presence of three doorways. He excavated near the center of the structure and found Lintel 54. The expedition broke camp a few days later, and they were unable to make a search for more lintels.

Because the existence of a triad of lintels seemed so certain, Linton Satterthwaite consented to excavate for them in 1935, in connection with his work on Piedras Negras. He found Lintel 57 in the east doorway on 19 April and Lintel 58 on the west side on 23 April.

156.

Structure 54, Lintels 58, 54, and 57. Drawings by Graham (1979:117, 123, 125).

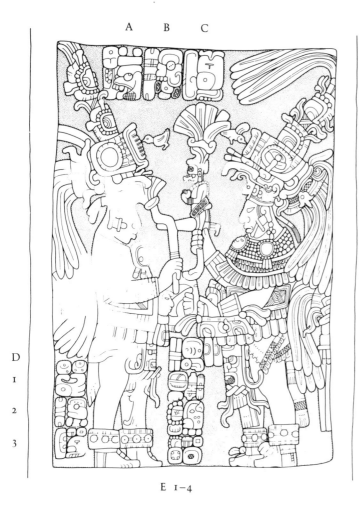

Lintel 58

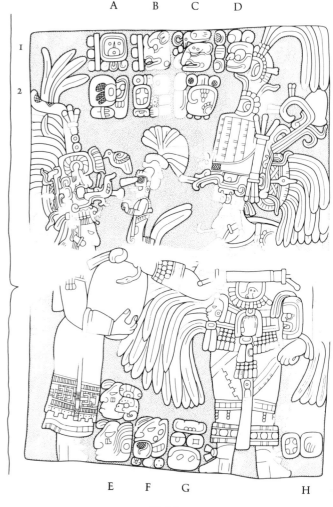

Lintel 54

Dimensions *(from Graham 1979)*

	MW	HSc	WSc	MTh	Rel
Lintel 58	0.75 m	0.96 m	0.66 m	0.22 m	1.0 cm
Lintel 54	0.77 m	0.97 m	0.67 m	0.31 m	1.5 cm
Lintel 57	0.75 m	0.91 mᵃ	0.63 m	0.28 m	1.4 cmᵃ

ᵃApproximate.

Present Location and Condition

Lintel 58	One piece, good condition, MNAH
Lintel 54	Two pieces, some chipping, MNAH
Lintel 57	One piece, eroding, propped on side under plastic in front of Structure 54

Dates and Protagonists

Lintel 58	No date recorded		Lord GS, SJII
Lintel 54	(9.16.5.0.0)	8 Ahau 8 Zotz	BJIV, Lady GS
Lintel 57	No date recorded		SJII, Lady GS

The practice of carving lintels without dates is characteristic only of the very early and very late periods at Yaxchilan, and this group is undoubtedly late, both stylistically and because the protagonists are known. I suspect that the undated lintels may commemorate homage paid by Shield Jaguar II to his mother's family. The earliest possible date must be after Shield Jaguar II became ruler, probably no earlier than 9.17.10.0.0, and more likely later.

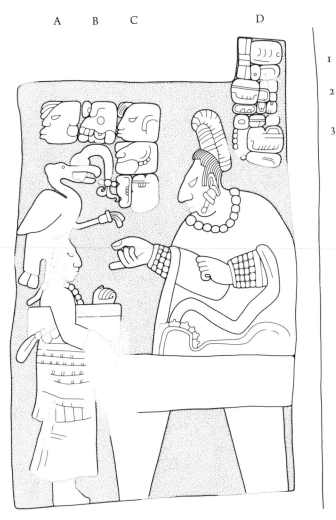

Lintel 57

Structure 55

(Lintels 51, 52, 53)

Dimensions: 20 by 6 m by 2 m high, approx.

Orientation: 8 (map).

The building and its three carved lintels were discovered by Bolles on 29 April 1931 (Morley 1937–1938:583). The building was then a long, low mound, and so it remains today. It is the first building with decorated lintels reached when traveling along the first bench east from the Main Plaza.

MONUMENTS

Dimensions (from Graham 1979)

	MW	HSc	WSc	MTh	Rel
Lintel 51	0.91 m	0.82 m	0.76 m	0.30 m	1.0 cm
Lintel 52	0.90 m	0.92 m	0.71 m	0.25 m	1.5 cm
Lintel 53	0.88 m	0.92 m	0.75 m	0.24 m	1.4 cm

Lintel 51 was found unbroken, lying face down in front of the east doorway of Structure 55. Much of the surface has suffered erosion. The top of the scene is in worse condition than the bottom. Currently it is in front of Structure 55, on its side, protected by a sheet of plastic.

Lintel 52 was found unbroken, with the sculpted face down, in front of the middle doorway. Morley's photographs indicate that it was in very good condition. The present erosion is due to its exposure since 1931. It is currently in front of the structure, propped up, with a plastic roof.

Lintel 53 was also found with the sculpted face downward, broken cleanly in two pieces. It was in good condition when found, but has since eroded noticeably. It was removed in 1964 to MNAH, where it was repaired and is now on display.

Dates and Protagonists

Lintel 51	No date recorded		?
Lintel 52	(9.16.15. 0. 0)	7 Ahau 18 Pop	BJIV,
Lintel 53	(9.13.17.15.13)[a]	6 Ben 16 Mac	SJ, LI

[a]This date probably refers to another date prominent at Yaxchilan: 6 Ben 16 Mac, recorded on Lintel 32, on which the same event with the same protagonists was commemorated (Proskouriakoff 1963:164).

Construction Completion Date

Both dates in the structure were surely recorded well after the events. The building was constructed during the reign of Shield Jaguar II, perhaps as early as 9.17.10.0.0.

157.

Structure 55, Lintels 51–53. Drawings by Graham (1979:111, 113, 115).

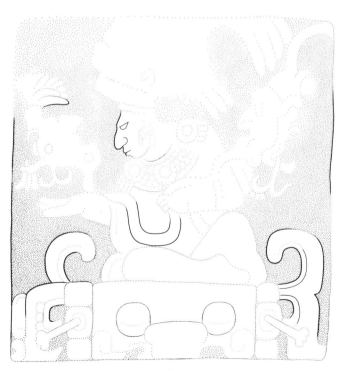

Lintel 51

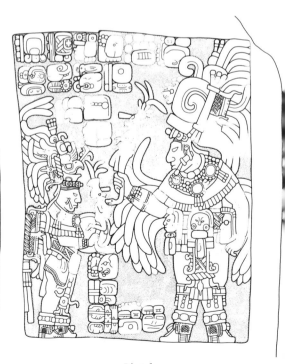

Lintel 52

(Stelae 25 and 26)

Structure and stelae were probably discovered by Ruppert and Bolles in 1931. The 1931 Carnegie report does not specifically state the discovery of the stelae, but it refers to having found twelve sculptured stelae. Stelae 25 and 26 are listed by Morley (1937–1938:361) as having been in front of Structure 62 in the Southeast Group, which was mapped by Bolles in 1931.

Today Structure 62 is unconsolidated, and little can be said about its original appearance. It sits on a small terrace off the Southeast Group plaza, abutting the steep hillside. Two stelae were erected there, most likely Period Ending stelae of Shield Jaguar II or Mah K'ina Skull III. The large fragments of these stelae are visible, but their relief is very difficult to perceive. Despite a thorough examination in 1987, I could make out little of the original design of the monuments. Fortunately, Marvin Cohodas, during a visit to Yaxchilan in 1971, made quick sketches of these two stelae. Stela 25, on the northwest side of the terrace, was once about 3 m tall. It is a Period Ending stela—Cohodas' sketches show a profile standing figure wearing a human-head backrack facing the viewer's left, with its hands extended, and liquid flowing from them down toward a kneeling figure whose torso is frontal and whose head is profile.

Stela 26, the more southeasterly of the two, is atypical of Yaxchilan designs. The single fragment upon which anything can be discerned is the lower quadrant of a stela, including a substantial plain butt and the lower portion of a single, frontal figure. The figure stands with his feet pointed in opposite directions. He wears heel-guard sandals with elaborate tassels ("pineapple foliage" style) and an elaborate loincloth, decorated with a large central circular medallion, matting, serpent snouts, and human profiles. Stylistically, this stela is most like the equally aberrant Stela 9 of Structure 36.

Construction Completion Date: probably after 9.17.0.0.0.

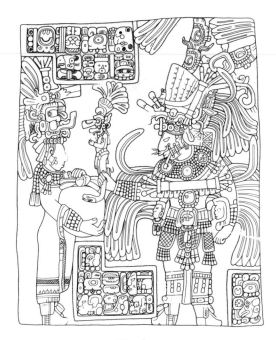

Lintel 53

Structure 64

(Stela 24)

Structure 64 is mentioned here because in 1931 Bolles found a fragment of stela that had been re-used as part of the masonry (Morley 1937–1938:355). It is a long, low platform, without a verifiable superstructure, located in the center of the Southeast Plaza, in front of Structure 62 on the first bank.

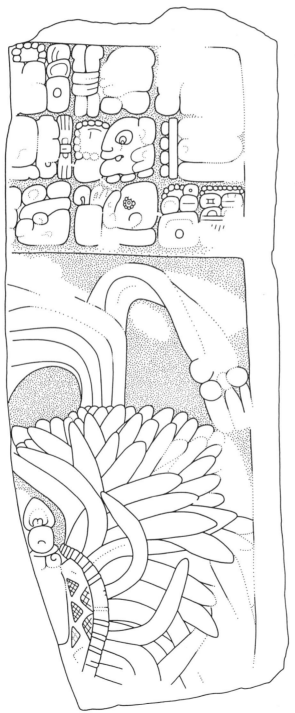

MONUMENT

Dimensions

Stela 24 fragment: length, 1.28 m; width, 0.50 m; thickness, 0.22 m. Carved on one side only (Morley 1937–1938:423).

The fragment was originally placed in the top course of the facing stones at the northwest end of Structure 64. It shows the plumes of a headdress and nine glyphs from the upper right portion of the monument. At present it has been pulled out and laid on the northwest end of the structure, under a sheet of plastic.

Date and Protagonist

The three columns of glyphs compose a nominal phrase for Shield Jaguar II. The last column is read straight down, so there were originally an uneven number of columns across the top. The re-use of a Shield Jaguar II monument suggests that Structure 64 was very late, built perhaps during the reign of Mah K'ina Skull III or even later.

Structure 88

(Lintel 55)

Structure 88 is a small pile of rocks nearly 1 km southeast of Structure 54. Bolles noted that the masonry terracing continued past Structure 53, but neither he nor Satterthwaite continued along the trail to investigate the structure.

MONUMENT

Dimensions

	H	HSc	W	Th
Lintel 55	1.20 m	0.71 m	0.95 m	0.18 m

The lintel was found in late 1933 or early 1934 by Ulises de la Cruz. He said it was falling from the doorway of this structure. It survived the years intact. Graham noted the use of plaster to fill imperfections in the stone (1979:119). It was removed to MNAH in 1964.

Date and Protagonist

The lintel has no dates nor glyphs. It probably dates to the reign of Mah K'ina Skull III or later. I would not rule out the possibility that this area was in control of a different family and was a secondary site to Yaxchilan. The artist used traditional Yaxchilan themes—a female holding a bloodletting bowl, a bearded serpent from whose mouth emerges a human head—and the fact that the monument is a carved lintel with two figures places it well within the sphere of influence of Yaxchilan.

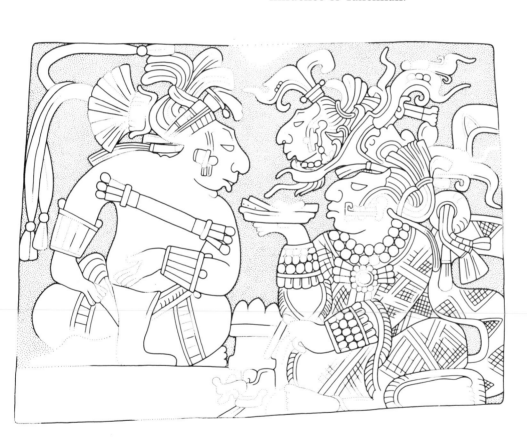

159.

Structure 88, Lintel 55. Drawing by Graham (1979:119).

Appendix 1

Location of Monumental Sculptures at Yaxchilan upon Discovery

Designation	Location
Stela 1	In the Main Plaza, aligned with the Grand Stairway
2	At intersection of first terrace and Grand Stairway
3	In center of southeast end of Main Plaza, elevated on a platform (suspected to have been associated originally with Structure 6)
4	Southeast in row of 4 stelae in front of stairway to Structure 20
5	Second from southeast in row of 4 stelae in front of stairway to Structure 20
6	Third from southeast in row of 4 stelae in front of stairway to Structure 20
7	Northwest end of row of 4 stelae in front of stairway to Structure 20
8	On summit of Structure 18
9	East of stairway leading to Structure 36, Central Acropolis
10	In front of Structure 39, South Acropolis
11	Middle of 3 stelae in front of Structure 40, South Acropolis
12	Southeast of 3 stelae in front of Structure 40, South Acropolis
13	Northwest of 3 stelae in front of Structure 40, South Acropolis
14	Northwest of 3 stelae in upper row on terrace in front of Structure 44, West Acropolis
15	Northwest in row of 2 stelae on second terrace in front of Structure 41, South Acropolis
16	Southeast in row of 2 stelae on second terrace in front of Structure 41, South Acropolis
17	Middle in row of 3 stelae on the first terrace in front of Structure 44, West Acropolis
18	Northwest in row of 3 stelae on first terrace in front of Structure 41, South Acropolis
19	Middle in row of 3 stelae on first terrace in front of Structure 41, South Acropolis
20	Southeast in row of 3 stelae on first terrace in front of Structure 41, South Acropolis
21	Northwest of 2 monuments on lower terrace in front of Structure 44, West Acropolis
22	Southeast of 3 stelae in upper row on terrace in front of Structure 44, West Acropolis
23	Southeast of 2 monuments on lower terrace in front of Structure 44, West Acropolis
24	Found re-used in the construction of Structure 64, Southeast Group
25	Northwest of 2 stelae in front of Structure 62, Southeast Group
26	Southeast of 2 stelae in front of Structure 62, Southeast Group
27	In front of Structure 9, river side structures
28	At intersection of Grand Stairway and First Terrace, to the northwest of Stela 2
29	In debris in front of Structure 44, West Acropolis
30	Found re-used as a metate on the easternmost of two small mounds just east of Structure 2 on First Terrace
31	Excavated from a pit in front of Structure 33 (stalactite stela)
32?	Uncarved stela (official designation uncertain); location unknown
33	Stela fragment excavated from within the platform supporting Stela 3, Southeast Plaza, in front of Structure 20
34?	Location unknown
35	Excavated from the interior of Structure 21[a]

Altar	1	Northeast of 2 altars in front of Structure 19, northwest end, Main Plaza
	2	Southwest of 2 altars in front of Structure 19, northwest end, Main Plaza
	3	Associated with 5 plain altars in front of stairway leading to Structure 36, Central Acropolis
	4	Within Structure 39, South Acropolis
	5	On terrace in front of Structure 39, South Acropolis
	6	On terrace in front of Structure 39, near Stela 10, South Acropolis
	7	In front of Structure 23 on floor of Main Plaza
	8	Along Grand Stairway, between First and Second Terraces
	9	In front of Structure 33 on northwest side of platform, Central Acropolis
	10	Northwest side of Stela 1, Main Plaza
	11	Northwest side of Stela 1, Main Plaza
	12	Northwest side of Stela 1, Main Plaza
	13	In front of Structure 40, at northeast corner of building's platform, near Stela 12, South Acropolis
	14	Immediately outside central doorway to Structure 40, South Acropolis
	15	In front of Structure 40, between Stelae 11 and 13, South Acropolis
	16	Near Stela 28, at intersection of First Terrace and Grand Stairway
	17	In front of Structure 22, on First Terrace
	18	In front of Structure 23, on First Terrace
	19	Partial monument, associated with Stela 2 on First Terrace
	20	Behind Stela 28 on First Terrace
	21	On temple side of Stela 4, First Terrace, on the floor of the Southeast Plaza
Lintel	1	Southeast entrance, Structure 33
	2	Middle entrance, Structure 33
	3	Northwest entrance, Structure 33
	4	In front of Structure 34
	5	East entrance, Structure 1
	6	Middle entrance, Structure 1
	7	West entrance, Structure 1
	8	Entrance on east end of Structure 1
	9	In front of Structure 2
	10	East entrance, Structure 3
	11	West entrance, Structure 3 (plain)
	12	Southeast entrance, Structure 20
	13	Middle entrance, Structure 20
	14	Northwest entrance, Structure 20
	15	Southeast entrance, Structure 21
	16	Middle entrance, Structure 21
	17	Northwest entrance, Structure 21
	18	Entrance at southeast end of Structure 22
	19	Entrance on northwest end of Structure 22
	20	Second entrance from southeast, Structure 22
	21	Middle entrance, Structure 22
	22	Fourth entrance from southeast, Structure 22
	23	Entrance on northwest façade of Structure 23
	24	Southeast entrance, Structure 23
	25	Middle entrance, Structure 23
	26	Northwest entrance, Structure 23
	27	Southwest entrance, Structure 24
	28	Northeast entrance, Structure 24
	29	Second entrance from northwest, Structure 10
	30	Third entrance from northwest, Structure 10
	31	Southeast entrance, Structure 10
	32	Middle entrance, Structure 13
	33	Northeast entrance, Structure 13
	34	Southwest entrance, Structure 12

35 Fifth entrance from southwest, Structure 12
36 Middle entrance, Structure 12
37 Sixth entrance from southwest, Structure 12
38 Southwest entrance, Structure 16
39 Middle entrance, Structure 16
40 Northeast entrance, Structure 16
41 Southwest entrance, Structure 42
42 Middle entrance, Structure 42
43 Northeast entrance, Structure 42
44 Southeast entrance, Structure 44
45 Middle entrance, Structure 44
46 Northwest entrance, Structure 44
47 Second entrance from southwest, Structure 12
48 Third entrance from southwest, Structure 12
49 Northeast entrance, Structure 12
50 Southwest entrance of Structure 13
51 East entrance, Structure 55
52 Middle entrance, Structure 55
53 West entrance, Structure 55
54 Middle entrance, Structure 54
55 Middle entrance, Structure 88
56 Likely from central entrance to Structure 11
57 East entrance, Structure 54
58 West entrance, Structure 54
59 Middle entrance, Structure 24
60 New Lintel, north façade of Structure 12

Full-figured-glyph Throne
1 Associated with Structure 6
2 Another of unknown provenience

Anthropomorphic Seated Figure
 Middle niche, interior of Structure 33

Wall Panel
 Structure 8

Hieroglyphic Stairway
I Structure 5
II Structure 33
III Structure 44
IV Structure 41
V Structure 20

Ballcourt Markers
 Along longitudinal axis of Structure 14 (five)

Stucco Decoration (still visible)
 Structure 6 frieze: inset panels with anthropomorphic masks
 Structure 13 frieze: masks
 Structure 19 frieze and roofcomb: something in niches
 Structure 18: glyphs painted in red on stucco along base
 Structure 20 frieze: seated figures in niches on thrones; low-relief monster and plant motifs
 Structure 21 interior: wall panel showing five figures seated on a split-sky throne, painted in polychrome
 Structure 23 interior: serpent band around vaultspring; exterior: bits of long-nosed monsters

Structure 33 frieze and roofcomb: seated figures in niches on thrones
Structure 39 frieze and roofcomb: seated figures surrounded by undulating forms
Structure 40 frieze: seated figures in shallow niches created by stone armature
Structure 41 frieze: band of glyphs below cornice; high-relief monster masks

Murals

Structure 40, interior
Structure 44, interior

Source: Based on compilations by Maler (1903) and Morley (1937–1938).
[a]Mathews 1988:10.

Appendix 2

Chronology of Yaxchilan

This appendix lists all recorded dates, whether correct or not. It also lists the reconstructions most likely in the author's opinion. Arguments are presented in Part Two.

Parentheses indicate that the date is reconstructed from partial calendric data; square brackets indicate that the date is implied by context. A question mark follows the uncertain part of a date or indicates missing information.

The correlation constant between Maya and Julian calendars used here is 584285.

Monument abbreviations: **A,** altar; **e,** front edge;

HS, hieroglyphic stair block; **Hse,** House; **L,** lintel; **MP,** Main Plaza; **SP,** Step; **St,** Stela; **u,** underside.

Event abbreviations: **A,** accession; **Anniv,** anniversary event; **B,** birth; **Ball,** ballgame; **Basket,** basket-staff event; **Bird,** bird-cross event; **Bl,** bloodletting; **C,** capture; **Comp,** completion; **D,** death; **Fire,** "fire" glyph (monument dedication); **Flap,** flapstaff event; **God K,** hand-holding-God-K verb; **K,** *katuns* as Ahau; **N,** "God N" (dedication event); **PE,** Period Ending; **Star,** "star-over-earth" war verb; **4,** 4 *te zotz* verb (relates to monument dedication); **819,** 819-day-count verb.

Long Count	Calendar Round	Recorded Event	Protag-onists	Structure, Monument	Julian Date
9. 0? 0. 0. 0	8 Ahau 13 Ceh?	?	?	40, A 13	10 Dec 435
9. 0.19. 2. 4	2 Kan 2 Yax	A?	R7	22, L 21	15 Oct 454
9. 3. 0. 0. 0	2 Ahau 18 Muan	?		Pop Panel	29 Jan 495
(9. 3. 3.16. 4)	2 Kan 2 Mac	?		Pop Panel	3 Dec 498
(9. 3.13.12.19)	1 Cauac 7 Yaxkin	?	KEJ	12, L 37	7 Aug 508
(9. 3.19.12.12)	9 Eb 10 Zac	?	KEJ	PN, L 12	30 Jun 514
9. 4. 0. 0. 0	(13 Ahau 18 Yax)	?	KEJ?	9, St 27	16 Oct 514
(9. 4. 6.14. 9)	5 Muluc 12 Zec	?		Pop Panel	30 Jun 521
9. 4. 8. 8.15	13 Men 13 Kayab	?	KEJ	44, St 14	26 Feb 523
9. 4.11. 8.16	2 Cib 19 Pax	A	MKSII	12, L 47–48	11 Feb 526
(9. 5. 2.10. 6)	1 Cimi 14 Muan	?	MKSII	12, L 35	14 Jan 537
(9. 6.10.14.15)	4 Men 3 Mac	C FB	KEJII	44, Sp 1	17 Nov 564
(9. 8. 0.15.11)	4 Chuen 9 Xul	C	?	44, Sp VI	29 Jun 594
[9. 9. 0. 0. 0	3 Ahau 3 Zotz]		?	33, St 2	9 May 613
[9. 9. 16.10.13	9 Ben 16 Yax]	A	BJIII	20, St 6	15 Sep 629
(9 .10. 3.11. 8)	9 Lamat 16 Ch'en	Ball	BJIII	33, Sp VIII	24 Aug 636
(9 .10. 14.13. 0)	10 Ahau 13 Mol	C	BJIII	44, Sp V	30 Jul 647
(9 .10. 16.10.13)	7 Ben 16 Zec	Comp 1k	BJIII	20, St 3	2 Jun 649
(9 .11. 6.16.11)	7 Chuen 14 Ch'en	C SJ?	Pacal	Pal Hse C	7 Aug 659
9 .11. 16.10.13	5 Ben 1 Uayeb	Comp 2k	BJIII	20, St 6	17 Feb 669
(9 .12. 8.14. 0)	11 Ahau 3 Pop	C AA	SJ	41, St 19	21 Feb 681
9 .12. 8.14. 1	12 Imix 4 Pop	C AA	SJ	44, Sp III	22 Feb 681
()				41, St 15	
()				44, L 45	

Appendix 2

Long Count	Calendar Round	Recorded Event	Protagonists	Structure, Monument	Julian Date
9 .12. 9. 8. 1	5 Imix 4 Mac	A	SJ	44, Sp III	20 Oct 681
()				23, L 25u	
[]				41, St 19	
(9 .12. 17.12. 0)	13 Ahau 3 Muan	C	SJ	44, L 44	26 Nov 689
9 .13. 0. 0. 0	8 Ahau 8 Uo	PE	SJ	41, Sp I	14 Mar 692
(9 .13. 9.14.14)	6 Ix 17 Kankin	C	SJ	41, St 20	17 Nov 701
[9 .13. 10. 0. 0	7 Ahau 3 Cumhu	PE	SJ]	41, St 20	22 Jan 702
(9 .13. 13.12. 5)	6 Chicchan 8 Yax (Zac)	D	LP	24, L 27	8 Sep 705
(9 .13. 16.10.13)	1 Ben 1 Ch'en	819	—	10, L 30	22 Jul 708
9 .13. 17.12.10	8 Oc 13 Yax	B	BJIV	10, L 29–30	23 Aug 709
(9 .13. 17.15.12)	5 Eb 15 Mac	Bl, N	SJ, Xoc	23, L 24u	24 Oct 709
		28(365.25) + 4 since accession SJ			
		80(365.25) + 39 since accession BJIII			
		Jupiter and Saturn aligned, stationary			
(9 .13. 17.15.13)	6 Ben 16 Mac	Bl	SJ, LIS	55, L53	25 Oct 709
()				13, L 32	
(9).14.(1.17.14)	5Ix 17 Kankin	C AK	SJ	44, L 46	14 Nov 713
()				44, Sp I	
9 .14.(9.12. 9	1 Muluc 12?) Yaxkin	Fire	Xoc	23, L 26e	20 Jun 721
		Summer solstice			
(9 .14. 11.10. 1)	7 Imix 14 Zotz	4, Fire	SJ	44, Sp IV	23 Apr 723
9 .14.(11.12.18	12 Etznab 11?) Yaxkin	Fire	Xoc	23, L 26e	19 Jun 723
		Summer solstice			
(9 .14. 11.15. 1)	3 Imix 14 Ch'en	N	Xoc	23, L 25e	1 Aug 723
(9 .14. 12. 6.12)	12 Eb O Pop	N	GI?, SJ	23, L 26u	7 Feb 724
(9 .14. 14. 8. 1)	7 Imix 19 Pop	Anniv	SJ, Xoc	23, L 23u	26 Feb 726
		Comp 45(360) reign			
9 .14.(14.13.16	5 Cib 14?) Yaxkin	Fire	Xoc	23, L 26e	21 Jun 726
		Summer solstice			
(9 .14. 14.13.17)	6 Caban 15 Yaxkin	Fire	Xoc	23, L 23u	22 Jun 726
		Summer solstice			
9 .14. 15. 0. 0	11 Ahau 18 Zac		?	23, A 7	13 Sep 726
	[BJIV becomes 2 Katun Ahau]				
(9 .14. 17.15.11)	2 Chuen 14 Mol	C AC	SJ	44, Sp I	10 Jul 729
		Jupiter & Saturn stationary & aligned			
	3 Eb 14 Mol	C AC	SJ	41, St 18	10 Jul 729
(9 .15. 0. 0. 0)	4 Ahau 13 Yax	Bl	SJ	44, Sp V	18 Aug 731
[41, St 18]	
(9 .15. 0.12. 0)	10 Ahau 8 Zotz	C NC	SJ	44, Sp V	14 Apr 732
(9 .15. 0.15. 3)	8 Akbal 11 Yaxkin	Bl	SJ	44, Sp V	16 Jun 732
		Summer solstice			
9 .15. 3. 1. 5	4 Chicchan 3 Zac	?		33, A 10	27 Aug 734
(9 .15. 3.16. 6)?	6 Cimi? 19 Yaxkin	Flap	SJ	41, St 16	24 Jun 735
(9 .15. 4.16.11)?	7 Chuen? 19 Yaxkin	Flap	SJ	41, St 16	23 Jun 736
9 .15. 6.13. 1	7 Imix 19 Zip	Fire	SJ,?	11, L 56	4 Apr 738
		1st appearance Venus as Morning Star			
[9 .15. 9. 8. 1	12 Imix 9 Pax]	Comp 3 K	SJ	MP throne	9 Dec 740
(9 .15. 9.17.16)	12 Cib 19 Yaxkin	Flap	SJ, BJIV	40, St 11	22 Jun 741
		Summer solstice			
(9 .15. 10. 0. 1)	4 Imix 4 Mol	Bl	BJIV	16, L 39	27 Jun 741
		Summer solstice; 1st appearance Venus as Morning Star			
()			LIS	21, St 35	
()			Lord &	20, L 14	
			Lady		
			Great		
			Skull		

Long Count	Calendar Round	Recorded Event	Protag-onists	Structure, Monument	Julian Date
(9 .15. 10.17.14)	6 Ix 12 Yaxkin	D	SJ	24, L 27	15 Jun 742
		10(365.24) since 44, SpV			
()				40, St 12	
()				19, A 1	
9 .15. 13. 6. 9	3 Muluc 17 Mac	Ball	BJIV	33, Sp VII	17 Oct 744
		35(365.25) since L 24; Jupiter stationary			
(9 .15. 15. 0. 0)	9 Ahau 18 Xul	Bl	SJ	40, St 11	31 May 746
			u cab		
			BJIV		
			??		
()				19, A 1	
(9 .15. 16. 1. 6)	5 Cimi 19 Yaxkin	Flap	BJIV	13, L 33	21 Jun 747
		Summer solstice			
9 .15. 16.10. 0?	10 Ahau 13 Pax?	?	?	33, A 16	12 Dec 747
		[BJIV becomes 3 Katun Ahau]			
(9 .15. 17.15.14)	3 Ix 17 Zip	D	Xoc	24, L 59–28	30 Mar 749
(9 .15. 18. 3.13)	5 Ben 16 Ch'en	Canoe	?	PN Str 013,	27 Jul 749
			Jaguar	L 3	
(9 .15. 19. 1. 1)	1 Imix 19 Xul	?	BJIV	40, St 11	31 May 750
		4(365.25) since 9.15.15.0.0, St 11			
		1st appearance Venus as Evening Star			
(9 .15. 19.14.14)	1 Ix 7 Uo	819	—	40, St 11	28 Feb 751
(9 .15. 19.15. 3)	10 Akbal 16 Uo	D	LIS	24, L 28	9 Mar 751
9 .16. 0. 0. 0	2 Ahau 13 Zec	PE	BJIV?	33, A 9	5 May 751
		1st zenith passage			
				41, Sp III	
(9 .16. 0.13.17)	6 Caban 5 Pop	C Q	BJIV	21, L 16	5 Feb 752
		36(260) since L 23 Fire event			
		26(360) since L 23 Fire event			
()				41, Sp III	
(9 .16. 0.14. 5)	1 Chicchan 13 Pop	B	SJII	20, L 13	13 Feb 752
		Bl	BJIV,		
			Lady		
			GS		
9 .16. 1. 0. 0	11 Ahau 8 Zec	A	BJIV	40, St 11	20 Apr 752
()				10, L 30	
				39, A 4	
				40, A 14	
()				33, L 1	
()				40, St 12	
()				41, Sp III	
(9 .16. 1. 0. 9)	7 Muluc 17 Zec	4	BJIV	22, L 21	8 May 752
		1st zenith passage			
(9 .16. 1. 2. 0)	12 Ahau 8 Yaxkin	Bird	BJIV,	1, L 5	8 Jun 752
			LAI		
()		God K	BJIV,	42, L 42	
			CoM		
9 .16. 1. 3. 5?	11 Chicchan 13 Mol?	?	BJIV?	33, A 11	3 Jul 752
(9 .16. 1. 8. 6)	8 Cimi 14 Mac	Basket	BJIV,	1, L 6	12 Oct 752
			CoM		
()		Bl	BJIV,	42, L 43	
			Ix		
(9 .16. 1. 8. 8)	10 Lamat 16 Mac	God K	BJIV	1, L 7	14 Oct 752
		8(365) after 3 Muluc 17 Mac ballgame			
9 .16. 1. 9. 3	12 Akbal 11 Kankin	?	BJIV	36, A 3	29 Oct 752
(9 .16. 3.16.19)?	4 Cauac? 12 Zip	Bl	LAI	21, L 15	24 Mar 755
		6(365.25) less 6 days since Xoc's death			

	Long Count	Calendar Round	Recorded Event	Protagonists	Structure, Monument	Julian Date
Appendix 2	(9 .16. 4. 1. 1)	7 Imix 14 Zec	C JS	BJIV, CoM	1, L 8	5 May 755
			1st zenith passage			
	()		Star	BJIV, LAI	42, L 41	
	(9 .16. 4. 6.17)	6 Caban 10 Yax (Zac)	Fire	Xoc	24, L 28	23 Aug 755
			41 (260) since L 23 fire event			
			5 (260) since capture of Q			
			46 (365.25) since BJIV birthday			
	(9 .16. 5. 0. 0)	8 Ahau 8 Zotz	God K	BJIV, Man of L 3	33, L 3	8 Apr 756
	()			BJIV, LGS	54, L 54	
	(9 .16. 6. 0. 0)	4 Ahau 3 Zotz	Bird	BJIV, SJII	33, L 2	4 Apr 757
	(9 .16. 7. 0. 0)	13 Ahau 18 Zip	Bl	Ix	16, L 40	29 Mar 758
			9(365.25) less 1 day since Xoc's death			
	(9 .16. 7. 9. 2)?	13 Ik? 0 Mac	?	BJIV	36, St 9	27 Sep 758
	(9 .16. 8.16.10)	1 Oc 18 Pop	819	—	33, St 1	16 Feb 760
	9 .16. 10. 0. 0	1 Ahau 3 Zip	Bl	BJIV	33, St 1	13 Mar 761
	(9 .16. 12. 5.14)	3 Ix 7 Mol	Bl	LAI	16, L 38	25 Jun 763
			22(365.25) + 2 days since 4 Imix 4 Mol			
	(9 .16. 13. 0. 0)	2 Ahau 8 Uo	Fire	BJIV	10, L 31	25 Feb 764
	(9 .16. 15. 0. 0)	7 Ahau 18 Pop	God K	BJIV, SJII	55, L 52	15 Feb 766
	(9 .16. 16. 0. 9)	12 Muluc 2 Uo	?	BJIV	Looted L	19 Feb 767
	(9 .16. 17. 2. 4)?	4 Kan? 12 Zip	Bl	LAI	21, L 15	20 Mar 768
	(9 .16. 17. 6.12)	1 Eb Stg Yaxkin	Flap	BJIV	2, L 9	16 Jun 768
			Summer solstice			
	(9 .17. 0. 0. 0)	13 Ahau 18 Cumhu	Comp	BJIV	10, L 31	20 Jan 771
	[9 .17. 1. 0. 0	9 Ahau 13 Cumhu?]	PE	SJII	20, St 7	14 Jan 772
	(9 .17. 1.15.13)?	10? Ben 1 Pax	Bl	SJII	44, St 21	23 Nov 772
	(9 .17. 4.15. 3)	1 Akbal 16 Kankin	819	SJII	20, St 4	29 Oct 775
	[9 .17. 5. 0. 0	6 Ahau 13 Kayab]	PE	SJII	20, St 4	25 Dec 775
	(9 .17. 16. 3. 8)	4 Lamat 6 Cumhu	C	SJII	Bon L 2	4 Jan 787
	(9 .17. 18. 1.13)?	13 Ben 1 Pax	Bl	SJII	44, St 21	19 Nov 788
	(9 .18. 6. 4.19)?	8 Cauac 7 (Kayab)?	C	SJII	20, HS 50	13 Dec 796
	(9 .18. 6. 5.11)	7 Chuen 19 Kayab	?	SJII	20, St 5	25 Dec 796
	()				20, HS 69	
	(9 .18. 7. 6. 0)	12 Ahau 3 Cumhu	C	SJII	20, HS 92	29 Dec 797
	(9 .18. 7.16. 9)	13 Muluc 7 Yax	C	SJII	20, HS 103	26 Jul 798
	(9 .18. 8. 3. 3)	3 (Akbal) 1 Muan	C	SJII	20, HS 113	28 Oct 798
	(9 .18. 8.10.13	10 Ben 6 Zotz)	C	SJII	20, HS 123	27 Mar 799
	(9 .18. 9. 6. 6)	10 Cimi 19 Kayab	C	SJII	20, HS 135	25 Dec 799
	(9 .18. 9. 7.18)	3 Etznab 6 Pop	C	SJII	20, HS 146	25 Jan 800
	(9 .18. 9. 9.14)	13 Ix 2 Zip	C	SJII	20, HS 157	2 Mar 800
	(9 .18. 9.10.10)	3 Oc 18 Zip	C	SJII	20, HS 167	18 Mar 800
	(9 .18. 17.12. 6)	7 Cimi 14 Zip	A?	MKSIII	3, L 10	12 Mar 808
	(9 .18. 17.13.10)?	5 Oc? 18 Zotz	Fire	MKSIII	3, L 10	5 Apr 808
	(9 .18. 17.13.14)	9 Ix 2 Zec	??	MKSIII	3, L 10	9 Apr 808

Appendix 3

English Paraphrases of Yaxchilan Hieroglyphic Texts

This information is based on the *Notebook for the XV Hieroglyphic Workshop at Texas*, by Linda Schele, and on a transcription of the commentary at that workshop transcribed and edited by Phil Wanyerka, called "The Proceedings of the Maya Hieroglyphic Workshop, March 9–10, 1991," unpublished photocopy.

Lintel 1

On 11 Ahau 8 Zec, the Lord of the Night put on the headband (A1–B1). He goes possessing the K'auil (God K) scepter (B2–C1). He dances (C1b) the ——— Dance (D1), the Sky God (C2–A3), Mix Nal Bird Jaguar (A4–A5), . . . He of 20 Captives (A6), the Guardian (Captor) of Ah Uc (A7–A8), the Guardian of Jeweled Skull (A9–E1), the 3 Katun conch shell player (A10–E2), the 3 Katun Yahau Te (F1–F2), Holy Yaxchilan Ahau (Lord) (G1), West Chac Te (Great Tree) (G2–H2). She goes receiving in the sky the First Man, First Serpent, Lady Pac, Ch'a Nal Uinic Lady Great Skull (I1–K3), mother of Chel-te, the Conch Shell Trumpet Lord (L1–L3).

Lintel 2

On 4 Ahau 3 Zotz (A1–B1) it expired (C1), his 5th *tun* (D1) as Ahau of the lineage (E1). He danced with the bird-cross staff (F1–G1), Bird Jaguar, He of 20 Captives (H1–I1), the Guardian of Ah Uc (J1–J2); the 3 Katun Ahau, the Holy Lord of Yaxchilan, Bacab (J3–L1). He goes doing the dance with the bird-cross staff (M1–O1), Cloudy Sky, Penis Chac (P1–P2), Chel-te, Chan Mah k'ina, Holy Lord of Yaxchilan (Q1–Q3).

Lintel 3

On 8 Ahau the 9th Lord of the Night took the headband on 8 te Zotz (A1–C1), the ending of the *hotun* (D1a). He went holding the God K scepter, dancing as Ch'ahom (One Who Scatters Incense) (D1'–D2) . . . Nix Nal Bird Jaguar (D3–E1), He of 20 Captives (E2), the Guardian of Ah Uc (F1–G1), the Guardian of Jeweled Skull (F2–G2), the 3 Katun Ahau (H1–I1), the 3 Katun Ch'ahom (H2–I2).

[Titles of] K'in Ahau Mo', Cahal (Secondary Lord).

Lintel 5

On 12 Ahau 8 Yaxkin (B1–C1) he danced the bird-cross scepter (B2–C2) . . . the Sky God, Mix Nal (D1–D2), Bird Jaguar IV, He of 20 Captives, Holy Yaxchilan Lord (D3–D5). Lady 6 Sky Ahpo Ik (A1–A3).

Lintel 6

On 8 Cimi 14 Mac (B1–B2) he danced the God K basket-staff (B3–B4), He of 20 Captives (B5), 3 Katun Ahau Bird Jaguar IV (B6–B7). He went dancing (A1–A2) *ti chac kot* (A3), the Guardian of Ko Te Ahau (A4–A5), Kan Tok Ba Cahal (A6–A7).

Lintel 7

On 10 Lamat 16 Mac (A1–B1) he danced the God K scepter (A2–B2), Mix Nal Bird Jaguar IV (B3–B4), the Guardian of Ah Uc (C1–D1), He of 20 Captives (E1), Holy Lord of Yaxchilan (E2). [Titles of] the woman (Lady Ix?) (F1–F2).

Lintel 8

On 7 Imix 14 Zec (A1–A2) was captured Jeweled Skull (A3–A4) the captive (E1) of Bird Jaguar IV, Holy Yaxchilan Lord (E2–E3), the Guardian of Ko Te Ahau, Kan Tok (B1–D1) . . . Secondary Lord (D3).

Lintel 9

On 1 Eb end of Yaxkin (A1–A3) he danced raising the sky staff (A4–B2), the 3 Katun Ahau Bird Jaguar (B3–B4), the Guardian of Ah Uc (B5–B6), He of 20 Captives (B7), Holy Yaxchilan Lord (B8). [Titles of] Lord Great Skull, He of 7 Captives (C1–C4).

Lintel 13

On 1 Chicchan 13 Pop (A1–A2) was born Chel-te (A3–A4). She went doing . . . , Lady Great Skull (C1–C3) . . . He went doing (E1), the First Man (E2), Bird Jaguar, He of 20 Captives (E3–E4), the Guardian of Ah Uc (F1–F2), 3 Katun Ahau, Holy Lord of Yaxchilan, Bacab (F3–F5).

Lintel 14

On 4 Imix 4 Mol (A1–B1) it was manifested (A2), the God K serpent of the sky (B2–B3), Chac Bay Chan (A4), its shamanic spirit (B4), by Lady Great Skull (C1–C4). It was recorded with the bloodletter . . . Lord Great Skull (D1–D5).

She acted, Lady Yaxchilan Ahau, Lady Yaxal (E1–G1).

Lintel 15

On 4 Cauac 12 Zip (A1–B1) it was manifested (A2), Yax Lo Na Chan (B2–C1), the shamanic spirit of God K (D1–E1). And then it was manifested *yax hem* out of the earth (D2–E3). It was recorded by Lady 6 Tun Ahpo Ik Lady Bacab (F1–F5).

Lintel 16

On 6 Caban 5 Pop (A1–B1) was captured "Q" (A2–B2), Secondary Lord of a great lord (A3–E1), by (F1) the 3 Katun Ahau Bird Jaguar IV, He of 20 Captives, Holy Lord of the Split Sky Place (F2–F5).

Lintel 17

He did . . . (A1). Was born Chel-te (A3–B3) . . . the 3 Katun Ahau, Bird Jaguar IV (A5–B5), He of 20 Captives, Holy Lord of Yaxchilan, Holy Lord of the Split Sky (C1–C3).

She acted (D1), Lady . . . Jaguar, Lady Ix Mountain, Ahau Bacab (E1–K1).

Lintel 21

And so it was 9 *baktuns*, 0 *katuns*, 19 *tuns*, 2 *uinals*, and 4 days on 2 Kan (A1–A4), 8th Lord of the Night (B4), Moon Age 7 (B5), 3 lunations in the half-year ended (A6). Name of lunation, 29 days in the lunation (B6), on 2 Yax (A7), was dedicated the cache in the building called Chan Xunal (A7b–B7b), the house of Mah K'ina Moon Skull (B7b–B8), the 7th successor of Yahau Te, the founder of Yaxchilan (C1–D2). And it was 5 days and 16 *uinals* and 1 *tun* and 15 *katuns* later, on 7 Muluc 7 Zec (C3–D5), it was planted the cache in Chan Xunal (C6) [by] the Sky God, Bird Jaguar IV, 3 Katun Ahau, He of 20 Captives (D6–D8).

Lintel 23 Front Edge

On 10 Muluc 17 Uo (A1–B1) was dedicated U Pasil (A2–B2), House of Lady Xoc (C1–D1), the sibling of Lady Pacal [Xoc?] (C2–D2). She was child of the mother Lady Xibalba (E1–E2) and child of the father the 1 Katun, the Secondary Lord Ah Kan Nun K'abal Xoc (F2–J1) who was the sibling of Lady Na Ta Hal Tun Bacab (I2–K1), who was the mother of Na K'abal Xoc (L1–L2). [The genealogy recorded on this lintel is very convoluted and not well understood.]

Lintel 23 Underside

Its change 16 days, 5 *uinals*, and 0 *tuns* after it had happened, 7 Imix 19 Pop (A1–C2), it ended his 5th *tun* in the 3rd *katun* as Ahau of the lineage (D2–B3), the Sky God (C3–D3), the Guardian of Ah Ahaual, Shield Jaguar, Holy Lord of the Split Sky Place (A4–D4). And then it happened, 6 Caban 15 Yaxkin (A5–C5), entered the smoke (D5) Ok K'in Ha Nal (name of Temple 23) (A6), its holy name (B6), the house of (C6) Holy Lady (D7) West (B8) Chac Te (C8), Lady Ahau Te (D8) . . . Lady Xoc . . . under the auspices of the 4 Katun Ahau Shield Jaguar (E1–H8).

Lintel 24

On 5 Eb 15 Mac (A1–B1) it was happening (B1b), the autosacrifice (C1) with the perforator (D1), his autosacrifice, the 4 Katun Ahau (E1) Shield Jaguar, Guardian (F1) of Ah Ahaual (F2), Holy Lord of the Split Sky Place (F3).

It was happening, her autosacrifice, Lady Fist Xoc (G1–G4).

It was dedicated, the sculpture, [by] Macaw Chac, the Sculptor (H1–H4).

Lintel 25 Underside

The One Who Scatters Incense, Lady Xoc, during the vigil for the ceremony in the plaza at the Split Sky Place (H1–I3).

On 5 Imix 4 Mac (A1), its conjuring, its substitute spirit (B1), its flint lance and war shield (C1), of He of Smoke, O Chac (D1), its holy perforator to conjure (E1) the 4 Katun Shield Jaguar, the Guardian of Ah Ahaual, the Holy Lord of Yaxchilan, Bacab (F1–F4).

It is recorded, [the] alter ego [in?] [of?] the house of the Founder of the Lineage (G1–G2).

Lintel 25 Front Edge

There is a change (A1) of 0 days, 7 *uinals*, 2 *tuns* (B1–B2), and 2 *katuns* later, since the conjuring of the founder's spirit, in the plaza at the Split Sky Place (C1–D2). And then it happened, on 3 Imix 14 Ch'en, she dedicated (E1–F2) the carving of her temple, Lady Holy (G1–H2) Lady Sky God Xoc, Lady K'abal Xoc (I1–J2), Lady Chac Te, in the opening to the Underworld at the Split Sky Place (K1–L2). His territory, the Guardian of Ah Ahaual, Shield Jaguar, Holy Lord of the Split Sky Place (M1–N2).

Lintel 26 Underside

On 12 Eb 0 Pop (O1–O2) it made its debut (O3), the sculpture . . . Ah Sak (the name of the Elegant Knot Artist) (R4).

He is going to leave (S1–T1) grasping? (T1b) . . . on the jaguar throne (U2) 7 Kinich Ahau, 4 Katun Ahau (U3–U4), his Guardian, Ah Ahaual (V1), Shield Jaguar, Holy Lord (W1–X1).

Lintel 26 Front Edge

On 9.14.14.13.17 6 Caban, G7 was the Lord of the Night, it was 8 days since the lunation arrived, the 4th lunation had ended, [Name of Lunation], its holy name, 30 days in the unripe lunation, on 15 Yaxkin

(A1–G2), to enter (H2) Name of Temple, its Holy Name House (I1–I2). She saw it (?) (J2) . . . Lady Xoc in the land of Shield Jaguar, Holy Lord of the Split Sky Place (K1–N2).

Lintel 27

On 6 Chicchan 8 Zac her spirit was diminished (A1–B2), Lady 6 Katun (D1a) Chac Te (D1b), Lady Pacal, Lady Yaxchilan Ahau, Lady Bacab (C2–D2). And then 9 days and 5 *uinals* and 17 *tuns* and 1 *katun*, it happened on 6 Ix 12 Yaxkin, his spirit was diminished (E1–F2), the 5 Katun Shield Jaguar (G1), the Guardian of Ah Ahaual (H1), the Holy Lord of the Split Sky Bacab (G2). And then 0 days and 17 *uinals* and 6 *tuns* (H2) [see Lintel 59].

Lintel 28

Lady Xoc (A1–B1). And 9 days and 15, 16, or 17 *uinals* and 1 *tun* later (A2), on 10 Akbal 16 Uo (B2–C1), her soul is diminished (D1). Lady One Man, Lady Serpent, . . . Holy Lady Ik Skull (C2–F1b). And then 14 days and 9 *uinals* and 4 *tuns* later (F1–E2), on 6 Caban 10 Zac (F2), it is dedicated (G1), the . . . of(?) Lady Xoc (H1–H2).

Lintel 29

Under the patronage of the month Yax it was 9.13.17.12.10 8 Oc (A1–A4). The 7th Lord of the Night ruled (B4) . . . 15 days after the full moon arrived (D1), five lunations had ended (C2), . . . was the holy name [of the unripe moon] (D2). It was a lunation of 30 days (D3). Six . . . fire is drilled (C4–D5).

Lintel 30

And 17 days, 1 *uinal*, and 1 *tun* after 1 Ben 1 Ch'en (A1–B2), when it was set in place (A3), the east (B3), red (A4); God K, the first created lord (A5–B5). On 13 Yax was born (C1–D1), Bird Jaguar IV (C2), He of 20 Captives (D2), Holy Lord of Yaxchilan, Holy Lord of the Split Sky Place (C3). And 10 days and 5 *uinals* and 3 *tuns* and 2 *katuns* later (D3–C4), his dance on 11 Ahau 8 Zec, he took the bundle as Ahau of the lineage (D4–D5).

Lintel 31

Bird Jaguar IV, He of 20 Captives (A1–B1), Holy Lord of Yaxchilan, Holy Lord of the Split Sky Place. And then 0 days and 0 *uinals* and 13 *tuns* later, counting to 2 Ahau 8 Uo (B2–A4), fire is drilled to dedicate Mah K'ina Itzam Na . . . its holy name, the temple (B4–C1) [of Bird Jaguar] (D1), He of 20 Captives, 3 Katun Holy Lord of Yaxchilan, Holy Lord of the Split Sky Place (C2–D2). And then 0 days and 0 *uinals* and 7 *tuns*, it was dedicated (?) (C3–D3) on 13 Ahau 18 Cumhu (C4–D4) . . . (C5), its 17th *katun* (D5).

Lintel 32

On 6 Ben 16 Mac (A1–B1) he went dancing (C1–D1) the bundle (E1–A2), the Sky God (A3–A4), Shield Jaguar (A5), the Guardian of Ah Ahaual, the 5 Katun Ahau (A6–A8), Ah Kan (A9) . . . Holy Lord of Yaxchilan, Holy Lord of the Split Sky Place (A11–A12).

Lady Holy Lady Ik Skull, "Sky Title" Lady Ah Chul, Lady Chac Te (H1–K3).

Lintel 33

On 5 Cimi 19 Yaxkin (A1–B1) he goes doing the dance (C1–D1), raising the sky (E1–F1). His 9 . . . *le* U Chac (G1–H1) . . . (A2) . . . the Sky God (A3–A8), Bird Jaguar IV, the 3 Katun Lord (A8), Guardian of Ah Cauac, Guardian of Jeweled Skull (A9–A12), He of 20 Captives, Holy Lord of Yaxchilan, Holy Lord of the Split Sky Place (I1–I3), West (I4) Chac Te, Bacab (I4–I6).

Lintel 34

. . . His holy bone (?) (A1–B1) . . . Holy Sky God (A2–B2) . . . Ahau (B3) . . . Lady Chuen (A5–B6), Lady Yax Pa Wa (?) . . .

Lintel 35

Its tenth in the succession of the royal accession (A1–B1) Mah K'ina Skull (A2), Holy Lord of the Split Sky Place (B2), had a relationship with Ah Cauac . . . Ahau . . . Jaguar [title] (A3–B4). Had a relationship with 9 [Name] [Titles] (A6–A7) Stela Lord (B8). Had a relationship with (C1) [Titles] (D1–D2) Knot Eye Jaguar, Lord of the Mat of Bonampak. On 1 Cimi 14 Muan (C4–D4) [relationship? verb] . . . placed the stone? (D6) Site Q Emblem Glyph (C7) . . .

Lintel 37

Its 8th in the succession of the royal accession (A1–B1) was Bird Jaguar II, Lord of the Place of the Split Sky (A2–B2). Had a relationship (?) with (A3) . . . Turtle Shell of Piedras Negras (A6–B6). Its 9th in the succession of the royal accession (A7–B7) was Knot Eye Jaguar, Lord of the Split Sky Place (A8–B8). He had a relationship (?) (C1) with [Name] of Bonampak (D1–D3). He had a relationship with Kan Te . . . Ahau (D4–D5). On 1 Cauac 7 Yaxkin (C6) he had a relationship with Jaguar . . . Ahau Jaguar Paw Skull (?) of Tikal (D6–D8).

Lintel 38

On 3 Ix 7 Mol (A1–B1) it was conjured, the God K Spirit (B2–A3), Lady Holy (A3–B3) Lady 6 Tun (C1–D1), Lady Ahpo Ik (C2–D2), Lady Bacab, West Chac Te (C3–D4).

Lintel 39

On 4 Imix 4 Mol (A1–B1) he conjured (A2) the substitute spirit of God K (B2), his territory (A3), he does it (A4), the Sky God (B4–C2), Bird Jaguar IV (D2), 3 Katun Ahau, He of 20 Captives (C3–D3), Holy Yaxchilan Ahau, Holy Ahau of the Split Sky Place (C4–D4).

Lintel 40

On 13 Ahau 18 Zip (A1–B1) she conjured the substitute spirit of God K (A2–B2), Lady Holy (A3–B3) Lady Jaguar (A4–B4), Lady Ix (C1–D1) . . . Ahau (D2), Lady Bacab (C3–D3), West (D4) . . .

Lintel 41

On 7 Imix 14 Zec (A1–B1) the star-shell-blood event *sa . . . huk* (B2). Was captured Jeweled Skull (C1–C2) by (C3) Bird Jaguar IV, Guardian of Ah Cauac (C4–C5), He of 20 Captives, 3 Katun Holy Ahau (E1–E3). Lady 6 Sky Ahpo Ik, Lady Bacab (F1–F4).

Lintel 42

On 12 Ahau 8 Yaxkin (A1–B1) he did the display of the God K scepter (C1–B2). He danced the . . . (B3–C3). Its shell-stone (?) (D1), 9 God K, He of Fire O Chac (E1–E2), his holy perforator (D3), he conjures (E3), Bird Jaguar, He of 20 Captives (D4–E4), 3 Katun Ahau, Guardian of Ah Cauac, Holy Lord of the Split Sky Place (F1–F4).

Lintel 43

On 8 Cimi 14 Mac (A1–B1) he dances (?), Bird Jaguar (A2–B2), . . . Guardian of Ah Cauac (A3–B3), He of 20 Captives, Holy Lord of the Split Sky Place (C1–C2). Lady Ix Witz, Lady Bacab (D2–D4).

Lintel 44

On 13 Ahau 3 Muan (A1–A2) was captured (A3) [name] by Shield Jaguar, Holy Lord of the Split Sky Place (A6).

Lintel 45

On 12 Imix 4 Pop (A1–B1) [was captured Ah Ahaual] (B1–A2) by (A2b) Shield Jaguar (B2) . . . [Guardian of] Ah Ahaual Ahau (C1–C2) [title] (C3), his replacement spirit (C5), the remembering of his shield (C6) . . .

Lintel 46

On [9.] 14. [1.7.14] 5 Ix . . . was the 14th day of the lunation, the 3rd lunation had ended . . . its holy name [of the lunation], 30 days in this lunation (B3–F2), on 14 Kankin (G2) was captured (F3) Ah Kan [titles] (G3–G4) by Shield Jaguar (F5–G5), Guardian of Ah Ahaual (F6–G6), Holy Lord of the Split Sky Place, his replacement (F7–G7), Knot Eye Jaguar (G8), his axe, his flint shield (F9–G9) . . .

Lintel 47

The 12th lunation had ended . . . was its holy name (A1–A2), 29 days in the lunation, on 19 Pax (B2–B3), he acceded as Ahau of the lineage (A4–B4) [titles of Ruler 10] (A4–D3), child of the father [titles] Mah K'ina Moon Skull (C4–D7), Split Sky Ahau (D7–C8), Chac Te (?) (D8).

Lintel 48

Under the patron of the month Pax there were 9 *baktuns* and 4 *katuns* and 11 *tuns* and 8 *uinals* and 15 *k'ins* on 2 Cib . . .

Lintel 49

. . . (A1–B2) the 5th in the succession of the royal lineage (A3–B3) was . . . (A4–B6). The 6th in the succession of the royal lineage was Mah K'ina Skull I (A8–B8), who had a relationship (?) (C1) with . . .

Bird Jaguar of Bonampak . . . (D1–D3). The 7th in the succession of the royal lineage was Moon Skull I, Split Sky Ahau (C4–D5). He had a relationship with Turtle Shell of Piedras Negras (C6–C7) and a relationship with . . . (D7–D8).

Lintel 50

He danced the flapstaff and raised the sky (A1–A3), Mah K'ina Skull III (A4–A5), [title], Holy Lord of Yaxchilan, Holy Lord of the Split Sky Place (A6–A8).

Lintel 52

On 7 Ahau 19 Pop (A1–B1), [verbs] (A2–C1), Ch'ahom [title] (D1) Bird Jaguar IV, He of 20 Captives (C2–D2), 3 Katun Ahau, Holy Yaxchilan Lord (E1–F1). He went doing it (G1) . . . , Shield Jaguar Chel-te (I1–I2), Mah K'ina Holy Yaxchilan Lord, Holy Lord of the Split Sky Place (I3–K1).

Lintel 53

On 7 Ben 16 Mac (A1–B1) he danced with the upended vase (?) (B2–C1), Shield Jaguar, the Guardian of Ah Ahaual (D1–C2), 5 Katun Ahau (D2). She went doing it with the upended vase (E1–E2), Lady Ik Skull Sky (E3–F1), Lady Ah Chul Nu (G2) . . . Chac Te (G3), Holy Yaxchilan Lord, Holy Ahau (H1–H2).

Lintel 54

On 8 Ahau 8 Zotz (A1–B1) he danced the [name of dance] (A2–B2), Bird Jaguar, the Guardian of Ah Cauac (C1–C2). Lady Great Skull (E1), Secondary Lady Nax Ahau, Holy Yaxchilan Ahau.

Lintel 56

Under the patronage of Zip, it was 9.15.6.13.1 7 Imix (A1–C2), the 9th Lord of the Night reigned, 11 days into the lunation, 5 lunations had ended, there were 30 days in the lunation (D2–F2), on 19 Zip (G1) it was dedicated (H1), [name] was its holy name (G2), the temple of (H2) Lady (I1), Lady of Site Q (?) (J1), Lady Choc Te (I2), Lady (J2) under the auspices of (J2b) the 5 Katun Ahau (K1), Guardian of Ah Ahaual (L1), Shield Jaguar, Holy Lord of the Split Sky Place (K2), Holy Lord of Yaxchilan, Bacab (L2).

Lintel 57

Lady Skull (A1–B1), Lady (C1), Secondary Lady (C2), Woman of Yaxchilan (C3). Chel-te (D1), Sky, Mah K'ina, Holy Lord of the Split Sky Place (D2–D3).

Lintel 58

He of 7 Captives, Lord Great Skull (A1–B1), the mother's brother (C1) of Chel-te (E1), Sky, Mah K'ina (E2), Shield Jaguar, Holy Yaxchilan Lord (E3–E4). *La chi* Great Skull, Mother's Brother Ahau (D1–D3).

Lintel 59

And then on 3 Ix 17 Zip (A1–C1) was diminished her soul, Lady Sky God Xoc (D1–H1).

Lintel 60

The 1st succession in the royal lineage (A1–B1) was Penis Jaguar (A2), Split Sky Lord (B2). He had a relationship to (?) (C1) . . . Turtle Shell (A6). The 2nd succession in the royal lineage was GIII Jaguar, Split Sky Ahau (B6–B8). He had a relationship to . . . [names] (C1–D2). The 3rd succession in the royal lineage was Bird Jaguar I, Split Sky Ahau (C3–D4). He had a relationship (?) to [names] (C5–C7). The 4th succession in the royal lineage was Yax Horn Skull (D7–D8).

Stela 1

Under the patronage of the month Zip, it was 9.16.10.0.0 3 Ahau (A1–D3) . . . , the first lunation had ended, there were 30 days in the lunation, . . . on 3 Zip he scattered his blood, Sky God, Bird Jaguar, 3 Katun Ahau, Guardian of Ah Cauac, Guardian of Jeweled Skull, Holy Yaxchilan Ahau, Holy Ahau of the Split Sky Place, Bacab, Chac Te.

Stela 3

It was completed, his 1st *katun* as Ahau of the lineage, Bird Jaguar III, . . . 6 Tun, Guardian of Great Moon, Holy Yaxchilan Ahau, Holy Ahau of the Split Sky Place.

Stela 4

Lady Moon . . . Lady Great Skull, Secondary Lady, the mother of . . .

Stela 6

Under the patronage of the month Uayeb, it was 9.11.16.10.13 5 Ben (A1–A5) . . . , it was the 6th day of the lunation, 2 lunations had ended, . . . was its holy name, there were 29 days in the lunation (A6–C4), on 1 Uayeb (C5) it was completed (C6), his second *katun* as Ahau of the lineage (C7), Bird Jaguar III, Guardian of (C8) Great Moon, He of 6 *tuns* (C9), Holy Lord of the Split Sky Place, Bacab (C10–C11).

Stela 7

Sky God, Shield Jaguar II Chel-te, Mah K'ina (pD1–pD3), Guardian of Tah Mo', guardian of Ix Witz (pC4–pD4), Holy Ahau of the Split Sky Place, Holy Yaxchilan Ahau, the unripe Bacab (pC5–pD5). Child of the mother Lady [titles], Holy Lady Great Skull Zero (pD6–pD7), Secondary Lady and child of the blood [of Bird Jaguar IV] . . . the 3 Katun Ahau, Holy Ahau of the Split Sky Place, Holy Yaxchilan Ahau (pC8–pD10).

Stela 9

On 12 Ik, seating of Mac, he danced (A2), shaking (B2) [his loincloth], Bird Jaguar III, Holy Yaxchilan Ahau.

Stela 10

Lady Ik Skull, Holy Lady of Site Q, East Chac Te.

Stela 11

On 12 Cib 19 Yaxkin he danced the stood-up sky, the 5 Katun Shield Jaguar, Holy Ahau of the Split Sky Place (L1–M3).

On 9 Ahau 18 Xul (C1–D1) he placed upright (E1) his stela (F1), *yetbal* (G1), the 5 Katun Lord . . . West Chac Te (H1–K1), under the auspices of the Guardian of Ah Cauac, Bird Jaguar IV, He of 20 Captives, 3 Katun Ahau, Holy Yaxchilan Lord, Holy Lord of the Split Sky Place (G2–G9).

On 1 Imix 19 Xul (Y1–Z1) he went doing (A'1) . . . 3 Katun Ahau, Bird Jaguar (C'1–D'1), the Guardian of Ah Cauac, Holy Yaxchilan Lord, Holy Lord of the Split Sky Place, Bacab, West Chac Te (C'2–D'5). She went doing, Lady Ik Skull, Holy Lady (W1–W4).

. . . Shield Jaguar, the Guardian of Ah Ahaual, Holy Lord of the Split Sky Place (X1–X4).

Under the patron of the month Zec, it was 9.16.1.0.0 11 Ahau, G8 was the Lord of the Night (A1–A8), . . . this was the 12th day of the lunation, the 5th lunation had ended . . . was its holy name, there were 39 days in this lunation . . . (A10–B1). It was 6 days and 3 *uinals* and 1 *tun* earlier, on 1 Ix 7 Uo was the seating of the 819-day count in the north (A2–A7) . . . on 8 Zec (B10b) he took the bundle as Ahau of the lineage (B11) . . . Sky God (B12–B13), 1 Akbal Cimi Uinic (B14), Bird Jaguar IV, He of 20 Captives (B15), Holy Lord of the Split Sky Place, Bacab (B16).

Under the patronage of the month Zec, it was 9.16.1.0.0 11 Ahau (N1–O4), G8 was the Lord of the Night (P1), it was 12 days into the lunation, the 5th lunation had ended, . . . was its holy name, there were 30 days in the lunation (Q1–P3), on 8 Zec (Q3) he took the bundle as Ahau of the lineage (P4–R1), Bird Jaguar IV, Guardian of Ah Cauac, 3 Katun Ahau Chac Te, Holy Ahau of Yaxchilan, Holy Ahau of the Split Sky Place (S1–S4). He was child of the woman Lady Ik Skull, Sky, Holy Lady, Lady Bacab (T1–T3), and child of the blood of the 5 Katun Ahau Shield Jaguar, Guardian of Ah Ahaual, Holy Yaxchilan Ahau, Holy Ahau of the Split Sky Place (T4–V4).

Stela 12

On 6 Ix 12 Yaxkin (A1–B1) was diminished his soul (A2–B2), Ch'ahom 5 Katun Ahau (A3–B3) Shield Jaguar, the Guardian of Ah Ahaual, the replacement of 6 Tun [Bird Jaguar III] (A4–A6). Count until 11 Ahau 8 Zec (B6–D1), was seated as Ahau of the lineage (C2–D2) Sky God (C3–D3), the Guardian of Ah Cauac (C4) Bat (D4) Jaguar (C5), Holy Yaxchilan (C4) Ahau, Holy Lord of the Split Sky Place (D5–D6).

He went doing as the shamanic alter ego . . . man of the one who incenses (E1–F2), the 5 Katun Ahau Shield Jaguar (E3–F3), the Guardian of Ah Ahaual Ah Kan . . . the Guardian of (E4–F5) . . .

The 5 Katun Ahau, Yahau Te (G1–H1), its first replacement spirit, God K (G2–H2), its first . . . (G3–H3), the 5 Katun Ahau Ballplayer (G4–H4) . . .

Stela 15

On 12 Imix 4 Pop (A1–B1) was captured Ah Ahaual (A2–B2) by the 5 Katun Ahau Shield Jaguar, Guardian of . . . , Holy Ahau of the Split Sky Place

(A3–B5), Guardian of . . . Ah Ahaual Ah Kan Bacab (C1–C3).

Stela 16

On 7 Chuen 19 Yaxkin he danced the stood-up sky, the 5 Katun Ahau, Shield Jaguar, Holy Ahau of the Split Sky Place.

Stela 18

Between day and night on 3 Eb 14 Mol (A1–A3) was captured Ah Chuen . . . of the Bat Place (A4–A8) by the wielder of the obsidian bloodletter (A9–A11), He Who Incenses (A12) . . . Sky God (B1), Sun, Holy (C1), headless GIII (B2). He went remembering (C2–B3) the bundled (?) sky [serpent?] (B3), Sky, God K (C3). He bundled the sky (?) in the earth and sky center (B4–C4) . . . the obsidian lancet (B5) with the sky in hand [a ceremonial staff?] (C5), Ahau of sacrifice (?) (B6) with 9 *hotun* bloodlettings (C6) . . . dedicated in the sky center (?) (D1) the 5 Katun Ahau, the 5 Katun Bate (E1–D2), He of One Great Fire Event (E2), He of 3 Period Ending Stelae (D3), Guardian of Ah Ahaual, Shield Jaguar (E3–E4), Holy Yaxchilan Ahau, Holy Ahau of the Split Sky Place, Bacab, Chac Te (D5–E6).

Ah Pom (?) Chuen of the Bat House (F1–F3).

Stela 20

On 6 Ix 17 Kankin (A1–A2) was captured (A3) . . . Ah Kan . . . (A6) by (A7) the Guardian of Ah Ahaual (B1–C1), Shield Jaguar, the 3 Katun Ahau (D1), . . . (E1) Bacab, Chac Te (D2–E2).

Stela 35

On 4 Imix 4 Mol (A1–B1) was conjured the shamanic spirit of God K (A2–B2) in the territory of 4 Lady Mah K'ina (A3–B3), 4 Lady . . . (A4). It was recorded with the obsidian lancet (B4–C1), Lady Ik Skull, Sky, Lady Holy Ba (C2–C4).

She went doing it with . . . (D1–E1) Lady Ik Skull (D2), sky quality (E2), Holy Lady (C1–C2), mother of (G1) the 3 Katun Ahau (H1) Bird Jaguar IV (G2), Holy Ahau of the Split Sky Place, Holy Yaxchilan Ahau, Bacab (H2–I2).

Hieroglyphic Stairway 2, Step VII

On 13 Manik 5 Pax (A1–B1) was the axe sacrifice of the head of Hunahpu (A2–B2). It was the 1st replacement of the Defeated One (A3–B3). And 17 days and 0 *uinals* and 19 *tuns* and 5 *katuns* (B3–A5), count

until 9 Cib 12 Xul (B5–B6), was the axe sacrifice (C1) of 1 Lizard Head (?) (C2), the 2nd replacement of the Defeated One (D2–C3). And then 11 days and 14 *uinals* and 10 *tuns* and 8 *katuns* and 3 *baktuns* (D3–C5), count until 1 Ahau 13 Xul (D5–D6), was the axe sacrifice(?) (E3) of Great Jeweled Ahau (?) (E4) . . . (F4), the 3rd replacement of the Defeated One (E5), Ballcourt (F5), the Black Chasm (G5) . . . (E6), Count to 6 . . . (F6–G6). Its location in the light and darkness (H6), 13.13.13.13.13.13.13.13 (I1–L2), 9.15.13.6.9, Lord of the Night, 3 Muluc 17 Mac (M1–P2), was the conjuring of the 3rd Defeated One (Q1–R1) in the Ballcourt, his stairway (Q2–R2). It was recorded Yax Lot Hun Uinic Na Chan (name of the vision serpent) (Q3–R4), the 3 Katun Ahau, He of 20 Captives, Bird Jaguar IV, Holy Ahau of Yaxchilan, Holy Ahau of the Split Sky Place, Bacab (Q5–R7).

Hieroglyphic Stairway 3, Step III

Under the patron of the month Pop, on 9.12.8.14.1 12 Imix (A1–B4), . . . it was 7 days into the lunation (B7), 5 lunations had been completed (D1), . . . was its holy name (C2), there were 29 days in the lunation, on 4 Pop (D2) was captured Ah Ahaual . . . (C3–D3), remembering the shield (?), with 9 bloodlettings (?) . . . (C4–D4), the Guardian of Ah Ahaual, the Guardian of . . . (C5–D5), the Guardian of Flint Shield, the Guardian of . . . (C6–D6), He of Fire, Chac (C7), Shield Jaguar, Holy Yaxchilan Ahau (D7), Holy Ahau of the Split Sky Place, Bacab (C8). Then it was 0 days and 12 *uinals* from the capture of Ah Ahaual, until 5 Imix 4 Mac, his hand held the mirror (D8–D10) . . . until his hand held the mirror (D11), 9 bloodlettings (C12), He of Fire Chac (D12) . . . (C13), One Who Incenses (D13) . . .

Hieroglyphic Stairway 3, Step IV

On 7 Imix 14 Zotz (A1) was the dedication of Chan Te Zotz (name of house) (B1), its house (A2a). Its recording . . . (A2b–B2) 4 Katun Zotz Kin (A3), Ahau 4 Katun (B3), Ahau, Guardian of Ah Ahaual, Shield Jaguar (A4–B4), child of the mother Lady Pacal, Lady of Yaxchilan (A5–B5), child of the father 4 Katun Ahau, 6 Tun Bird Jaguar (A6–B6), Holy Ahau of Yaxchilan, Chac Te. And he remembered (?), Kan Bat, the debut (?) of the guardian of Bat (?) (B7), the Secondary Lord (C4), the sibling of (C5) 7 . . . (C6), the holy Yaxchilan sky-center place (?) (C7).

Notes

Preface

1. Clifford Geertz, *Local Knowledge,* 1983:94.
2. Ibid.:99.
3. Ibid.:96–97.
4. As the bumpersticker pasted on the back door of Merle Greene Robertson's house in Palenque will tell you, "Archeologists will date any old thing!"
5. Floyd G. Lounsbury, "Astronomical Knowledge and Its Uses at Bonampak, Mexico," in *Archaeoastronomy in the New World,* ed. Anthony F. Aveni, 1982:143–168.

1. Maya Society in the Ceremonial City

1. Eighteen of the Yaxchilan monuments are on display in the Museo Nacional de Antropología e Historia in Mexico City, six lintels are in the British Museum, one lintel was destroyed in Berlin in World War II, and one hieroglyphic step is missing. About fifty fragmentary monuments are in the locked storeroom or buried on the site.
2. John L. Stephens, *Incidents of Travel in Central America, Chiapas, and Yucatan,* 1969:365.
3. Teobert Maler, *Researches in the Central Portion of the Usumatsintla Valley* 2, no. 2(1903):109.
4. Ibid.:113.
5. Ian Graham, *Corpus of Maya Hieroglyphic Inscriptions* 3, part 1(1977):8.
6. Maler 1903:104–105.
7. Sylvanus G. Morley, "Report of the Yaxchilan Expedition," *Carnegie Institute of Washington Year Book,* 1931:134.
8. Tatiana Proskouriakoff, "Historical Data in the Inscriptions at Yaxchilan," *Estudios de Cultura Maya* 3(1963):149–167; and 4(1964):177–201. Quotes are from 1964:177.
9. Tatiana Proskouriakoff, "Portraits of Women in Maya Art," in *Essays in Pre-Columbian Art and Archaeology,* ed. S. K. Lothrop, 1961:81–99.

10. Roberto García Moll and Daniel Juárez Cossío, *Yaxchilán: Antología de su descubrimiento y estudios,* 1986:8.
11. Michael Baxandall, *Painting and Experience in Fifteenth Century Italy,* 1972:34–36.
12. Gary H. Gossen, *Chamulas in the World of the Sun,* 1974:30.
13. Barbara Tedlock, *Time and the Highland Maya,* 1982:2–3.
14. John M. Watanabe, "In the World of the Sun," *Man* 18, no. 4(1983):713.
15. Ibid.
16. Miguel León-Portilla, *Time and Reality in the Thought of the Maya,* 2d ed., 1988:186–200.
17. Gossen 1974:72.
18. J. Eric S. Thompson, *Maya History and Religion,* 1970:195.
19. Helen Neuenswander, "Vestiges of Maya Time Concepts in a Modern Community," *Estudios de Cultura Maya* 13(1981):125–160; Duncan MacLean Earle and Dean R. Snow, "The Origin of the 260-Day Calendar," in *Fifth Palenque Round Table, 1983,* ed. Merle Greene Robertson and Virginia M. Fields, 1985:241–243.
20. See Michael D. Coe, *The Maya,* 4th ed. 1987:47–50.
21. B. Tedlock 1982:107–171.
22. Christopher Jones and Linton Satterthwaite, *The Monuments and Inscriptions of Tikal: The Carved Monuments,* 1982:Fig. 49.
23. Evon Z. Vogt, "Ancestor Worship in Zinacantan," *Actas del XXXVI Congreso Internacional de Americanistas, Madrid, 1964,* 1966, and *Zinacantecos of Mexico,* 1970:4–6.
24. Evon Z. Vogt, *Tortillas for the Gods,* 1976:1, 16, 112.
25. Ibid.:1.
26. Frank Ching, *Ancestors,* 1988:20.
27. John M. Watanabe, "We Who Are Here," 1984:95–105.
28. Vogt 1976:23.

29. B. Tedlock 1982:109.

30. Linda Schele, *Notebook for the Maya Hieroglyphic Writing Workshop at Texas*, 1984a:60, 78.

31. B. Tedlock 1982:156.

32. Ibid.:124.

33. Walter F. Morris, *Living Maya*, 1987:155.

34. Alan Roland, *In Search of Self in India and Japan*, 1988:7–8.

35. Ibid.

36. Vogt 1976:24.

37. Nancy M. Farriss, *Maya Society under Colonial Rule*, 1984:132.

38. Louanna Furbee and Robert A. Benfer, "Cognitive and Geographic Maps," *American Anthropologist* 85(1983):323.

39. Ching 1988:20.

40. B. Tedlock 1982:142.

41. Ralph L. Roys, trans., *Ritual of the Bacabs*, 1965:xi.

42. Ibid.:13.

43. Dennis Tedlock, trans., *Popol Vuh*, 1985:163–164.

44. Vogt 1976:58.

45. Ibid.

46. In *The Blood of Kings*, 1986, Linda Schele and Mary Ellen Miller devote a chapter to the iconography of warfare.

47. Adrian Recinos and Delia Goetz, trans., *The Annals of the Cakchiquels*, 1953:73–74.

48. Victoria Reifler Bricker, *The Indian Christ, the Indian King*, 1981:145.

49. *Relaciones de Yucatan*, 1898–1900:2:22, 186, 209.

50. David Stuart, "The 'Count of Captives' Epithet in Classic Maya Writing," in *Fifth Palenque Round Table, 1983*, ed. Merle Greene Robertson and Virginia M. Fields, 1985a:97–102.

51. William Gates, *Friar Diego de Landa's "Yucatan" before and after the Conquest*, 1978:97.

52. Watanabe 1984:151, 163.

53. David Stuart, "Epigraphic Evidence of Political Organization in the Usumacinta Drainage," n.d.

54. Farriss 1984:131.

55. Juan de Villagutierre Soto-Mayor, *Historia de la conquista de la provincia de el Itza . . .*, 1983:106.

56. Farriss 1984:321.

57. Alonso de Zorita, *Life and Labor in Ancient Mexico*, 1963:193–194.

58. Fray Ximénez, *Historia de la provincia de San Vicente de Chiapa y Guatemala . . .*, 1720, 1929–1931:2:200.

59. Munro S. Edmonson sees the strongest sense of ethnic solidarity in Zinacantan to be among members of "a sib, a clan, a village, a moiety, a cult, or a lineage" ("Nativism, Syncretism, and Anthropological Science," *Middle American Research Institution Publication* 19[1960]:189). Members of one such group share a strong sense of corporate identity implicit in the way they ridicule and gossip about others.

60. The practice of burying the bodies of ancestors in agricultural fields or under the house sacralizes the environment and also can serve as evidence of a claim to land (Kent Flannery, "The Origins of the Village as a Settlement Type in Mesoamerica and the Near East," in *Man, Settlement, and Urbanism*, ed. P. J. Ucko, R. Tringham, and G. W. Dimbleby, 1972a:19).

61. When the Spanish campaigns for the "pacification" of the Petén were underway, the Manche branch of the Chol speakers who were encountered in the area now occupied by the Lacandones "worshipped a variety of dramatic natural features—rapids, caves, mountains, etc." (Villagutierre Soto-Mayor 1983:101n397). These same Maya lived in small, extended family settlements and had little interfamily organization. All Maya groups who live near mountains believe that the animal souls and the social souls of their ancestors occupy those mountains, where they convene to deliberate the affairs of the living and wait for offerings (Evon Z. Vogt, "Some Aspects of the Sacred Geography of Highland Chiapas," in *Mesoamerican Sites and World Views*, ed. Elizabeth P. Benson, 1981:119–142).

62. Watanabe 1984:105.

63. See Katherine B. Branstetter, "Tenejapans on Clothing and Vice Versa" (Ph.D. dissertation), 1974:133; Allan F. Burns, *An Epoch of Miracles*, 1983:5; Bricker 1981:178.

64. Calixta Guiteras-Holmes, *Perils of the Soul*, 1961:19. Also, the people of Chiquin called the speech of their neighbors in Popola and Sinsimato *"acha maya"* because they considered them to be of "vile and low understanding" (reported in the RG).

65. The "jester god" was identified by Linda Schele, "Accession Iconography of Chan-Bahlum in the Group of the Cross at Palenque," in *Segunda Mesa Redonda de Palenque*, ed. Merle Greene Robertson, 1976a:9–34. It is depicted as a miniature anthropomorphic being with a trilobal head similar to the hat of a medieval European court jester. It refers to the generative aspect of the First Ancestor.

66. Nicholas A. Hopkins, "Classic Maya Kinship Systems" (paper presented at annual meeting of American Anthropological Association), 1984.

67. Farriss 1984:240.

68. Maurice Bloch, ed., *Political Language and Oratory in Traditional Societies*, 1975:3.

69. Gossen 1974:46–47.

70. Ibid.:232–233.

71. Thelma Sullivan, "A Scattering of Jades," in *Symbol and Meaning beyond the Closed Community*, ed. Gary H. Gossen, 1986:9.

72. Burns 1983:11–16.

73. Benjamin N. Colby, "Elements of a Mesoamerican Personality Pattern," *XXXV International Congress of Americanists, Mexico* 2(1962):126; "Psychological Orientations," in *Handbook of Middle American Indians*, vol. 6, *Social Anthropology*, ed. Robert Wauchope and Manning Nash, 1967:420.

74. D. Tedlock, trans. 1985:79.

75. In a volume of essays called *Political Lan-*

guage and Oratory in Traditional Societies, 1975, editor Maurice Bloch found that among all the societies represented, great stress and value was put on types of language and the ritual of political procedure in each society, and that the structure of political oratory was similar in each instance. His point was that the structure of political oratory is a phenomenon that can be explained on a cross-cultural basis as well as on the level of a single group, because it is part of social process. I suggest that each of Bloch's "traditional" societies could also be called "locative" in Jonathan Z. Smith's model (Map Is Not Territory, 1978), and that in those societies, political power depends on the dynamics of interaction and change in a hierarchical community.

76. Morris 1987:213.

77. Robert Bruce, Lacandon Dream Symbolism 1 (1975):35–39.

78. Morris 1987:212–213.

79. Barbara Tedlock, ed., Dreaming, 1987:116.

80. Farriss 1984:119–121.

81. George Kubler, "Pre-Columbian Pilgrimages in Mesoamerica," in Fourth Palenque Round Table, 1980, ed. Merle Greene Robertson and Elizabeth P. Benson, 1985:316.

82. Carolyn E. Tate, "The Use of Astronomy in Political Statements at Yaxchilan," in World Archaeoastronomy, ed. Anthony F. Aveni, 1989:421–423. Two multiple-day rituals at Palenque and Yaxchilan had very similar astronomical underpinnings involving a rare stationary conjunction of Jupiter and Saturn and solar-year anniversaries of the kings' fathers' accessions and the kings' own accessions.

83. Marshall Joseph Becker, "Priests, Peasants, and Ceremonial Centers," in Maya Archaeology and Ethnohistory, ed. Norman Hammond and Gordon R. Willey, 1979:3–20.

84. Richard E. Blanton, "Advances in the Study of Cultural Evolution in Prehispanic Highland Mesoamerica," in Advances in World Archaeology 2 (1983):260.

85. Kent Flannery, "The Cultural Evolution of Civilizations," Annual Review of Ecology and Systematics 3 (1972b):400.

86. Joyce Marcus, "On the Nature of the Mesoamerican City," in Prehistoric Settlement Patterns, ed. Evon Z. Vogt and Richard M. Leventhal, 1983:239.

87. Quoted in ibid.:207.

88. Mary Elizabeth Smith, Picture Writing from Ancient Southern Mexico, 1973:39.

89. Marcus 1983.

90. S. J. Tambiah, World Conqueror and World Renouncer, 1976.

91. Mircea Eliade, Patterns in Comparative Religion, 1958:375.

92. Paul Wheatley, City as Symbol, 1969:7.

93. Clifford Geertz, Negara, 1980:14.

94. Evon Z. Vogt, "Cardinal Directions and Ceremonial Circuits in Mayan and Southwestern Cosmology," National Geographic Research Reports (NGR) 21(1985):490.

95. Alfa Hurley Vda. de Delgaty and Agustín Ruiz Sánchez, Diccionario tzotzil de San Andrés con variaciones dialectales, 1978:234.

96. Mary W. Helms, Ancient Panama, 1979:172–175.

97. David Carrasco, Quetzalcoatl and the Irony of Empire, 1982:65–72, 96; Robert Redfield and Milton Singer, "The Cultural Role of Cities," Economic Development and Cultural Change 3(1954):53–56.

98. Claude Lévi-Strauss, The Savage Mind, 1966.

99. J. Z. Smith 1978:137–138.

100. Several scholars have made enormous contributions to the understanding of societies and cities with locative points of view. Jonathan Z. Smith's work was informed by that of the late Mircea Eliade, and examples and explanations of elements of similarity in perceived cosmic structure among many societies appear in Eliade's classic work Shamanism: Archaic Techniques of Ecstasy, 1972. The Pivot of the Four Quarters: A Preliminary Enquiry into the Origins and Character of the Ancient Chinese City by Paul Wheatley (1971) is a classic study of the enactment of cosmic principles in the design of social structure and ceremonial city.

101. J. Z. Smith 1978:142.

102. Ibid.: 101–103, 366.

103. Morris 1987:35.

2. Public Art: Aesthetics and Artists

1. Jacques Maquet, The Aesthetic Experience, 1986:33.

2. Robert Plant Armstrong, The Powers of Presence, 1981:17–18.

3. Alfredo Barrera Vásquez, Diccionario maya Cordemex, 1980.

4. Armstrong 1981:6–18.

5. Walter F. Morris, Jr., Living Maya, 1987:105–153.

6. William Gates, trans., Friar Diego de Landa's "Yucatan" before and after the Conquest, 1978:76.

7. Maquet 1986:57.

8. Victoria Reifler Bricker, The Indian Christ, the Indian King, 1981:8.

9. Linda Schele, Notebook for Maya Hieroglyphic Writing Workshop at Texas, 1987:135, cites the work of David Stuart in identification of the "fire" glyph as one for temple dedication.

10. Munro 1965:21.

11. Ibid.: 102.

12. Miguel León-Portilla, Pre-Columbian Literatures of Mexico, 1969:81–83.

13. Gary H. Gossen, Chamulas in the World of the Sun, 1974:161.

14. Brent Berlin, Tzeltal Numerical Classifiers, 1968.

15. Gossen, 1974:244.

16. Ibid.: 32.

17. Ibid.: 35–36.

18. Ibid.

19. David Stuart, "The Lu-bat Glyph and Its Bearing on the Primary Standard Sequence," 1986.

20. David Stuart, *Ten Phonetic Syllables*, 1987b.

21. Teobert Maler, *Researches in the Central Portion of the Usumatsintla Valley* 2, no. 2 (1903): 177.

22. Numbers referring to glyphs are taken from J. Eric S. Thompson, *A Catalog of Maya Hieroglyphs*, 1962.

23. Barbara MacLeod, "Remembrances of Cycles Past," in *Contribution to Maya Hieroglyphic Decipherment, I*, ed. Stephen Houston, 1983: 50–59.

24. Mary Ellen Miller, "The Cookie Cutter Master of Yaxchilan" (paper presented at College Art Association), 1985.

25. Linda Schele, "The Hauberg Stela," in *Fifth Palenque Round Table, 1983*, ed. Merle Greene Robertson and Virginia M. Fields, 1985: 141–142.

26. See Stuart 1987b.

27. Linda Schele and Mary Ellen Miller, *The Blood of Kings*, 1986: 39.

28. Marvin Cohodas, "The Identification of Workshops, Schools, and Hands at Yaxchilan," *Proceedings of the 42nd International Congress of Americanists, Paris* 7 (1976a): 301–313.

3. Manifesting Tradition: Imagery at Yaxchilan, Part I, The Cosmos, Rulers, and Regalia

1. Tatiana Proskouriakoff, "Historical Implications of a Pattern of Dates at Piedras Negras, Guatemala," *American Antiquity* 25(1960): 454–475.

2. David Humiston Kelley, "The Birth of the Gods at Palenque," *Estudios de Cultura Maya* 5 (1965): 93–134.

3. Linda Schele and Mary Ellen Miller, *The Blood of Kings*, 1986: 48–51.

4. Michael D. Coe, *The Maya Scribe and His World*, 1973.

5. David A. Freidel (personal communication) argues that the First Mother, born before the present era, was a fiction invented by Chan Bahlum of Palenque because his father, Pacal (b. A.D. 603, d. 683) had inherited the throne from his mother rather than his father. See also Linda Schele and David Freidel, *A Forest of Kings*, 1990: 244–253.

6. Schele and M. E. Miller 1986: 48–51.

7. Dennis Tedlock, trans., *Popol Vuh*, 1985: 35.

8. The Maya ballgame was a sacred combat in which kings battled supernaturals and humans fought each other for ritual-political purposes. Most Maya cities had at least one structure, I-shaped in plan, in which the ballgame was played. Apparently it could be played recreationally for lesser stakes and is the game from which soccer evolved.

9. Kelley 1965.

10. D. Tedlock, trans. 1985: 35.

11. Ibid.; Schele and M. E. Miller 1986: 48–49.

12. Schele and M. E. Miller 1986: 48.

13. Ibid.

14. For the sacrifice of the Baby Jaguar on codex-style pots, see Francis Robiscek and Donald M. Hales, *The Maya Book of the Dead*, 1981: Vessels 17–31. "Codex style" is a term used to describe a group of Late Classic ceramics with a cream-colored base slip on which scenes involving supernaturals are painted with fluid black lines.

15. For the Postclassic Quiché version of the story, see D. Tedlock, trans. 1985: 153–160.

16. God K was first named by Paul Schellhas, *Representations of Deities of the Maya Manuscripts*, 1904.

17. Eduard Seler, *Gesammelte Abhandlungen zur amerikanischen Sprach-und Alterhumskunde*, 1902–1923: 1: 376–377.

18. See Schele and M. E. Miller 1986: 45.

19. J. Eric S. Thompson, *Maya History and Religion*, 1970: 227. Itzam Na is Thompson's name for Seler's Earth Monster, the monster now called Cosmic or Celestial.

20. Kelley 1965.

21. Linda Schele, "Accession Iconography of Chan-Bahlum in the Group of the Cross at Palenque," in *Segunda Mesa Redonda de Palenque*, ed. Merle Greene Robertson, 1976a: 12; Schele and Miller 1986: 49.

22. D. Tedlock, trans. 1985: 158–159.

23. Evon Z. Vogt, *Zinacantan*, 1969: 35.

24. Karl Taube, "The Classic Maya Maize God," in *Fifth Palenque Round Table, 1983*, ed. Merle Greene Robertson and Virginia M. Fields, 1985: 178.

25. Linda Schele, "Human Sacrifice among the Classic Maya," in *Ritual Human Sacrifice in Mesoamerica*, ed. Elizabeth H. Boone, 1984b: 21.

26. David Stuart, "Epigraphic Evidence of Political Organization in the Usumacinta Drainage," ms., 1983.

27. Linda Schele, *Notebook for the Maya Hieroglyphic Writing Workshop at Texas*, 1984a: 79.

28. Peter Mathews, "A Maya Hieroglyphic Syllabary," in *Phoneticism in Mayan Hieroglyphic Writing*, ed. John S. Justeson and Lyle Campbell, 1984: 311–314.

29. William Gates, trans., *Friar Diego de Landa's "Yucatan" before and after the Conquest*, 1978: 120.

30. Evon Z. Vogt, "Some Aspects of the Sacred Geography of Highland Chiapas," in *Mesoamerican Sites and World Views*, ed. Elizabeth P. Benson, 1981: 120; also Vogt, *Zinacantecos of Mexico*, 1970: Chs. 1, 3.

31. See Carolyn E. Tate, "The Maya Cauac Monster," thesis, 1980: 72.

32. Schellhas 1904: 20; Clemency Chase Coggins, "The Shape of Time," *American Antiquity* 45 (1980): 727–739; Victoria Reifler Bricker, "Directional Glyphs in Maya Inscriptions and Codices," *American Antiquity* 48(1983): 347–353.

33. Linda Schele, *Notebook for the XIV Maya Hieroglyphic Writing Workshop at Texas*, 1990: 37, discusses their readings and adds some supporting examples.

34. Merle Greene Robertson, *The Sculpture of Palenque* 3(1985b):74.

35. John Carlson, "Venus and Ritual Warfare in Ancient Mesoamerica," paper presented at Simposio de Arqueoastronomía y Etnoastronomía, 1984.

36. Tate 1980:15–16.

37. For an inventory of symbols appearing in sky-bands, see John Carlson and Linda Landis, "Bands, Bicephalic Dragons, and Other Beasts," in *Fourth Palenque Round Table, 1980,* ed. Merle Greene Robertson and Elizabeth P. Benson, 1985:115–140.

38. Andrea Stone, "The Zoomorphs of Quirigua," dissertation, 1983:158–178.

39. Schele 1976a:18.

40. David A. Freidel and Linda Schele, "Kingship in the Late Preclassic Maya Lowlands," *American Anthropologist* 90(1988):547–567.

41. Marvin Cohodas, "The Iconography of the Panels of the Sun, Cross, and Foliated Cross at Palenque," in *Segunda Mesa Redonda de Palenque,* ed. Merle Greene Robertson, 1976b:158.

42. Freidel and Schele 1988.

43. Linda Schele and Jeffrey Miller, *The Mirror, the Rabbit, and the Bundle,* 1983:66–68.

44. Merle Greene Robertson, "The Ritual Bundles of Yaxchilan," paper presented at Tulane Symposium on the Art of Latin America, 1972.

45. Maricela Ayala Falcón, "La Estela 39 de Mundo Perdido, Tikal," in *Memorias del Primer Coloquio Internacional de Mayistas,* 1987:599–654.

46. Schele and J. Miller 1983:66–72.

47. V. Garth Norman, *Izapa Sculpture,* 1976:133–136.

48. William R. Coe, *Tikal,* 1967:100–101.

49. Schele and M. E. Miller 1986:48.

50. Lawrence W. Bardawil, "The Principal Bird Deity in Maya Art," in *Segunda Mesa Redonda de Palenque,* ed. Merle Greene Robertson, 1976:195–209; Constance Cortez, "The Principal Bird Deity in Preclassic and Early Classic Maya Art," master's thesis, 1986.

51. Teobert Maler, *Researches in the Central Portion of the Usumatsintla Valley* 2, no. 2(1903):128, 143.

52. Sylvanus G. Morley, *The Inscriptions of Peten,* 1937–1938:421.

53. J. Eric S. Thompson, *Maya Hieroglyphic Writing,* 3d ed., 1971:274.

54. George Kubler, *Studies in Classic Maya Iconography,* 1969:166.

55. Norman Hammond, "*Pom* for the Ancestors," *Mexicon* 3(1982):77–79. In 1978 Barbara MacLeod suggested, on linguistic evidence, that the drops were copal.

56. Schele 1984b:21.

57. David Stuart, "Royal Auto-sacrifice among the Maya," *RES* 7/8(1984):9–12.

58. Identified by P. David Joralemon, "Ritual Blood Sacrifice among the Ancient Maya," in *Primera Mesa Redonda de Palenque, Part 2,* ed. Merle Greene Robertson, 1974:59–75.

59. Taube 1985.

60. Cecelia Klein, "Mayamania," *Art Journal* 47 (1988):42–46. Klein mentions several other recent authors who have dealt with the identification of these circles in Maya art.

61. Mercedes de la Garza, *El universo sagrado de la serpiente entre los mayas,* 1984.

62. Schele 1984b:42. Dicey Taylor observed that the first appearance of this headdress was on the Oval Palace Tablet at Palenque in "Classic Maya Costume," dissertation, 1983:182.

63. For illustrations, see Tatiana Proskouriakoff, *A Study of Classic Maya Sculpture,* 1950:Fig. 44*b*, and Frans Blom and Gertrude Duby de Blom, *La selva lacandona* 2(1957):164–168.

64. A very early example of the "balloon" headdress appears on Uaxactun Stela 5, style-dated to 8.17.0.0.0 (see Proskouriakoff 1950:104 and Fig. 38*a*). Its first use at Piedras Negras is on Lintel 4, in a scene of royalty and warriors dedicated around 9.11.7.0.0 (see Maler 1903:Pl. 32). Something similar which may be related is the Copan version of the "balloon" headdress, which appears on Stela 1 at 9.11.15.0.0.

65. Proskouriakoff 1950:Fig. 38*a*.

66. See Schele 1984b:32–33.

67. Eduard Seler, *Observations and Studies in the Ruins of Palenque,* 1915b:59, Figs. 104–113.

68. Merle Greene Robertson, "The Quadripartite Badge," in *Primera Mesa Redonda de Palenque, Part I,* ed. Merle Greene Robertson, 1974:77–94.

69. Schele 1976a:18.

70. David A. Freidel, "Maya Cosmology," talk given at Introduction to Maya Hieroglyphic Writing Workshop, 1986.

71. Ibid.

72. Mircea Eliade, *Shamanism,* 1972:43.

73. Carolyn E. Tate, "Summer Solstice Events in the Reign of Bird Jaguar III of Yaxchilan," *Estudios de Cultura Maya* 16(1985):85–112.

74. Dennis E. Puleston, "The People of the Cayman/Crocodile," in *Aspects of Ancient Maya Civilization,* ed. François-Auguste de Montequin, 1976:1–26.

75. Herbert Spinden, *A Study of Maya Art,* 1913:61.

76. Schele and M. E. Miller 1986:54–55.

77. Schele and J. Miller 1983:12.

78. David Stuart, "A New Child-Father Relationship Glyph," *Research Reports on Ancient Maya Writing* 2(1985b):7.

79. Floyd G. Lounsbury, "Astronomical Knowledge and Its Uses at Bonampak, Mexico," in *Archaeoastronomy in the New World,* ed. Anthony F. Aveni, 1982:143–168.

80. Barbara Tedlock, *Time and the Highland Maya,* 1982:140.

81. The first published identification of this outfit and the association of ritual warfare with the first appearances of Venus as Morning or Evening Star was by Schele 1984b:33–34.

82. Andrea Stone, "Disconnection, Foreign Insignia, and Political Expansion," in *Cultural Adjustments in Mesoamerica after the Decline of Teotihuacan*, ed. Richard A. Diehl and Janet Catherine Berlo, 1989:153–172.

83. Mary W. Helms, *Ancient Panama*, 1979:136.

84. Janet Catherine Berlo, *Teotihuacan Art Abroad*, 1984:214–215.

85. Taylor 1983:193.

86. Carolyn E. Tate, "The Royal Women of Yaxchilan," in *Memorias del Primer Coloquio Internacional de Mayistas*, 1987:807–828.

4. Manifesting Tradition: Imagery at Yaxchilan, Part II, Scenes of Royal Ritual

1. Tatiana Proskouriakoff, "The Hand-grasping-fish and Associated Hieroglyphs on Classic Maya Monuments," in *Mesoamerican Writing Systems*, ed. Elizabeth P. Benson, 1973:165–178.

2. Linda Schele, "Human Sacrifice among the Classic Maya," in *Ritual Human Sacrifice in Mesoamerica*," ed. Elizabeth H. Boone, 1984b:22; David Stuart, "Royal Auto-sacrifice among the Maya," *RES* 7/8(1984):6–9.

3. Identified by P. David Joralemon, "Ritual Blood Sacrifice among the Ancient Maya," in *Primera Mesa Redonda de Palenque, Part 2*, ed. Merle Greene Robertson, 1974:59–75.

4. Carolyn E. Tate, "The Use of Astronomy in Political Statements at Yaxchilan," in *World Archaeoastronomy*, ed. Anthony F. Aveni, 1989:416–429.

5. Proskouriakoff 1973.

6. Linda Schele, Peter Mathews, and Floyd G. Lounsbury, "Parentage and Spouse Expressions from Classic Maya Inscriptions," paper presented at International Conference on Maya Iconography and Writing, 1977.

7. Tatiana Proskouriakoff, "Historical Data in the Inscriptions of Yaxchilan, Part I," *Estudios de Cultura Maya* 3(1963):156.

8. Stuart 1984.

9. See Schele and Freidel 1990:267, Fig. 7:3b.

10. George Kubler, *Studies in Classic Maya Iconography*, 1969:167.

11. Peter T. Furst, "Fertility, Vision Quest, and Auto-Sacrifice," in *Segunda Mesa Redonda de Palenque*, ed. Merle Greene Robertson, 1976:187, 184.

12. Carolyn E. Tate, "Maya Astronomical Rituals Recorded on Yaxchilan Structure 23," *Rutgers Art Review* 7(1986a).

13. Evon Z. Vogt, *Zinacantan*, 1969:298–303.

14. Stuart 1984.

15. Linda Schele, "The Hauberg Stela," in *Fifth Palenque Round Table, 1983*, ed. Merle Greene Robertson and Virginia M. Fields, 1985:142, 144.

16. David A. Freidel and Anthony P. Andrews, "The Loltun Bas-relief and the Origins of Maya Kingship," ms., 1984.

17. Gary H. Gossen, *Chamulas in the World of the Sun*, 1974:161.

18. In *Diccionario Cordemex*, under *chakaw k'ab*, which means heat, is a statement that this phrase refers to the cold or hot "quality" of things.

19. Gossen 1974:37.

20. Stuart 1984:12.

21. John G. Fought, *Chorti (Mayan) Texts (I)*, 1972:75ff, 114ff.

22. Gossen 1974:86.

23. Nicolai Grube suggests that T714 reads *tsak*. In Yucatec, this means "a kind of conjuring," "conspiracy." In Tzotzil, it means "to catch a wild animal" or "capture." His argument is included in Linda Schele's *Workbook for the XVth Maya Hieroglyphic Workshop at Texas*, 1991:86–88.

24. Linda Schele, *Maya Glyphs: The Verbs*, 1982:73.

25. Herbert Spinden, *A Study of Maya Art*, 1913:50–52; Linda Schele, "Accession Iconography of Chan-Bahlum in the Group of the Cross at Palenque," in *Segunda Mesa Redonda de Palenque*, ed. Merle Greene Robertson, 1976a:24.

26. Elizabeth P. Benson, "Ritual Cloth and Palenque Kings," 1976:45–58.

27. Relief IX; see P. David Joralemon, *A Study of Olmec Iconography*, 1971:Fig. 141.

28. Carolyn E. Tate, "The Maya Cauac Monster," thesis, 1980:Fig. 5.

29. Peter Mathews and David Pendergast, "The Altun Ha Jade Plaque," *Contributions of the University of California Archaeological Research Facility* 41(1979):197–214.

30. Rafael Girard, *Los mayas*, 1966:121–126.

31. Ibid.:126; my translation.

32. Helen Neuenswander, "Vestiges of Maya Time Concepts in a Modern Community," *Estudios de Cultura Maya* 13(1981):147–148.

33. Barbara MacLeod and I discussed this phrase in 1984. She suggested that we consider the *wa' chan* here as parallel to the "6 sky" event performed by GI on the Tablet of the Cross at Palenque (at D10). Nicholas Hopkins and Kathryn Josserand worked on the Yaxchilan summer solstice phrase in 1985, and suggested the gloss used here.

34. Mary Ellen Miller and Stephen Houston, "The Maya Ballgame," ms., 1982.

35. Schele 1982:194.

36. H. Wilbur Aulie and Evelyn W. de Aulie, *Diccionario ch'ol-español; español-ch'ol*, 1978.

37. Teobert Maler, *Researches in the Central Portion of the Usumatsintla Valley* 2, no. 2(1903):126.

38. *Diccionario de Motul*:669–670, cited by Linda Schele and Jeffrey Miller, *The Mirror, the Rabbit, and the Bundle*, 1983:12.

39. Schele 1982:169.

40. I use the term "tropical year" to refer to a reckoning cycle of 365.25 days. (The actual solar year is 365.2422 days.)

41. Schele and J. Miller 1983:80–85.

42. Dorie Reents-Budet, "Narrative in Classic

Maya Art," in *Word and Image in Mayan Culture,* ed. William F. Hanks and Don S. Rice, 1989, uses a classificatory system for narrative observed in the work of Kurt Weitzmann.

43. Dennis Tedlock, trans., *Popol Vuh,* 1985: 63–64.

5. The City as a Solar Cosmogram

1. George F. Andrews, *Maya Cities,* 1975:53, 140–146.

2. Horst Hartung, *Die Zeremonialzentren der Maya,* 1971.

3. Frans Blom, "Archaeology," *Carnegie Institute of Washington Year Book* 23(1924):217–219.

4. Karl Ruppert, "A Special Assemblage of Maya Structures," in *The Maya and Their Neighbors,* ed. Clarence L. Hay et al., 1940:222–231.

5. Anthony F. Aveni, *Skywatchers of Ancient Mexico,* 1980:218–316.

6. Gary H. Gossen, *Chamulas in the World of the Sun,* 1974:27, 22.

7. Evon Z. Vogt, "Cardinal Directions and Ceremonial Circuits in Mayan and Southwestern Cosmology," *National Geographic Research Reports* 21 (1985):487–496; Victoria Reifler Bricker, "Directional Glyphs in Maya Inscriptions and Codices," *American Antiquity* 48(1983):347–353; Gossen 1974.

8. The initial observation and report of this phenomenon was made by John and Clay Odom.

9. Alfonso Morales C. pointed this out to me.

10. In 1985 James Strickland and Tabor R. Stone were helping me with solstice observations at Yaxchilan, and they reported this phenomenon first, while I was down in the plaza looking for possible interaction of the sun with Structure 13 summer solstice monuments. That year I sent Jim and Tabor to Structure 33 so that Jim, who had sprained his ankle in a cave the day before, would not have to climb up to Structure 40, where I anticipated that something would happen where Stela 11 had been. I did not expect that the statue of Bird Jaguar would be illuminated inside the temple, but after their report I went there the next morning and photographed the passage of the sun across the statue, and have done so several times since. I have also been up to Structure 33 at sunrise at most other times of the year, and the sunlight has not entered the temple.

11. Structure 19, with its labyrinthine hallways and rooms, shows most similarity in construction techniques to Structure 20, which was certainly built late in the reign of Bird Jaguar IV or by Shield Jaguar II.

12. See also Carolyn E. Tate, "The Use of Astronomy in Political Statements at Yaxchilan," in *World Archaeoastronomy,* ed. Anthony F. Aveni, 1989: 416–429.

13. Altitude taken from the Defense Mapping Agency Aerospace Center Map ONC J-25, available from NOAA Distribution Branch (N/CG33), National Ocean Service, Riverdale, MD 20737.

6. The Design of the Ceremonial City: A History

1. Cf. Clifford Geertz, *Negara,* 1980:5.

2. Tatiana Proskouriakoff, "Historical Data in the Inscriptions of Yaxchilan, Part I," *Estudios de Cultura Maya* 3(1963):153.

3. Linda Schele, Peter Mathews, and Floyd G. Lounsbury, "Parentage and Spouse Expressions from Classic Maya Inscriptions," paper presented at International Conference on Maya Iconography and Writing, 1977.

4. See the descriptions of the individual buildings and sculptures in Part Two for arguments for assertions made in this section. Stela 19 is discussed in the section on Structure 41.

5. See Merle Greene Robertson, *The Sculpture of Palenque* 3(1985b):32, for a discussion of the dating of Palenque Palace House D piers.

6. Ibid.:Figure 319.

7. Chapter 2 presents arguments for the identification of these and other artists mentioned in this chapter.

8. David Stuart first suggested that the *"lu-bat"* (T62.756) phrase may be used to refer to the carver of a sculpture, in a paper delivered in Guatemala City in 1986. He cites himself in print in *Ten Phonetic Syllables* (1987b).

9. Linda Schele, *Notebook for the Maya Hieroglyphic Writing Workshop at Texas,* 1979c:135.

10. For an illustration in color, see Linda Schele and Mary Ellen Miller, *The Blood of Kings,* 1986: Pl. 33a.

11. Carolyn E. Tate, "Maya Astronomical Rituals Recorded on Yaxchilan Structure 23," *Rutgers Art Review* 7(1986a):1–20, and "The Royal Women of Yaxchilan," in *Memorias del Primer Coloquio Internacional de Mayistas,* 1987:807–828, report on summer solstice events and on Lady Xoc and other royal women at Yaxchilan.

12. See note 8 above.

13. Walter F. Morris, Jr., "Flowers, Saints and Toads," *NGR,* Winter 1985, interprets the star motif (p. 76) and the "earth opening" quatrefoil (p. 73).

14. Linda Schele, "The Hauberg Stela," in *Fifth Palenque Round Table, 1983,* ed. Merle Greene Robertson and Virginia M. Fields, 1985:135–150.

15. Linda Schele, *Notebook for Maya Hieroglyphic Writing Workshop at Texas,* 1987:135, has a chart comparing "dedication" events at Copan, Palenque, and Yaxchilan. The work is largely that of David Stuart supplemented by Schele. The statement that summer solstice events marked inception and closing of the work on Structure 23 and the decipherment of the Lintel 23 front edge date are my own.

16. Ibid.

17. Barbara MacLeod, "The God N/Step Set in the Primary Standard Sequence," in *The Maya Vase Book*, by Justin Kerr, vol. 2, 1990:337–340.

18. Barbara MacLeod, personal communication, July 1990.

19. Tatiana Proskouriakoff, "Historical Data in the Inscriptions of Yaxchilan, Part I," *Estudios de Cultura Maya* 4(1964):180.

20. Sandra Bardslay, "Inaugural Art of Bird Jaguar IV," thesis, 1987:16.

21. Tate 1987.

22. Proskouriakoff 1964:180.

23. Tate 1987:817.

24. Xoc's name, parentage, and ceremonies were recorded among the four lintels of Structure 23. I am convinced that Lady Xoc was not the wife of Shield Jaguar but had a ceremonial function congruous to the role of the Lady of Altar 5 at Tikal (also not the mother of the next king) and the ladies of the Site Q altar.

25. Schele and Freidel 1990:265–271.

26. Bardslay 1987:16.

27. Ibid.

28. Berthold Riese, "Epigraphy of the Southeastern Zone in Relation to Other Parts of the Maya Realm," in *The Southeast Classic Maya Zone*, ed. Elizabeth H. Boone and Gordon R. Willey, 1988:67–94.

29. See Carolyn E. Tate, "Summer Solstice Events in the Reign of Bird Jaguar III of Yaxchilan," *Estudios de Cultura Maya* 16(1985):85–112.

30. Karen Bassie, "The Relationship between Text and Image on Late Classic Maya Sculpture," paper presented at meeting of Society for American Anthropologists, 1987. Bassie convincingly argues against Schele's interpretation of the Palenque Cross Tablets, the Dumbarton Oaks Tablet, and the Temple XIV tablet, saying that each contains information about first and second lineage rites for the kings, and

extending the interpretation to Stela 11 of Yaxchilan and other monuments.

31. Tate 1985:96–98.

32. Schele 1987:135–136; 1989:39.

33. Proskouriakoff 1984:186–190.

34. Sylvanus G. Morley, *The Inscriptions of Peten*, 1937–1938:551.

35. Linda Schele, *Maya Glyphs: The Verbs*, 1982:194.

7. Individualism and the Collapse

1. Gordon R. Willey and Demitri B. Shimkin, "The Maya Collapse: A Summary View," in *The Classic Maya Collapse*, ed. T. Patrick Culbert, 1973:459–495.

2. Linda Schele and Mary Ellen Miller, *The Blood of Kings*, 1986:142.

3. J. Eric S. Thompson, "Sixteenth and Seventeenth Century Reports on the Chol Mayas," *American Anthropologist* 40(1938):591–594.

4. Teobert Maler, *Researches in the Central Portion of the Usumatsintla Valley* 2, no. 2(1903):200.

5. *National Geographic* 168, no. 4(October 1985):514–543.

Conclusions: The Art of Tradition

1. Linda Schele and Mary Ellen Miller, *The Blood of Kings*, 1986:41.

2. Cecelia Klein, "Mayamania," *Art Journal* 47 (1988):44.

3. Cecelia Klein, "The Ideology of Autosacrifice at the Templo Mayor," in *The Aztec Templo Mayor*, ed. Elizabeth H. Boone, 1987:350–360.

4. Ibid.:359.

Bibliography

Adams, Richard E. W.
1977 *Prehistoric Mesoamerica.* Boston: Little, Brown and Company.

Adams, Richard E. W., and Woodruff D. Smith
1981 "Feudal Models for Classic Maya Civilization." In *Lowland Maya Settlement Patterns,* edited by Wendy Ashmore, pp. 335–350. Albuquerque: University of New Mexico Press.

Adams, Robert McC.
1966 *The Evolution of Urban Society: Early Mesopotamia and Prehispanic Mexico.* Chicago: Aldine Publishing Co.

Andrews, E. Wyllys V
1976 "Review of *Maya Cities: Placemaking and Urbanization,* by George F. Andrews." *American Antiquity* 41:241–243.

Andrews, George F.
1975 *Maya Cities: Placemaking and Urbanization.* Norman: University of Oklahoma Press.

Armstrong, Robert Plant
1981 *The Powers of Presence: Consciousness, Myth, and Affecting Presence.* Philadelphia: University of Pennsylvania Press.

Aulie, H. Wilbur, and Evelyn W. de Aulie
1978 *Diccionario ch'ol-español; español-ch'ol.* Serie de Vocabularios y Diccionarios Indígenas, no. 21. Mexico City: Instituto Lingüístico de Verano.

Aveni, Anthony F.
1980 *Skywatchers of Ancient Mexico.* Austin: University of Texas Press.
1988 "The Nazca Lines." Lecture presented at Dumbarton Oaks.

Ayala Falcón, Maricela
1987 "La Estela 39 de Mundo Perdido, Tikal." In *Memorias del Primer Coloquio Internacional de Mayistas,* pp. 599–654. Mexico City: Universidad Nacional Autónoma de México.

Bardawil, Lawrence W.
1976 "The Principal Bird Deity in Maya Art—An Iconographic Study of Form and Meaning." In *Segunda Mesa Redonda de Palenque,* edited by Merle Greene Robertson, pp. 195–209. Pebble Beach, Calif.: Robert Louis Stevenson School.

Bardslay, Sandra
1987 "Inaugural Art of Bird Jaguar IV: Rewriting History at Yaxchilan." Master's thesis, University of British Columbia, 1987.

Barrera Vásquez, Alfredo
1980 *Diccionario Maya Cordemex.* Mérida: Ediciones Cordemex.

Barthes, Roland
1968 *Writing Degree Zero, and Other Elements of Semiology.* Translated by Annette Lavers and Colin Smith. Boston: Beacon Press.

Bassie, Karen
1987 "The Relationship between Text and Image on Late Classic Maya Sculpture." Paper presented at annual meeting of Society for American Anthropologists, Chicago.

Baxandall, Michael
1972 *Painting and Experience in Fifteenth Century Italy.* London: Oxford University Press.

Becker, Marshall Joseph
1979 "Priests, Peasants, and Ceremonial Centers: The Intellectual History of a Model." In *Maya Archaeology and Ethnohistory,* edited by Norman Hammond and Gordon R. Willey, pp. 3–20. Austin: University of Texas Press.

Benson, Elizabeth P.
1976 "Ritual Cloth and Palenque Kings." In *Proceedings of the Segunda Mesa Redonda de Palenque,* edited by Merle Greene Robertson, pp. 24–58. Pebble Beach, Calif.: Robert Louis Stevenson School.

Berlin, Brent
1968 *Tzeltal Numerical Classifiers: A Study in Ethnographic Semantics.* The Hague: Mouton.

Berlin, Heinrich
1963 "The Palenque Triad." *Journal de la Société des Américanistes,* n.s. 52:91–99. Paris.

Berlo, Janet Catherine
1984 *Teotihuacan Art Abroad: A Study of Metropolitan Style and Provincial Transformation in Incensario Workshops*, Parts 1 and 2. B.A.R. International Series 199(i). Oxford.

Beyer, Hermann
1935 "The Date on Lintel 10 of Yaxchilan." *Maya Research* 2(4):394–397. New York.

Blanton, Richard E.
1981 "The Rise of Cities." In *Handbook of Middle American Indians, Supplement*, vol. 1, *Archaeology*, edited by Victoria Reifler Bricker and Jeremy A. Sabloff, pp. 392–400. Austin: University of Texas Press.
1983 "Advances in the Study of Cultural Evolution in Prehispanic Highland Mesoamerica." In *Advances in World Archaeology*, vol. 2, edited by Fred Wendorf and Angela Close, pp. 245–288. New York: Academic Press.

Bloch, Maurice, ed.
1975 *Political Language and Oratory in Traditional Societies*. London, New York, and San Francisco: Academic Press.

Blom, Frans
1924 "Archaeology: Report of Mr. Franz Blom on the Preliminary Work at Uaxactun." *Carnegie Institute of Washington Year Book* 23:217–219.

Blom, Frans, and Gertrude Duby de Blom
1957 *La selva lacandona: Andanzas arqueológicas*, vol. 2. Mexico City.

Branstetter, Katherine B.
1974 "Tenejapans on Clothing and Vice Versa: The Social Significance of Clothing in a Mayan Community in Chiapas, Mexico." Ph.D. dissertation, University of California at Berkeley.

Bricker, Victoria Reifler
1981 *The Indian Christ, the Indian King: The Historical Substrate of Maya Myth and Ritual*. Austin: University of Texas Press.
1983 "Directional Glyphs in Maya Inscriptions and Codices." *American Antiquity* 48:347–353.

Bruce, Robert
1975 *Lacandon Dream Symbolism*, vol. 1. Mexico City: Ediciones Euro-Americanas.

Burns, Allan F.
1983 *An Epoch of Miracles: Oral Literature of the Yucatec Maya*. Austin: University of Texas Press.

Calvino, Italo
1974 *Invisible Cities*. Translated by William Weaver. New York: Harcourt Brace Jovanovich.

Carlson, John
1984 "Venus and Ritual Warfare in Ancient Mesoamerica: New Light from the Maya Grolier Codex." Paper presented at El Simposio de Arqueoastronomía y Etnoastronomía en Mesoamérica, Mexico City.

Carlson, John, and Linda Landis
1985 "Bands, Bicephalic Dragons, and Other Beasts: The Skyband in Maya Art and Iconography." In *Fourth Palenque Round Table, 1980*, edited by Merle Greene Robertson and Elizabeth P. Benson, pp. 115–140. San Francisco: Pre-Columbian Art Research Institute.

Carrasco, David
1982 *Quetzalcoatl and the Irony of Empire: Myths and Prophecies in the Aztec Tradition*. Chicago: University of Chicago Press.

Carrasco V., Ramón
1986 "La lápida del edificio 8 y los cambios en la Gran Plaza de Yaxchilan." Paper presented at Sexta Mesa Redonda de Palenque.

Charnay, Désiré
1863 *Cités et ruines américaines*. Paris: Gide.
1885 *Les anciennes villes du Nouveau monde*. Paris: Hachette.
1887 *Expédition au Yucatan*. *Société des Américanistes de Belgique*, 3d ser. 10:65–78. Brussels.

Childe, V. Gordon
1950 "The Urban Revolution." *Town Planning Review* 21:3–17. University of Liverpool.

Ching, Frank
1988 *Ancestors: 900 Years in the Life of a Chinese Family*. New York: William Morrow and Co.

Coe, Michael D.
1965 "A Model of Ancient Community Structure in the Maya Lowlands." *Southwestern Journal of Anthropology* 21(2):97–114.
1973 *The Maya Scribe and His World*. New York: Grolier Club.
1978 *Lords of the Underworld*. Princeton: Princeton University Press.
1987 *The Maya*. 4th ed. New York: Thames and Hudson.

Coe, William R.
1967 *Tikal: A Handbook of the Ancient Maya Ruins*. Philadelphia: University Museum, University of Pennsylvania.

Coggins, Clemency Chase
1975 "Painting and Drawing Styles at Tikal: An Historical and Iconographical Reconstruction." Ph.D. dissertation, Harvard University.
1976 "A Role for the Art Historian in an Era of New Archaeology." *Proceedings of the 42nd Internationl Congress of Americanists, Paris* 7:315–320.
1979 "A New Order and the Role of the Calendar: Some Implications of the Middle Classic Period at Tikal." In *Maya Archaeology and Ethnohistory*, edited by Norman Hammond and Gordon R. Willey, pp. 38–50. Austin: University of Texas Press.
1980 "The Shape of Time: Some Political Implications of a Four-Part Figure." *American Antiquity* 45:727–739.

Cohodas, Marvin
1976a "The Identification of Workshops, Schools, and Hands at Yaxchilan, a Classic Maya Site in Mexico." *Proceedings of the 42nd International Congress of Americanists, Paris*

7:301–313.

1976b "The Iconography of the Panels of the Sun, Cross, and Foliated Cross at Palenque: Part III." In *Segunda Mesa Redonda de Palenque,* edited by Merle Greene Robertson, pp. 155–176. Pebble Beach, Calif.: Robert Louis Stevenson School.

Colby, Benjamin N.

1962 "Elements of a Mesoamerican Personality Pattern." *XXXV International Congress of Americanists, Mexico* 2:125–129.

1967 "Psychological Orientations." In *Handbook of Middle American Indians,* vol. 6, *Social Anthropology,* edited by Robert Wauchope and Manning Nash, pp. 416–431. Austin: University of Texas Press.

Cortez, Constance

1986 "The Principal Bird Deity in Preclassic and Early Classic Maya Art." Master's thesis, University of Texas at Austin.

Cortez, Constance, M. D. Hieronymous, and Ruth J. Krochock

1982 "Selected Hieroglyphic Texts Pertaining to the Life of Bird Jaguar III of Yaxchilan." Manuscript courtesy of authors.

de la Fuente, Beatriz

1967 "Las esculturas de Yaxchilan en el Museo de Antropología." *Anales del Instituto de Investigaciones Estéticas* 9(36):5–13.

1974 "La escultura maya clásica en la provincia del Usumacinta." *Artes de México* 167:61–81.

de la Garza, Mercedes

1984 *El universo sagrado de la serpiente entre los mayas.* Mexico City: Universidad Nacional Autónoma de México.

1987 Extasis de sueño y muerte en iniciaciones mayas. In *Memorias del Primer Coloquio Internacional de Mayistas,* pp. 1096–1106. Mexico City: Universidad Nacional Autónoma de México.

Delgaty, Alfa Hurley Vda. de. *See* Hurley Vda. de Delgaty, Alfa

Diccionario de Motul

1929 *Maya-español, atribuido a Fray Antonio de Ciudad Real, y Arte de lengua maya, por Fray Juan Coronel.* Edited by Juan Martínez Hernández. Mérida: Talleres de la Compañía Tipográfica Yucateca.

Duncan, James S.

1976 "Landscape and the Communication of Social Identity." In *The Mutual Interaction of People and Their Built Environment,* edited by A. Rapoport, pp. 391–406. The Hague: Mouton; Chicago: Aldine.

Durkheim, Emile

1915 *The Elementary Forms of the Religious Life: A Study in Religious Sociology.* Translated by Joseph Ward Swain. New York: Macmillan Co.; London: G. Allen and Unwin.

Earle, Duncan Maclean, and Dean R. Snow

1985 "The Origin of the 260-day Calendar: The Gestation Hypothesis Reconsidered in Light of Its Use among the Quiché Maya." In *Fifth Palenque Round Table, 1983,* edited by Merle Greene Robertson and Virginia M. Fields, pp. 241–243. San Francisco: Pre-Columbian Art Research Center.

Edmonson, Munro S.

1960 "Nativism, Syncretism, and Anthropological Science." *Middle American Research Institution Publication* 19:181–204. New Orleans: Tulane University.

Eliade, Mircea

1958 *Patterns in Comparative Religion.* London: Sheed and Ward.

1965 *The Myth of the Eternal Return.* New York: Pantheon Books.

1972 *Shamanism: Archaic Techniques of Ecstacy.* Translated by William R. Trask. Rev. ed. Bollingen Series 76. Princeton: Princeton University Press.

Farriss, Nancy M.

1984 *Maya Society under Colonial Rule: The Collective Enterprise of Survival.* Princeton: Princeton University Press.

Flannery, Kent

1972a "The Origins of the Village as a Settlement Type in Mesoamerica and the Near East." In *Man, Settlement, and Urbanism,* edited by P. J. Ucko, R. Tringham, and G. W. Dimbleby, pp. 17–22. London: G. Duckworth and Co.

1972b "The Cultural Evolution of Civilizations." *Annual Review of Ecology and Systematics* 3:399–426.

Folan, William J., Ellen Kintz, and Laraine A. Fletcher

1985 *Coba: A Classic Maya Metropolis.* New York: Academic Press.

Fought, John G.

1972 *Chorti (Mayan) Texts (I).* Edited by Sarah S. Fought. Philadelphia: University of Pennsylvania Press.

Fox, James A., and John S. Justeson

1986 "Classic Maya Dynastic Alliance and Succession." In *Handbook of Middle American Indians, Supplement,* vol. 4, *Ethnohistory,* edited by Victoria Reifler Bricker and Ronald Spores, pp. 7–34. Austin: University of Texas Press.

Frankfort, Henri

1948 *Kingship and the Gods: A Study of Ancient Near Eastern Religion as the Integration of Society and Nature.* Chicago: University of Chicago Press.

Freidel, David A.

1981 "The Political Economics of Residential Dispersion among the Lowland Maya." In *Lowland Maya Settlement Patterns,* edited by Wendy Ashmore, pp. 372–382. Albuquerque: University of New Mexico Press.

1983 "Political Systems in Lowland Yucatan: Dynamics and Structure in Maya Settlement." In *Prehistoric Settlement Patterns,* edited by

Evon Z. Vogt and Richard M. Leventhal, pp. 375–386. Albuquerque: University of New Mexico Press.

1986 "Maya Cosmology." Talk given at Introduction to Maya Hieroglyphic Writing Workshop, Austin.

Freidel, David A., and Anthony P. Andrews

1984 "The Loltun Bas-relief and the Origins of Maya Kingship." Manuscript courtesy of authors.

Freidel, David A., and Vernon Scarborough

1982 "Subsistence, Trade, and the Development of the Coastal Maya." In *Maya Subsistence*, edited by Kent Flannery, pp. 131–151. New York: Academic Press.

Freidel, David A., and Linda Schele

1988 "Kingship in the Late Preclassic Maya Lowlands: The Instruments and Places of Ritual Power." *American Anthropologist* 90(3): 547–567.

Furbee, Louanna, and Robert A. Benfer

1983 "Cognitive and Geographic Maps: Study of Individual Variation among Tojolabal Mayans." *American Anthropologist* 85(2): 305–334.

Furst, Peter T.

1976 "Fertility, Vision Quest, and Auto-Sacrifice: Some Thoughts on Ritual Blood-Letting among the Maya." In *Segunda Mesa Redonda de Palenque*, edited by Merle Greene Robertson, pp. 181–193. Pebble Beach, Calif.: Robert Louis Stevenson School.

Fuson, Robert H.

1969 "The Orientation of Mayan Ceremonial Centers." *Annals of the Association of American Geographers* 59(5): 494–511.

Galindo, Juan

1833 "Description of the River Usumacinta, in Guatemala." *Journal of the Royal Geographical Society* 3: 59–64.

García Moll, Roberto

1977 "Los escalones labrados del edificio 33, Yaxchilan, Chiapas." *Revista Mexicana de Estudios Antropológicos* 23(3): 395–423.

1978 "Conservación de monumentos en Yaxchilan, Chiapas." *Revista Mexicana de Estudios Antropológicos* 24(3): 257–286.

García Moll, Roberto, and Daniel Juárez Cossío

1986 *Yaxchilán: Antología de su descubrimiento y estudios*. Mexico City: Instituto Nacional de Antropología e Historia, Serie Arqueología.

Gates, William, trans.

1978 *Friar Diego de Landa's "Yucatan" before and after the Conquest*. New York: Dover. Originally published as Maya Society Publication no. 20, Baltimore, 1937.

Geertz, Clifford

1980 *Negara: Theatre-State in 19th Century Bali*. Princeton: Princeton University Press.

1983 *Local Knowledge: Further Essays in Interpretive Anthropology*. New York: Basic Books.

Girard, Rafael

1966 *Los mayas*. Mexico City: LibroMex.

Gossen, Gary H.

1974 *Chamulas in the World of the Sun: Time and Space in a Maya Oral Tradition*. Cambridge, Mass.: Harvard University Press.

1986 "Preface" and "Mesoamerican Ideas as a Foundation for Regional Synthesis." In *Symbol and Meaning beyond the Closed Community*, edited by Gary H. Gossen, pp. ix–x, 1–8. Albany: Institute for Mesoamerican Studies.

Graham, Ian

1977 *Corpus of Maya Hieroglyphic Inscriptions*, vol. 3, part 1, Yaxchilan. With Eric von Euw. Cambridge, Mass.: Peabody Museum of Archaeology and Ethnology, Harvard University.

1979 *Corpus of Maya Hieroglyphic Inscriptions*, vol. 3, part 2, Yaxchilan. Cambridge, Mass.: Peabody Museum of Archaeology and Ethnology, Harvard University.

1982 *Corpus of Maya Hieroglyphic Inscriptions*, vol. 3, part 3, Yaxchilan. Cambridge, Mass.: Peabody Museum of Archaeology and Ethnology, Harvard University.

Greene Robertson, Merle

1972 "The Ritual Bundles of Yaxchilan." Paper presented at Tulane Symposium on the Art of Latin America, New Orleans. Manuscript courtesy of author.

1974 "The Quadripartite Badge: A Badge of Rulership." In *Primera Mesa Redonda de Palenque, Part I*, edited by Merle Greene Robertson, pp. 77–94. Pebble Beach, Calif.: Robert Louis Stevenson School.

1984 *The Sculpture of Palenque*, vol. 1, *The Temple of the Inscriptions*. Princeton: Princeton University Press, 1984.

1985a *The Sculpture of Palenque*, vol. 2, *The Early Buildings of the Palace and the Wall Paintings*. Princeton: Princeton University Press.

1985b *The Sculpture of Palenque*, vol. 3, *The Late Buildings of the Palace*. Princeton: Princeton University Press.

Grieder, Terence

1975 "The Interpretation of Ancient Symbols." *American Anthropologist* 77(4): 849–855.

Guillemin, George F.

1968 "Development and Function of the Tikal Ceremonial Center." *Ethnos* 33: 1–39.

Guirard, Pierre

1971 *Semiology*. London and Boston: Routledge and Kegan Paul.

Guiteras-Holmes, Calixta

1961 *Perils of the Soul: The World View of a Tzotzil Indian*. New York: Free Press of Glencoe.

Gurvitch, Georges

1964 *The Spectrum of Social Time*. Dordrecht, Holland: D. Reidal.

Hall, Edward

1959 *The Silent Language*. New York: Doubleday.

Hammond, Norman

1982 "Pom for the Ancestors." *Mexicon* 3(5): 77–79.

1987 "Inside the Black Box: Defining Maya Polity."

Paper written for School of American Research Seminar on the Classic Maya. Manuscript courtesy of author.

Hartung, Horst
1971 *Die Zeremonialzentren der Maya: Ein Beitrag zur Untersuchung der Planungsprinzipien.* Graz: Akademische Druck-u. Verlagsanstatt.
1984 "Alignments in Architecture and Sculpture of Maya Centers: Notes on Piedras Negras, Copan, and Chichen Itza." *Ibero-Amerikanisches Archiv* N.F. Jg. 10, H.2: 223–240.

Helms, Mary W.
1979 *Ancient Panama: Chiefs in Search of Power.* Austin: University of Texas Press.

Heyden, Doris
1986 "Metaphors, Nahualtocaitl, and Other 'Disguised' Terms among the Aztecs." In *Symbol and Meaning beyond the Closed Community,* edited by Gary H. Gossen, pp. 35–43. Albany: Institute for Mesoamerican Studies.

Higushi, Tadahiko
1983 *The Visual and Spatial Structure of Landscapes.* Cambridge, Mass.: MIT Press.

Holland, William
1963 "Psicoterapía maya en los altos de Chiapas." *Estudios de Cultura Maya* 3: 261–278.

Hopkins, Nicholas A.
1984 "Classic Maya Kinship Systems: Epigraphic and Ethnographic Evidence for Patrilineality." Paper presented at annual meeting of American Anthropological Association.

Hunt, Eva
1977 *The Transformation of the Hummingbird: Cultural Roots of a Zinacantan Mythical Poem.* Ithaca: Cornell University Press.

Hurley Vda. de Delgaty, Alfa, and Agustín Ruiz Sánchez
1978 *Diccionario tzotzil de San Andrés con variaciones dialectales.* Serie de Vocabularios y Diccionarios Indígenas, no. 22. Mexico City: Instituto Lingüístico de Verano.

Isaac, Erich
1961–1962 "The Act and the Covenant: The Impact of Religion on the Landscape." *Landscape* 2: 12–17.

Izquierdo, José Antonio
1980 "The Lessons of Yaxchilan." Master's thesis, University of Texas at Austin.

Jacobs, Jane
1969 *The Economy of Cities.* New York: Random House.

Jones, Christopher, and Linton Satterthwaite
1982 *The Monuments and Inscriptions of Tikal: The Carved Monuments.* Tikal Report 33, part A. Philadelphia: University Museum, University of Pennsylvania.

Jones, Grant D.
1982 "Agriculture and Trade in the Colonial Period Central Maya Lowlands." In *Maya Subsistence,* edited by Kent Flannery, pp. 275–293. New York: Academic Press.

Joralemon, P. David
1971 *A Study of Olmec Iconography.* Studies in Pre-Columbian Art and Archaeology, vol. 7. Washington, D.C.: Dumbarton Oaks.
1974 "Ritual Blood Sacrifice among the Ancient Maya: Part I." In *Primera Mesa Redonda de Palenque, Part 2,* edited by Merle Greene Robertson, pp. 59–75. Pebble Beach, Calif.: Robert Louis Stevenson School.

Kelley, David Humiston
1962 "Glyphic Evidence for a Dynastic Sequence at Quirigua, Guatemala." *American Antiquity* 27(3): 323–335.
1965 "The Birth of the Gods at Palenque." *Estudios de Cultura Maya* 5: 93–134.
1975 "Planetary Data on Caracol Stela 3." In *Archaeoastronomy in Pre-Columbian America,* edited by Anthony F. Aveni, pp. 257–262. Austin: University of Texas Press.
1977 "Maya Astronomical Tables and Inscriptions." In *Native American Astronomy,* edited by Anthony F. Aveni, pp. 57–73. Austin: University of Texas Press.

Kidder, Tristram R.
1985 "Artifacts." In *A Consideration of the Early Classic Period in the Maya Lowlands,* edited by Gordon R. Willey and Peter Mathews, pp. 95–110. Albany: Institute for Mesoamerican Studies.

Klein, Cecelia
1977 "The Identity of the Central Deity on the Aztec Calendar Stone." In *Selected Readings in Pre-Columbian Art History,* edited by Alana Cordy-Collins, pp. 167–190. Palo Alto: Peed Publications.
1987 "The Ideology of Autosacrifice at the Templo Mayor." In *The Aztec Templo Mayor,* edited by Elizabeth H. Boone, pp. 293–370. Washington, D.C.: Dumbarton Oaks.
1988 "Mayamania: 'The Blood of Kings' in Retrospect." *Art Journal* 47(1): 42–46.

Kubler, George
1943 "The Cycle of Life and Death in Metropolitan Aztec Sculpture." *Gazette des Beaux Arts* 23: 259–268.
1962 *The Shape of Time: Remarks on the History of Things.* New Haven: Yale University Press.
1969 *Studies in Classic Maya Iconography.* Memoirs of the Connecticut Academy of Arts and Sciences, vol. 18. New Haven.
1971 "Commentary on 'Early Architecture and Sculpture in Mesoamerica' by Tatiana Proskouriakoff." In *Observations on the Emergence of Civilization in Mesoamerica,* edited by R. F. Heizer and J. A. Graham. *Contributions of the University of California Archaeological Research Facility* 11. Berkeley.
1975 *The Art and Architecture of Ancient America.* 2d ed. London: Penguin Books.
1985 "Pre-Columbian Pilgrimages in Mesoamerica." In *Fourth Palenque Round Table, 1980,* edited by Merle Greene Robertson and Eliza-

beth P. Benson, pp. 313–316. San Francisco: Pre-Columbian Art Research Institute.

Kurjack, Edward B.

1974 *Prehistoric Lowland Maya Community and Social Organization: A Case Study at Dzibilchaltun, Yucatan, Mexico. Middle American Research Institute Publication* 38. New Orleans: Tulane University.

Landa, Diego de. *See* Gates, William, trans. 1978

Laughlin, Robert M.

1976 *Of Wonders Wild and New: Dreams from Zinacantan.* Smithsonian Contributions to Anthropology 22. Washington, D.C.: Smithsonian Institution Press.

Layton, Robert

1981 *The Anthropology of Art.* New York: Columbia University Press.

León-Portilla, Miguel

1968 *Tiempo y realidad en el pensamiento maya.* Mexico City: Instituto de Investigaciones Históricas, Universidad Nacional Autónoma de México.

1969 *Pre-Columbian Literatures of Mexico.* Norman: University of Oklahoma Press.

1988 *Time and Reality in the Thought of the Maya.* 2d ed. Norman: University of Oklahoma Press.

Leventhal, Richard M.

1983 "Household Groups and Classic Maya Religion." In *Prehistoric Settlement Patterns,* edited by Evon Z. Vogt and Richard M. Leventhal, pp. 55–76. Albuquerque: University of New Mexico Press.

Lévi-Strauss, Claude

1966 *The Savage Mind.* Chicago: University of Chicago Press.

Lounsbury, Floyd G.

1982 "Astronomical Knowledge and Its Uses at Bonampak, Mexico." In *Archaeoastronomy in the New World,* edited by Anthony F. Aveni, pp. 143–168. Cambridge: Cambridge University Press.

1986 "Mayan Attention to Jupiter's Departures from the Second Stationary Point." Paper presented at Second Oxford International Conference on Archaeoastronomy, Mérida.

Lynch, Kevin

1960 *The Image of the City.* Cambridge, Mass.: MIT Press.

MacLeod, Barbara

1983 "Remembrances of Cycles Past: T669b in Palenque Katun Histories." In *Contribution to Maya Hieroglyphic Decipherment, I,* edited by Stephen Houston, pp. 50–59. New Haven: Human Relations Area Files.

1989 "Writing on the Curved Page: A Reading for the Manik Collocation in the Primary Standard Sequence. *Mexicon* 11:2730.

1990 "The God N/Step Set in the Primary Standard Sequence." In *The Maya Vase Book,* edited by Justin Kerr, 2:331–348. New York: Kerr Associates.

Maler, Teobert

1901 *Researches in the Central Portion of the Usumatsintla Valley.* Memoirs of the Peabody Museum, vol. 2, no. 1. Cambridge, Mass.

1903 *Researches in the Central Portion of the Usumatsintla Valley.* Memoirs of the Peabody Museum, vol. 2, no. 2. Cambridge, Mass.

1911 *Explorations in the Department of Peten, Guatemala: Tikal.* Memoirs of the Peabody Museum, vol. 5, no. 1. Cambridge, Mass.

Maquet, Jacques

1986 *The Aesthetic Experience: An Anthropologist Looks at Art.* New Haven: Yale University Press.

Marcus, Joyce

1983 "On the Nature of the Mesoamerican City." In *Prehistoric Settlement Patterns,* edited by Evon Z. Vogt and Richard M. Leventhal, pp. 195–242. Albuquerque: University of New Mexico Press.

Marquina, Ignacio

1964 *Arquitectura prehispánica.* Memorias del Instituto Nacional de Antropología e Historia. Mexico City.

Mathews, Peter L.

1984 "A Maya Hieroglyphic Syllabary." In *Phoneticism in Mayan Hieroglyphic Writing,* edited by John S. Justeson and Lyle Campbell, pp. 311–314. Albany: Institute for Mesoamerican Studies.

1985 "Maya Early Classic Monuments and Inscriptions." In *A Consideration of the Early Classic Period in the Maya Lowlands,* edited by Gordon R. Willey and Peter Mathews, pp. 5–54. Albany: Institute for Mesoamerican Studies.

1988 "The Sculpture of Yaxchilan." Ph.D. dissertation, Yale University.

Mathews, Peter, and David Pendergast

1979 "The Altun Ha Jade Plaque: Deciphering the Inscription." In *Contributions of the University of California Archaeological Research Facility* 41:197–214. Berkeley.

Maudslay, Alfred P.

1889–1902 *Biologia Centrali-Americani,* vol. 2, *Archaeology.* London: Dulen and Company.

Mayer, K. H.

1984 *Maya Monuments of Unknown Provenience in the United States.* Ramona, Calif.: Acoma Books.

Miles, S. W.

1957 "Maya Settlement Patterns: A Problem for Ethnology and Archaeology." *Southwest Journal of Anthropology* 13:239–248.

Miller, Mary Ellen

1985 "The Cookie Cutter Master of Yaxchilan." Paper presented at College Art Association annual meeting, in the symposium "New Approaches in the Study of Style and Aesthetics in Mesoamerican Art."

1986 *The Murals of Bonampak.* Princeton: Princeton University Press.

Miller, Mary Ellen, and Stephen Houston

1982 "The Maya Ballgame." Manuscript courtesy

of authors.

Millon, Henry, and Linda Nochlin, eds.
1978 *Art and Architecture in the Service of Politics.* Cambridge, Mass.: MIT Press.

Morley, Sylvanus G.
1931 "Report of the Yaxchilan Expedition." *Carnegie Institution of Washington Year Book,* pp. 132–139. Washington, D.C.
1937–1938 *The Inscriptions of Peten,* vols. 2 and 5. Carnegie Institution of Washington Publication 437. Washington, D.C. (Page references are to vol. 2, plate references to vol. 5.)

Morley, Sylvanus G., George Brainerd, and Robert Sharer
1983 *The Ancient Maya.* 4th ed. Stanford: Stanford University Press.

Morris, Walter F., Jr.
1985 "Flowers, Saints and Toads: Ancient and Modern Maya Textile Design Symbolism." *NGR,* Winter, pp. 63–79.
1987 *Living Maya.* New York: Harry N. Abrams.

Munn, Nancy
1966 "Visual Categories: An Approach to the Study of Representational Systems." *American Anthropologist* 68:936–950.

Munro, Thomas
1965 *Oriental Aesthetics.* Cleveland: Press of Western Reserve University.

Nash, June
1970 *In the Eyes of the Ancestors: Beliefs and Behavior in a Maya Community.* New Haven: Yale University Press.

Neuenswander, Helen
1981 "Vestiges of Maya Time Concepts in a Modern Community." *Estudios de Cultura Maya* 13:125–160.

Nicholson, H. B.
1973 Eduard Georg Seler, 1849–1922. In *Handbook of Middle American Indians,* vol. 13, *Guide to Ethnohistorical Sources, Part Two,* edited by Robert Wauchope, Howard F. Cline, and John B. Glass, pp. 348–369. Austin: University of Texas Press.

Norman, V. Garth
1976 *Izapa Sculpture: Parts I and II.* Papers of the New World Archaeology Foundation 30. Provo, Utah: Brigham Young University Press.

Pasztory, Esther
1987 "Texts, Archaeology, Art, and History in the Templo Mayor: Reflections." In *The Aztec Templo Mayor,* edited by Elizabeth H. Boone, pp. 451–462. Washington, D.C.: Dumbarton Oaks.

Peirce, Charles S.
1955 *Philosophical Writings of Peirce.* Edited by Justus Buchler. New York: Dover Publications. Originally published in 1940.

Pérez Campa, Mario, and Mauricio Rosas K.
1987 "Dos nuevas lápidas esculpidas en Bonampak." In *Memorias del Primer Coloquio Internacional de Mayistas,* pp. 749–774. Mexico City: Universidad Nacional Autónoma de México.

Pettit, Philip
1975 *The Concept of Structuralism: A Critical Analysis.* Berkeley: University of California Press.

Preziosi, Donald
1979 *Architecture, Language, and Meaning: The Origins of the Built World and Its Semiotic Organization.* The Hague: Mouton.
1989 *Rethinking Art History: Meditations on a Coy Science.* New Haven: Yale University Press.

Proskouriakoff, Tatiana
1950 *A Study of Classic Maya Sculpture.* Carnegie Institution of Washington Publication 593. Washington, D.C.
1960 "Historical Implications of a Pattern of Dates at Piedras Negras, Guatemala." *American Antiquity* 25:454–475.
1961 "Portraits of Women in Maya Art." In *Essays in Pre-Columbian Art and Archaeology,* edited by S. K. Lothrop, pp. 81–99. Cambridge, Mass.: Harvard University Press.
1963 "Historical Data in the Inscriptions of Yaxchilan, Part I." *Estudios de Cultura Maya* 3:149–167.
1964 "Historical Data in the Inscriptions of Yaxchilan, Part II." *Estudios de Cultura Maya* 4:177–201.
1973 "The Hand-grasping-fish and Associated Hieroglyphs on Classic Maya Monuments." In *Mesoamerican Writing Systems,* edited by Elizabeth P. Benson, pp. 165–178. Washington, D.C.: Dumbarton Oaks.

Puleston, Dennis E.
1976 "The People of the Cayman/Crocodile: Riparian Agriculture and the Origin of Aquatic Motifs in Ancient Maya Iconography." In *Aspects of Ancient Maya Civilization,* edited by François-Auguste de Montequin, pp. 1–26. St. Paul: Hamline University.
1983 *The Settlement Survey of Tikal.* Tikal Report 13. Philadelphia: University Museum, University of Pennsylvania.

Recinos, Adrian, and Delia Goetz, trans.
1953 *The Annals of the Caqchiquels.* Norman: University of Oklahoma Press.

Redfield, Robert, and Milton Singer
1954 "The Cultural Role of Cities." *Economic Development and Cultural Change* 3:53–73.

Reents-Budet, Dorie
1989 "Narrative in Classic Maya Art." In *Word and Image in Maya Culture: Explorations in Language, Writing, and Representation,* ed. William F. Hanks and Don S. Rice, pp. 189–197. Salt Lake City: University of Utah Press.

Relaciones de Yucatan
1898–1900 In *Colección de documentos inéditos relativos al descubrimiento, conquista, y organización de las antiguas posesiones de Ultramar,* n.s. 11 and 13. Madrid: Real Academia de la Historia.

Ricketson, O. G., Jr.
1928 "Astronomical Observations in the Maya Area." *Geographical Review* 18:215–225.

Riese, Berthold
1977 *Yaxchilan (Menche Tinamit): Dokumentation der Inschriften.* Hamburg: Hamburgisches Museum für Völkerkunde.
1988 "Epigraphy of the Southeastern Zone in Relation to Other Parts of the Maya Realm." In *The Southeast Classic Maya Zone,* edited by Elizabeth H. Boone and Gordon R. Willey, pp. 67–94. Washington, D.C.: Dumbarton Oaks.
Riesman, David, Nathan Glazer, and Reuel Denney.
1953 *The Lonely Crowd.* New York: Doubleday.
Robertson, Donald
1963 *Pre-Columbian Architecture.* New York and London: George Braziller, Inc., and Prentice-Hall International.
Robertson, Merle Greene. *See* Greene Robertson, Merle
Robiscek, Francis, and Donald M. Hales
1981 *The Maya Book of the Dead: The Ceramic Codex.* Charlottesville: University of Virginia Art Museum.
Roland, Alan
1988 *In Search of Self in India and Japan: Toward a Cross-Cultural Psychology.* Princeton: Princeton University Press.
Roys, Ralph L., trans.
1965 *Ritual of the Bacabs.* Norman: University of Oklahoma Press.
1972 *The Indian Background of Colonial Yucatan.* Norman: University of Oklahoma Press. Originally published by Carnegie Institute of Washington, 1943.
Ruppert, Karl
1940 "A Special Assemblage of Maya Structures." In *The Maya and Their Neighbors,* edited by Clarence L. Hay et al., pp. 222–231. New York: D. Appleton-Century Co.
Ruz L., Alberto
1973 *El Templo de las Inscripciones, Palenque.* 3d ed. Instituto Nacional de Antropología e Historia, pub. 7. Mexico City.
Sahagún, Bernardino de
1969 *Florentine Codex: General History of the Things of New Spain,* Book 6. Translated by Arthur J. O. Anderson and Charles E. Dibble. Santa Fe: School of American Research and University of Utah.
Sanders, William T., and David Webster
1988 "The Mesoamerican Urban Tradition." In *American Anthropologist* 90(3): 521–546.
Saussure, Ferdinand de
1959 *Course in General Linguistics.* Translated by C. Bailey and A. Sechehaye. London: Owen.
Schaedel, Richard P.
1966 "Urban Growth and Ekistics on the Peruvian Coast." In *XXXVI Congreso Internacional de Americanistas* 1: 531–539. Seville. Offprint, Institute of Latin American Studies Offprint Series, no. 41, Austin.
Schele, Linda

1974 "Observations on the Cross Motif at Palenque." In *Primera Mesa Redonda de Palenque,* edited by Merle Greene Robertson, pp. 41–61. Pebble Beach, Calif.: Robert Louis Stevenson School.
1976a "Accession Iconography of Chan-Bahlum in the Group of the Cross at Palenque." In *Segunda Mesa Redonda de Palenque,* edited by Merle Greene Robertson, pp. 9–34. Pebble Beach, Calif.: Robert Louis Stevenson School.
1976b "The Palenque Triad: A Visual and Glyphic Approach." In *XLII Congrès International des Americanistes, Paris,* pp. 407–424.
1977 "Palenque: The House of the Dying Sun." In *Native American Astronomy,* edited by Anthony F. Aveni, pp. 43–56. Austin: University of Texas Press.
1979a "The Puleston Hypothesis: The Waterlily Complex in Classic Maya Art and Writing." Manuscript courtesy of author.
1979b "Genealogical Documentation on the Tri-figure Panels at Palenque." In *Tercera Mesa Redonda de Palenque,* edited by Merle Greene Robertson, pp. 41–70. Monterey, Calif.: Pre-Columbian Art Research, Herald Printers.
1979c *Notebook for the Maya Hieroglyphic Writing Workshop at Texas.* Austin: Institute of Latin American Studies.
1981 "Sacred Site and World View at Palenque." In *Mesoamerican Sites and World Views,* edited by Elizabeth P. Benson, pp. 87–118. Washington, D.C.: Dumbarton Oaks.
1982 *Maya Glyphs: The Verbs.* Austin: University of Texas Press.
1984a *Notebook for the Maya Hieroglyphic Writing Workshop at Texas.* Austin: Institute of Latin American Studies.
1984b "Human Sacrifice among the Classic Maya." In *Ritual Human Sacrifice in Mesoamerica,* edited by Elizabeth H. Boone, pp. 7–45. Washington, D.C.: Dumbarton Oaks.
1985 "The Hauberg Stela: Bloodletting and the Mythos of Maya Rulership." In *Fifth Palenque Round Table, 1983,* edited by Merle Greene Robertson and Virginia M. Fields, pp. 135–150. San Francisco: Pre-Columbian Art Research Institute.
1987 *Notebook for Maya Hieroglyphic Writing Workshop at Texas.* Austin: Institute of Latin American Studies.
1989 *Notebook for the XIII Maya Hieroglyphic Workshop at Texas.* Austin: Institute of Latin American Studies.
1990 *Notebook for the XIV Maya Hieroglyphic Writing Workshop at Texas.* Austin: Art Department, University of Texas at Austin.
1991 *Workbook for the XVth Maya Hieroglyphic Workshop at Texas.* Austin: Art Department, University of Texas at Austin.
Schele, Linda, and David Freidel
1990 *A Forest of Kings: The Untold Story of the*

Ancient Maya. New York: William Morrow and Company.

Schele, Linda, Peter Mathews, and Floyd G. Lounsbury
1977 "Parentage and Spouse Expressions from Classic Maya Inscriptions." Paper presented at International Conference on Maya Iconography and Writing, Guatemala City.

Schele, Linda, and Jeffrey Miller
1983 *The Mirror, the Rabbit, and the Bundle: Accession Expressions from the Classic Maya Inscriptions.* Studies in Pre-Columbian Art and Archaeology, vol. 25. Washington, D.C.: Dumbarton Oaks.

Schele, Linda, and Mary Ellen Miller
1986 *The Blood of Kings: Dynasty and Ritual in Maya Art.* Fort Worth: Kimbell Art Museum.

Schellhas, Paul
1904 *Representations of Deities of the Maya Manuscripts.* Papers of the Peabody Museum of American Archaeology and Ethnology vol. 4, no. 1. Cambridge, Mass.

Schmandt-Besserat, Denise
1978 "The Earliest Precursors of Writing." *Scientific American* 238:50–59.

Seler, Eduard
1902–1923 *Gesammelte Abhandlungen zur amerikanischen Sprach- und Altertumskunde.* 5 Vols. Berlin.
1915a "Die Teotihuacan-Kultur des Hochlands von Mexiko." In *Gesammelte Abhandlungen zur amerikanischen Sprach- und Altertumskunde* 5:405–585. Berlin.
1915b *Observations and Studies in the Ruins of Palenque.* Translated by Gisela Morgner. Reissued, Pebble Beach, Calif.: Robert Louis Stevenson School, 1977.

Simpson, Jon Erik
1972 "The Sacred Rite of Kingship at Yaxchilan." Master's thesis, Tulane University.
1976 "The New York Relief Panel—and Some Associations with Reliefs at Palenque and Elsewhere, Part I." In *Segunda Mesa Redonda de Palenque,* edited by Merle Greene Robertson, pp. 95–105. Pebble Beach, Calif.: Robert Louis Stevenson School.

Singer, Milton
1980 "Signs of the Self: An Exploration in Semiotic Anthropology." *American Anthropologist* 82:485–507.

Sjoberg, Gideon
1960 *The Pre-Industrial City: Past and Present.* Glencoe, Ill.: Free Press.

Smith, Jonathan Z.
1978 *Map Is Not Territory.* Leiden: Brill.

Smith, Mary Elizabeth
1973 *Picture Writing from Ancient Southern Mexico.* Norman: University of Oklahoma Press.

Smith, Robert Eliot
1987 *A Ceramic Sequence from the Pyramid of the Sun, Teotihuacan, Mexico.* Papers of the Peabody Museum of Archaeology and Ethnology, vol. 75. Cambridge, Mass.

Spinden, Herbert
1913 *A Study of Maya Art.* Memoirs of the Peabody Museum, vol. 6. Cambridge, Mass.: Harvard University Press.

Stephens, John L.
1969 *Incidents of Travel in Central America, Chiapas, and Yucatan.* 2 vols. New York: Dover Publications, Inc. (Originally published in 1841 by Harper and Row.)

Stone, Andrea
1983 "The Zoomorphs of Quirigua." Ph.D. dissertation, University of Texas at Austin.
1985 "Sacrifice and Sexuality: Metaphorical Relationships in Classic Maya Art." Paper presented at 45th International Congress of Americanists, Bogotá.
1989 "Disconnection, Foreign Insignia, and Political Expansion: The Warrior Stelae at Piedras Negras." In *Cultural Adjustments in Mesoamerica after the Decline of Teotihuacan,* edited by Richard A. Diehl and Janet Catherine Berlo, pp. 153–172. Washington, D.C.: Dumbarton Oaks, Trustees for Harvard University.

Stone, Doris Zemurray
1932 *Some Spanish Entradas, 1524–1695.* Middle American Research Series, No. 4, pp. 213–296. New Orleans: Tulane University.

Stone, Doris Z., trans.
1986 *Antonio de León Pinelo's Report Made in the Royal Council of the Indies on the Pacification and Population of the Manche and Lacandon, which Don Diego de Vera Ordonez de Villaquiran, Cavalier of the Order of Calatiava, etc., Wishes to Undertake.* Culver City: Labyrinthos.

Stuart, David
1983 "Epigraphic Evidence of Political Organization in the Usumacinta Drainage." Manuscript courtesy of author.
1984 "Royal Auto-sacrifice among the Maya: A Study of Image and Meaning." *RES* 7/8:6–20.
1985a "The 'Count of Captives' Epithet in Classic Maya Writing." In *Fifth Palenque Round Table, 1983,* edited by Merle Greene Robertson and Virginia M. Fields, pp. 97–102. San Francisco: Pre-Columbian Art Research Institute.
1985b "A New Child-Father Relationship Glyph." *Research Reports on Ancient Maya Writing* 2:7. Washington, D.C.: Center for Maya Research.
1986 "The Lu-bat Glyph and Its Bearing on the Primary Standard Sequence." Paper presented at the Primer Simposio Mundial sobre Epigrafía Maya, Guatemala City, August.
1987a "The Paintings of Tomb 12, Rio Azul." In *Rio Azul Reports,* No. 3, *The 1985 Season,* edited by R. E. W. Adams. San Antonio: University of Texas at San Antonio.

1987b *Ten Phonetic Syllables.* Research Reports on Ancient Maya Writing, No. 14. Washington, D.C.: Center for Maya Research.

1989 "Hieroglyphs on Maya Vessels." In *The Maya Vase Book,* edited by Justin Kerr. New York: Kerr Associates.

n.d. "Epigraphic Evidence of Political Organization in the Usumacinta Drainage." Manuscript provided by the author.

Sullivan, Thelma

1986 "A Scattering of Jades: The Words of the Aztec Elders." In *Symbol and Meaning beyond the Closed Community,* edited by Gary H. Gossen, pp. 9–17. Albany: Institute for Mesoamerican Studies.

Szalay, Lorand B., and Bela C. Maday

1983 "Implicit Culture and Psychocultural Distance." *American Anthropologist* 85:110–118.

Tambiah, S. J.

1976 *World Conqueror and World Renouncer: A Study of Buddhism and Polity in Thailand against a Historical Background.* Cambridge: Cambridge University Press.

Tate, Carolyn E.

1980 "The Maya Cauac Monster." Master's thesis, University of Texas at Austin.

1982 "The Maya Cauac Monster: Dynastic Contexts." In *Selected Readings in Pre-Columbian Art History,* edited by Alana Cordy-Collins, pp. 33–54. Palo Alto: Peek Publications.

1985 "Summer Solstice Events in the Reign of Bird Jaguar III of Yaxchilan." *Estudios de Cultura Maya* 16:85–112.

1986a "Maya Astronomical Rituals Recorded on Yaxchilan Structure 23." *Rutgers Art Review* 7:1–20.

1986b "The Language of Symbols in the Ritual Environment at Yaxchilan, Chiapas." Ph.D. dissertation, University of Texas at Austin.

1987 "The Royal Women of Yaxchilan." In *Memorias del Primer Coloquio Internacional de Mayistas,* pp. 807–828. Mexico City: Universidad Nacional Autónoma de México.

1989 "The Use of Astronomy in Political Statements at Yaxchilan." In *World Archaeoastronomy,* edited by Anthony F. Aveni, pp. 416–429. Cambridge: Cambridge University Press.

1991 "The Cosmological Stelae of Yaxchilan." In *Sixth Palenque Round Table, 1986,* edited by Merle Greene Robertson and V. M. Fields, pp. 102–109. Norman: University of Oklahoma Press.

Taube, Karl

1985 "The Classic Maya Maize God: A Reappraisal." In *Fifth Palenque Round Table, 1983,* edited by Merle Greene Robertson and Virginia M. Fields, pp. 171–181. San Francisco: Pre-Columbian Art Research Institute.

Taylor, Dicey

1983 "Classic Maya Costume: Regional Types of Dress." Ph.D. dissertation, Yale University.

Tedlock, Barbara

1982 *Time and the Highland Maya.* Albuquerque: University of New Mexico Press.

Tedlock, Barbara, ed.

1987 *Dreaming: Anthropological and Psychological Interpretations.* School of American Research Book. Cambridge: Cambridge University Press.

Tedlock, Dennis, trans.

1985 *Popol Vuh: The Definitive Edition of the Mayan Book of the Dawn of Life and the Glories of Gods and Kings.* New York: Simon and Schuster.

Thompson, Edward H.

1886 "Archaeological Research in Yucatan." *Proceedings of the American Antiquarian Society,* n.s. 4:248–254.

Thompson, J. Eric S.

1931 *Archaeological Investigations in the Southern Cayo District, British Honduras.* Field Museum of Natural History Anthropology Leaflet 25. Chicago.

1938 "Sixteenth and Seventeenth Century Reports on the Chol Mayas." *American Anthropologist* 40(4):584–604.

1946–1948 "The Dating of Structure 44, Yaxchilan, and Its Bearing on the Sequence of Texts at That Site." *Notes on Middle American Archaeology and Ethnology* 3(71):62–75. Washington, D.C.: Carnegie Institution of Washington.

1962 *A Catalog of Maya Hieroglyphs.* Norman: University of Oklahoma Press.

1970 *Maya History and Religion.* Norman: University of Oklahoma Press.

1971 *Maya Hieroglyphic Writing.* 3d ed. Norman: University of Oklahoma Press.

Townsend, Richard F.

1979 *State and Cosmos in the Art of Tenochtitlan.* Studies in Pre-Columbian Art and Archaeology, vol. 20. Washington, D.C.: Dumbarton Oaks.

1987 "Coronation at Tenochtitlan." In *The Aztec Templo Mayor,* edited by Elizabeth H. Boone, pp. 371–409. Washington, D.C.: Dumbarton Oaks.

Tozzer, Alfred M.

1911 *Preliminary Study of the Prehistoric Ruins of Tikal, Guatemala.* Memoirs of the Peabody Museum, vol. 5, no. 2. Cambridge, Mass.

Tuckerman, Bryant

1964 *Planetary, Lunar, and Solar Positions: A.D. 2 to A.D. 1649 at Five-day and Ten-day Intervals.* Philadelphia: American Philosophical Society.

Turner, Victor

1967 *The Forest of Symbols.* Ithaca: Cornell University Press.

Villagutierre Soto-Mayor, Juan de

1983 *Historia de la conquista de la provincia de el*

Itza . . . (1701). Translated by Robert D. Wood from 2d Spanish ed. Edited by Frank Camparato. Culver City: Labyrinthos.

Vogt, Evon Z.

1966 "Ancestor Worship in Zinacantan." *Actas del XXXVI Congreso Internacional de Americanistas, Madrid, 1964* 3:281–285.

1969 *Zinacantan.* Cambridge, Mass.: Belknap Press, Harvard University Press.

1970 *Zinacantecos of Mexico: A Modern Maya Way of Life.* Case Studies in Cultural Anthropology. New York: Holt, Rinehart and Winston.

1976 *Tortillas for the Gods: A Symbolic Analysis of Zinacanteco Ritual.* Cambridge, Mass.: Harvard University Press.

1981 "Some Aspects of the Sacred Geography of Highland Chiapas." In *Mesoamerican Sites and World Views,* edited by Elizabeth P. Benson, pp. 119–142. Washington, D.C.: Dumbarton Oaks.

1983 "Ancient and Contemporary Maya Settlement Patterns: A New Look from the Chiapas Highlands." In *Prehistoric Settlement Patterns,* edited by Evon Z. Vogt and Richard M. Leventhal, pp. 89–114. Albuquerque: University of New Mexico Press.

1985 "Cardinal Directions and Ceremonial Circuits in Mayan and Southwestern Cosmology." *National Geographic Research Reports (NGR)* 21:487–496.

Watanabe, John M.

1983 "In the World of the Sun: A Cognitive Model of Mayan Cosmology." *Man* 18, no. 4: 710–728.

1984 "'We Who Are Here': The Cultural Conventions of Ethnic Identity in a Guatemalan Indian Village, 1937–1980." Ph.D. dissertation, Harvard University.

Weitzmann, Kurt

1970 *Illustration in Roll and Codex: A Study of the Origin of Text Illustration.* Princeton: Princeton University Press.

Wheatley, Paul

1969 *City as Symbol.* University College London: H. K. Lewis and Co.

1971 *The Pivot of the Four Quarters: A Preliminary Enquiry into the Origins and Character of the Ancient Chinese City.* Chicago: Aldine Publishing Co.

Willey, Gordon R., and Demitri B. Shimkin

1973 "The Maya Collapse: A Summary View." In *The Classic Maya Collapse,* edited by T. Patrick Culbert, pp. 457–502. Albuquerque: University of New Mexico Press.

Ximénez, Fray

1929–1931 *Historia de la provincia de San Vicente de Chiapa y Guatemala de la Orden de Predicadores, 1720.* Biblioteca Goathemala, vols. 1–3. Guatemala.

Zorita, Alonso de

1963 *Life and Labor in Ancient Mexico: The Brief and Summary Relation of the Lords of New Spain.* Translated by Benjamin Keen. New Brunswick, N.J.: Rutgers University Press.

Zuidema, R. Tom

1964 *The Ceque System of Cuzco: The Social Organization of the Capital of the Incas.* Leiden: Bull Publisher.

Index